AFRICA
ADORNED

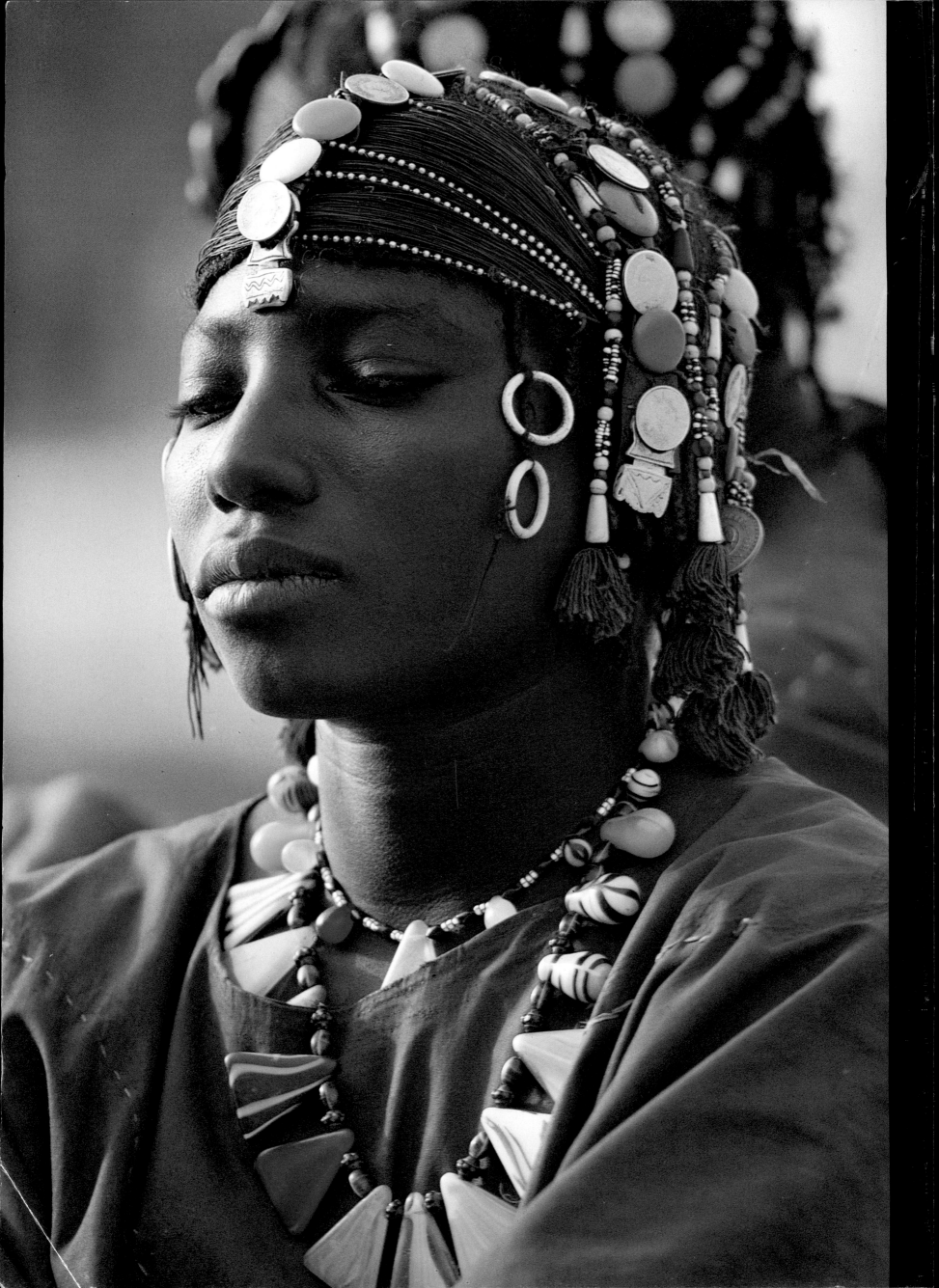

AFRICA ADORNED

Angela Fisher

THE HARVILL PRESS
LONDON

First published in Great Britain by Collins Publishers 1984
Reprinted 1985 (twice)
Published by Collins Harvill 1987
Reprinted 1988, 1989, 1992, 1994

This edition first published in 1996 by
The Harvill Press
2 Aztec Row, Berners Road, London N1 0PW

3 5 7 9 8 6 4

Copyright © Angela Fisher, 1984

A CIP catalogue record for title is available from the British Library

ISBN 1 86046 291 X

Photoset in Apollo by Ace Filmsetting Ltd, Frome, Somerset
Printed and bound in Italy by Conti Tipocolor, Florence

Designed by Stephen Coe and Ronald Clark
Typography by Marian Morris
Maps by Tom Stalker Miller

FRONTISPIECE: *Bella woman, Upper Volta.*

CONTENTS

ACKNOWLEDGEMENTS

The concept of this book arose in the first place from discussions with my brother, Simon Fisher, with whom I'd travelled extensively in Africa and the Middle East, and who has always encouraged my interest in traditional jewellery. His constructive help and advice over the seven years it has taken to complete the book have been invaluable. The idea of the book became reality through the support and apparently endless participation and contribution of expertise from Stephen Coe on the design, Don Paul on the text and John Goldblatt on the initial format. To these people I extend my greatest thanks, as to Toby Eady who steered the project through, and to my publisher Christopher MacLehose for his immense faith in the idea of the book. I am greatly indebted too to Ron Clark for his help in editing the pictures, in typography and in general art design, to Angela Dyer and Ariane Goodman for their work in editing the text, and to Marian Morris, Michael Devenish and Sara Kerruish of Collins; I appreciated their enthusiasm as much as I valued their assistance.

Equal thanks go to Fabby K. J. Nielsen for his extensive photographic contribution. This included not only participating in some of the most difficult travels in the field over a period of two years, but also help in the initial recording of jewellery in European collections. I am grateful, too, to all those who contributed field photographs (listed in the back of the book) and would like to thank in particular John Hawkins and George Zaloumis. The vast job of photographing collection pieces, in the hands of both private collectors and museums, was successfully undertaken by Heini Schneebeli in London and Bruno Piazza in Brussels.

Of all the contributions in this book, one of the most valuable was that of Pierre Loos, who gave generously of his knowledge and professional expertise in overseeing the selection of jewellery in collections to be included in this book. He not only gave much of his time but helped organize all the photographic work in Brussels. I am also grateful for the cooperation of all the collectors, museum curators and staff whose interest and dedication helped make it possible to photograph pieces of the highest quality. I extend my appreciation and thanks in this respect to Jef Vander Straete (Brussels), Collette and Jean Pierre Ghysels (Brussels), Klaus and Gertrude Anschel (London), Anne-Marie Gillion Crowet (Brussels), Max Itzikovitz (Paris), René and Anne Vander Straete (Brussels), J. Mestach (Brussels), Mimi Lipton (London), Nicole Church (Nairobi), Martial Bronsin (Brussels), Pierre Loos (Brussels), Asher Eskenasy (Paris), Jean Pierre and Annie Jernander, the Hon. Omari Bwana MP (Mombasa), Jette Botchinskie (Mombasa), Madame van Geluwe at the Musée Royale d'Afrique Centrale, Tervuren (Belgium), and the staffs of the Museum of Mankind (Ethnographic Department of the British Museum) and the National Museums of Kenya.

The library staff at the Museum of Mankind made my job of research not only easier but also much more pleasant than it might have been, and the foreign texts were helpfully translated by Yvette Wiener, Pierre Marchand and Karen Lambert. The time and care taken in reading and correcting my text by Werner Gillon, John Picton, Dr John Mack, Max Itzikovitz, Toby Jacks and A. L. Manjalla Benchaga M. Ahmed was both reassuring and immensely valuable.

Encouragement and personal support has come first and foremost from my mother, Kate Fisher, in South Australia and, despite all the problems of distance, has never wavered over the long seven years. In London, I've met with invaluable help and enthusiasm from Klaus and Gertrude Anschel (who also helped in translation and in reading the text), Hansjorg Meyer and Mimi Lipton, Ben and Linda Beveridge, Maureen Bell, Susan and James Beveridge, Korky and Susan Paul, Tessa Paul, Richard Ibrek, Patrick Dyer and Hans Peter Roettgger.

During fieldwork in Africa, many people provided generous assistance and hospitality; I should like to thank the following in particular. In Kenya: Dione and Barry Thatcher, Christine and Larry Jenkin, Diana and Peter Low, Yens Hessel, Tepilit Ole Saitoti, Ahmed Sheik Nabahani, James de V. Allen, and John Eames who provided the title. In Sudan: Alex Duncan, Jil Paul, and the managers of Interfreight Ltd in Juba. In Ethiopia: Jill and Geoffrey Last, Alemayehu K. Mariam, Feleke Ashine, Kessela Mengestu and Haileselassie Alemayehu. In Cameroun, Father Paul Fuchs and in Ghana, Jo and Peggy Appiah. In Niger: Carol Beckwith and Marion van Offelen (both of whose support outside Niger, too, has been outstanding), Makao bii Gao, and the companies Fougerolles and SATOM. In Morocco: Jilali Labghali, Marie-France Risser, Annie Brumbaugh and Patrick Williams. All these people helped more than they can have known in making me feel welcome, in giving me a base from which to work, or in providing first-hand information on their countries and on how best to set about my task of locating and meeting the peoples who form the subject of this book.

INTRODUCTION

My fascination with Africa stems from my first trip in 1970, when I visited southern Africa primarily to see the vast herds of animals which still wander freely on this beautiful continent. A year later I travelled to Tanzania, and it was on the Serengeti plains that I first encountered Maasai warriors grazing their cattle, their tall, slender bodies gleaming with fat and ochre and their long limbs accentuated with brightly coloured beads. Struck by their distinctive, dramatic style, my general interest in Africa crystallized at that moment into a specific desire to get to know both the nomadic and settled peoples of the African bush, and above all to capture for myself something of their presence, the elusive 'spirit' of Africa.

Later, in Kenya, a meeting with a close relative proved both helpful and significant. She was collecting tribal ornaments for her private museum and suggested that I should assist her by searching for pieces in the desert regions of northern Kenya. I jumped at the chance.

Travelling in this remote area was like stepping onto a different planet. Never before had I imagined such a variety of peoples, all distinguished by their striking and often strange body decoration. Some were covered with beads, others patterned with ritual scars, their ears and lips distended and plugged with ornaments. Ochre highlighted the graceful bodies of the young girls, while some of the elders wore remarkable hairstyles packed in blue clay. Led on by my new-found curiosity, I began to discover that all these exotic fashions – in jewellery, body art, even clothing – were not merely adopted for beauty. Each item was of individual significance and proffered a wealth of information about the wearer – about which tribe he came from, which age set within the tribe; about his exploits in battle or love. I learnt, for example, that young men remodelled their elaborate clay bun coiffures as they were initiated into adulthood, or marked their foreheads with ritual scars; that young girls declared themselves untouchable for a healing period of six weeks following circumcision, by covering their bodies with chalk and wearing no beads.

Later, as my travels took me from Kenya into neighbouring Ethiopia and then across Zaire into western Africa, I found that throughout the vastness of the continent the jewellery continued to change according to the materials available, the life-style and cultural contacts of the people. It even changed with the terrain in which they lived, differing from desert to forest, savannah to mountainside, between settled and nomadic groups of one tribe. In some areas such as northern Kenya, plant and animal materials were predominant until recently: belts might be made from ostrich eggshell or fine antelope bones, bracelets from leather, necklaces from the fibre of palm trees. Elsewhere, people had access to elements more precious by Western standards: ivory, bronze, silver and gold. Materials, designs and techniques might be of local origin, or brought along trade routes centuries old; certain pieces might be inspired by the achievements

of an illustrious chief, others by legend or simply by the creativity of a local craftsman. As I delved back through the oral and written history of Africa, I became increasingly aware of the refinements in form and technique achieved in parts of the continent – often centuries ago and sometimes well in advance of similar developments in Europe.

Recording this vast range of jewellery from so many different regions necessitated travelling in some very remote areas, as only there could I hope to find the traditional ornaments being made or worn. Sometimes it was impossible to reach a place by car or truck. Remote mountain villages in Ethiopia were easier to visit on horseback, though at times I was required by law to take an armed guard, for fear of bandits. Recording the culture of the nomads in the Sahel entailed a journey of six weeks on foot, travelling every day in the heat of the midday sun. And in southern Sudan, twelve-foot-high elephant grass in the world's largest swamp was impenetrable to any vehicle except dugout canoe. Even when it was possible to use a car, the roads at times were so bad that I averaged only fourteen kilometres an hour for days at a stretch. Road conditions aside, I was concerned by my lack of mechanical skills, and sometimes just felt that the continent was too big for me to tackle alone. On two major, long and difficult trips I was very glad to have the company of Fabby Nielsen, a Danish photographer from Kenya. His knowledge of the African bush was invaluable, and I am indebted to him for his important photographic contribution to this book as well as for his patience in helping me to develop my own skills with a camera.

In Africa the greatest problem is time. To gain acceptance and win the trust of local people, I had to adopt the pace of their life and learn to be patient. Only then would I be able to witness the unique ceremonies and rituals which are usually closed to the outside world. For me this was crucial, for it is only on such occasions that people wear their finest jewellery. At these ceremonies, too, the various stages in the 'passage of life' are often graphically indicated by changes in adornment.

The difficulties of witnessing festivals and ritual ceremonies are further increased by the fact that their timing may be affected by numerous factors: the death of a chief, the success of a harvest, the coming of the seasonal rains. In the West African Sahel I had to walk for five weeks with the Wodaabe nomads while we waited for the rains to begin, for it was not until there was enough pasture to support all their herds in one place that the thousands of nomads could gather for their annual celebration. Often, when I accepted an invitation for a particular date in the future, the problem was not simply one of waiting but of making a return visit without knowing exactly where to locate the same small group of nomads when the occasion arrived. Moreover, the ceremonies of many different peoples fall at much the same times of the year, and I plainly could not be in two different places at once. In planning to record such important ceremonies as the *Eunoto* – the transition to elderhood of Maasai warriors, which occurs every seven years in Kenya – I realized that I would have to set aside a great deal of time in order to complete this book.

Travelling as a woman alone, I was often viewed with suspicion, because in Africa a woman's role is traditionally restricted within the confines of the family. It was therefore vital that my motives were understood. However, once I had been accepted as part of the group, I found that there were distinct advantages to being a woman; as an honoured guest I was able to form close contacts with both sexes, being a threat to neither. As I was expected to sleep with the women and children, I was able to observe their domestic situation at first hand. Staying with a group of Guedra dancers in Morocco, for example, I watched and photographed the women's hair being braided and adorned and their hands tinted with henna, and discovered the stories behind each item they used and every design they drew. This intimacy and freedom with a camera would never have been allowed to me had I been a man. On the other hand, I was also included, as

a visitor and natural recipient of hospitality, in the men's activities, and was often invited to join them at mealtimes, so I was able to build up a bond of trust with them which later enabled me to witness some of the ceremonies denied even to their own women.

An enormous amount of care was needed to keep my camera equipment clean in the dusty or humid conditions I encountered, and to safeguard the film between exposure and development during the months of travelling in extreme temperatures. Such practical problems were insignificant, however, beside the complex social considerations of taking photographs in Africa.

My interest in buying examples of jewellery from local craftsmen often provided an entrée into their lives, and hence an opportunity to photograph the techniques they used in making jewellery. But still I frequently found it difficult or even impossible to get the pictures that I needed. This was mainly because many Africans believe that to capture their image is to capture their soul and take away its power, so they are suspicious, even terrified, of cameras. Less common, but becoming more prevalent with the increase in tourism, is the problem of photographic exploitation. When apparently innocent snapshots, agreed to in good faith, reappear as postcards on sale in the local market, it is hardly surprising that people feel anger and resentment and refuse to let further pictures be taken. Alternatively, they may demand a share in the apparent profits, as was the case in the old town of Jenné in Mali, where I was asked to pay £50 for the privilege of photographing an old woman whose huge gold earrings I felt it essential to record.

Photography is also a sensitive political issue, as 'emergent' Africa strives to present a sophisticated image to the rest of the world. Government officials usually regard their traditional culture, which we in the West value so highly, as 'primitive' in a derogatory sense, and often do not want it to be recorded or revealed. As a result, photography in some areas was either totally prohibited or else subject to severe restrictions – in central Africa, for instance, a permit could be obtained to photograph jewellery, but not people. So sensitive is this issue that on one occasion when I was recording an important ceremony attended by 10,000 nomads in a remote corner of the West African savannah, a certain Minister for the Interior ordered my arrest, and in the middle of the night I was taken without warning by a police escort and forced to leave the country.

Communication, too, has its problems, with each country of the continent presenting a multitude of languages and dialects. Translation into French or English often required two interpreters using a third language, a process which must have affected the accuracy of the facts I gathered. A greater difficulty still lay in understanding the complexity of African beliefs and superstitions, so far removed from the Western mind, that often give to jewellery a significance that is difficult, at times impossible, for outsiders to appreciate. Talismanic objects can carry the power to determine life or death for the wearer or a close relative, so these pieces are seldom shown to strangers, the secret stories behind them rarely revealed, and photographs are often clearly out of the question. (Many I had to photograph in private collections in Europe.) Old people who still maintained their traditional practices sometimes jealously guarded their meaning, at other times gave explanations that were vague or confused, the result of failing memories. The young, though willing to talk, were often uninterested in their own cultural heritage or simply ignorant of it. Interpreters, traders and artisans, in their eagerness to please or make a sale, were tempted to fabricate interesting but inaccurate details. No wonder that the information I obtained on my travels was sometimes confused and contradictory – to overcome this, I always double-checked my sources and wherever possible consulted numerous people on the same subject; when I returned to Europe I corroborated their statements with extensive research.

During seven years of travelling in Africa to research this book, I was con-

stantly aware that many traditions – including some of the outstanding styles of jewellery and dress – were rapidly becoming rarer or had already disappeared. That this should be so is tragic but understandable. Increasing contact with the rest of the world through trade and tourism has encouraged African peoples to adopt some of the ways and trappings of other nations. On successive visits to the isolated Dinka people in the Nile swamps of southern Sudan, I noticed that in a matter of months these proud nomads, traditionally naked except for a covering of ash and body beads, had, like many others on the continent, begun to wear synthetic headscarves, motif T-shirts, and even platform-heel shoes obtained from visiting traders, and were proudly displaying them as items of status. Political and religious pressures have added to this process of Westernization. In Kenya, I found Pokot women were discarding their earlobe stretchers and lip ornamentation at the request of a visiting government official who felt these were reminders of a 'primitive' past in a growing nation that was looking towards a more sophisticated future. And as Christianity and Islam continue to challenge traditional beliefs, the wonderful variety of form of symbolic jewellery is steadily being replaced by more standardized necklets with pendant Christian crosses or containers of metal or leather holding verses from the Koran.

Although my travels in Africa provided the basis of material for this book, I found that a considerable amount of reading on the subject was necessary to explain the religious, cultural and historical background to each area so that the jewellery could be understood in its proper context. It was also important to make a study of African ornaments in private collections and museums throughout Europe and Africa. In making, from this wealth of material, a final selection of the pieces to be shown in this book I received a great deal of help and co-operation from collectors, dealers and the staffs of many museums and libraries.

Their research and mine only served to emphasize what I already knew – that many great traditions had passed before my time, and that those I had been lucky enough to witness and record were now in danger of being lost. The desire to preserve these works of art, combined with a natural human acquisitiveness, had led museums and private collectors, most of them located outside the continent of Africa, to acquire more fine pieces of African jewellery than now remain in their country of origin. However, without their interest and the records they have compiled, many of the pieces shown in this book would have been discarded, destroyed or lost for ever.

Enthralled as I still am by this continent, I cannot hide my deep regret and sadness every time I return to see the waning tradition and colour of each ceremony or festival, each family or village scene. The most comforting areas to revisit are the lands of the nomadic wanderers and those few isolated settled peoples whose cultural and moral framework is still strong, who guard their traditional beliefs and are wary of Western influence. Their loyalty to time-honoured custom and their reluctance to change makes it possible for them to borrow from the outside world rather than be swamped by it. In them, artistic creativity is still very much alive; they are able to select from new materials and ideas, and transform them into innovative and unique art forms, clearly reflecting their own beliefs and sense of style.

For me, Africa will always be remembered as the home of an immense variety of peoples, outstanding in their many and imaginative forms of body decoration. In making this book, and in combining photographic images of these people and the jewellery they wear today with records of the most beautiful ornaments made in Africa since the thirteenth century, I have endeavoured to reveal the creative spirit of this extraordinary continent.

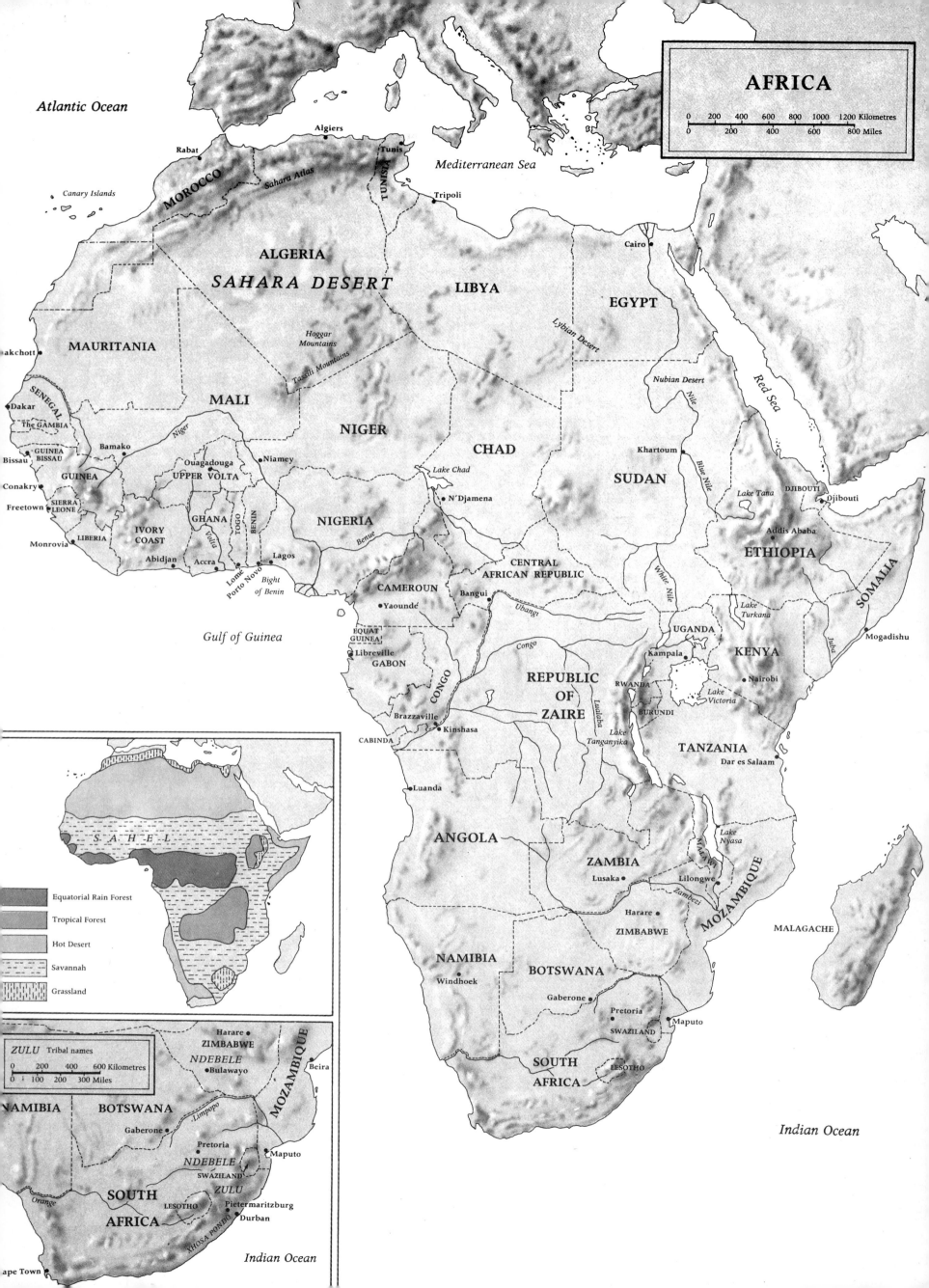

AFRICA

| 0 | 200 | 400 | 600 | 800 | 1000 | 1200 | Kilometres |
| 0 | | 200 | 400 | | 600 | 800 | Miles |

Atlantic Ocean

Mediterranean Sea

Algiers

Rabat

MOROCCO

Sahara Atlas

Canary Islands

TUNISIA

Tunis

Tripoli

Cairo

ALGERIA

SAHARA DESERT

LIBYA

EGYPT

Lybian Desert

MAURITANIA

akchott

Hoggar Mountains

Tassili Mountains

Nubian Desert

Nile

Red Sea

MALI

NIGER

CHAD

SUDAN

Khartoum

Blue Nile

Lake Tana

DJIBOUTI

Djibouti

SENEGAL

Dakar

The GAMBIA

Bissau

GUINEA BISSAU

Bamako

Niger

Niamey

Ouagadouga

UPPER VOLTA

Lake Chad

N'Djamena

Addis Ababa

ETHIOPIA

Conakry

GUINEA

SIERRA LEONE

Freetown

GHANA

Volta

TOGO

BENIN

NIGERIA

Benue

CENTRAL AFRICAN REPUBLIC

Bangui

White Nile

SOMALIA

Monrovia

LIBERIA

IVORY COAST

Abidjan

Accra

Lomé

Porto Novo

Lagos

Bight of Benin

CAMEROUN

Yaoundé

Ubangi

UGANDA

Lake Turkana

KENYA

Mogadishu

Gulf of Guinea

EQUAT GUINEA

Libreville

GABON

Congo

CONGO

Brazzaville

Kinshasa

CABINDA

Congo

REPUBLIC OF ZAIRE

RWANDA

BURUNDI

Kampala

Lake Victoria

Nairobi

Juba

Lualaba

Lake Tanganyika

TANZANIA

Dar es Salaam

Luanda

ANGOLA

Lake Nyasa

ZAMBIA

Lusaka

Lilongwe

MOZAMBIQUE

MALAGACHE

Harare

ZIMBABWE

Zambezi

Malawi

NAMIBIA

Windhoek

BOTSWANA

Gaberone

Pretoria

SWAZILAND

Maputo

SOUTH AFRICA

LESOTHO

Indian Ocean

Inset map (climate zones):

S A H E L

	Equatorial Rain Forest
	Tropical Forest
	Hot Desert
	Savannah
	Grassland

Inset map (southern Africa, tribal):

ZULU Tribal names

| 0 | 200 | 400 | 600 Kilometres |
| 0 | 100 | 200 | 300 Miles |

Harare

ZIMBABWE

NDEBELE

Bulawayo

MOZAMBIQUE

Beira

NAMIBIA

BOTSWANA

Gaberone

Limpopo

Pretoria

Maputo

NDEBELE

SWAZILAND

ZULU

SOUTH AFRICA

Orange

LESOTHO

XHOSA PONDO

Pietermaritzburg

Durban

ape Town

Indian Ocean

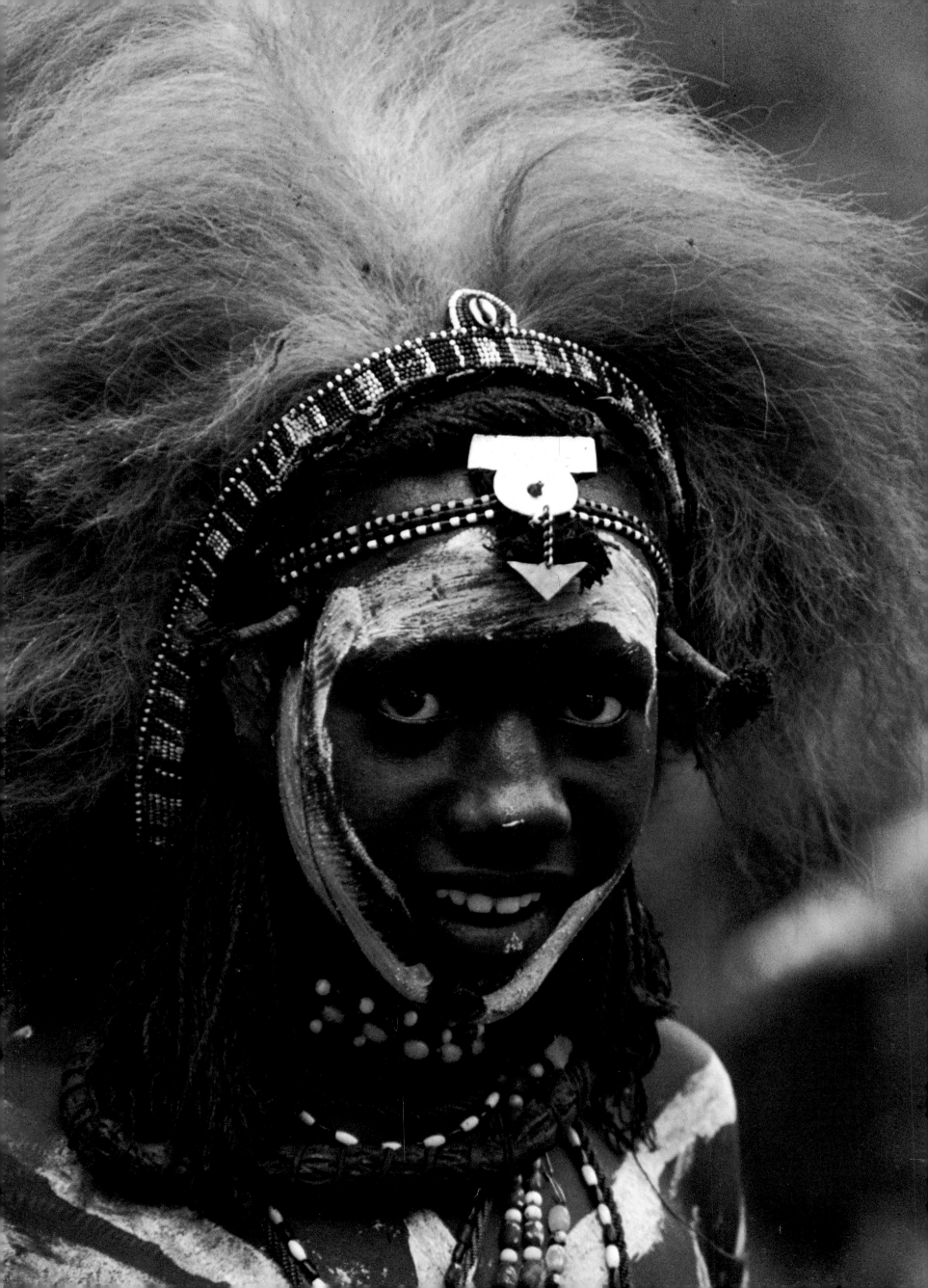

The physical appearance of the ingenerate robber Masai, says Sir Harry Johnston, is splendid. It is a treat . . . to gaze on such magnificent examples of the fighting man. An exclusive diet of milk, blood . . . combined with a rigorous training in warlike and athletic exercises have developed him into a sinewy, muscular man of admirable proportions, broad of chest, with a smallish head, a graceful neck and limbs whose muscles seem as hard as iron. There is no fat on his body, the ears are large and the lobes are distended with ivory or wooden discs, loops of iron chains, or brass coiled wire like catherine wheels. The warriors go naked except for ornaments. When they go to war the warriors wear a headdress of ostrich feathers arrayed like an aureole.

The Living Races of Mankind, no date.

EAST AFRICA

The Body as Art

East African nomads is a term used to describe the pastoralist tribes living on the sweep of land extending from the vast swampland of the Sudd in southern Sudan down to the Serengeti plains a thousand miles south, to the east of Lake Victoria.

Some of these tribes came from the Upper Nile region, crossing the Sudd and moving south in search of pastures for their great herds of cattle; others migrated over the frontiers of Ethiopia and Somalia to the north and east. The Maasai, particularly renowned for their strength and fighting spirit, pushed on southwards to claim ownership of the best grazing lands, the Serengeti plains, while other groups were forced to settle for the desolate stretches of the north.

Although the tribes vary widely in their customs and way of life, they have in common finely chiselled features, attributable to their northern ancestry, and a magnificent physique. Their different lifestyles are dictated by the needs of their herds, which in turn are determined by the nature of the land. The tribes that secured the most fertile land are able to lead a more settled life than those who are forced to keep on the move in their attempt to scratch a living in the arid regions of northern Kenya.

The Dinka and their neighbours in southern Sudan remain at one base during the six months of the year that they can rely on the rains, but move their cattle between several different camps during the dry season. The Gabbra, Boran and Rendille in the northern desert of Kenya live in semi-permanent camps, moving only four or five times a year – with the exception of the young men tending the camels, who must move much more frequently in search of pasture, often travelling up to forty miles a day. Their neighbours to the west, the Turkana, split up into small, highly mobile family groups in an attempt to eke out a living from the sparse desert land.

Although they vary in the amount they travel, all these tribes have a minimum of material possessions, as they must be able to pack up easily and travel light when necessary. Their houses are simple structures of branches and hides that can be transported on the back of a donkey or camel. Architecture and other artistic pursuits that demand a settled way of life, such as metal casting and wood sculpture, have had little chance to develop. Instead, the creativity of these

Maasai warrior, Kenya.

people has been directed towards beautifying and adorning themselves.

The nomads place particular emphasis on the body's natural form. They wear few clothes, but highlight their features with painting and scarification, and wear elaborate coiffures and headdresses. Jewellery accentuates their long, slender limbs and graceful movements. Different styles of body art are associated with particular tribes, just as various types of sculpture are peculiar to the different settled peoples of West Africa. Body art also serves as a detailed sign language, conveying information about the wearer's age, achievements and social standing.

In East Africa, more than anywhere else on the continent, nomadic societies are ordered by the age set system. This is a series of clearly defined stages through which every male member of the tribe must pass, each one specifying the role and behaviour expected of him at that time. For most tribes there are three stages or sets – childhood, warriorhood and elderhood – but the more complex system of the Boran consists of five sets, each lasting eight years.

The transition from one age set to the next is always marked by ritual and ceremony, most complex among the pastoralists of the more fertile lands, where the whole tribe remains together in relative proximity. By contrast, those who live in harsher terrain, and who are often forced to split up in order to survive, do not have so much time or opportunity for social contact and for the celebrations associated with the age set system – nor do they need the discipline this brings to a larger social group.

For the Maasai and Samburu the initial stage of childhood, during which boys learn to tend the herds and do menial tasks around the camp, ends at puberty with an initiation ceremony that carries them through into warriorhood – the

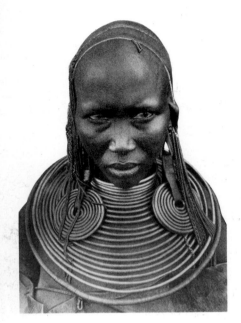

Maasai iron necklaces worn before the importation of glass beads, nineteenth century.

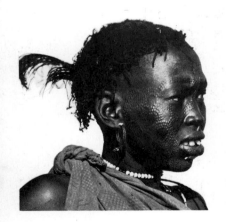

Decorative facial scarification, Murle, southern Sudan.

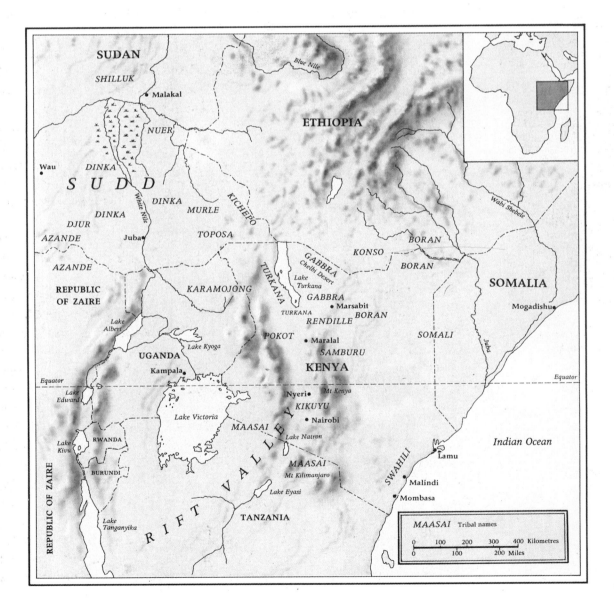

14

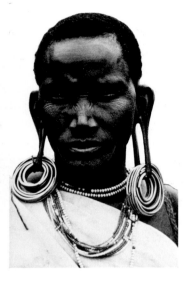

Coiled earlobe stretchers, Nandi, Kenya.

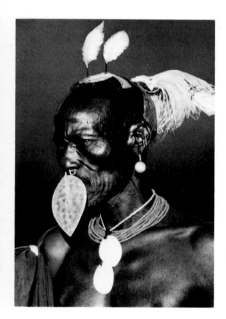

Pokot elder with aluminium leaf-shaped nose pendant.

most exciting stage of their lives and one on which they will always look back with nostalgia. As warriors they are free to roam the country, to hunt and raid, and to choose lovers from among the uncircumcized girls, whom they court with song and dance. This is the golden period; after several years, and again with ceremony, the warriors leave their bachelor days behind to embark on elderhood which, by comparison, is subdued and serious. Only then can a man seek a wife and begin a family, start to build up his herds, and take a more responsible part in the decisions of the community.

For women, the pattern is simpler: they pass from childhood to womanhood at puberty; they are circumcized shortly before marriage but with none of the public ceremony associated with this event for men. After marriage they gain additional status only as each of their sons passes into warriorhood.

Nowhere is the change of age set more dramatically and colourfully illustrated than in the *Eunoto* ceremony of the Maasai, which marks the passage from warriorhood to elderhood. Maasai warriors are renowned for their exceptional physique and intrepid fighting spirit; they epitomize the image of warriorhood, and have become one of the most celebrated and well-known tribes of Africa.

Up to four hundred of these magnificent warriors gather for the highly emotive occasion of the *Eunoto* ceremony, which takes place every seven to fourteen years. The visiting warriors, some of whom have marched for three days to reach the chosen site, arrive in full regalia, their spears gleaming in the sun and their thigh belts clanking with every stride. There is considerable tension as the warriors meet, for although they are members of the same age set who underwent circumcision together, many will only have seen each other since then as enemies in cattle raids.

The men stay together in a ceremonial kraal built for the occasion. During the entire ceremony, which lasts up to five days, they go through elaborate rituals of body painting, the designs reflecting their powers as warriors. Dressed for the last time in all their glory, their headdresses blowing in the wind, the warriors dance and sing ever more wildly – to the admiration of the women, freshly adorned with ochre and laden with beads in their honour. The climax of the ceremony is the shaving of the warriors' heads – which symbolizes the end of warriorhood, and is the occasion of much emotion. The years of privilege are over, and the men enter their new state as elders bareheaded and wrapped in a simple blanket. Such ceremonies are milestones in the life of the nomads, and the body ornaments so closely linked with them remain a graphic statement of Maasai belief.

The hub of the pastoralists' life is their animals; for certain peoples in northern Kenya these are camels and a handful of sheep and goats – the only animals that can survive in this harsh desert terrain. For the Maasai and most of the other tribes, however, cattle are of prime importance. From them comes the milk so crucial to the nomads' diet as well as hides for housing, for clothes and for mats to lie on. Cattle are their source of wealth, their currency, their dowry and, above all, their religion.

Of all the tribes in Africa the Dinka are the most devoted to their cows. They live with their vast herds – more splendid even than those of the Maasai – in the largest area of swampland in the world, the Sudd of southern Sudan. Their lives are inextricably bound up with their cattle which are, the Dinka believe, their only link with the spiritual world. The story goes that once a Christian gave a lecture on salvation and the joys of heaven, at the end of which an elder asked if his cattle could accompany him there. When the Christian, confounded, did not reply, the Dinka simply shrugged and remarked that without his cattle heaven was not worth going to anyway.

When a Dinka boy comes of age he is given a young bush calf. This becomes his 'namesake ox', after which he himself is named. For the next few years he will identify extraordinarily closely with the young bull, imitating and emulating it

as the two mature together, even believing that he and the animal are one. As a sign of his devotion he hangs cow's-tail tassels from the bull's horns just as he suspends them from his own ivory bracelets (see p. 57). The ivory which hangs from his necklace is carved in the shape of horns, and deep marks are cut across his forehead in the same design, or in parallel lines – an excruciating ordeal which the young man must endure without any show of pain.

For the Dinka, scarification such as this signifies initiation into adulthood, and also helps to distinguish between the various sub-tribes. Common among East African nomads, scarification is a form of body art difficult for a Westerner to appreciate. Sometimes, as here, it is part of a ritual; at other times it signifies status or achievement, or it may be purely ornamental. A warrior of the Turkana tribe, a large group of pastoralists living around Lake Turkana in the Great Rift Valley, will use thorns to scarify his arms and thus proclaim that he has killed an enemy. Boys and girls of the Murle, a small group of people living in southern Sudan, have their faces and part of their chests scarred with intricate circular patterns in a process known as cicatrization. In this, a sort of bas-relief tatoo, the skin is pierced and the wound rubbed with ash so that it becomes inflamed and later heals as a hard scar in relief.

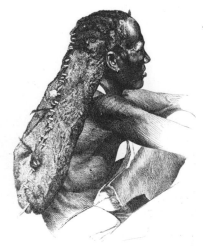

Pokot coiffure incorporating ancestor hair, nineteenth century.

Shilluks crossing a river, southern Sudan, nineteenth century.

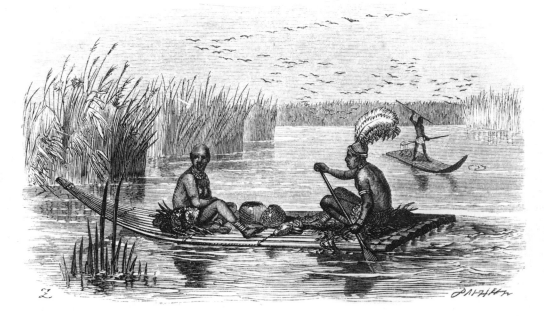

Another practice difficult for outsiders to appreciate is that of wearing lip plates or plugs. The huge plates protruding from the lips of older Kichepo women, a tribe living near the Ethiopian border, may have originated during the nineteenth century when the slave trade flourished in that area. A popular story told to travellers over the years is that the plates were inserted as a means of disfigurement, to deter the traders. Whatever their origin, even today older Kichepo women consider themselves undressed without them; often as large as saucers and requiring the support of one hand, they are never removed in front of strangers (see p. 55).

Less bizarre, though equally distinctive, are the variety of intricate coiffures sported by both men and women of many different tribes; some, in the form of clay buns, become more and more elaborate as feathers and beadwork are added with increasing age and status. By creating these coiffures, and by painting, scarifying and adorning their bodies, the nomads achieve the image they desire and also declare much about themselves to the world. By changing the colour of the beads on her headband a Rendille woman, for example, may indicate that she is barren. A Samburu woman will wear a double strand of beads looped between her ears for each son passing into warriorhood. Elders of the Turkana and their southerly neighbours the Pokot wear aluminium leaf pendants suspended from the nose to announce a daughter's engagement.

16

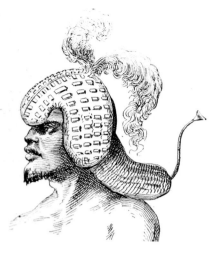

Pastoralist of the White Nile with 'beaver tail' hairstyle, 1930s.

Maasai warrior with errap armlet, 1930s.

The simple lifestyle of these people, particularly the more fortunate and settled tribes, allows them to sit for hours under a tree in the heat of the day engaged in self-adornment. The women and children thread beads and design skirts and bodices while the men create exotic hairstyles or mud-pack buns for each other.

Until this century the East African nomads were relatively undisturbed by invaders or traders from the outside world. Their ornaments were generally made from natural substances gleaned from their surroundings: bones, teeth, shells, skins, stones, roots and clay. These basic elements were used with great imagination to create effects both dramatic and beautiful, though occasionally grotesque to the Western eye. Hunting trophies such as ivory, giraffe hair and snake vertebrae were made into ornaments used to indicate status. A few specialist blacksmiths forged iron into ornaments and weapons; the Maasai smiths bought their iron from the Swahili people of the coast, while in northern Kenya and southern Sudan iron ore was smelted locally.

Blacksmiths are still respected as craftsmen and yet, despite using their services, the nomads despise them for their lack of cattle and consider them a group apart. The Dinka call them *djur* (wild men) and, it is said, laugh at them because they make spears but are unable to use them. In the twentieth century, with a ready supply of metal in the form of aluminium cooking pots, cartridge cases and other items from which to glean scrap metal, smiths can now avoid the tedious process of smelting ore. Copper and brass, either brought by traders or stolen off telegraph poles, are preferred for their malleability as well as their bright colours and have, with aluminium, now largely replaced iron in jewellery.

Glass beads, originally brought from Persia and China by Arab traders, and later from Europe by the Portuguese, were widely used as a form of barter. By the turn of the century, mass-produced beads from Europe were being traded by the million along the East African coast. These were known as 'trade-wind beads' in Kenya, and as 'pound beads' (sold by the pound) in Sudan; small, regular and brightly coloured, they were easy to work with and appealed to the nomads. They soon replaced many of the natural elements, although shells and the skins of sacrificial animals are still used, as are sweet-smelling roots which perfume the wearer's body.

In East Africa, body art has always been the main outlet for artistic expression. Jewellery, adding colour and emphasizing movement, is used to accentuate and highlight this form of art, creating a dramatic impact of a kind unsurpassed elsewhere on the continent. In addition, all these forms of decoration convey a wealth of information about their wearer; to recognize and to understand them is to begin to know the East African nomads.

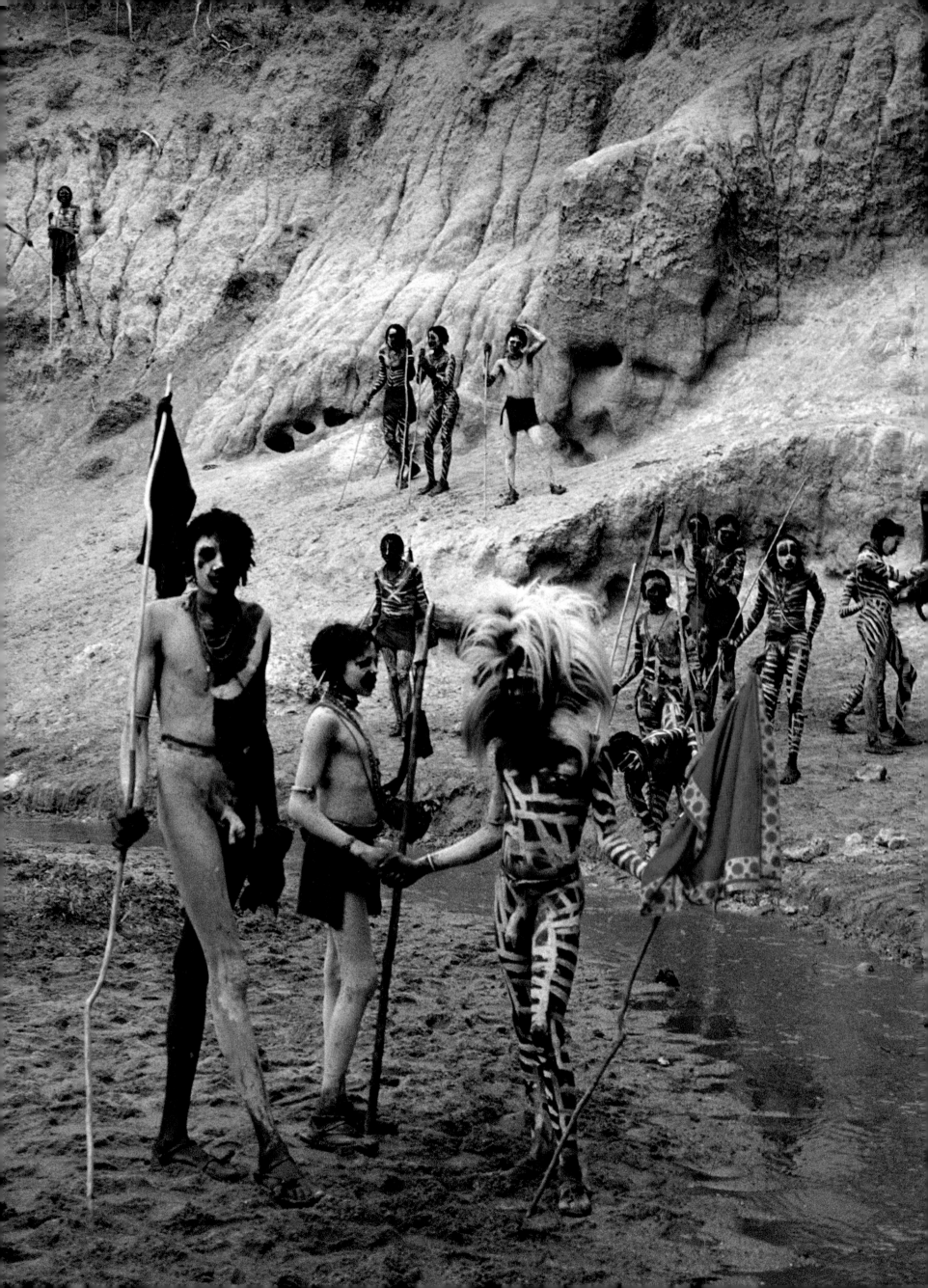

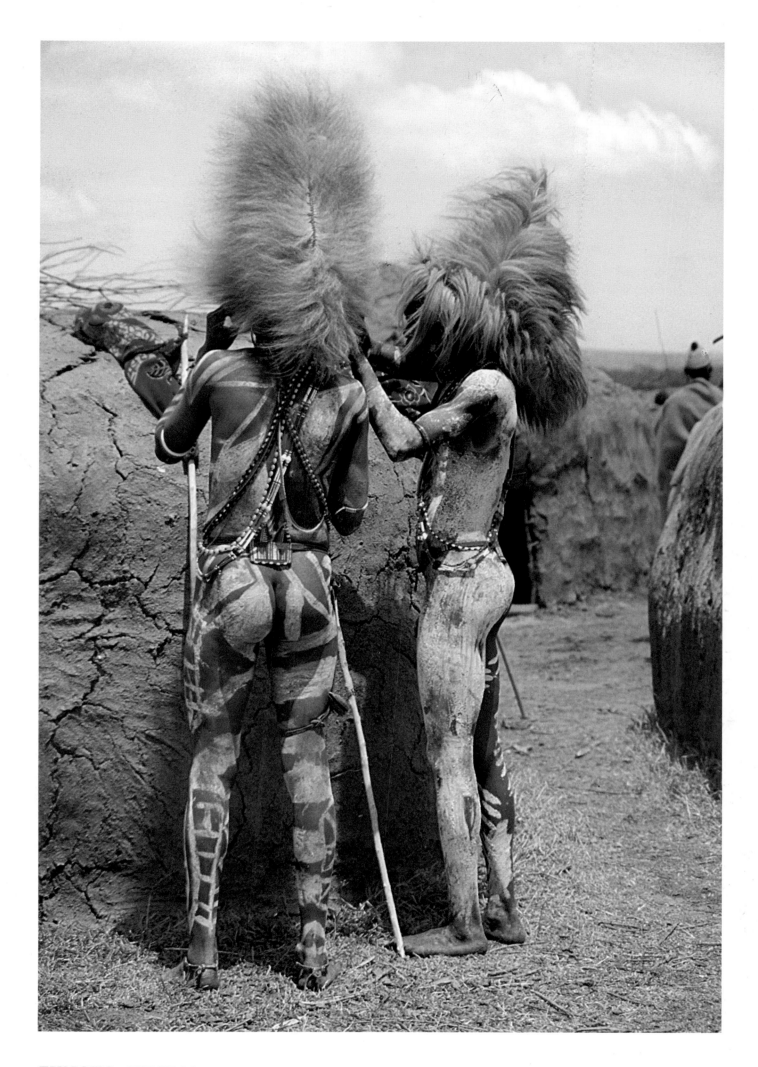

EUNOTO CEREMONY

ABOVE The lion's mane headdress, *olawaru*, proclaims that a Maasai has killed a lion during warriorhood. The beaded belts, in which the warriors carry their knives, are gifts from mothers and girlfriends, signifying their love and admiration for the men.

LEFT *Al Ungula Nalporr*, the White Crossing, a sacred limestone cliff in a forested area of the Maasai plains on the border of Kenya and Tanzania where warriors gather to make use of the chalk for their ritual body painting.

OVERLEAF Warriors dip their fingers into the wet chalk and draw designs on their bodies. Some disguise themselves as zebras, others use symbolic patterns to indicate their bravery in having killed a lion or a man.

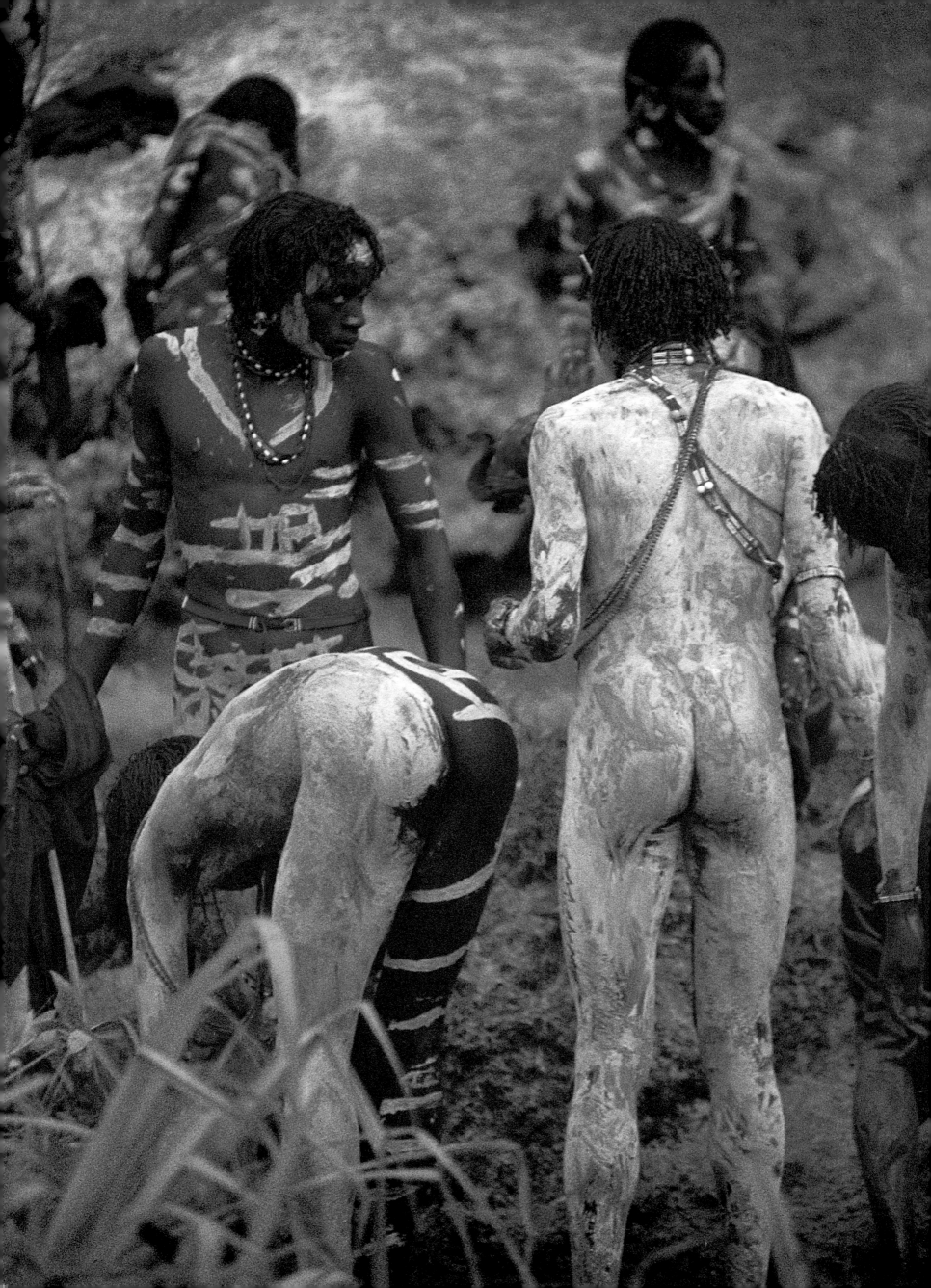

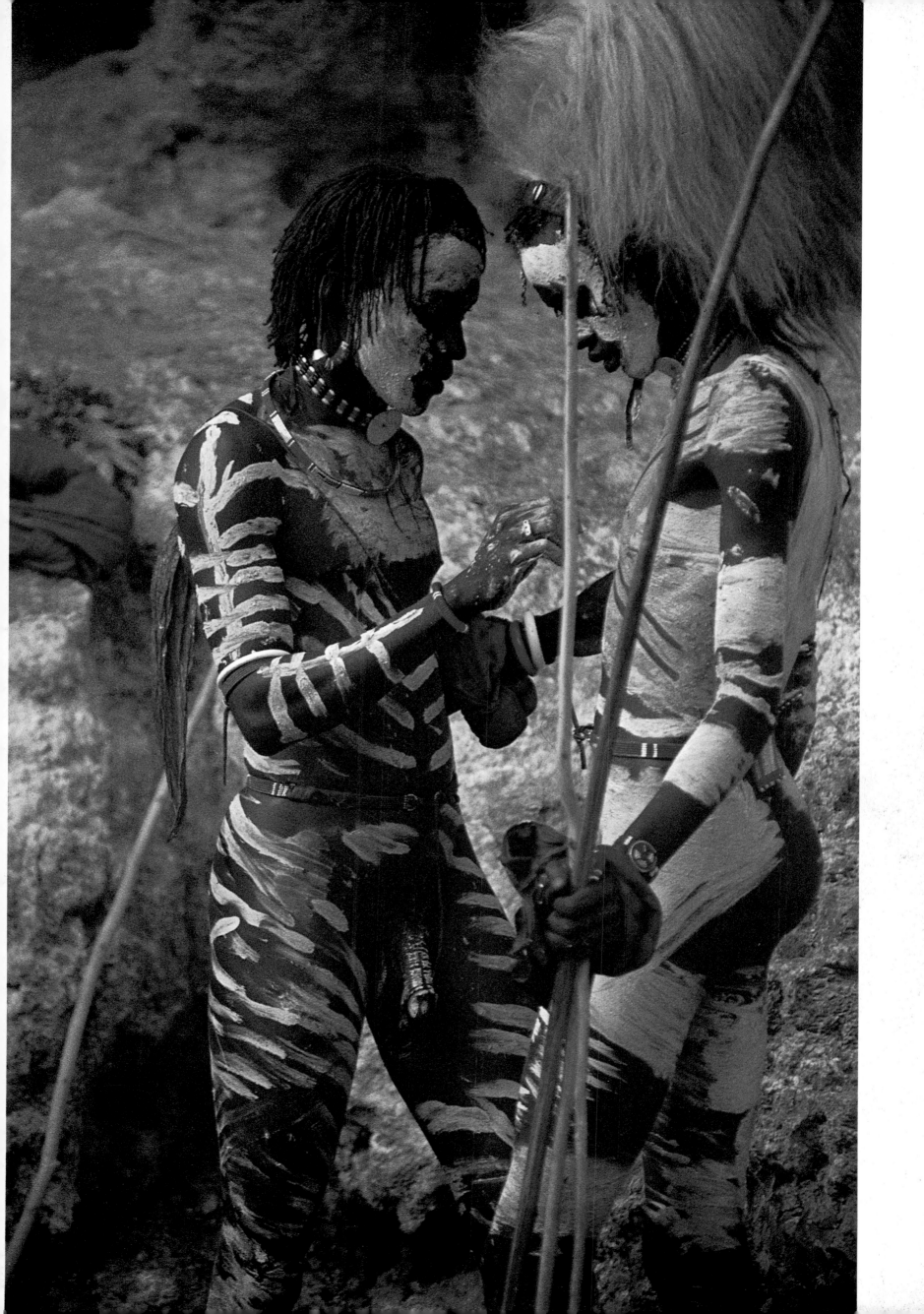

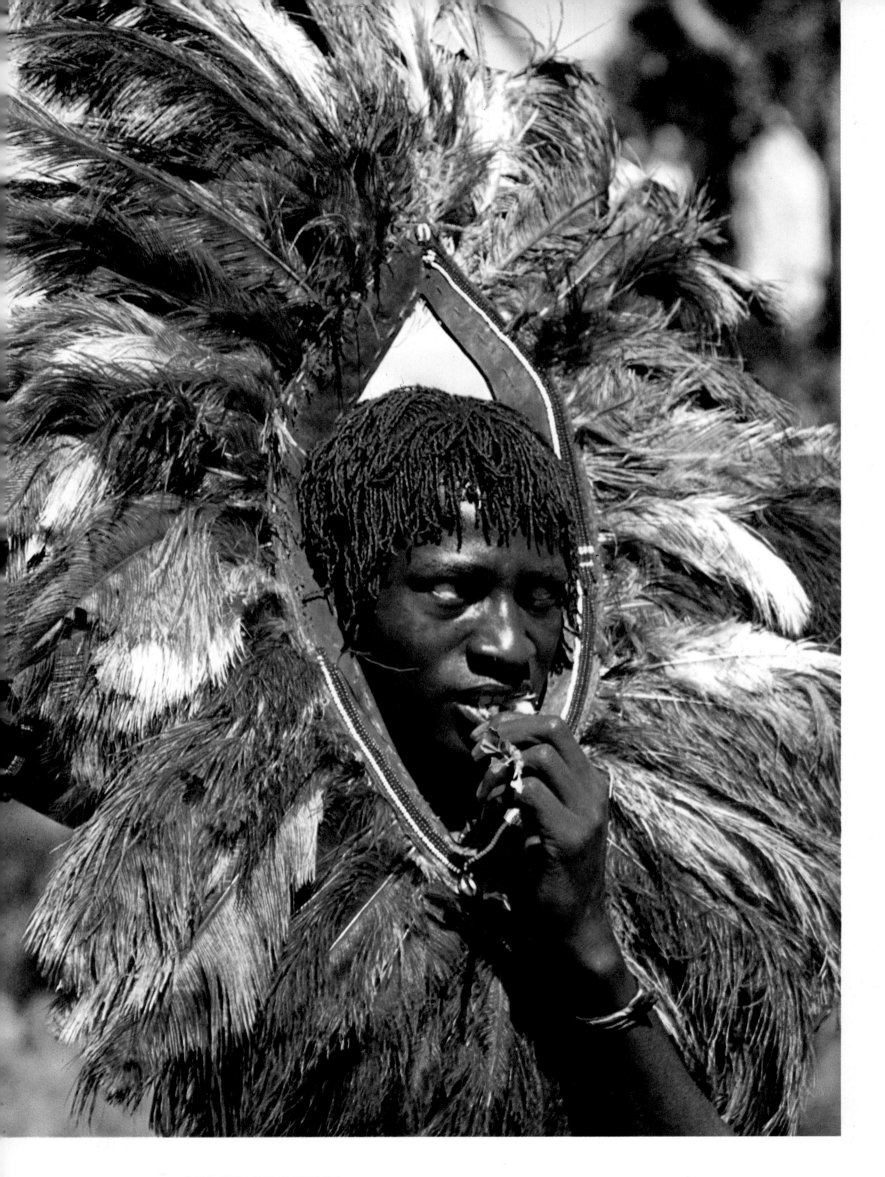

ORDER OF MERIT

The ostrich feather headdress, *enkuraru*, is worn by those warriors who have not yet killed a lion. Like the lion's mane, it was originally worn during raids and wars to give psychological advantage by its added height, but is now used only for major ceremonies and dances.

ABOVE RIGHT After ritual painting the warriors return to the ceremonial kraal led by a robed elder. His black cloak is called *engilaa alamal*, or 'ceremonial skin'.

BELOW RIGHT The elders help to guide the excitable warriors through each stage of the ceremony.

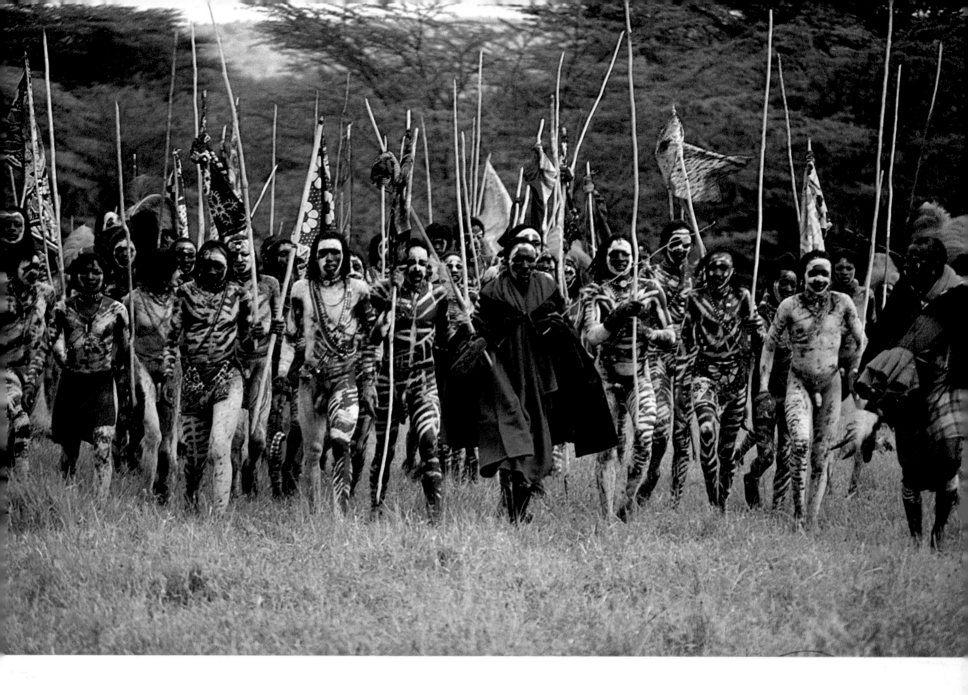

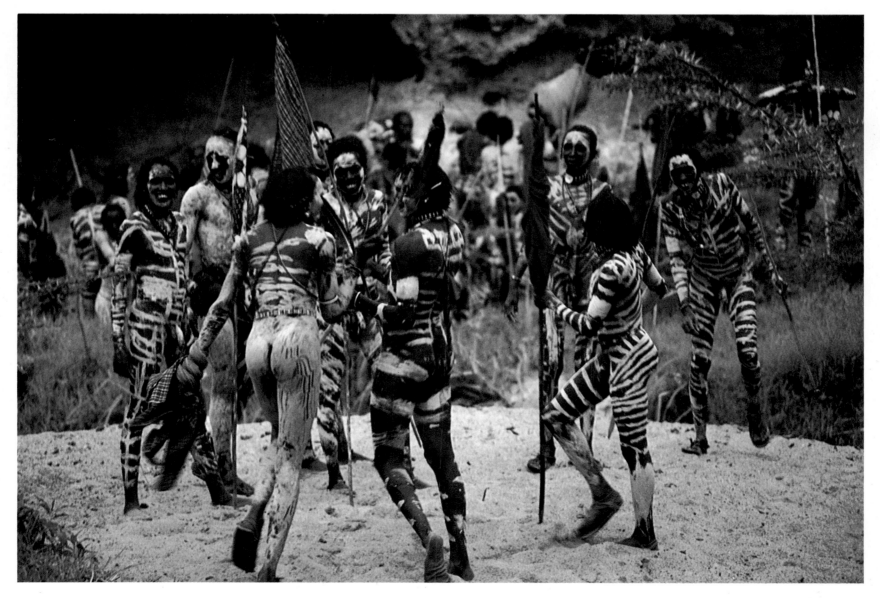

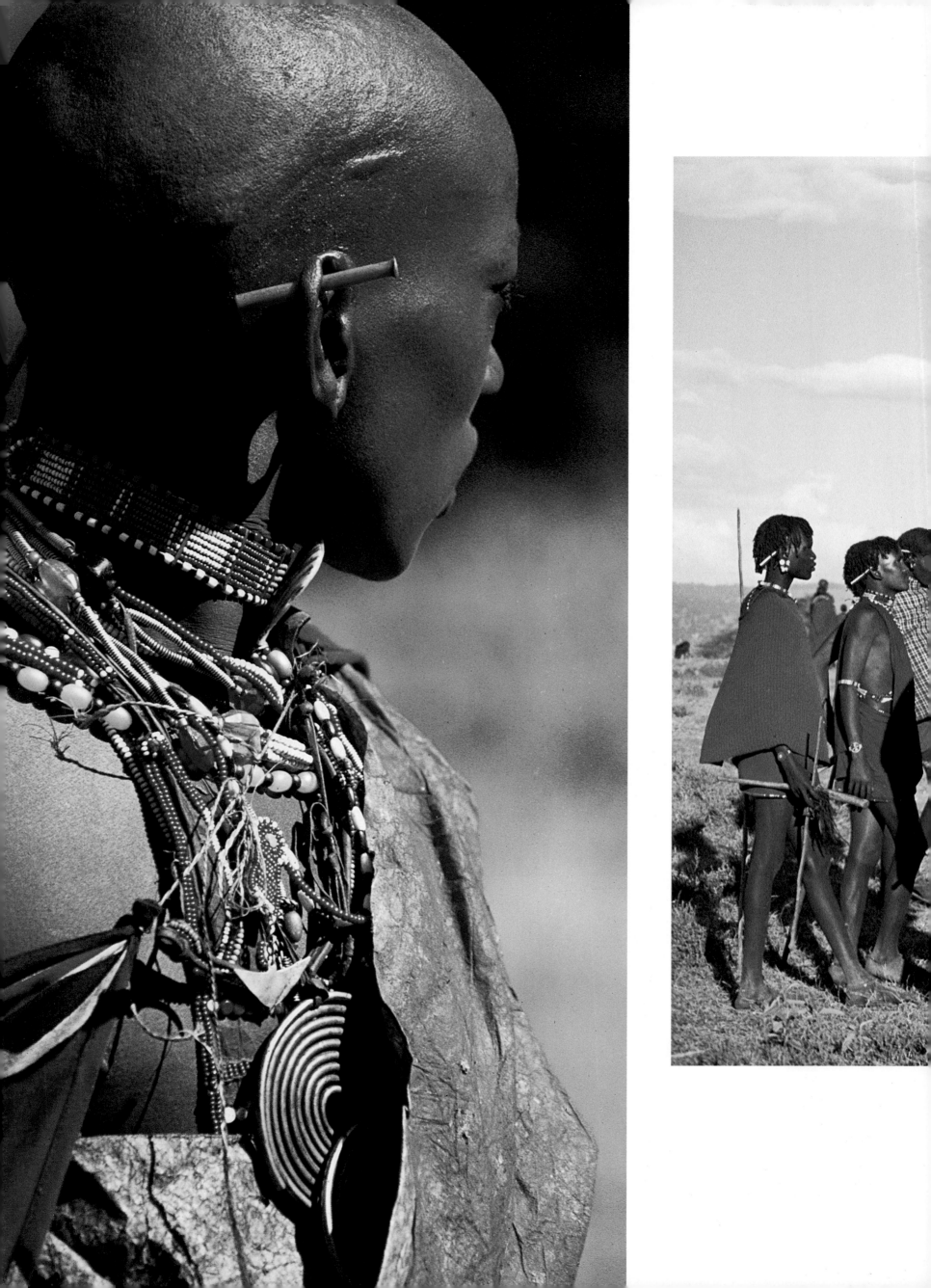

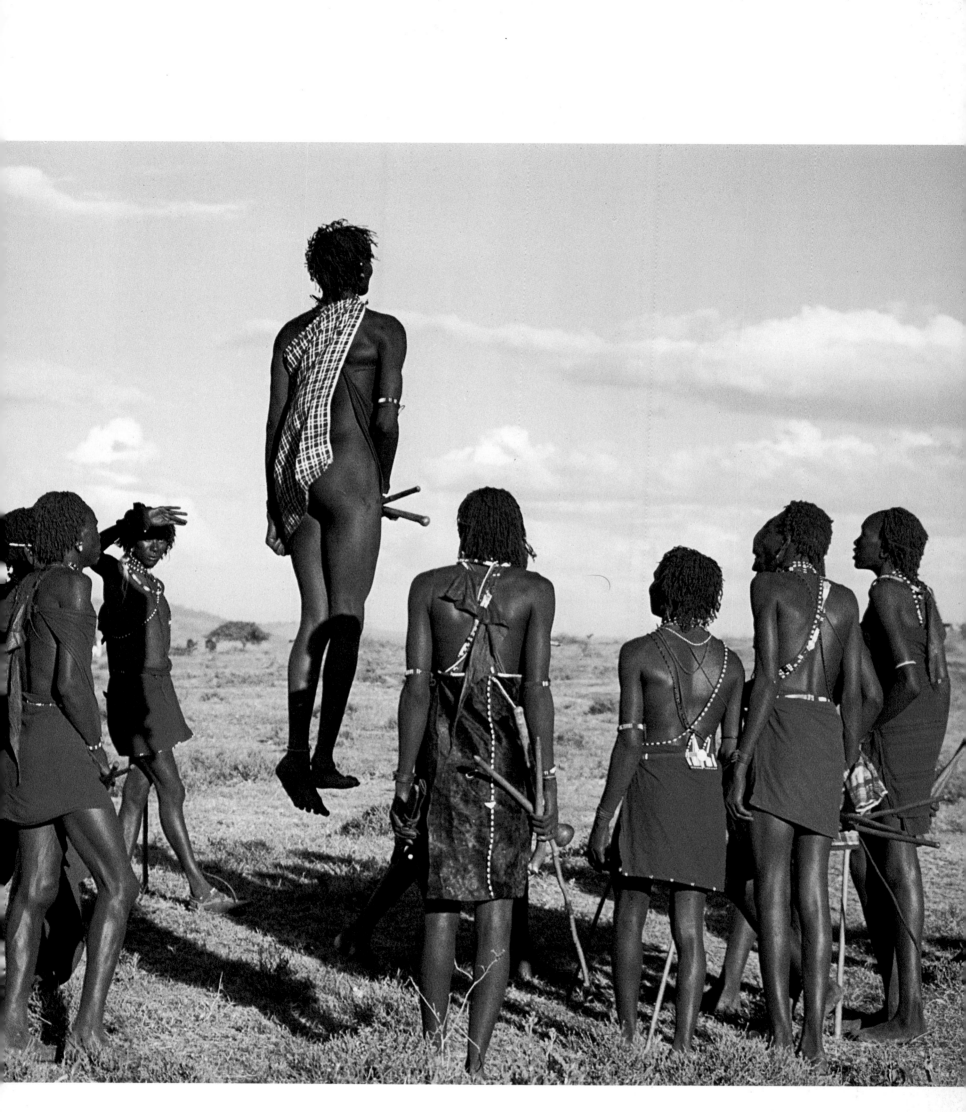

'THE CHOSEN ONE'

LEFT The brass coiled pendants worn on the chest of this Maasai warrior signify his unique position as *loosurutia* ('the one who wears the pendants'), the warrior elected on account of his unblemished character to lead the others through to elderhood. The pendants, called *surutia*, are generally worn by women and will have been lent to the *loosurutia* by his mother for the duration of the ceremony.

ABOVE Towards evening the warriors relieve the tension of the day's events by singing and dancing. One by one they leap in the air in time to the vocal rhythms, competing for height. By this time their chalk designs will have worn off, to be replaced at a second ritual painting early the next morning. The leather objects hanging at the back of the two central warriors are caps to protect their hairstyles when they sleep.

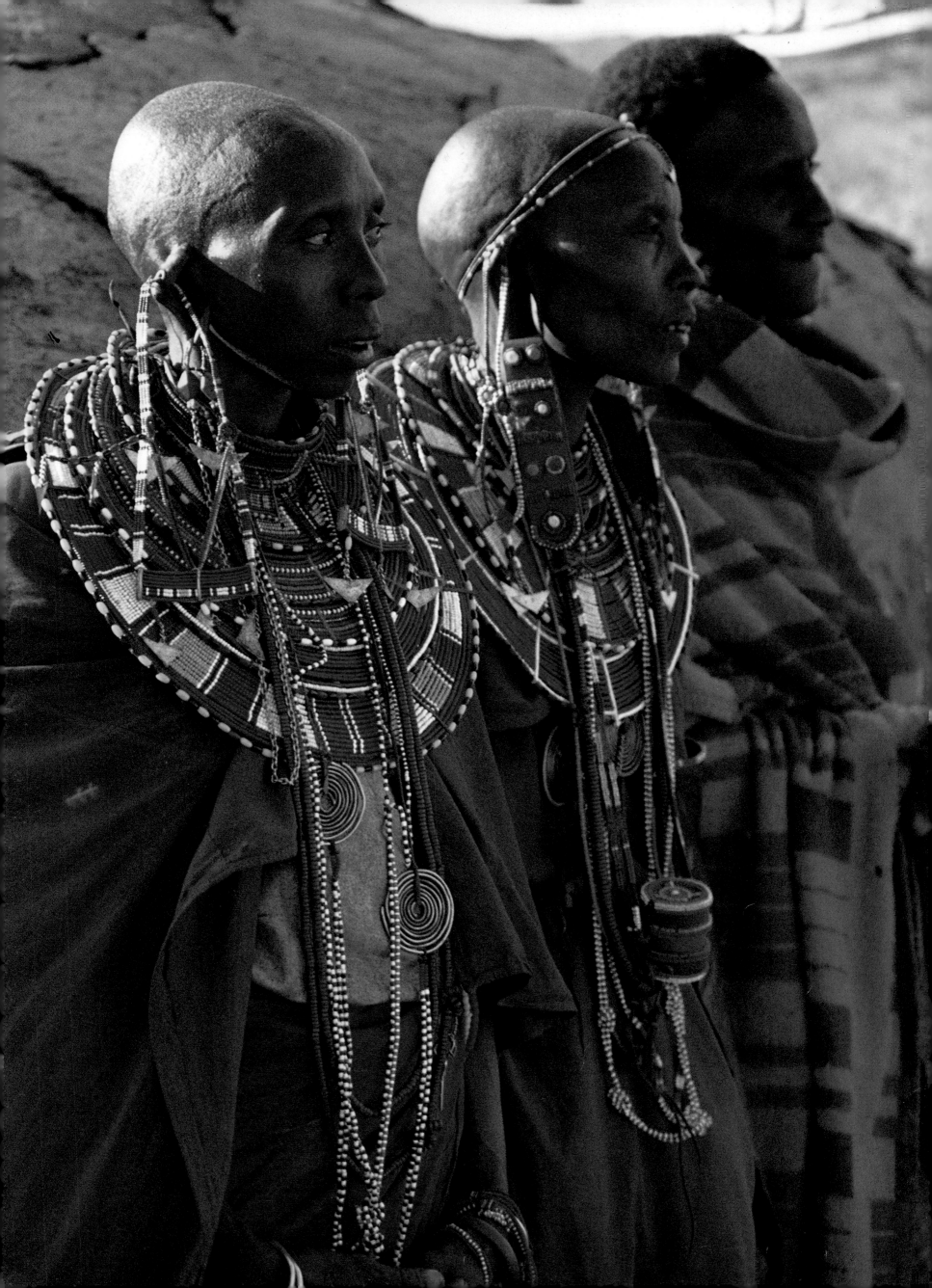

PROUD MOTHERS

LEFT Mothers watch intently as their warrior sons prepare for the ceremonial rite of head shaving which takes place at the transition of each age set. The women regularly shave their own heads to draw attention to their colourful jewellery. Their flat neck collars are made of beads threaded on wire and spaced with strips of cow-hide. *Nborro*, the long blue beads, are worn only by married women, as are the beaded snuff containers suspended round their necks. Maasai say that blue beads are 'God', as they are the colour of the sky he inhabits, and green beads are 'vegetation after rainfall', the symbol of peace.

ABOVE RIGHT These long beaded ear flaps show that a Maasai woman is married, and the Maasai hold that a man should never see his wife without them. The pendants, *surutia*, proclaim that she has a circumcised son; she will have lent them to him during the healing period following his circumcision, and for the *Eunoto* ceremony if he was chief warrior.

BELOW RIGHT A mother shaves her warrior son's head, a traumatic event during which the man, overcome with emotion, often trembles, weeps and foams at the mouth. The loss of his hair, which has not been cut at all during his warriorship, signifies the end of the most enjoyable and privileged years of his life.

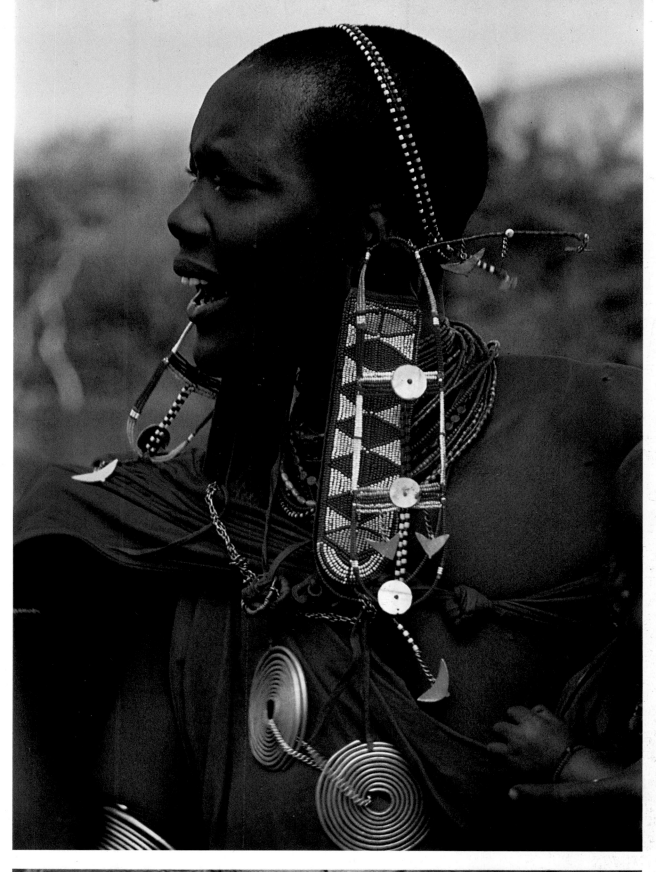

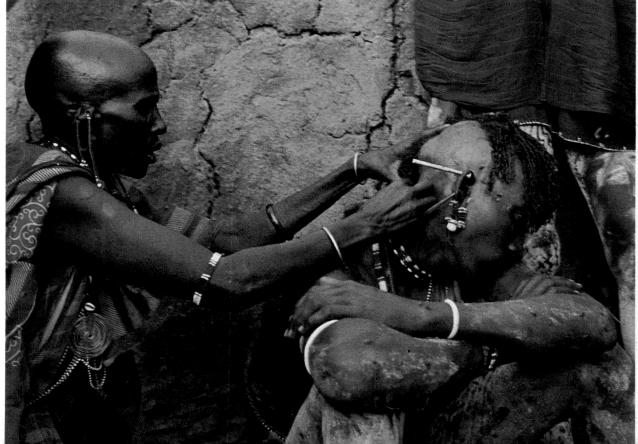

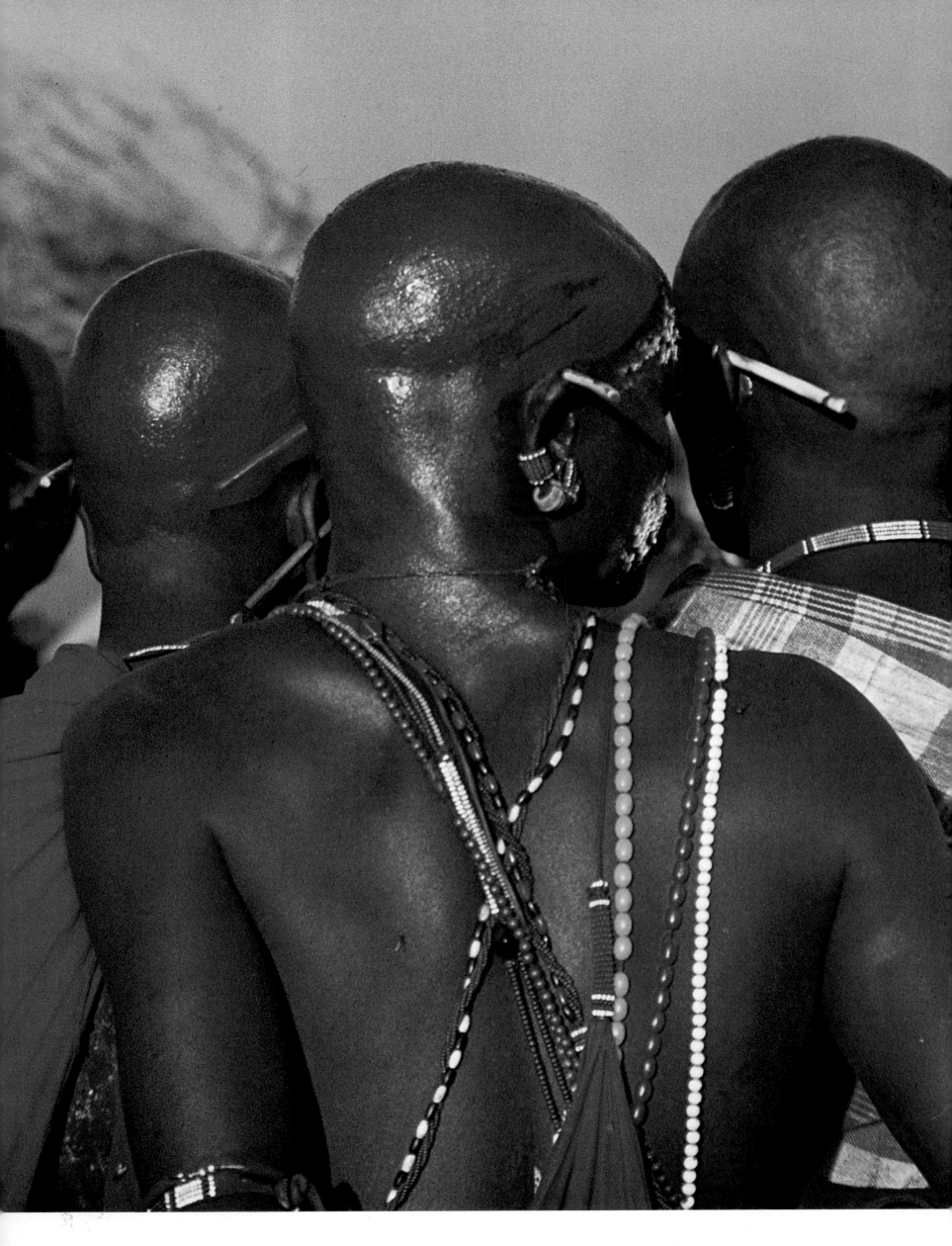

COMING OF AGE

Once shaved, the heads of former warriors are annointed with ochre and animal fat, signifying the beginning of their new life as elders. They will now participate in serious decisions concerning the community's physical and spiritual well-being, and will soon marry and start to acquire wealth and security.

RIGHT The elders no longer wear jewellery to accentuate their fine physique and achievements as warriors. Now their adornment is sparse and they carry few possessions: perhaps a beaded bamboo snuff container (a traditional gift from a first-born daughter), a wildebeest-tail fly whisk, and a thick red cotton blanket.

BELOW The young uncircumcised girlfriends of the Maasai warriors decorate only the upper part of their ears. Their large, swinging earrings and flat bead collars are designed to draw attention to their every movement and enhance their natural grace. There are about 40 different types and designs of Maasai beadwork, made by women and girls for themselves and for the warriors.

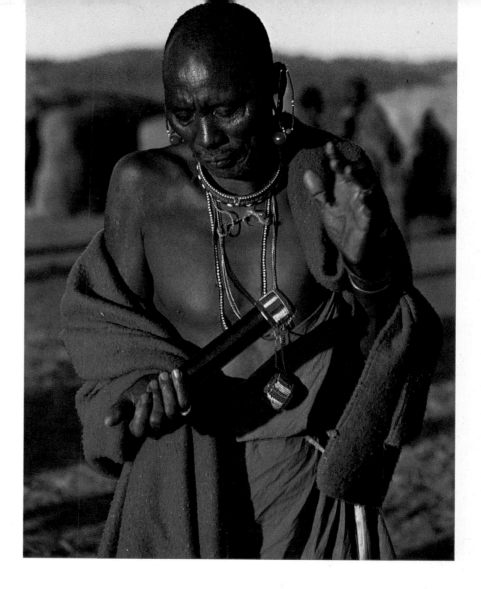

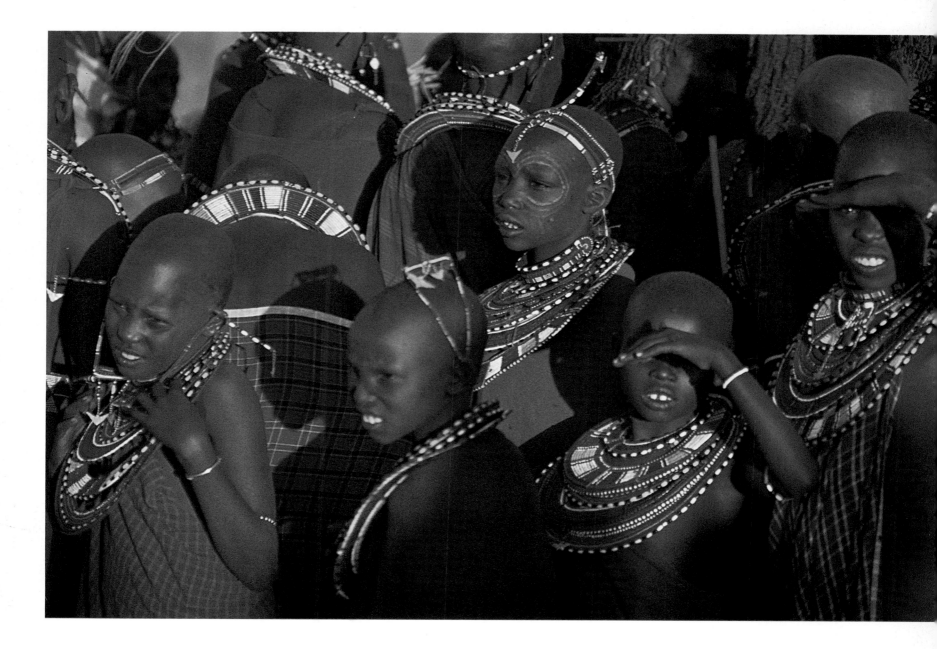

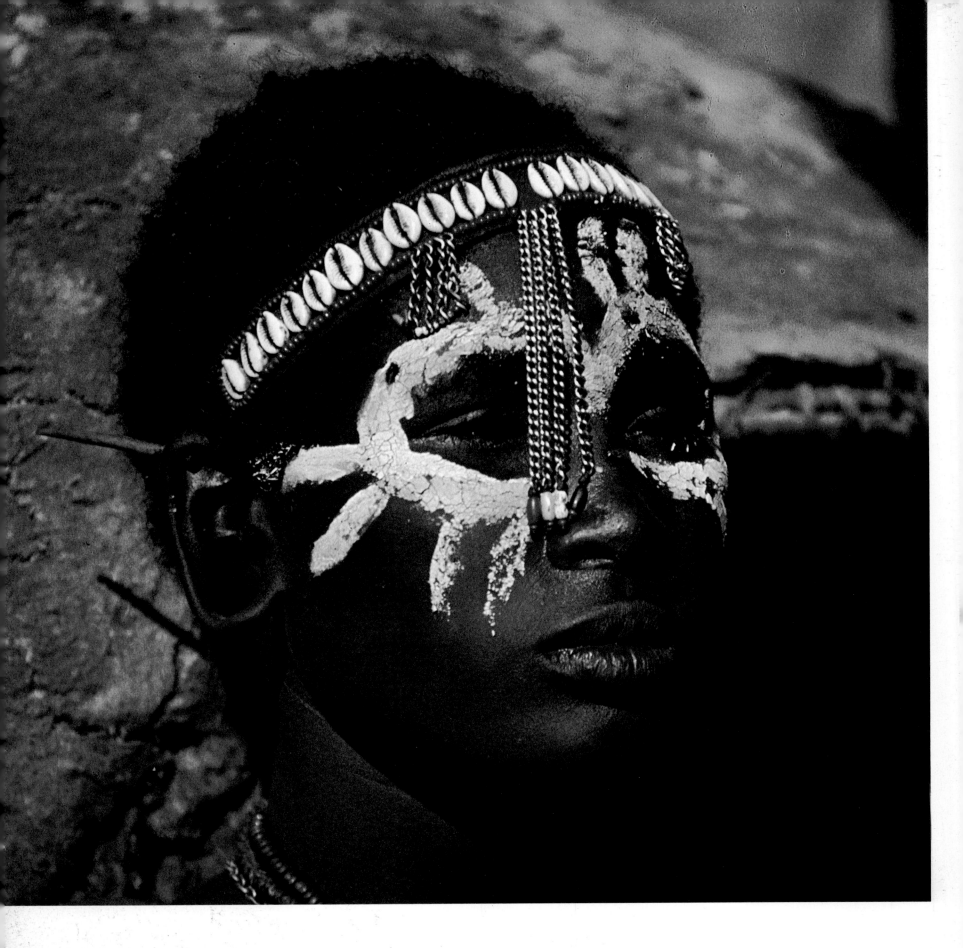

THE SHROUD OF CIRCUMCISION

Before they can marry, young girls must be circumcised, an operation in which the clitoris is removed. During the six-week period of recuperation they are forbidden to talk to men or strangers, and are dressed so as not to look provocative. Maasai girls at this time are known as *ormaisen*, 'girls in healing'; they paint their faces distinctively with white chalk and wear headbands made of cowrie shells (symbols of fertility) to indicate their state.

RIGHT Circumcised Pokot girls completely cover their faces with white chalk and wear a leather cloak to conceal their bodies. They are called *chemerion*, 'neither girl nor yet woman'. During the confined period they are instructed by the older women on sexual matters and married conduct. Once healed, both Maasai and Pokot girls have their heads ritually shaved, and are then considered to be clean and ready for marriage, which usually follows soon after.

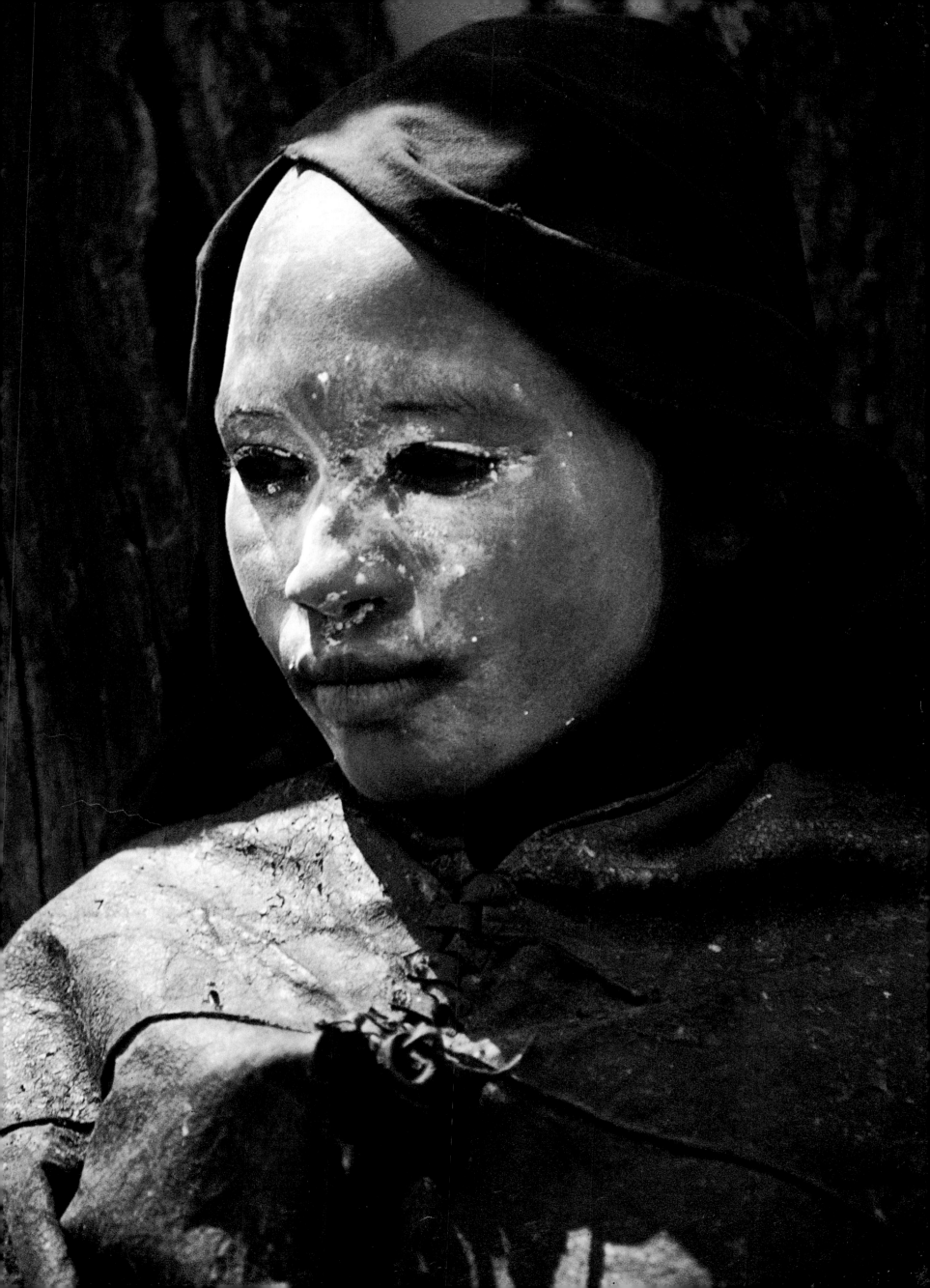

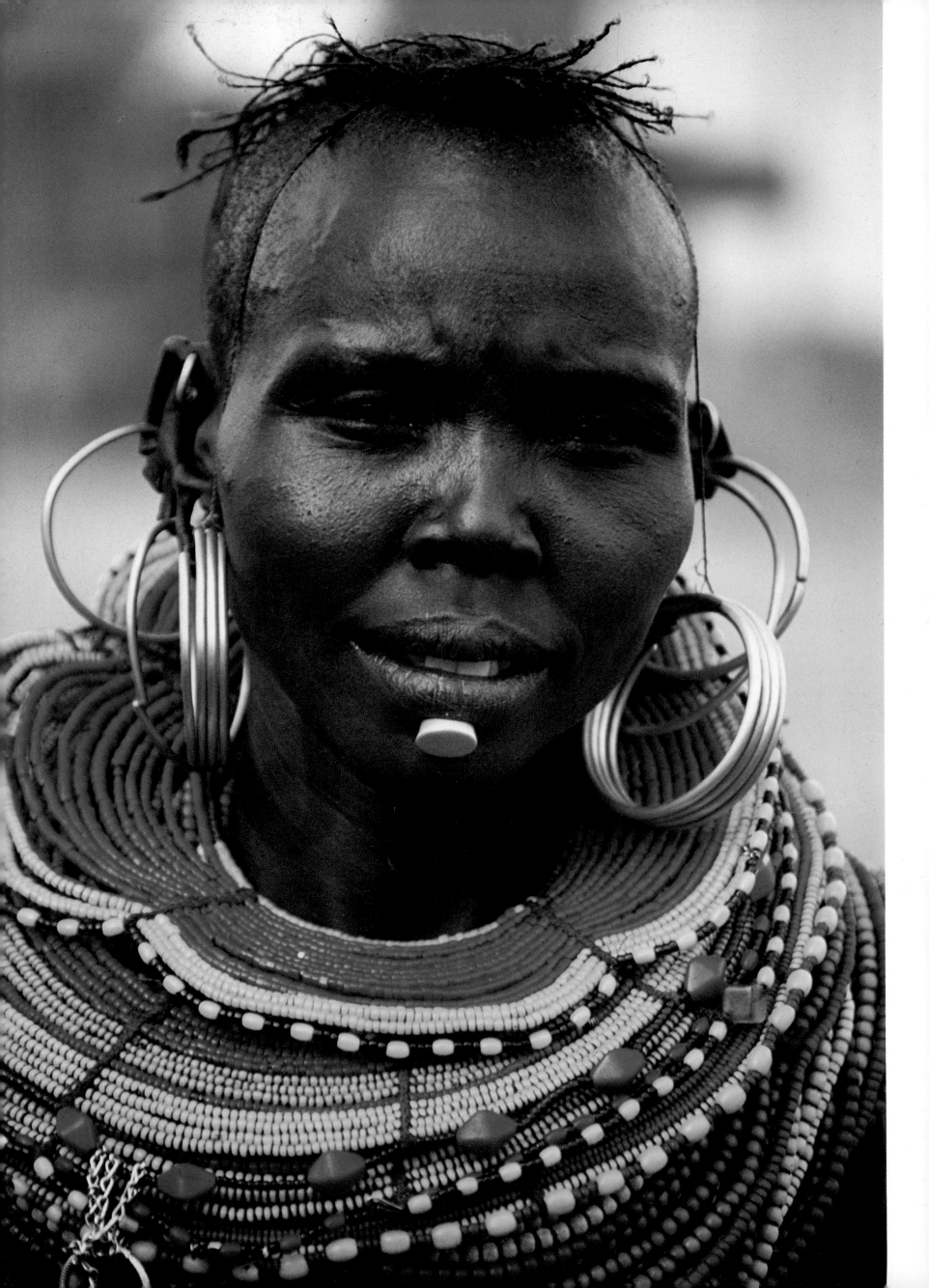

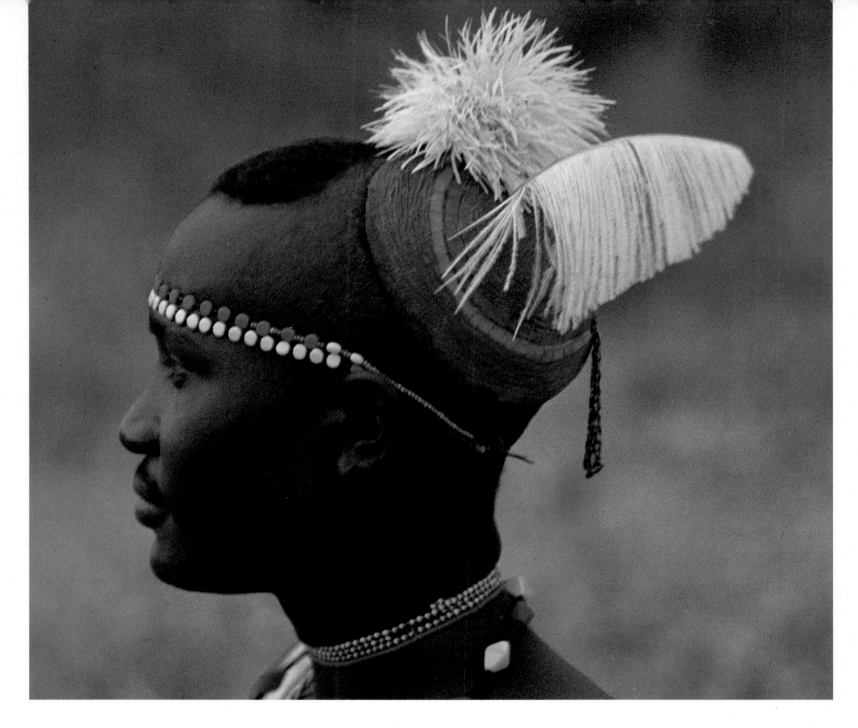

POKOT STYLE

LEFT When a Pokot girl has recovered from circumcision, brass hoops and coils are threaded through holes in her ears and she begins to wear bead collars. She will not wear a lip plug, however, until she is married.

ABOVE For Pokot men, hairstyles are symbols of status. This blue skullcap, *siliop*, is adopted by initiates of the coming-of-age ceremony; thereafter, the *siliop* designs become more elaborate as the man's social standing increases.

BELOW Brass jewellery made from traded wire, telephone lines and cartridge cases. The central coiled wire bracelet is worn widely throughout East Africa; the other two by the Dinka and Nuer of Sudan. Both pairs of coiled earrings are worn by Samburu women of Kenya, the conical ones by Pokot men and the brass lip plug by women of the Turkana tribe.

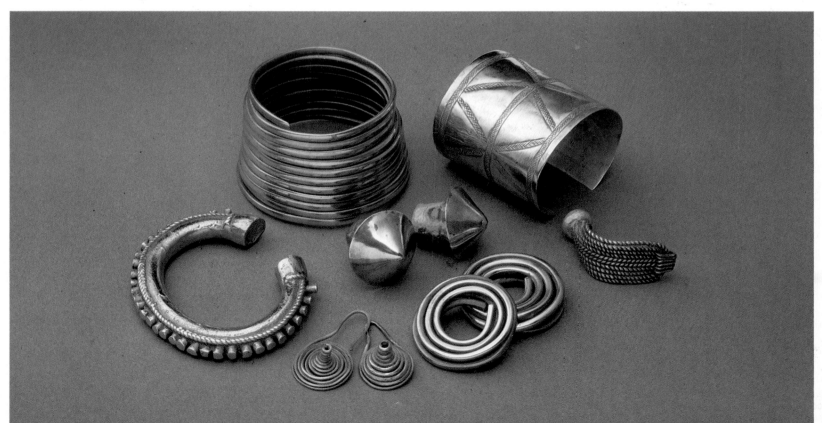

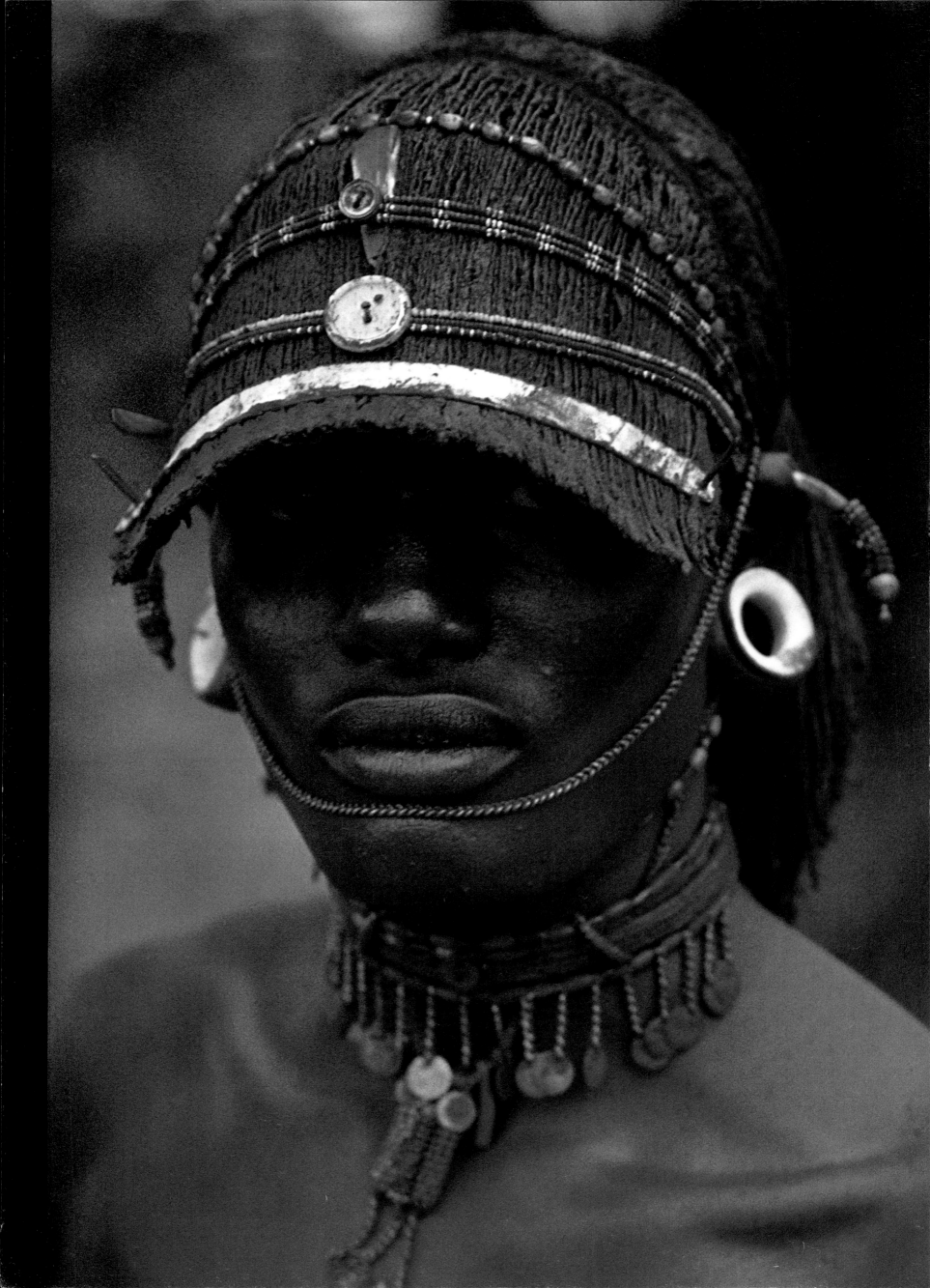

SAMBURU VANITY

BELOW Samburu girls like to wear many strands of loose beads rather than the flat collars favoured by their neighbours, the Maasai. The beads are gifts from admirers, and by the age of 15 or 16 the girls should have collected enough to invite a proposal of marriage. It is held by Samburu men that women do not have enough beads until their chin is supported by their necklaces. A typical head pendant is this stylized bird made of aluminium.

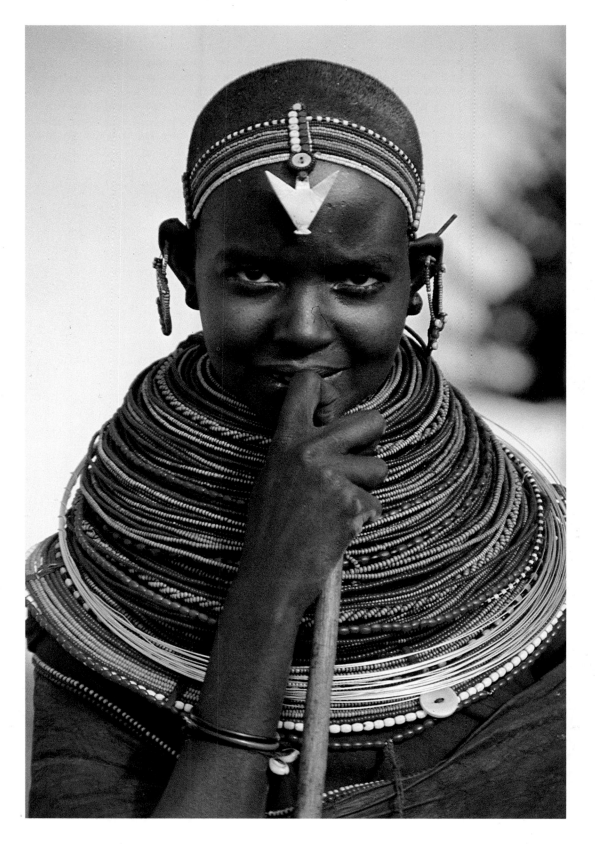

LEFT *Samburu* means butterfly, an apt name for these colourful warriors who spend much of their time displaying themselves in their finery and flitting from one place to another. They while away the hours decorating their bodies, discussing their looks, and whenever possible gazing at themselves in the wing mirrors of cars that occasionally pass by. They lengthen their hair by entwining it with sisal string, then cover it with animal fat and red ochre.

To make his hair stand out like a visor, this Samburu warrior has supported it under the fringe with a piece of cloth, also dyed with red ochre – a hairstyle known as *ilmasi wala*. Besides having more elaborate hairstyles than Maasai warriors, Samburu are distinguished by the ivory rings in their ears and finely executed facial make-up. Their delicate appearance and languid, almost effeminate looks belie a courageous and fearsome warrior spirit.

OF HUMBLE ORIGIN

The dramatic jewellery of the Gabbra, a tribe from the Chelbi Desert, is made of aluminium melted down from the old cooking pots traded into the area. Chiselled and incised aluminium beads and bracelets are worn by Gabbra women and their neighbours, the Boran, married Gabbra women being distinguished by their twisted headbands (*right*). Both tribes wear leather pouches strung from their necklaces containing charms against evil spirits.

Before aluminium became available early in the twentieth century beads were carved from natural materials found locally: the top two necklaces shown below would have been made of soapstone, the belt (worn by Turkana women) of the tiny bones of an antelope. The lower necklace is made of iron beads. The iron ore came from near Lake Turkana; later, the Turkana turned to aluminium for their beads as they found it easier to work.

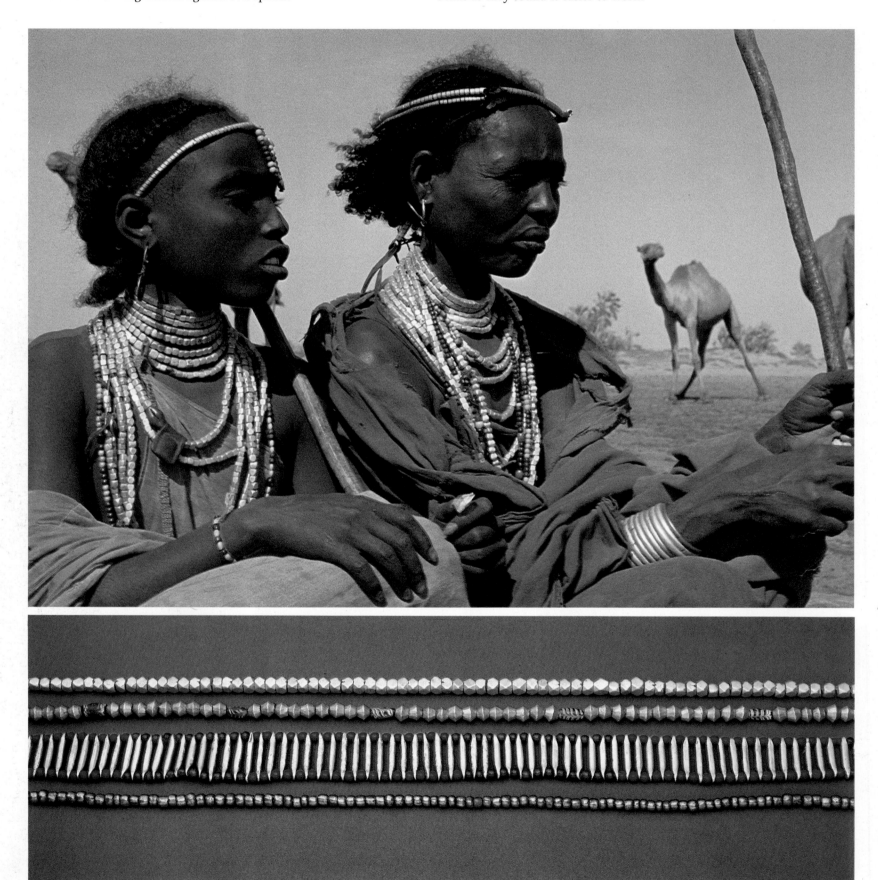

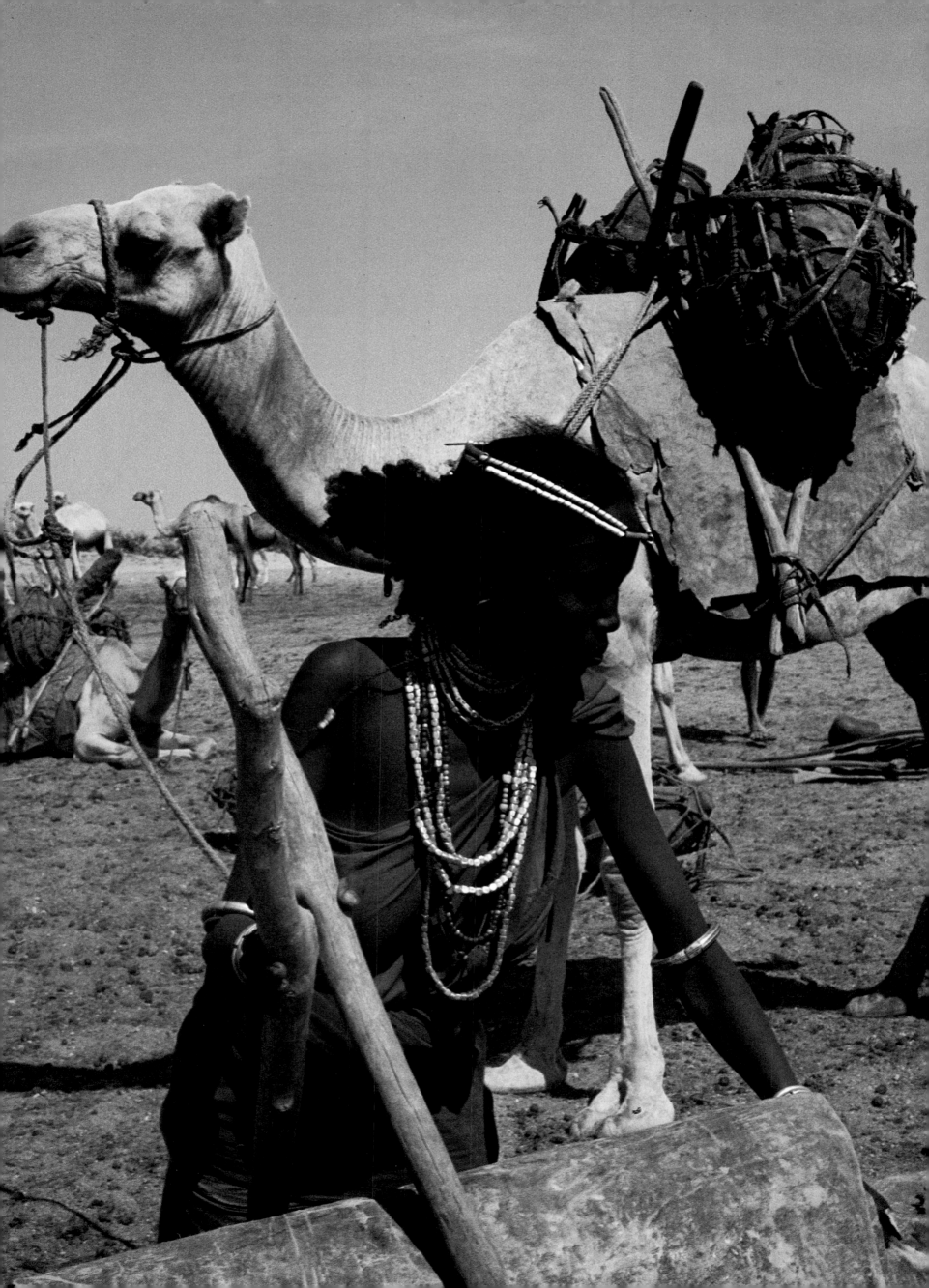

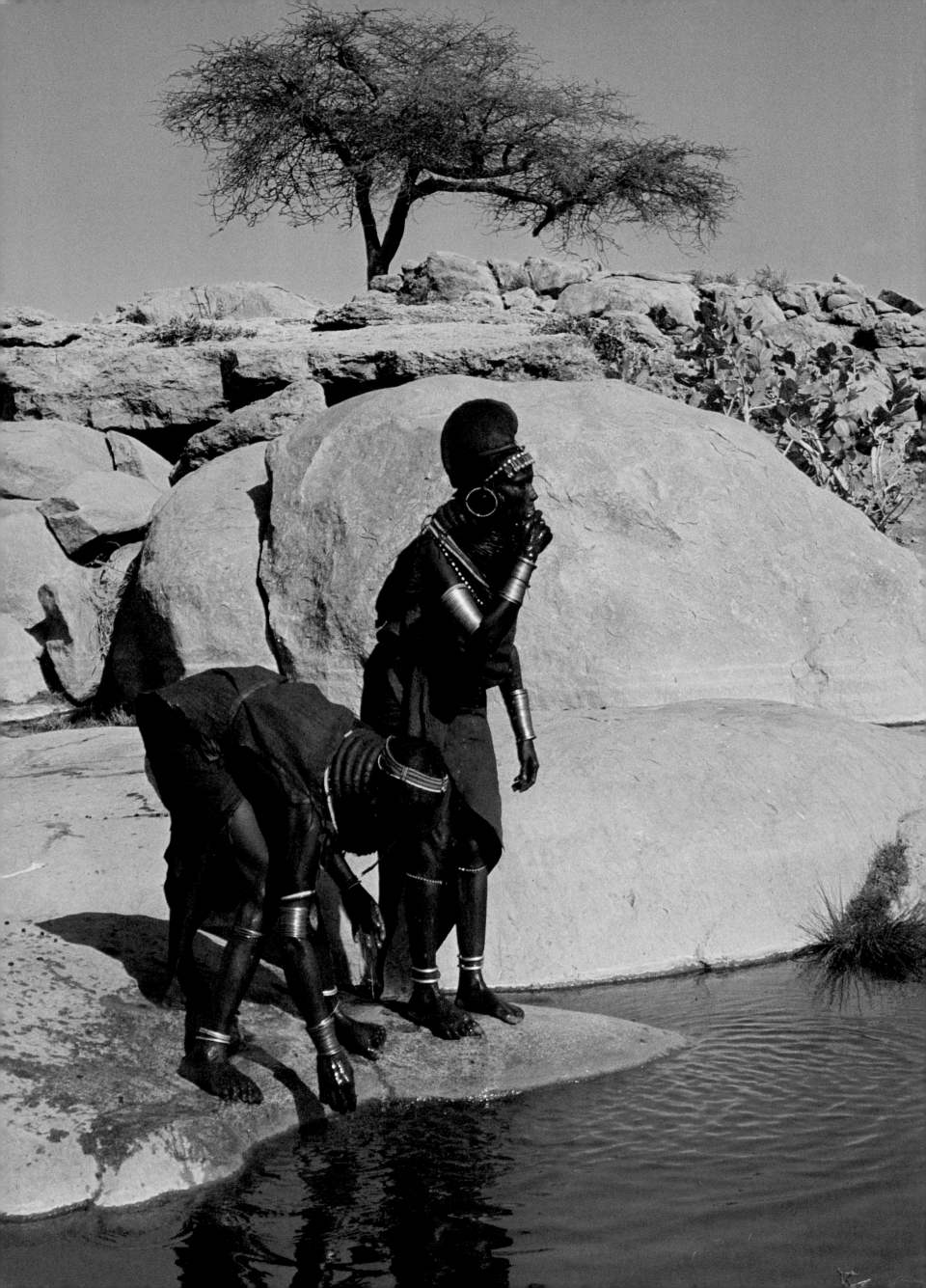

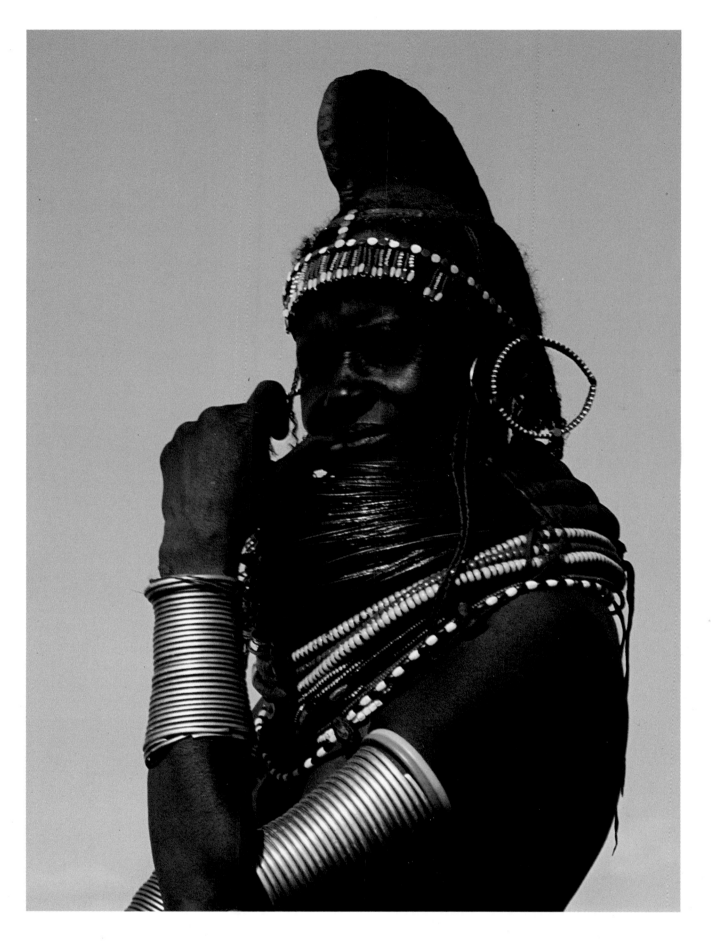

MOTHERHOOD

LEFT To show that they have given birth to their first son, Rendille women of the northern desert of Kenya wear their hair in a coxcomb made from mud, animal fat and ochre. This permanent fixture is constantly repaired, and will be worn until the boy is circumcised or until a close male relative dies, when the head will be shaved. Highly prized necklaces, *mpooro engorio*, of doum palm fibres bound together with strips of ochred cloth (worn also by Samburu women) are received at marriage. When elephants were numerous these necklaces were made of hairs from an elephant's tail.

ABOVE Coiled armlets of brass and iron wire are placed on the lower arm of Rendille women at the time of marriage, and on the upper arm once the first son has been circumcised.

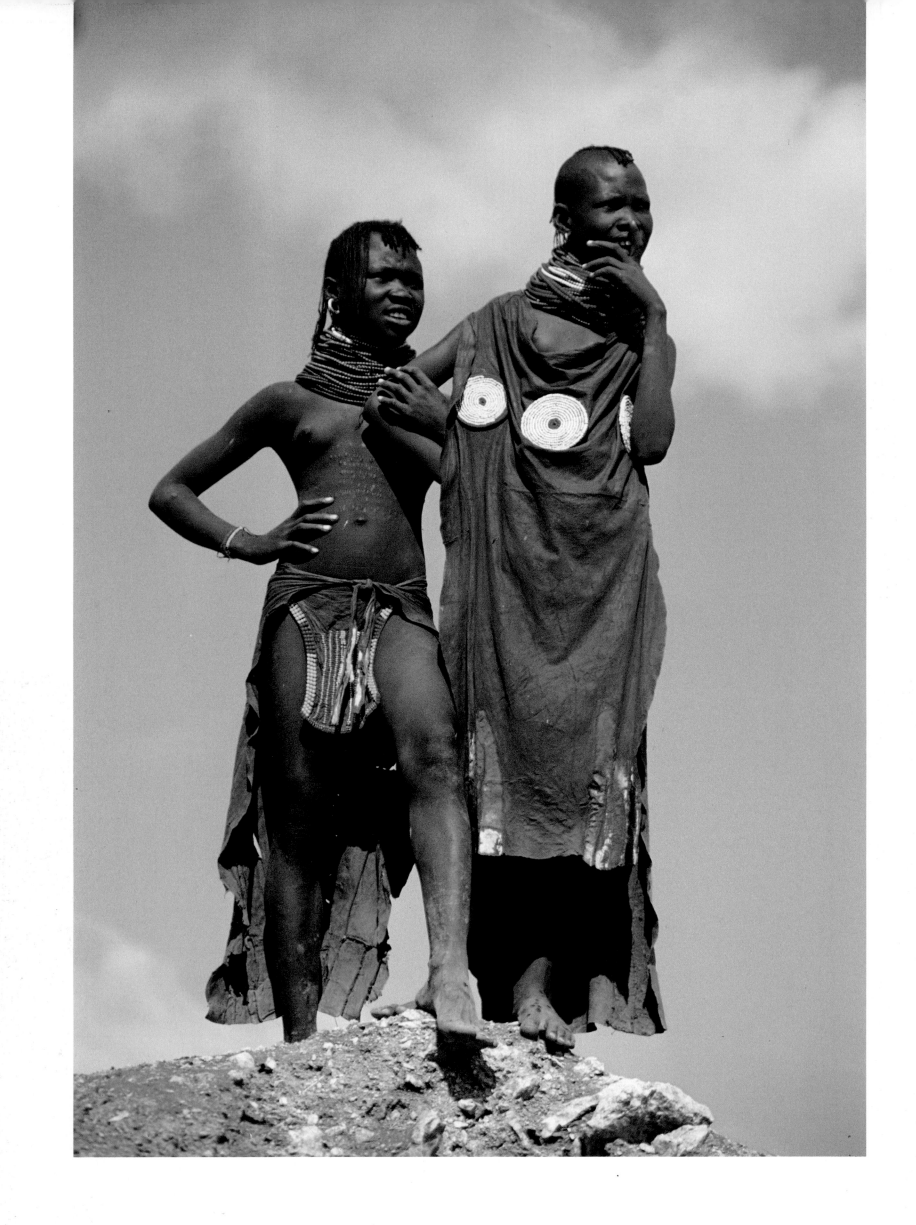

TURKANA BEADWORK

The large beads and bold, contrasting colours used in Turkana beadwork suit the very dark skin and somewhat heavy features of these fiercely independent and aggressive nomads. The beaded circles on the goatskin worn by the girl on the right indicate that she is not yet married.

LEFT Turkana women wear skirts of animal hide; many a hot afternoon is spent decorating them with beads. Small children wear just a string of beads, while adolescent girls have tiny skirts at the front and back, *araci*, decorated with glass or ostrich eggshell beads. These skirts will gradually become longer as the girls reach marriageable age.

RIGHT Wooden pendants sewn into the hair are believed by the Turkana to afford protection from evil spirits. Good luck pendants, made from ground snail shells, and lip plugs are worn by married men and women.

BELOW Turkana nomads carrying animal skins return to the camp. The hides may be used as sleeping mats; if they are to be used for clothing they will be scraped and stretched, softened and coloured with animal fat and ochre, before being decorated with beads.

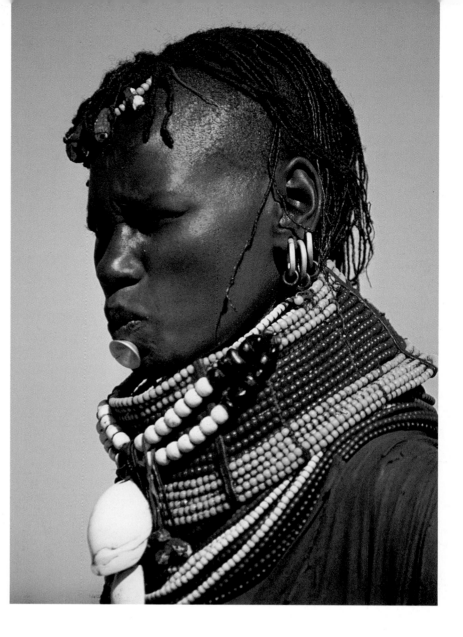

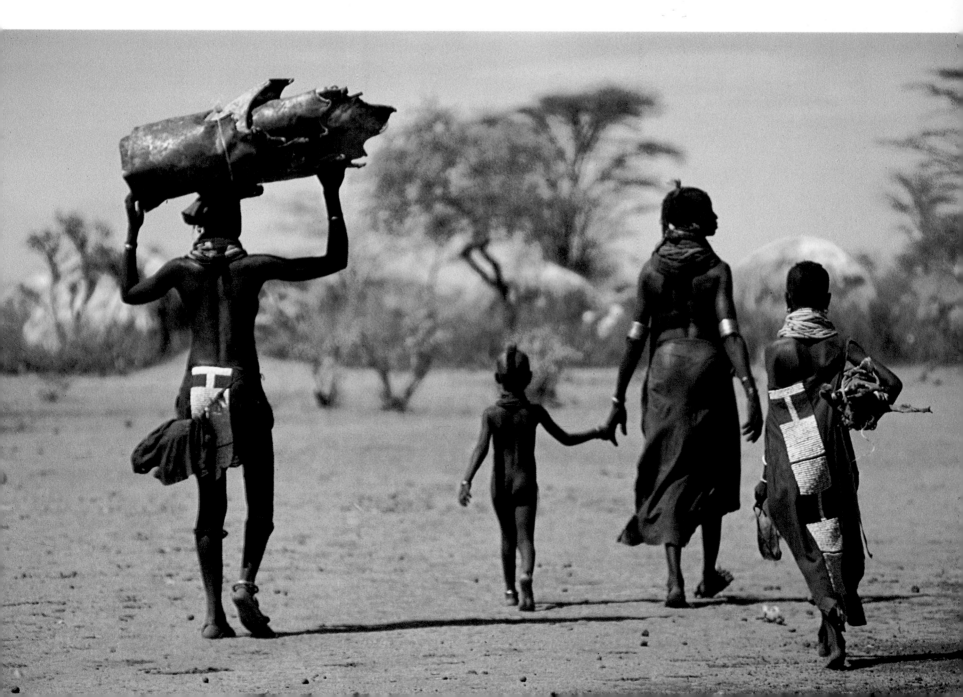

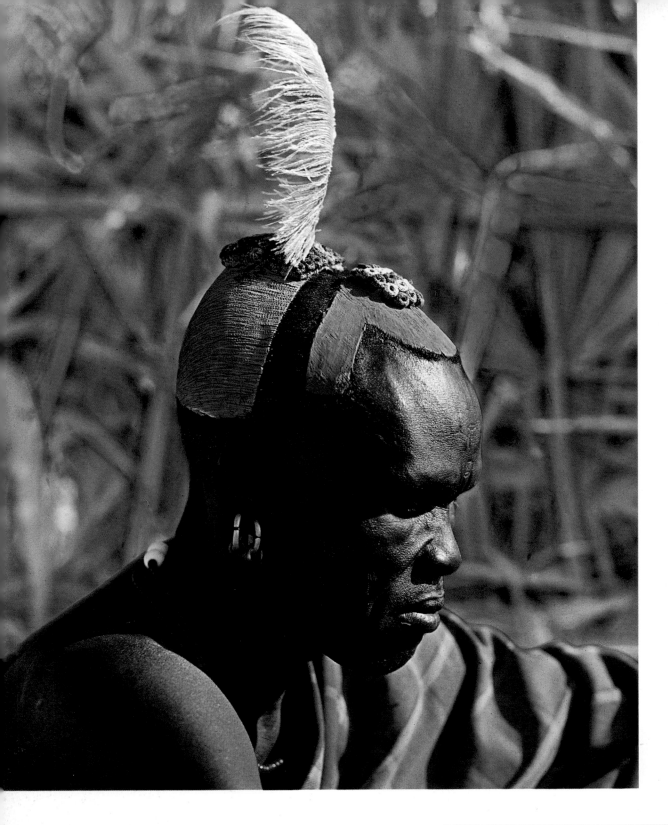

NATURAL ELEMENTS

Before imported glass beads were readily available in any quantity in East Africa, jewellery was made sometimes of iron and clay, but mainly of animal and vegetable substances: bone, horn, hair, wood, roots and seeds. Ostrich eggshells were chipped and rounded into beads, a process used in Kenya since at least 7000 BC.

Turkana men say of a lovely woman, 'It is the things she wears that make her beautiful.' When a young girl is ready for marriage she covers her body with ochre and fat, wears an elaborate bead pendant necklace and an ostrich feather in her hair. An ostrich eggshell belt, *n'gakirim*, holds up her long beaded skirt.

LEFT Clay is traditionally used by Turkana men to fashion their elaborate hairstyles. The hair is twisted into small plaits which are covered with clay and shaped into a bun on top of the head. The hairstyles of Turkana men, unlike those of the Pokot, remain the same throughout their lives; status is shown by inserting ostrich feathers into holders of cow gut or macramé, which are placed in the hair while the clay is still wet. The hairstyle may take up to three days to perfect and is meticulously remade every three months.

RIGHT Examples of necklaces made largely from natural substances. Occasionally seen today, these designs were more common before the introduction of glass beads.

1 A Dinka warrior's necklace of carved shell beads and seeds.

2 A necklace worn by Maasai warriors made from the lining of a goat's stomach and perfumed with aromatic seeds. The button is fashioned from crocodile eggshell.

3 A belt worn by Samburu and Turkana women, made from the toe bones of a small antelope strung with glass beads.

4 A Dinka woman's necklace made from ostrich eggshells with a centrepiece of old stone beads.

5 A Dinka elder's necklace of snake vertebrae with old glass beads and cowrie shells.

6 A Nuer necklace of carved wooden beads. The pendant has been shaped to resemble cows' horns.

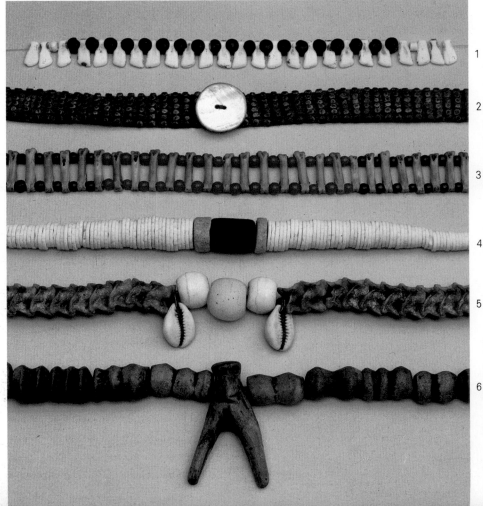

1

2

3

4

5

6

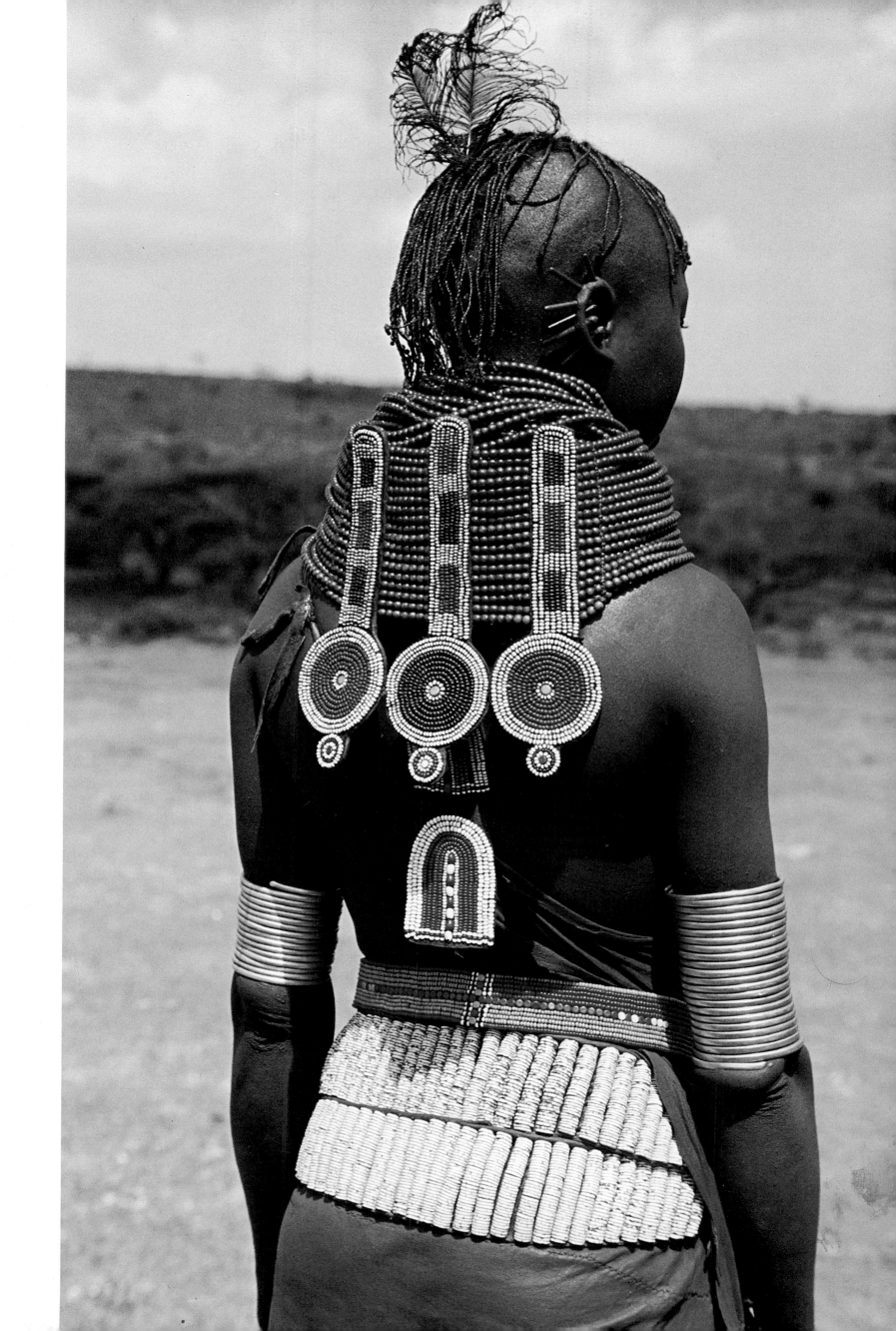

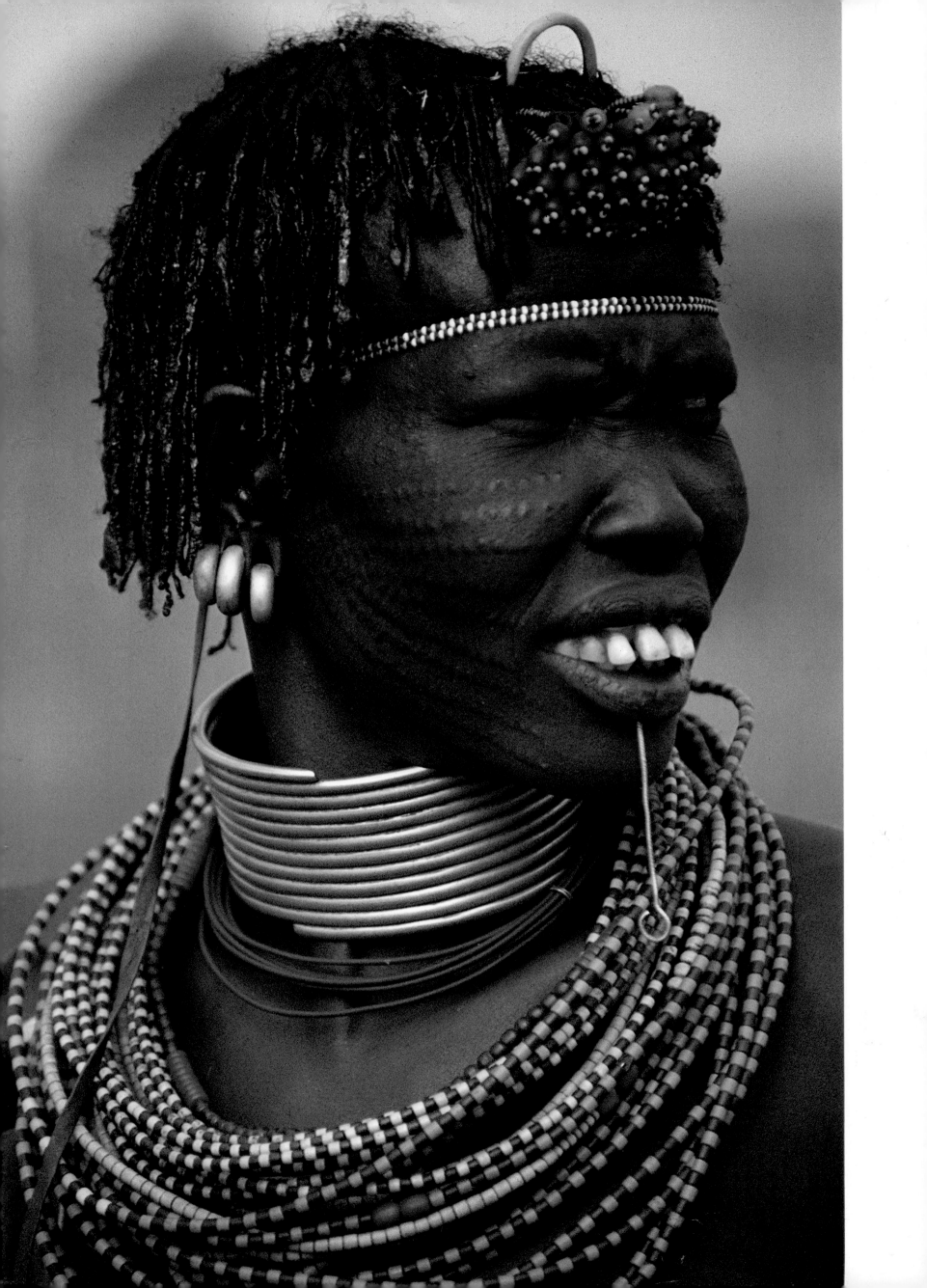

PATTERNS OF IDENTITY

LEFT The Toposa, northern neighbours of the Turkana, are great cattle herders. They often have their lower teeth extracted in order to make the upper jaw and teeth protrude unnaturally, a practice they think makes them resemble their precious cows rather than the ugly and inferior goat.

RIGHT Married Toposa women are distinguished by their hairstyle of tiny pigtails glistening with fat. Red seed beads and an ostrich feather complete this coiffure, and a long wire is also fitted to the lower lip. This woman is also wearing a coiled torque of iron wire, a gift from her husband at the time of their marriage.

BELOW The bracelets worn by Toposa men may be of copper, brass or iron and, as with the Turkana and Pokot, the metal chosen often indicates their 'alternation' – the group into which the men are born and which dictates their role in warfare and cattle raids. The wife's torque will always be of a metal different to that ordained by her husband's alternation.

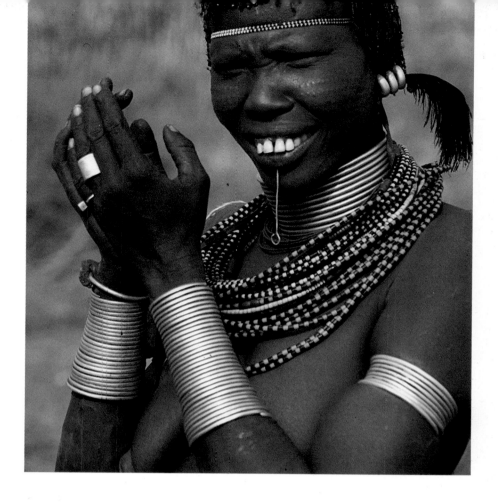

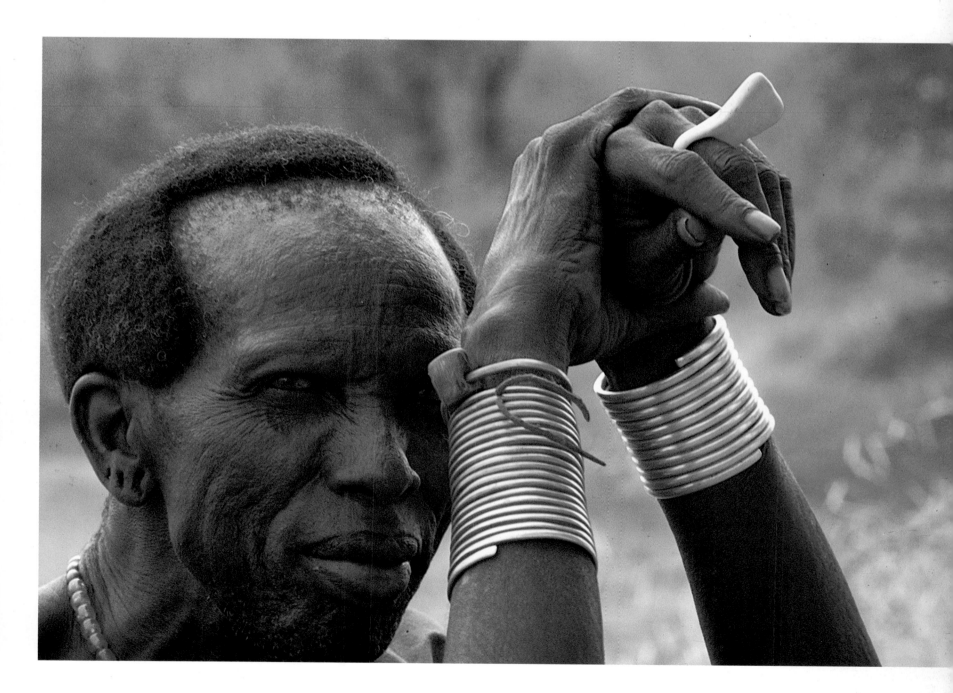

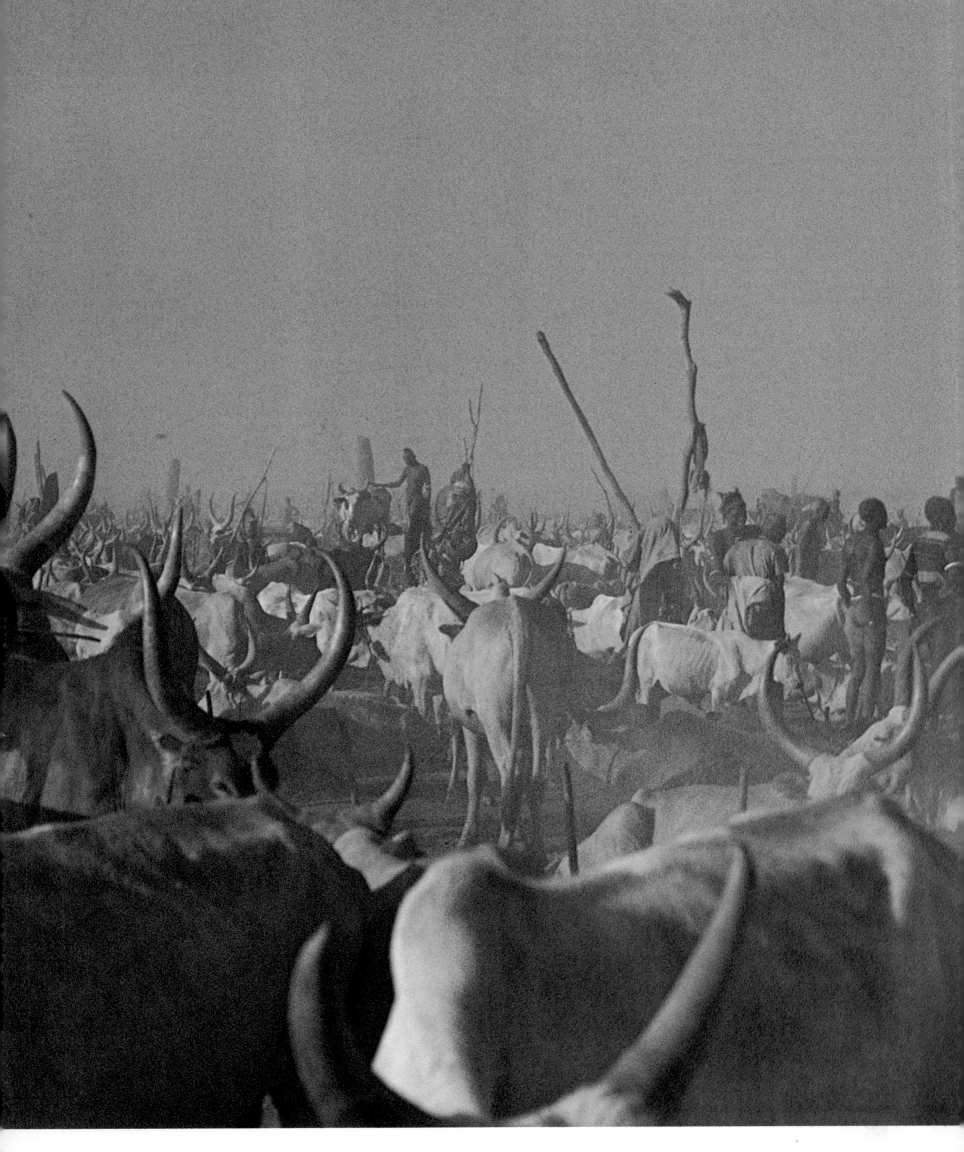

MINIMAL ATTIRE

In the dust and heat of a dry season Dinka cattle camp, the men are
sparsely adorned and consider it unmanly to use covering even on
cold nights.

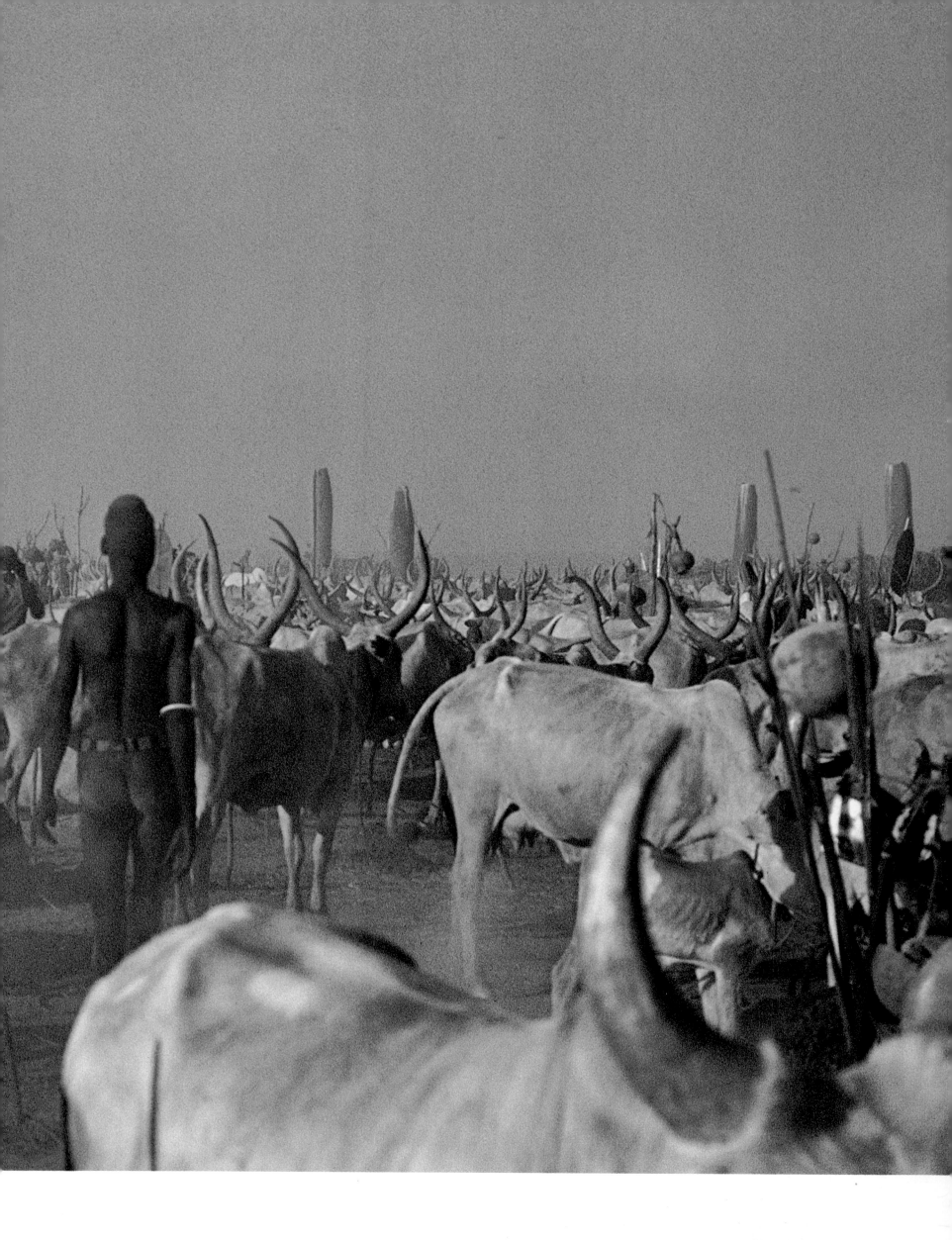

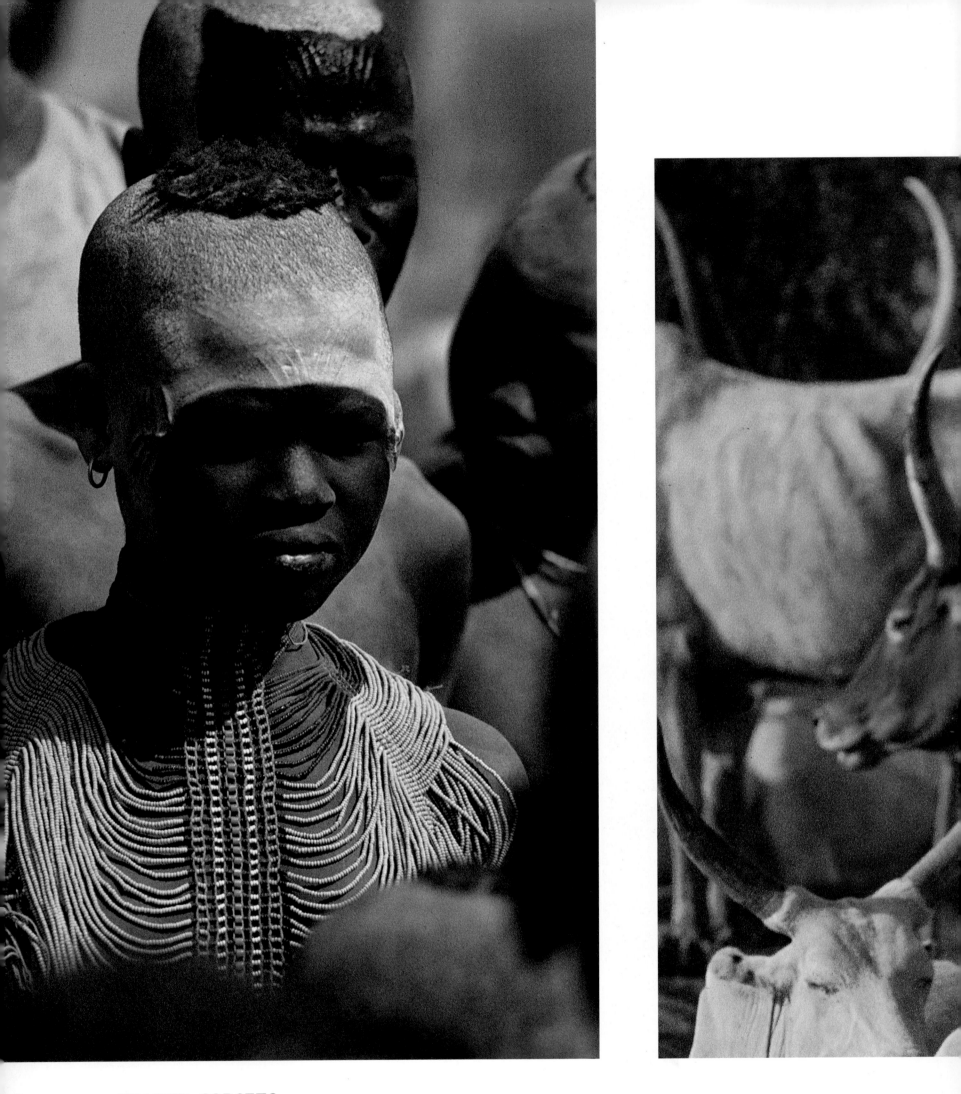

BEADED CORSETS

Tight beaded corsets are everyday wear for some of the Dinka men, the colour indicating their position in the age set system: red and black are worn by 15- to 25-year-olds; pink and purple by the 25-30 age set, and yellow by those over 30. Their bodices are usually sold to younger brothers for the price of a bull – a high price for the Dinka. Some Dinka have now replaced the corset with a smaller, more comfortable beaded belt.

Flat ivory armlets indicate the wearer's skill and bravery in elephant hunting, or simply show that he is rich in cattle.

Dinka men bleach their hair yellow by applying a paste of cows' urine and ash. Although primarily done for beauty, this treatment also acts as a disinfectant. The practice among both men and women of shaving the hairline and applying ash paste (*left*) is purely ornamental.

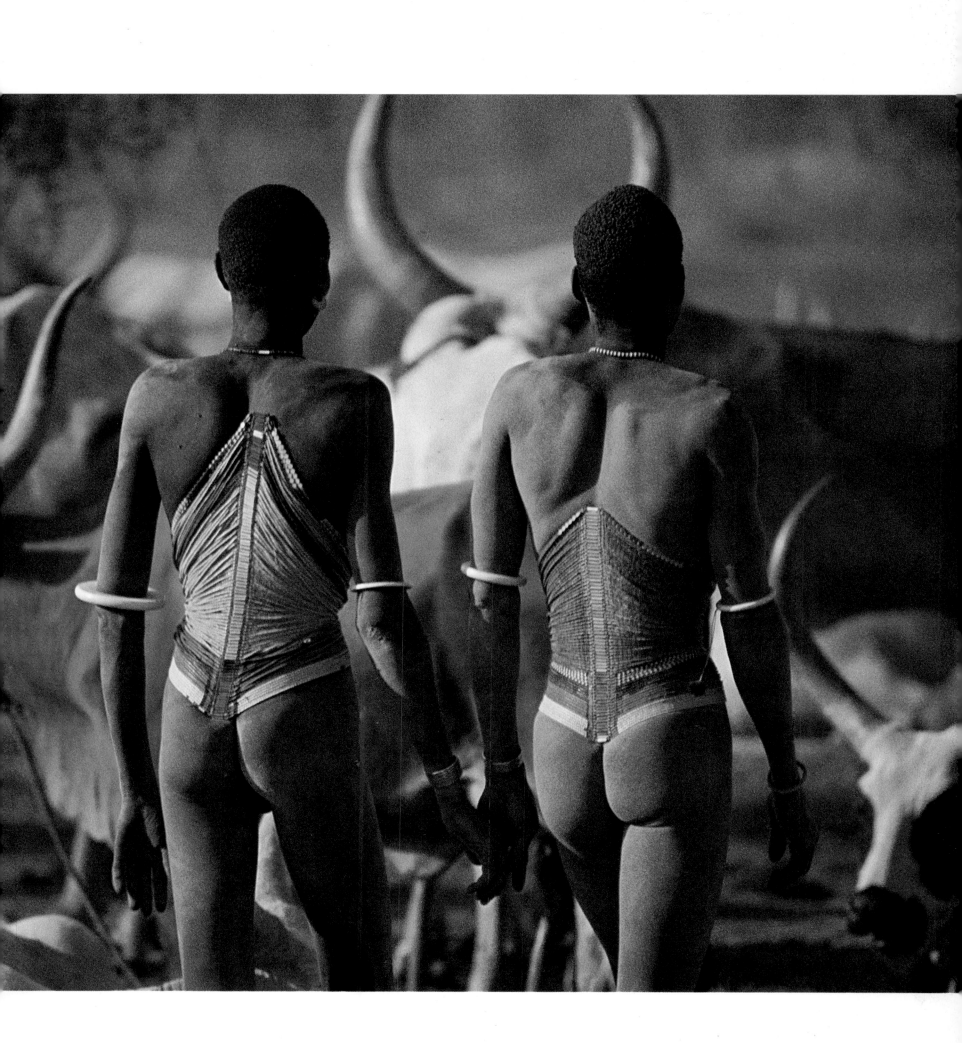

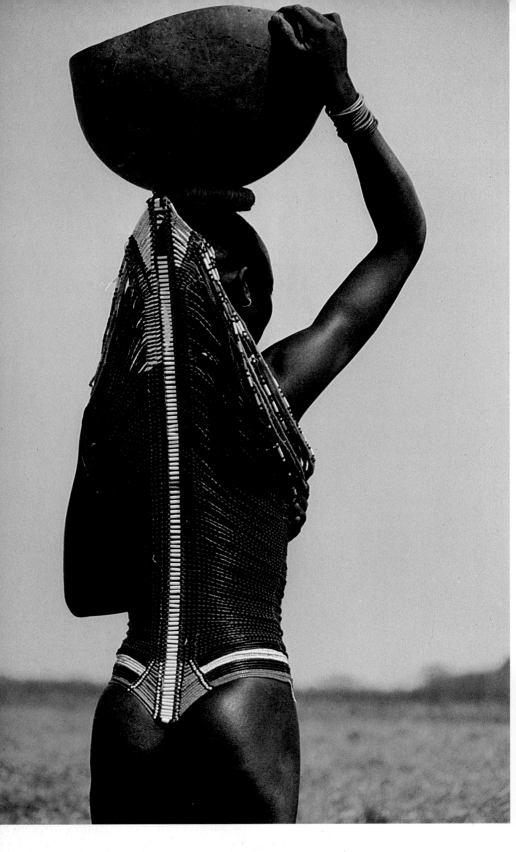

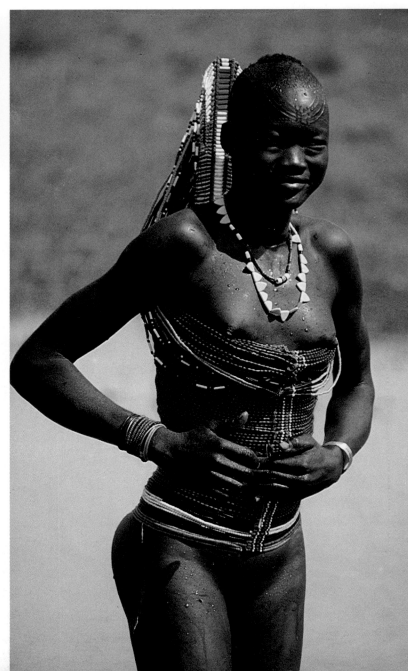

HIGH FASHION

ABOVE AND RIGHT Corsets are rarely seen on Dinka women, and this one is particularly unusual because of the height of the projection at the back; its size indicates that this girl belongs to a family with considerable wealth in cattle. The corsets, supported by two rigid wires at the spine, are sewn tightly in place at the front and there they remain until they are cut open – which, for a woman, is on the occasion of her marriage.

OPPOSITE Like a Nile crane, a Dinka warrior stands guard on one foot. His corset will stay in place day and night, only being changed for one of a different colour when he progresses on to the next age set.

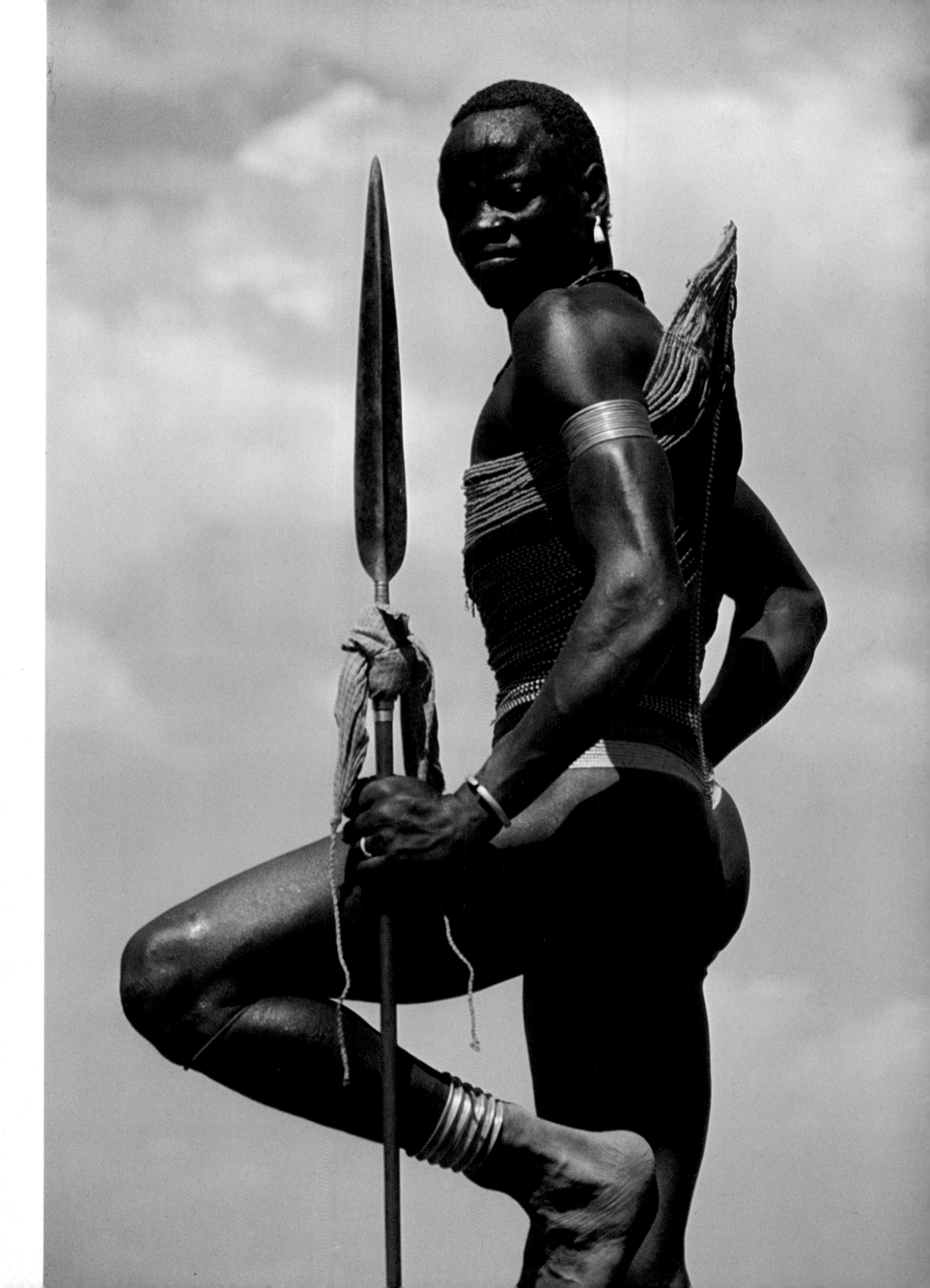

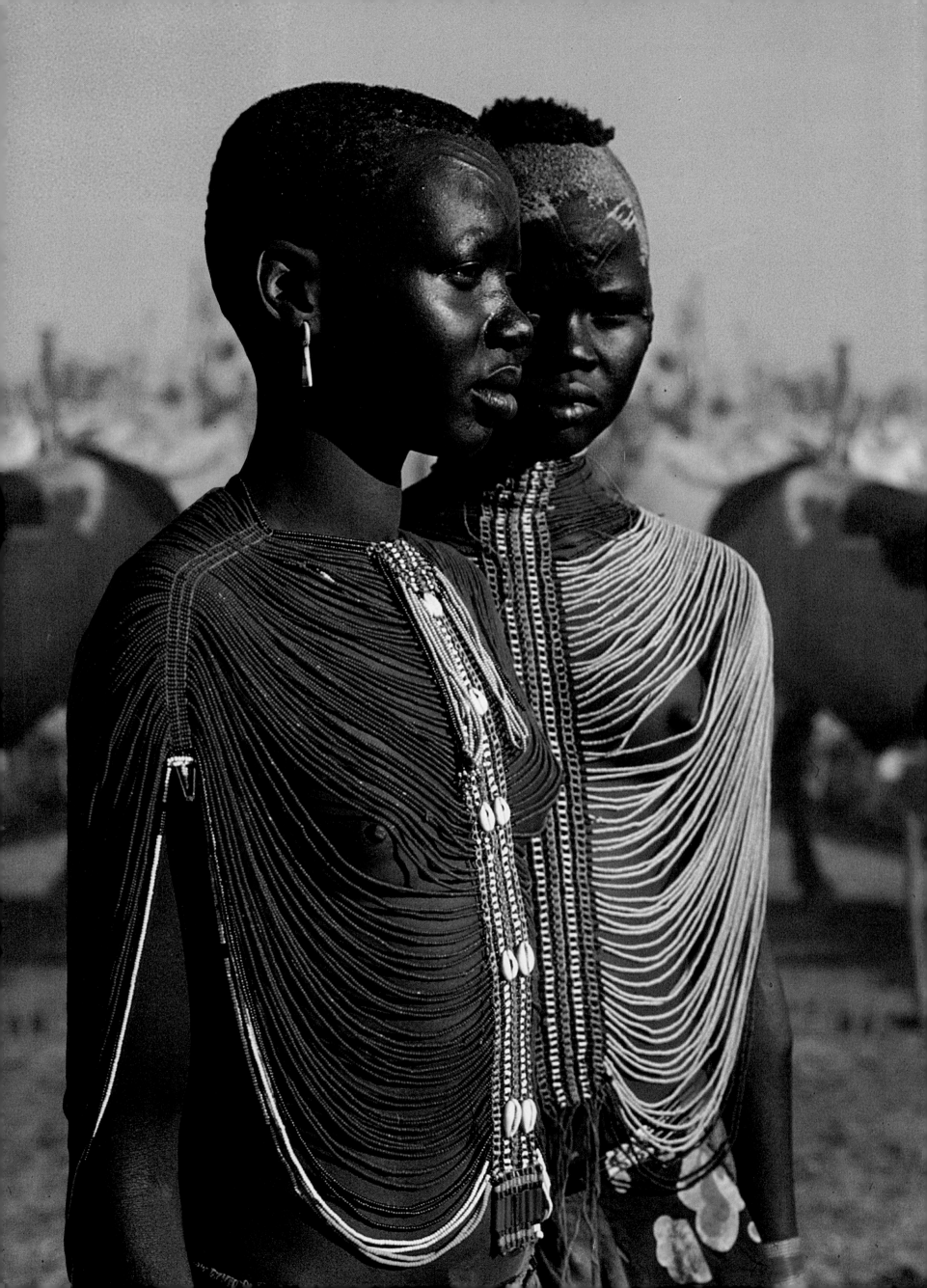

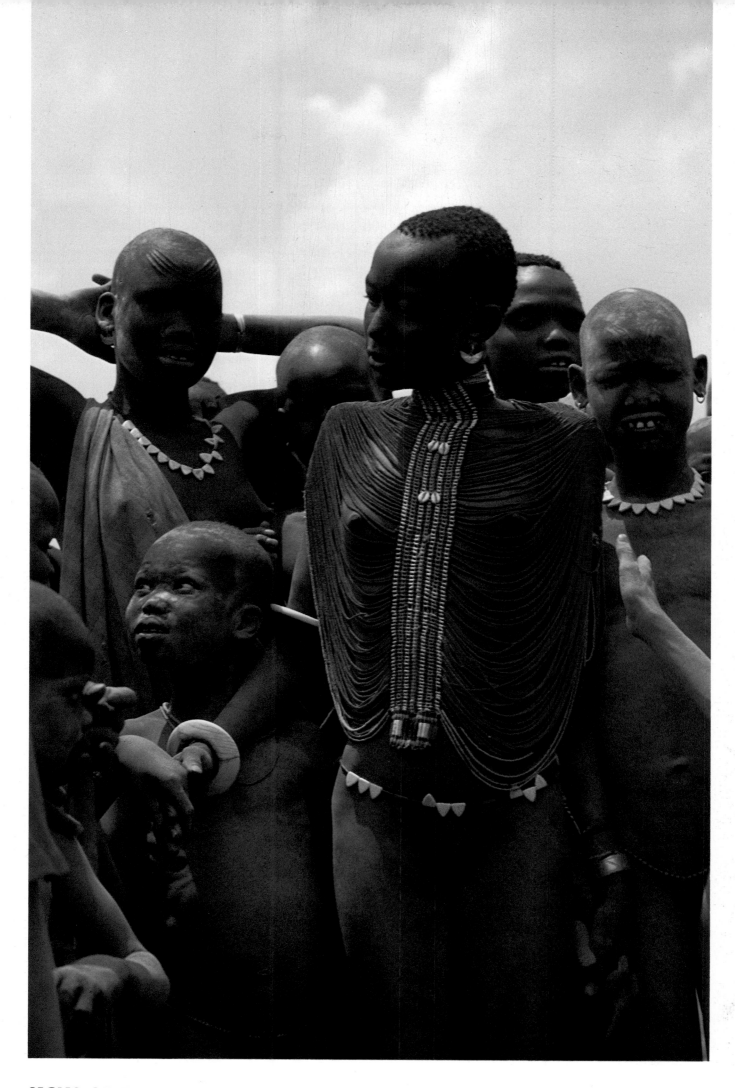

SIGNS OF ELIGIBILITY

These alluring loose bead bodices are worn by Dinka girls who are eligible for marriage. At the age of 17 or 18 the girls are fattened by their families to make them look rich and attractive. A beautiful bride will cost a man many head of cattle and will thereby add considerably to her family's wealth. Beads, provided by the girl's family, are applied in patterns which indicate the family's prosperity, and cowrie shells are attached to promote fertility.

Ivory bracelets denote wealth or status for the Dinka, and the segmented ivory bracelet, *afiok*, seen above is believed to contain magical properties too. These bracelets are sometimes given as presents by admiring boyfriends.

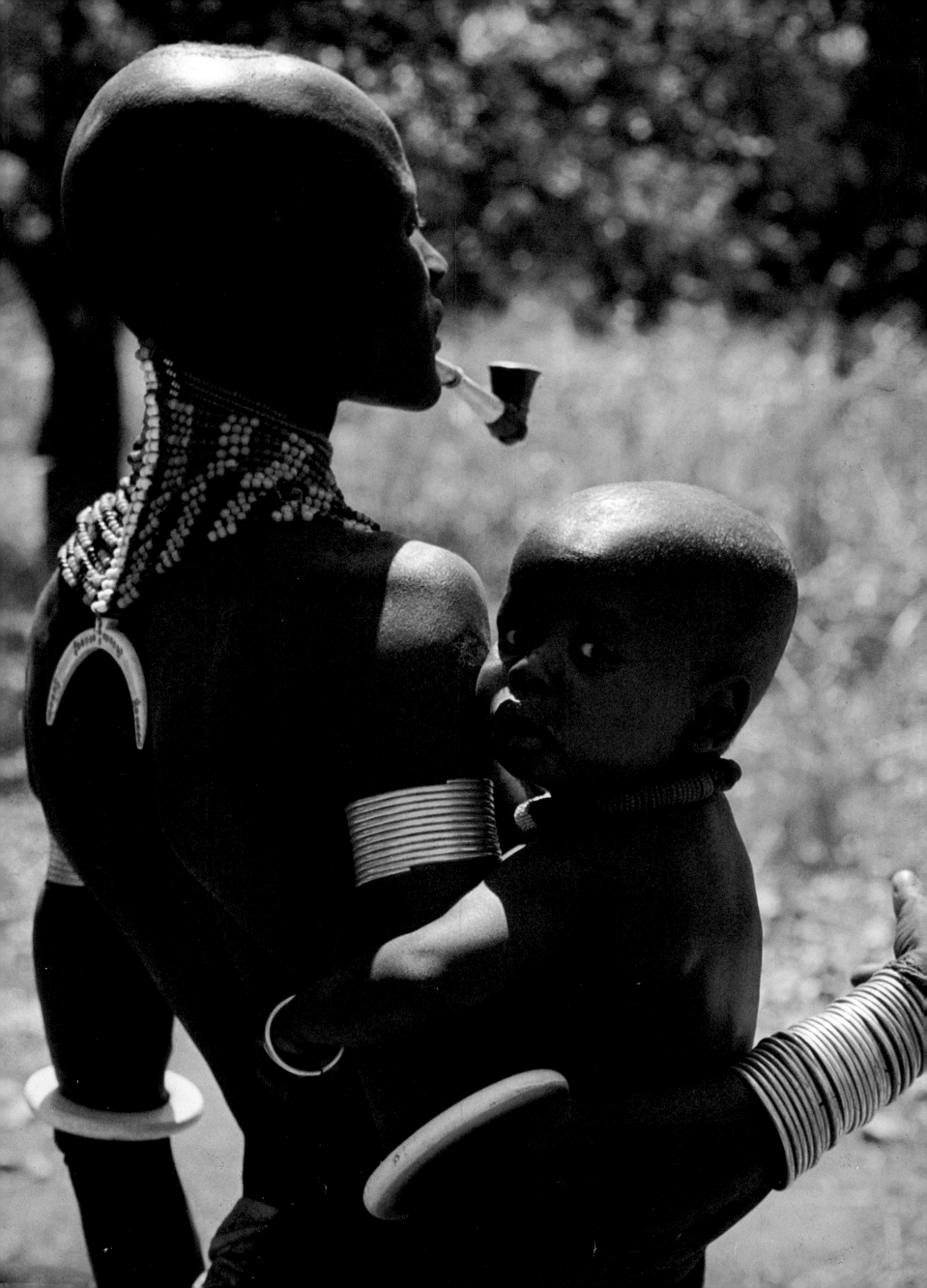

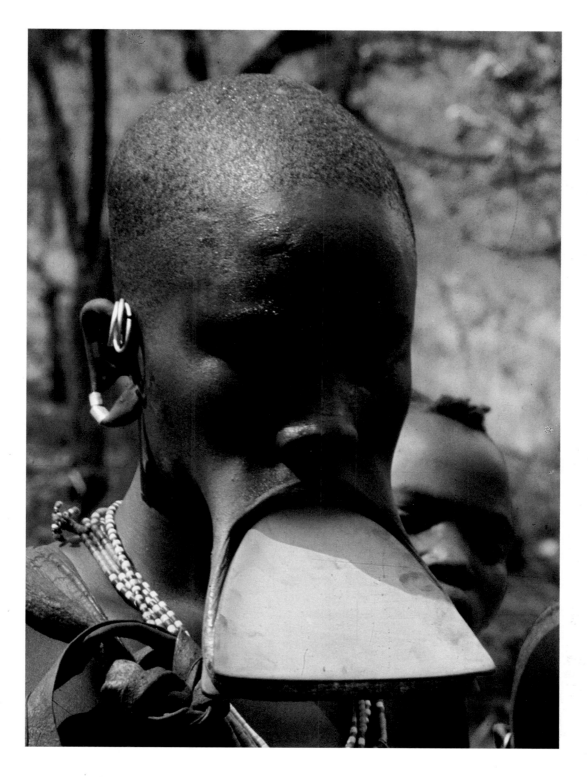

EMPHASIS AND EXAGGERATION

LEFT Like the corset, bracelets and armlets are fitted very tightly to accentuate the body's natural form. Coils of wire are wound so firmly round the arms and wrists that they only just permit circulation and often cause the limbs to swell, but the Dinka admire roundness of limbs and will endure the discomfort with pride. Of the Dinka, Dr Georg Sweinfurth wrote in his book *Heart of Africa* (1874), 'Heavy rings load their wrists and ankles, clank and resound like the fetters of slaves. Free from any other domination . . . they are not free from the fetters of fashion.'

ABOVE Vast wedge-shaped or circular lip plates are worn by the Kichepo of south-east Sudan. They have long been considered an essential part of a woman's adornment and were traditionally worn in the presence of men or mothers-in-law. Some maintain that the practice originated as a means of discouraging slave traders; others that it is associated with animal worship, in that the women extend their lips to make themselves look like certain birds – broadbills and spoonbills for example. Today, large plates are worn only by the older generation; younger women who resist the custom wear much smaller plugs or none at all (*see p. 16*).

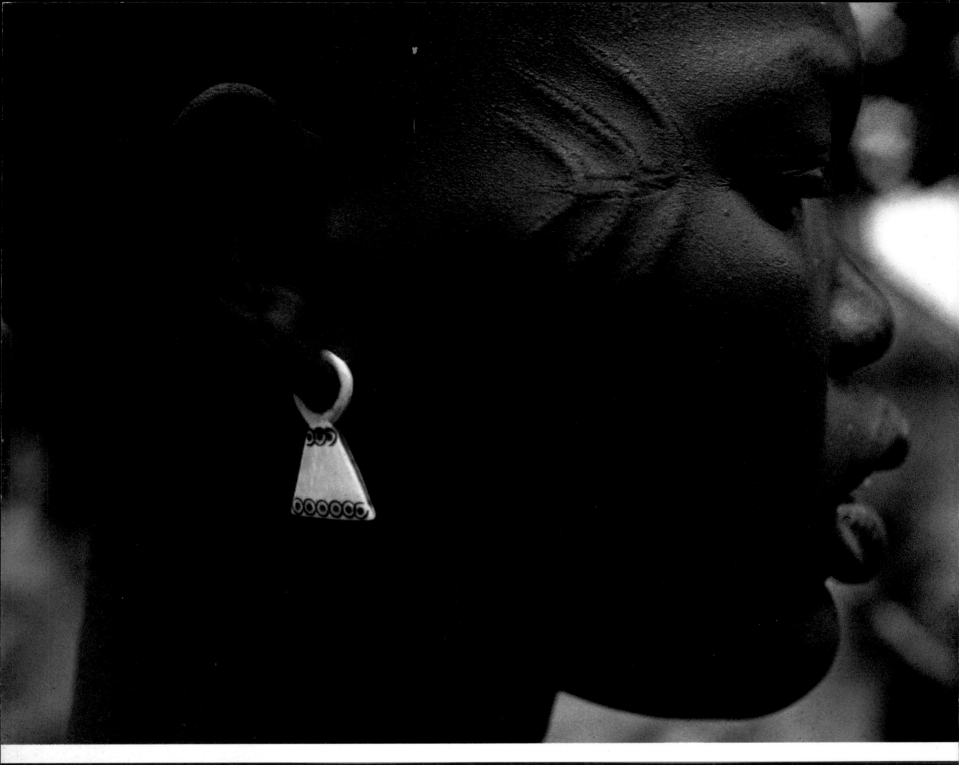

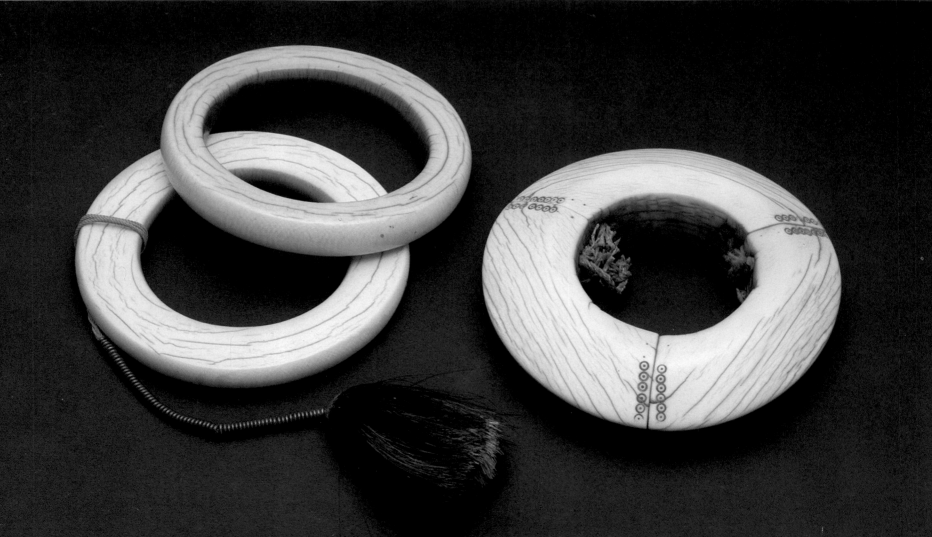

IVORY

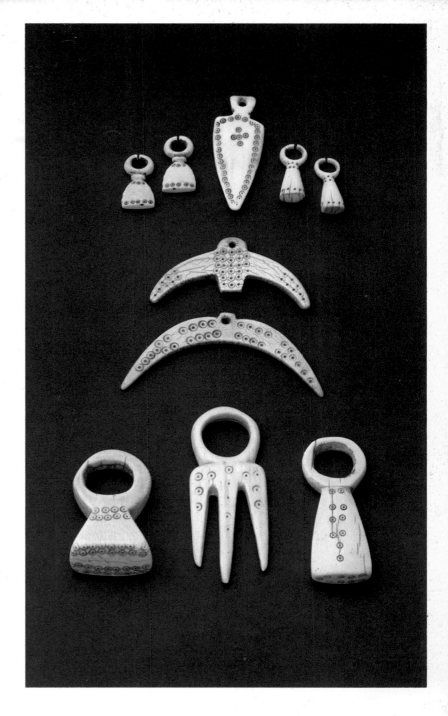

ABOVE LEFT A young Dinka girl with incised ivory earrings. The scarification on her temples takes the shape of cows' horns.

BELOW LEFT Dinka ivory bracelets. The flat ones on the left are worn generally on the upper arm, and men sometimes add to them a cow's tail tassel similar to the one that hangs from the horns of their namesake ox (*see p. 16*). The segmented bracelet, *afiok*, is worn on the wrist, particularly by girls who are available for marriage. Whereas flat bracelets are worn by many of the Dinka, segmented ones are confined to particular groups.

RIGHT Ivory is so highly valued by the Dinka that broken bracelets are not discarded but carved into smaller items of jewellery such as earrings, pendants and rings. The earrings (*top row*) are worn by both men and women, as is the pendant. Finger rings (*centre*) are worn by men only and indicate status. The two pendants shaped like cows' horns are suspended from the back of the glass bead necklaces given by men to their wives at marriage – these are evidence, as is the scarification in the picture opposite, of the integral part that cattle play in the life of the Dinka. (Largest ring 10cm)

BELOW Nuer women can be distinguished from Dinka women by the string of glass beads worn tightly across the forehead. Many of their ornaments resemble those of the Dinka: both men and women wear ivory armlets and bracelets of brass and aluminium.

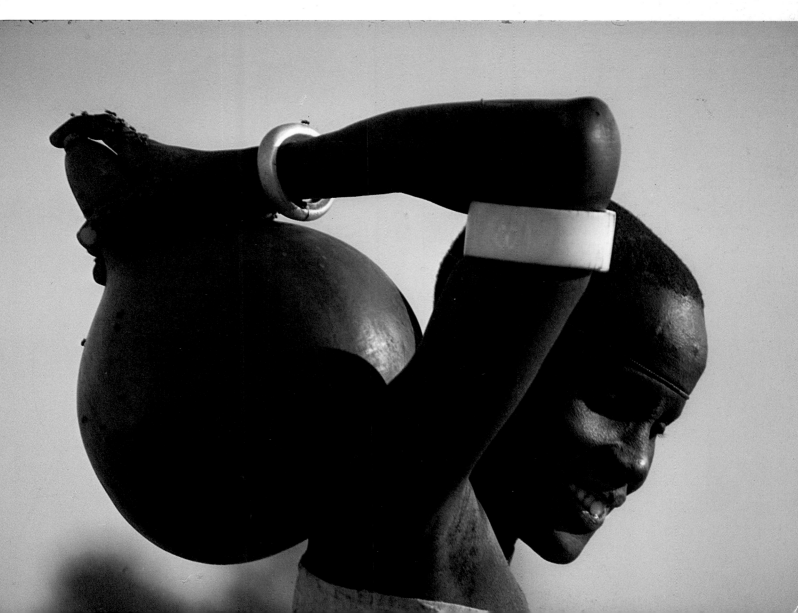

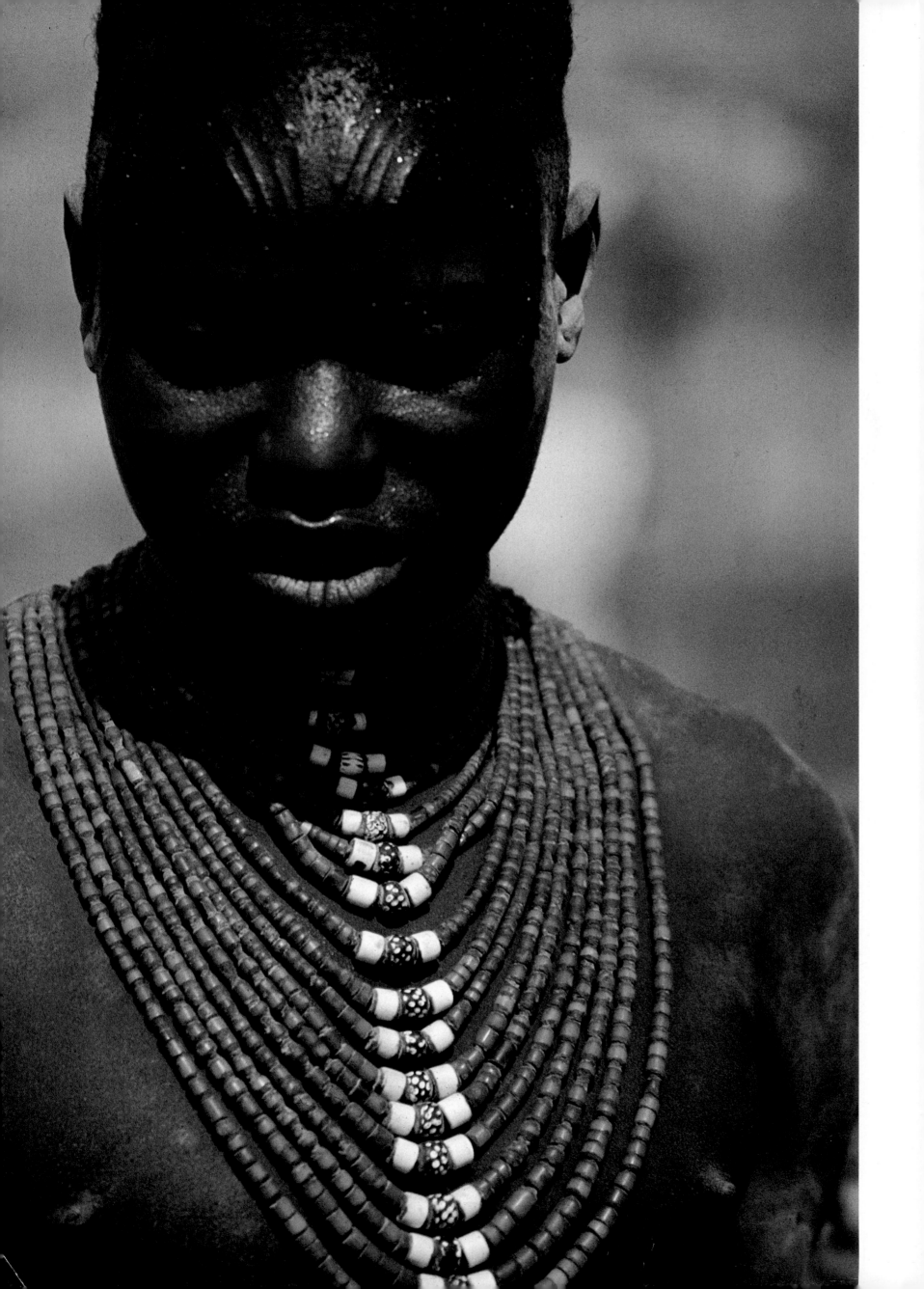

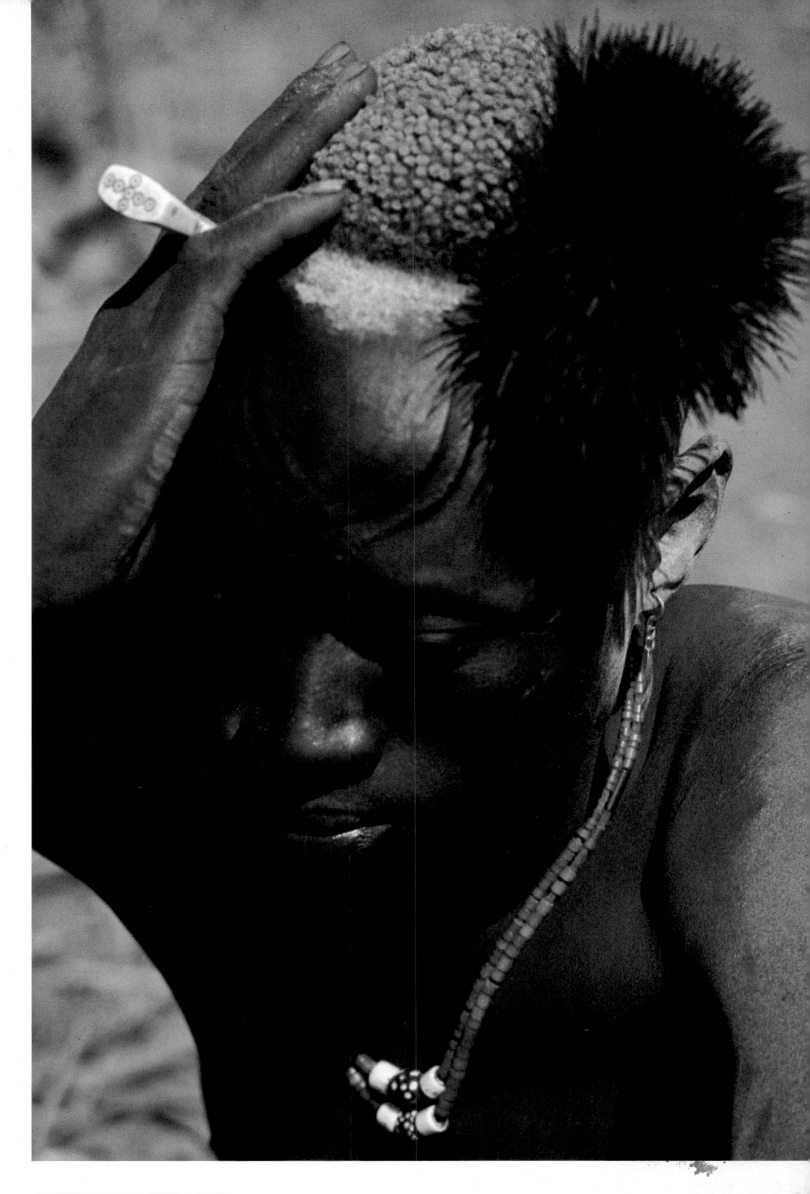

A SHOW OF WEALTH

Old glass beads, like ivory, indicate prosperity among the Dinka. This wedding necklace of Venetian glass beads (*opposite*) represents the wealth of the bridegroom's family. Each strand is worth an ox, and though the groom himself may have only a couple of strands (*above*) he will borrow others from his family before the wedding. These he will give to his new bride but the borrowed beads must be eventually returned.

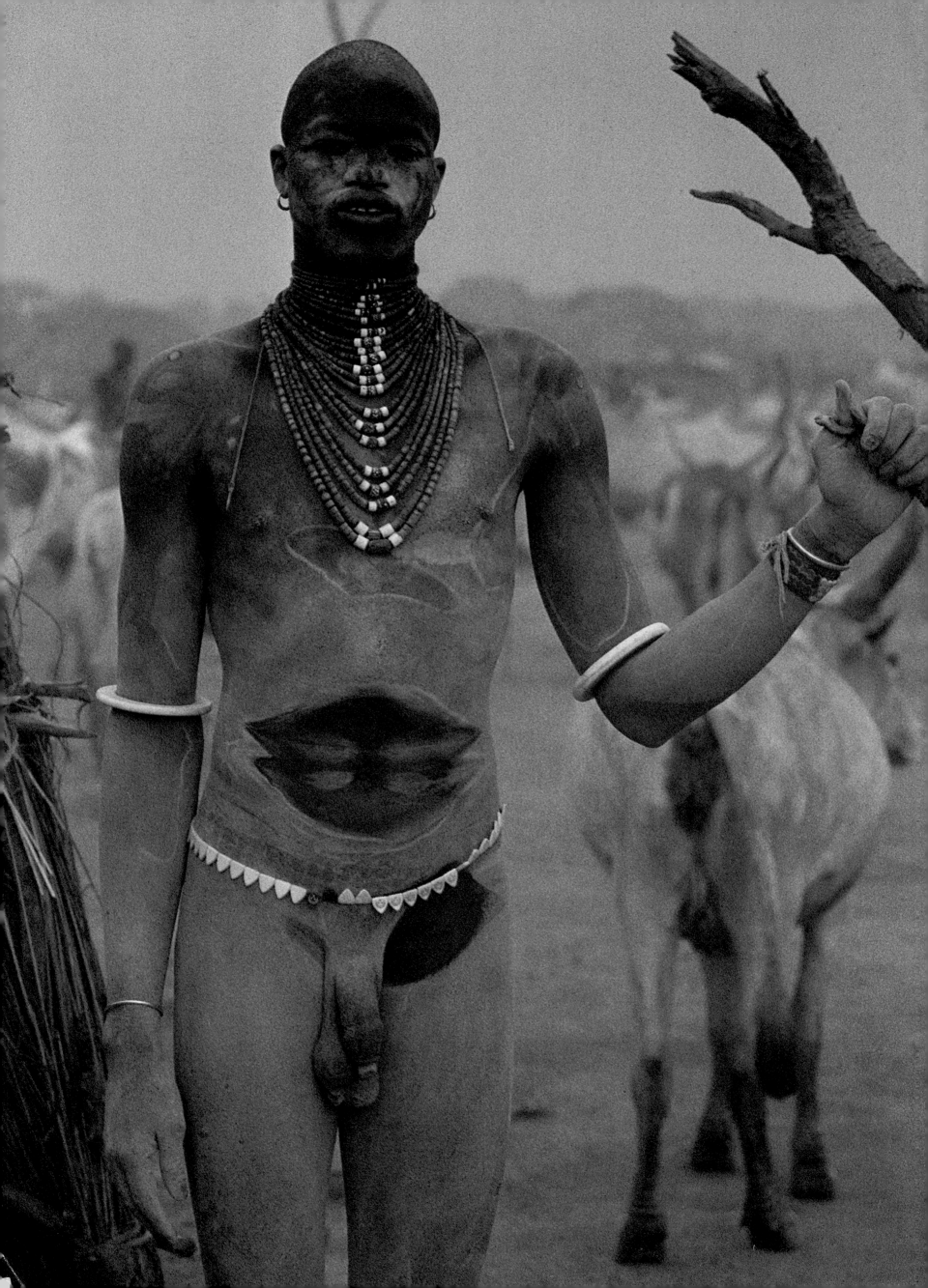

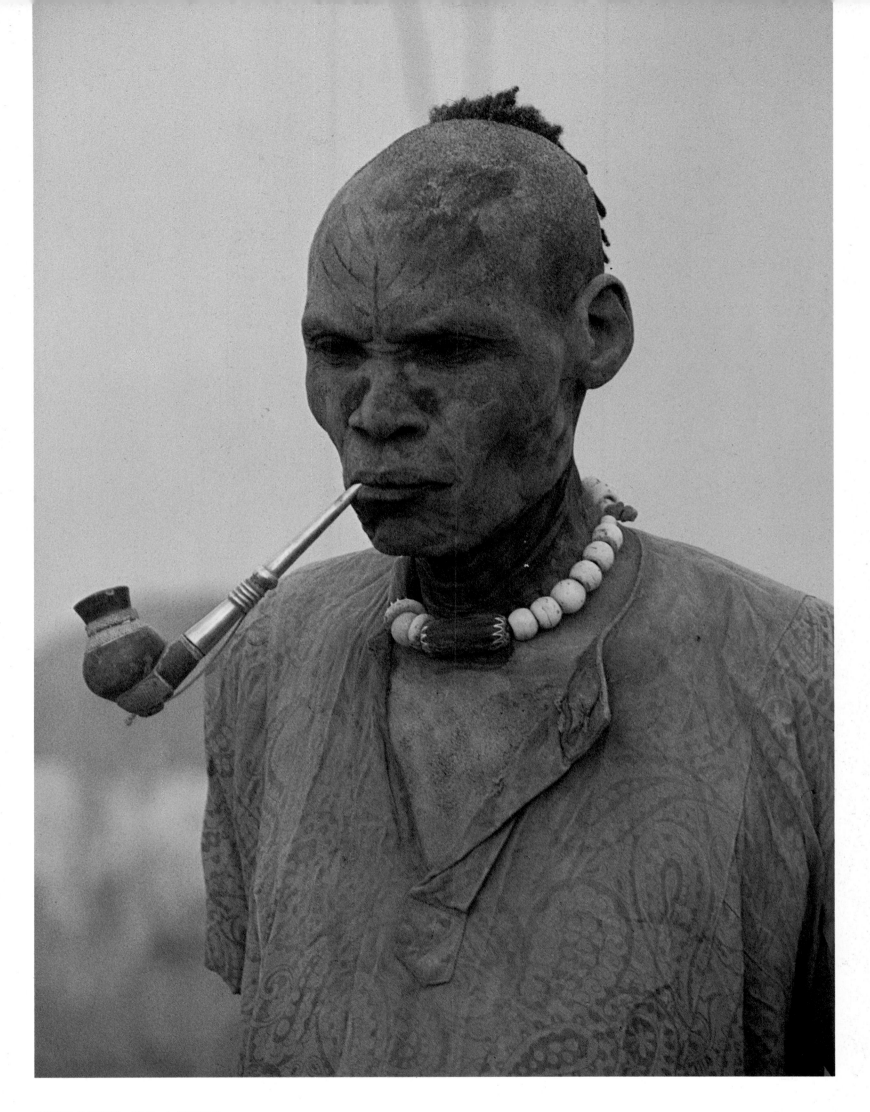

SCULPTED IN ASHES

The Dinka call themselves Monyjang, the 'men of men'. Their magnificent physique and the practice of caking their bodies in ash has earned them the name 'ghostly giants'. They are indeed an un-forgettable sight, some as tall as seven feet, with fine expressive faces and wierdly pallid bodies adorned only with ivory beads.

A traveller in the nineteenth century, Sir Samuel Baker, wrote of the Dinka, 'They are something superlative . . . the men are as naked as they came into the world, their bodies rubbed with ashes and their hair stained red by a plaster of ash and cow's urine. These fellows are the most unearthly looking devils I ever saw – there is no other expression for them.'

The Dinka elder (*above*) claimed that his glass bead necklace was a gift from God. These old Venetian beads are rare in East Africa and probably came via trade routes from the west.

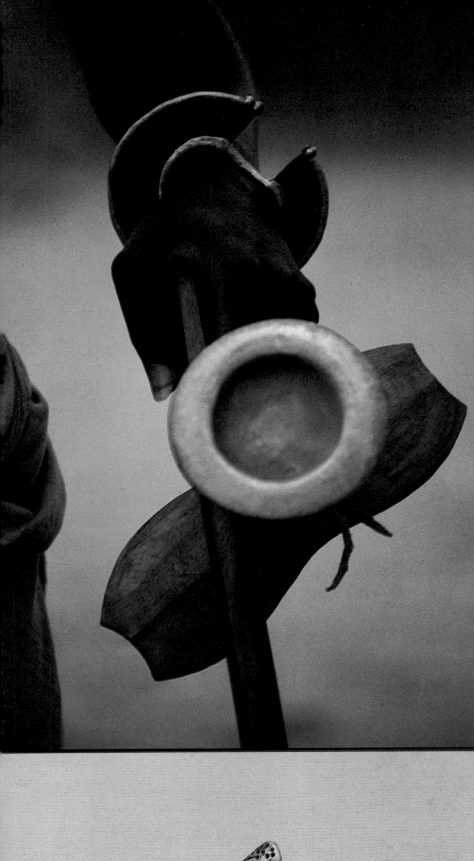

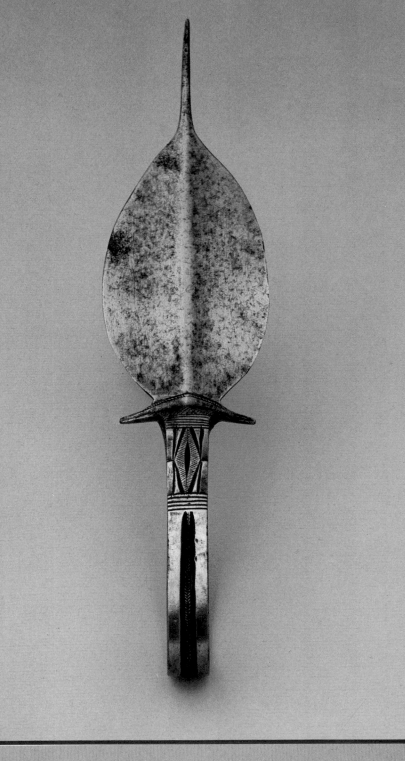

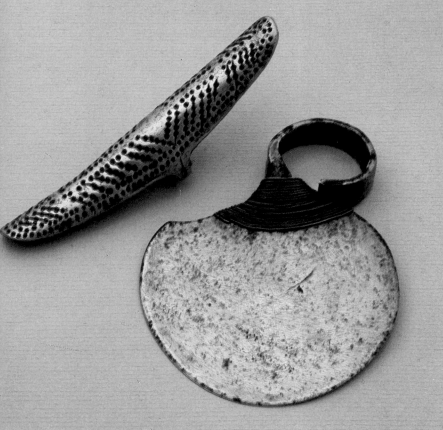

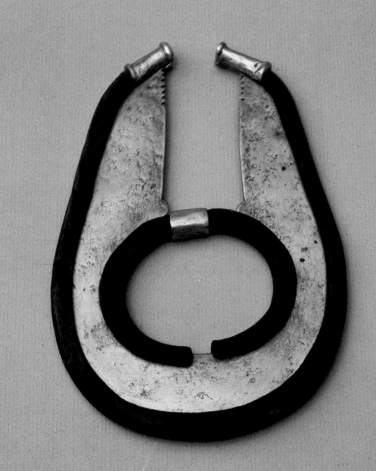

WAR AND PEACE

Men's ornaments often have a practical value as well as being aesthetically pleasing; many double as weapons, some are thought to give the wearer protection, others are used as containers.

1 An *abarait*, a wrist knife commonly worn by Pokot, Turkana and Karamojong men. A narrow leather sheath covers the sharp cutting edge during everyday wear; in cattle raids it may be used to gouge out an opponent's eyes. Men also carry wooden headrests to protect their elaborate hairdos while they relax or sleep. The headrest here is used by Turkana men.

2 A lethal wrist knife from southern Sudan, or possibly Sierra Leone. (25cm)

3 A long iron finger ring, a symbol of status among Maasai warriors, and an iron thumb knife, *akoli*, bound with copper wire, used by Karamojong and Turkana men for both fighting and domestic purposes. (10cm, and 8cm)

4 A Toposa wrist knife from Sudan, of more sophisticated design than those used by the Turkana, Pokot or Karamojong. (15cm)

5 *Errap*, an arm ornament of cow horn wrapped in copper wire, worn on the upper arm by Maasai warriors who have killed a man in battle. (17cm)

6 A phallic headpiece, *kalacha*, made of aluminium attached to a bone base and worn on a leather strap around the head by Boran men. It is passed from father to son during the initiation ceremony. These headpieces are cast by the Konso tribe of Ethiopia, who trade with the Boran. Phallic symbols are believed to preserve the strength of men whose virility might be drained by sexual intercourse; they are often found on the roofs of men's sleeping quarters for this reason. (12cm)

7 These snuff containers worn by Maasai elders are made of buffalo and cow horn and have leather lids decorated with old glass beads. They are worn on hand-made iron chains around the neck at all times. (Largest 7cm)

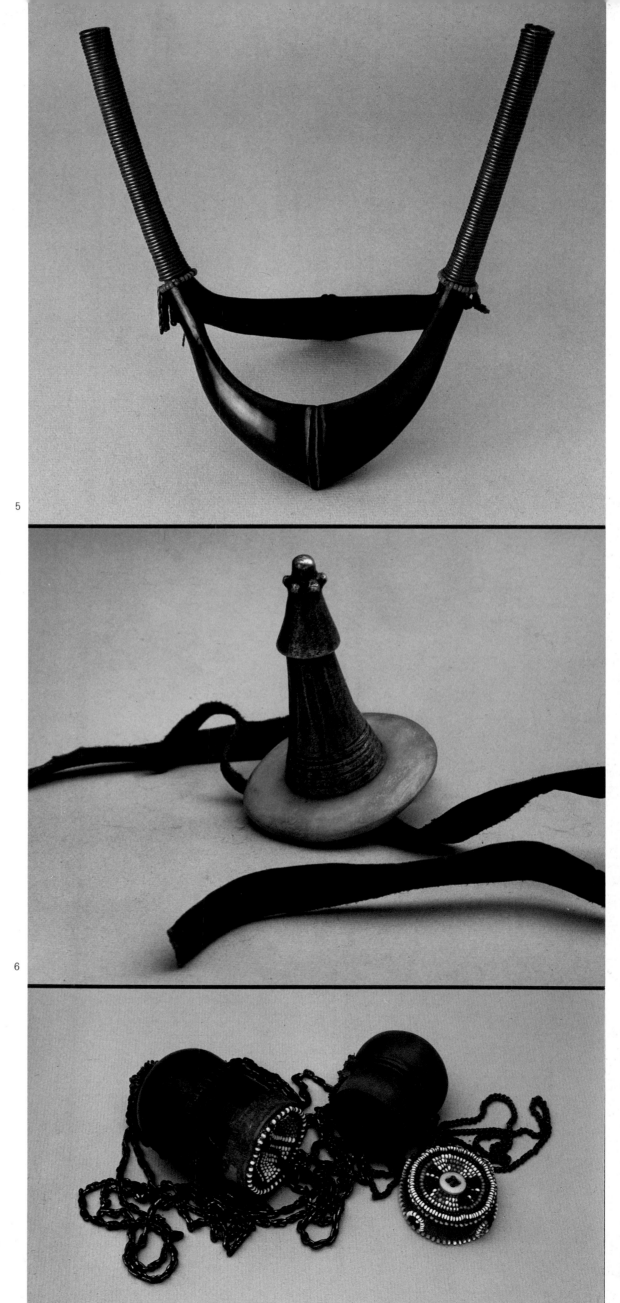

5

6

7

63

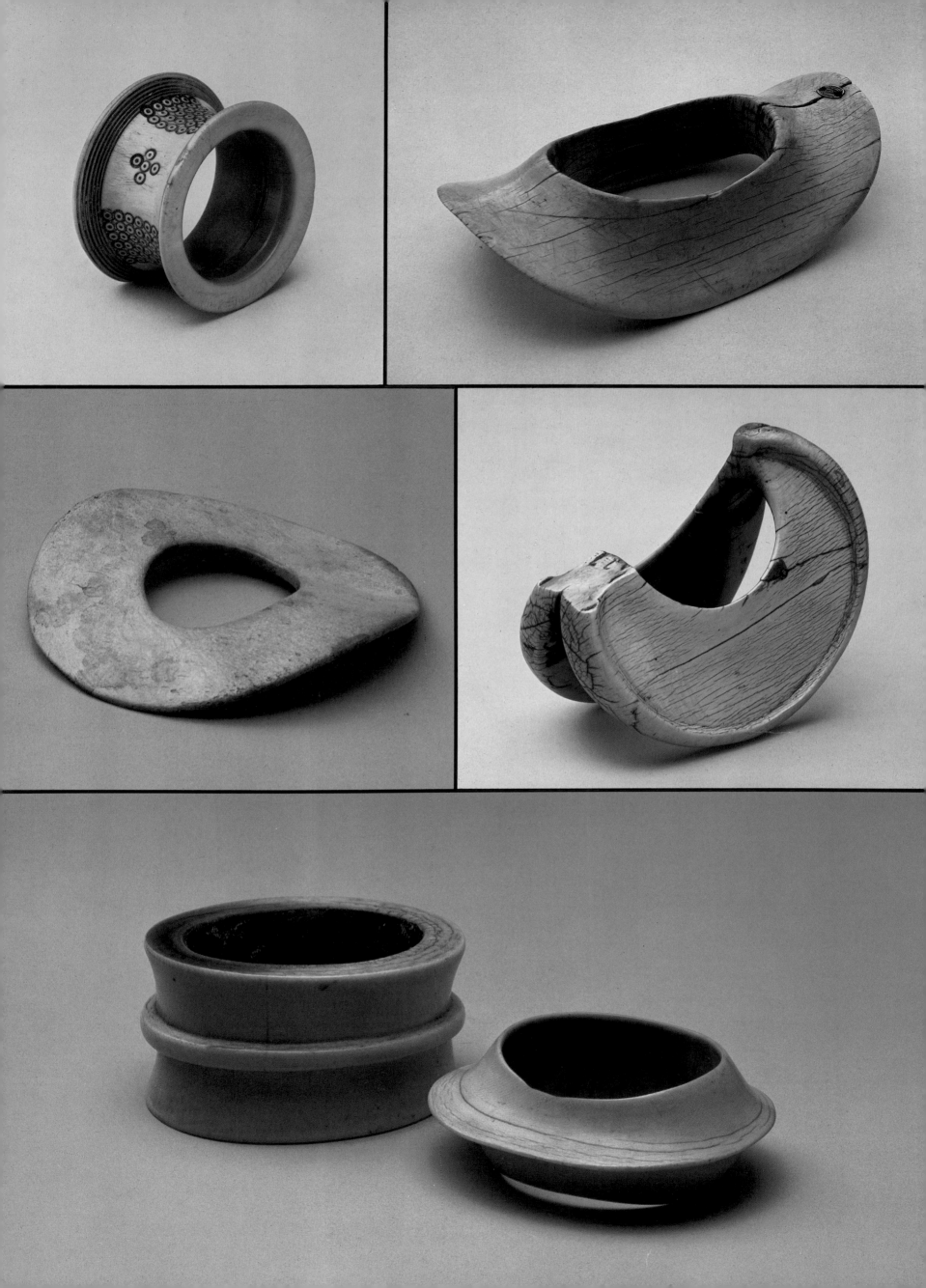

CARVED IN IVORY

1 Ivory bracelet with a circle and dot design made by the Fur tribe of Darfur Province and traded across Sudan to the Rashaida in the east and the Azande in the south. These bracelets are worn mainly by women. (9cm)

2 Beautifully sculpted ivory bracelet probably worn by the Nuer or Shilluk of Sudan. It has been repaired in the traditional fashion with brass wire. (18cm)

3 Bone armlet, probably worn by men, from South or East Africa. (17cm)

4 Ivory armlet worn by men of the Kikuyu, a settled tribe living north of the Maasai. Armlets of this shape and size are rare. (16cm)

5 Ivory armlets from the upper Nile region of Sudan. The one on the left has been packed with resin, a common way of fitting it firmly to the wearer's arm. (Diameter 13cm)

6 Sculpted ivory finger ring of rare quality and design, worn by a Dinka man of high standing. (9cm)

7 Ivory lip plugs worn in the lower lip by elders of some importance in the Turkana community. The ball-shaped lip plugs, *ekalaitom*, may be made of ivory, stone or metal. The one shown here on the left has a removable wooden stopper, while that on the right is carved in one piece. The plugs are inserted in the bottom lip and the lower incisors are usually removed at puberty to make room for them. (8cm and 6cm)

8 Ivory armlets worn by Dinka men. The large armlets are highly valued since it is now almost impossible to find big enough tusks from which to carve them. The larger the armlet, therefore, the greater the wearer's wealth or prowess in hunting. (Weight of the largest: 1.25 kilos, diameter 15cm)

6

7
8

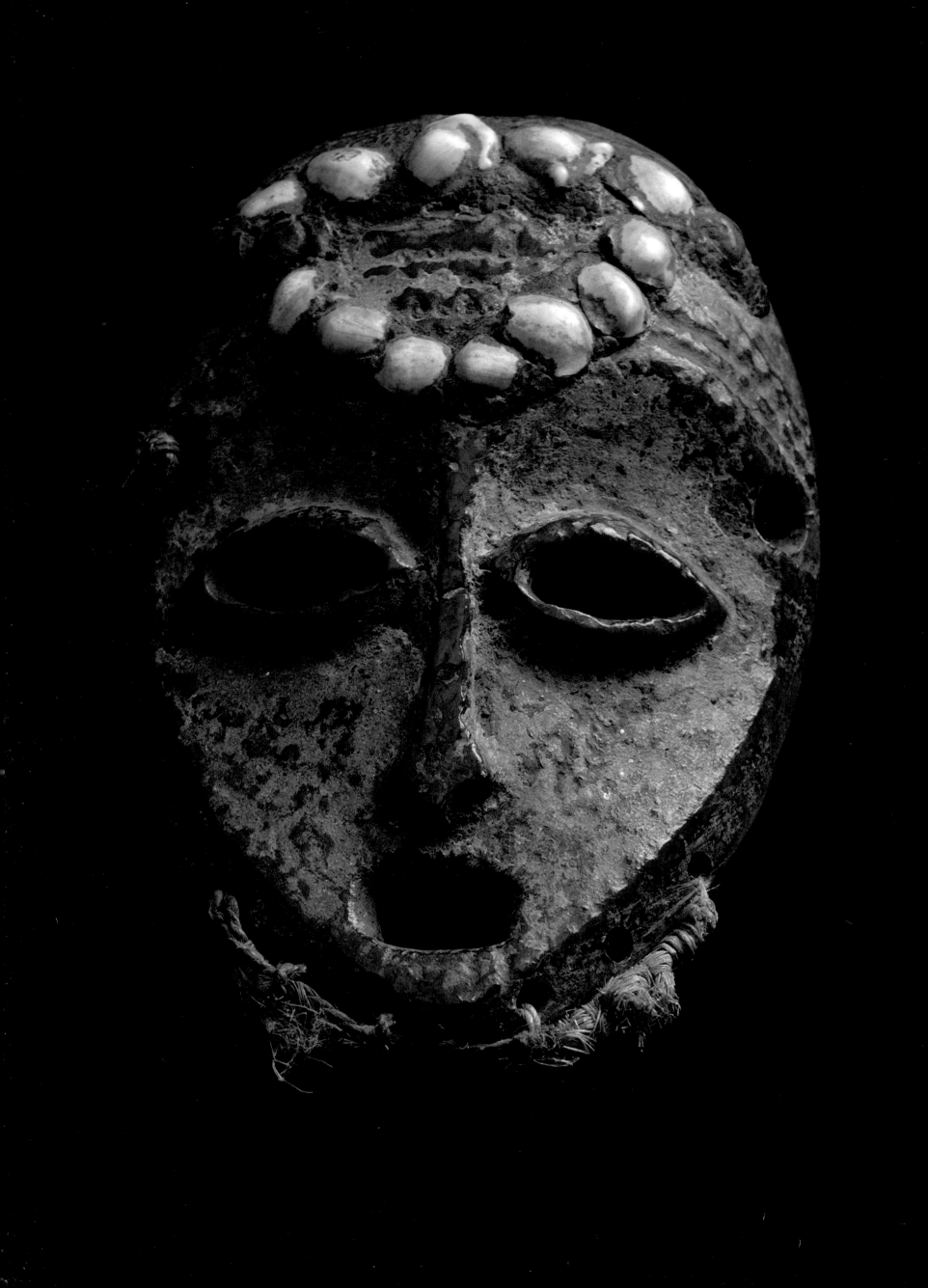

EQUATORIA

Treasures and Trade

From Zaire to the West African coast, a distance of more than three thousand miles, stretches the equatorial forest belt. From this region has come some of the most valuable and finely wrought jewellery – carved ivory, cast bronze, gold and glass bead ornaments – ever made on the continent of Africa.

The people of these forests derived their wealth, and the rich diversity of their jewellery, from trade. Gold, unworked ivory and slaves were originally taken north along the Saharan trade routes and later, in greater quantity, by ship from the coast of West Africa, to be exchanged for glass beads, copper, brass and coral with the Portuguese sea traders who first arrived at the beginning of the fifteenth century, to be joined over the course of the next hundred years by the Dutch, English, French and others.

European traders were surprised to discover in West Africa a number of affluent and sophisticated kingdoms of which the kings or chiefs were regarded as divine beings and held absolute power. Their elevated status was reflected in their jewellery; thought to embody supernatural powers, it played a vital role in rituals and was forbidden to ordinary people. The kings patronized skilled craftsmen, casters and smiths, who were treated with the greatest respect and encouraged to work with creativity and the utmost attention to detail, so that every object they made was a work of art.

In the nineteenth century the explorer Georg Schweinfurth, having trekked from north-east Zaire to Sudan, expressed amazement at the sophistication of the Mangbetu court. According to Schweinfurth the Mangbetu King, Munza, supported several thousand wives and kept a huge retinue of craftsmen employed in carving furniture, producing weapons and creating superb ornaments in ivory and copper – works of art far superior to any that Schweinfurth saw in Sudan. At a ceremonial feast in the royal reception hall, an architectural feat of vast proportions constructed solely of palm fibre, trumpeters played ivory horns – too large to lift – as delicately as flutes, saluting the King as he danced weighed down by all his finery.

Today Chief Tiengu, a descendant of King Munza, no longer commands an empire but administers the affairs of his village and is still revered by the Mangbetu. In his home are ceremonial horns and trumpets, remnants of his proud

Ivory mask pendant, Lega people, Zaire.

Woman from Zaire with bamboo hooped coiffure, nineteenth century.

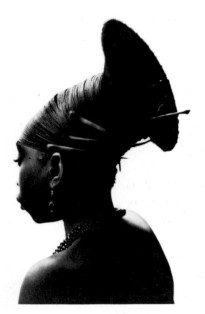

Mangbetu cylindrical coiffure with bone hairpins, nineteenth century.

lineage. From the roof hangs a 30-foot-long sedan chair in which, until recently, he was carried on his visits to neighbouring villages. He laments the demise of the old kingdom, and regrets the dispersal of much of its treasure through generations of wars and negligence.

Ivory has long been valued in the equatorial forests, for its association with the rulers and its supposed magical powers, as well as for its vibrant patina which becomes more beautiful with age and use. Specially appointed ivory carvers worked under the patronage of chiefs and kings, designing and making ornaments for court and religious officials and others of high standing.

In southern Nigeria and Cameroun as well as Zaire, ivory was widely available; any that was not used by local craftsmen was traded by the chiefs and kings, and for many years it rivalled gold and slaves as the principal export of the forest kingdoms. As trade developed and hunting decimated the elephant population, true ivory was replaced by substitutes such as hippopotamus teeth and wart hog tusks. These were not as valuable, however, being smaller, more dense and therefore harder to carve. Teeth of other animals were worn in their natural state and, in societies such as the Mangbetu and their neighbours the Azande, men hung the teeth of their slain enemies round their necks as trophies.

Different tribes, often isolated from one another by impenetrable jungle, developed their own characteristic styles of jewellery. In Cameroun fetish priests wore figure pendants of ivory depicting religious predecessors of particularly high repute; these pendants were thought so powerful that they could answer questions and advise on important issues.

For the Ibo of Nigeria status was measured by material wealth; ornaments made of ivory conferred prestige in terms of their weight alone, and a man's improving fortunes might enable him to give his wife huge ivory anklets and bracelets which, blessed and purified by special rituals, entitled her to the highest social status. These cumbersome pieces consisted simply of cross-sections of the largest tusks available, cut and fitted by the smith onto a woman's arms and legs. The ivory was not carved or decorated, and the smith's only skill lay in manipulating the pieces onto the limbs, a protracted and painful procedure.

In the great kingdom of Benin, in Nigeria, the tusks of every elephant killed were the property of the Oba, the Divine Ruler, who retained one tusk for himself

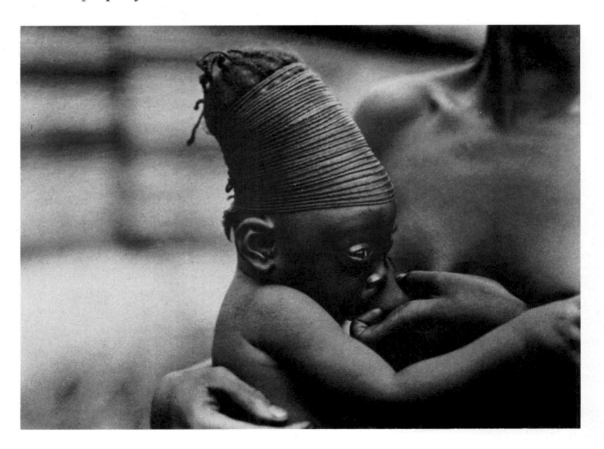

Mangbetu baby with bound head, 1930s.

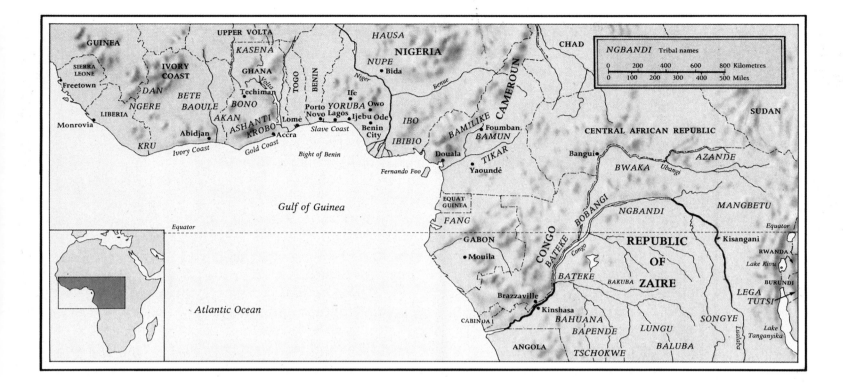

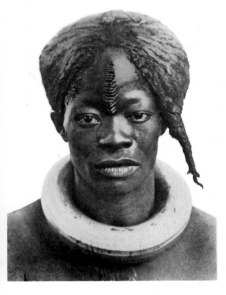

Woman from Zaire with twenty-pound brass neck torque, nineteenth century.

and offered the other one for sale. The Oba supported a guild of carvers who designed belts, masks, bells, armlets and a variety of other ornaments in both ivory and wood for the royal court.

While the Oba's regalia was primarily of ivory, his chiefs were resplendent in bronze. According to Benin legend, the lost wax method of casting bronze was learnt in the thirteenth century when the Oba invited a Yoruba smith from the old forest kingdom of Ife to teach the technique at his palace. This method of casting is now known to have originated in the Middle East and to have been brought to West Africa via the Saharan trade routes as long ago as the ninth century.

Benin became renowned as a centre of bronze casting; the use of bronze was determined by the Oba alone and the guild of casters was part of his royal household. The palace of Benin, decorated with bronze heads, sculptures and bas-reliefs, became one of the finest achievements of African architecture. With the decline of the Benin Empire after the sixteenth century, European brass and copper was brought in increasing quantities to the West African coast and was traded further inland. The lost wax technique spread east into Cameroun and west as far as Guinea on the Atlantic coast. (See p. 87.)

The brass and copper brought first by the Portuguese came in the form of horseshoe-shaped bars called *manillas*; the English and Dutch, in the seventeenth century, brought it in small ingots and in some areas it was introduced as bowls called neptunes. In Zaire and Gabon these ingots and bowls, traded for slaves, ivory and rubber from the inland forests, were either melted down to make jewellery or used in their original form as currency or containers.

To the west, the Dan and their neighbours on the border of the Ivory Coast and north-east Liberia adopted the lost wax technique to cast heavy bronze anklets. These became part of a woman's dowry and were forged onto her ankles. Like the neck collars and anklets worn in Zaire and Gabon they were ungainly and uncomfortable and their immense weight was tolerated only for the status they bestowed.

In Nigeria the competitive Ibo women suffered from the size of their metal ornaments as much as from the weight of their ivory. Smiths hammered brass bars into thin plate-like anklets so wide that the women were obliged to waddle – a gait considered attractive – and, it was said, had to sleep with their feet hanging over the end of the bed to avoid discomfort.

Some of the most imaginative bronze casting was seen in ornaments depicting spiritual beliefs. In some societies this was the province of specialist casters who made cult objects and adornments for the various religious groups. The Yoruba religion, which has hundreds of *orishas* (spirits), gave rise to a profusion of ornaments, their designs being complex symbols of the wearer's cult group, status and beliefs.

Lost wax casting was practised in Ghana in the late seventeenth century but, for the Asante, the emphasis was on gold rather than bronze. The right to own gold was determined by the King, and every nugget found over a certain size became his property. Gold was representative of status and wealth, a powerful talisman and symbolic spirit of the sun and eternal life – the ideal medium for the ceremonies of religion, kingship and state.

Thomas Bowditch, sent on a diplomatic mission from England to Ghana to increase the gold trade early in the nineteenth century, found the Asante royal court a scene of unbelievable wealth – 'a colourful and orgiastic display'. Gold covered the thrones and stools, and golden threads embroidered the robes of royalty. It was cast into every conceivable form of ornament, from the King's crown to courtiers' talismans, and the gold leaf applied to ceremonial staffs was even used to cover the collars of dogs at the court. At festivals thousands of courtiers, extravagantly adorned, paraded under silk-tasselled umbrellas, their ornaments proclaiming the prosperity of the Asante kingdom. The location of the gold mines was kept a secret by the princes who controlled them, and the goldsmiths worked in strict privacy, all strangers being excluded from the royal compounds while the craftsmen were at work.

Lavish gold jewellery is still worn several times during the year, at enthronements, the marriages of chiefs and at other traditional ceremonies. Great quantities of gold paraphernalia remain in the hands of kings and chiefs along the Gulf of Guinea, and, apart from increasing the grandeur of their robes, the Asante have changed their regalia little over the centuries. Each new king or chief brings personal additions to the treasury – sandals, staffs and gold ornaments made specifically to express his character or his involvement with political and social events. He often wears a gold ring on every finger, each referring to one of his exalted personality traits. His dress is so highly symbolic that he can indicate an opinion or a change of plan simply by changing his costume and ornaments and reappearing newly clothed to the awaiting assembly. For a lesser chief to surpass a higher chief or king in the sumptuousness of his attire is an unforgivable sin. Discreet enquiries are made as to the level of dress expected on each occasion, and all will dress accordingly.

From the sixteenth century onwards, gold in Ghana, like ivory and slaves in other parts of the equatorial forests, was traded for goods brought by the Portuguese. Among the most popular items introduced from Europe were glass beads, which soon became symbols of wealth and rank, each kingdom favouring different designs. Highly decorative beads from Venice featuring flowers, stripes and mosaic designs appealed particularly to the Africans' love of bright colour. Over the next four hundred years vast quantities of gold beads of different types, according to local preference, were brought from Europe to trading posts from the Atlantic coast as far east as Zaire. Early in the twentieth century the sea trade extended to South Africa, there tiny pound beads became especially popular; it is interesting to see how their application in southern Africa differs from that seen in the equatorial forests.

Before this influx, glass beads had been rare and highly prized. Ancient beads of unknown origin called *aggrey* have been found in the graves of chiefs and kings in the region. The Yoruba of Nigeria, among others, still believe these buried beads grow like plants in the ground; in fact most were traded across the Sahara by Arabs from the ninth century onwards. Among the Asante some of the very old beads, made of powdered glass, were each worth their weight in gold, one

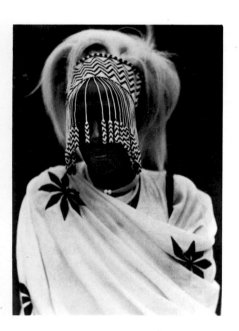

The Tutsi Queen Mother, Rwanda, 1930s.

Zulu witch doctor, nineteenth century.

being equivalent in value to seven slaves. Called *bodom* – meaning 'to bark' in Akan, the language of the Asante – they were believed to have supernatural powers and to protect their owners in times of danger by barking like a dog. Royal babies were washed in *bodom* to make them grow, and it was thought that if these beads were kept in a safe place they could reproduce themselves. Only the King could afford to wear a whole necklace of them; other chiefs wore one as master bead in a necklace, or singly on a cord round the arm.

Intrigued by the new Venetian beads, some African craftsmen became interested in making their own. Although glass had been made in Nigeria and Ghana from local clay containing silicone, they found it easier to use discarded European bottles and medicine jars, or even imported beads, for their raw material. To this day, the Krobo in Ghana still melt powdered glass in small bead moulds, while the Nupe of Bida in central Nigeria wind molten glass on long iron rods to make beads and bracelets.

Over centuries of trade with the Western world, the jewellery of the equatorial forests and southern Africa changed dramatically. Initially it was enhanced by the increased variety and wealth of materials available, but over the last century the gradual adoption of Western ways and a decline in the power of royalty and chiefs have led to a loss of patronage and a marked drop in the quality and range of much of the jewellery.

Many traditional pieces have disappeared from the forest regions; lost, destroyed or removed to museums and private collections outside Africa. However, much of the jewellery associated with ritual practices and spiritual beliefs has retained its importance and can still be seen in places such as Ghana and Benin. Here, it reflects the intensity and splendour of ritual and provides an insight into the life and beliefs of the people of the equatorial forests, past and present.

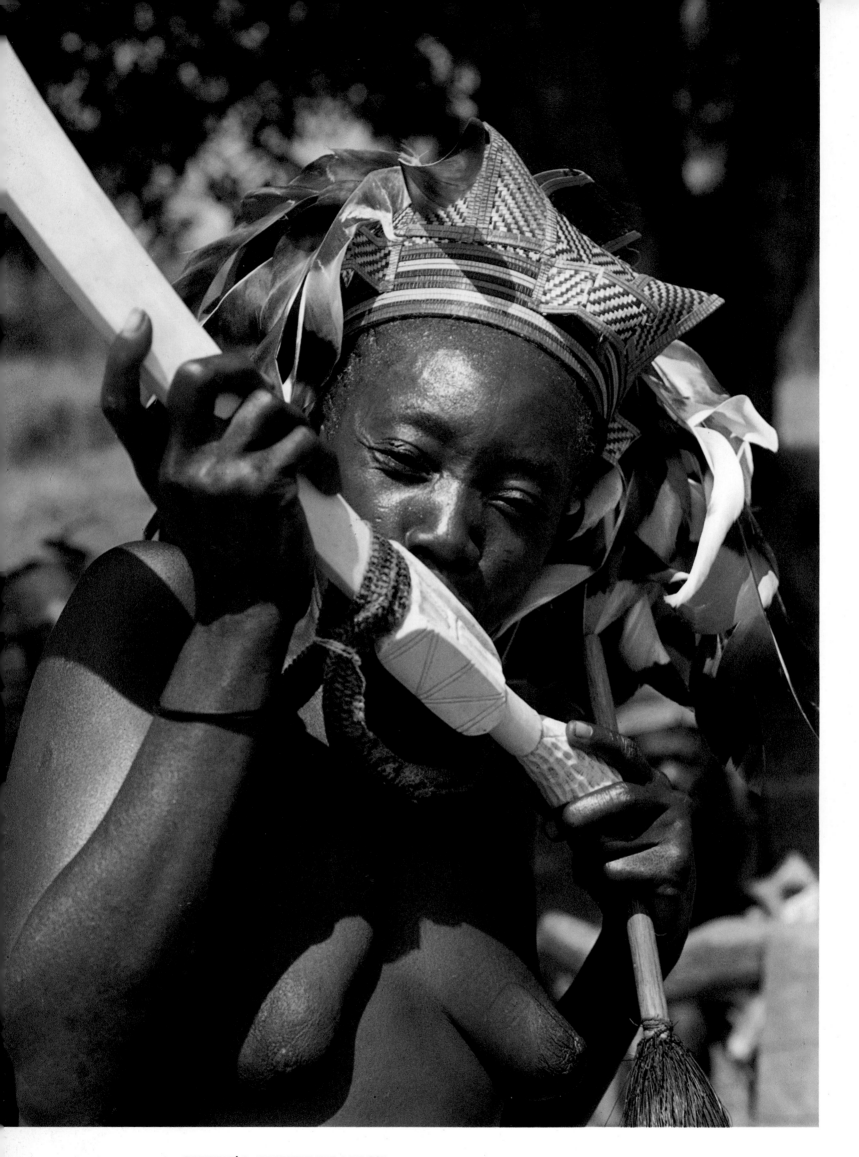

A CHIEF'S INHERITANCE

One of the 25 wives of Chief Tiengu, a prominent Mangbetu chief in northern Zaire, plays the *nembongo*, a huge trumpet carved from an elephant's tusk. On ceremonial days the chief's dancers, including his wives and other members of his family, sport hats woven of dyed raffia and decorated with brightly-coloured parrot feathers. Some of the more well-to-do women wear skirts made of grass and colobus monkey skin.

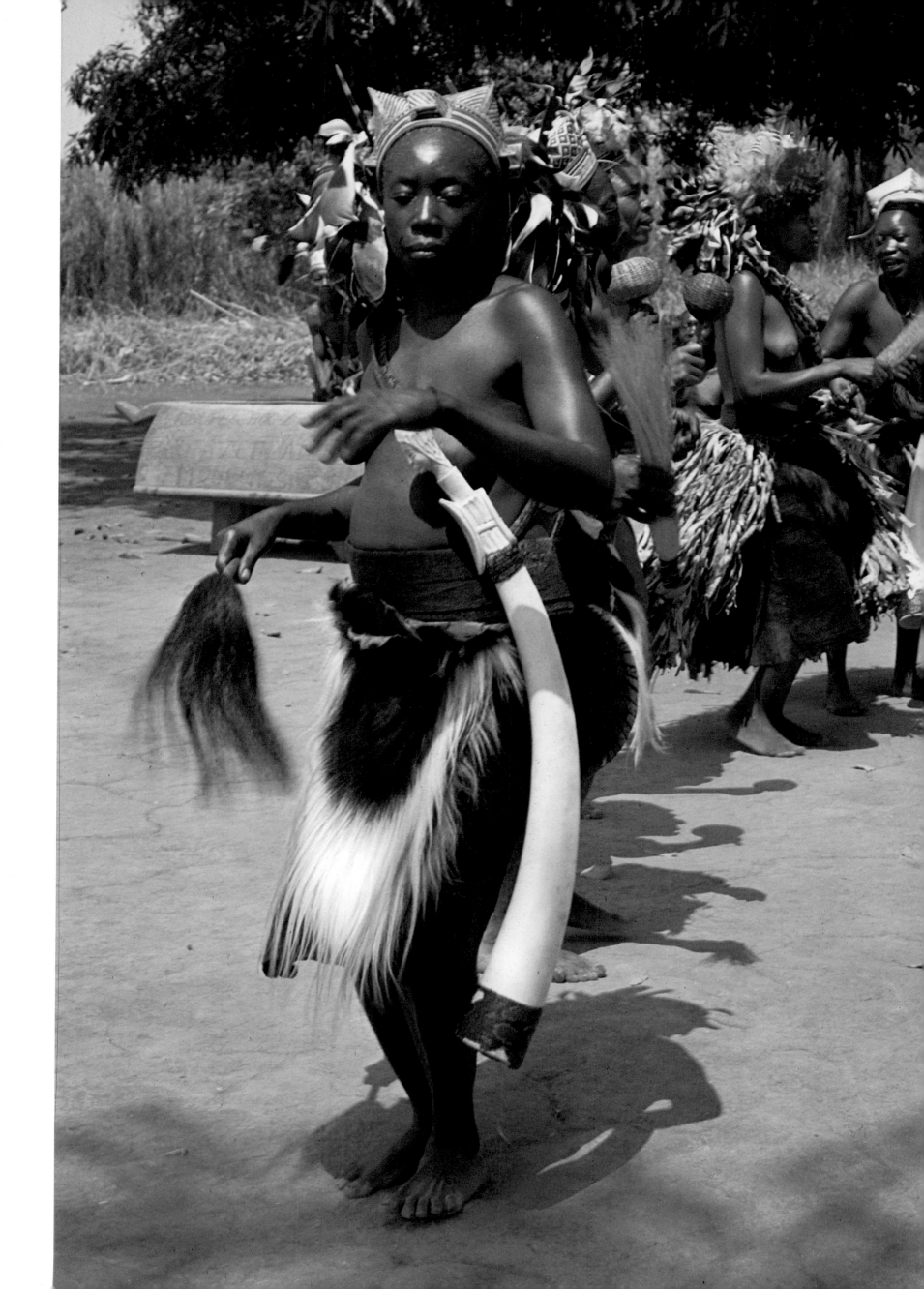

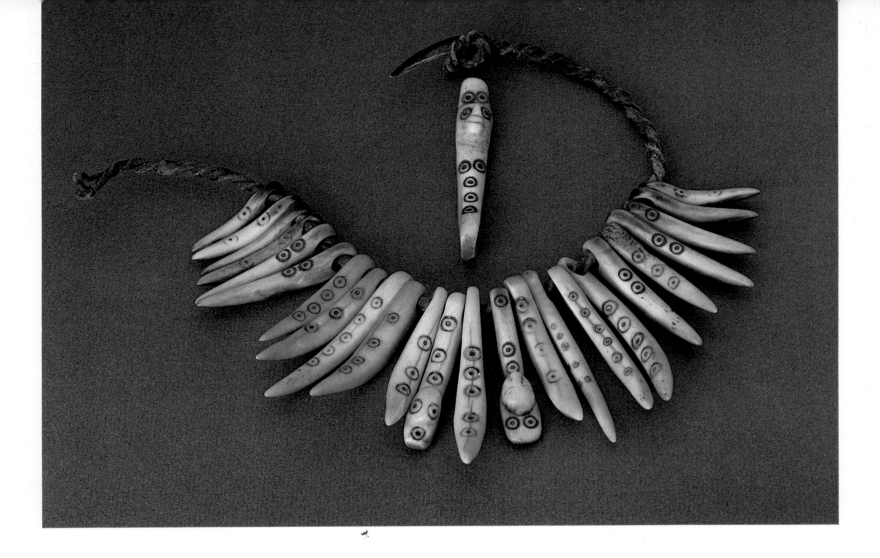

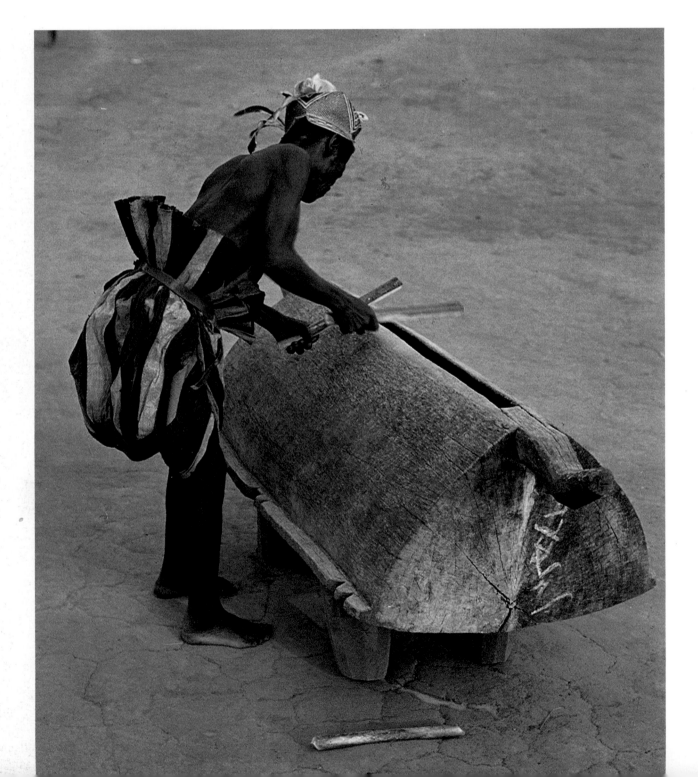

WEALTH FROM THE FOREST

ABOVE An ivory necklace worn by a Songye chief of Zaire. The pendants are carved in the shape of teeth and some incorporate human faces.

LEFT This large drum, carved from one trunk, provides the rhythm for dancing and is also used to send messages across the forest. The men's pantaloons are of bark cloth – made from the bark of the fig tree, soaked in water and beaten with wooden or ivory hammers until it is pliable enough to be sewn. Bark cloth is worn throughout equatorial Africa wherever the fig tree grows.

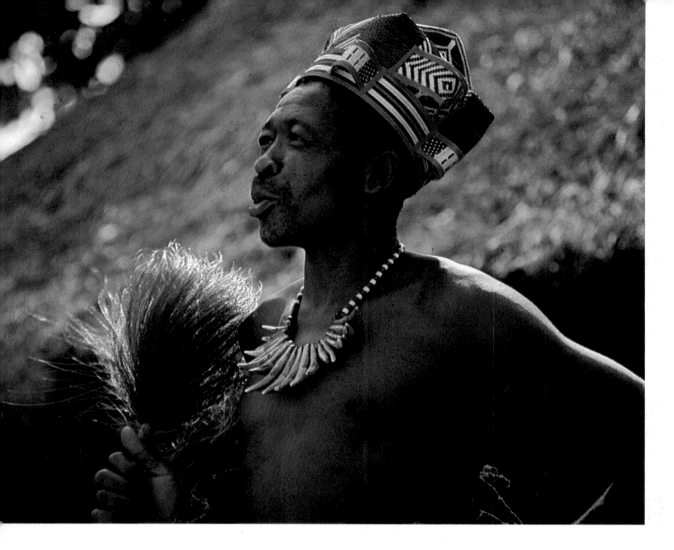

ABOVE A Mangbetu elder indicates his eminence by wearing a raffia hat and a necklace of leopards' teeth, and by carrying an elephant-tail fly whisk. A similar necklace is worn by the Lega people of Zaire. The Mangbetu also used to carve ivory into the shape of leopards' teeth for necklace pendants, and sometimes strung the teeth of their vanquished human enemies round their necks.

RIGHT Ivory bracelets decorated with lead or silver studs were worn by both the Songye of Zaire and the Hausa and others in northern Nigeria. The large Songye bracelet is extremely rare and is thought to have been worn during religious and magical rites to encourage the birth of male heirs. (Diameters: armlet 14.5 cm, bracelets 13cm, and 11cm)

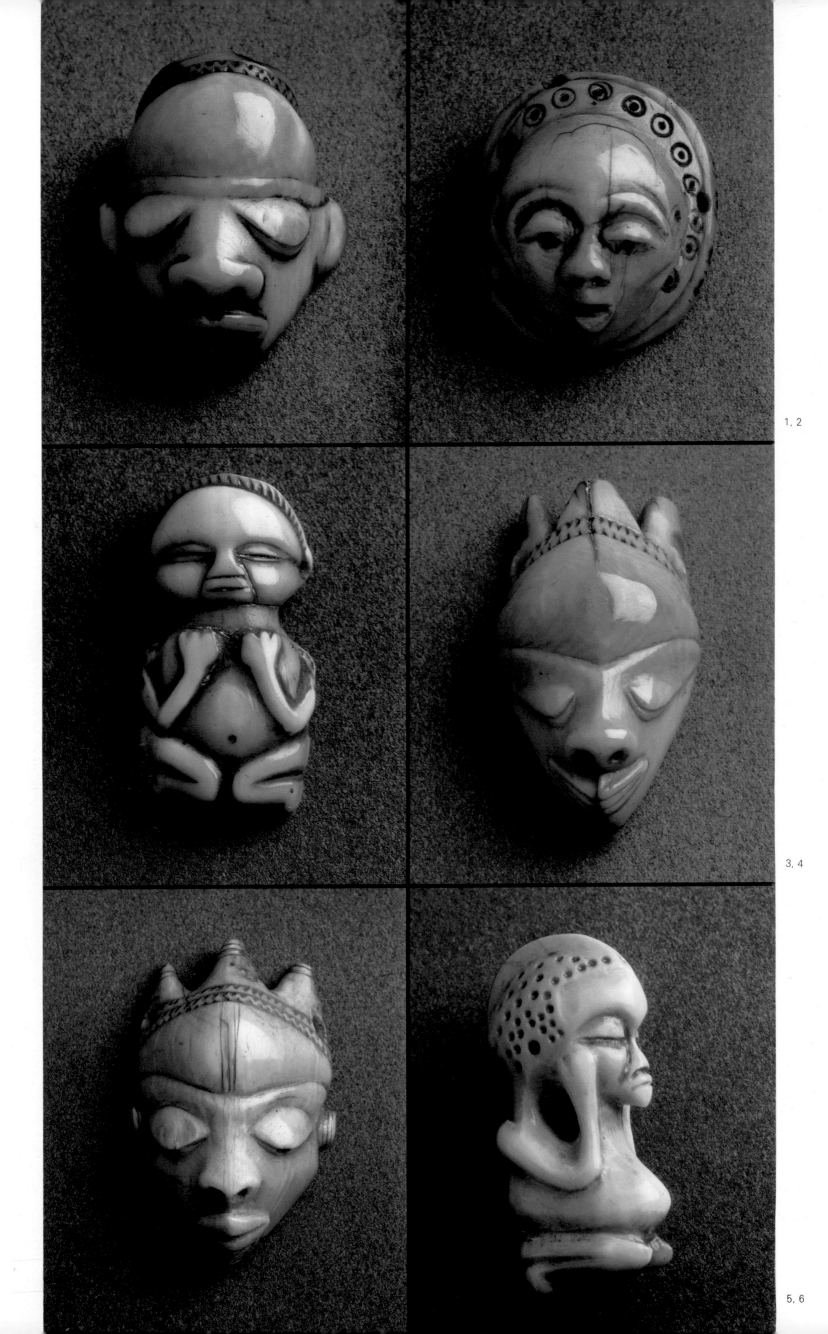

1, 2

3, 4

5, 6

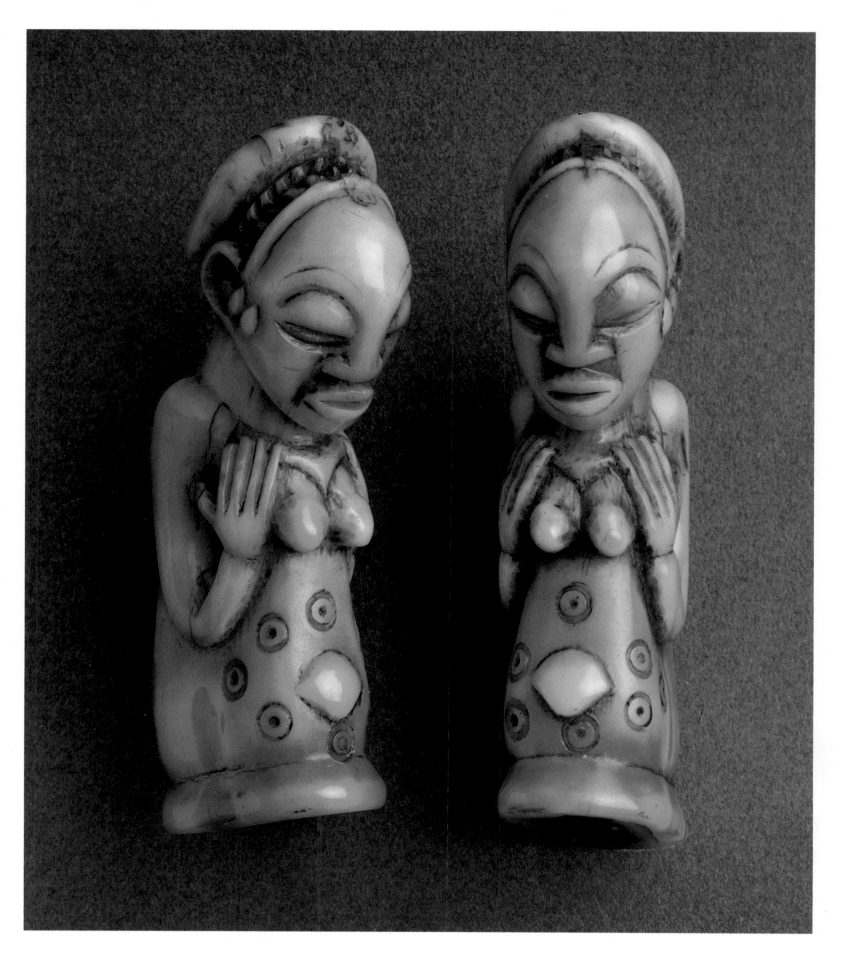

TALISMANS IN HUMAN SHAPE

Some of the peoples of Zaire wear small pendants representing ancestor faces and figures; these are believed to retain the powers of the dead and are seen as a valuable source of protection. Individuals revered in the community are portrayed in the belief that the wearer will acquire their strength of character and personality traits.

LEFT The mask pendants which the Bapende wear round their necks are known as *ikhoko*. For males they offer protection and strength during the rigours of initiation and later act as a reminder of moral codes learnt at that time. They are smaller versions of the face masks worn during the same ceremonies, of similar triangular shape and purity of line. Both are carved by eminent sculptors who will have received the title of Chief. Similar pendants are made for women and children though never of ivory, only of wood or seeds. The Bapende

rarely carve the whole figure; the Bahuana favour squatting figures in foetal position.

The ivory turns from creamy white to mahogany with age, and the gradual absorption of palm oil applied to the wearer's body often makes the back of a pendant darker than the front. (All approx. 6cm)

ABOVE Pendants of the Baluba, Zaire, carved from hippopotamus teeth and wart hog tusks, the shape of the latter lending itself to the graceful curve of the female figure. The female sex is very important in Baluba society, a fact reflected in the prevalence of female figurines among their ornaments. The figures carved are finely detailed, often in solemn repose, reflecting deep human emotions. These pendants, which commemorate dead relatives, are worn on the belt or arm, or hidden in the armpit. (13cm)

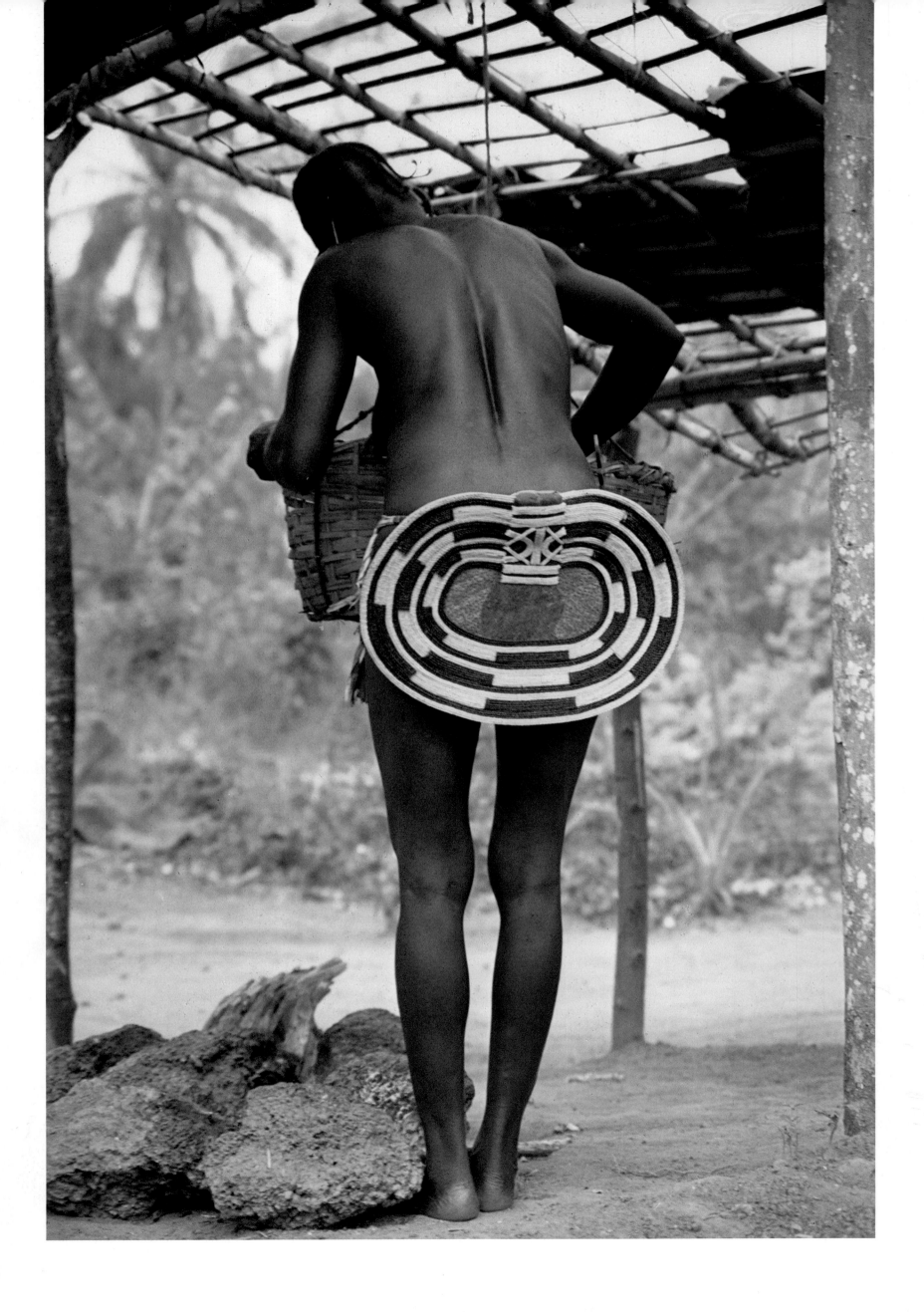

EXAGGERATED FORMS

LEFT At ceremonial dances Mangbetu women wear the *negbe* attached to their buttocks. Made from sycamore bark and fine grasses dyed and woven into geometric patterns, it is intended to attract the male eye.

RIGHT The deliberate elongation of the cranium as a process of beautification, and possibly as protection against witchcraft, was practised until recently by upper-class Mangbetu. Soon after birth a baby's head was either confined between two pieces of wood or bound tightly with strips of bark. Later the deformation was emphasized by putting the hair back into a high cylindrical chignon. The hair of dead enemies was added to increase the height of the chignon, and long pins of carved ivory were used for support and decoration. The practice of deforming the skull was discontinued in the 1950s and is now only seen among the older generation. The Mangbetu were known by the traders of Khartoum as *Gurrugurroo* because of their ear perforations, through which they often wore a monkey bone used for parting the hair.

BELOW RIGHT Ivory hairpins decorated the elaborate hairstyles of the Mangbetu and their northern neighbours the Azande. Both tribes were renowned for the complexity of their coiffures, and their elegant carved hairpins whose length, design and the numbers in which they were worn were all indications of the wearer's status. With the exception of the centre hairpin which is Azande, all those shown here are Mangbetu. The crescent-shaped pendant with circle and dot design is a rare piece from the Lungu people of south-east Zaire, probably only worn by those of high standing. (Longest hairpin 37cm)

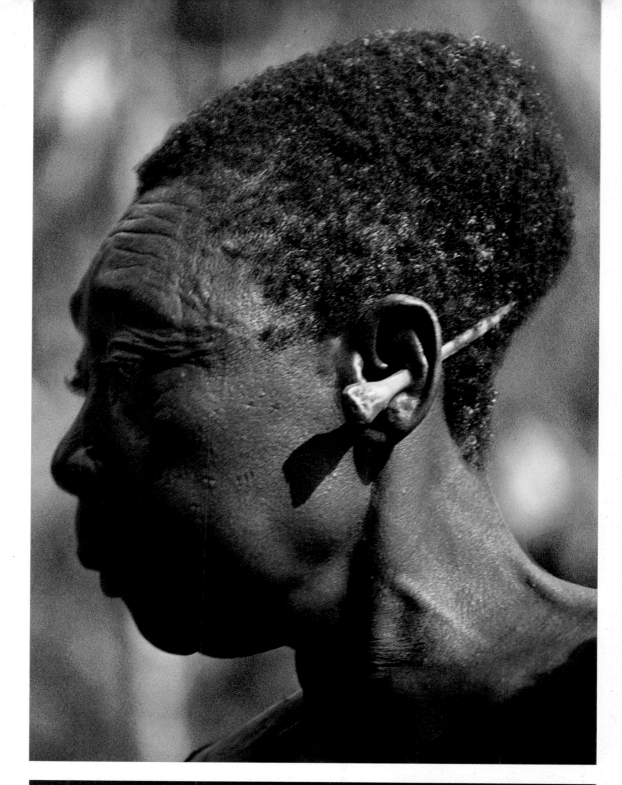

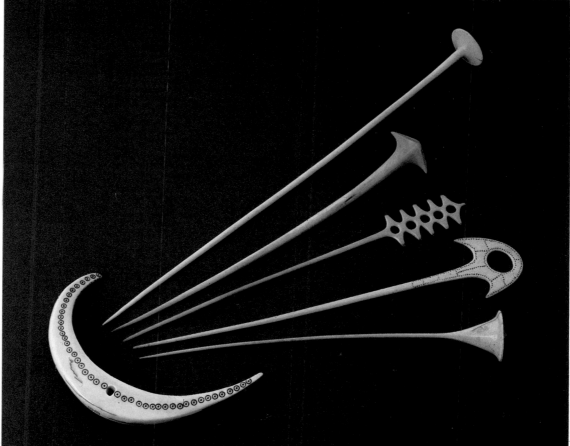

1

2

3

4

5

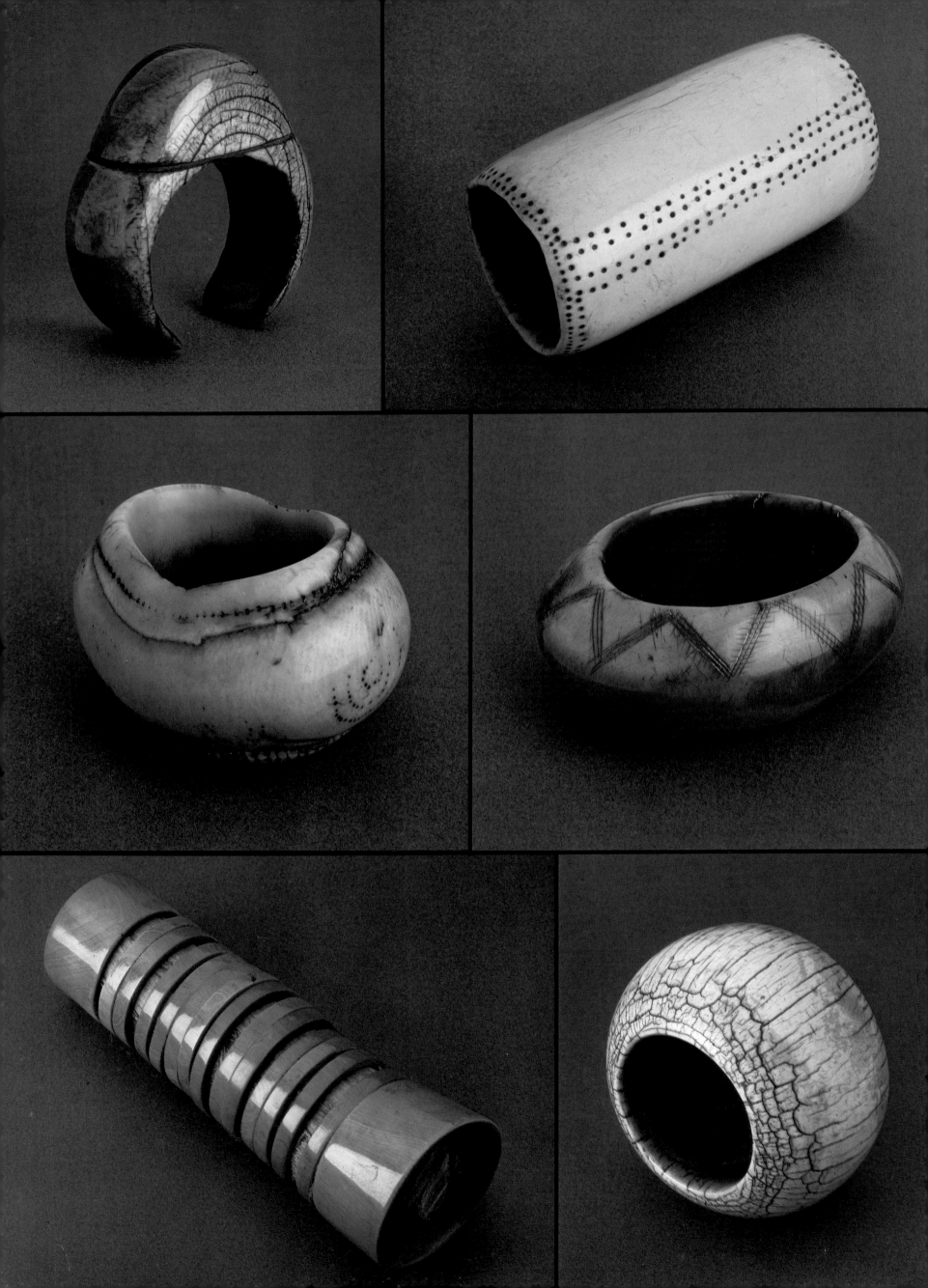

VARIATIONS IN STYLE

Ivory carvers from the forests between Zaire and Cameroun favoured bold, sculptural forms and simple decoration; by contrast, the Benin craftsmen of Nigeria depicted historical events and military manoeuvres in a style that was finely executed but sometimes lacking in dynamism. Their work was partly influenced by Portuguese traders, for whom some of it was made.

Carvers pay great attention to the colour and grain of ivory and design their jewellery to emphasize its natural characteristics. Styles and colours vary from one region to another; many admire ivory in its natural shade, though the people of Zaire and Cameroun, who prefer a deep golden brown, stain it with charcoal, tree sap or pigments from camwood all mixed with oil, a process which also preserves the ivory and prevents it cracking.

1 The colouring and grain of the ivory have been used to enhance this sculpted form from the Bamun, Cameroun. This style of bracelet was worn by the wife of the Sultan of Foumban. (9cm)

2 An unusually long cylindrical ivory bracelet, possibly from northern Zaire. (18cm)

3 An ivory bracelet of the Songye, Zaire – its unusual shape emphasized by age and wear. (11.5 cm)

4 Stained ivory bracelets from the Lega, eastern Zaire. The Lega used to sand down ivory objects, mixing the dust with water and drinking it to combat disease. (13cm)

5 A collection of ivory bracelets worn by the Fon, the Supreme Chief, and some district chiefs of the Bamilike, Cameroun. The bracelets are all cut from one tusk and worn only on ceremonial occasions; when not in use they are threaded, as shown, on a wad of palm fibres. (24cm)

6 An ivory bracelet showing the marks of age and wear, probably from the Bamun. (10cm)

ABOVE RIGHT The Oba of Benin in full regalia. His vest and cap, which weigh about 9 kilos, are of coral beads, originally brought by the Portuguese. The Benin name for coral, *eshugu*, means rank and wealth, and coral is believed to protect the fertility of the land – a property renewed every year by washing the beads in blood. This jewellery, including the mask pendants and intricately carved bracelets worn here, is handed down through generations of Obas; some of the pieces may be 400 years old.

BELOW RIGHT An ivory bracelet from Owo, showing Benin and Yoruba influence. A masterpiece of craftsmanship, it was probably made in the nineteenth century to a sixteenth-century design of two interlocking cylinders carved from a single block of ivory. Some of the motifs are similar to those on the armlets of the Oba of Benin, but are bolder and more realistic in style. The figures on horseback are believed to be associated with the Yoruba Ogboni cult, which worships the goddess of the Earth. (17cm)

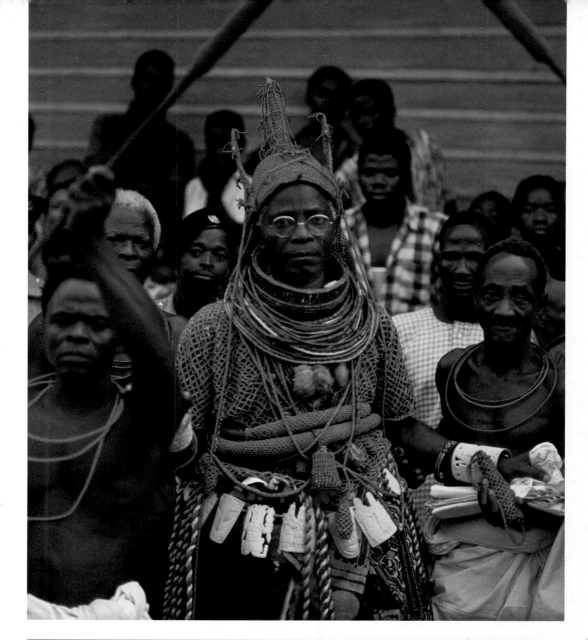

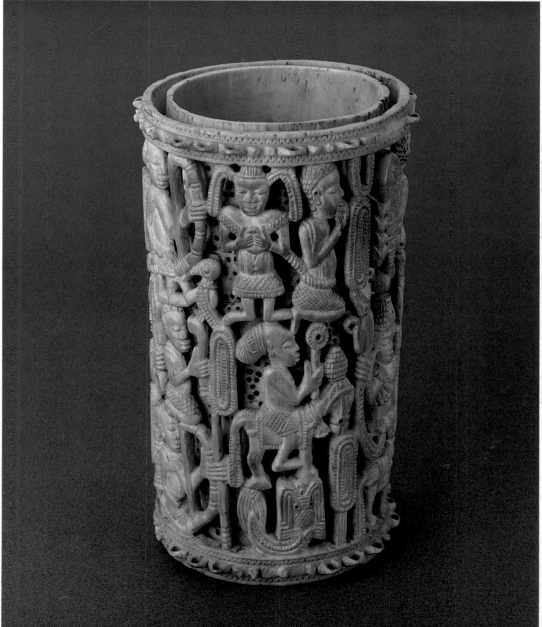

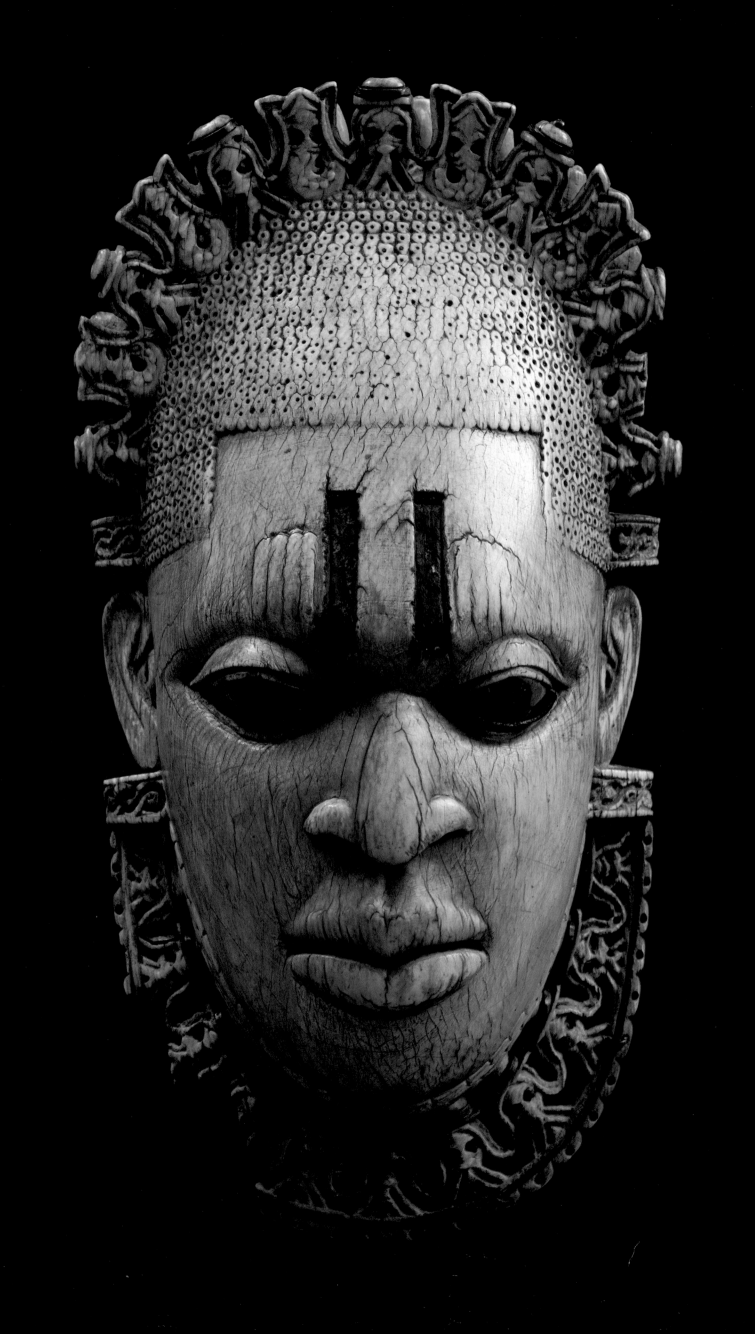

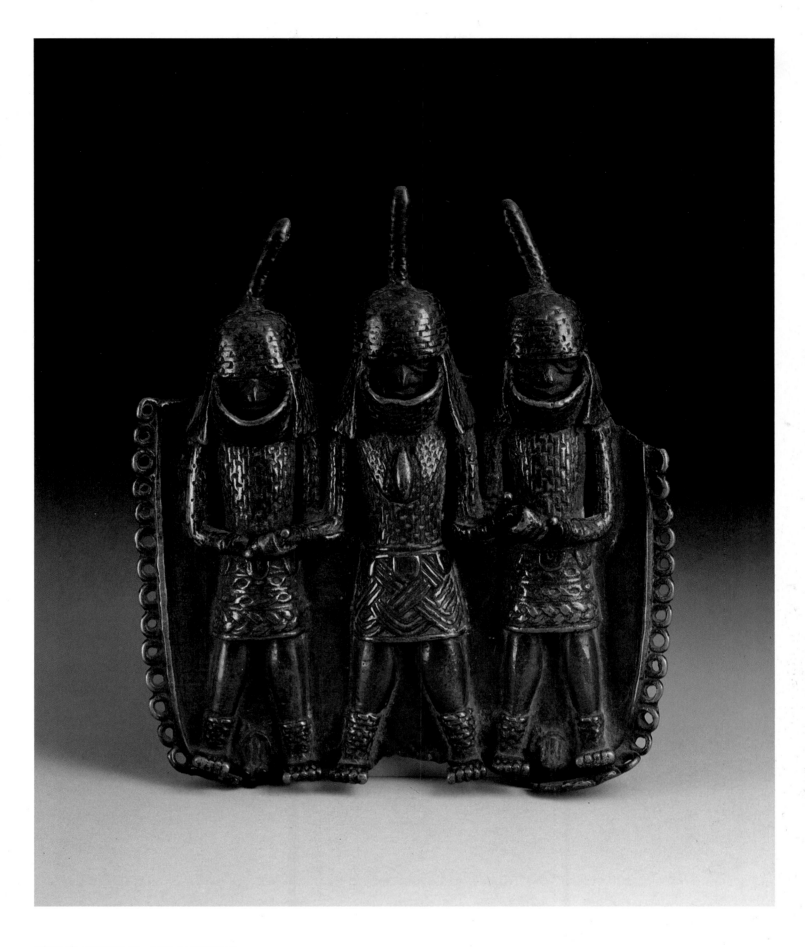

TREASURES OF BENIN

Benin ivories (*left*) represent four centuries of exquisite craftsmanship; all the work was carried out under the patronage of the Oba, and many of the best pieces were made exclusively for him. The ivory belt mask, a particularly fine example of Benin carving, is one of several found in the Oba's bedchamber in 1897. The style and marks on the forehead are reminiscent of the early period of Benin art before European contact, but the stylized heads in the tiara, of Portuguese influence, show that it was carved after their arrival in the sixteenth century. This mask is believed to have belonged to King Esigie and

probably portrayed his mother; he would certainly have worn it during the commemorative rites following her death. Today the Oba wears five or six replicas of such masks round his waist during ceremonies. (25cm)

ABOVE The workmanship of early Benin bronzes is one of the highest achievements of African art. The bronze pendant here, cast with remarkable finesse, was worn on the belt of the Oba, and depicts warriors or royal attendants in armour. Bronze casting was the domain of the Iguneromuron, the royal casters' guild, located to this day outside the palace in Benin (15cm)

THE WEIGHT OF PROSPERITY

Bronze collars were traditionally associated with wealth and prestige. A Bamun dignitary (Cameroun) in ceremonial dress (*above*), wears a bronze collar with bush cow or buffalo heads like (1) opposite. These collars, cast by the lost wax method, were awarded by a chief to his men in recognition of bravery, or worn by members of the council when important decisions were to be made.

Collars, originally worn only by chiefs, became a type of currency exchanged for wives, livestock, food and in payment of services and fines. In the early nineteenth century they were adopted by married women who wore them permanently, only tolerating their weight for the prestige they conferred. At 7 kilos the bronze collar (7)

worn by Yoruba women, and (6), a collar of 5 kilos worn by chiefs of the Bobangi of Zaire, are among the heaviest.

In Zaire and Gabon the lost wax method was not known; casting was done by the primitive open mould technique, in holes in the ground, and the pieces were then shaped with a wooden hammer. An example of this is (2), a brass collar worn by the Fang of Gabon. Some pieces, like those of the Bateke (3, 5) were cast in a hollowed-out tree trunk, and chiselled designs might be added. The Bwaka collar (4) is of copper, locally mined and more common than bronze in certain areas far from the trade routes. (1: 30cm, 2: 14cm, 3: 32cm, 4: 32cm, 5: 29cm, 6: 32cm, 7: 27cm)

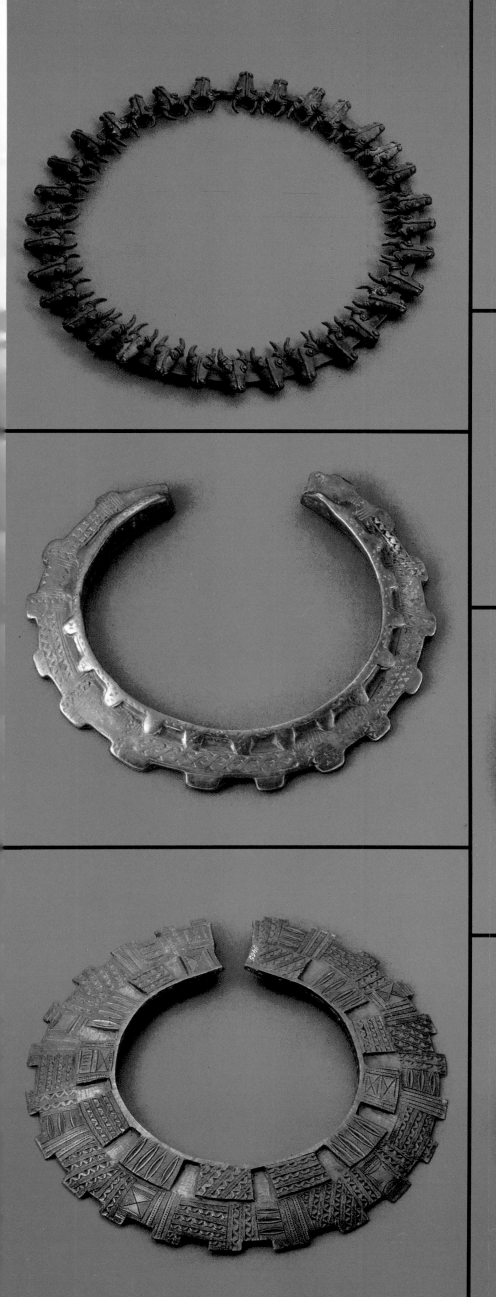

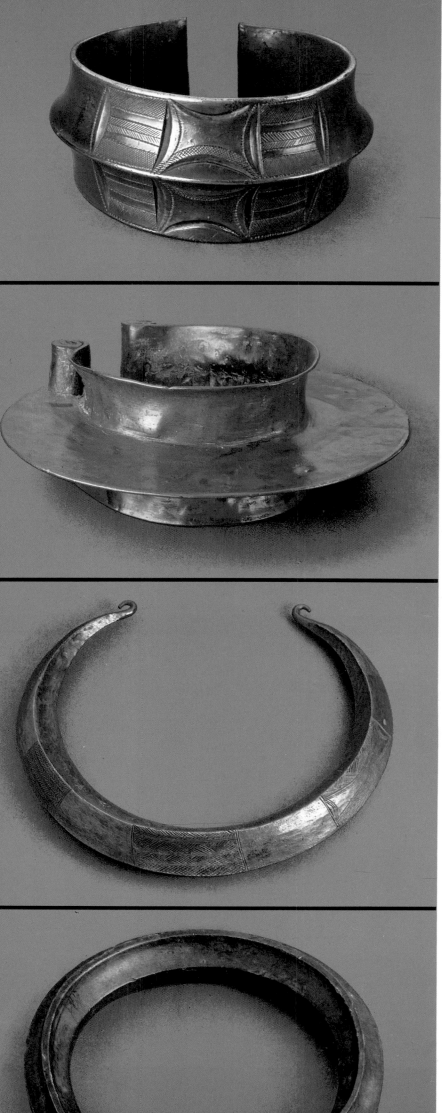

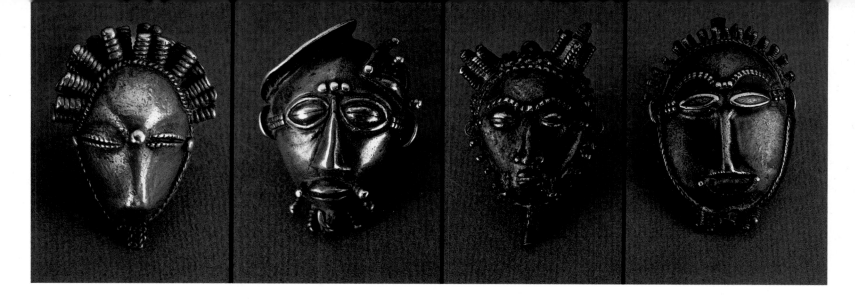

BRONZE CASTING

The Bamun acquired their skill in casting bronze from their northern neighbours, the Tikar. The caster working here is from a family renowned as bronze casters for the Sultan of Foumban. They now also sell to the tourist trade, though for this market the standard of craftsmanship has dropped and their talent is revealed only in the few individual commissions they receive. In lost wax casting, a model of the object is made of wax and a clay mould formed around it. The wax is then melted out or 'lost' and hot metal poured in. Each casting is unique, as the mould is broken to reveal the finished work.

ABOVE For the Baoule of the Ivory Coast, small bronze masks represent the faces of enemies killed in battle. Valued as charms, they are either worn around the neck as pendants or attached to the top of their swords. (All approx. 6cm)

BELOW Rings featuring animals, such as the one being cast here, were worn by Bamun notables. Bronze weights were used for measuring gold dust, the traditional currency of the Akan peoples. Originally of geometric design, they later depicted animals, insects and humans, some illustrating scenes from Asante proverbs. Sometimes the weights, with attachments, were worn as pendants or rings – jewellery for those who could not afford gold. The animals were chosen for their symbolic qualities: the mudfish (*top*) represents help, nourishment and protection, the crocodile (*bottom*) is the symbol of the Queen Mother, and the catfish with its sharp serrated spines is associated with danger, from the proverb 'The river fish's game is no safe game'. (Mudfish 5cm, catfish 5.5cm, crocodile 5.5cm)

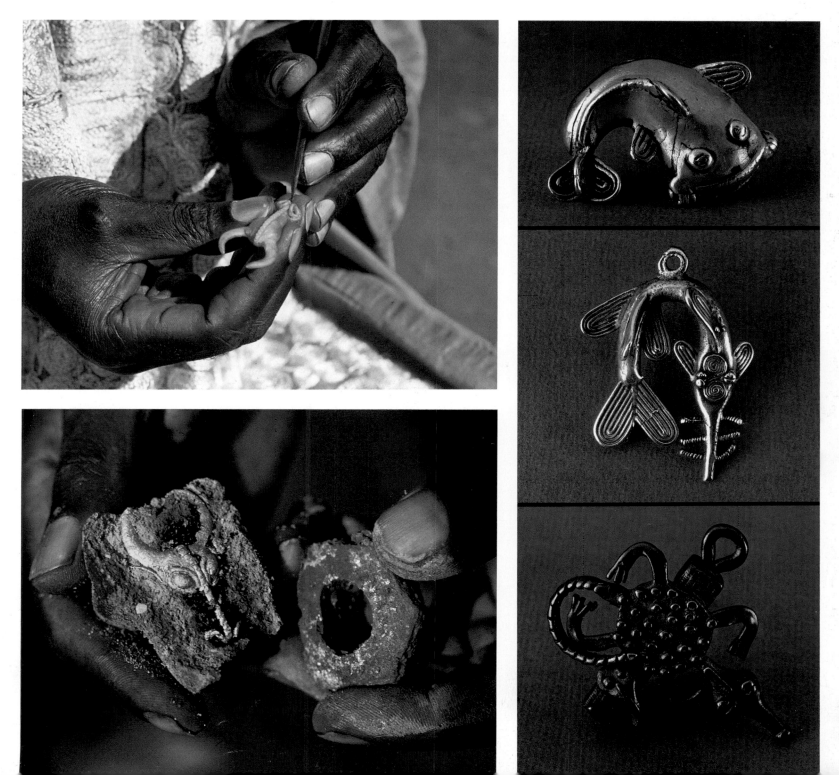

87

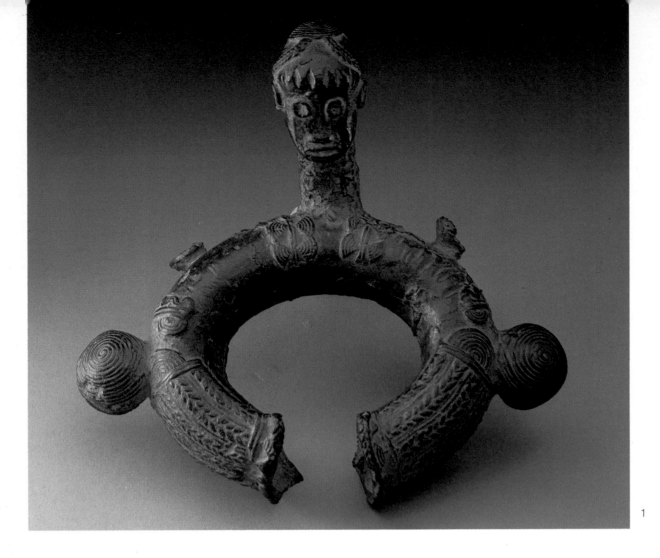

THE PRICE OF DISCOMFORT

In the equatorial forests anklets of great weight, traditionally part of a woman's dowry and symbols of status, were forged onto women's legs to be worn to the grave unless they were removed by smiths. In the mid-twentieth century the Liberian government forbade women wearing these anklets because it was thought to make them look like slaves. Lighter, removable designs were adopted and the large anklets are now valued only as currency.

1 A rare bronze anklet featuring a human head, from the Ibibio tribe in south-east Nigeria. (2.5 kilos, 20.5cm)

2 These heavy bronze anklets worn by the Kasena women of Ghana are rarely seen today.

3 The large anklet worn by the Dan and their neighbours of the Ivory Coast and Guinea has been replaced by the smaller one (*left*) more suited to everyday life and work in the fields. The bracelet (*right*) was worn by Ngere women. (Large anklet: 15cm)

4 A bronze ornament worn on the upper arm by the Kenga people of Chad. Armlets, like anklets, though decorative in origin were later used as currency. (1 kilo, 20cm)

5 Some of the heaviest and largest anklets were worn by the Kru of Liberia. Bell-shaped anklets such as this, weighing up to 6 kilos, denoted status and were believed to ward off the evil spirits of the ground. (21cm)

6 This anklet, worn by Fang women of Gabon, was cast in a hole in the ground and then hammered into shape. (3 kilos, 12cm)

7 A bronze anklet of the Bete people, Ivory Coast, worn by women of status. The intricacy of design that can be achieved by the lost wax method is evident here, as in the Baoule anklet (8). (17cm, and 18cm)

9 *Ogba* anklets worn by the Ibo of Nigeria. Skilled smiths hammered them out of European brass bars, sometimes to a thickness of only 2mm. They were attached by the smiths to the ankle, and women had to swing their legs outwards as they walked to avoid tripping. They were only removed to be replaced by even larger ones indicating greater prestige. (35cm)

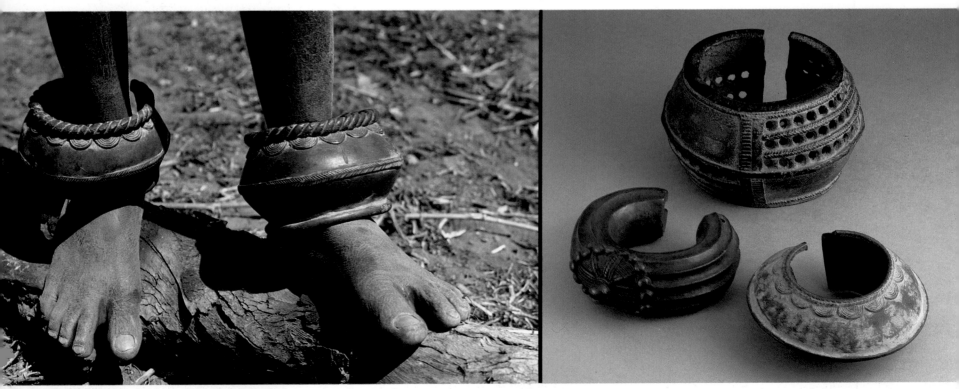

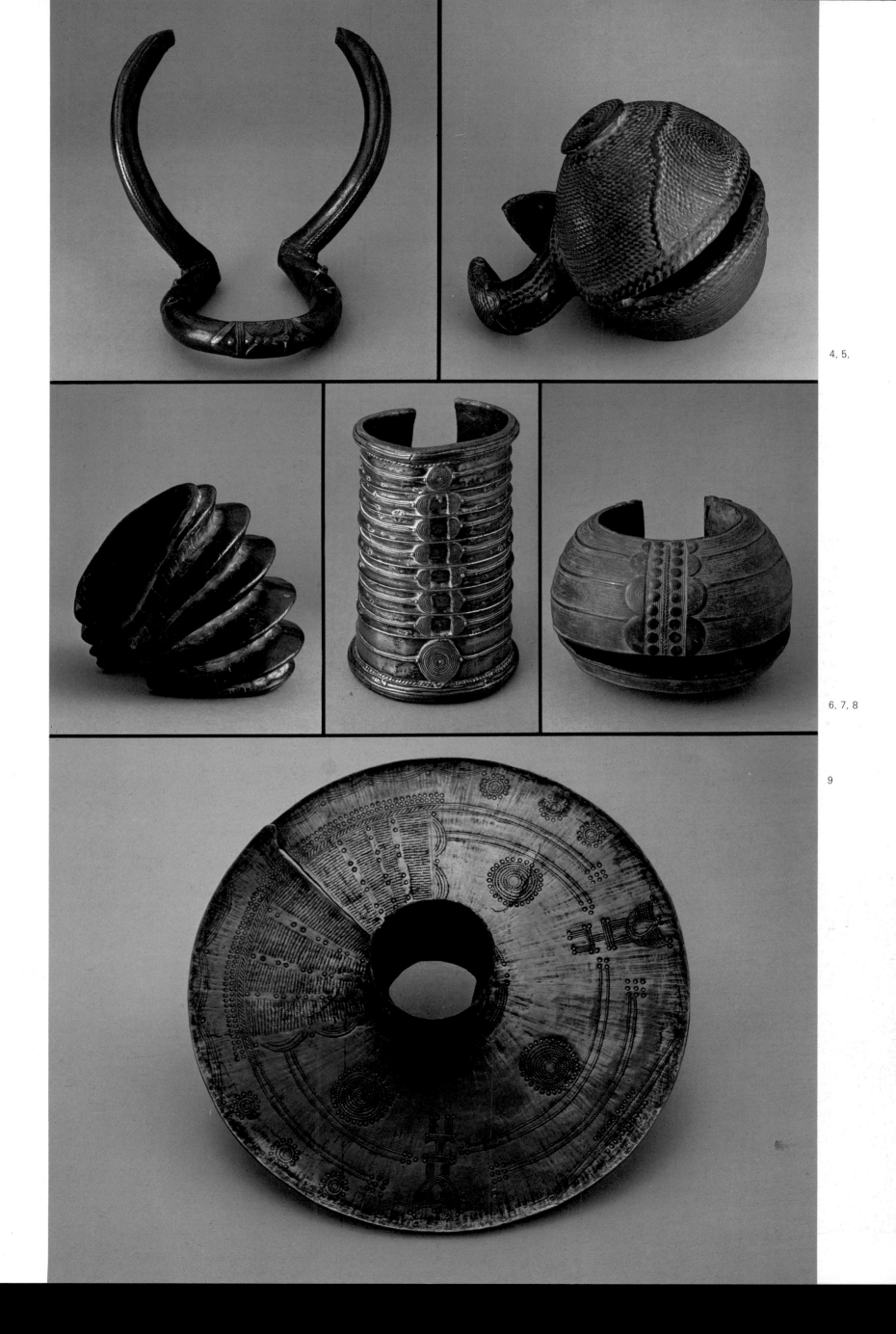

CHANGING INTO GOLD

In former times, when the King of the Asante was dying, he and his wives would select whom they wanted to die with him. At the funeral the chosen women, dressed in white and wearing all their gold jewellery, would drink themselves into oblivion before being strangled and buried with the King.

Today, Asante funerals are less dramatic but equally important occasions. Gold is worn only by the few young female dancers; the rest of the community is dressed in *adinkra* robes of sombre red or black. The dancers, *adosawa*, are managed by Nana Pokuaa, a dethroned Queen Mother from the village of Amoman. She is seen here preparing her charges, her own hair cut short and painted with a blue-black dye out of respect for the dead. A true professional, she trains the dancers, arranges their travel to distant funerals, and carries out their lengthy dressing procedure which may take two days.

Many gold bracelets are worn, and gold and glass beads are painstakingly attached on cotton threads to the neck, arms, waist and legs of the dancers. The glass beads are a mixture of imported Venetian designs and more simple ones made locally by the Krobo people of south-east Ghana. The large gold bracelets seen here (*below*) are called *benkum benfra*, a popular Asante design often worn by chiefs.

OVERLEAF LEFT The final item to be placed on the dancer is the large gold breast-shaped ornament. She wears a band of gold threads round her head (*also seen opposite*) and a scorpion cast in gold as a finger ring.

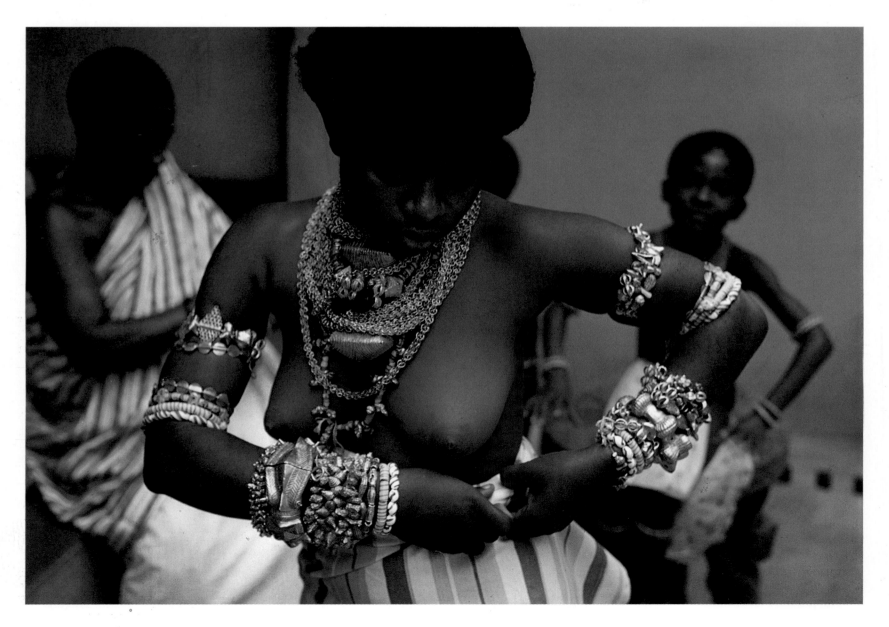

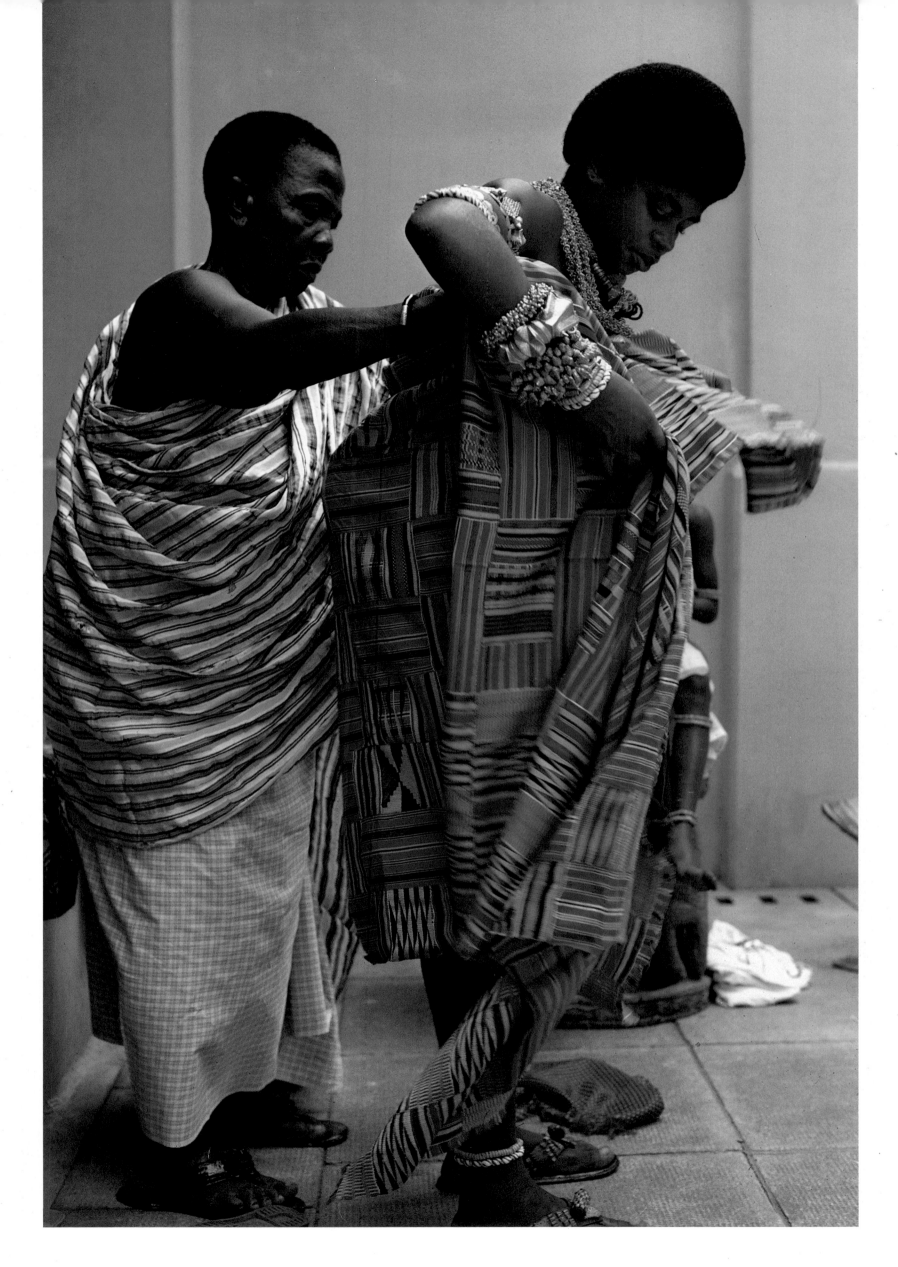

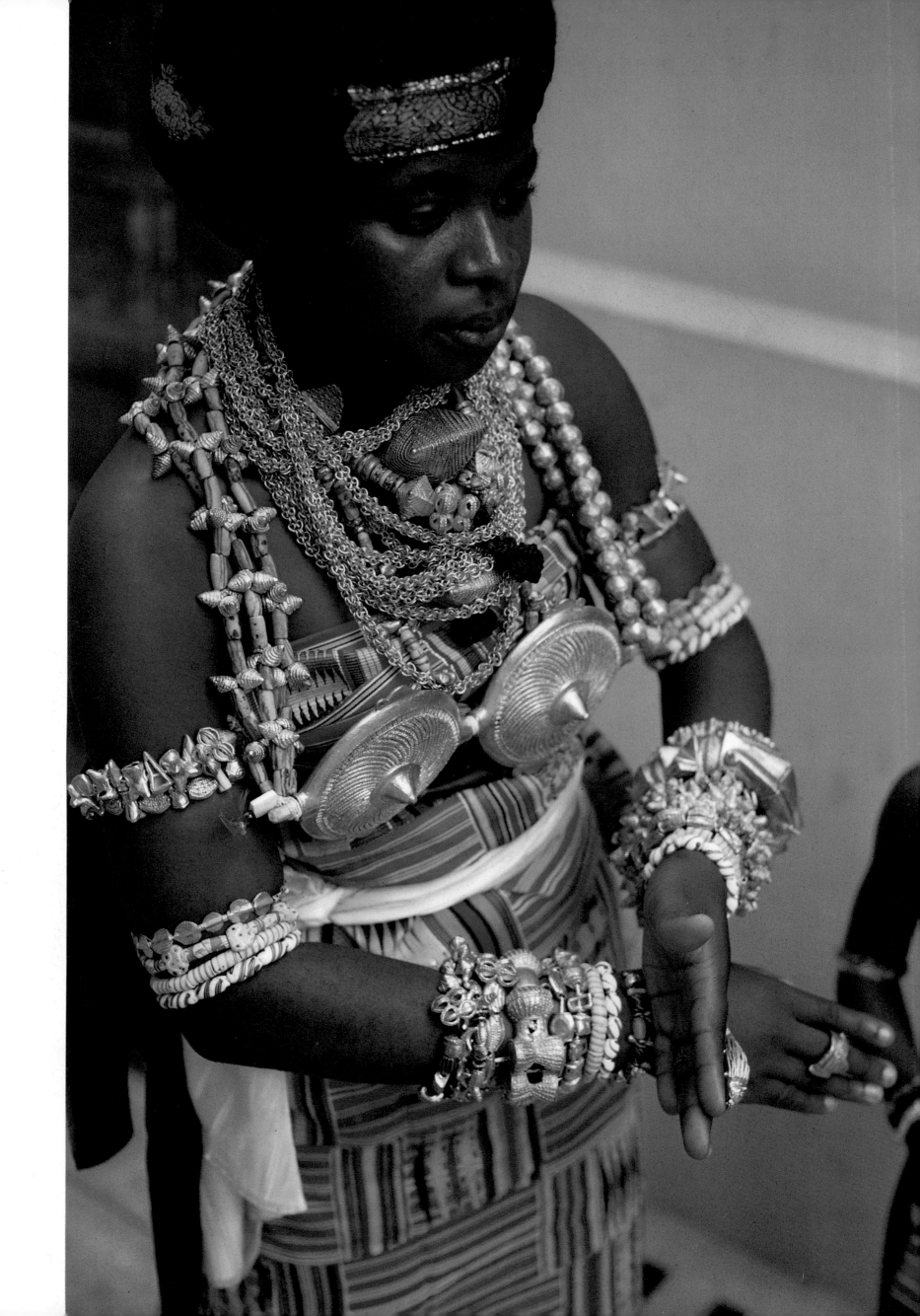

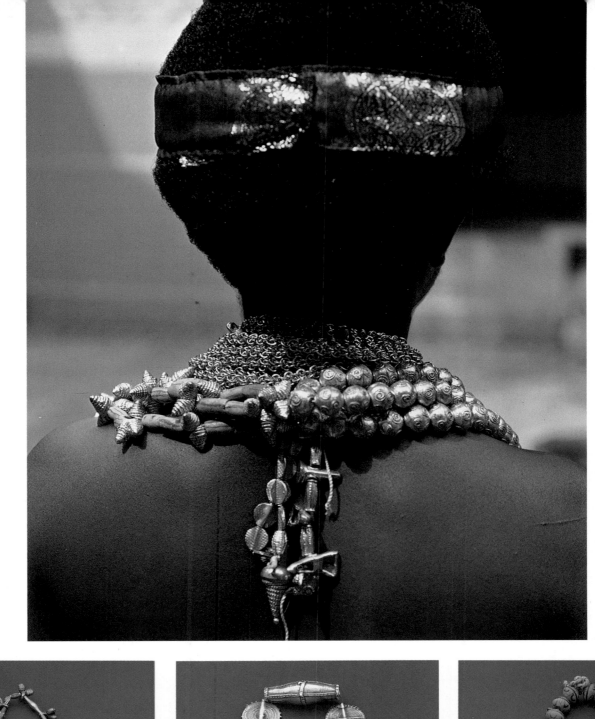

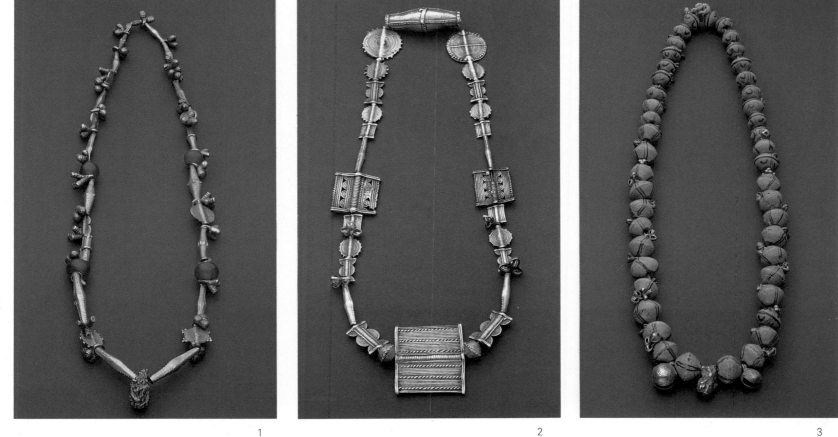

1 2 3

AKAN WEALTH

Goldsmiths of the Akan-speaking peoples who fashioned the exquisite bronze weights for measuring gold also made bronze beads and necklaces to the same design as gold beads. Although not worn by nobles, these were nevertheless highly valued.

1 An Akan necklace of brass beads incorporating blue glass beads imported from Holland, probably in the nineteenth century. Conical buttons of finely cut openwork are typical of the Asante. (35cm)

2 Baoule brass beads cost by the lost wax method, fine waxed threads being used to achieve the detailed line decorations. The geometric shapes are typical of Baoule bead designs; closely associated through history and culture with the Asante, the Baoule like them were influenced by the angular designs from North Africa and the detailed art of the Benin. (35cm)

3 An Akan necklace of highly prized glass beads of Venetian origin interspersed with brass pendants and bells; a gold nugget forms the centrepiece. (40cm)

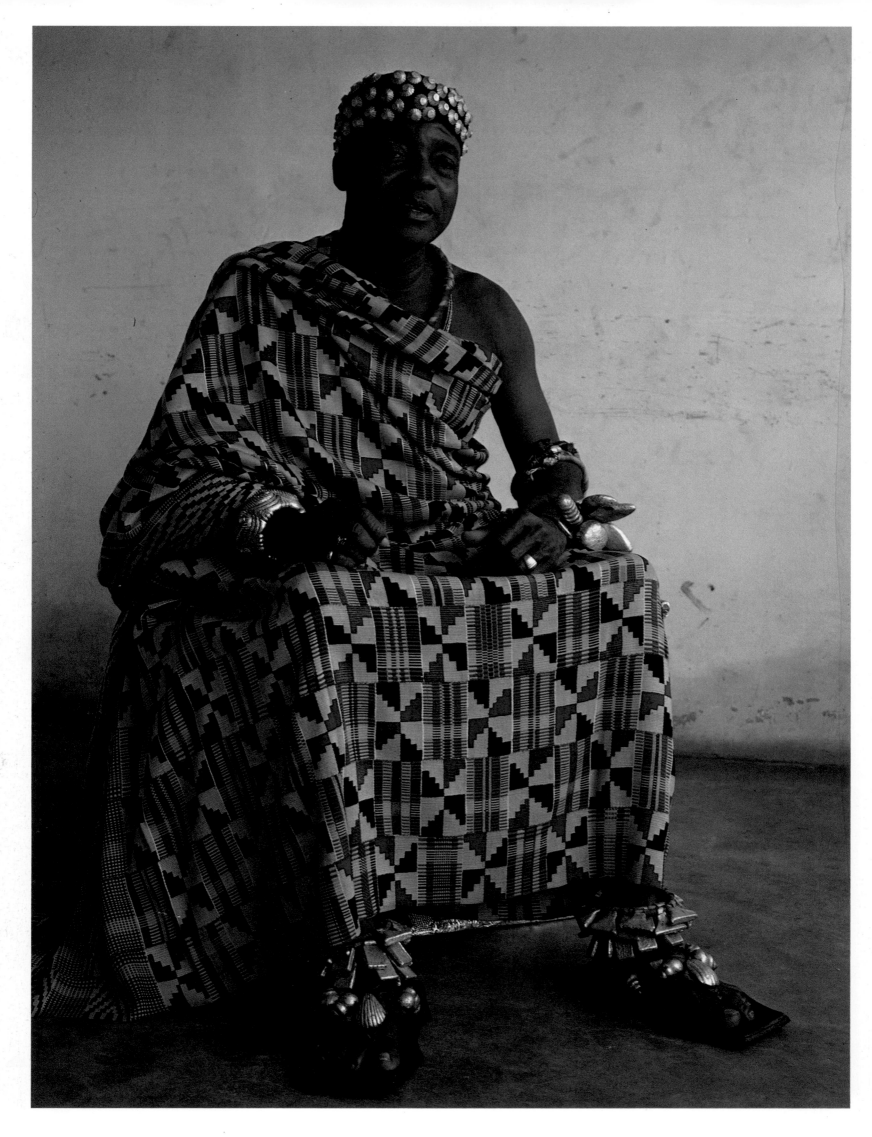

COURT FINERY

Nana Kwakye Ameyaw II, Paramount Chief of Techiman in Bono State, Ghana, wears some of his official gold regalia and a ceremonial Kente cloth. At the time of this photograph the Chief's position was in danger and some of his gold jewellery had been sent away for safekeeping. The chain around his neck and the large hollow-cast bracelet are of gold, and gold leaf has been applied to other items of his regalia such as the crown, the sandals, and the amulet pendants worn on wrists and ankles. These amulets, made of leather, enclose Islamic verses. The Bono are believed to be the originators of the figurative style of gold weights, used widely among the Akan peoples.

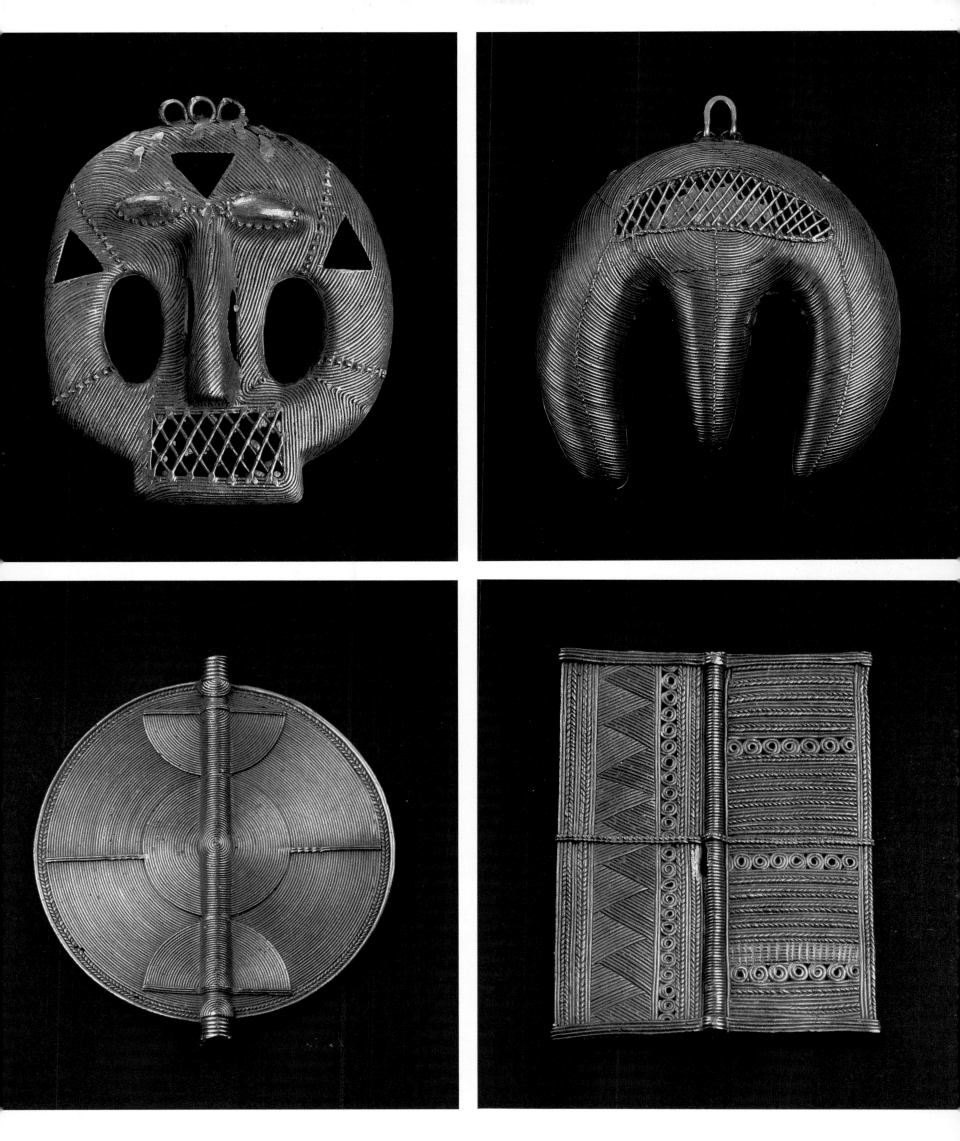

BAOULE GOLD

The eighteenth-century traveller John Barbot described finding in this area 'very fine gold casting that even a European artist would find difficult to imitate.'

TOP LEFT A gold mask pendant worn by chiefs or royalty. It is hung or attached to the hands or feet by the loops at the top. (12.5cm)

TOP RIGHT A gold ram's head pendant, with horns like the crescent moon. The ram symbolizes the god of thunder and the crescent represents rain and water. Called *sarai* (the moon), it is worn on the head by chiefs and royalty. (9cm)

ABOVE LEFT AND RIGHT These delicately cast pendants were probably worn by a Baoule king. Like many Baoule beads, these pendants have cylindrical ridges for the thread to pass through. (9cm)

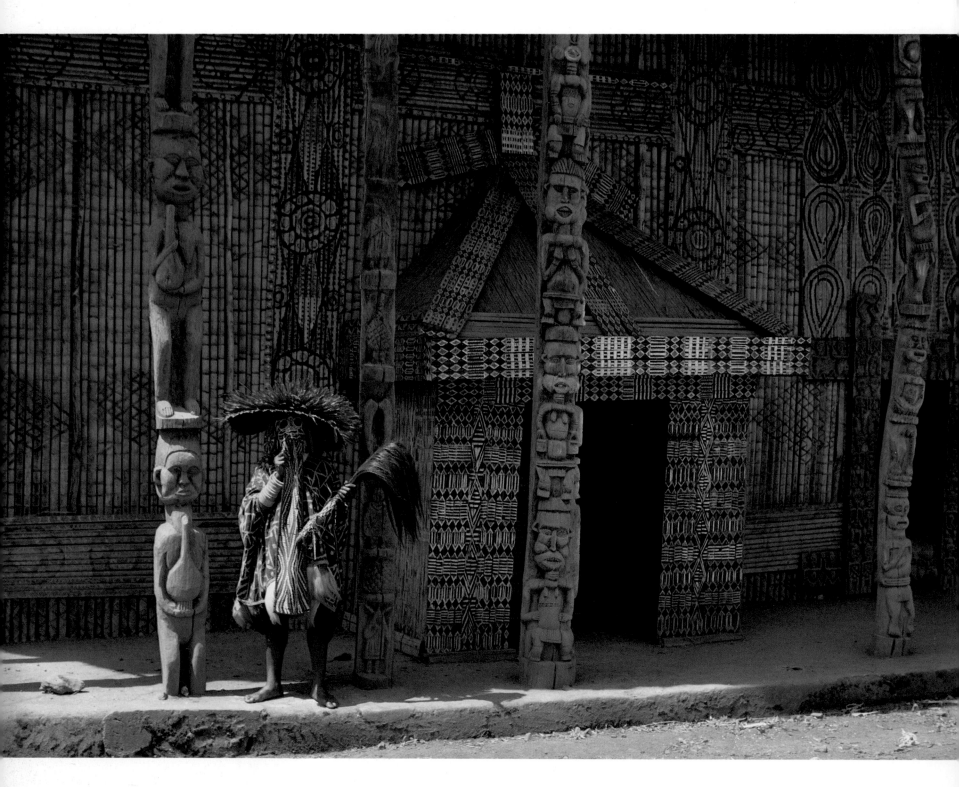

GLASS BEAD SCULPTURE

The chiefdom of Bandjoun is the most notable Bamilike feudal village in Cameroun. The home of the Supreme Chief, or Fon, is vast and impressive, constructed of bamboo and supported by carved wooden pillars. Bamilike hats are made from red parrot feathers, and the Fon wears the largest one ever seen, with a diameter of nearly two metres. Warriors who have rendered a great service to the Fon are eligible members of the Aka or 'elephant mask' society. They dance at the funeral of the Fon and at their twice-yearly meetings wearing smaller feathered hats, elaborate beaded elephant masks and coats of indigo blue. Every item of their costume is intended to display the wealth, power and privilege of the Fon.

RIGHT A dancer of the Aka society moves in a loping dance, his ear flaps swinging. His ivory bracelet and chevron bead necklace are the property of the Fon; chevron beads are worn only by chiefs and those in positions of responsibility. Since the last century tiny 'pound beads', so called because they were sold by the pound,

reached the equatorial forests in an almost limitless range of colours. This and their regular size inspired peoples like the Bamilike of Cameroun, the Yoruba of Nigeria and the Bakuba of Zaire to create an entirely new art form of sculptural beadwork incorporating symbolic animal and plant designs.

OVERLEAF LEFT An exquisite example of a beaded elephant mask. The elephant and leopard symbolize force and power, attributes for which the Fon is renowned. It is believed that he can transform himself into either animal at will. (153cm)

OVERLEAF RIGHT *Ade*, a Yoruba beaded crown. Today there are about 50 Yoruba Obas who still wear crowns and claim to be descendants of the mythical first king of Ife. The sculpted birds and human images remind his subjects that the Oba's head is sacred and that, for the well-being of the kingdom, his power must never wane. The veil of beads which covers his face protects commoners from looking directly at so powerful a being. (186cm)

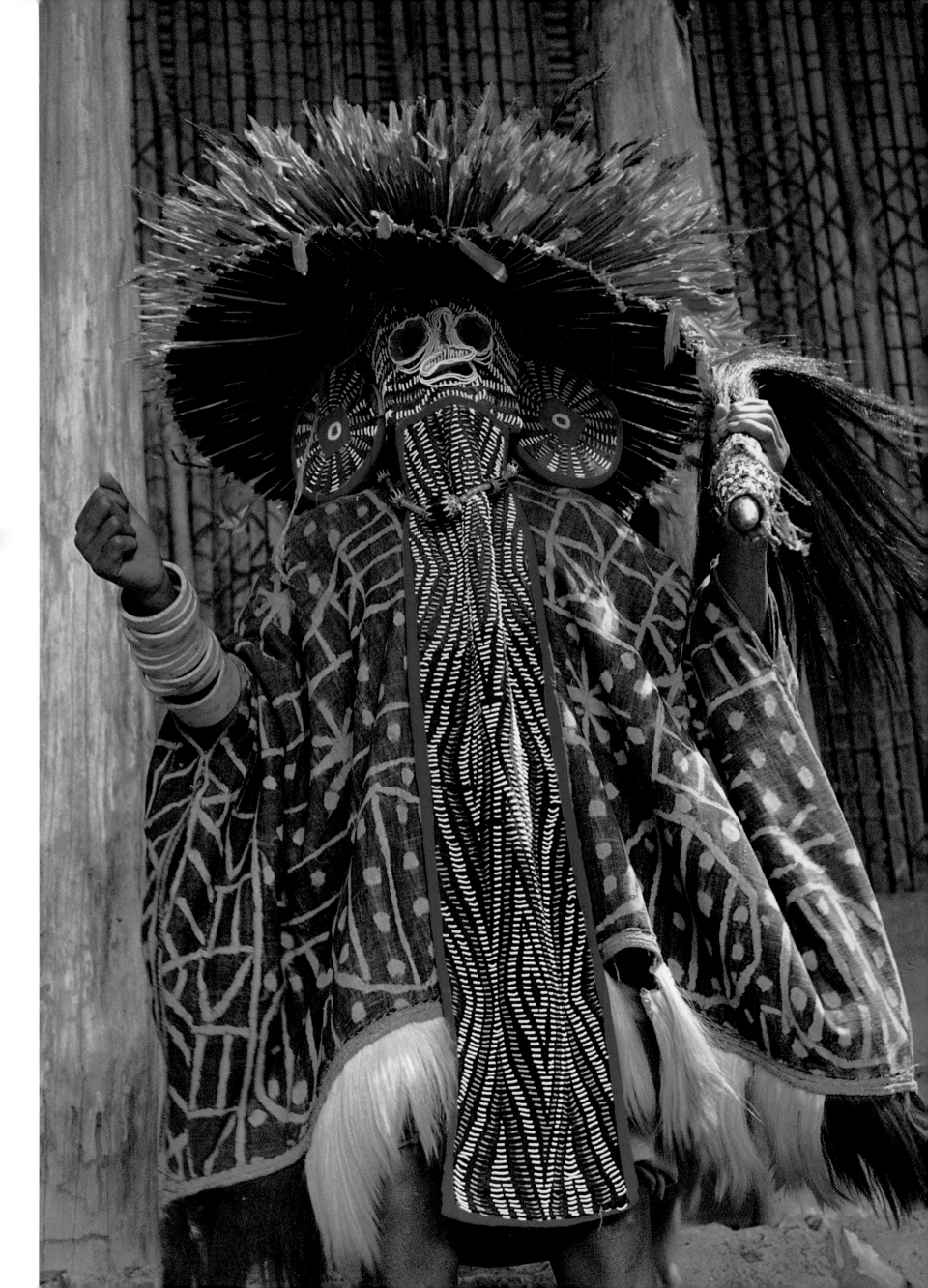

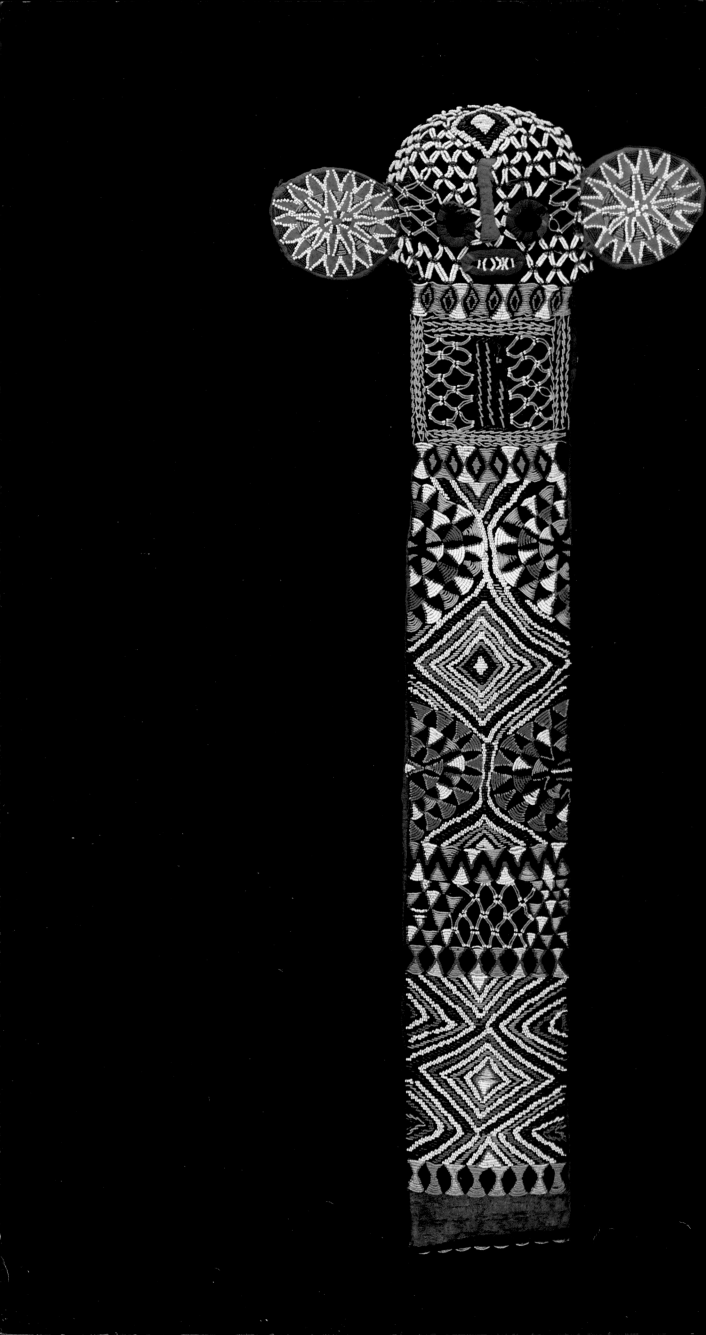

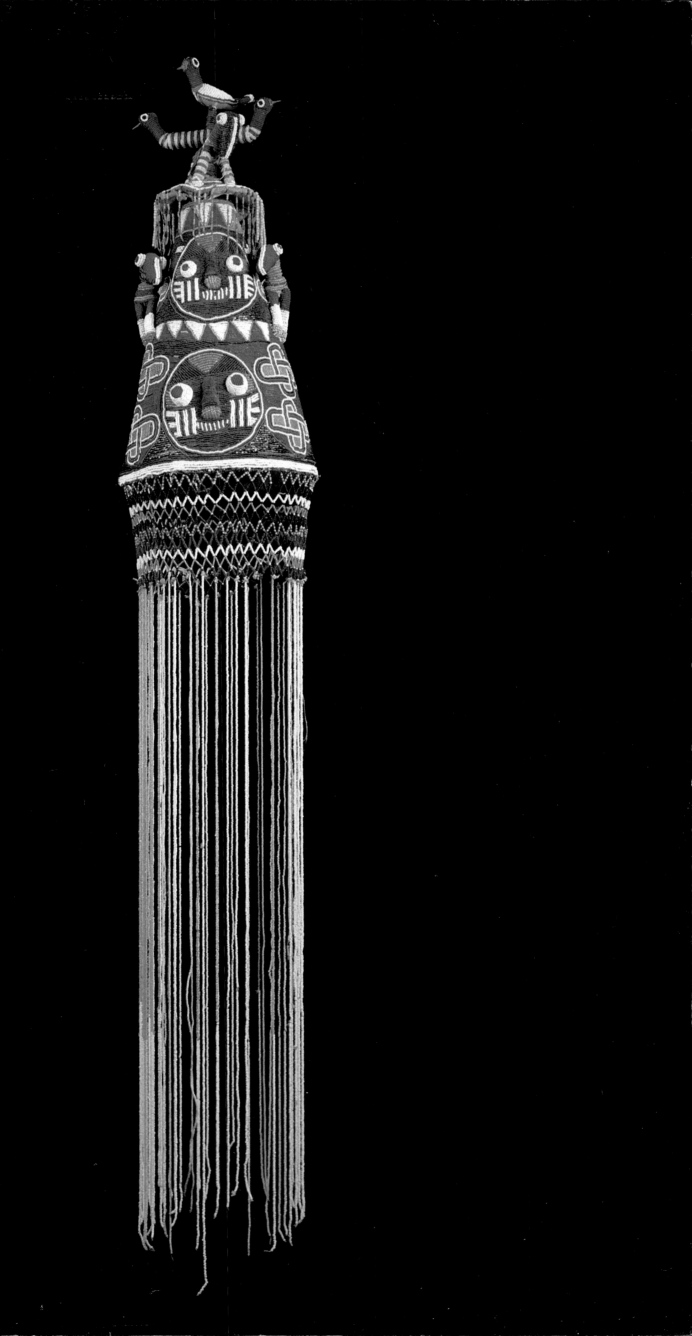

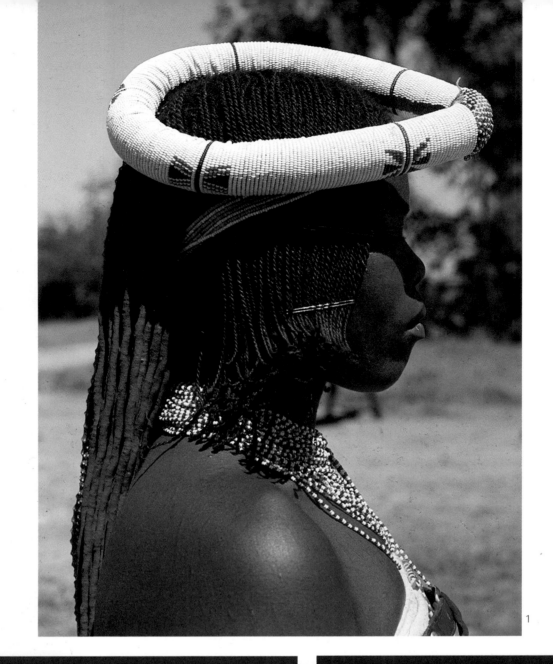

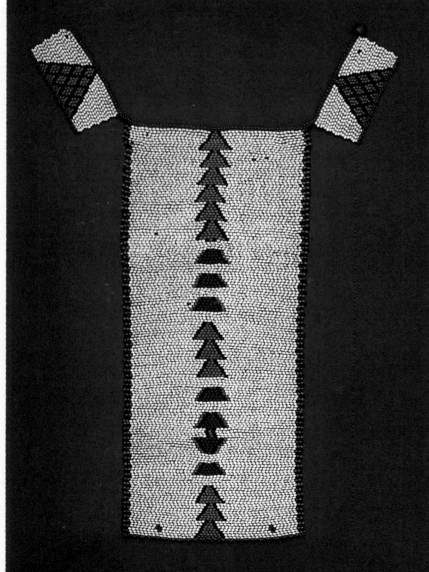

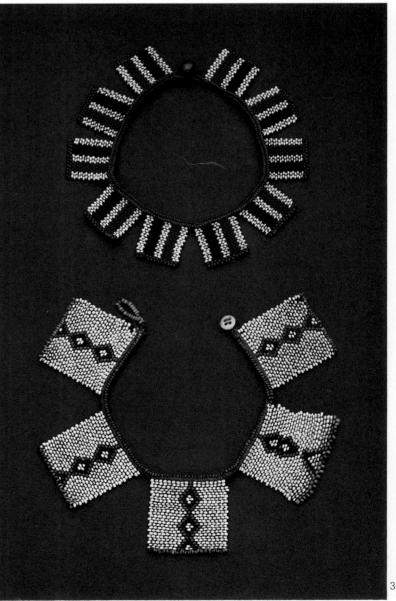

THE LANGUAGE OF GLASS

In contrast to the sculptural beadwork of Cameroun, Zaire and Gabon, bead jewellery virtually takes the form of costume for the Bantu of southern Africa. There it is worn permanently, in marked contrast to the practice in the equatorial forests where its appearance is mainly restricted to festival times and rites of passage. Small glass beads have been widely available since the early twentieth century and of the South African Bantu the Ndebele, Xhosa and Zulu peoples have made the most extensive and aesthetically pleasing use of them.

1 Different styles of beaded hoops indicate the various stages in a woman's life: the headband of this Pondo girl denotes that she is married.

2 A long pendant necklace of white beads worn by Zulu people to ward off evil spirits. (45cm)

3 Colour-coded messages in beadwork are said to be contained in the tab pendants of these Zulu necklaces. These bead tabs, referred to as love letters, *ubala abuyisse*, are made by girls and are much prized by the young men to whom they are given. Messages of love, longing, hope and disappointment, or invitations to courtship are interpreted from the patterns and colours of the beads used. White beads symbolize purity of love: 'My heart is pure and white in the long lonely days.' Black says, 'Darkness prevents my coming to you.' Pink stands for poverty and green, coolness. Beads of royal blue symbolize rejection: 'You are a wandering noisy bird.' (Tab lengths 3 and 4cm)

4 *Mapato*, the apron worn by married women of the Ndebele tribe of Zimbabwe and South Africa. Here the beads are applied to goatskin (others have a canvas base) and there is a leather fringe in the centre, a popular design worn for dances and celebrations. Ndebele beadwork patterns, principally in red and blue, reflect their painted house designs. (52 × 44cm)

5 A simpler style of *mapato* apron, of predominantly white beads. (60 × 75cm)

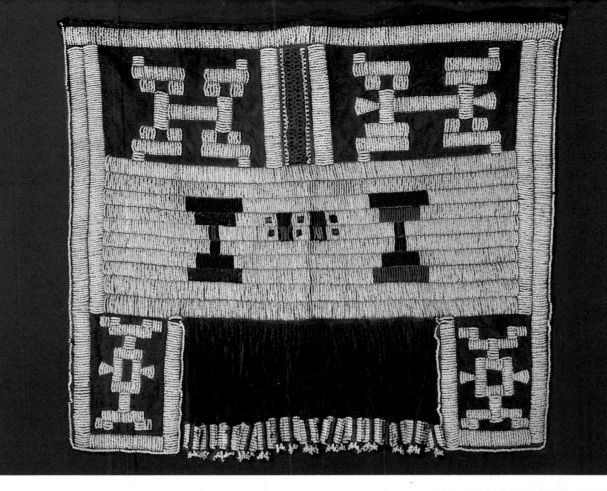

4

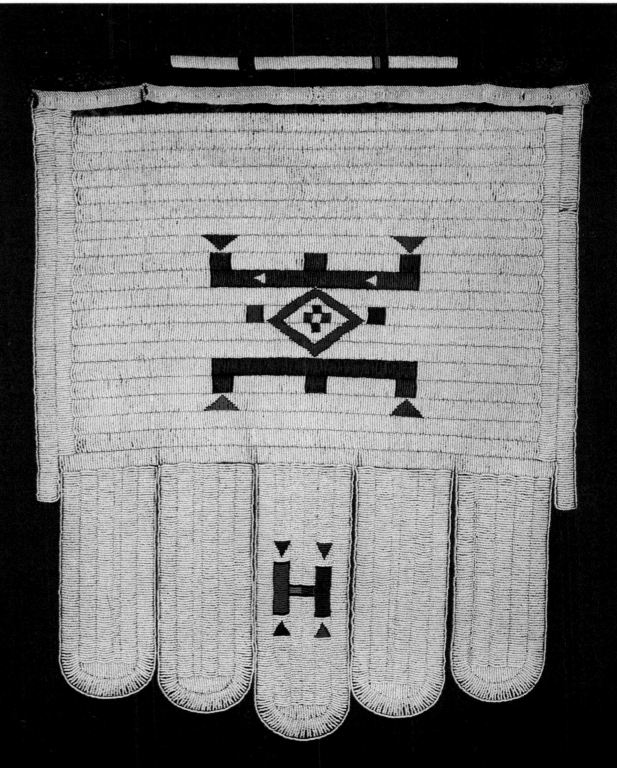

5

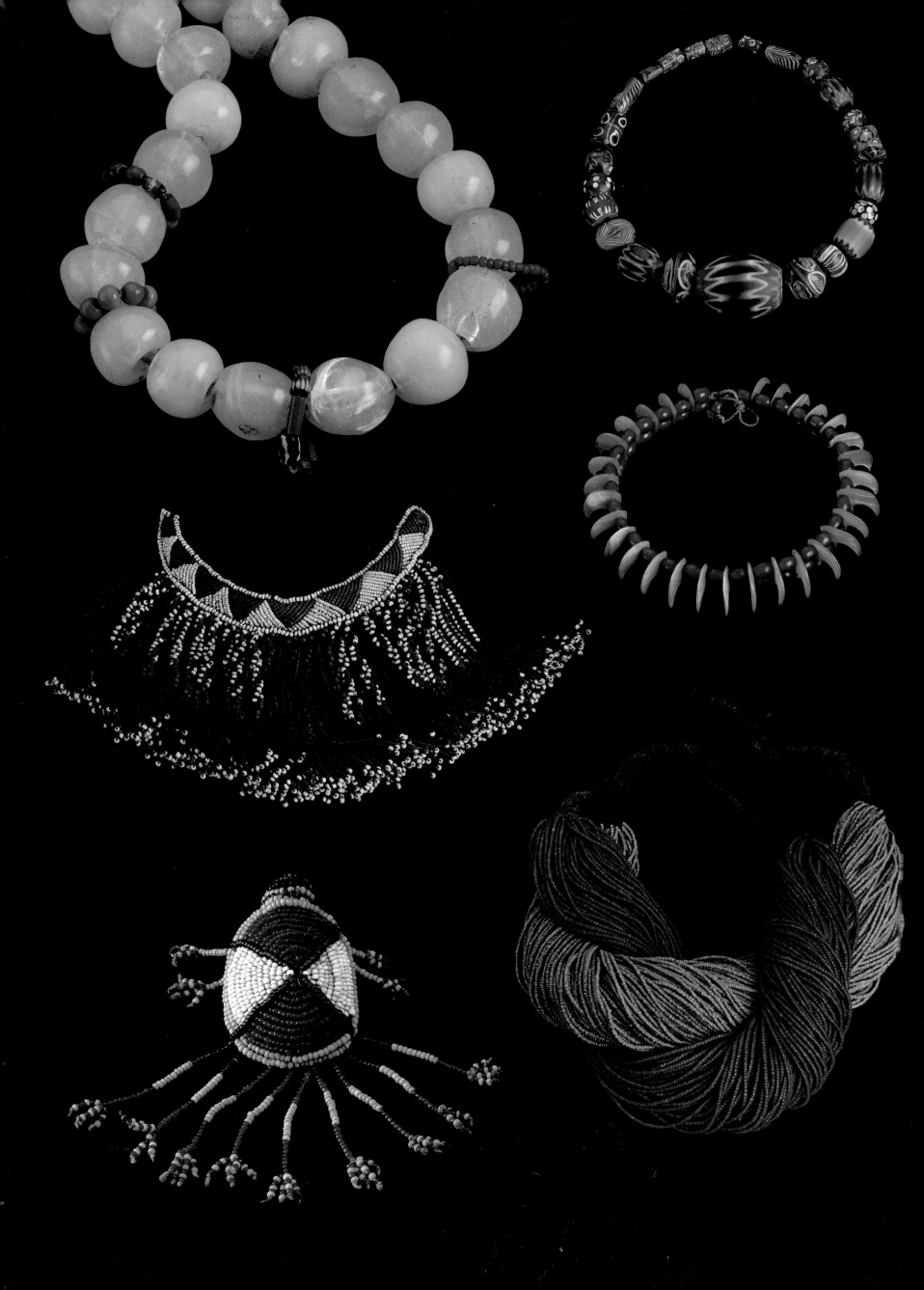

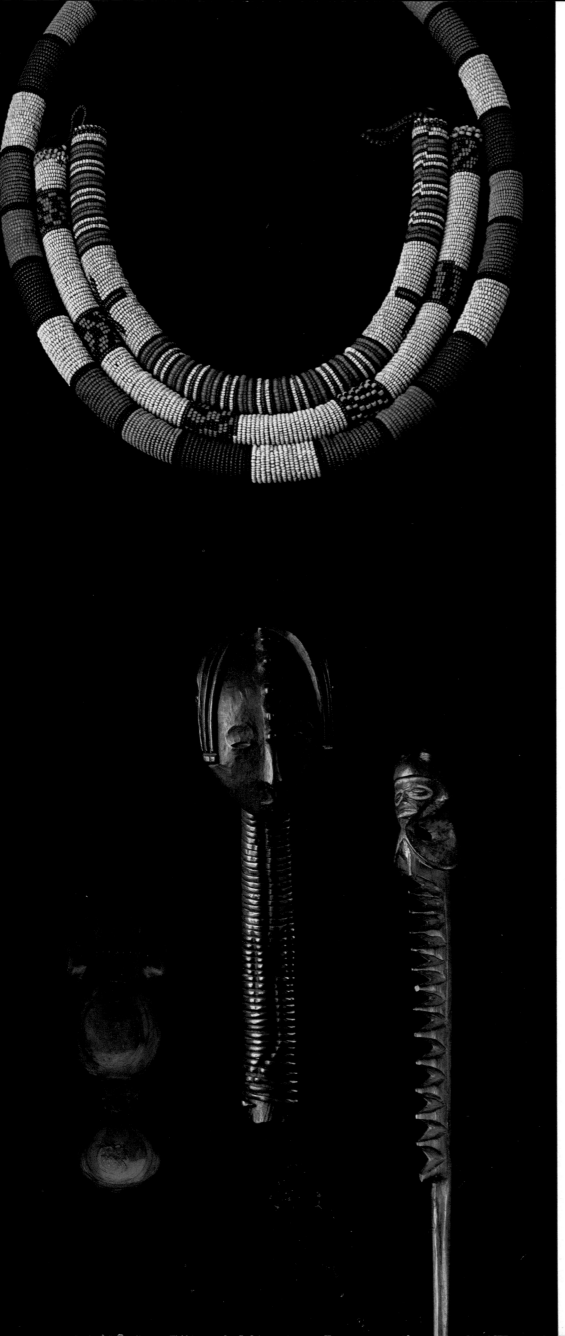

TREASURES AND TRADE

TOP ROW LEFT TO RIGHT A necklace of old glass
beads, possibly made by the Yoruba of Nigeria,
some of the earliest makers of glass beads in
the region. The necklace was certainly worn
by priests, for whom the beads could have had
spiritual significance. The strings of tiny beads
attached in rings around the larger ones are
characteristic of the jewellery of Yoruba priests.
(Each large bead 4.5cm)

A necklace of old Venetian glass beads (*see
key*). In Cameroun the chevron bead (a) was
usually in blue, white and red, but rare chevrons with a green translucent inner
core were found in Ghanaian markets in the
1960s. In Nigeria chequer beads of feather
design (b) were prevalent. Mosaic (c, d, e and
f) and millefiori (g) designs were however
popular throughout the coast region. Some of
the most expensive Venetian beads were
individually hand-painted (h, i and j). In
Ghana the vogue was for many different types
of beads in one necklace; a single strand of
beads might include 30 to 40 designs. (Centre
bead 5cm)

In the sixteenth century Venice was the
European centre of glass bead production;
in the nineteenth century Amsterdam and
later Czechoslovakia overtook Venice in the
making of pressed porcelain beads.

MIDDLE ROW LEFT TO RIGHT A bead and leather
apron worn by Zulu girls. Beaded patterns are
often symbolic: the triangle, for example,
represents the female element. (29cm)

A necklace of lions' claws and old red glass
beads, worn by a Zulu chief as a sign of
prestige and power. (Diameter 16cm)

BOTTOM ROW LEFT TO RIGHT A beaded
ornament in the shape of a turtle, worn on
the upper arm by members of the Mbwolye
Society of the Shaba, Zaire. (40cm)

Heavy 'pound bead' necklaces worn by Tutsi
women, Rwanda. The number of strings worn
denotes wealth: here the red necklace has 130
strings, the pink 181. (Length 50cm)

Beaded hoops, tubes or bundles of grass fibre
decorated with beads in a range of geometric
designs are made and worn by Zulu women.
Some are worn around the neck, others
(particularly the large ones found among the
Ndebele) are worn in abundance at the waist,
neck and wrists. (Thickness 2.5cm)

An ivory whistle pendant worn by Bapende
hunters, Zaire, on a cord round their necks.
They used it to call their dogs and communi-
cate with fellow-hunters in the forest. (9.5cm)

This sculpted wooden head, partly wrapped
in copper bands, is worn on the arm by
warriors from the Ngbandi people of Zaire. It
is seen as a good luck charm and a source of
protection when hunting. (18cm)

A carved wooden hairpin possibly from the
Bahuana tribe, Zaire. The highly skilled ivory
carvers of Zaire received their early training
in carving wood. (21cm)

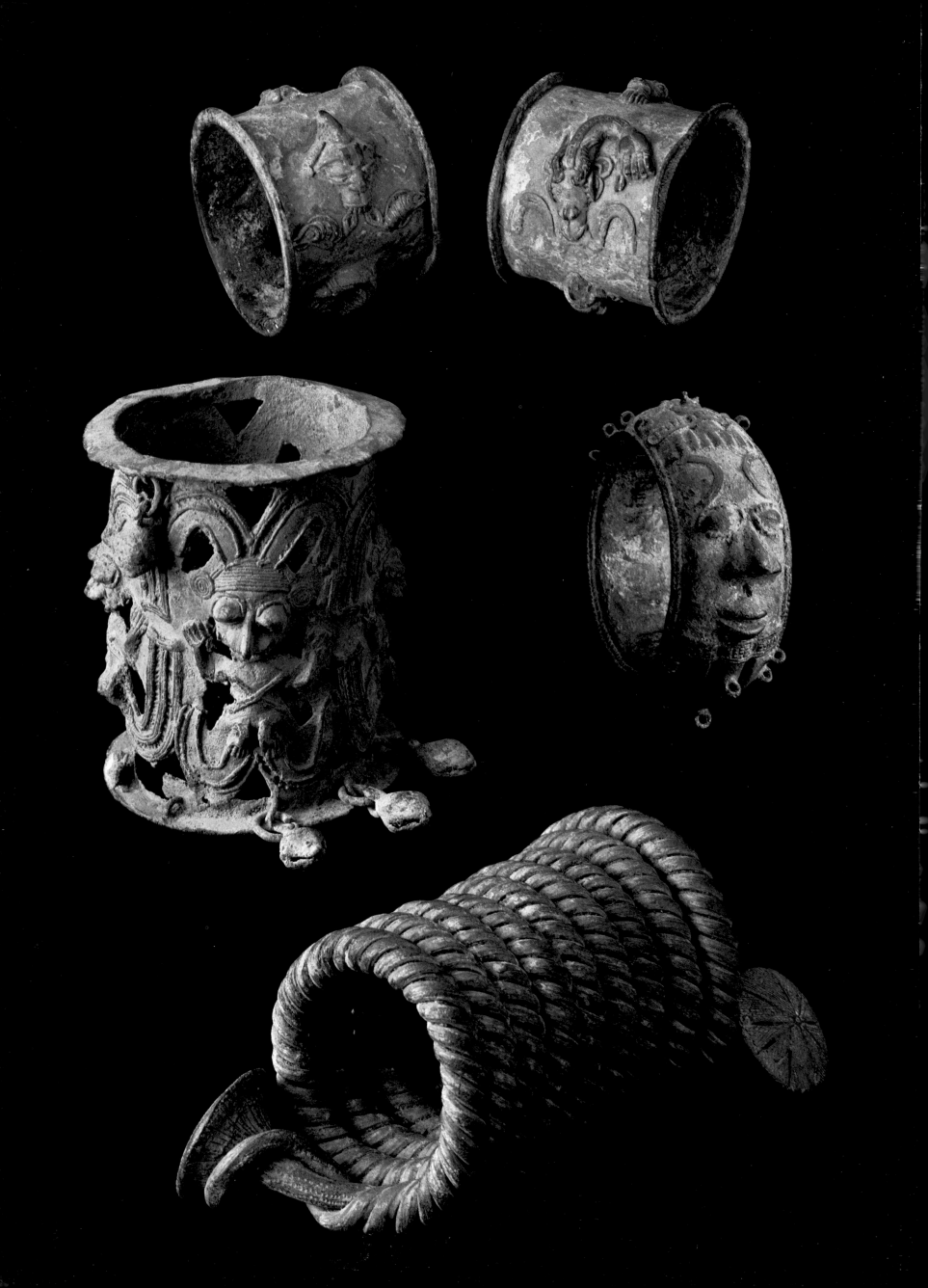

1 A pair of Yoruba bronze bracelets of the eighteenth century or earlier from Owo in Nigeria, one incorporating the head of a man and two fishes, the other a human hand and fish combined. Bracelets such as these were worn at secret meetings of the Oro society, an extension of the Ogboni cult (*see p. 81*) to which priests, chiefs and other men of high standing belong. (6cm)

2 An old bronze armlet from Ijebu-Ode in Nigeria, portraying spiritual figures, worn by members of the Ogboni cult. Yoruba smiths are still responsible for making ritual cult objects and ornaments for the various religious groups. (13cm)

3 A Yoruba bronze armlet worn by members of the Ogboni cult, decorated with a human face. (12cm)

4 An old forged bronze armlet of rare design formerly worn by the Oba of Ife. (23cm)

5 A 'soul washer's badge', a gold pendant worn by a courtier of the King of Baoule who serves him when the King's life force is running down, or in the event of death. The Baoule sometimes attach these pendants to the lower arm, whereas the Asante wear them on the breast. The one shown here is decorated with two buffaloes, two birds and a snake at the centre. (9cm)

6 *Nfre*, strings of precious beads and gold, are worn as bracelets or threaded into necklaces by the Queen Mother and by royal wives and princesses (the latter during their puberty rites) of the Asante people in Ghana. Asante bead designs include natural forms such as snails, cocoons and seeds as well as abstract shapes, both of which serve as protective charmes. (Diameter 10cm)

7 A bracelet of twisted iron and brass from an unknown source in Zaire. (8cm)

8 Brass jewellery of the Tikar people, Cameroun, cast by the lost wax method. *From the top*: a brass ring, a chameleon pendant, and a bracelet. The ring is believed to represent a bird's nest, and is similar in design to those made by the Akan of Ghana and the Ivory Coast. The chameleon was the motif of feudal leaders. The bracelet has an abstract design of a spider, an important creature to the Tikar who believe it to mediate between God and man. (Pendant 6cm)

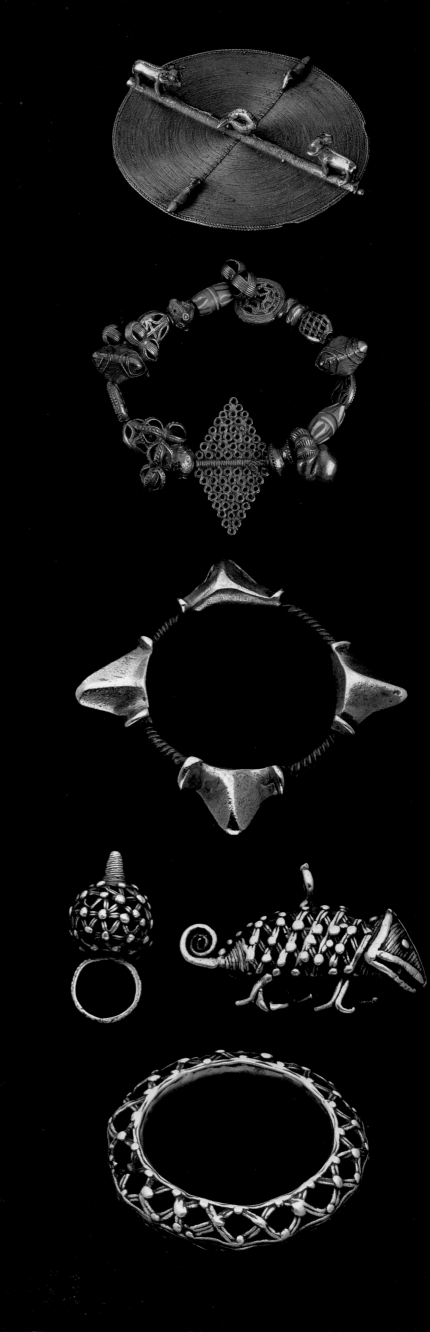

Whatsoever was the original of these Grigri *[amulets], people will willingly part with anything they have to be furnished with as many as they are able to purchase, according to their quality and profession; and take great pride in them. Some will give two or three slaves for one* Grigri; *others two, three or four oxen, answerable to the qualities assigned to it. To say the truth, some of the principal Blacks are so well furnished all over with* Grigris *on every part of their bodies, under their shirts and bonnets, that they cannot well be wounded with any Assagaia, or javelin.**

John Barbot. *A Collection of Voyages and Travels, 1732.*

OLD AFRICA

Pockets of Ancient Tradition

Between the equatorial forest regions and the savannah grasslands of West Africa live isolated groups of people, separated largely by choice from the outside world. These people, mostly animists, resisted both the conquest of the savannah by the medieval Islamic empires and the Christian faith brought by the Europeans; instead, they adhered passionately to their own traditional religions.

Their beliefs are dominated by the idea that their destiny is in the hands both of spirits which live in the bush and of their own ancestors, who are held responsible for their individual and communal well-being. These supernatural forces are as real to them as the actual world in which they live. In order to maintain their traditional view of the world and the way of life based upon it, they have had to flee from religious zealots and empire builders, often taking refuge in harsh and infertile mountain retreats.

The Dogon people of Mali originally lived on the bend of the River Niger, but escaped from the threat of Islam to the almost unscalable cliff face of the Bandiagara Plateau to the south. The Lobi, Gurunsi and Kasena peoples retreated deeper into the forest regions where the three lands of Upper Volta, Ghana and Ivory Coast meet, protecting themselves in fortified compounds with multi-storeyed terraces reminiscent of medieval castles, and living mainly by hunting. The Kirdi in Cameroun had smaller dwellings but, like the Dogon, they built on steep, inaccessible mountain slopes, their villages nestling beneath the vast volcanic plugs of the Mandara Mountains.

The name Kirdi, meaning 'infidels', was given to the group of peoples in Cameroun by the Muslims who drove them into their hilltop refuges from the plains below. Like all ancestor worshippers and animists, they are despised by their Muslim neighbours for what is considered to be a thoroughly uncivilized lifestyle.

The Kirdi are contented to live simply, however, with few material possessions. They work hard, tilling the land by hand in order to eke out an independent living and thus preserve their long-held spiritual beliefs. In the less remote areas of West Africa, animist traditions have been under threat not only from Muslim infiltration but also, in this century, from Western influence, through the pressures of local government. The Mossi, Bobo and Senufo in Upper Volta and the Ivory Coast have all been subject to these strictures to conform but many of them have turned a blind eye.

A Dogon granary hung with fetishes (see p. 103).

* Here Barbot refers to the Asante of Ghana, but his description could as aptly apply to the people of Upper Volta and Ivory Coast.

DOGON ANCESTOR WORSHIP

Vertical cliffs descend from the Bandiagara Plateau to the plains 600 metres below. Centuries ago the Dogon took refuge in this natural fortification from the Fulani, who were forcibly extending their territory in the name of Islam. Mud huts and granaries built hard against the stone cliffs allow every inch of land to be used for crops. The houses are flat-roofed while the granaries have cone-shaped roofs. Power is believed to emanate from the walled-in caves at the top of the cliff edge where the Dogon still bury their dead, hoisting them up with ropes.

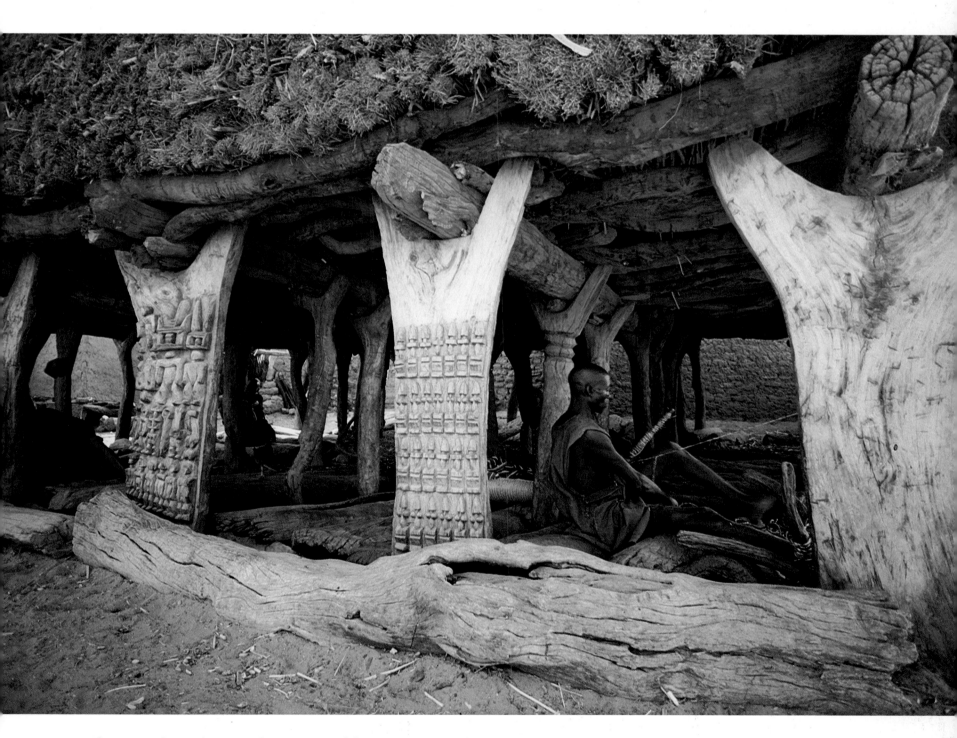

ABOVE The *toguna*, the men's meeting house, is one of the most important buildings in the village; its carved wooden roof supports represent the eight mythological Dogon ancestors. During the day the men weave and make rope here, or smoke their pipes and meditate in its coolness. At sundown the Dogon ancestors are thought to enter the building, and since no important decisions are taken without consulting them it is here that the elders hold their meetings, often led by the Hogon, a supreme religious leader.

113

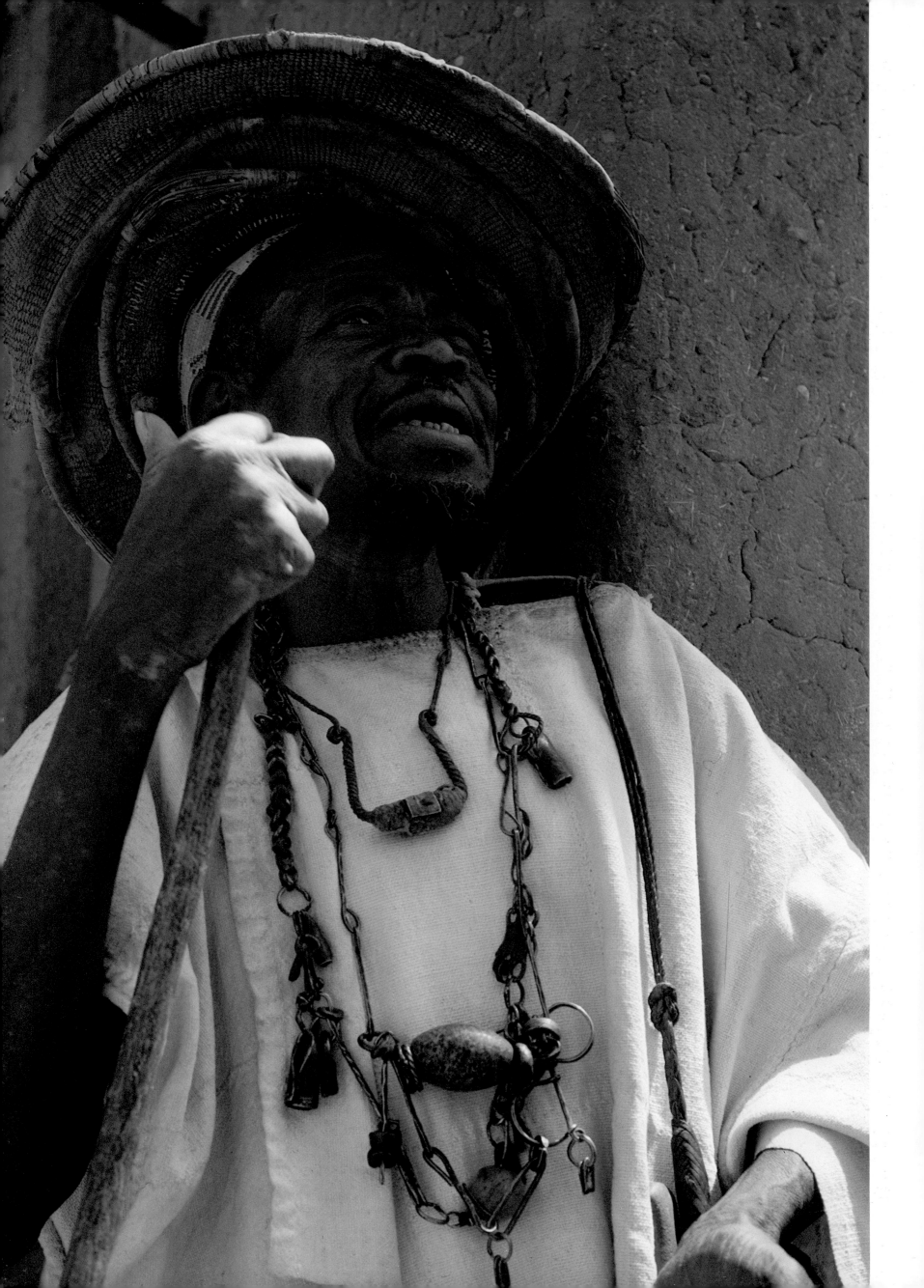

ELEMENTS OF RITUAL

OPPOSITE There are four Hogons, each of whom has several guardians called *benekesena*. These, usually the oldest men in the village, are chief priests and spiritual figureheads who assist the Hogon in practical duties and help him to prepare fetishes on ritual occasions. Like the Hogon, they wear sacred iron and stone bead necklaces. The stones, according to Dogon mythology, are covenant stones, *douge*, representing the bones (and hence the power) of the Lebe, the first Hogon. He is thought to visit the Hogons each night in the form of a serpent, licking their bodies from head to foot in order to purify them and impart to them the strength of their ancestors.

The iron bracelets (*below right 1 and 2*) encasing the *douge* are worn by Dogon priests on the arm or carried during ritual practices, while the iron ring (3) is worn by the Hogon on his left ankle. West African ironwork dates back 2500 years. (3: 12cm)

The ritual necklace (*below far right*) worn by priests and the Hogon consists of a variety of links, some encasing the *douge*, others with pieces of metal attached, iron bells, a looped ring and a stylized bird pendant. The number and pattern of the stones are believed to give order and structure to Dogon society. Necklaces of simple design with one stone pendant are worn every day; on ceremonial occasions these are replaced by iron chains of complex design. (Length of bird pendant 16cm)

Spindle whorls – sometimes mistaken by outsiders for ancient beads – are now sold and used as jewellery in Mali (*above right*). Made of clay and stone, and incised with geometrical patterns, they are recognizable by their enlarged central hole. Recent excavation in the old city of Jenné-Jeno near the modern town of Jenné show these whorls to have been used at least since AD 1000. Sometimes the Dogon incorporate whorls into fetish necklaces, like the one seen here (*above far right*) suspended beside a dead civet cat on the wall of a granary, both giving spiritual protection to the crops within. (Each bead 2.25cm)

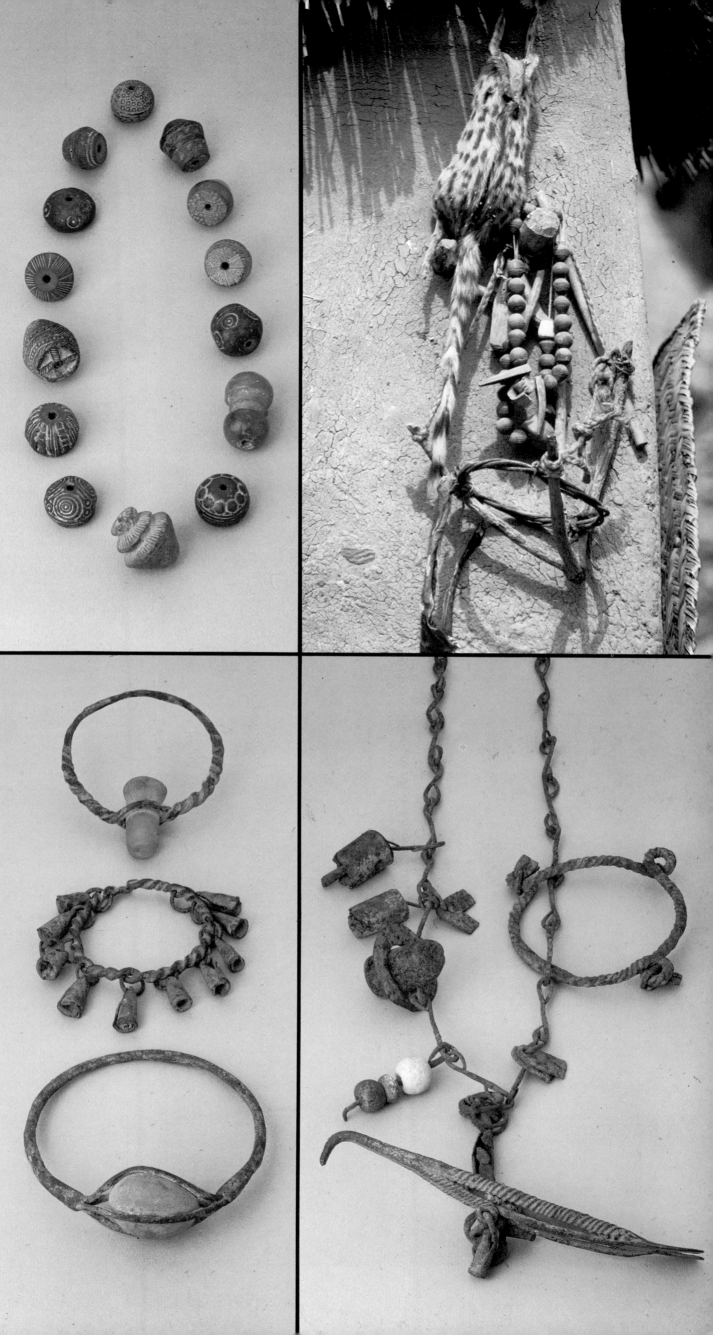

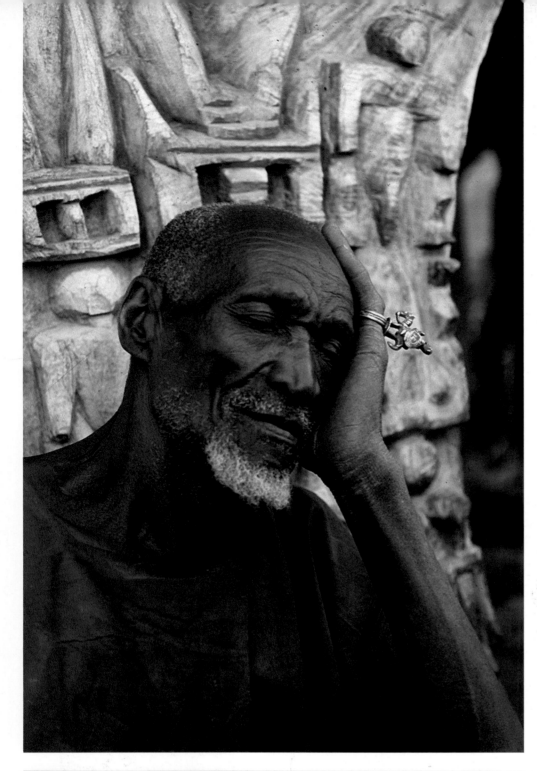

ANCIENT MYTH AND SYMBOL

Old bronze rings are rarely seen in West Africa now, and rings in use today are often newly cast and of simpler design. Antique designs are sometimes faked for the collectors' market.

Bronze rings, their design often inspired by myth or legend, were worn as a sign of status by older men. They also served as amulets, and sometimes as a form of offering to the ancestors or bush spirits. Some of the old designs were miniature versions of ceremonial dance masks, and probably had the same function of warding off evil spirits or imparting to their wearer the traits of the animals they represented. In an attempt to appease the spirit of an animal slain, the creature might be portrayed. Subjects included frogs, important in mythology, and birds, which symbolize peaceful co-existence.

LEFT A Dogon elder wears a bronze ring incorporating a horse and rider.

BELOW LEFT For the Dogon the woman's mouth is the symbol of the weaving loom from which language was derived. They believe that speech began by threads being drawn between the sharp points of the ancestor spirits' teeth. The Dogon file their own teeth to recall the origin of language, and the ornaments on a woman's mouth and nose symbolize the weaving apparatus. Dogon men traditionally believe that a woman without these ornaments is naked, and 'for a woman to be naked is to be speechless'.

The leather pouches hanging from thongs around this woman's neck are amulets containing objects such as the beak of a maribou stork and hairs from a hyena or elephant tail, believed to have magical qualities.

OPPOSITE

1,5 The bronze finger rings with a dance mask design come from the Bobo people of Upper Volta. These rings could hold the same properties as the wooden dance mask worn to promote an animal's fertility and protect hunted species. (9cm, and 5.5cm)

2 This bronze ring from the Bobo of Upper Volta, displaying a bush cow head, is modelled on the design of a woman's anklet. Women of the Bobo and Senufo tribes wore anklets in this style to protect themselves from bush spirits; the ring was thought to possess the same properties. (5cm)

3 A Bobo bronze ring showing a tick bird. This bird, often represented in bronze ornaments, is valued for its symbiotic relationship with bush cows and buffaloes: the tick bird removes insects from the animal's skin, providing nourishment for itself while ridding the animal of irritating parasites. (6cm)

4 This bronze ring of geometric design was probably worn by the Bobo people. (5cm)

6 This Dogon ring shows a warrior mounted on a horse, the incised disc representing his shield. Such a ring was given by the Hogon to the military chieftain to wear during his ritual prayers. For the neighbouring Mossi this type of ring symbolized chieftainship, power and wealth; for the Senufo it was associated with divination. (6cm)

7 Dogon ring with a warrior on horseback. Sometimes the rider was an ancestor figure, worn to impart spiritual power. If the rider was female, the ring had yet another significance: as a gift from the Hogon to a man who had only daughters and wanted a son. The man would wear it on the little finger of his right hand until a son was born. The Hogon would then be presented with small gifts and the ring returned to him. (8.5cm)

8 A Bobo ring featuring a cow's head, on which sits a tick bird. (5cm)

9 This Dogon ring with a frog-like creature poised on top of a water lily is particularly impressive both in size and design. (15cm)

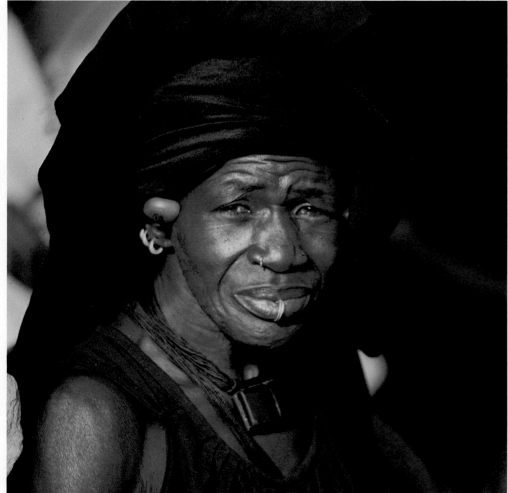

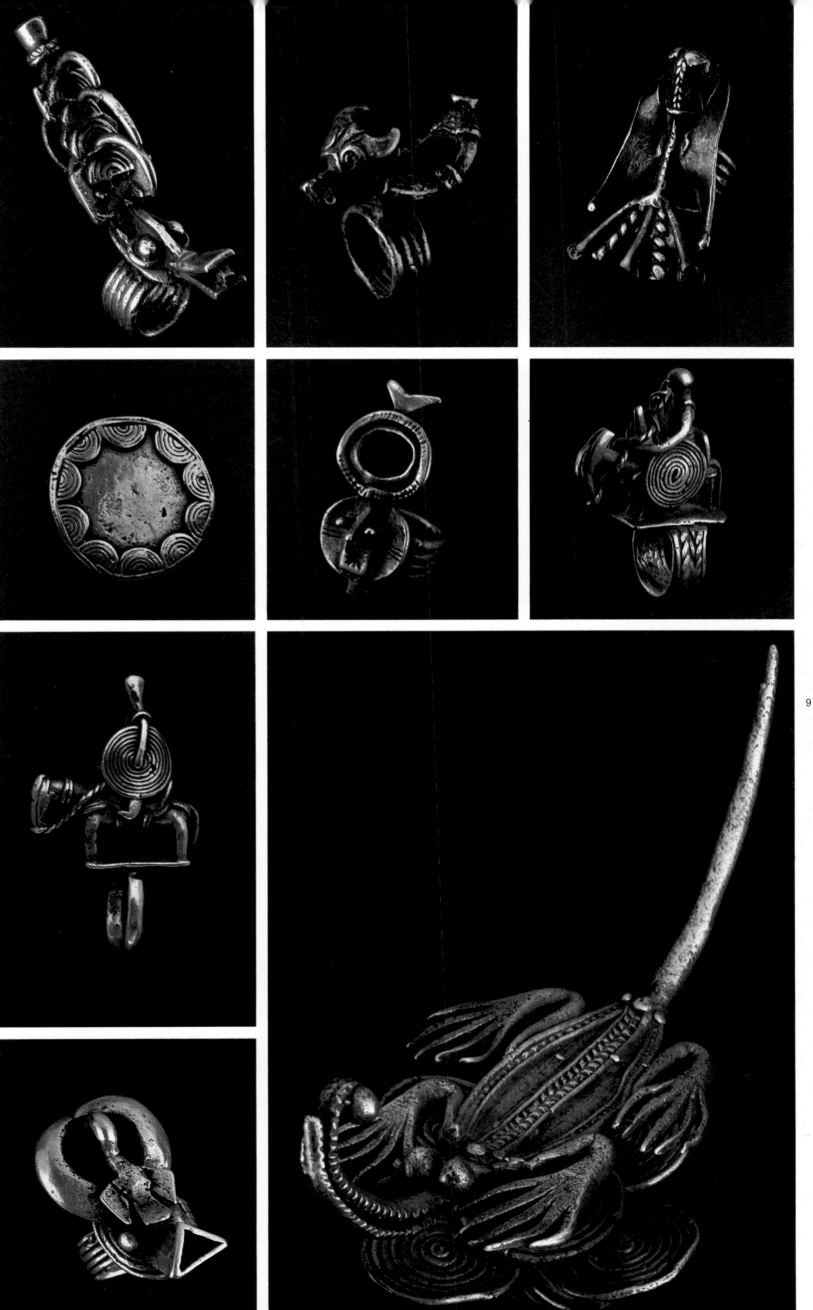

1, 2, 3

4, 5, 6

7

8

9

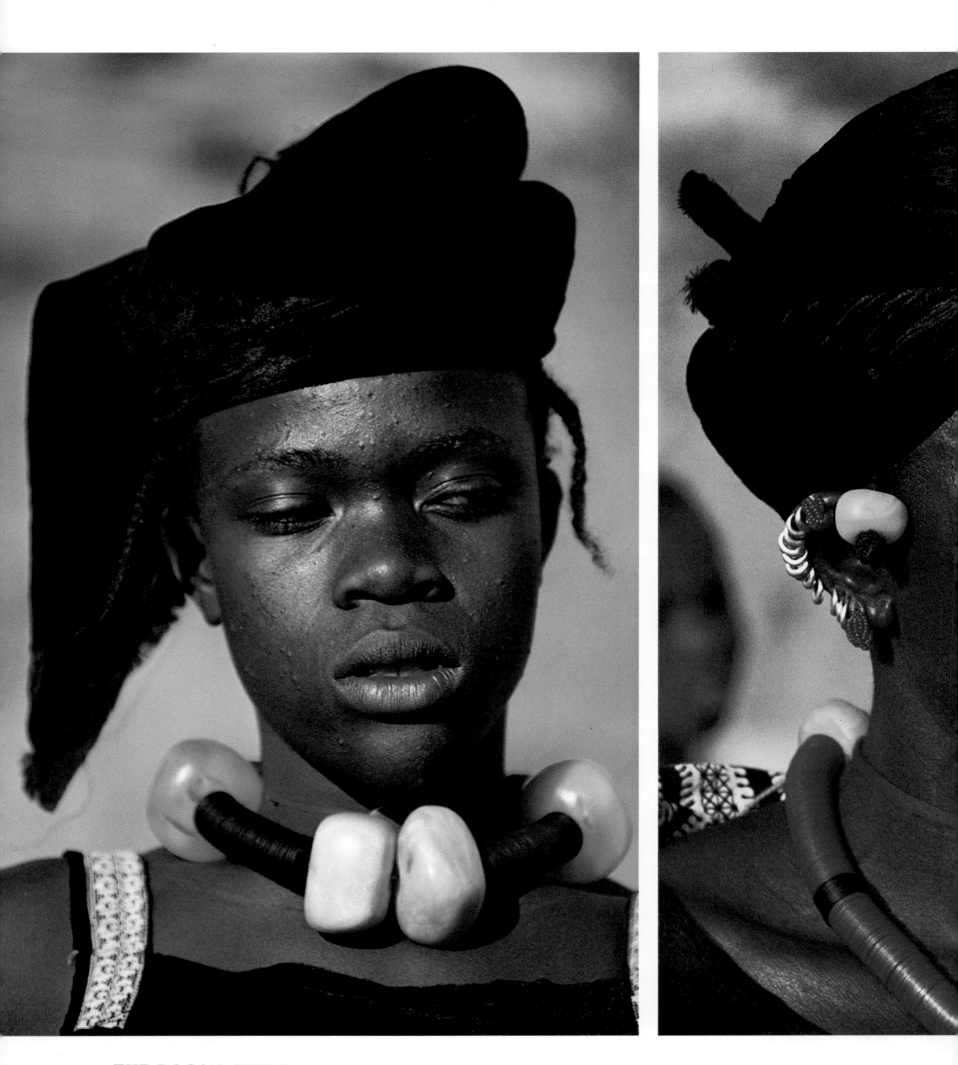

THE DOGON STYLE

Traditional ornaments worn by Dogon women are thought to recall the appearance of the Nommo, the celestial twins. The necklace represents the wrinkles of their necks while red beads and the red cord worn round the neck symbolize the redness of their eyes and forked tongues. The ear is bisexual in both man and woman; the red beads (*centre*) on the rim of the ear represent the testicles and the inner ear is the clitoris. Traditionally the eight rings were worn on the rim of the ear and stood for the eight Dogon ancestors. Today, amber is valued for its decorative qualities and found in necklaces, bracelets and pendants. It has also become an important form of investment. The black discs threaded with amber beads are slithers of coconut shell; the red beads of similar design are a synthetic substitute. Black velvet headscarves have begun to replace the indigo ones traditionally woven and dyed in the Dogon villages.

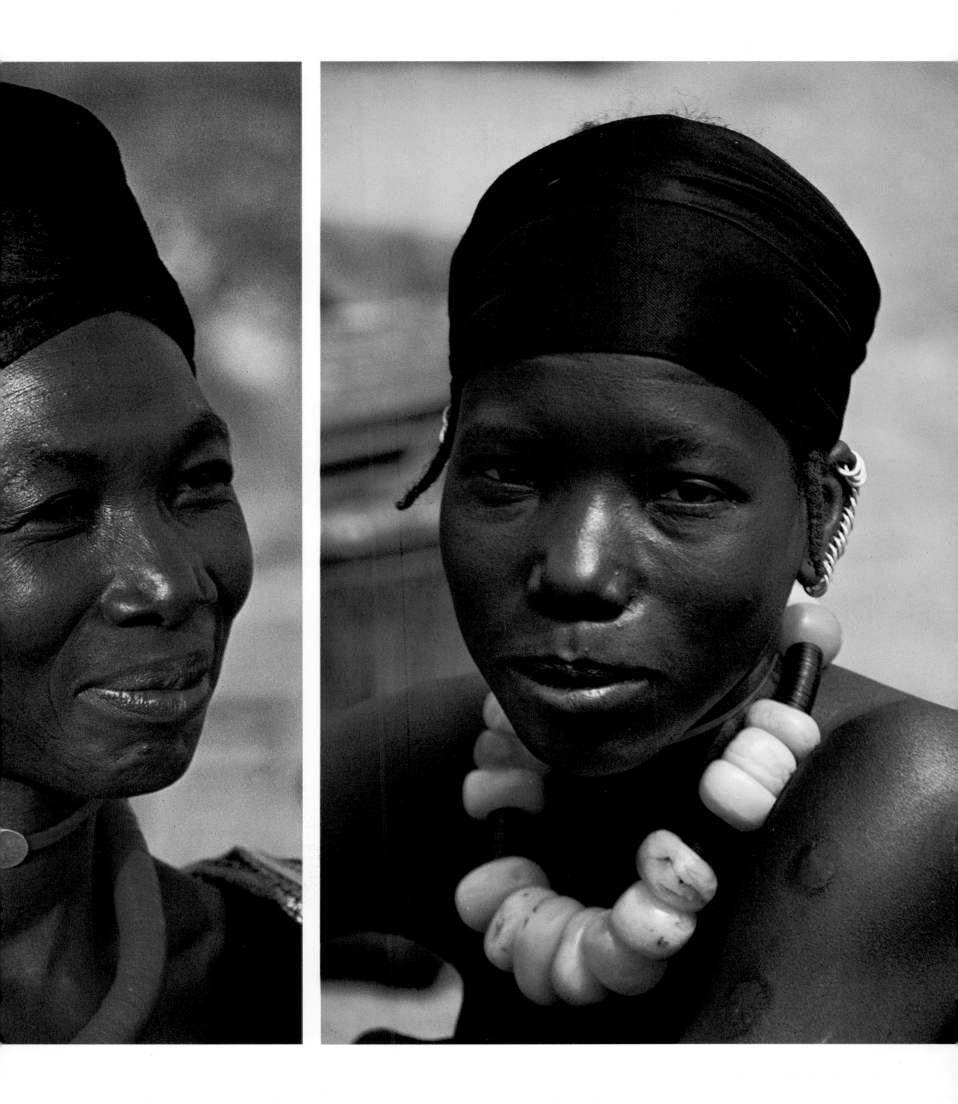

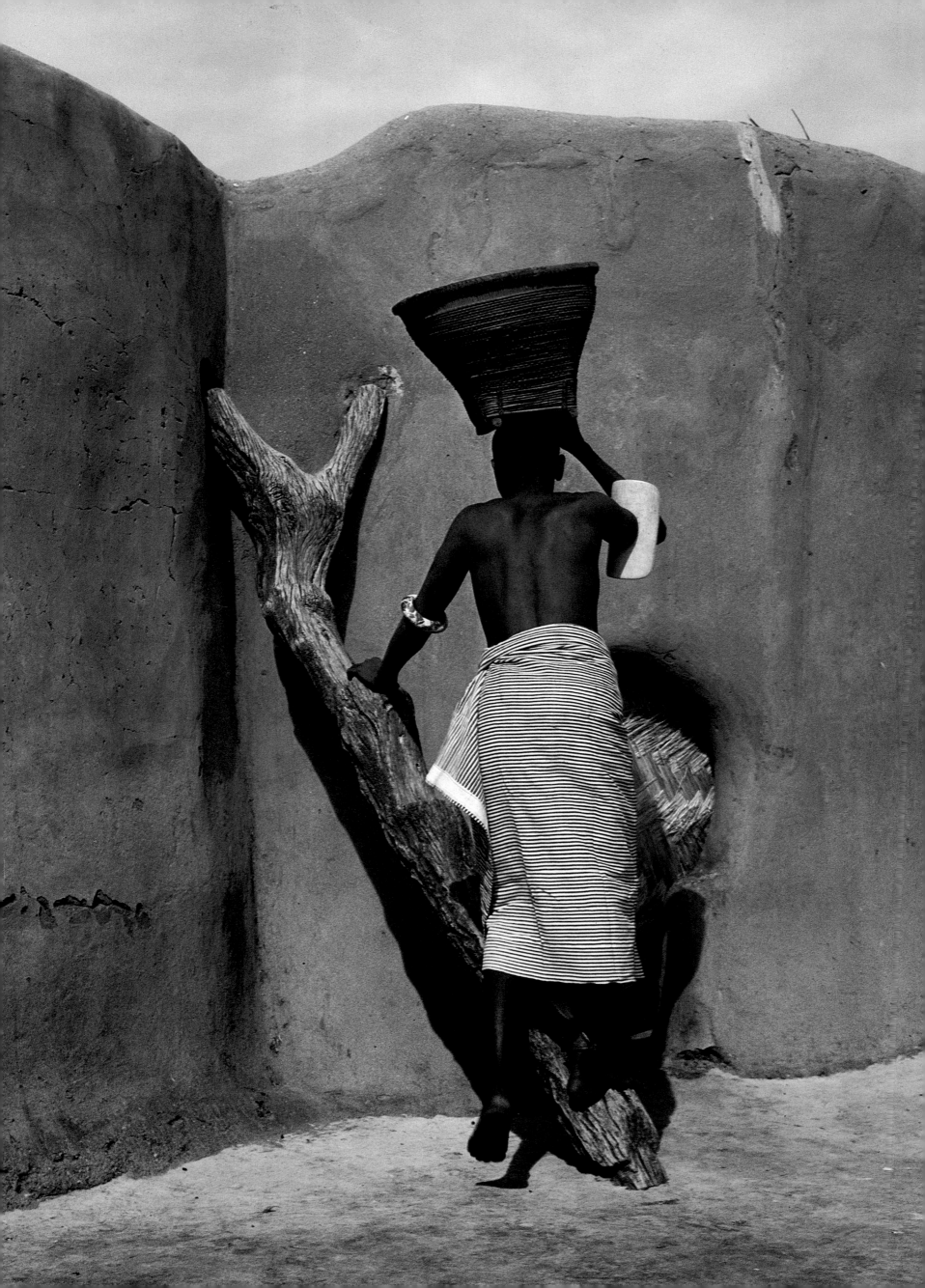

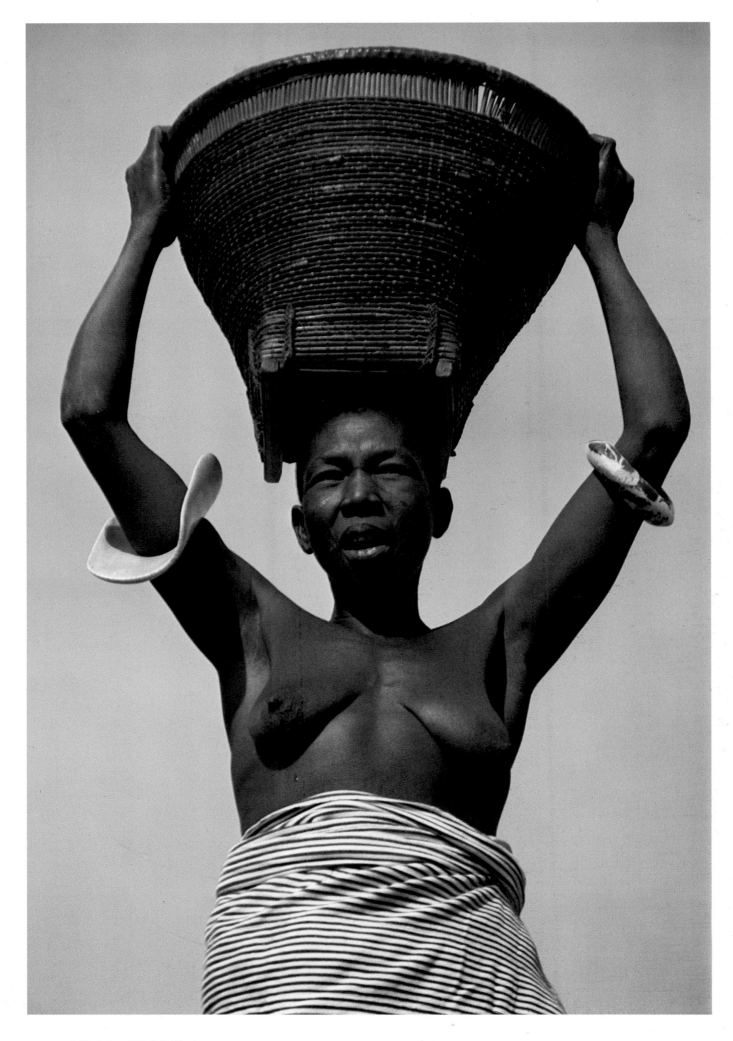

KASENA IVORY

A Kasena woman from northern Ghana takes a basket of millet grain to the flat roof of her mud-walled compound where she will spread it out to dry. The ladder she climbs is a tree trunk with notches to serve as footholds. Her brass anklet, *nadung*, is made locally by lost wax casting, and is similar to those worn by Kapsiki women in northern Cameroun. She wears two armlets, one of ivory and one of marble. *Gungulu*, the ivory armlet, is cut longitudinally from the tusk of an elephant, hence its curved form and considerable size. Such armlets are a sign of prosperity and are sometimes worn as a means of identification with one's dead father, or as protection from troublesome bush spirits.

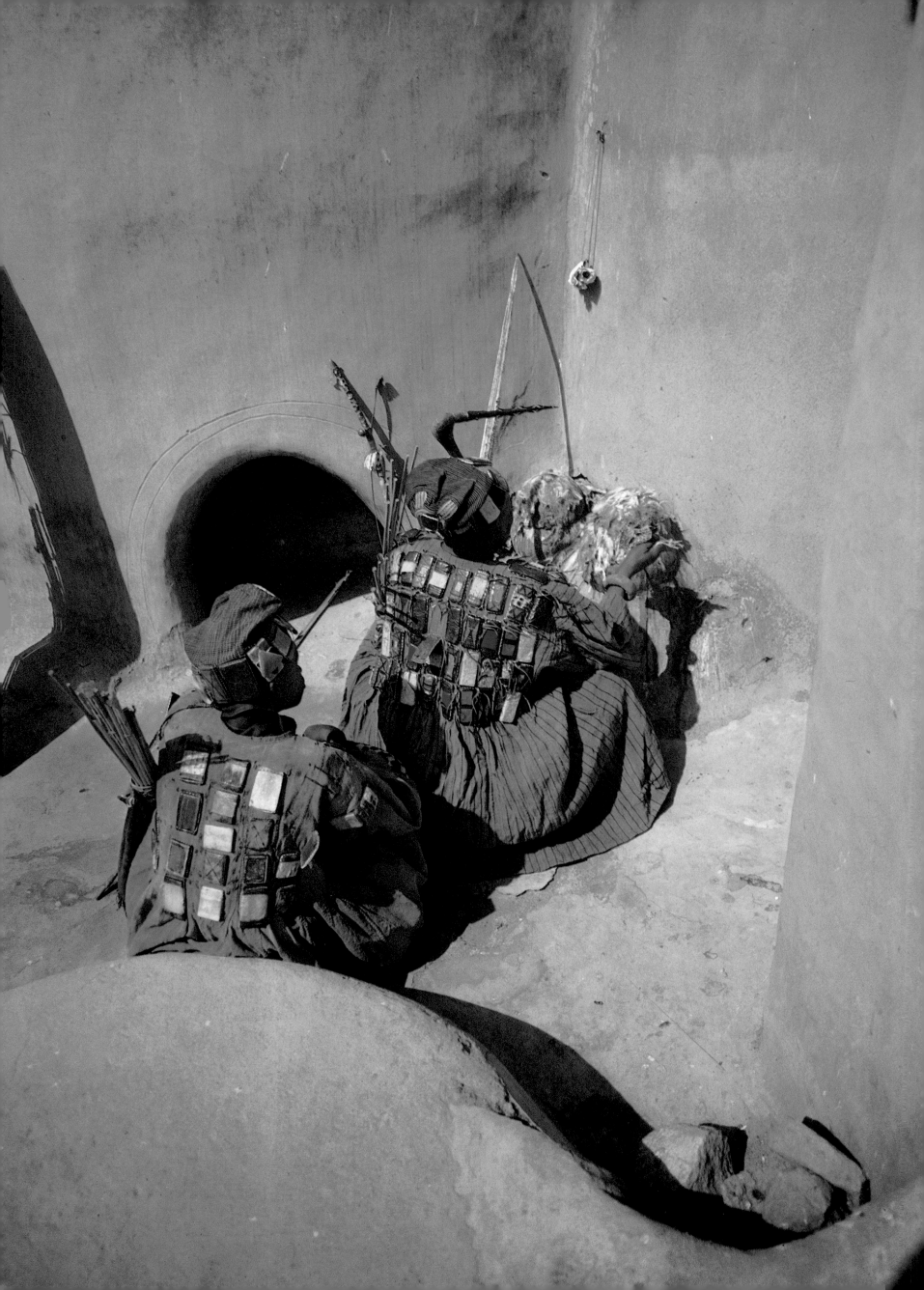

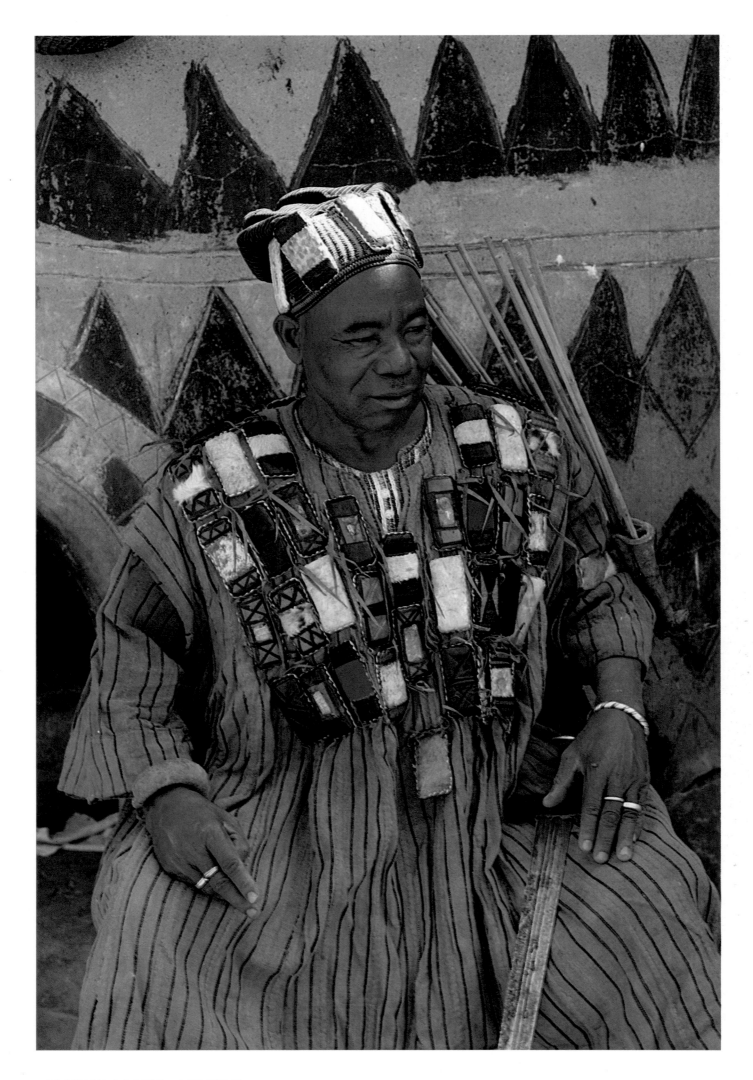

TALISMANIC ATTIRE

In several West African tribes woven shirts, *batakari*, and hats covered with leather talismans are worn by chiefs, and by other men during war or hunting expeditions. The talismans contain verses from the Koran; Thomas Bowdich, travelling among the Asante in the nineteenth century, records that men dressed in *batakari* shirts were prepared to let the British fire at them, so confident were they of their protective powers. Kasena hunters (*left*) in traditional hunting attire – the *batakari* shirt and amulet hat – are equipped only with bow and arrow and leather-padded wrist protectors. Before leaving the family compound they sacrifice a chicken to bring good luck and protection during their hunt in the forest for elephants, buffalo and antelope. Chief Atoge Zangwio (*above*) a respected Kasena village chief, photographed in the *batakari* worn for his installation and other important ceremonies, particularly the funerals of other chiefs.

ANCESTOR IMAGERY

BELOW Wearing jewellery in the image of the ancestors is considered to elicit their power and protection and to aid communication between living and dead. The bronze anklet (1) with four ancestor heads comes from the Mossi or their neighbours, the Gurunsi or Bobo in Upper Volta. In the eighteenth century bronze was rare in this part of Africa, and often more highly valued than gold. (22cm)

The pendants beneath are from the Lobi. The figure (2) is of bronze; the figure (3) is a rare piece carved in wood. (10.5cm, and 9cm)

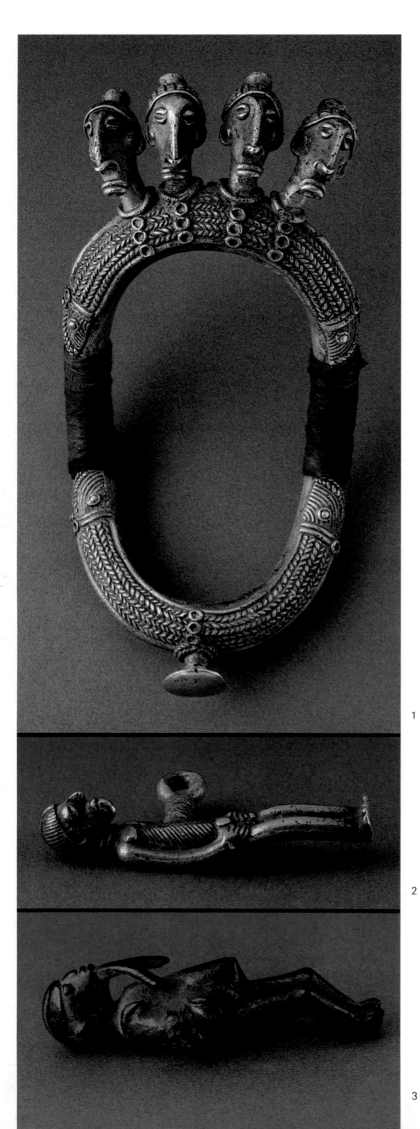

1

2

3

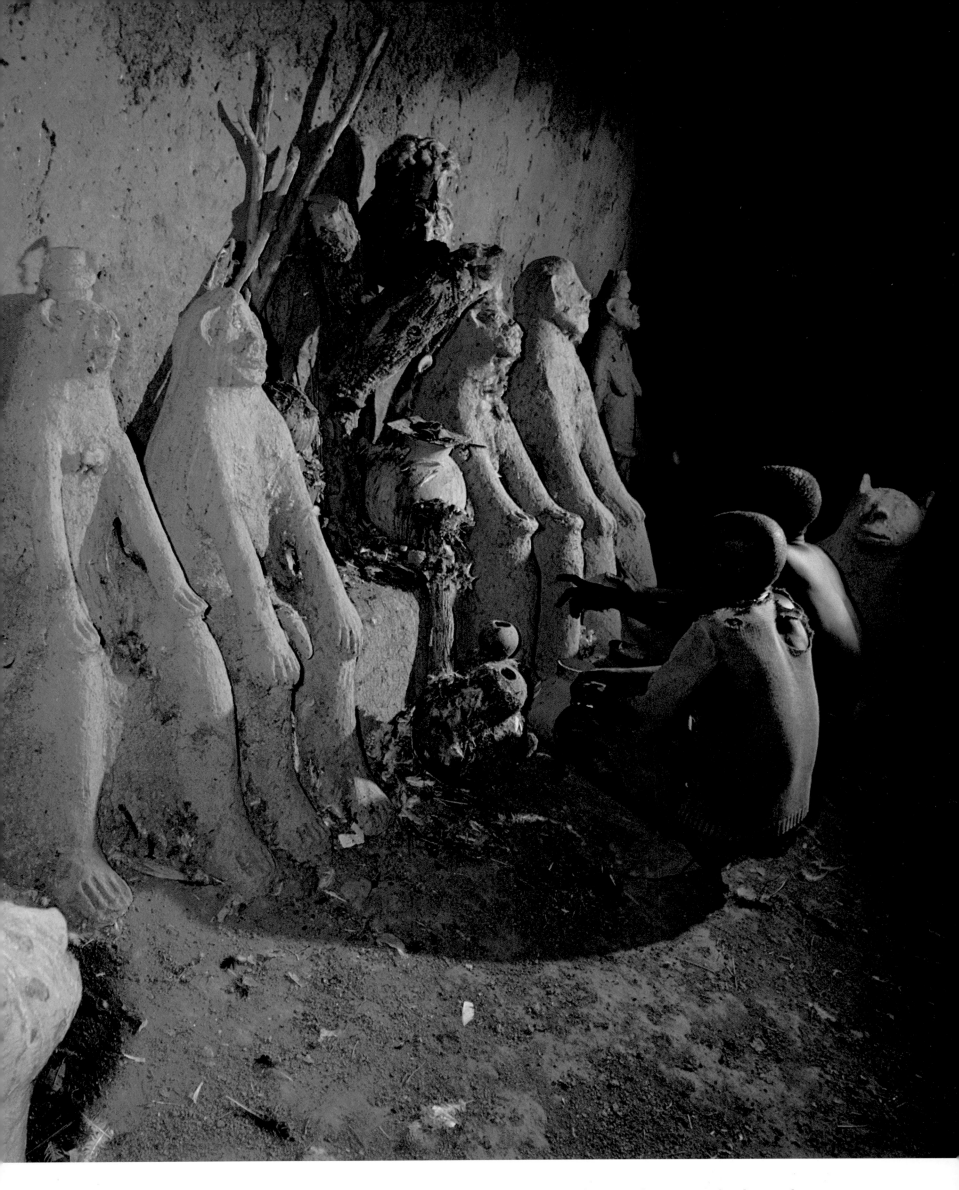

Private altar in a Lobi family compound, Upper Volta, with pairs of ancestral figures moulded in local clay, flanked by two attendant cats. Chickens and small animals are sacrificed to pacify the vital forces when, for instance, trees fall or animals are accidentally slain. As the sacrifices are made it becomes possible to speak with the ancestors, who pass on the family's requests to the gods. When a family member dies, pairs of ancestor figures are sculpted in wood to ensure protection. The head of the family attends the altar; he is the only one authorized to make sacrifices. It is taboo to take money or any metal objects into the chamber; these must be deposited along with shoes outside the door.

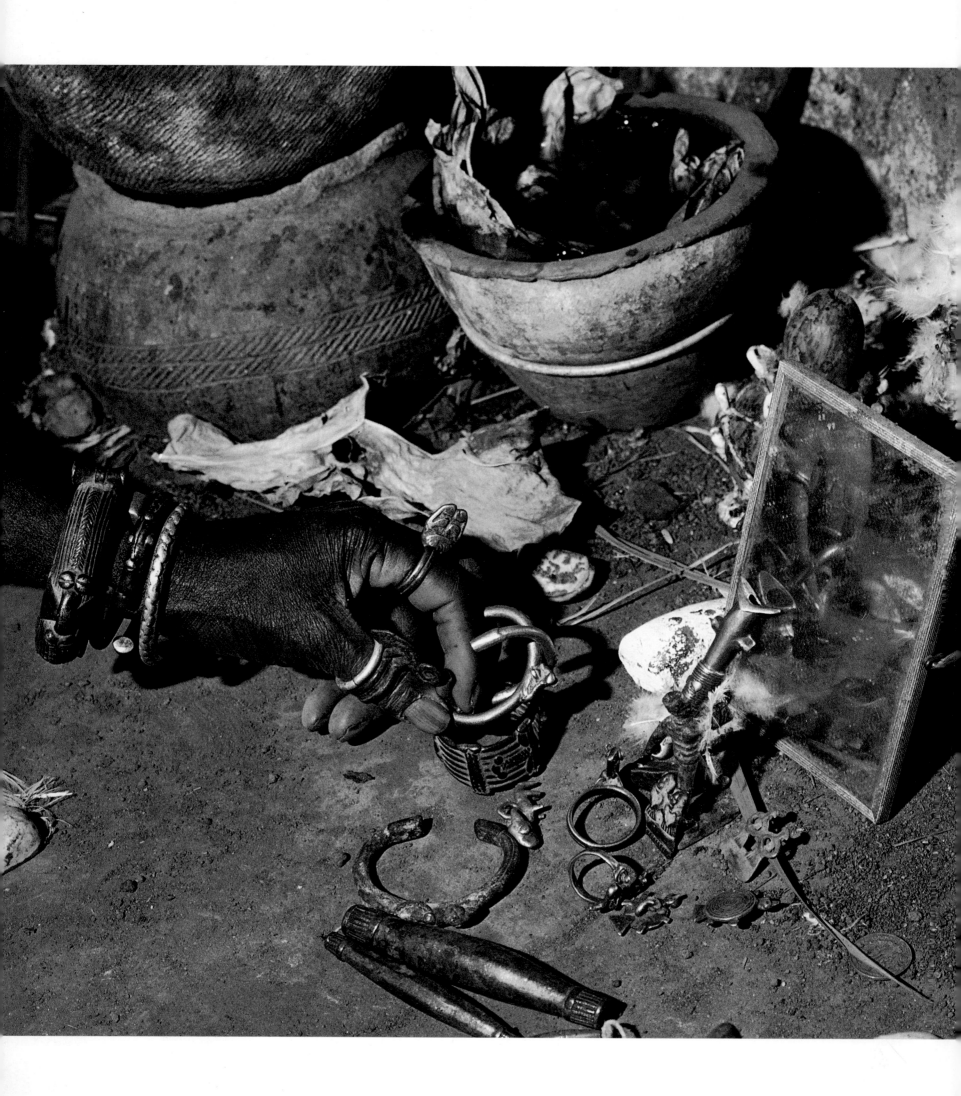

126

SOOTHSAYER BRONZES

LEFT AND ABOVE RIGHT A Senufo diviner, Ivory Coast, at work. A mirror stands in front of a small sacrificial altar covered in chicken blood and feathers. Beside it is a clay pot full of tree sap, water and leaves for the devil to bathe in, and other pots containing sacrificed chickens. A pair of small ancestor figures in front of the mirror help and advise the soothsayer. He wears a bracelet decorated with a stylized python – believed to be both messenger and medium between diviners and the spirits. The woman's anklet (lying near his leg) is used as part of his ritual paraphernalia. In his hands is a turtle shell filled with a collection of cowrie shells, seeds and small bronze figurines which he will throw on the ground. By the way in which they fall he will interpret his client's problems and, after consultation with the spirits, will be able to advise the necessary action.

According to his advice, the client will wear specific bronze rings, pendants or amulets. Those pieces depicting ancestor figures, usually a pair, are worn to obtain forgiveness and protection. Single figures are less common and usually represent spirits that haunt the forest. The four-figure pendant is especially rare. (centre 7cm, bottom left 4.5cm, bottom right 4.5cm)

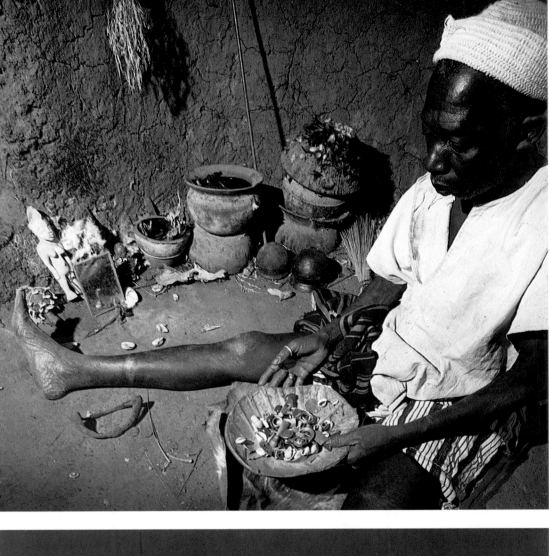

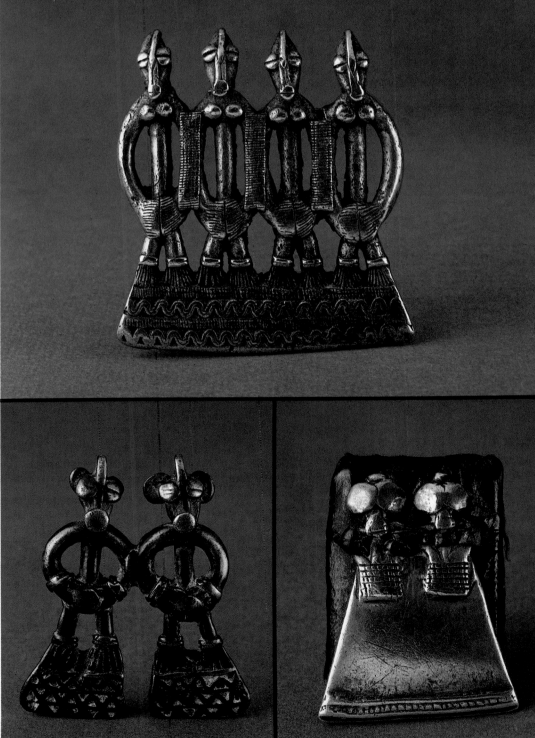

127

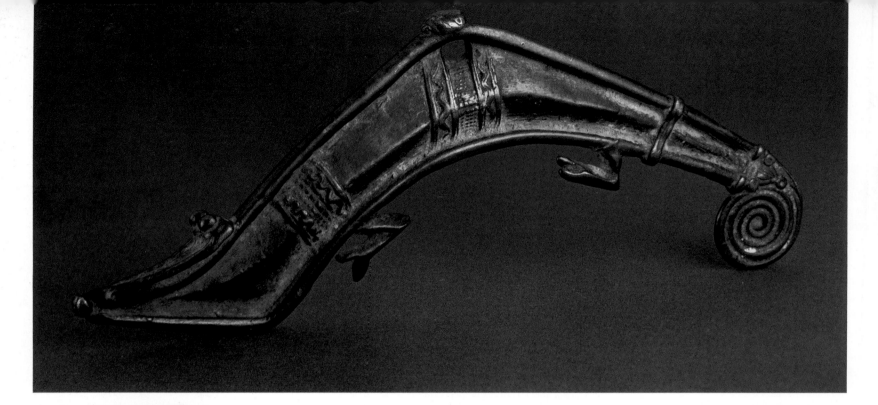

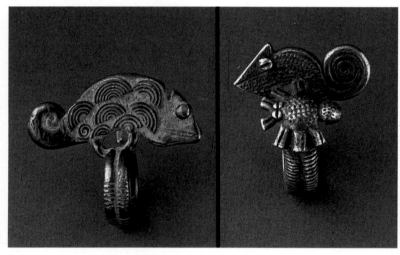

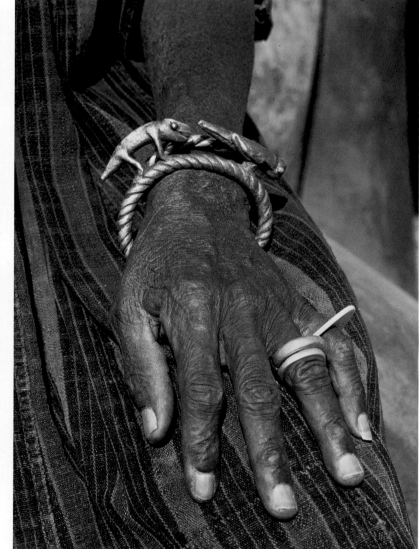

REPTILES AND INSECTS

Animals as well as humans are portrayed on jewellery; for the Senufo these are usually the chameleon, snake, turtle, crocodile and ground hornbill – according to Senufo mythology, the first five beings created. In this part of Africa, the chameleon is second only to the python as the most common motif in personal jewellery. The chameleon pendant (*top*) of Gurunsi or Lobi origin is a fine example of bronze casting, of significant age and individuality. Gurunsi, Lobi and Bobo jewellery is similar in theme to that of the Senufo but often more stylized. (19.5cm)

CENTRE Among the Lobi, chameleon rings are worn only by men; the one on the right also depicts a spider. (6cm and 4cm)

BELOW LEFT Bracelets worn by Lobi women. The iron looped one with a wavy decoration helps the wearer to fight witches; its design is reminiscent of a coiled snake. The bronze bracelet with a pair of mating chameleons is worn as a source of fertility.

BELOW RIGHT The brass bracelet, worn by a Kasena chief, depicts a chameleon and cricket. The cricket is sacred to the Bulsa people, neighbours of the Kasena in northern Ghana, from whom this bracelet probably came.

OPPOSITE A Lobi woman prepares millet stalks for basket-making. Her forehead is covered with white clay and ash which indicates that she is mourning the death of her husband. The Lobi are particularly superstitious and wear a lot of protective jewellery; this woman's lip plug prevents evil spirits from entering her mouth, and her chameleon, snake and bell pendants, and iron leggings with snake motif, are all worn for their protective powers. The bells summon the vigilant spirits of the dead and the cowrie shells promote fertility.

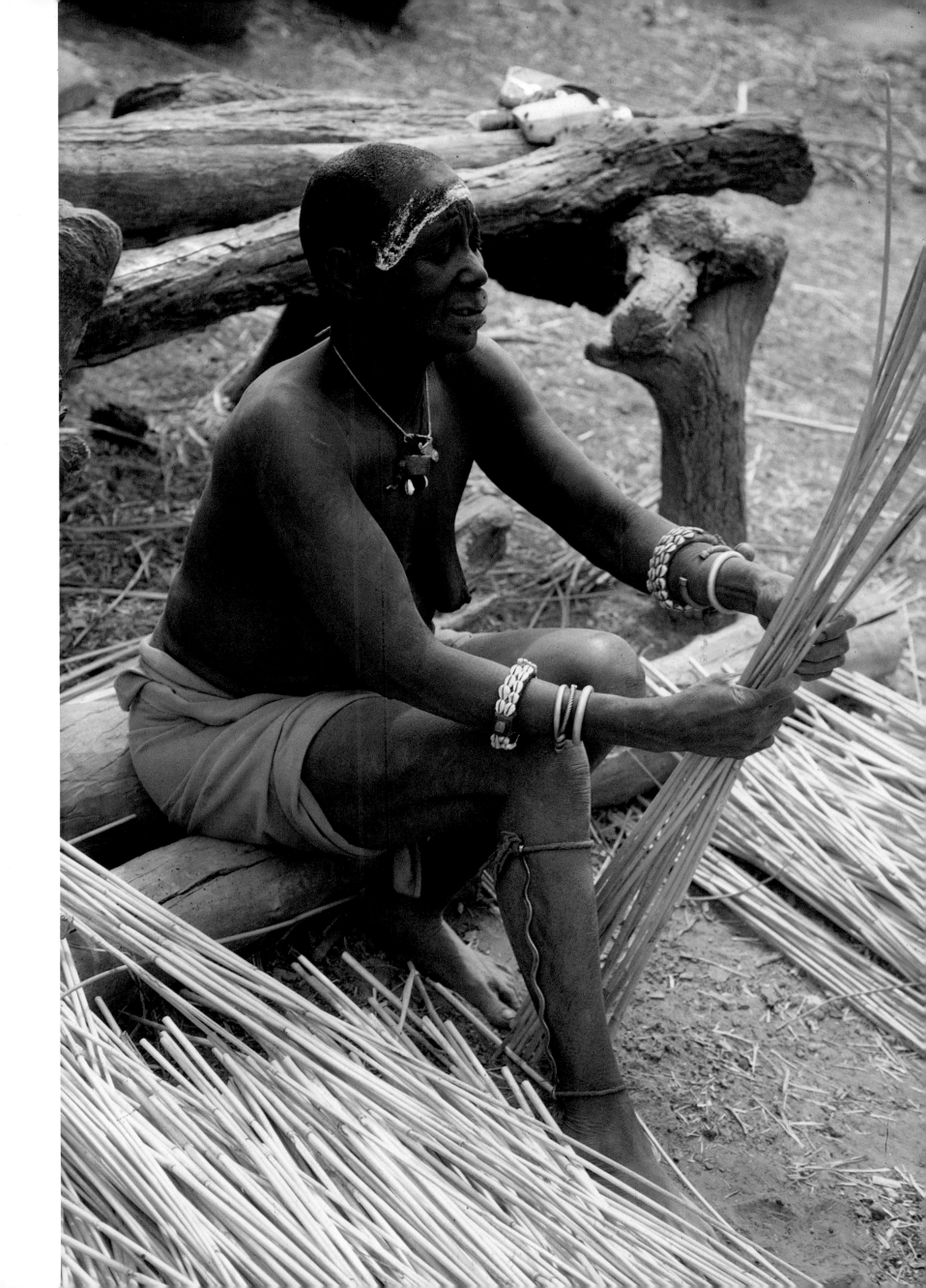

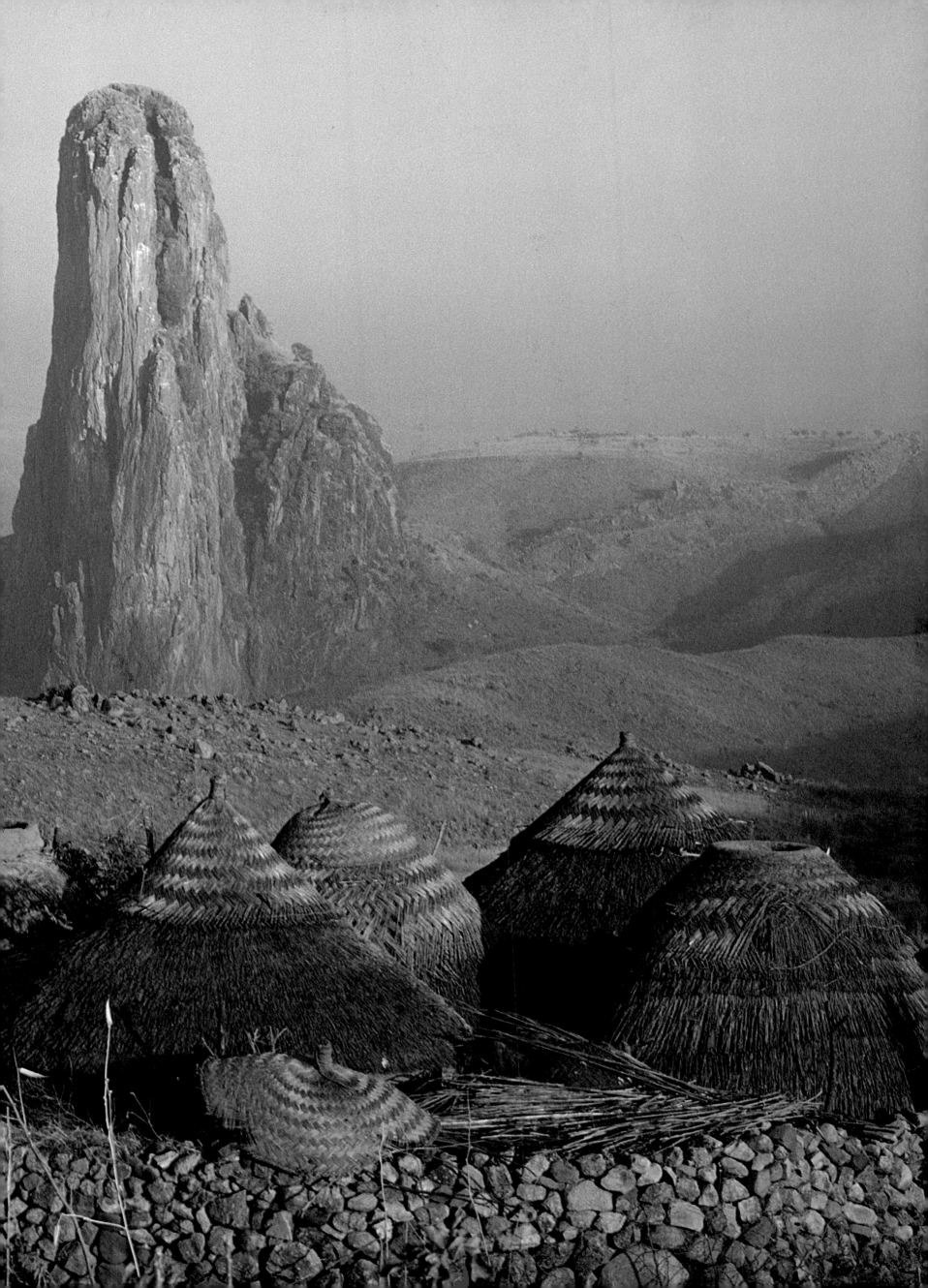

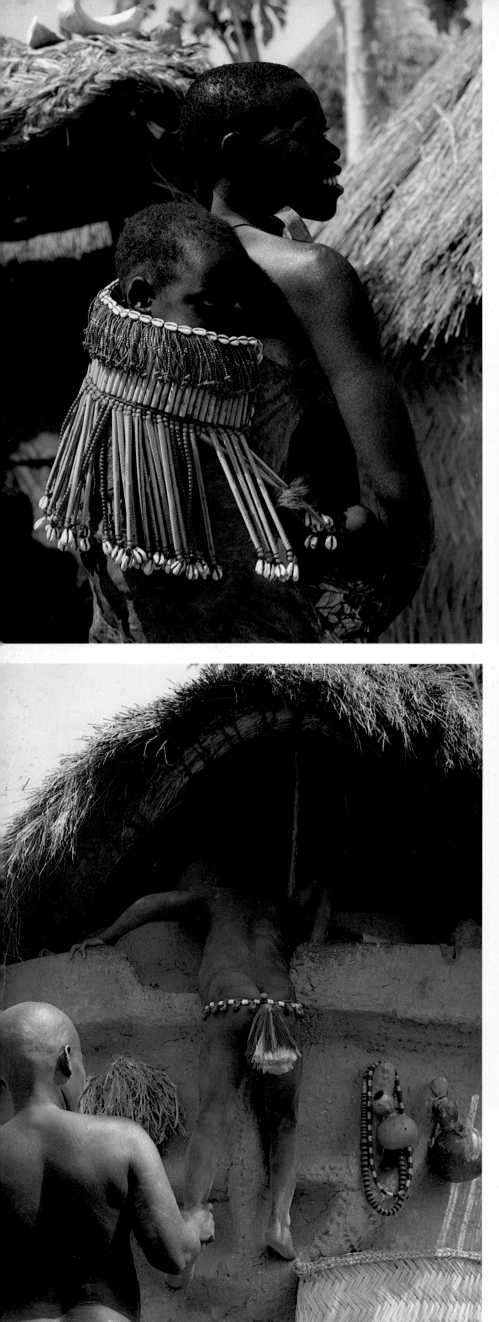

YIELDED FROM THE HARVEST

PREVIOUS PAGE The Kirdi took refuge from Fulani slave traders among the great pinnacles of lava formed by the volcanic chimneys of the Mandara Mountains in northern Cameroun. They built their villages in tight clusters, hugging the mountain slopes, and terraced all the available land for cultivation.

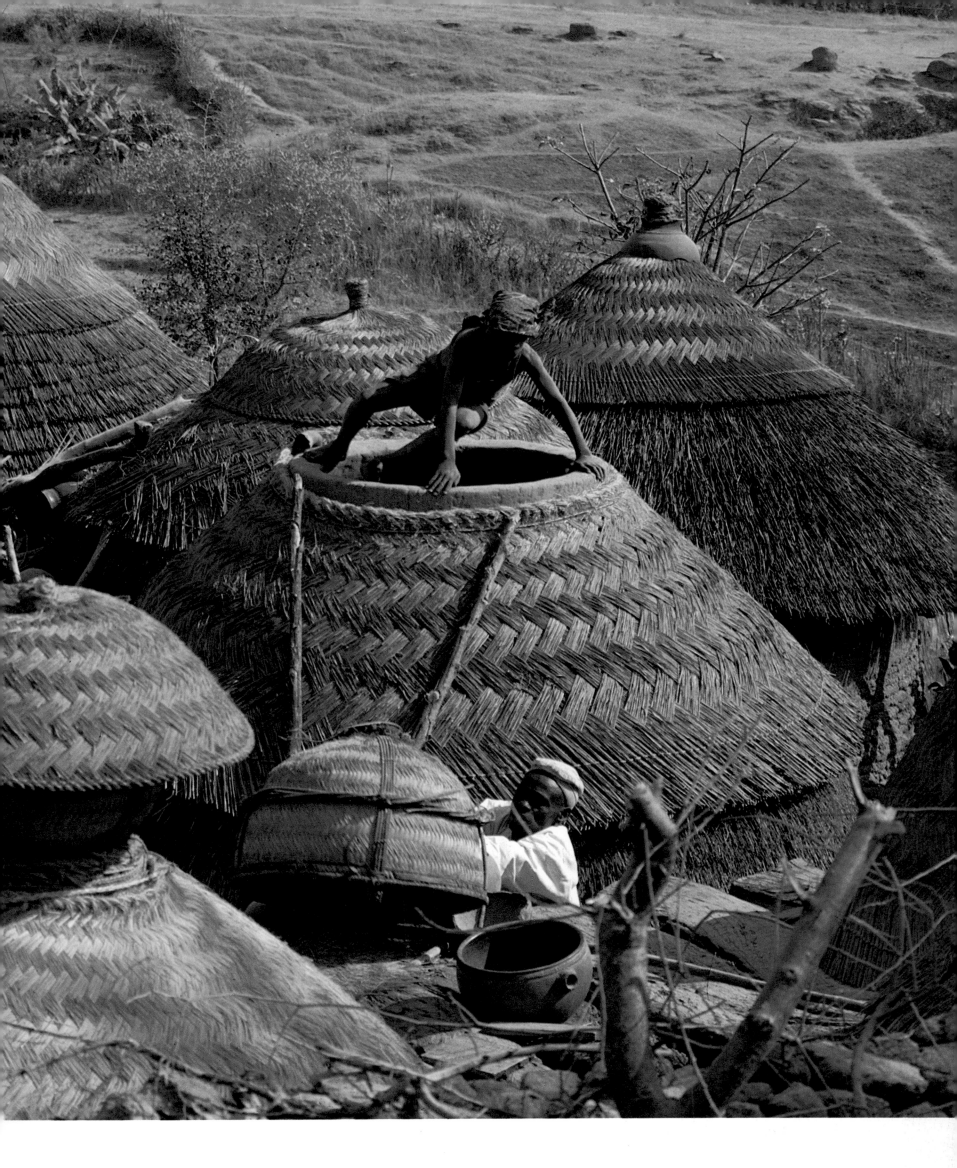

ABOVE Kirdi huts and granaries are thatched with millet stalks, which protect the stone and loam buildings from sun, rain and insects.

Every man has two granaries – and each of his wives one – in which to store millet, peanuts and beans. Millet is the main crop; as well as a food, it is used for making beer, for thatching and for baskets. The Fali, one of the Kirdi tribes living in the Tinquelin Massif to the south, use it to make baby carriers. Children of the Doyaos people, another Kirdi tribe, (*below left*) hang millet together with woollen strands from their beaded belts.

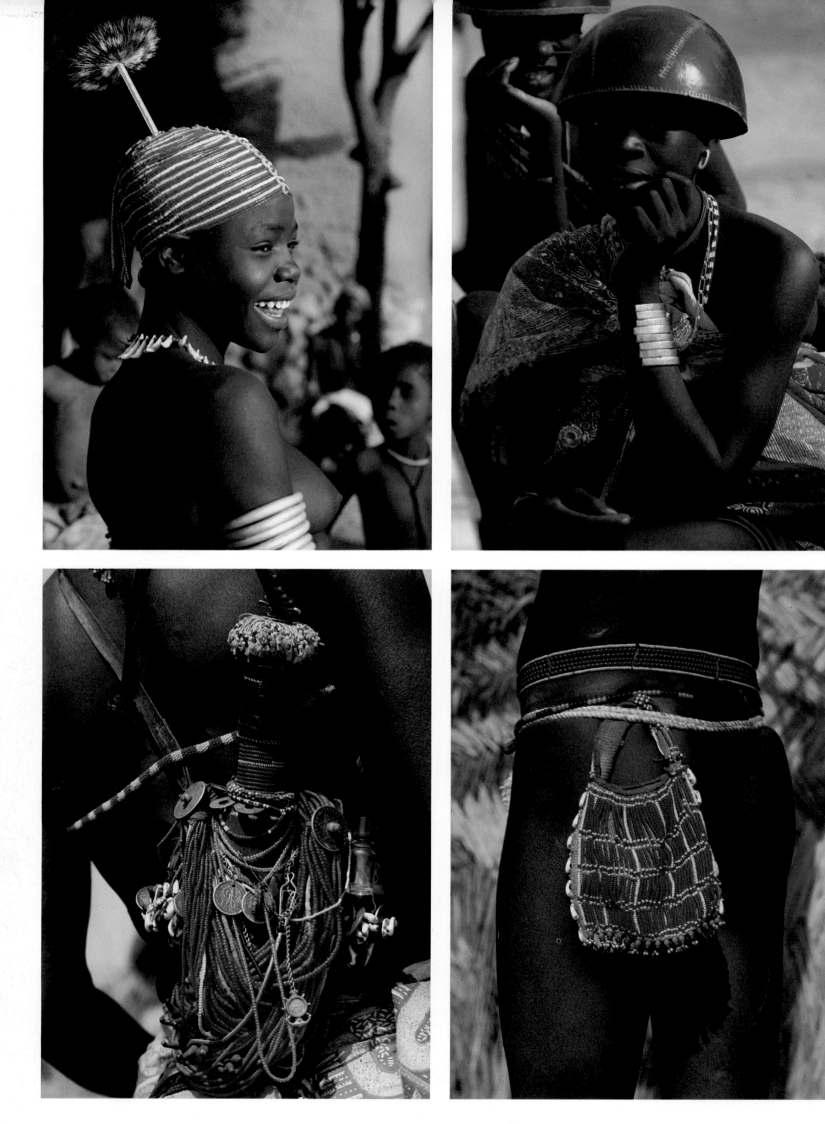

KIRDI VILLAGE STYLES

The various groups of Kirdi cling to their own part of the mountainside, displaying their identity in the differing styles of their houses and ornaments.

OPPOSITE The Podokwo of the Mora Massif celebrate the harvest and pay tribute to their ancestors in a ceremony of feasts and dancing. To emphasize the rhythm of the dance they wear aluminium bracelets and calabash leg rattles filled with seeds.

A dancer (*top left*) wears a beaded skullcap with mongoose fur pompom and a necklace of leopards' teeth. On festive occasions, Mora women (*top right*) wear polished calabash hats and protective aluminium sticks protrude from their noses. A Fali girl (*below left*) wears a betrothal doll, *ham pilu*, given to her by her fiancé, of the same sex as the child he wishes her to bear, whilst the beaded bag (*below right*) is worn by the married Fali woman.

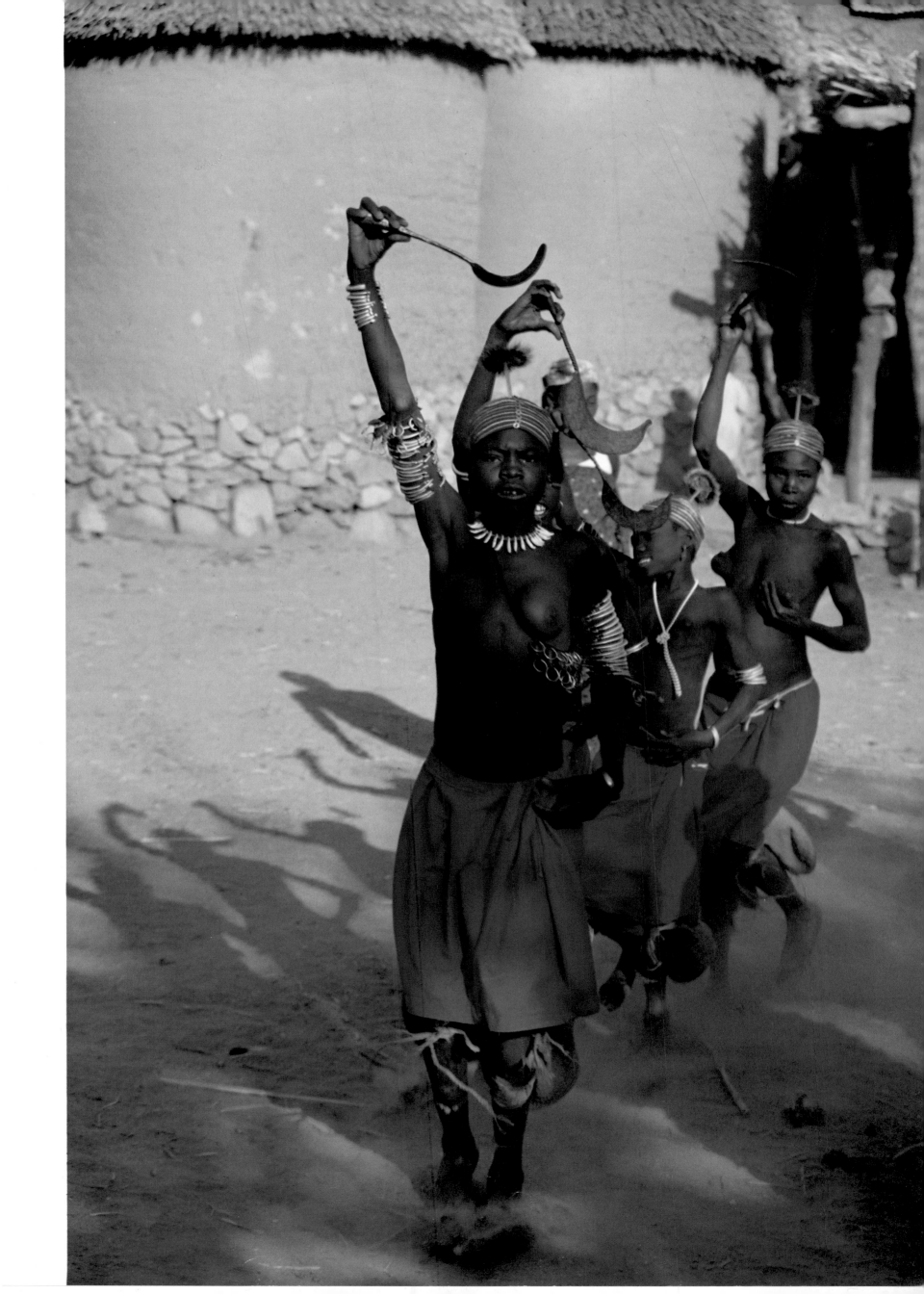

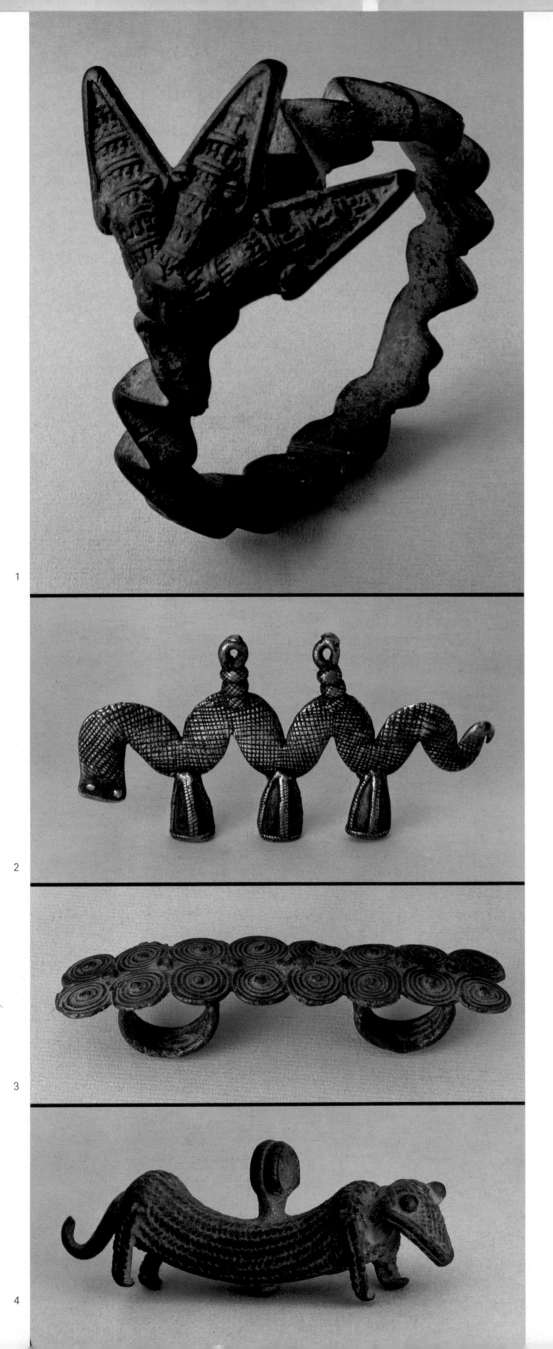

ANIMIST BRONZES

1 This ring with three serpent heads, although designed to be worn on the upper arm, was possibly more often used by the Lobi as an object of ritual than one of adornment. The Lobi casters vied with one another in producing imaginative designs; they mastered the art of casting bronze from the Asante of Ghana, and have produced some of the most accomplished work in Africa. (11cm)

2 This stylized snake pendant was also made by the Lobi. (9cm)

3 This double finger ring, cast by the Bobo or Dogon, bears a design of four waterlilies. The waterlily is one of the few flowers seen in Dogon country, for away from small waterholes and streams the land is too dry to support much vegetation. (12cm)

4 The pendant portraying a leopard was worn by the Lobi, who used to hunt this animal in the forests. (10cm)

5 A bronze pendant in the stylized shape of a pregnant woman. This type of pendant was worn round the neck by the Abron, an Akan-speaking group living north of the Baoule in the Ivory Coast. (9.5cm)

6 This Bobo bronze bracelet may originally have been intended as a weapon. Among its fierce spikes it features a stylized antelope's head. (14.5cm)

7 The two figures with coiffured heads on this bracelet may be ancestors. The piece probably comes from the Mossi or Gurunsi people from Upper Volta. (11.5cm)

8 The bush cow was believed to bestow on members of the Nookanga, the Senufo healers' society, knowledge of the trees used in herbal medicine, thus enabling them to become skilled healers. This ring is the insignia of members of the society; it is worn on the second finger during the healing process, but otherwise is carried in a genet string bag at the waist. On certain occasions such as the funeral of a member of the society, it is held between the teeth by initiates to seal their lips. These rings are among the finest achievements of the Senufo bronze casters. (15cm)

1

2

3

4

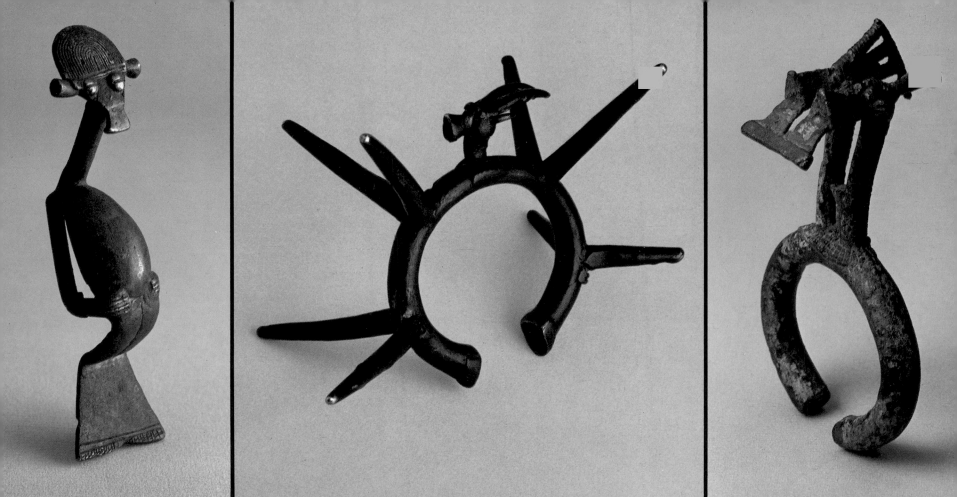

5, 6, 7

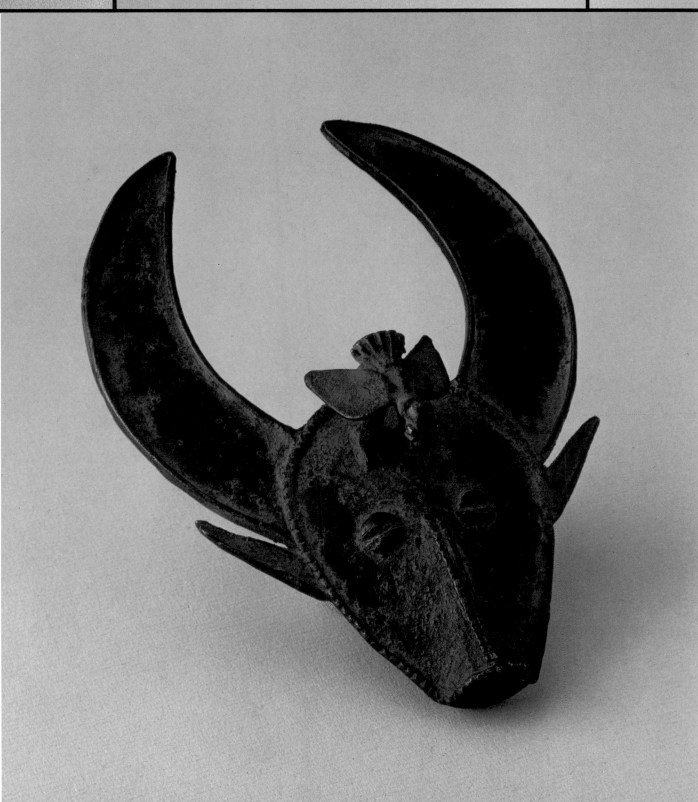

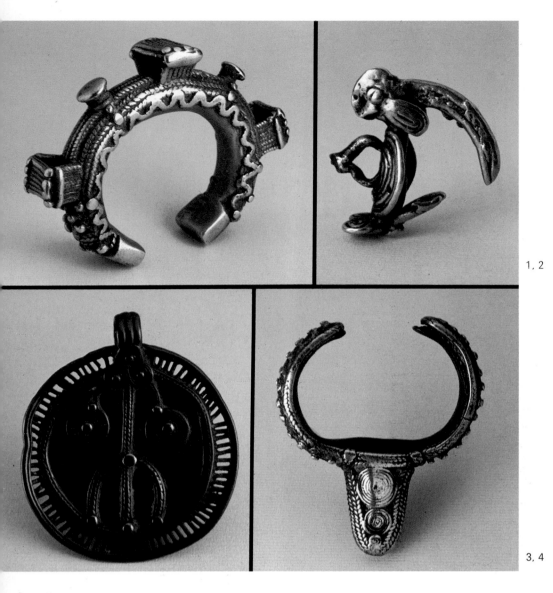

1, 2

3, 4

5, 6, 7

ANIMIST BRONZES *continued*

1 A Dogon bronze bracelet of unusual design with a wavy line symbolizing the python. (11.5cm)

2 This Tusyan bronze pendant represents the African hornbill, a bird which symbolizes the life force and is believed to be the carrier of ancestors' souls. In this region work is interrupted when he flies overhead so that he will not be distracted from finding his way to the final resting place of souls. (4.5cm)

3 A Dogon pendant in bronze portraying an ancestor figure with both breasts and penis, probably depicts the bisexuality of the Nommo ancestral twins (*see p. 109*) and signifies fertility. (7cm)

4 Bronze bracelet cast in the shape of a bush cow's head with remarkably large horns. The bush cow is the most popular animal motif in the jewellery of the Bobo people. (10cm)

5 Bronze spider bracelet probably from the Bobo or Senufo. The spider is of spiritual significance to several of the animist peoples. Some believe that, like the hyena, it has the power to speak and act like a man. They say that if you meet a spider in the bush it can tell you how to become rich; you must then kill it and offer a sacrifice to it in gratitude. (19cm)

6 Bronze bracelet worn on the fighting arm by a Kapsiki of Cameroun marks him as an initiate at the *Rundri* ceremony. (18.5cm)

7 The Tiv of central Nigeria use this type of bronze ring for taking snuff, which is placed on the flat surface at the top and offered to important figures and guests by the elders. (19.5cm)

8 These ivory armlets, *gungulu*, are worn by Gurunsi women in Upper Volta. The Gurunsi make a feature of jewellery repairs which often enhance the design of the piece, like the copper and nail repair seen here. (25cm)

9 Lobi ivory bracelet tied with fibre. (14cm)

10 Ivory jewellery worn by men in Upper Volta: the finger ring (*left*) was probably an indication of status for the Gurunsi, while the pendant (*centre*) is a whistle worn by hunters. The ivory pendant on the right, *thungbubiel*, is worn by esteemed Lobi men at festivals and funerals. Few craftsmen made them and one pendant might have cost an ox and a large number of cowrie shells. (21cm)

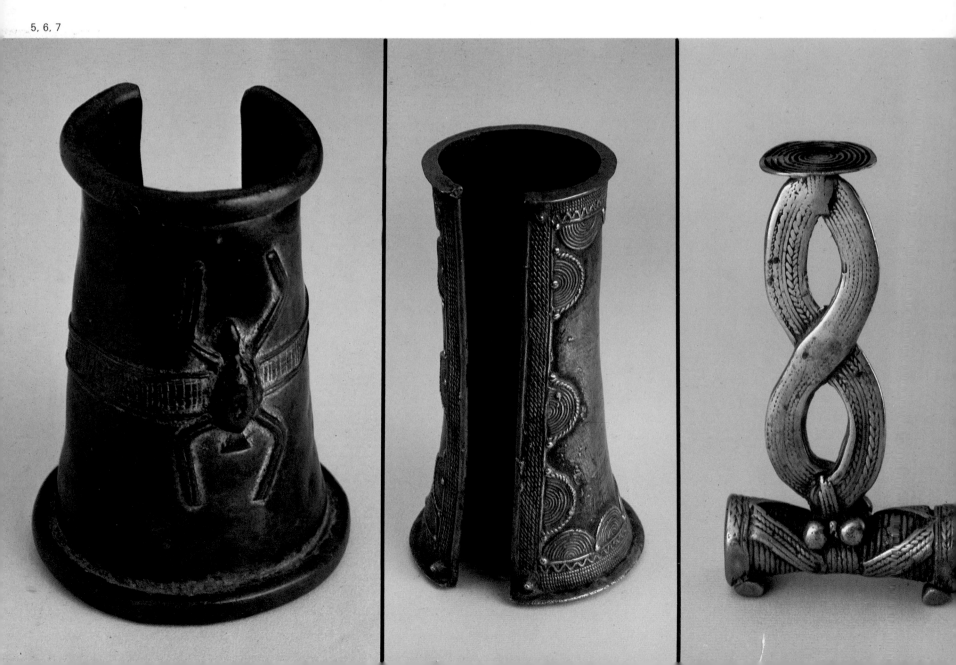

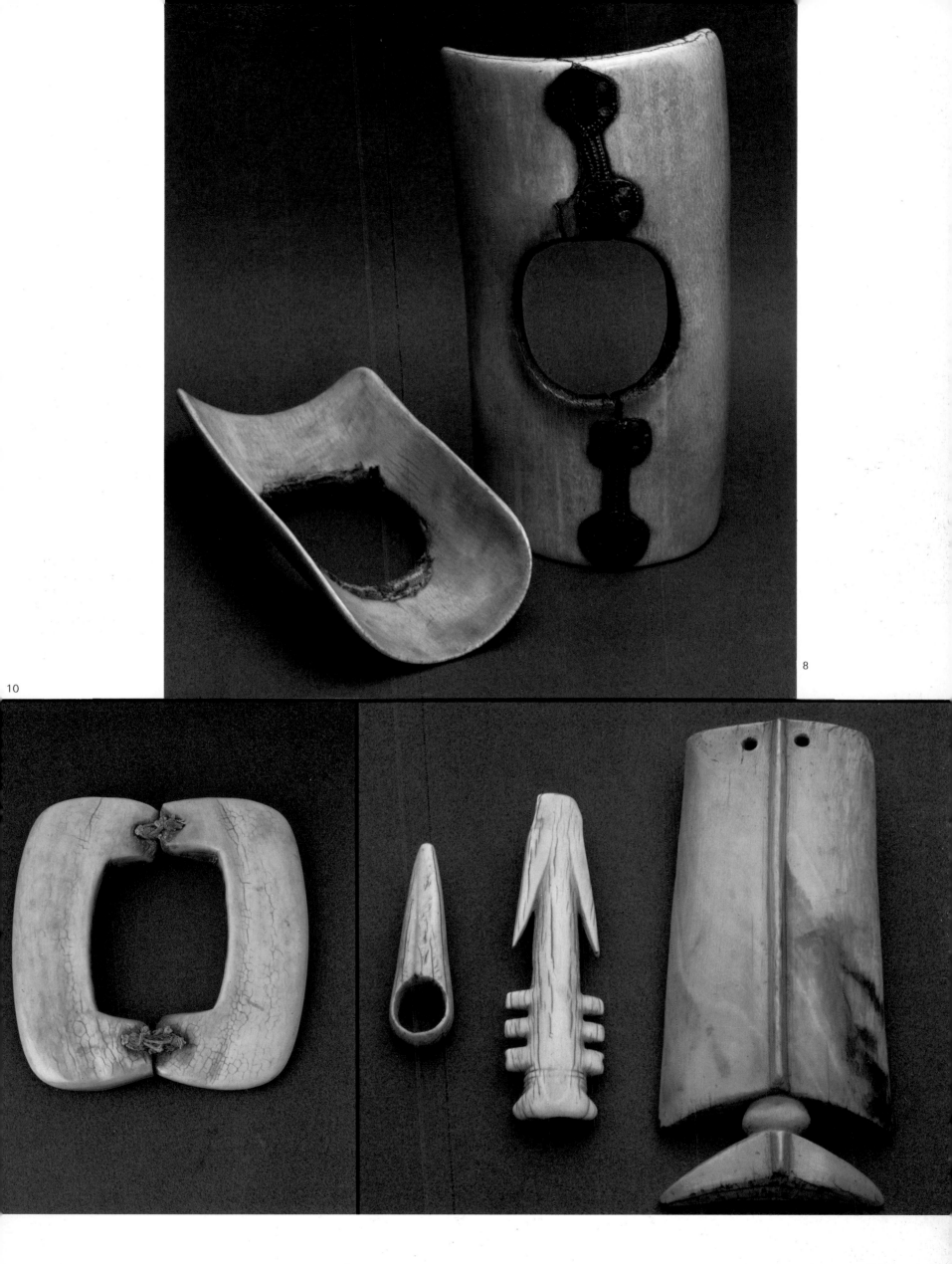

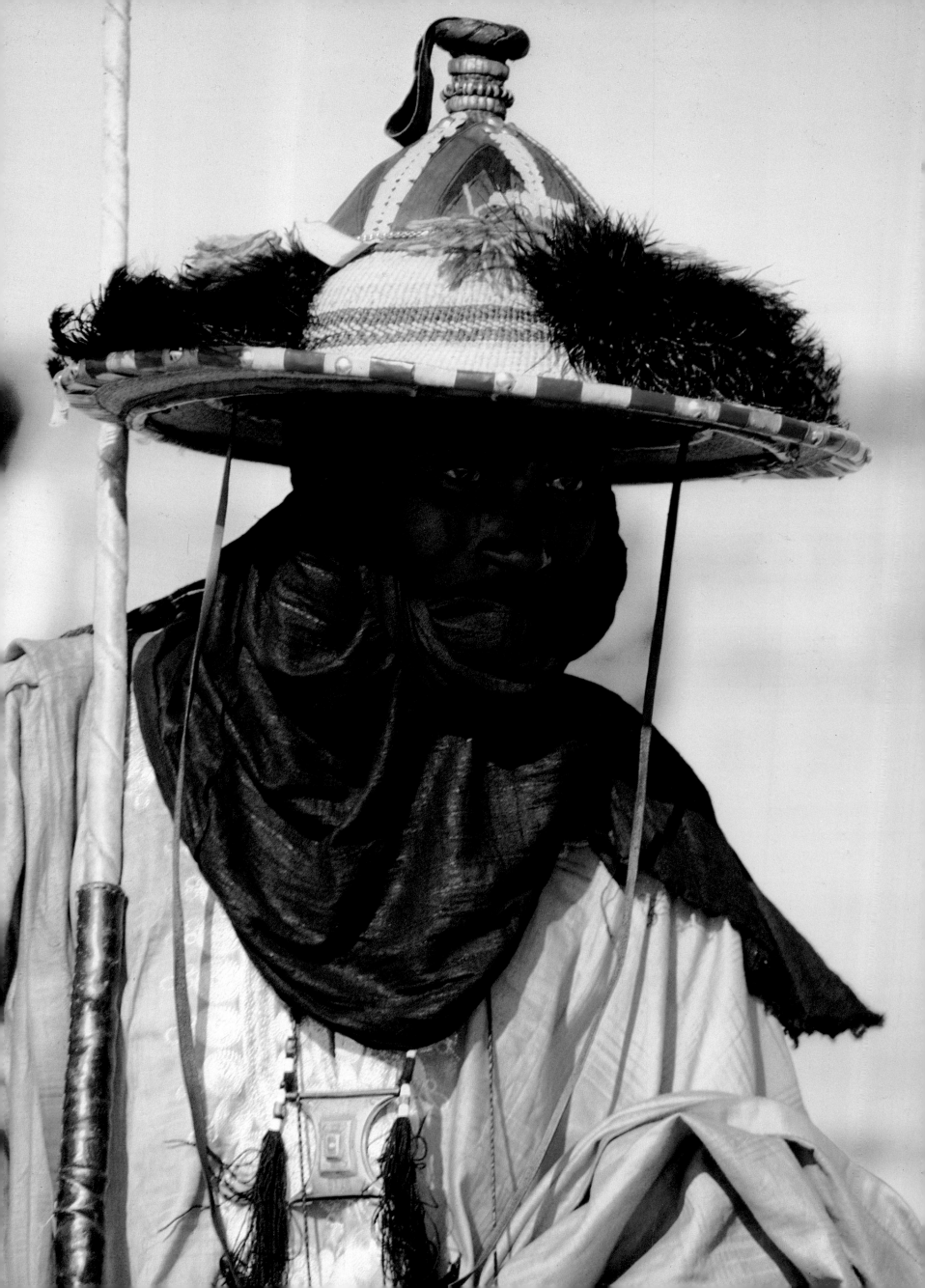

Ibn Batouta's description of Timbuctoo being amply sufficient, I prefer to speak of the women of the city, that is to say, those of its aristocratic families. By reason of continual intermarriage with the Berber and Arab races, their features have become more regular and considerably refined, and the whole face is pleasantly lighted by wonderful eyes, whose gentle, intelligent glance seems to enfold you.

These natural charms are supplemented by the art of coquetry. Their foreheads are charmingly adorned with bands of pearls and sequins, and the most accomplished hair-dressers arrange their tresses in wonderful top-knots interspersed with ornaments of golden filigree. Earrings of the same precious metal dangle from their ears, and necklaces of gold, coral or amber are wound round their throats; they also embellish their nails with henna and darken their eyes with antimony.

Felix Dubois. *Timbuctoo, the Mysterious,* 1897.

THE SAVANNAH

Crossroads of Style

The West African savannah stretches from the Atlantic coast of Senegal to the shores of Lake Chad in central Africa, and separates the Sahara from the equatorial forest belt. This land of bush scrub and grass plains is traditionally the home of farmers, traders and herders who roam with their cattle and other livestock in search of pasture. The vast areas of savannah south of the Sahara demand the utmost in resilience and the will to survive. In times of drought many dispirited nomads are left struggling for a living on the outskirts of towns.

Despite its scarce pastures and infertile land, the savannah boasts a colourful history of wealthy and powerful empires which flourished for more than a thousand years before the arrival of the first Europeans. Moreover, the area lies at the heart of the trade routes that linked North and West Africa, and the constant exchange of ideas and artefacts between travelling merchants and the local peoples is in marked contrast to the isolation of the East African nomads who, until recently, wandered with their cattle relatively undisturbed by the outside world.

In the west of the savannah the era of the great empires began in the eighth century; the Kingdom of Ghana flourished until the thirteenth century when it was superseded by the larger and more powerful Empire of Mali. Gold, mined locally, provided the prosperity with which both empires were sustained; their lavish gilded courts impressed even the most sophisticated of Arab visitors with their pomp and splendour. Timbuktu, an important centre of the Mali Empire, reached its zenith in the fifteenth century, when it became the second largest imperial court in the world and a renowned centre of Islamic learning. It continued to thrive under the subsequent Empire of Songhai, which in turn fell to the Moroccan Berbers, the Tuareg and finally to the Europeans, all equipped with Western firearms. To the east, independent of these empires, flourished the Kanem Bornu civilization near Lake Chad. This Muslim kingdom held sway for a thousand years; until 1800 its fierce cavalrymen, clad in chain mail like medieval knights, terrorized the savannah with their ceaseless religious campaigns.

Fulani nomad, Niger.

The West African savannah, with its colourful history, is also the home of the Fulani, who were all herders until the fifteenth century and gradually moved with their cattle from Senegal to Chad, spreading across the region to acquire new pasturelands. Believed by some to have come originally from the Upper Nile, they are an elegant race with fine bones, fair skin and long hair. They have become the most numerous and widespread people of the region and are known in different areas as Fulani, Fulbe, Fula or Felaata.

On reaching Nigeria some succumbed to the influence of Islam and became fanatical believers, the founders of religious states. A few intermarried with the Hausa, a tall, negroid Muslim race while others spread Islam further west to Mali

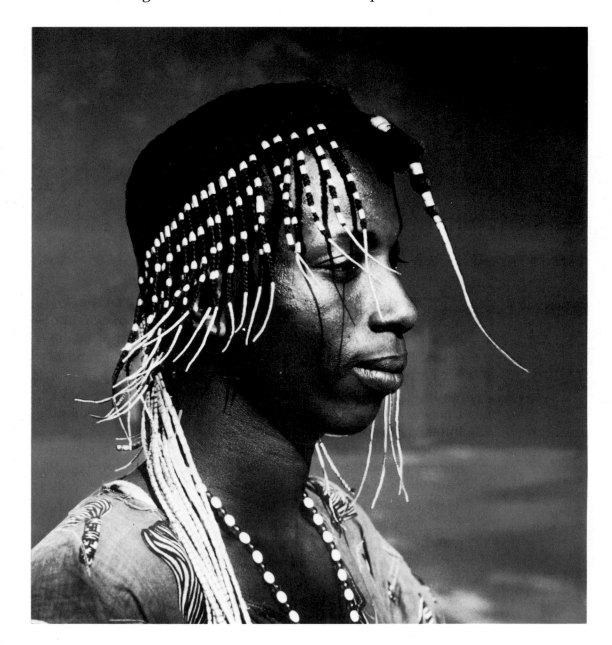

Intricate Wodaabe coiffure, Cameroun.

and Guinea, forming strongholds there and settling down as farmers or traders. Many of these Fulani retained their cattle, but employed herders to tend them; their livestock thus became a symbol of wealth and status rather than forming the basis of a way of life.

For the Fulani who remained nomads, cattle retained all their importance and they have particular affection for the beloved zebu, the mahogany cattle with lyre-shaped horns around which their lives revolve. Valuing their freedom, they despise their settled neighbours and have resisted where possible all outside influence and cultural change. Many call themselves Wodaabe, meaning 'people of the taboo', that is, those who adhere to the traditional code of behaviour characterized by modesty, forethought and reserve. In turn the sedentary Fulani

call them Bororo, a name derived from their cattle, and think of them as 'those who live in the bush and do not wash', dismissing their unruly lifestyle and primitive ways with scorn.

The Wodaabe live in central Niger, parts of Nigeria and Cameroun. They travel in small family groups in search of grazing land for their cattle, camels and donkeys, and become even more scattered during the long dry season as the water holes dry up and the struggle for pasture intensifies. Once a year, however, at the height of the rainy season when the grass is lush enough to support large herds, up to three thousand Wodaabe gather to celebrate the *Geerewol* festival. This is the chance for the herders to meet, to exchange news and gossip and to make new friends. It is a time for seduction: the main opportunity of the year for the young to abandon themselves in erotic dance and to pursue lovers. The Wodaabe are polygamous but only their first marriages are by tradition prearranged. The spontaneous liaisons that arise during the *Geerewol* may develop into permanent relationships and second, third or fourth marriages (always of individual choice) are often initiated at this time.

They devote enormous care to their appearance for the *Geerewol*, and the young men in particular spend hours decorating themselves in front of small hand mirrors. The Wodaabe believe that they have been given the greatest beauty on Earth. It is of the utmost importance for a woman to give birth to a beautiful child; sometimes, if a man is not good-looking, he will allow his wife to sleep with a more handsome man in order to gain an attractive child. Mothers gently stretch the limbs of their young babies and press their noses between thumb and forefinger to lengthen them and make them thinner. Ugliness and physical deformities will bring suffering to the person concerned, though these can be offset by skills in singing, story-telling or poetry; personal charm and charisma, revealed in dancing, will do more than anything to increase a person's popularity.

The Wodaabe rely strongly on jewellery to beautify themselves for the *Geerewol* and for marriages and baby-naming ceremonies, all held during the few weeks at the height of the rainy season. For the rest of the year they normally wear little jewellery, and what they do wear is simple and often talismanic. At birth, boys are given a small leather amulet to promote virility and girls one of a different design to aid fertility. At circumcision boys receive from their fathers a set of charms to ensure the potency of their herds; these usually consist of amulets containing claws, teeth, shells, cows' hair or verses from the Koran. The

Wodaabe still believe in the evil spirits of the bush and although they sometimes adopt Muslim prayers and rituals they use these only to supplement their traditional Fulani practices.

A man's wealth and source of prestige lies in his herds, a woman's in her collection of ceremonial calabashes, *elletel* and *kakool*, which are given by a mother to her daughter when the girl finally leaves home to live in her husband's camp. They are hardly ever used for domestic purposes, but are carried through the bush on the back of a special ox and carefully displayed when camp is pitched at the end of the day. They are decorated with incised designs, mirrors, coins, thumb tacks, spoons and other oddments of individual choice which not only indicate the owner's prosperity and lineage but also provide an outlet for her artistic talents. The calabashes thus supplement the role of jewellery, though it may seem strange that objects so large and cumbersome, so impractical and difficult to transport, should be accorded such importance in a nomadic way of life.

The Wodaabe have long considered it unworthy of cattle-breeders to manufacture anything other than the rope they use to tether their calves. Today, although some Wodaabe men make leather ornaments and all the women string glass bead necklaces, they see this as a creative, pleasant pastime rather than a serious occupation. They still believe that work compromises their freedom and is beneath them unless it is directly related to the welfare of their herds, and they prefer to sell sheep and goats to pay for the services of others. Most of their jewellery, therefore, is made by Tuareg, Bella or Hausa craftsmen living in small market towns, who follow specific designs given to them by the Wodaabe – in this way the nomads both express their own creativity and preserve the Fulani designs. Although unwilling to become artisans themselves they respect these craftsmen, for according to legend it was a smith who gave the Fulani their first cow.

Unlike the Wodaabe, the settled Fulani and other savannah peoples whose ancestors have witnessed the rise and fall of empires have developed materialistic and hierarchical societies. Status has come to play an important part and wealth is ostentatiously displayed, especially in lavish hair decoration, a tradition retained from the imperial past. The traveller Cado Mostro wrote in 1455 of the elaborate coiffures of West Africa, describing how 'both sexes weave their hair into beautiful tresses which they tie in various knots'. And John Barbot, travelling in Senegal in 1732, recorded the 'fantastic hair treatment, plaited and twisted and adorned with some few trinkets of gold, coral and glass . . . and a coif standing up five or six inches above their heads, which they think a fine fashion'.

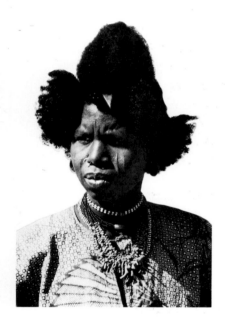

Kanuri woman, northern Nigeria.

Women's hairstyles have become both the focus of adornment and the culmination of artistic expression. Highly imaginative styles are created by dividing and lengthening the hair, dressing it with palm oil or melted butter and shaping it with cloth or fibre padding or even over arched bamboo supports. A rich assortment of jewellery – pendants, rings, coins and beads – is then attached. Gold, carnelian, agate, amber and European glass beads are all worked into the hair; many of them were brought centuries ago by camel caravan across the Sahara. Curiously, in Timbuktu ancient rings of agate were valued at twice the price of gold and were much sought after as a form of hair decoration.

Hairstyles vary from one region to another, and according to the woman's age and social standing. In Mali the Fulani display their wealth in gold earrings and hair ornaments. Around the ancient city of Jenné 'ponytails' decorated with amber distinguish the daughters of cattle herders from those of agriculturalists. In Upper Volta silver coins, originally introduced by European colonialists, are sewn onto hair crests and plaits alongside small carnelian beads. Here Fulani women announce the birth of their first child by wearing their hair plaited at the side and joined under the chin; white beads at the end of each plait signify the woman's wisdom and serenity. The most elaborate hairstyles have always been

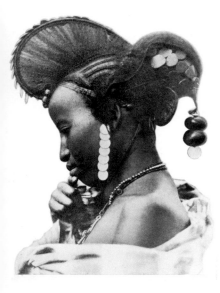

Fulani woman with bamboo hair support, French Guinea, nineteenth century.

the privilege of married women. In Fouta Djalon, Guinea, Fulani women wear a style, an architectural triumph in itself, in which the hair is moulded into shapes like huge butterfly wings. Further east, the Kanuri women of Lake Chad, part of the former kingdom of Bornu, wear impressive plaits of ancestral hair running from the forehead to the nape of the neck. Wealthy Senegalese women have always paid large sums of money to have their hair styled each month, a popular style being the *gossi*, in which sisal and other fibres are worked into the hair to lengthen it, and butter and crushed charcoal are applied before the hair is braided. Each morning the women use a candle to singe off any sisal fibres which are sticking out, and refresh their coiffures with petroleum and lamp black. In southern Senegal, the Fulani women give their hairstyles imaginative names, a practice possibly adopted from the Songhai women who have numerous names for their own coiffures such as '*pirogue* (boat) of the sky', 'bellow of the forge', and 'spend the night with the one you love'.

The concern for beauty is evident even among poorer women, who have to make do with cheaper elements in their hairstyles. Coins of mixed metal may replace those of silver; among the Bella – former slaves of the Tuareg – glass and plastic beads are used instead of coral, amber and stones. The Songhai women of Timbuktu are renowned for their duplication of traditional gold designs in straw dipped in a bath of henna to make it resemble the precious metal. Yet, despite all these economies, hairstyles have retained their dramatic and sophisticated form.

The Fulani have always had a highly developed artistic awareness, combining their habit of borrowing, which stems from a nomadic past, with a naturally discerning eye and an ability to use the adopted ideas with originality and flair. The design of their jewellery has been influenced by the styles and techniques of the many peoples they have conquered – Wolof, Toucoulour, Songhai, Hausa and Kirdi – as well as by Moorish and Tuareg art. The spread of Islam has led to the practice, among both men and women, of wearing verses from the Koran which, sealed into boxes, act as talismans. The Islamic belief that gold is a bad omen has restricted its use in much of the savannah; it is certainly never worn on the finger, following the Islamic edict that no prayer would be accepted from a hand bearing so luxurious a metal. But the savannah peoples, even those who have adopted Islam, still set great store by the magical and protective powers of their traditional materials and symbols.

As the savannah empires grew more wealthy and powerful, the trade routes across the Sahara became more extensive and others stretched south to link them with the equatorial forest region. New designs and sophisticated techniques were introduced, including fine filigree work and the use of cabochon stones, both of which are still evident in Senegalese jewellery today and can also be seen worn by the Songhai and Fulani in the old towns of Jenné and Timbuktu. The amber and coral earrings of the Fulani echo the fibula designs of the Moroccan Berbers and some of their pendants and necklaces are reminiscent of those found in medieval Spain.

With the decline and fall of the empires, trade suffered and the flow of rich materials decreased. Even the craftsmanship lost much of its quality, and filigree was replaced by simple engraving and repoussé work. Traces of early influences linger on, however, and today the ornaments, clothes and hairstyles of the settled peoples of the savannah are not only an indication of their wealth and hierarchy but a vivid reminder of their rich and colourful history.

By contrast Wodaabe jewellery, with its emphasis on personal adornment and protection, reflects the egalitarian lifestyle and constant movement of these nomadic people, their preoccupation with their herds and their adherence to traditional Fulani beliefs.

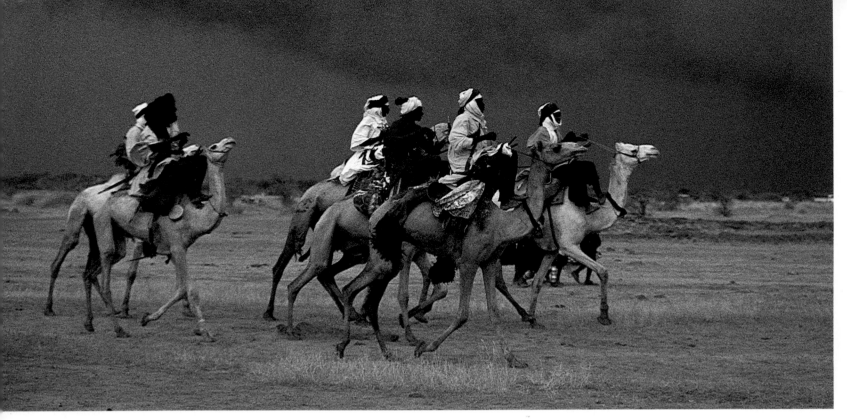

THE GEEREWOL FESTIVAL

Each year when the rains come, Wodaabe nomads gather to celebrate the annual *Geerewol* festival. Family groups travel many miles, the men on camels, the women and children by donkey or on foot. The *ruume*, the welcoming dance, is performed every morning and evening throughout the festival. Young men wearing large hats form a tight circle around the elders, stepping, clapping and singing; the elders encourage their dancing, while young girls parade under umbrellas and admire them.

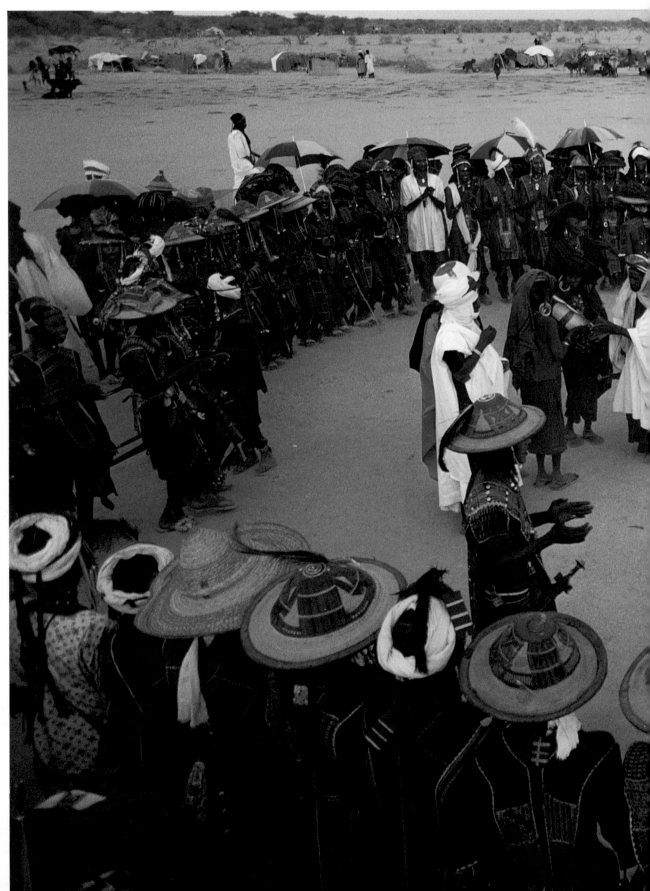

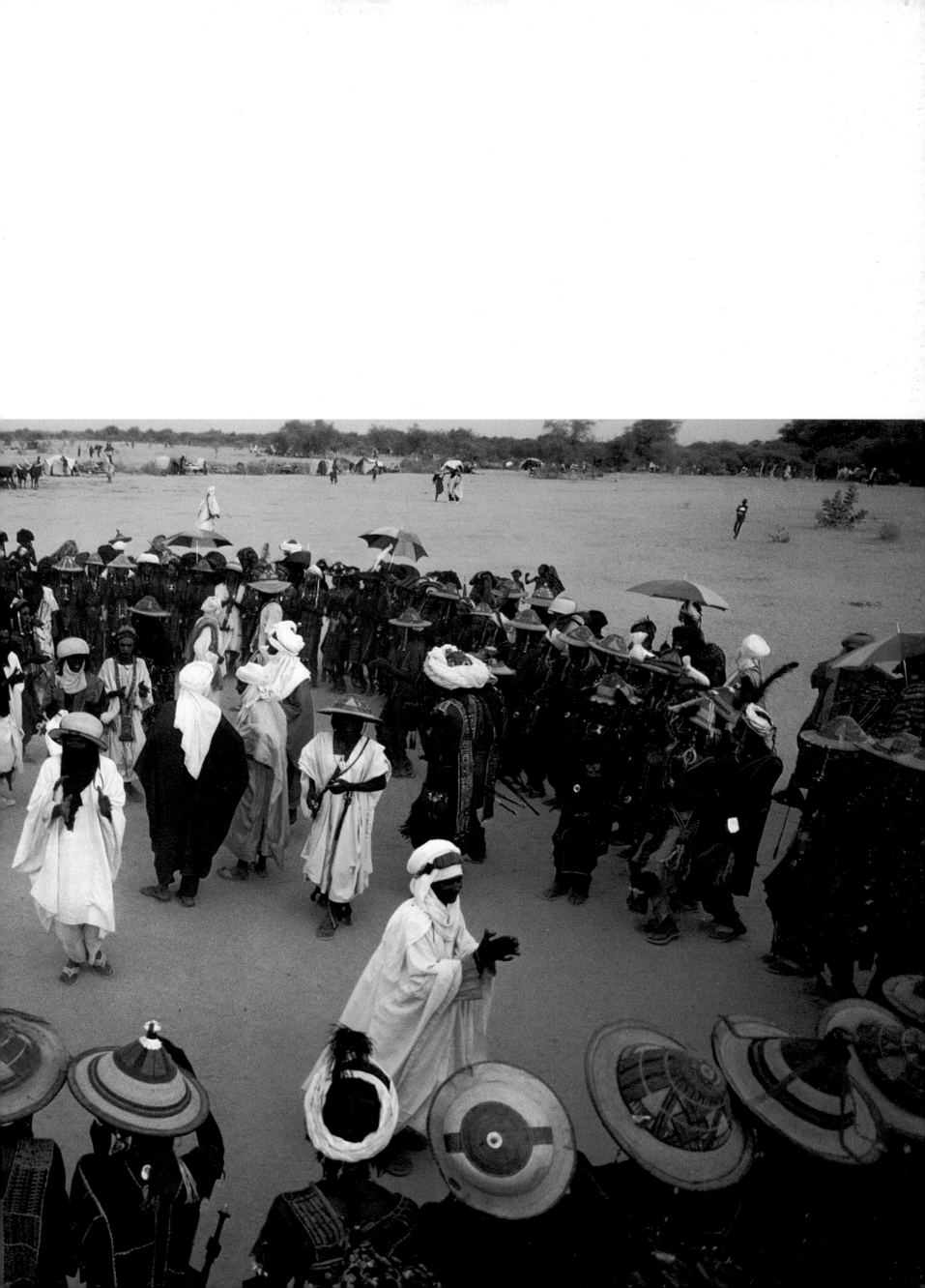

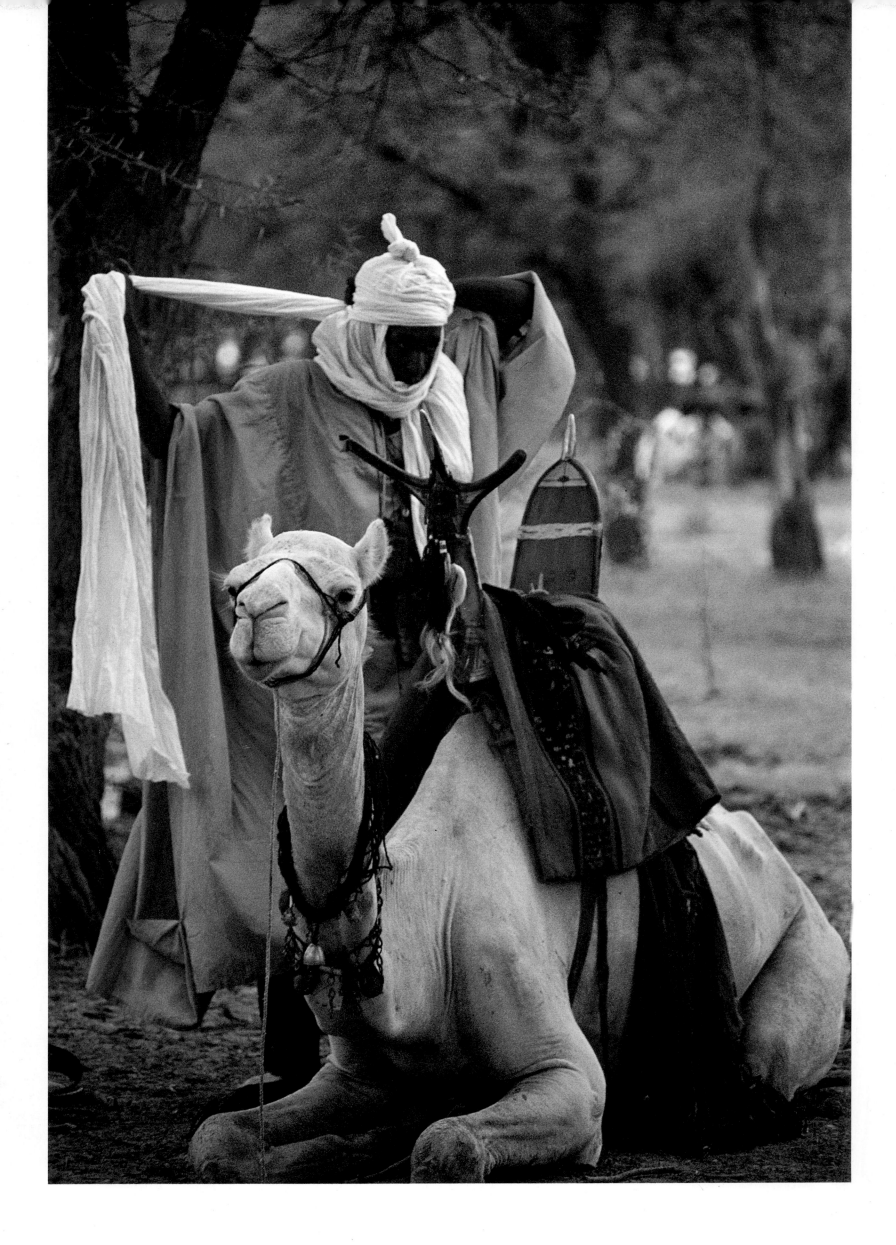

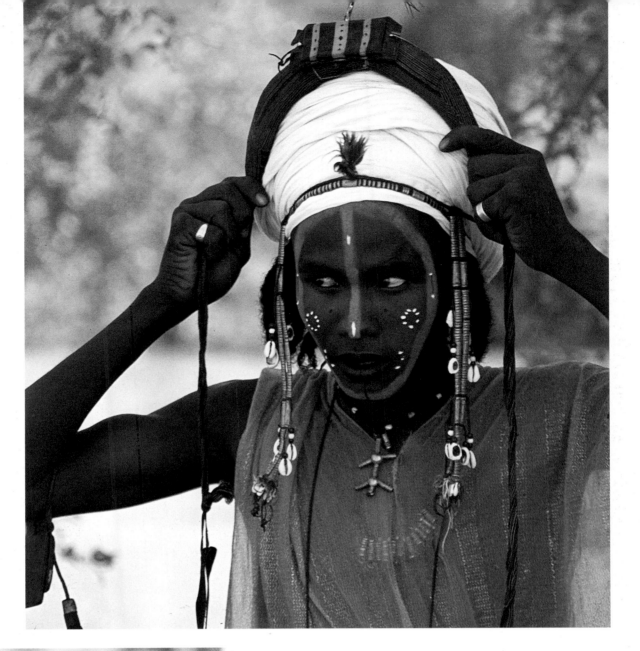

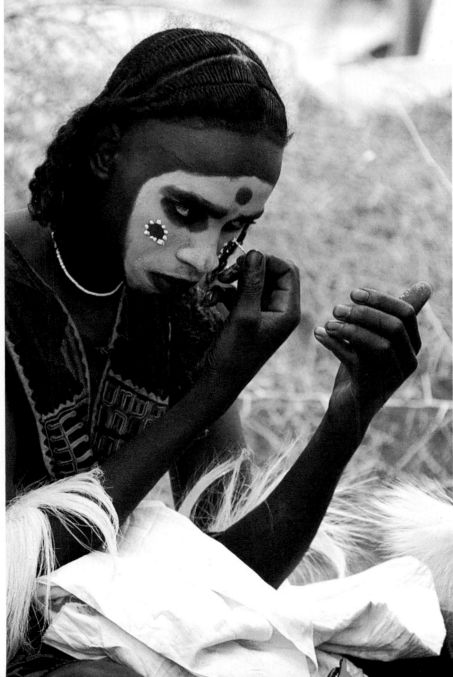

PRELUDE TO THE DANCE

OPPOSITE At the festival the older men wear
turbans and flowing gowns called *bou-bou*
instead of the simple tunic and cotton trousers
worn when they travel with their herds. They
decorate their camels with brightly coloured
saddle blankets and often sport new saddles
for the occasion. Leather amulet pouches
called *liagi* hang permanently around the
camels' necks, offering protection to these
valued animals.

LEFT Young men devote much time and care to
preparing their make-up and dress for the
seven days of dancing ahead. The hairline is
shaved and the hair intricately plaited. Kohl
is used to blacken the eyelids and the lips,
and a paste called *pura* made from yellow
powder masks the face; prepared according to
a magic rite, this is believed to increase the
dancer's powers of seduction. Circle and dot
designs in red and white are added, purely
for beauty.

When the make-up is completed (*above*) white
hair armlets – made from billy goats' beards –
are attached to the dancer's elbows and a
white turban is wrapped around his head,
with a leather amulet for protection and a
black ostrich feather for virility secured on
top. *Silkin*, strips of leather bound with brass
and decorated with cowrie shells, are hung at
each side of his face. A diaphanous tunic puts
the finishing touches to this dramatic
ensemble.

153

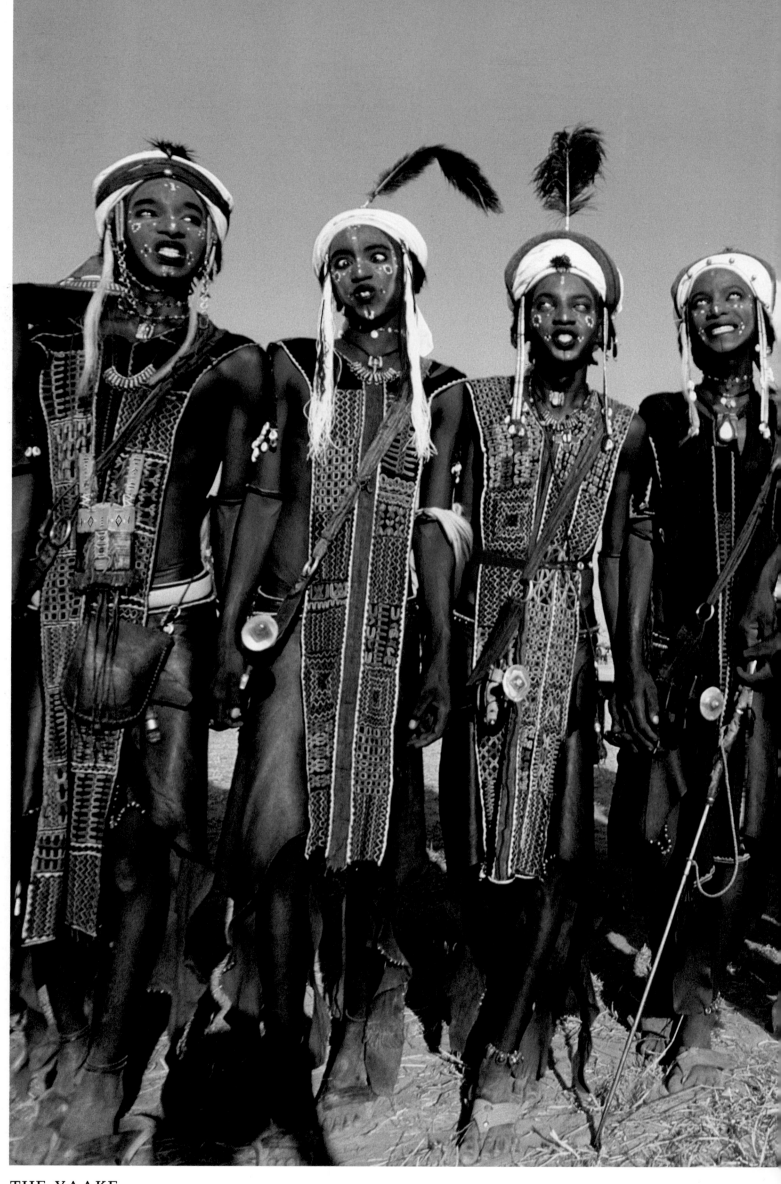

THE YAAKE

During the festival, young men assemble in the late afternoon to perform the *yaake*, a dance in which they display their beauty, charisma and *togu*, or

charm. This is the time for each man to enjoy a fantasy image of himself, far removed from the mundane routine of his everyday life. The men compete in

luring young girls with their langourous looks and apparent wild grimaces; before the dance they drink stimulating concoctions made from pulverized bark,

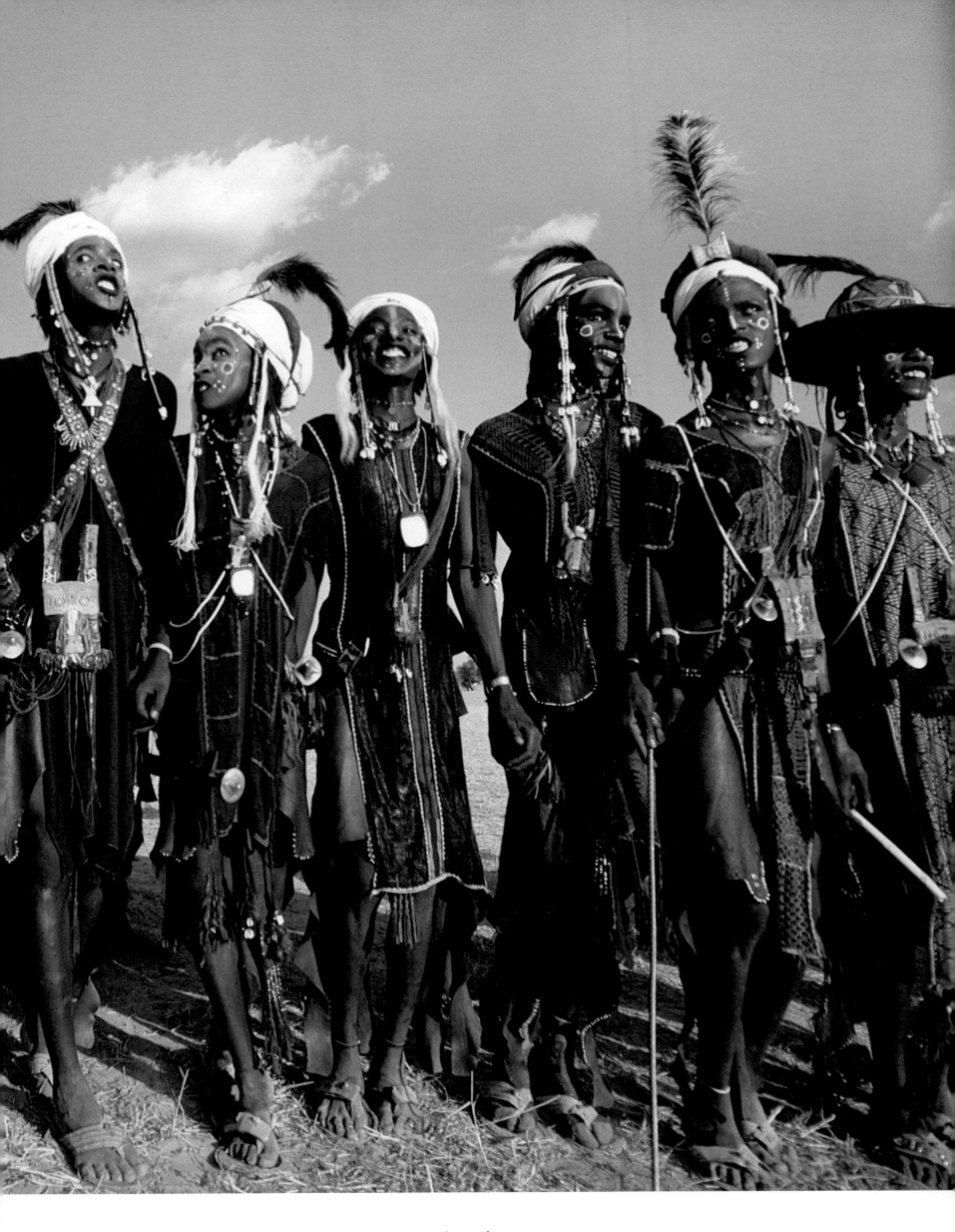

which enable them to perform for hours in a trance-like state. Teetering on tiptoe, they turn their heads from side to side and part their kohl-black lips to reveal their teeth. To emphasize the whites of their eyes they roll their eyeballs, holding them in a fixed stare for added effect.

155

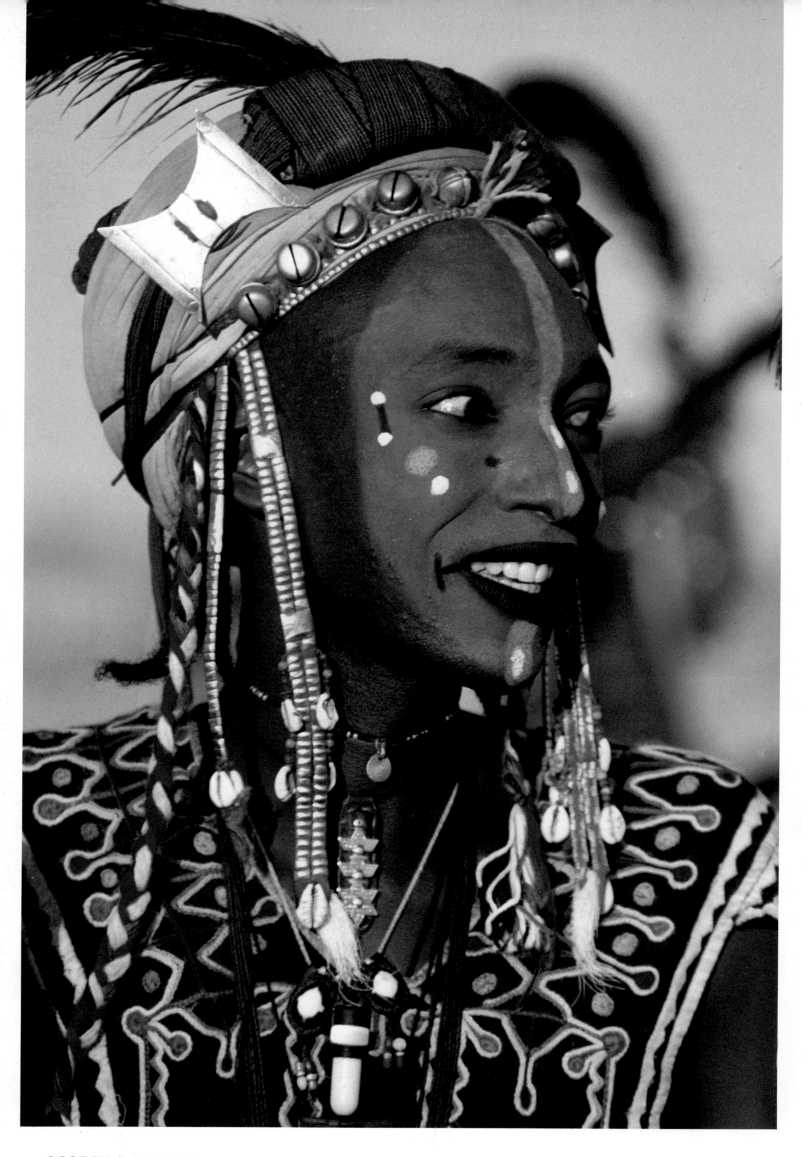

SCORING POINTS

Long slender noses accentuated with painted lines, white eyes, white, even teeth, and tall, lean bodies are the criteria of Wodaabe beauty. At the end of the dance, girls can select the men they find most attractive, with whom they may discreetly spend the night.

The men's finely embroidered tunics are made for them by their girlfriends, though the men themselves buy other eye-catching items in the market, such as string vests and pink broderie anglaise to adorn their hats. The brass and copper head plaques are made for them to specific Wodaabe designs by Hausa and Bella craftsmen, whereas the simple brass *silkin* (*see p. 153*) are made by the Wodaabe themselves.

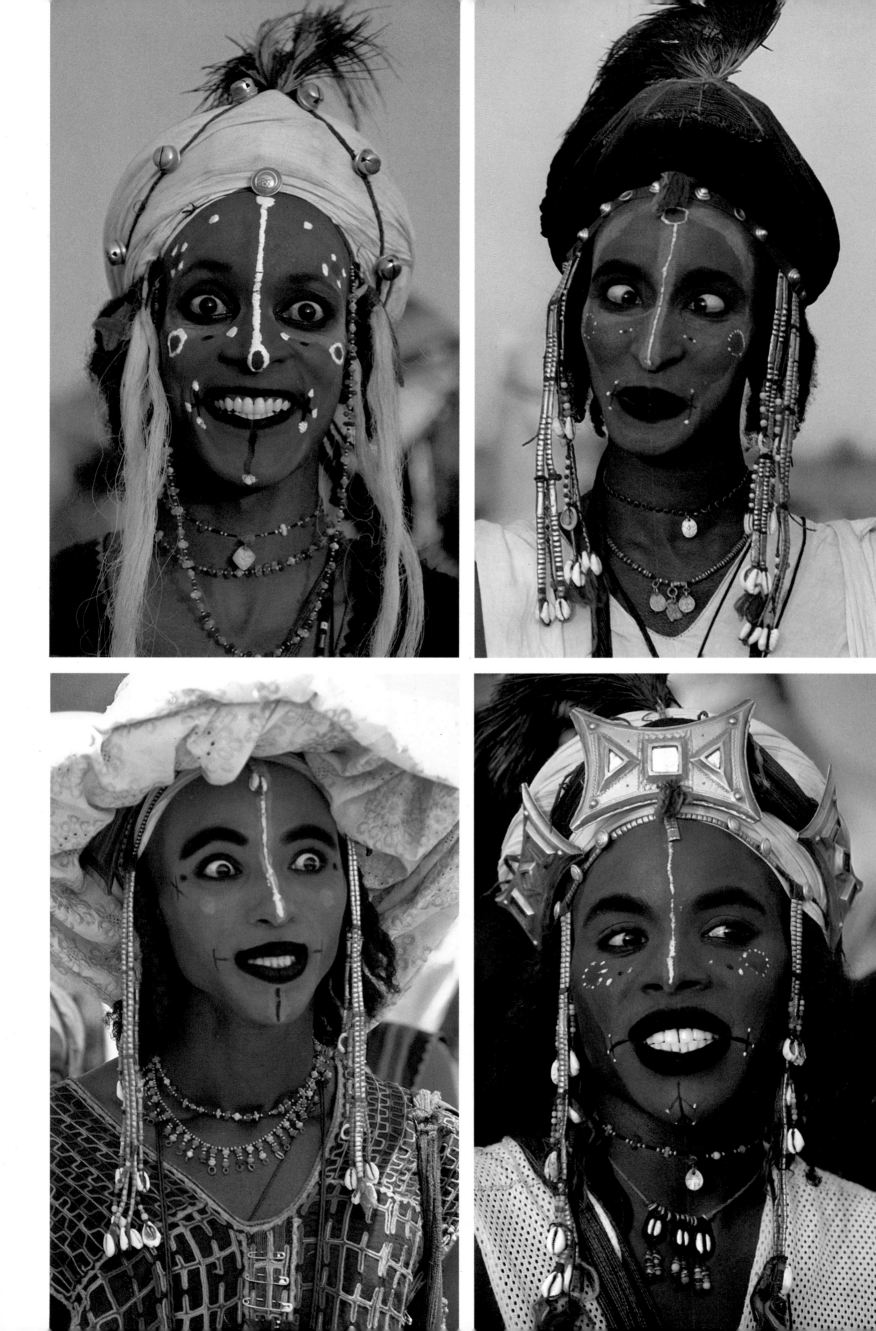

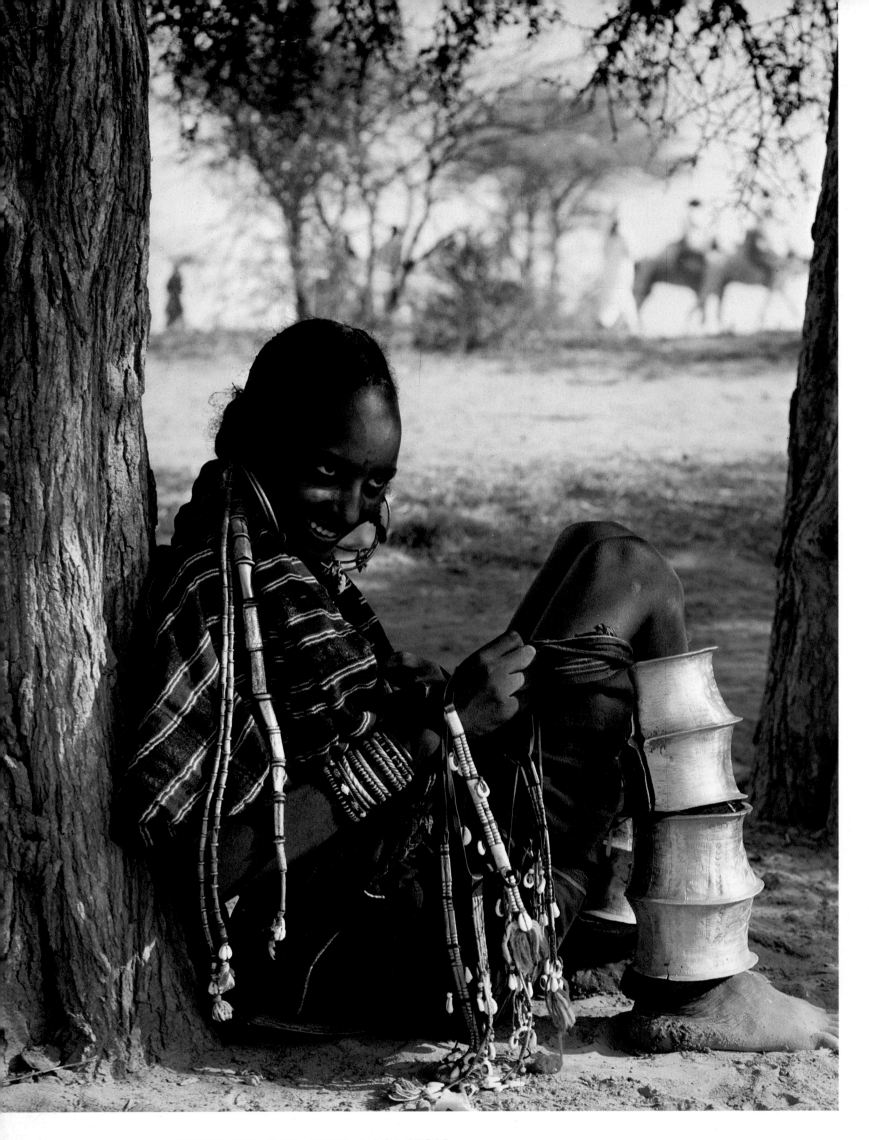

DRESSED FOR THE OCCASION

ABOVE Long plaits of hair wrapped in brass indicate that this girl is considered partieularly beautiful, and will partake in judging the performance of the young men dancing at the *Geerewol* ceremony. Her heavy brass anklets, called *jabo*, are traditionally given by a mother to her daughter and are worn to attract men's attention; their weight, which tends to make the hips swing while

walking, adds an extra element of seduction. Well-to-do girls wear two or three pairs, protecting their legs from the inevitable chafing with cloth wrappings. The anklets are worn only until the girl has borne her first child.

OPPOSITE The young Wodaabe in ceremonial outfit adds the final touch with a pair of sunglasses, carefully selected for their colour and considered the height of fashion.

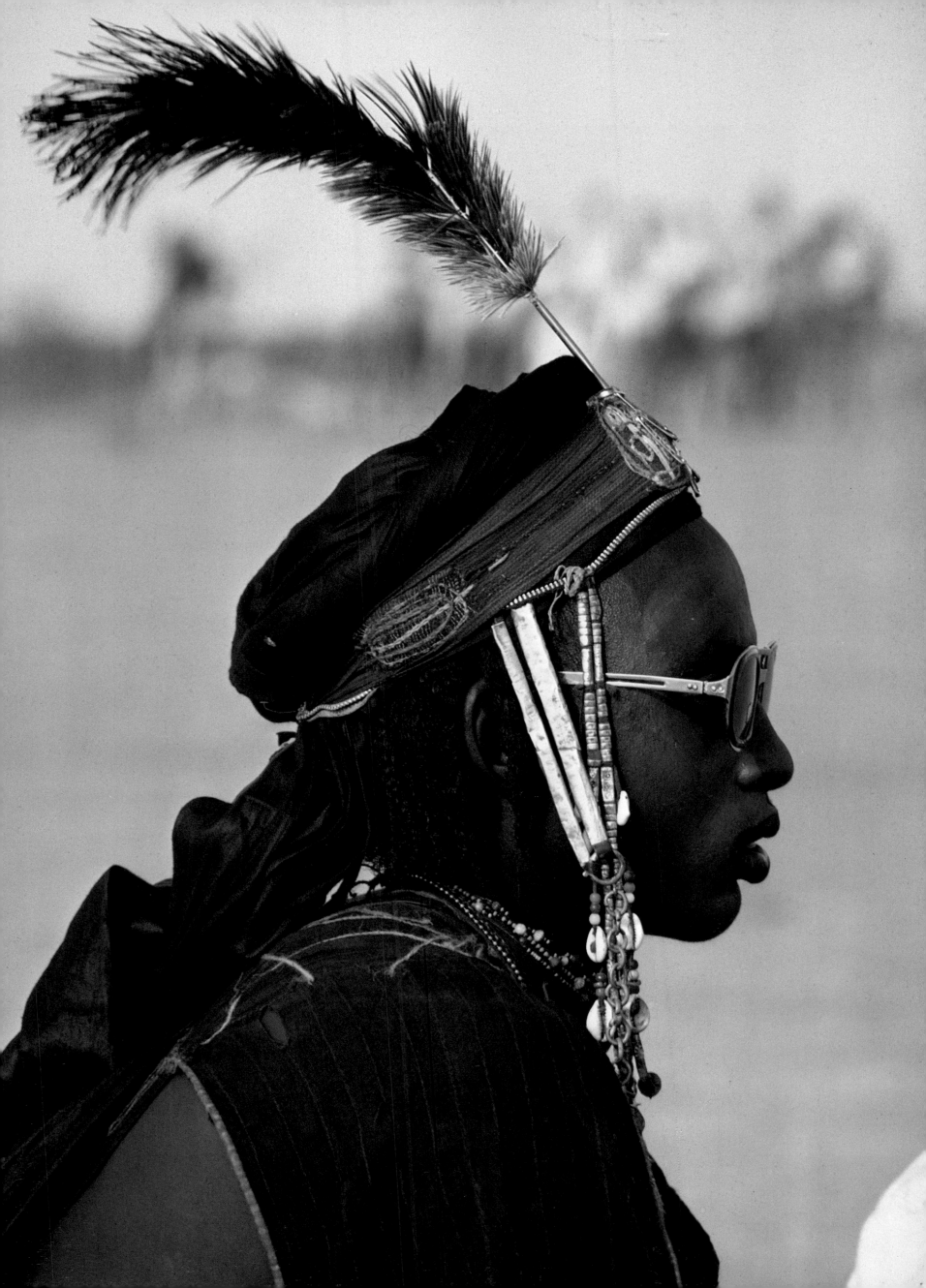

SERENDIPITY

With a real feeling for style, a love of outlandish fashion and a great sense of fun, young Wodaabe men and women search for objects in the marketplace with which they can create new and exciting ornaments. Into their traditional festive attire they incorporate odds and ends that they feel will make them look even more stunning.

Items such as suitcase locks and imitation gem stones are made into decorative neck pendants by the men, while the women add small hand mirrors to their embroidered skirt designs and hang torch bulbs beside leather amulet pouches as part of their decorative belts, called *lookatagi*. Plastic keyrings have a strong appeal for the neighbouring Bella herdsmen: both men and women string them together in large numbers to form prestigious pendants.

Not available in the local markets but perhaps a gift from a passing traveller is the toy gun worn with aplomb by this Wodaabe man alongside the traditional sword as part of his ceremonial regalia.

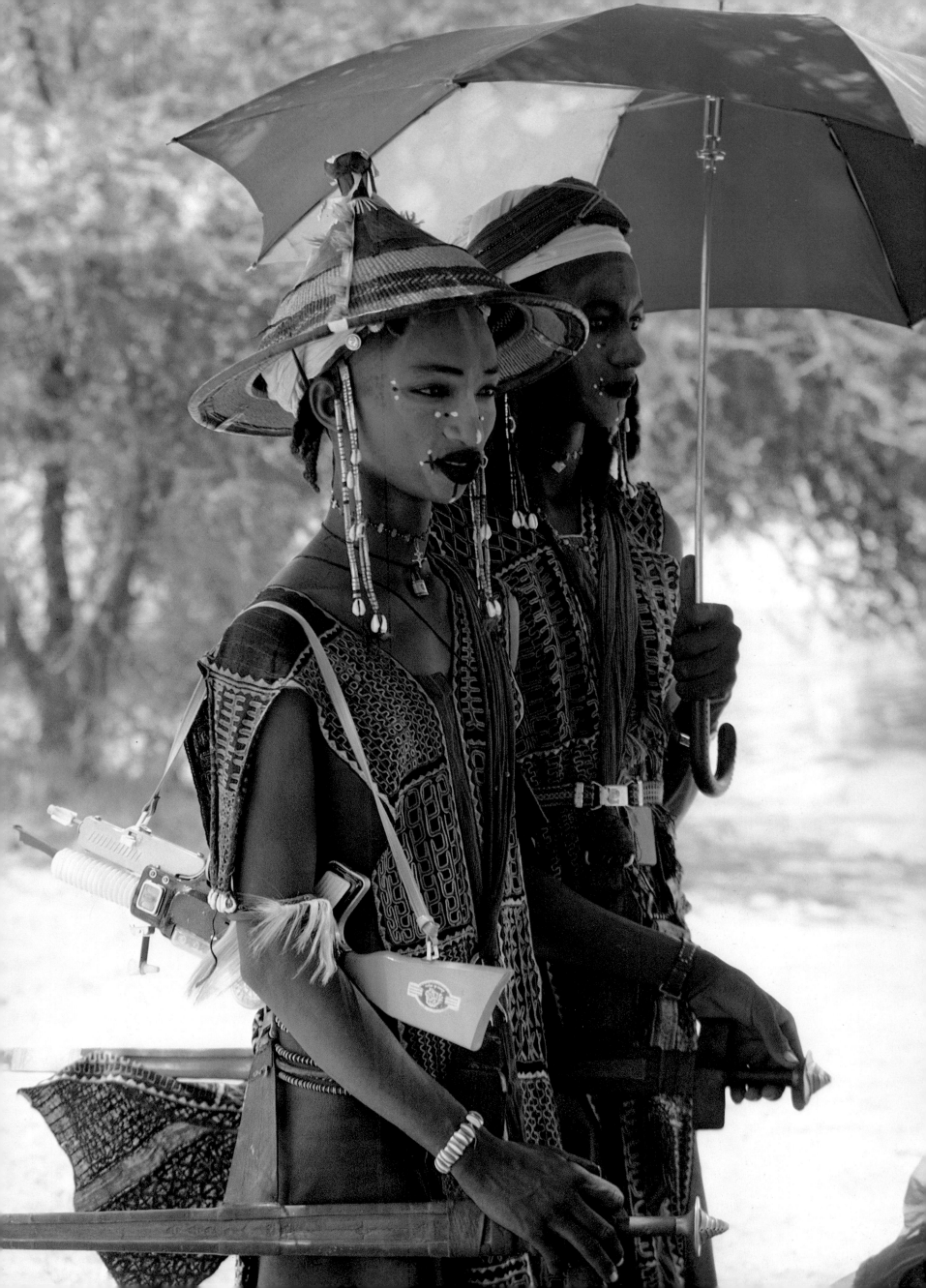

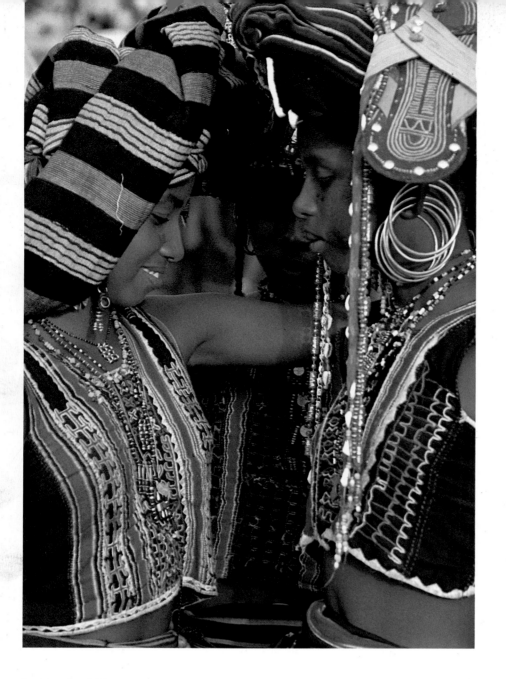

INTENTION TO SEDUCE

During the dry season, as they travel from camp to camp on donkeys, the young girls embroider blouses and skirts and collect small objects from which to make jewellery in preparation for the *Geerewol* ceremony. This festival provides the main chance of the year for them to initiate relationships and find a second, third or fourth husband.

Folded headcloths are stylishly decorated with brass chains, cowrie shells and beads. Sometimes Tuareg leather sandals are studded with thumb tacks and attached to the headcloth; this is considered extremely chic. Brass hooped earrings, *yamde*, are threaded through as many as eleven holes in the rim of the ear, pierced in early childhood.

The small embroidered plaque (*below left*) is made of glass beads and gold-coloured pendants and is worn hanging in front of the skirt

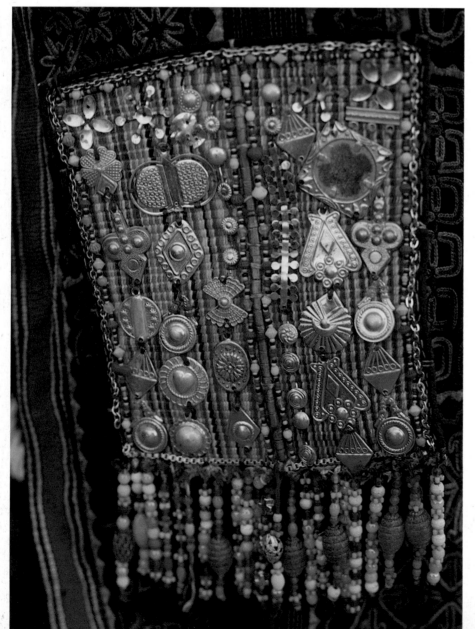

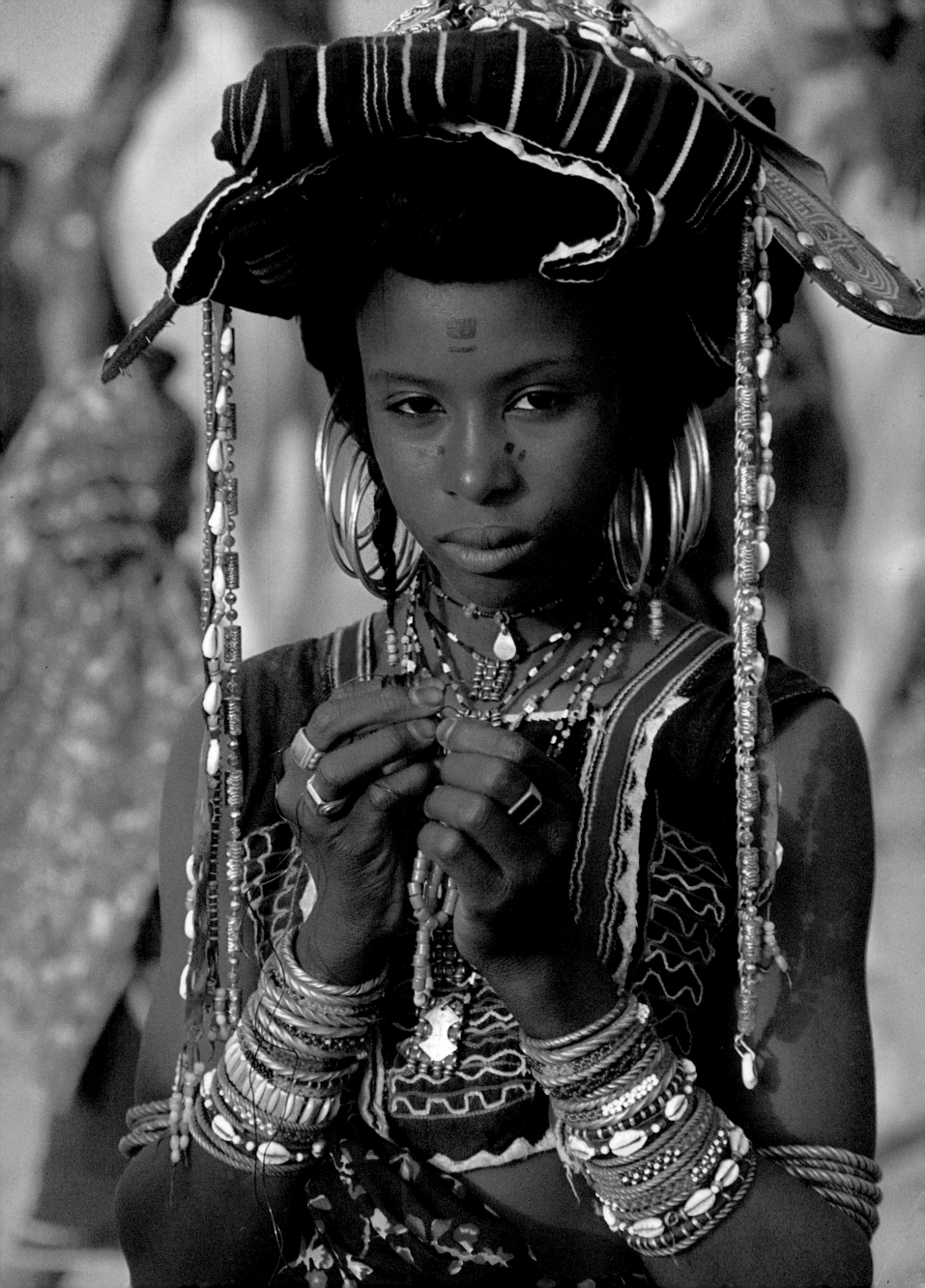

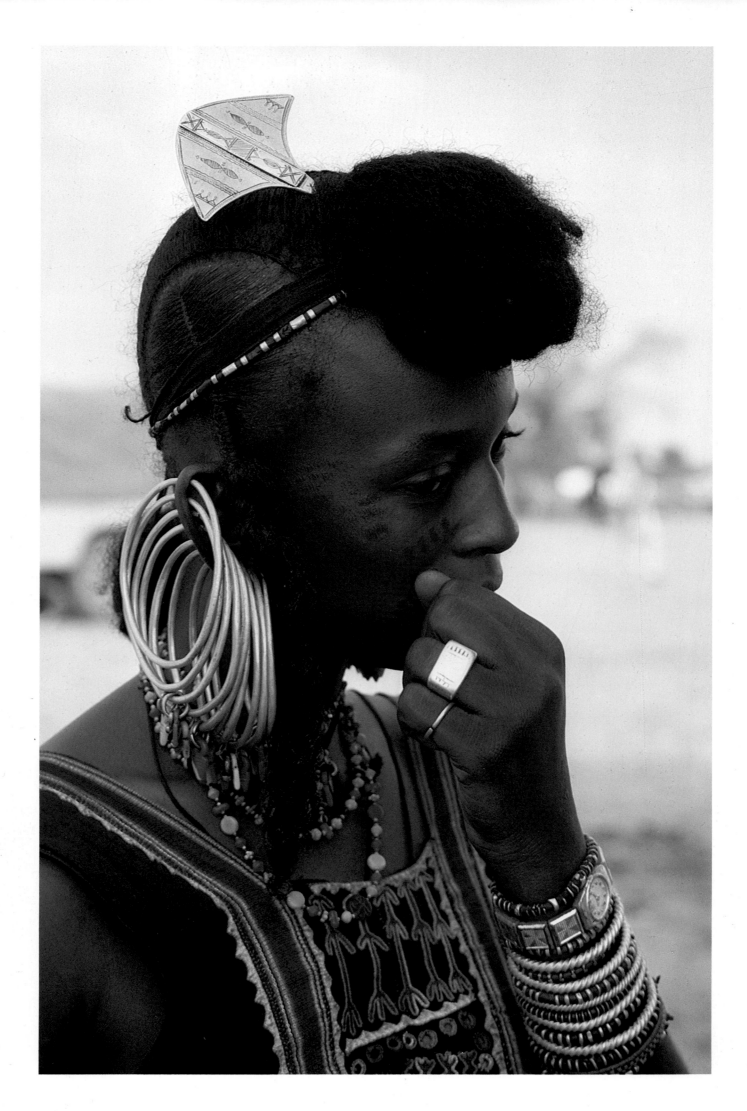

PURE FULANI

ABOVE Wodaabe women shave their hairlines to increase the length of their faces and enhance their beauty. In traditional Fulani style they bunch their hair into a large topknot over the forehead, a fashion mocked by Muslim Fulanis who say that it prevents the women praying in true Islamic style, prostrating themselves and touching their foreheads to the ground.

RIGHT The Wodaabe tattoo their faces with traditional designs some of which, like the triangular pattern at the corner of the mouth, offer protection against the evil eye.

Ornamental hairpins in aluminium and brass, called *sarogal*, are mainly used at festival time, and *yamde* (earrings) are only worn in their full quota of eight to eleven on ceremonial occasions.

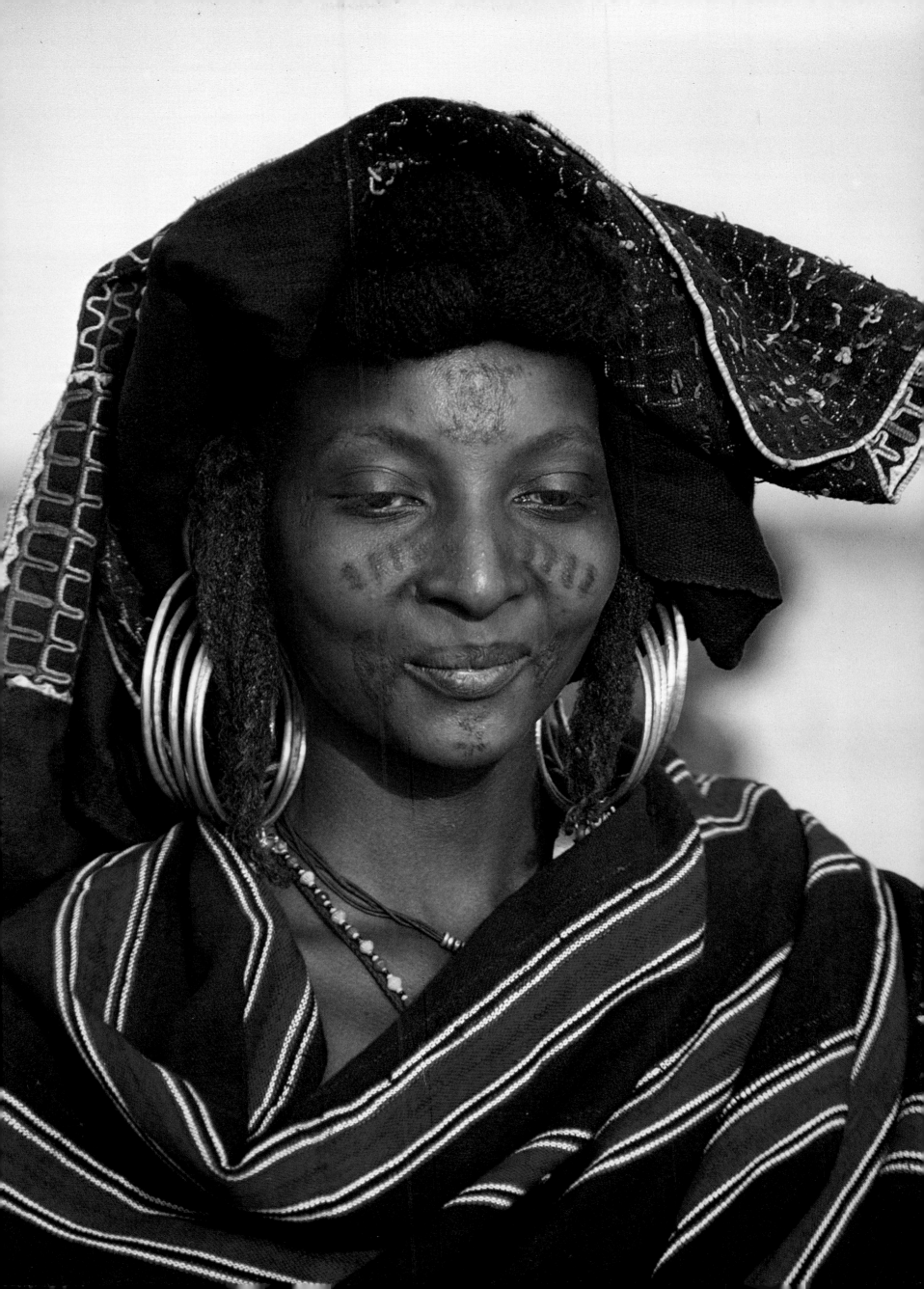

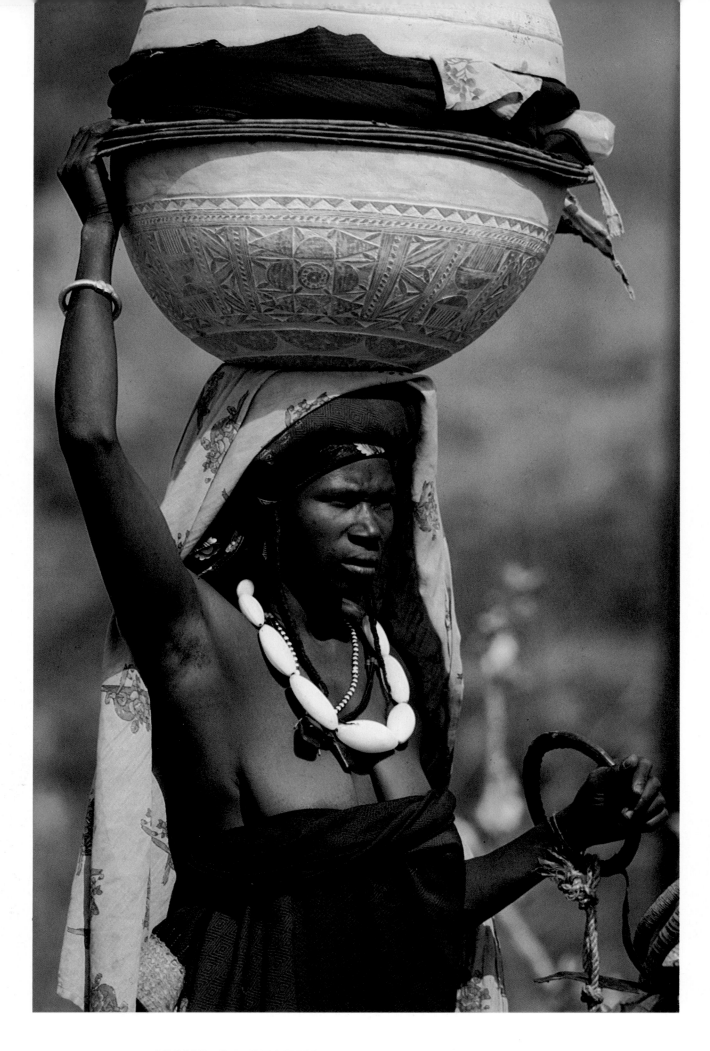

SIGNS OF STATUS

Where the Fulani have settled they have developed many different
ways of combining agriculture with raising cattle. Some, permanently
settled, live in villages and towns and are engaged in farming, trading
and running the community. Many still own cows which are grazed
by herdsmen over a wide area, some even in other countries. Between
the extremes of the fully nomadic and the settled Fulani there are
many intermediate lifestyles; some are mainly nomadic but do a little
farming wherever they set up camp in the wet season, others live in
permanent camps from which only the young men go out with the
herds during the dry season.

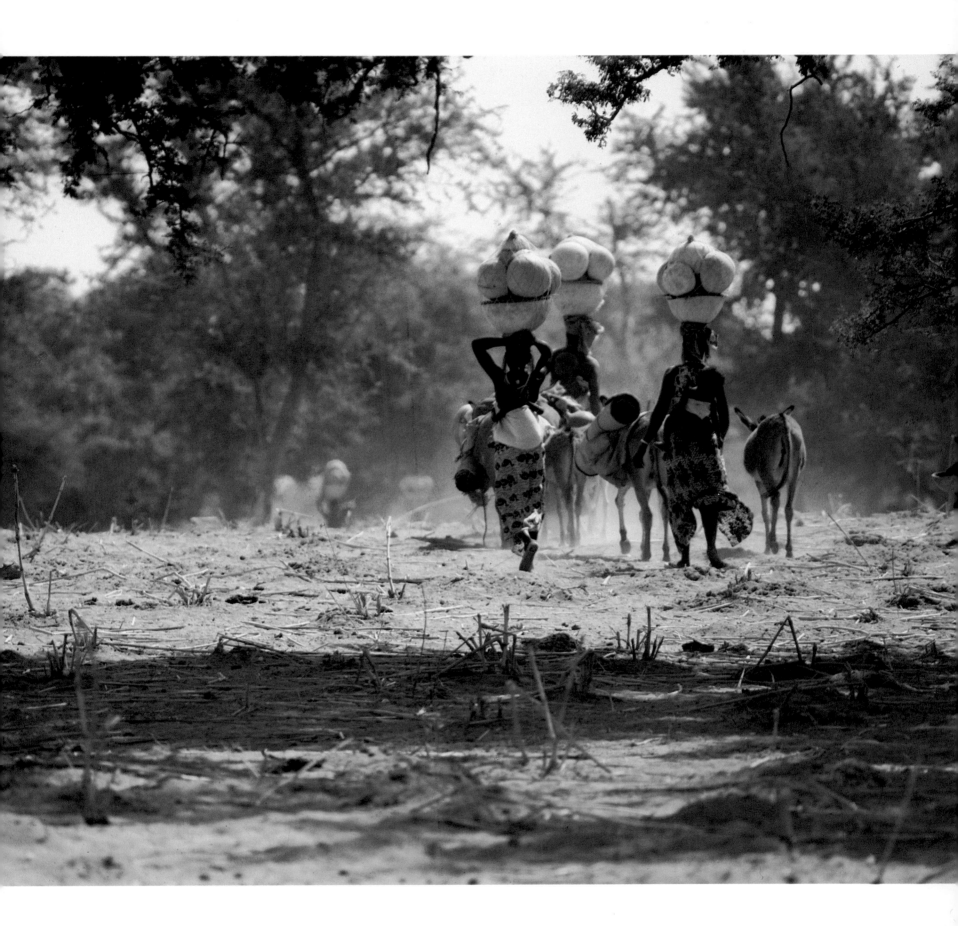

Some semi-nomadic Fulani women in Nigeria demonstrate their status
by their intricately carved calabashes and white agate bead necklaces.
But unlike the Wodaabe, who keep most of their calabashes as objects
for display, these Fulani women use them to carry milk from one
camp to another or to the local market. Between the head and the
calabash is a hair protector, its size and shape depending on the
hairstyle. The white agate beads have been made by one of the
earliest techniques: once shaped, they are polished on a wetted stone
and drilled by hand. Such beads were originally brought to Africa
from India via caravan routes across the Sahara, and later were made
locally. The leather pouches that hang beneath the necklace are
amulets, worn by women to protect them against evil and ensure
that their cattle produce a plentiful supply of milk.

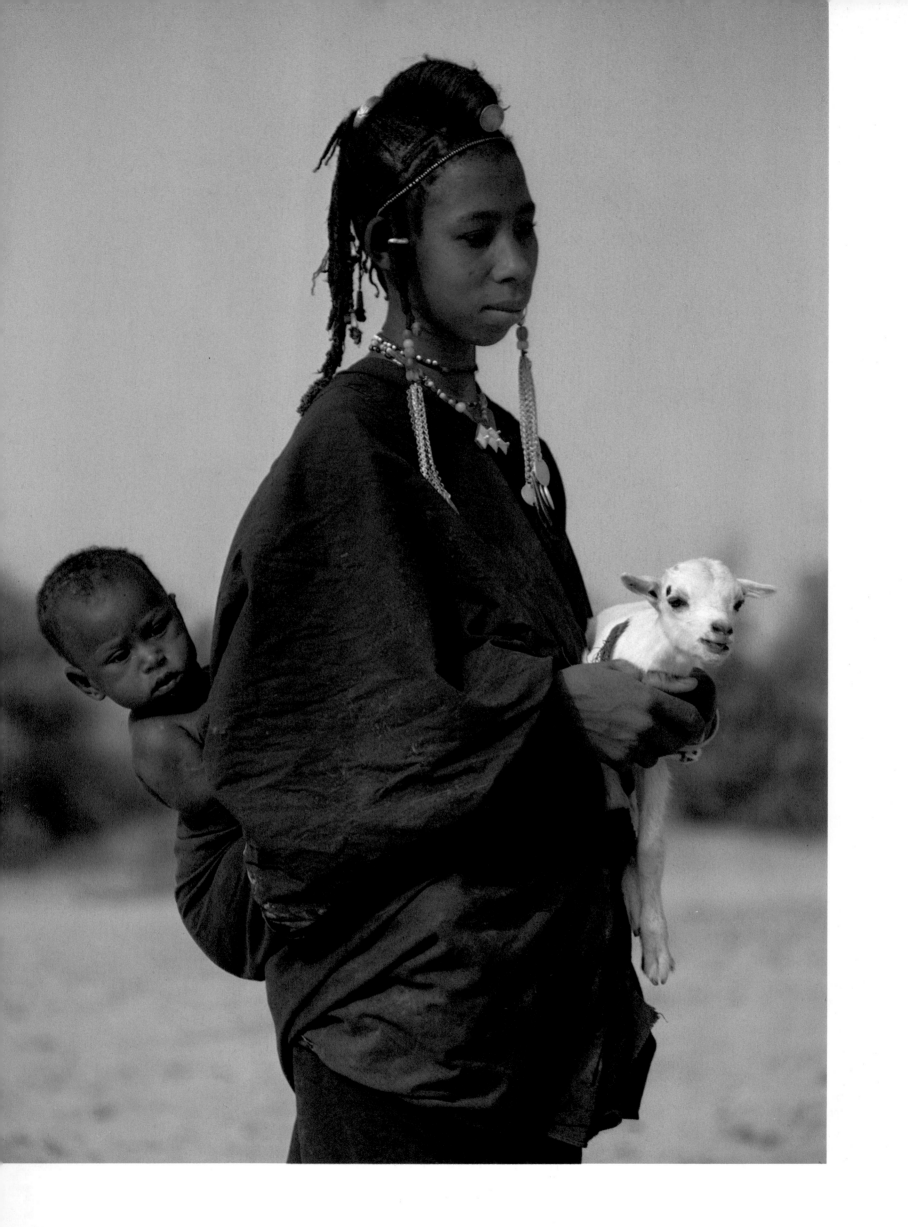

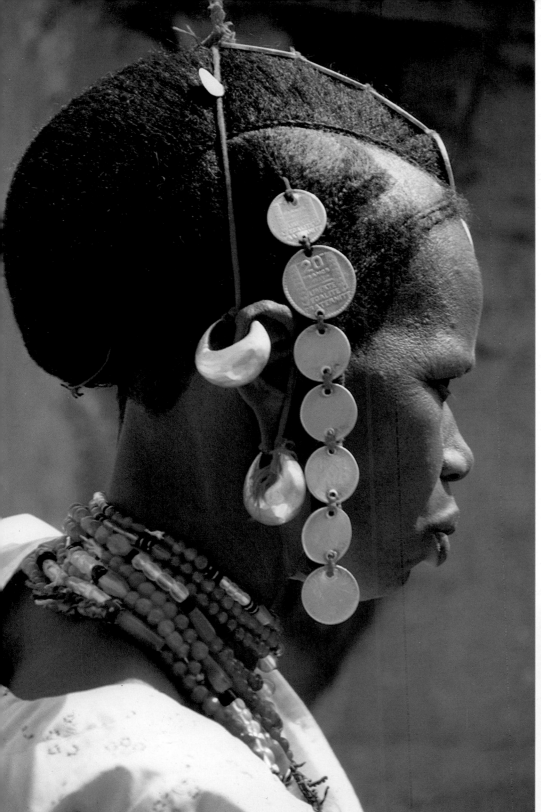

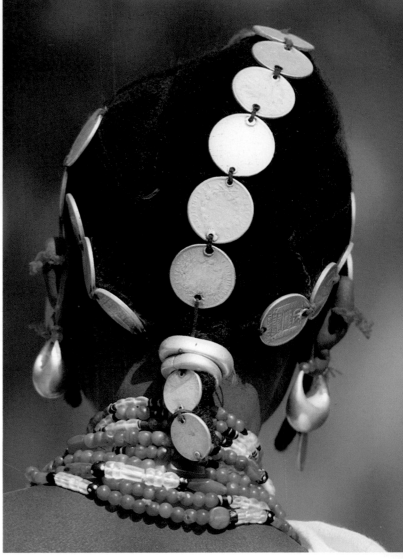

FOCUS ON HAIR

In the savannah grasslands hair becomes an element of sculpture; it is greased with butter, parted, padded and supported in an amazing variety of forms. Once styled, it is decorated with precious metals and beads that reflect the woman's status and the different stages in her life. The multiple chains hanging from the plaits of Fulani women from northern Upper Volta (*left*) are worn after the onset of puberty and during the first few years after marriage.

Regional hairstyles also reflect wealth, which is closely related to the fertility of the land. Northern Upper Volta suffers more than the south from a chronic lack of rain and consequent overgrazing, and silver coins are seen less often there than in the south, where they are often used in the hair as a form of decoration by married women.

Necklaces of carnelian and Venetian glass beads are valued by many of the Fulani: carnelian is believed to ease menstrual pains and help cure sicknesses of the blood.

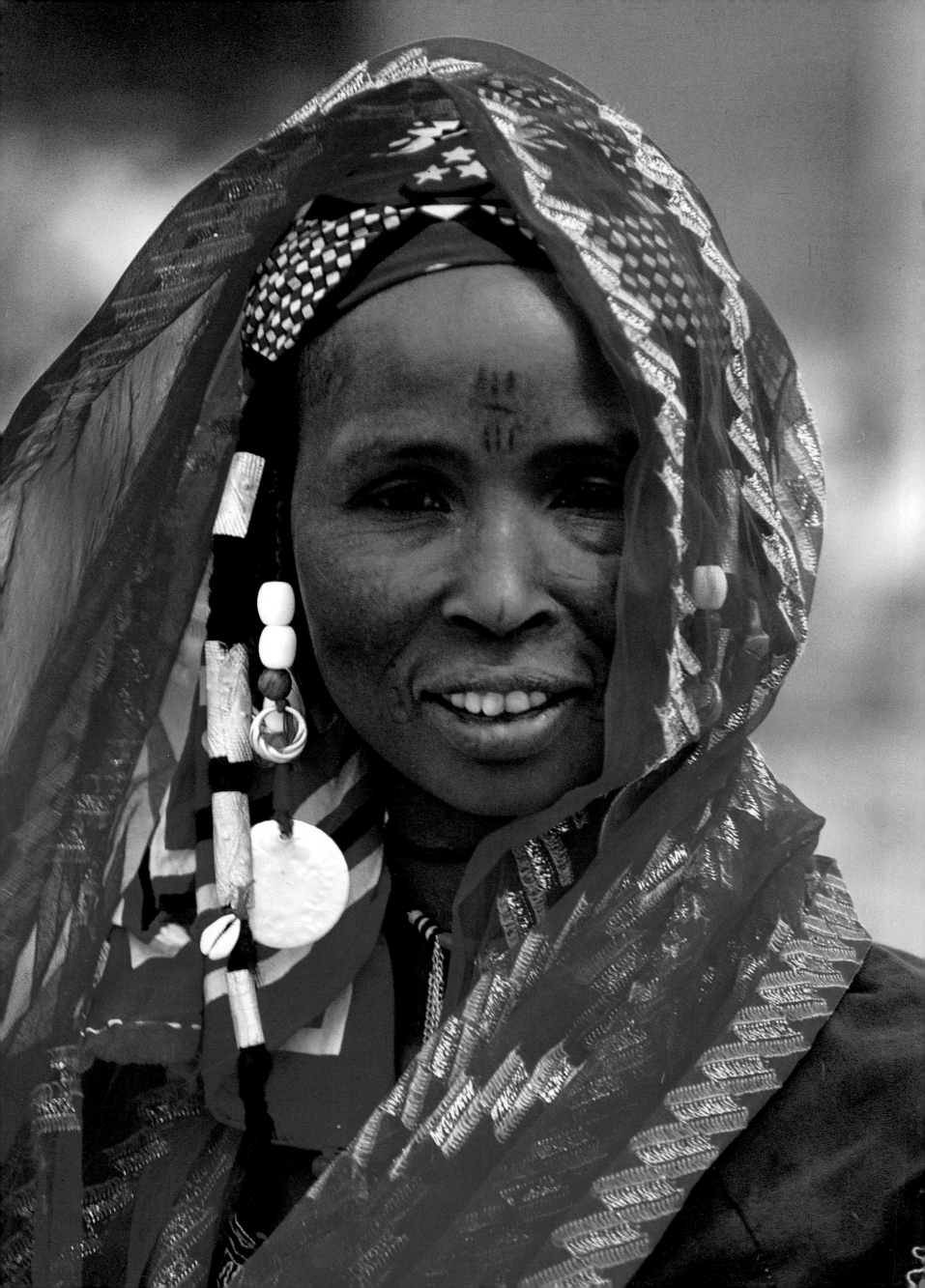

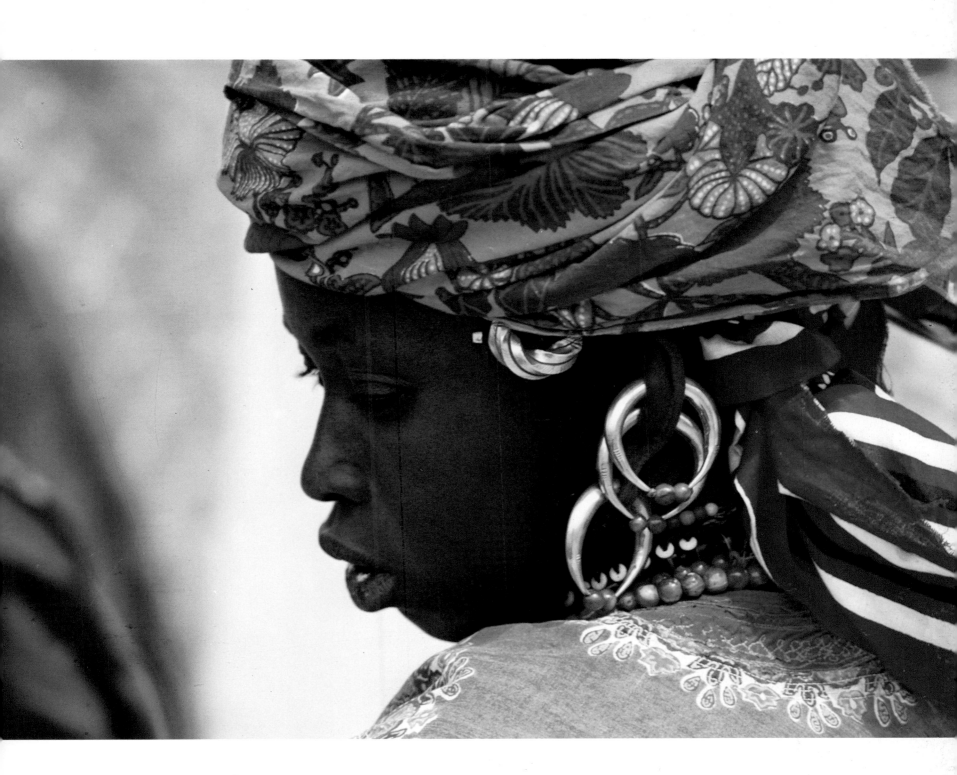

A SENSE OF STYLE

To the Fulani, headscarves are objects of both
glamour and prestige. They love brightly
coloured fine and diaphanous materials;
European cloth has been available in the
savannah for centuries, first brought across
the Sahara by camel and traded for slaves,
gold, ivory, rhinoceros horn and ostrich
feathers. The quantity of material used is
significant and voluminous scarves, like robes,
are a sign of opulence. They often conceal
elaborate hairdos, and are usually worn on
trips to the market.

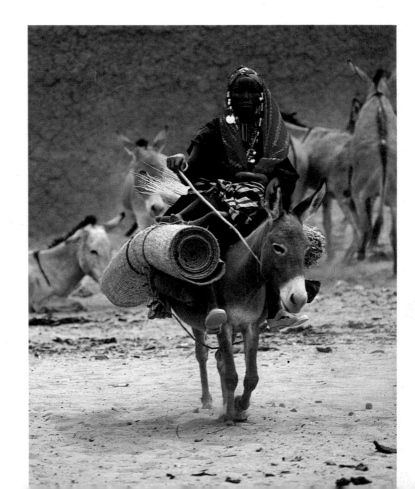

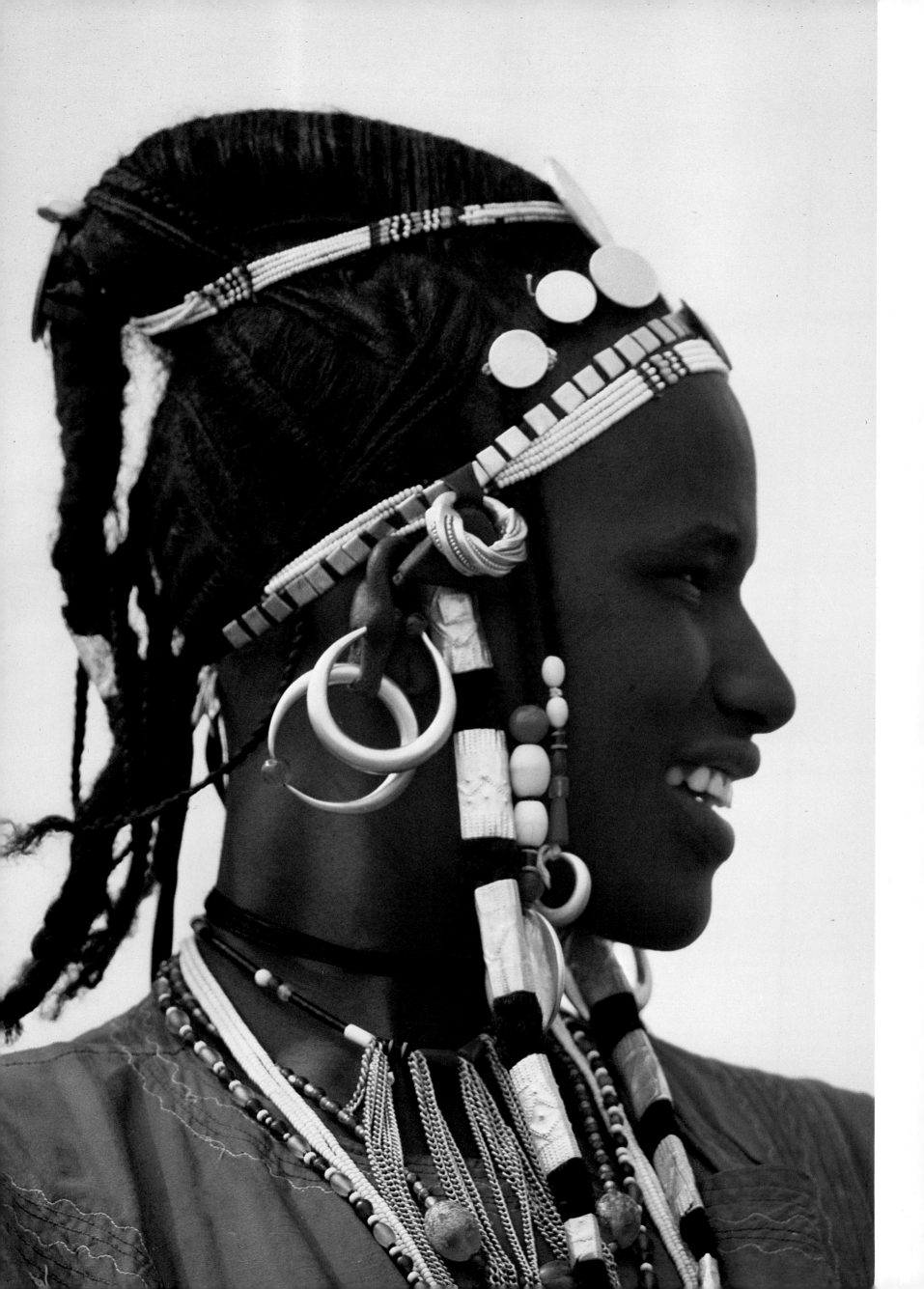

COINS AS ORNAMENTS

Maria Theresa dollars from Austria and French franc pieces, originally imported into Africa as currency, have been widely used across the savannah as hair decorations. They were also used by smiths as a source of high quality silver for making other items of jewellery (the Maria Theresa dollar is about 78 per cent proof). The Fulani of northern Upper Volta have crest-like hairstyles, sometimes padded with a piece of cloth inside, which they decorate with French francs while the larger Maria Theresa dollars are suspended from long plaits on either side of the face. The silver bracelets, hair rings and repoussé silver bands wrapped around the plaits are all made from the same melted-down coinage.

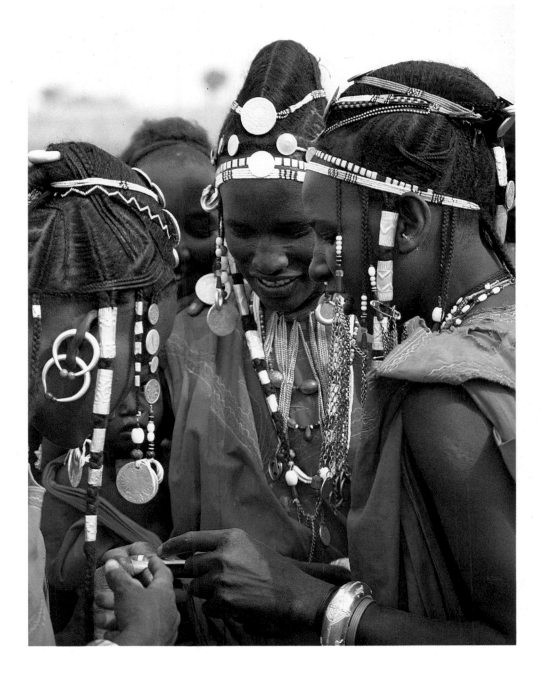

OVERLEAF ## ECHOED IN MINIATURE

The twelfth-century mosque of Jenné has been called a miracle of Sudanese architecture. While Timbuktu flourished in the Middle Ages, Jenné expanded as a sister city to become an important centre of Islamic religion and a prosperous port on the Niger River handling trade from all over West Africa.

Rings, pendants and hair ornaments seen in the savannah regions today have been influenced by designs that prevailed in the days of the great empires. Not only does the jewellery resemble ornaments of the imperial courts, it often echoes the sophisticated lines of the architecture that flourished under early Islamic influence. The collection of silver rings are worn across the savannah from Senegal

to Lake Chad: the finger rings 1 and 7 by Kanuri women in Nigeria, and 9, 10 and 11 by both Kanuri and Shuwa women. The larger finger rings are worn by men: 3 and 6 by Fulani in Mali, and 4 and 5 by Fulani in Nigeria; the latter were made by Nupe silversmiths. The crescent-shaped ring (2) is worn as an earring by Fulani women in Upper Volta, who also wear the twisted ring (8) as a hair ornament or pendant. (Largest ring 5cm)

173

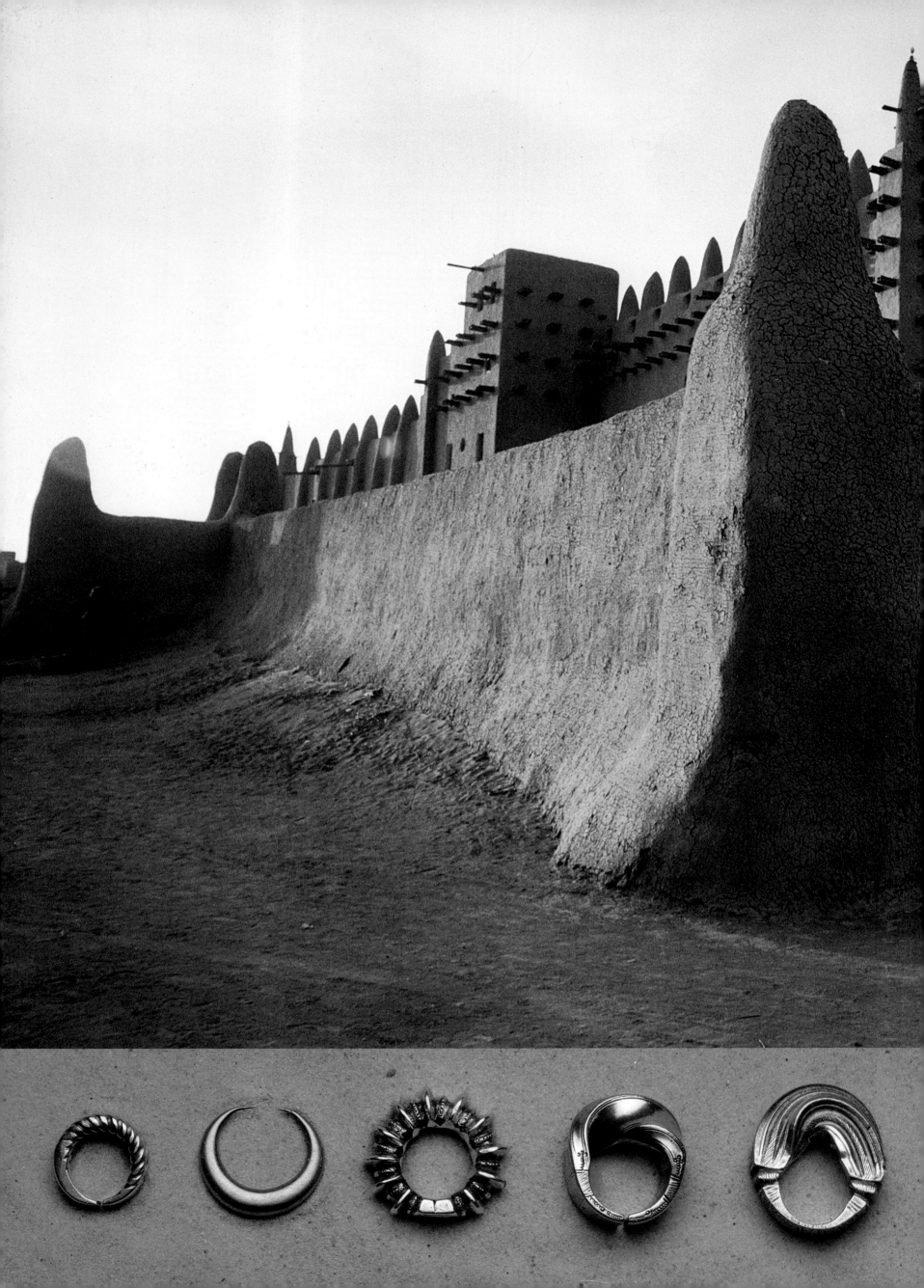

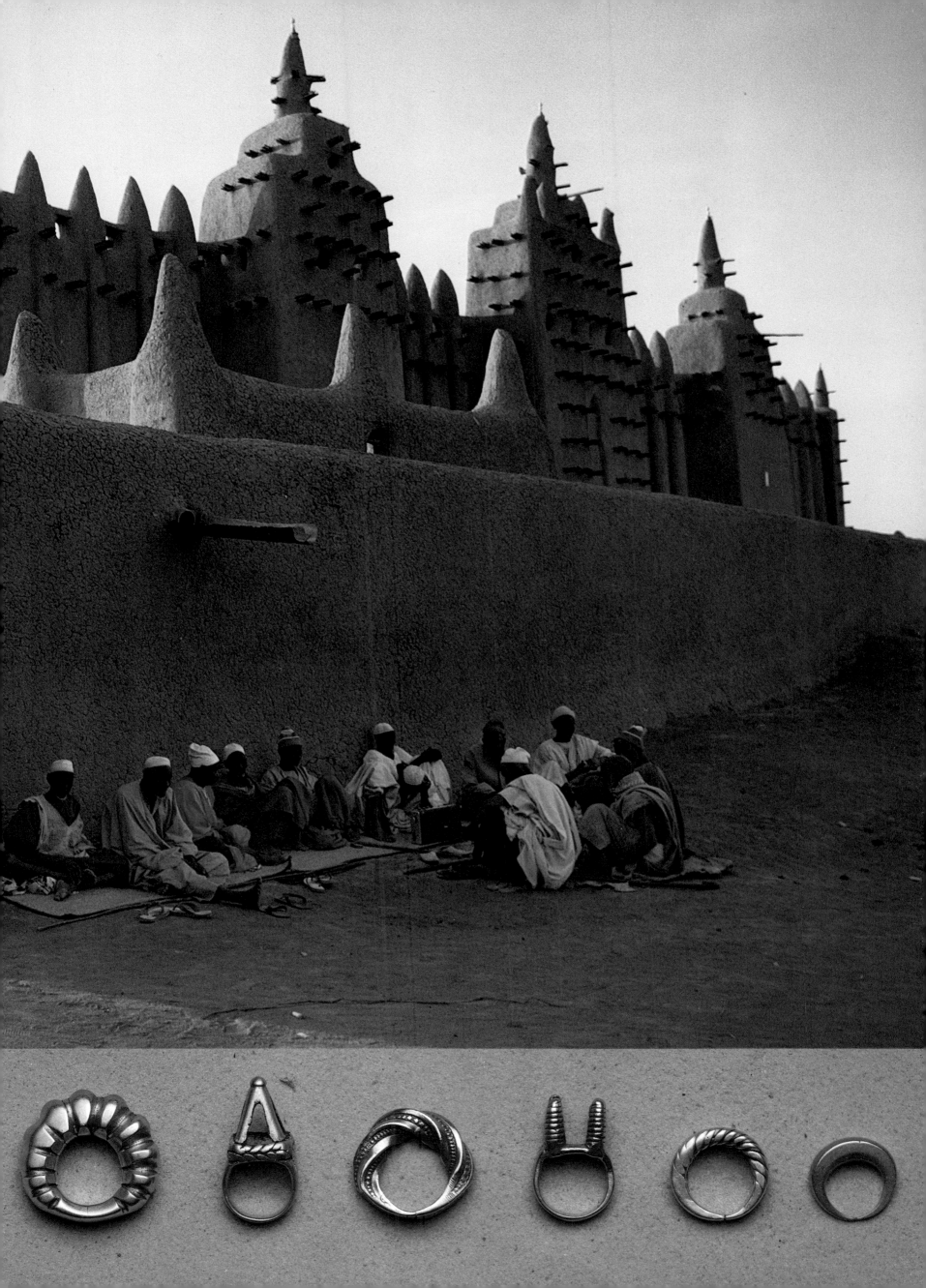

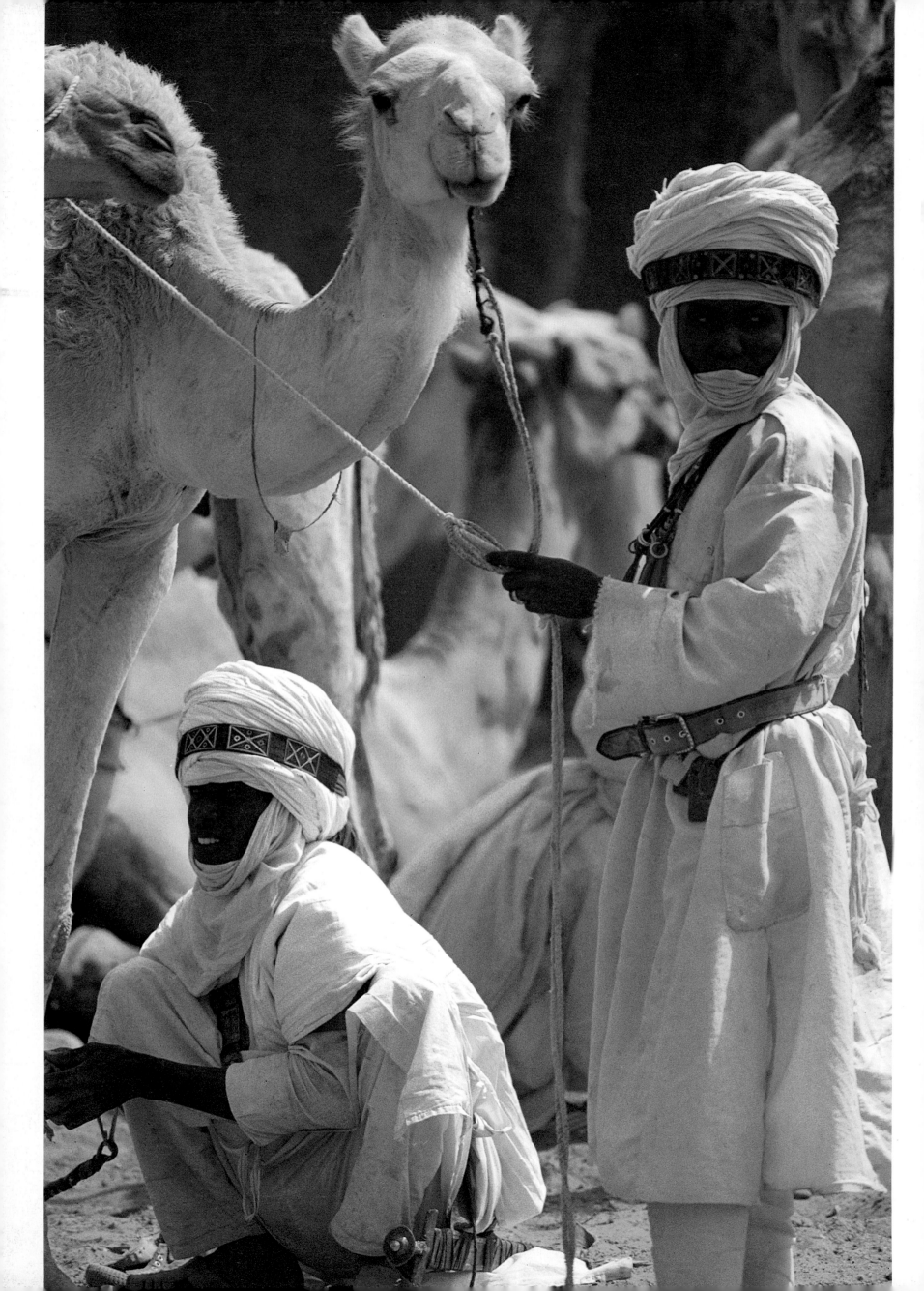

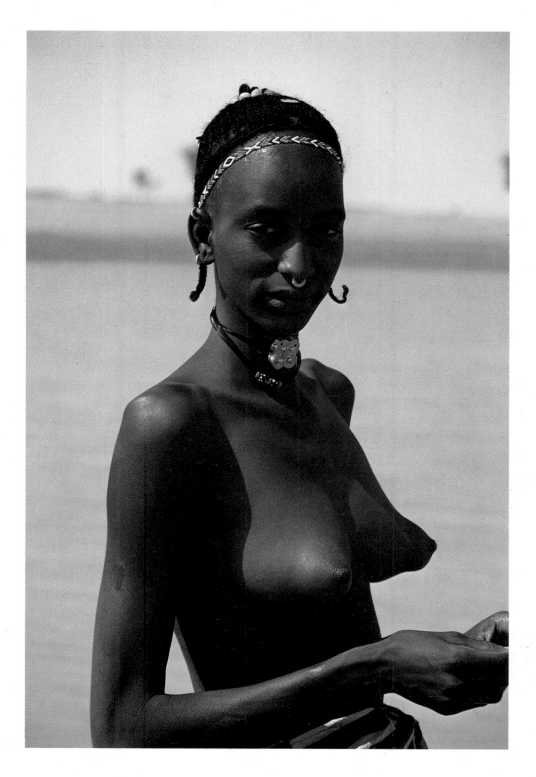

EXTREMES OF ATTIRE

In parts of the savannah bordering on the desert, turbans and voluminous gowns called *bou-bou* are worn, seen here on Bella herdsmen in the deserts of northern Mali. These clothes are traditionally worn to protect them against extremes of temperature, drying winds and vicious sandstorms, but the style has been adopted widely in the less harsh parts of the savannah, even by men settled in towns.

In the more southerly regions of the savannah clothing can be minimal when women gather by the river to do their chores. In public, however, they must be almost completely covered to conform to the code of Islam, wearing flowing headscarves and elaborate jewellery which also convey their wealth and social position.

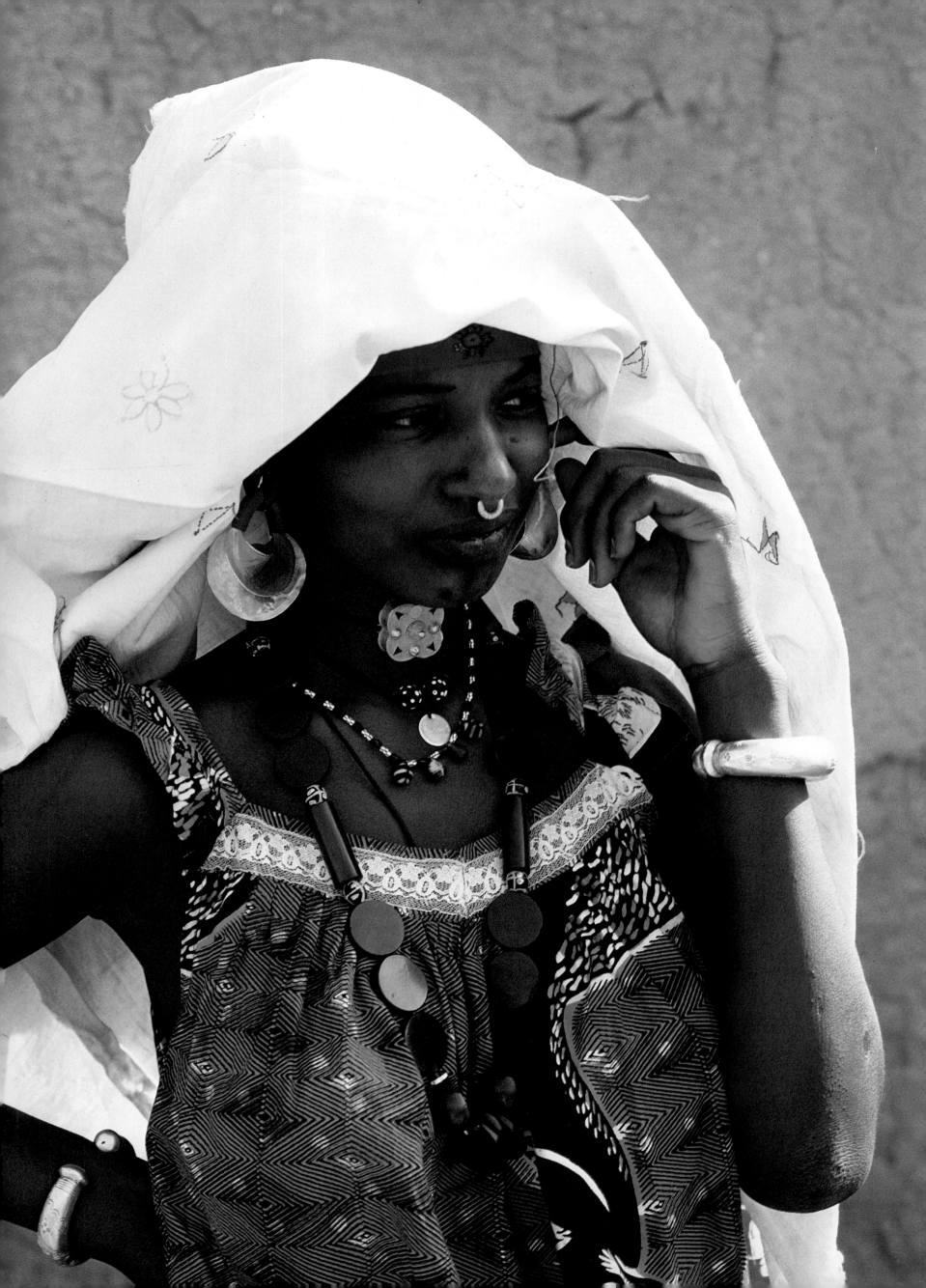

SYMBOLS OF WEALTH OR PROTECTION

BELOW This Fulani herdsman from Upper Volta wears a decorated leather box that contains Koranic verses or magical substances and acts as a talisman to protect him and his herds. His jewellery, made of shells, glass beads or buttons from the local market, is simple; his coarse handwoven shirt is in distinct contrast to the elegant *bou-bou* worn by settled Fulani.

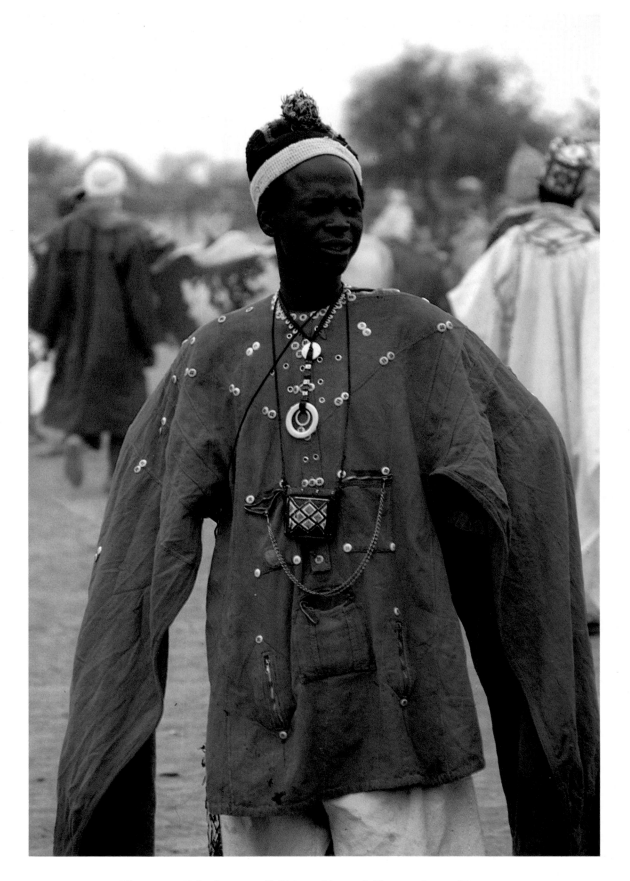

The young Fulani woman (*left*) is making a deliberate show of her wealth at the weekly market in Jenné. Her nose ring, earrings and neck pendant are gold, her bracelets silver and her necklace made of European glass beads. Many wealthy women of Jenné are financially independent of men; they inherit gold jewellery, and every woman has her own herd. Jenné goldsmiths learned their filigree technique (seen in her neck pendant) from Moroccan Jewish goldsmiths who settled in Walata in southern Mauritania. Gold, found extensively in northern Senegal at the time of the old Ghana Empire, has been handed down over the generations, and is found in the same area today, although in much smaller quantities.

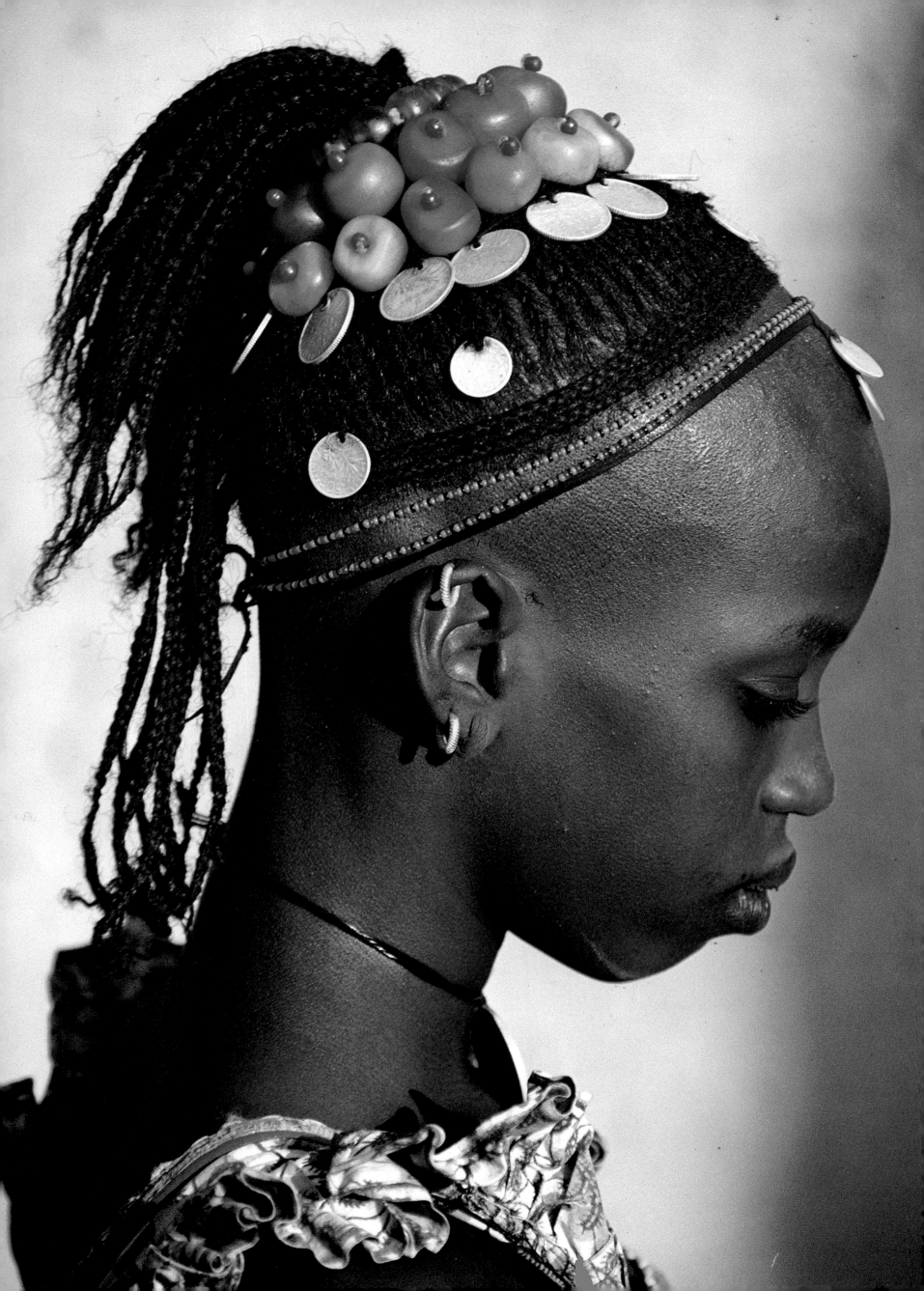

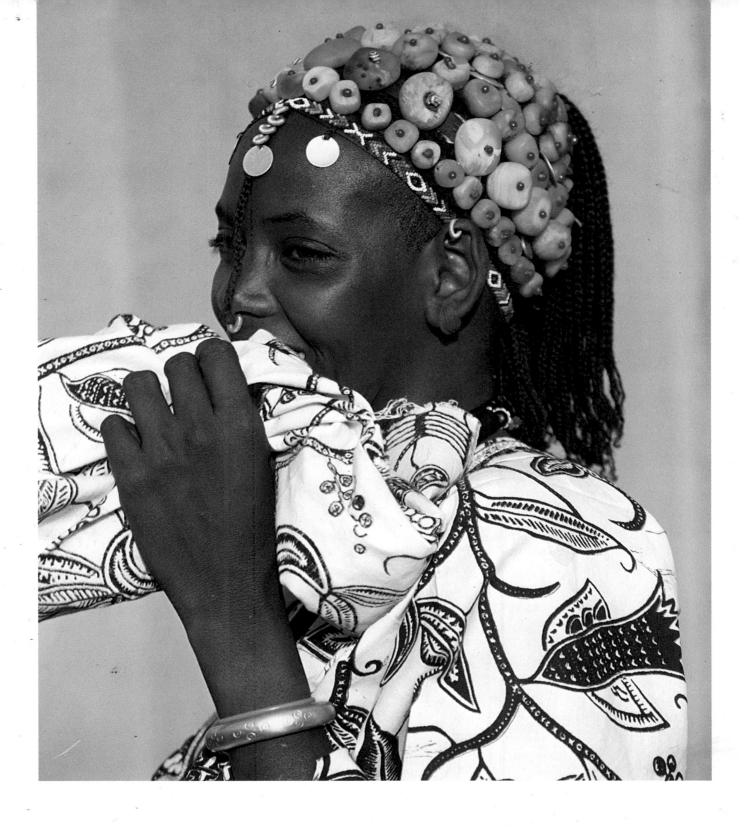

AMBER AND GOLD

South of the Niger bend in Mali live some of the most well-to-do Fulani. Their prosperity is founded on the river which provides a reliable source of water for crops and herds. These Fulani invest their wealth – and display their status – in amber and gold. Skullcaps of amber (*opposite and above*) are worn in the vicinity of Jenné by unmarried Fulani girls from herder families while those whose families cultivate the land wear bead necklaces of amber, jasper and agate. Originally from the Baltic, amber was traded across the Sahara.

Once married, a girl will wear large gold earrings called *kwottenai kanye* (*below*) and, in place of the skullcap, several large amber beads.

OVERLEAF Especially large *kwottenai kanye* are worn by Fulani women in the towns of Mopti and Jenné. They are received by a woman either on the death of her mother or as a gift from her husband who often has to sell cattle to be able to afford them. The top of each earring is bound with red wool or silk to protect the ear, and the blades are incised with patterns, some of flowers, others of cattle. They are usually made of 14-carat gold and today the largest are valued at between £1500 and £2000 according to the weight of gold, the craftsmanship being of little monetary value. They are made by local smiths: a bar of gold is chiselled and after heating in the fire is hammered into thin blades and twisted into shape. Small gold rings and earrings (*overleaf, left*) are sewn to the hair and used to decorate the ears, and the teeth are capped in gold. Beside the silver finger ring is an agate one of *tanfouk* design. The necklace is composed of segments of white tree roots, valued for their magical properties.

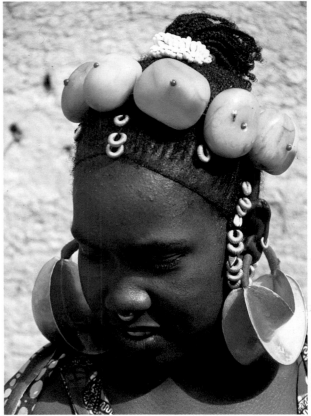

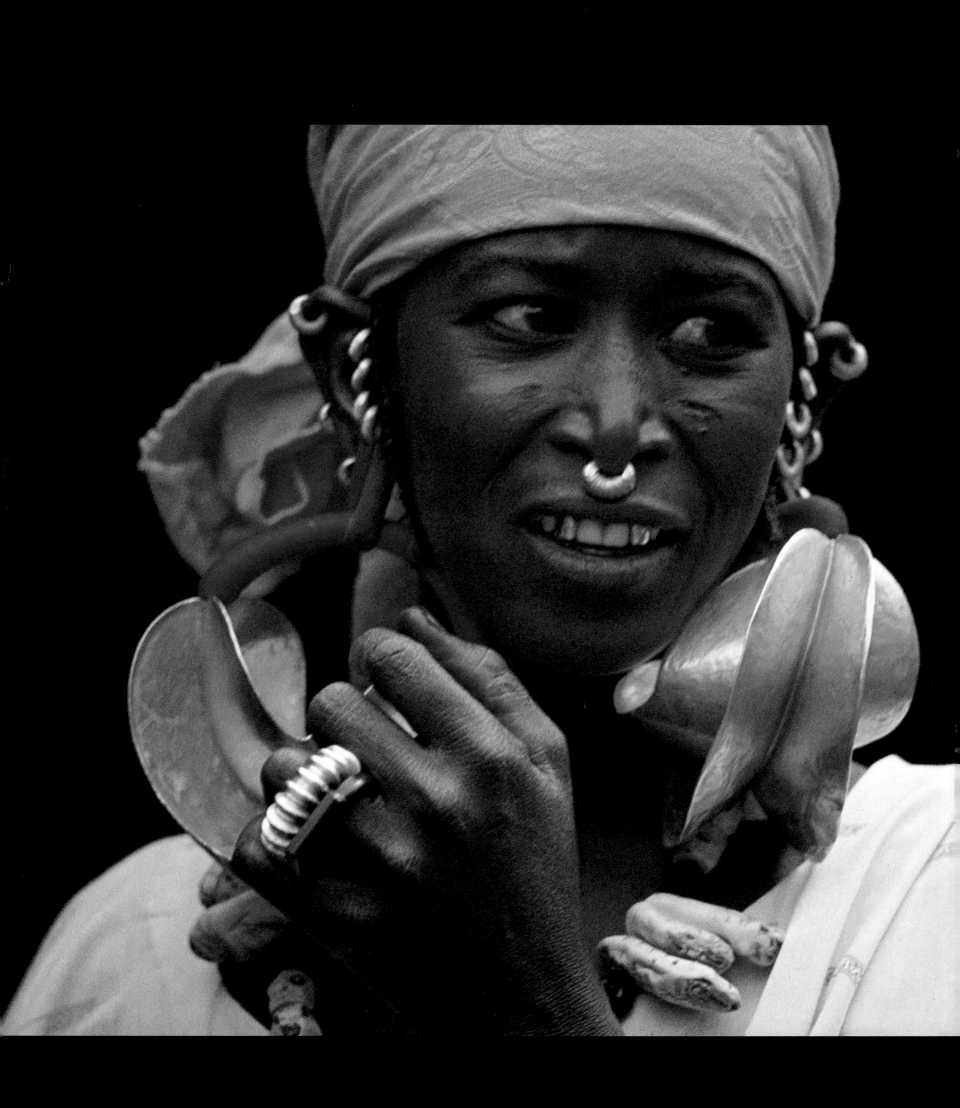

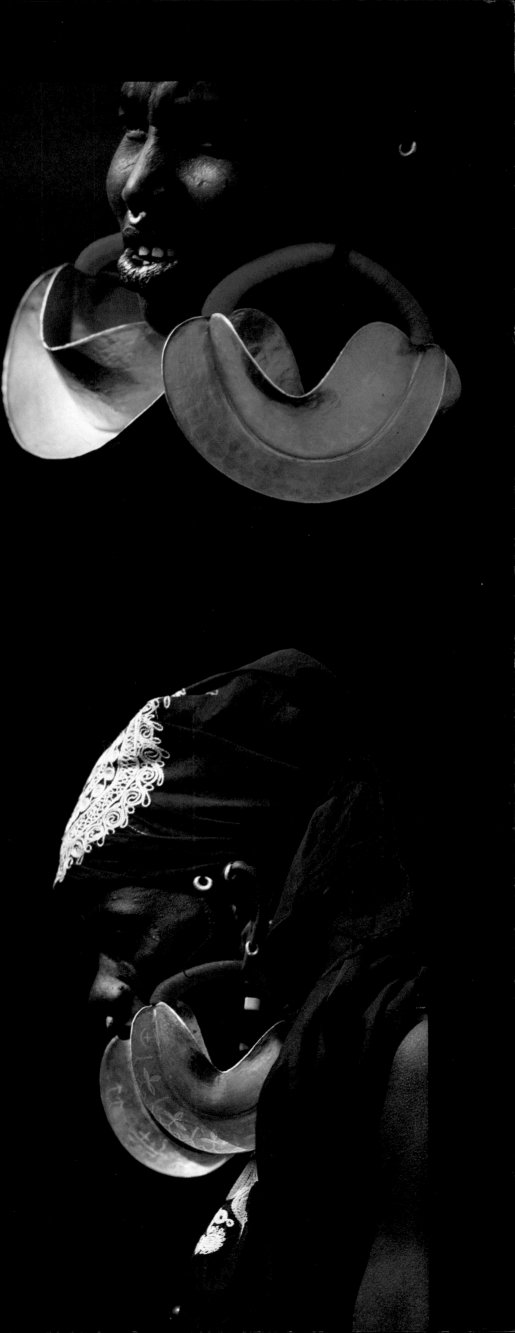

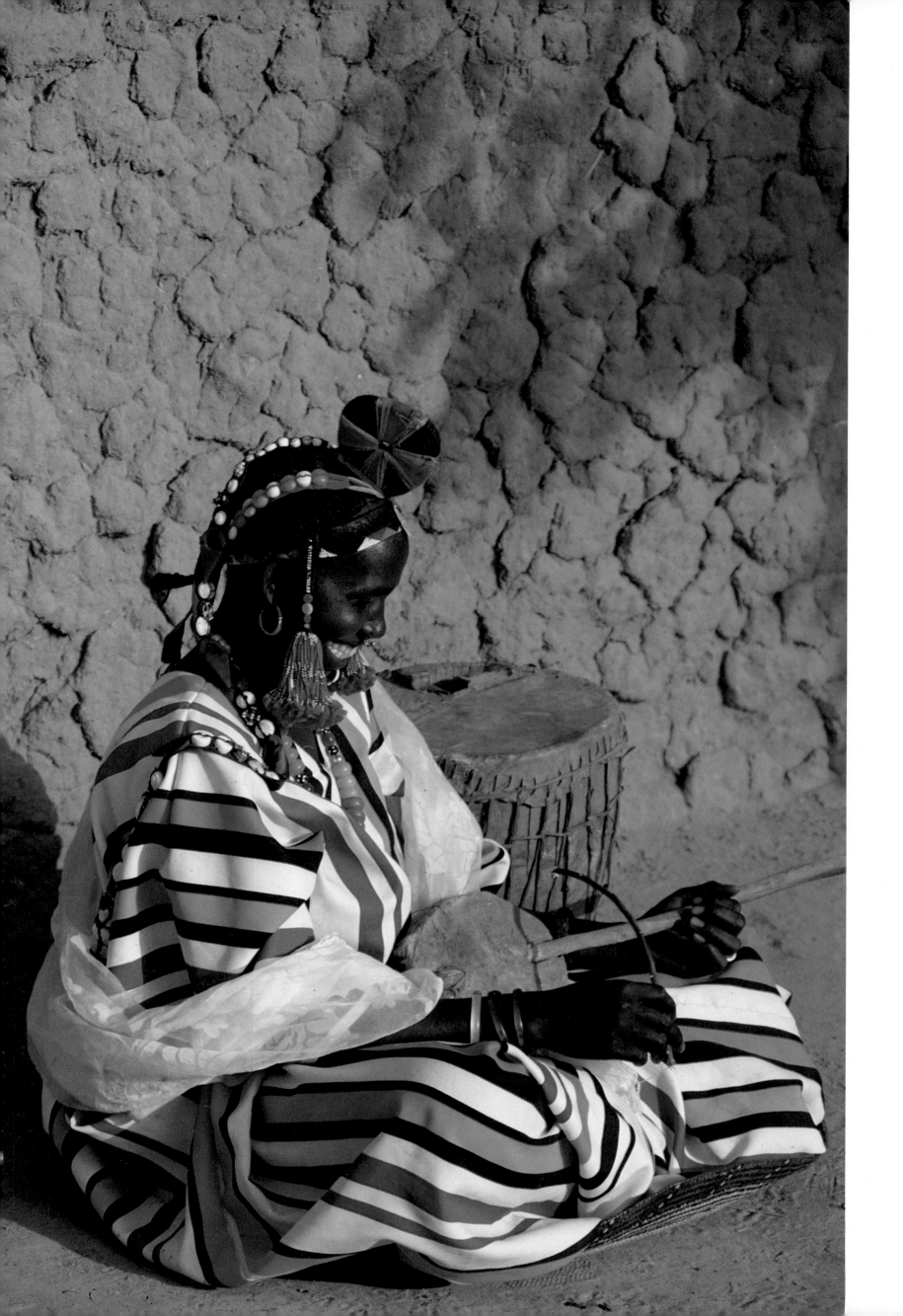

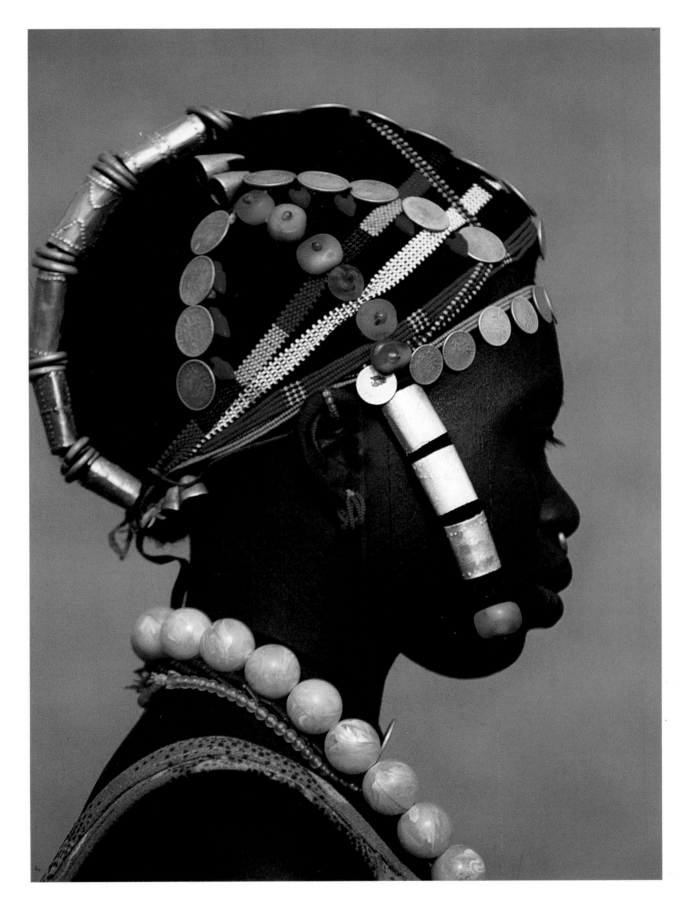

IMPERIAL HERITAGE

The remarkable coiffures of the Songhai women of
Timbuktu and Gao in Mali are reminiscent of the sophi-
sticated styles of the Songhai Empire which held sway
for 600 years until the end of the sixteenth century.

LEFT A Songhai musician entertains outside the court in
Gao. Her hairstyle is one also worn by married Songhai
women on festive occasions: the *zoumbo*, the circular
woollen disc at the front, was a feature of imperial
coiffures and the shells, brass and amber bead decorations
are reminders of the old decorated horse harnesses. The
triangular *tanfouk* pendants of carnelian imported from
India, worn here at the back of the head, have always
been valued by the savannah peoples who believe they
offer protection from the evil eye. Bunches of glass beads
worn over the ears now replace the coral and pearls that
were used in the past.

The Songhai woman (*above*) from the Bandiagara Plateau
in Mali wears this elaborate hairstyle incorporating brass,
copper, silver, amber and coloured glass ornaments every
day. Many Songhai women still possess valuable amber
necklaces, but this one is of imitation European beads.
Likewise, the brass and copper of her hair ornaments
probably replace the more traditional gold. Crests of hair
and decorated plaits worn at the side of each ear by
Fulani women are believed to be of Songhai origin.

VARIATIONS IN STYLE

Jewellery worn by women right across the savannah is focused upon the hair, in a wide variety of regional styles. For the Fulani woman from Upper Volta (*below*), white shell beads attached to the end of each plait at the back of the head signify wisdom and serenity.

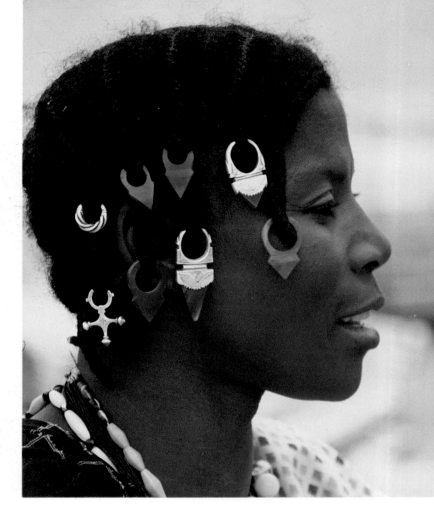

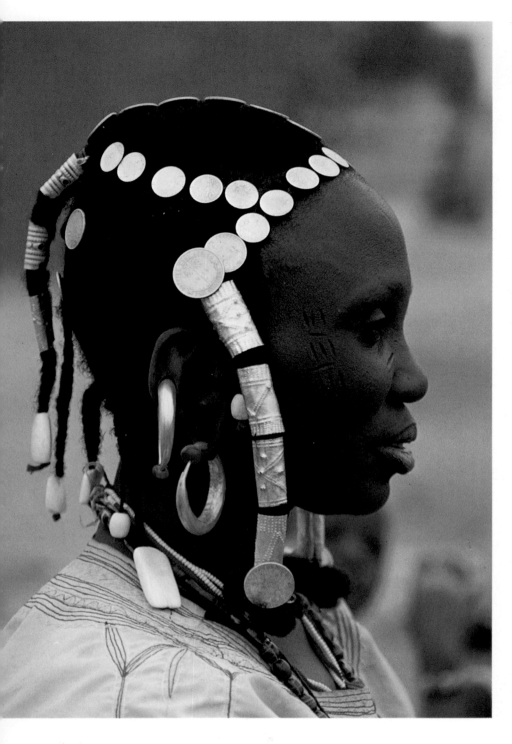

The silver coins indicate her family's wealth. The poorer Bella (former slaves of the Tuareg) replace these coins with glass buttons, beads and nickel coins, like those seen below right and opposite.

The Bella, of part negroid blood, have short, tightly curling hair which they braid finely all over the head. In order to make it appear longer and thus enhance their beauty some women, like the one opposite, wear a band of giraffe hair.

Much Bella jewellery shows the influence of their former masters. An unusually wealthy woman from Mali (*above right*) wears glass and carnelian *tanfouk* pendants in her hair, small versions of the Agadez cross, and silver rings set with carnelian (traditionally men's finger rings), all of which are Tuareg designs.

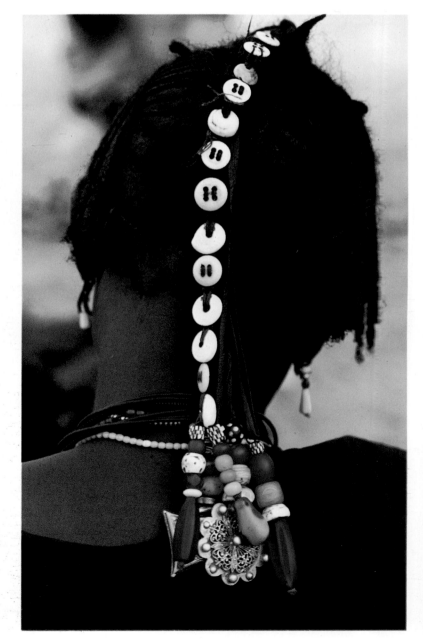

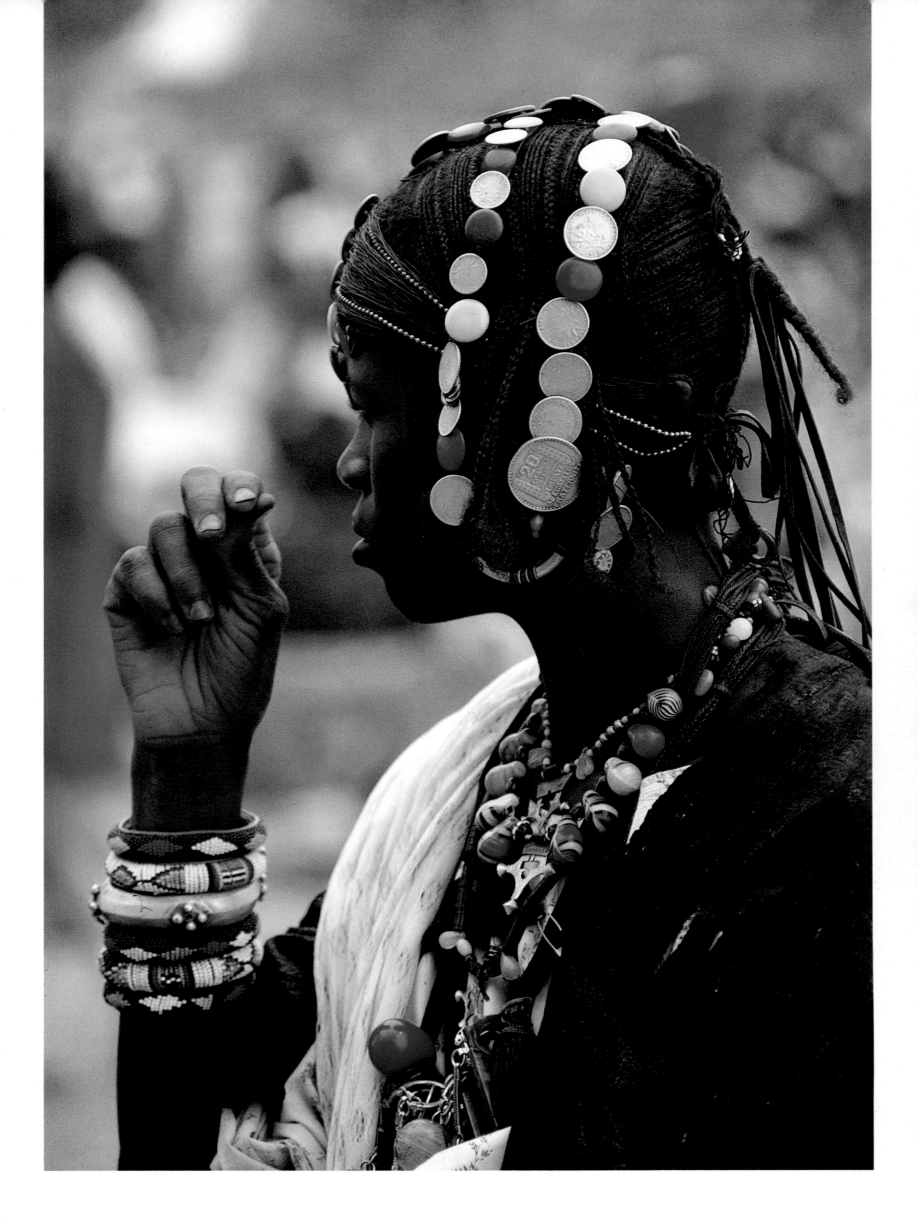

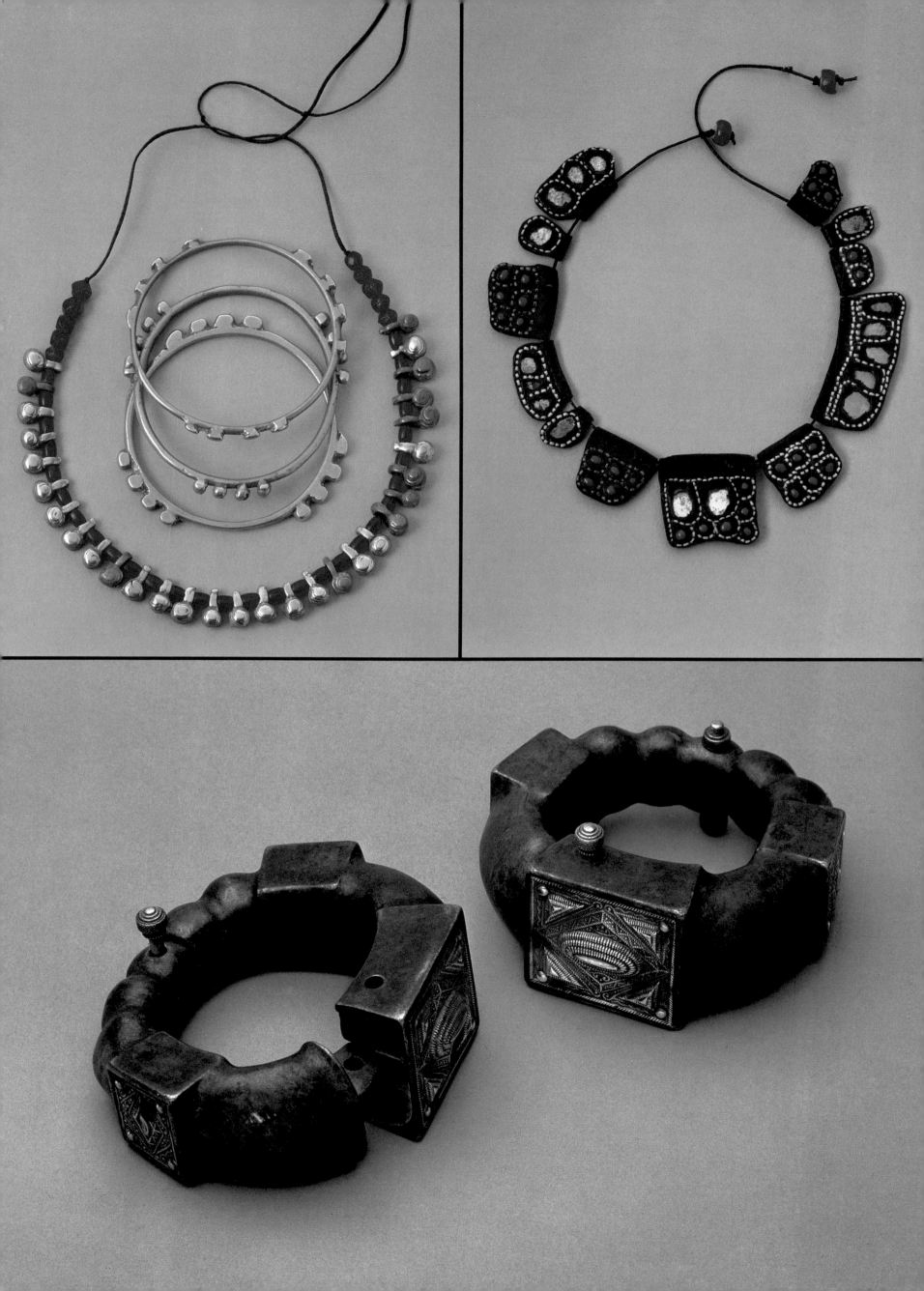

SAVANNAH JEWELLERY

The brass bracelets and necklace of brass pendants and red glass beads (1) are worn by nomadic Fulani in northern Nigeria, as is the necklace (2) of leather pendants stitched with cotton, with appliquéd mirrors and red seeds. The mirrors are believed to protect the wearer from the evil eye. The aluminium anklets (3) have thin plates of gold, finely worked in a repoussé technique, riveted to the front and sides. This is an old design for a woman's anklet, first recorded in Timbuktu, though similar ones are seen today in Mauritania. Beads of finely woven plastic thread, traditionally made of leather, (4) and a silver pendant attached to a leather tab are threaded onto leather thongs and worn by Bella women in northern Nigeria. The design of some silver and aluminium pendants worn by the Bella curiously does not appear to be influenced by other styles found in the savannah.

The necklace of cowrie shells (5) is worn by Fulani, both men and women, in Upper Volta. Cowrie shells from the Indian Ocean were brought across the desert via Chad in abundance during the Middle Ages. They were used as a form of currency in exchange for gold and slaves, and were still in use in the 1940s as change in markets. The five pieces of shell set in a leather pendant on the Bella necklace (6) represent the five fingers of the hand. This stylized hand, *khomissar*, is a Tuareg design showing the influence of Islam, and is worn by both Tuareg and Bella in eastern Mali. (1: bracelet diameter 8cm, 2: long pendant 7.5cm, 3: diameter 15cm, 4: tab 8cm, 5: cowrie pendant 5cm, 6: pendant 8.5cm)

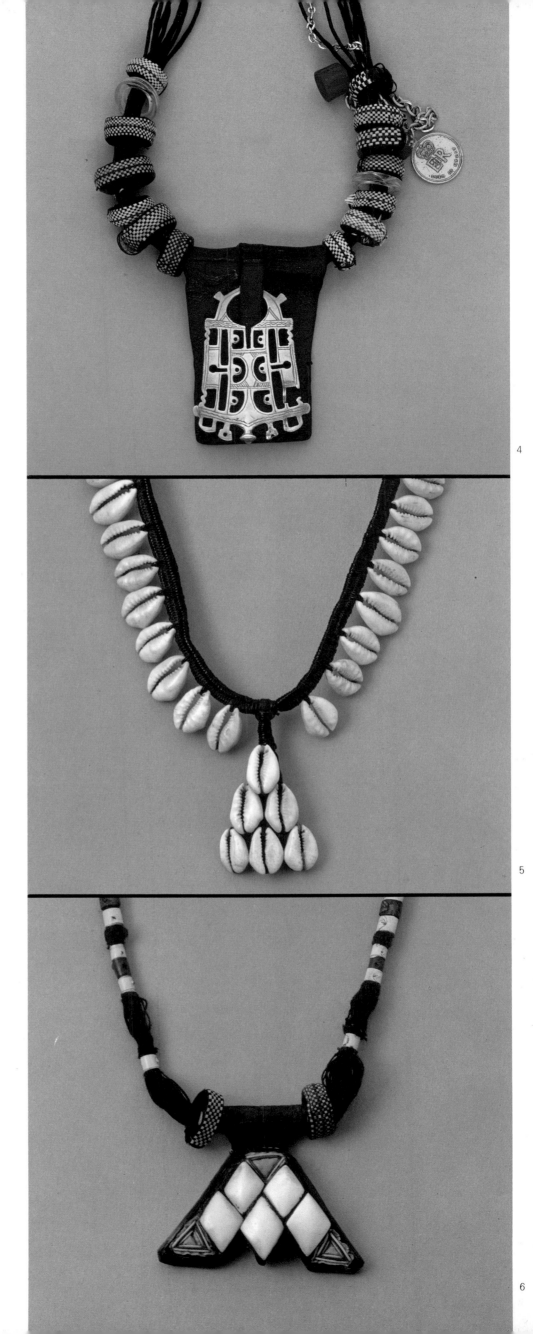

4

5

6

189

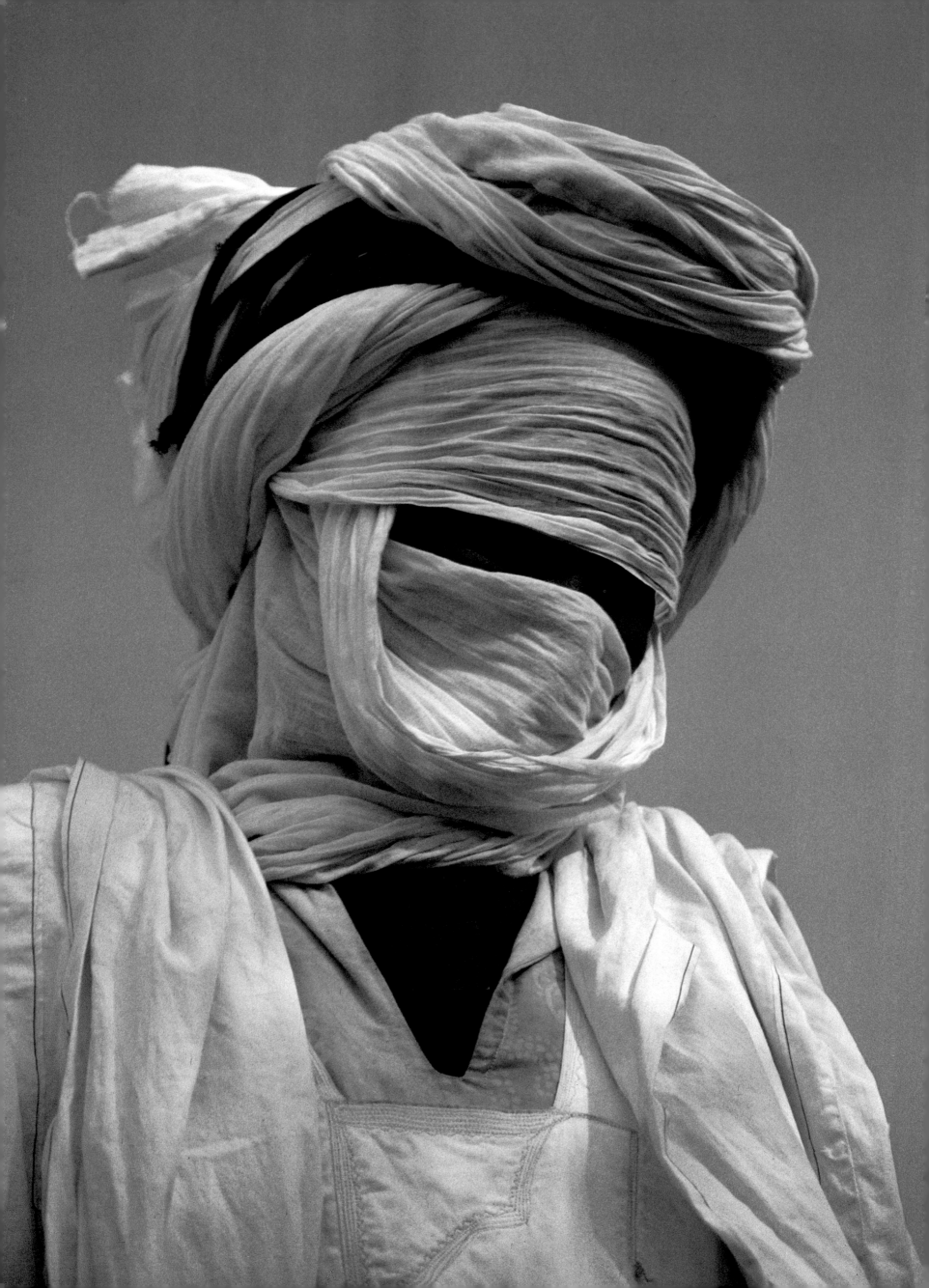

The Touaregs, who are the Berber lords, were haughty beyond words. Few came to town except on some special occasion, such as a visit of the Governor General or a great market week. Then you might see them mounted on camels or horses hung with sumptuous leather fringework. If they deigned to look down on you, it was with a stare in which fearless hostility and fearless curiosity seemed at a hair trigger balance. Since they swathe their heads in a turban and veil the lower part of their faces, all you see of them is their eyes, which are the most remarkable in both colour and setting I have ever seen. At one instant you would see them jet black, only at the next to see them full of golden gleam; and they are big and set wide apart under noble brows, deep and fringed with thick lashes.

Leland Hall. *Timbuctoo*, 1934.

THE SAHARA

Dictates of the Desert

No stranger can fail to be affected by the dramatic beauty and sheer grandeur of the Sahara – the largest desert in the world. Yet, apart from an occasional small oasis this is an infertile region, hostile to most forms of life. Mile after mile of shifting sand dunes and gravel plains are interrupted only by barren plateaux of sandstone or volcanic rock and dry river beds. At night temperatures can drop to below freezing point, and during the day sand hangs on the hot wind, blotting out the horizon.

This inhospitable terrain is the home of the Tuareg and the Moors, both descended from the ancient race of Berbers, some of whom trekked southwards into the desert about a thousand years ago, to escape the Arabs who were invading their fertile lands in North Africa. The Tuareg crossed the plains of sand and gravel in northern Algeria, finally taking refuge in the central mountains and the less arid land to the south along the borders of Mali and Niger. The Moors travelled across the vast stretch of Mauritanian desert to the west, called Shinguit by the Arabs, the majority reaching the desert fringes of the south near the Senegal River where the sand dunes were more stable and where they found scrub and summer grass.

Today, the contrasting dress and jewellery of these two peoples reflects the way in which their lives evolved. The Tuareg refused to integrate with other desert tribes and remained fiercely independent, maintaining their Berber ways and characteristic bold, and simple designs. The Moors on the other hand intermarried – first with local negroid people from the western savannah and later with the Arabs; their traditional designs were influenced by both, but in particular by the flamboyant heritage of the Arabs.

To provide themselves with transport in the desert the Saharan nomads took up camel breeding and produced magnificent beasts of burden which they later used in their great trans-Saharan caravans, carrying slaves, gold and ivory to the Mediterranean and returning with salt and other goods from Europe and Arabia. With this freedom and mobility they became the lords of the desert, renowned for their bravery in war, their fierce raids on other tribes and attacks on camel caravans. Bands of Tuareg would suddenly appear out of the sands; cracking their whips through the savannah markets they would chase the traders, steal their

A Taureg of Niger.

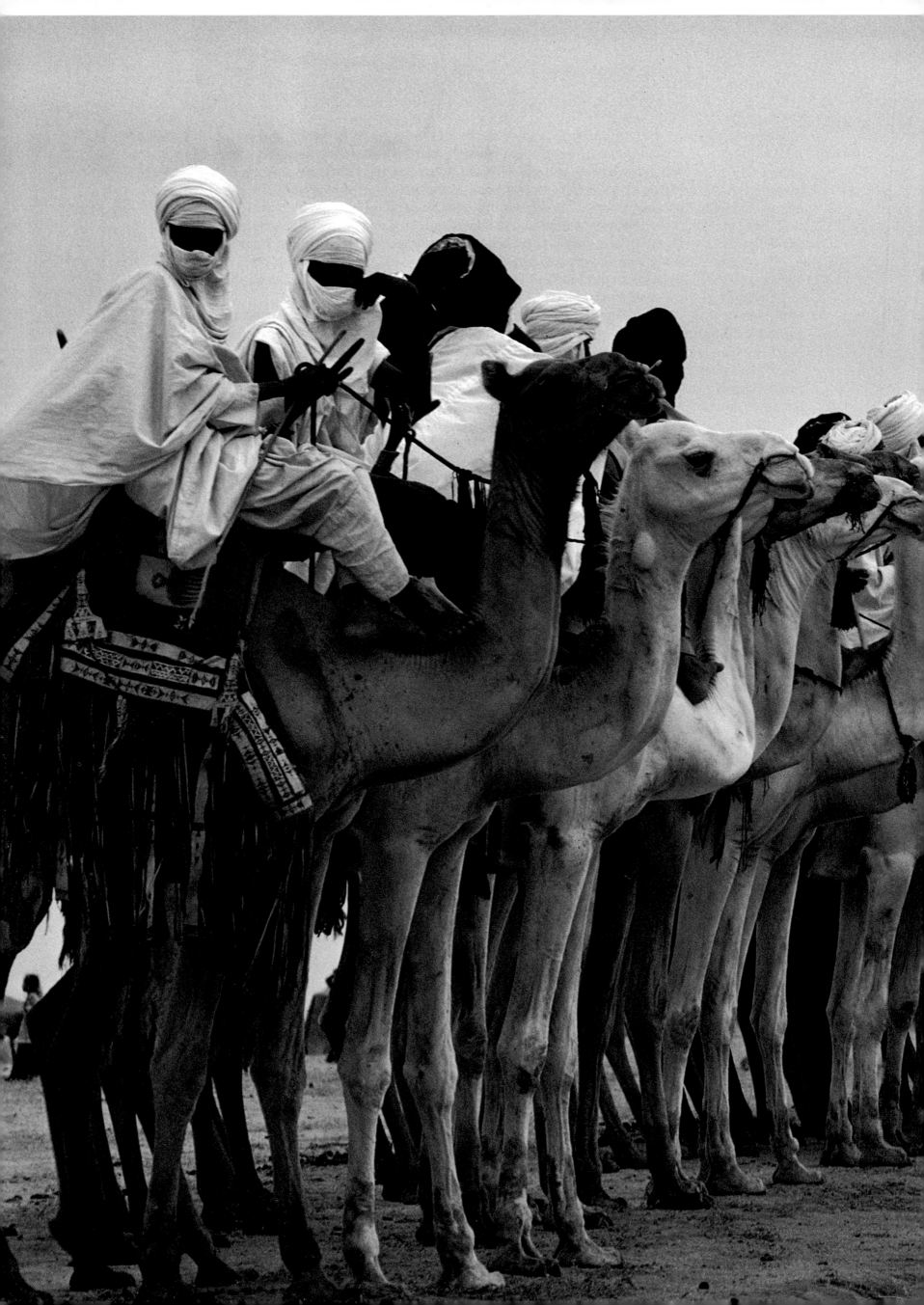

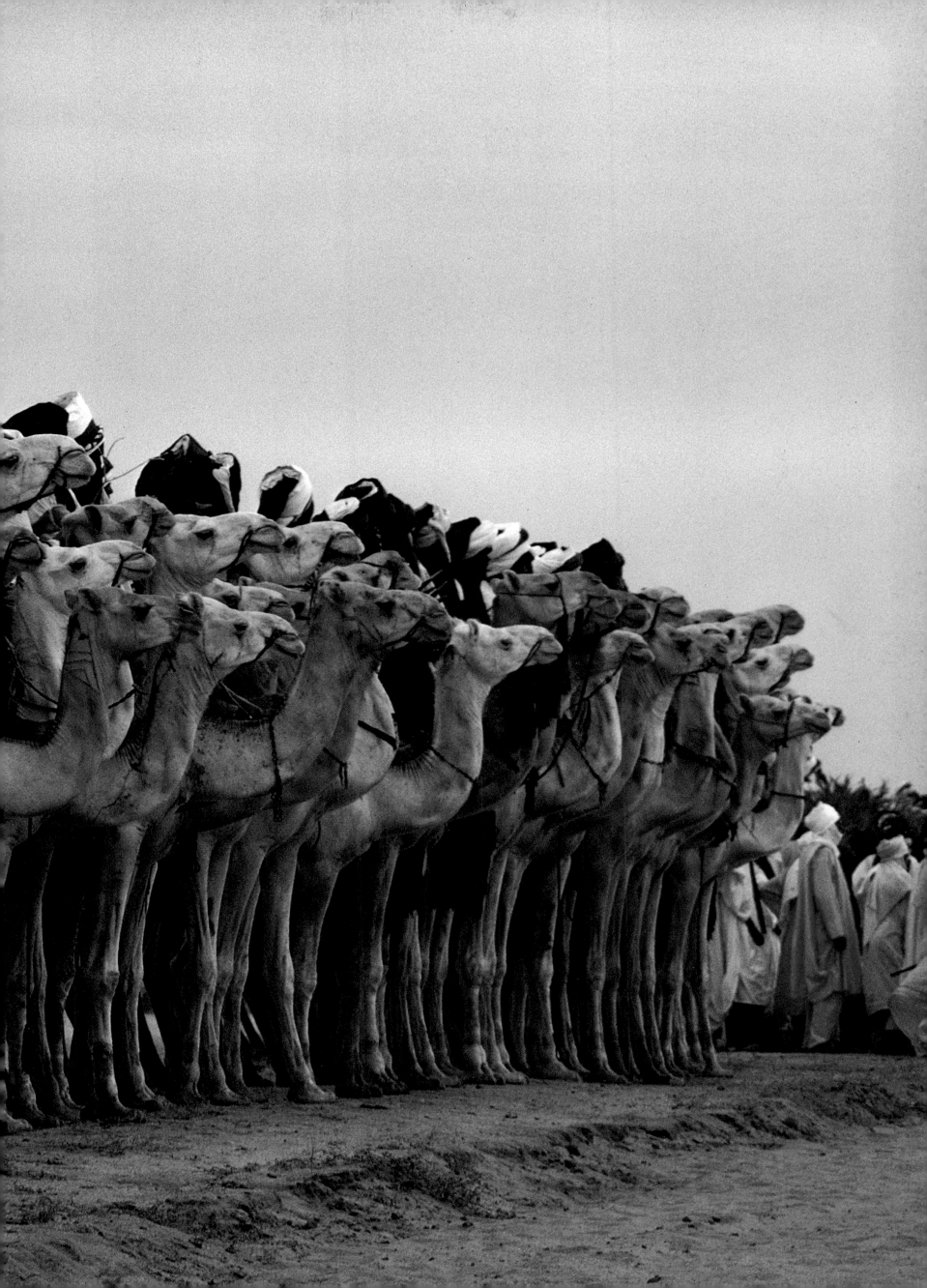

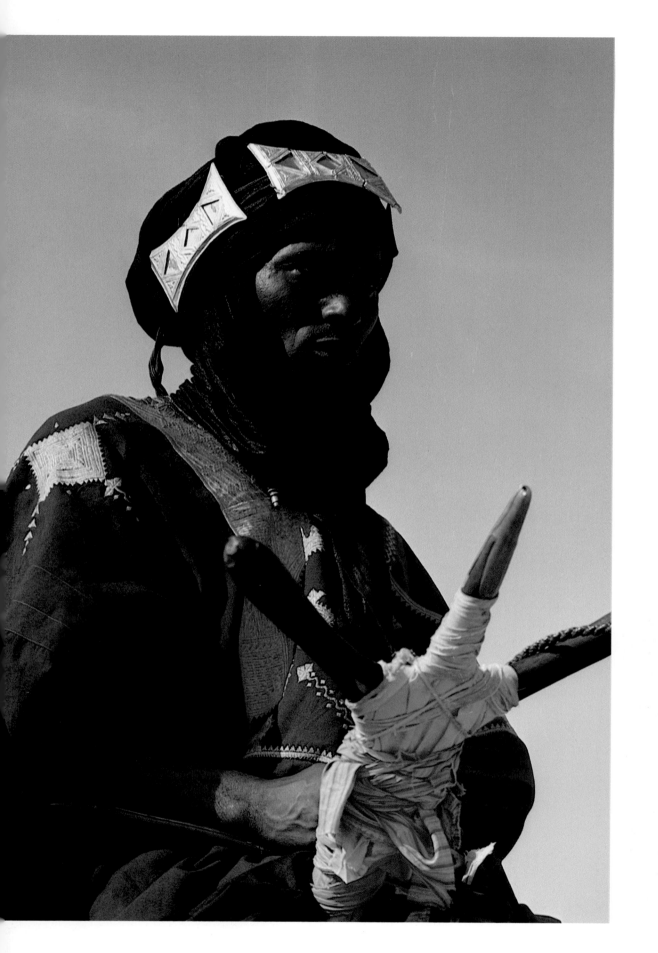
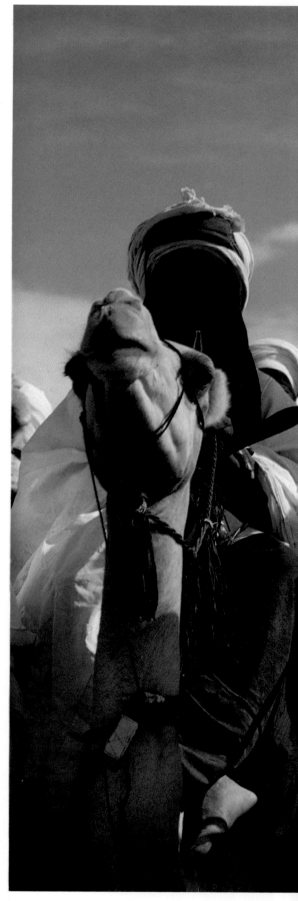

THE CURE SALEE FESTIVAL

Once a year, in the vicinity of In Gall in northern Niger, the Tuareg and Wodaabe nomads who graze their camels and cattle in this area of the Sahel meet to celebrate the *Cure Salee* festival. The rains, in August and September, bring to the surface of this very saline soil the salt necessary for the animals' diet, and after the first rains 300 or so of the nomads gather so that their beasts can benefit from the fresh grass containing this salt. They celebrate their meeting with dancing, singing, feasting and camel races.

PREVIOUS PAGE At the start of the festival the nomads line up on their best riding camels. The Tuareg are more formal in habit and dress than the Wodaabe, having accepted the restrictions of Islam and the rigid conformity imposed by desert life. The various Tuareg tribes are differentiated by the type of cloth used by the men for their veils, *tagelmoust,* and the exact way in which these are worn indicates the men's status.

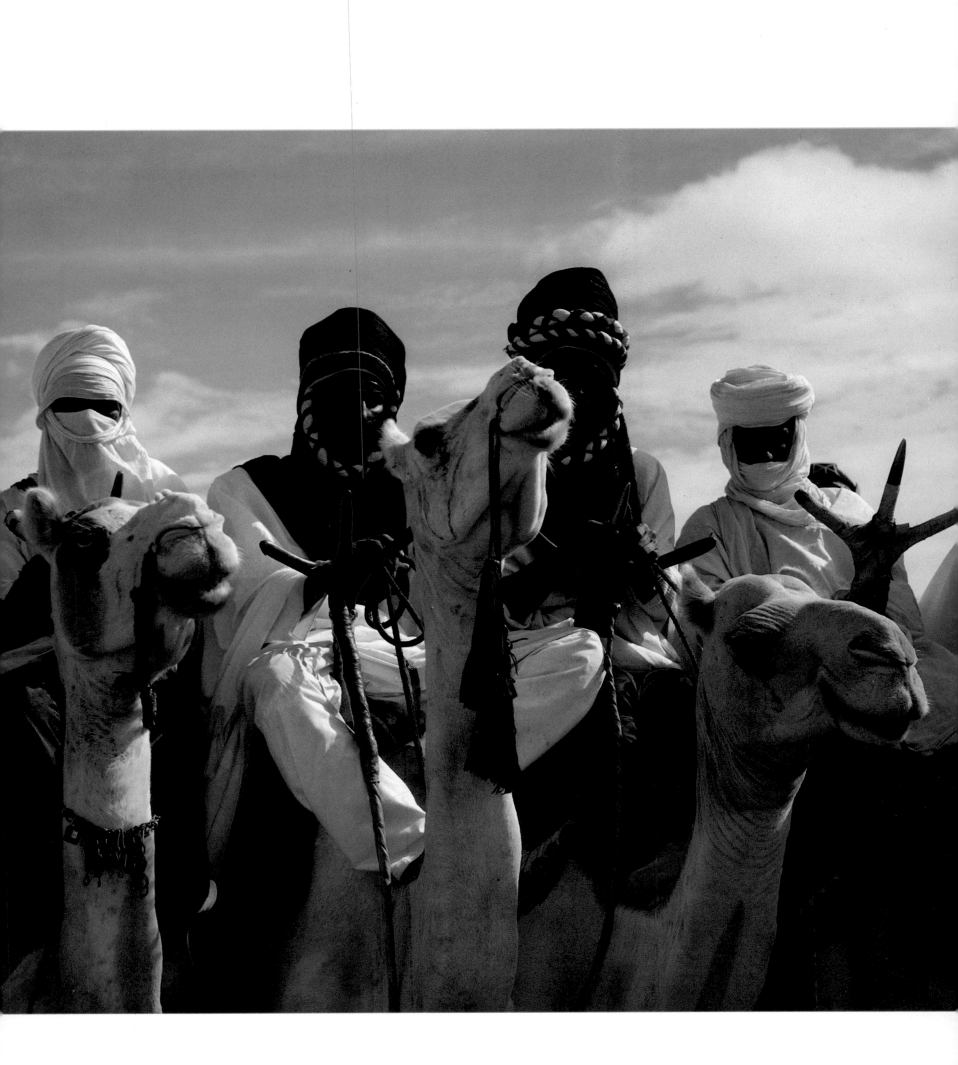

The *tagelmoust*, a strip of cloth 20 feet long, protects them from the heat of the desert and the blowing sand, but even in camp it is seldom removed and when a man drinks he passes the cup under the veil so as not to reveal his mouth. Tuareg men are veiled from puberty onwards: some, like the man on the left in the above group, wear cloth amulets attached to the *tagelmoust*; others of greater nobility (*left*) have amulet boxes, *tcherot*, made of brass and copper, or silver.

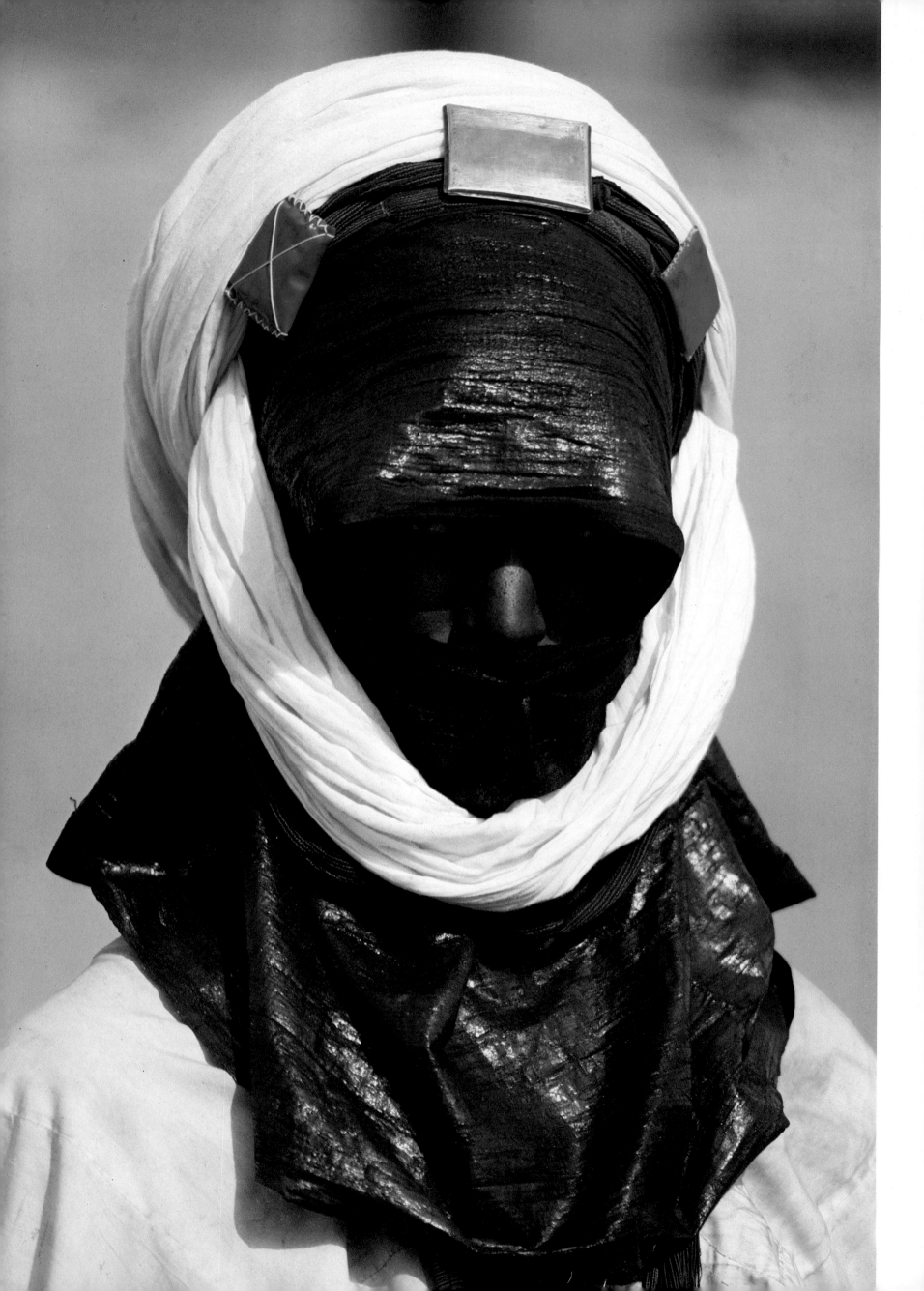

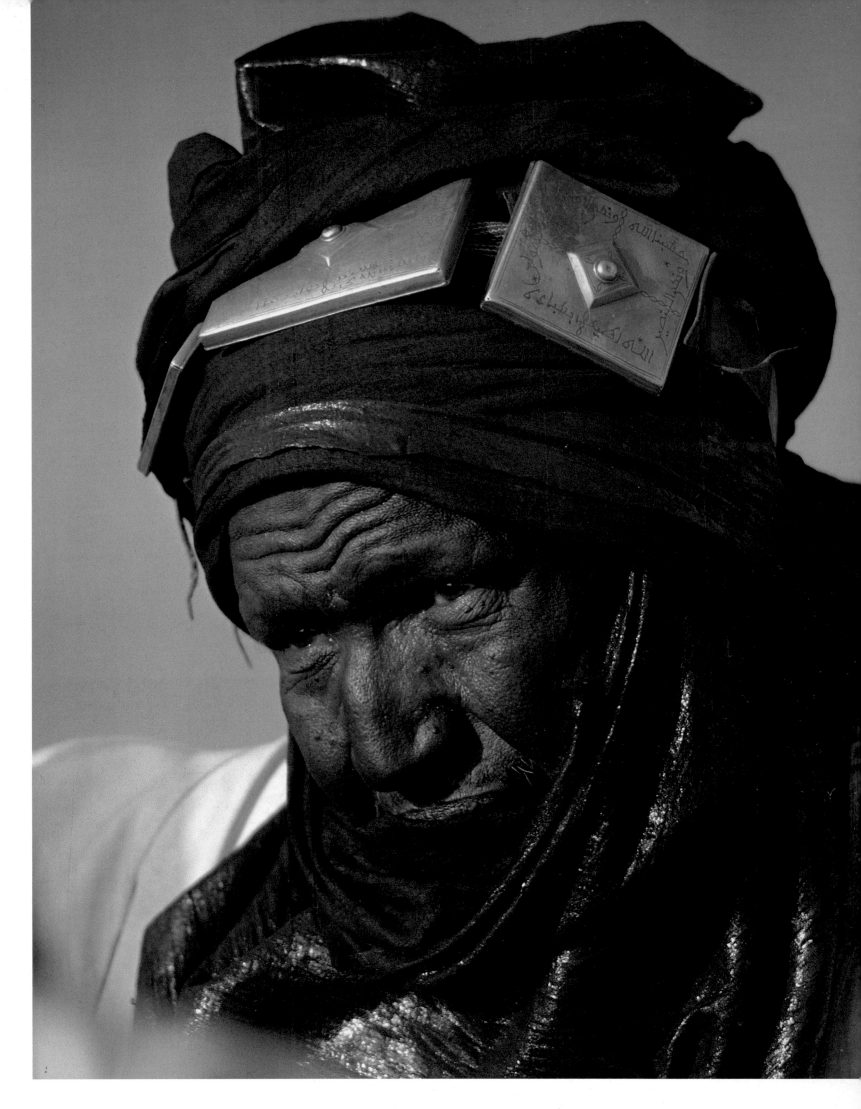

DESERT VEILS

The higher the social standing of a Tuareg the more concerned he will be to conceal his face on meeting strangers. He will make certain that he does not reveal the tip of his nose, and will often hitch the *tagelmoust* so high that only his eyes may be seen. Wealthy men wear veils of deep indigo cloth which has a metallic sheen as a result of the dye being beaten rather than soaked into the fabric due to lack of water. The dye easily rubs off and permeates the skin, earning the Tuareg the name 'Blue Men of the Desert'. This dyeing adds an element of status, for in the desert indigo, being costly, represents wealth.

ABOVE Hamadaba Muhammad, chief of a faction of the Niger group of Tuareg living in Mali, has three beautiful brass *tcherot* attached to his *tagelmoust*; the front one is inscribed – a further sign of prestige.

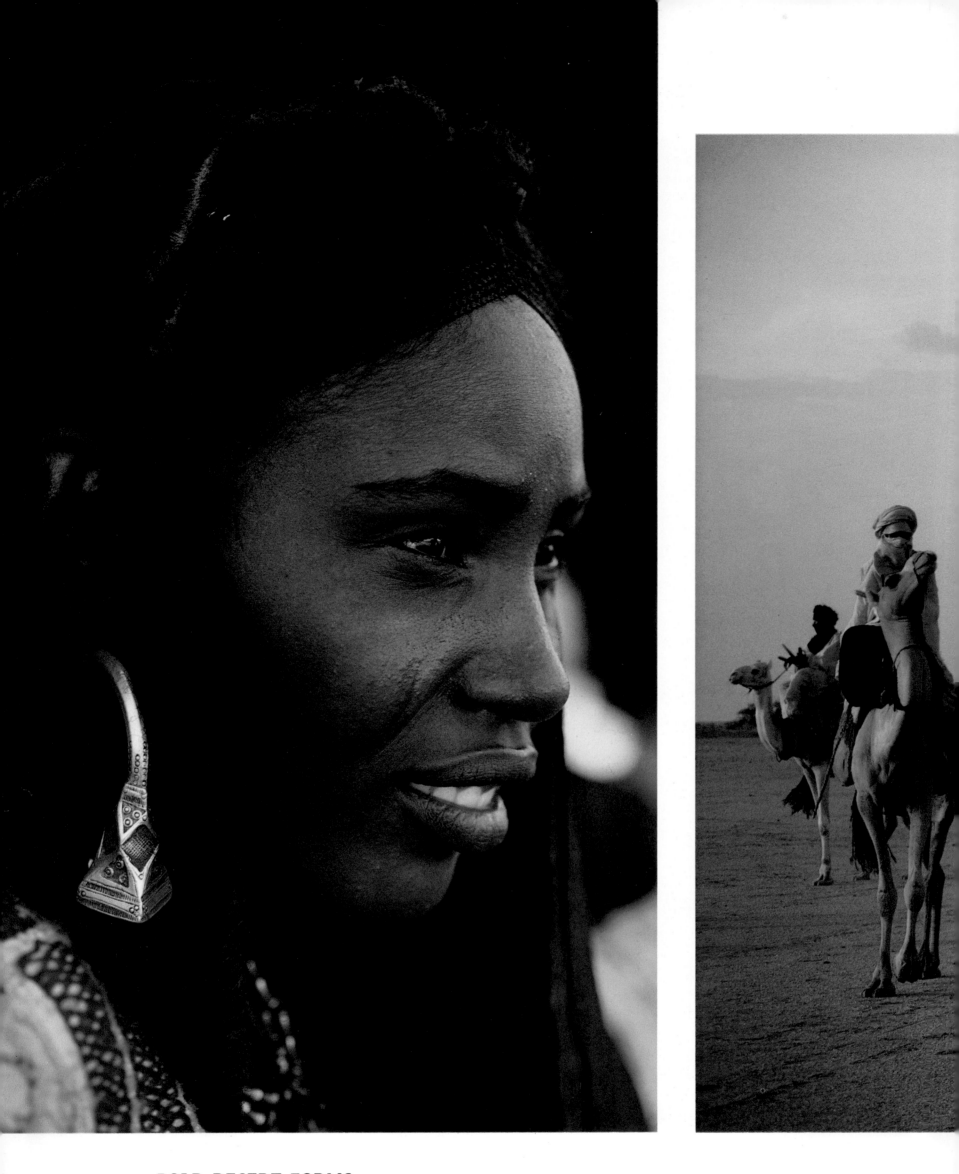

BOLD DESERT FORMS

Tuareg life is austere, in keeping with their environment, and rigidly stratified. This is reflected in the clean-cut, geometric lines of their jewellery which over the centuries has expressed the singularity of the Tuareg character.

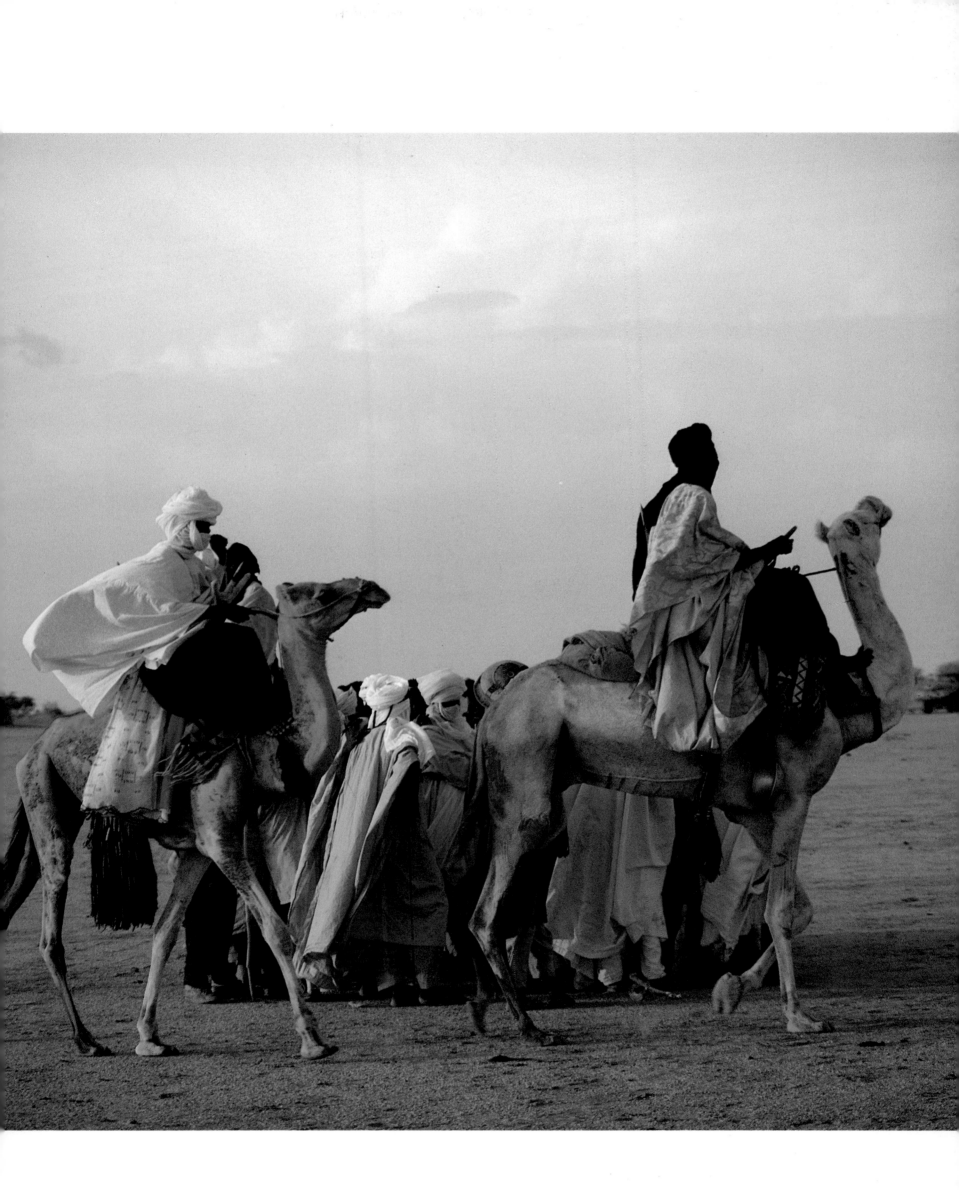

LEFT A woman of the Ullimeden Tuareg wears *tsabit* earrings with a pyramid-shaped terminal knob. These intricately decorated earrings of solid silver are an obvious mark of wealth.

ABOVE Tuareg riders prepare to race their camels with their voluminous robes, *gandoma*, blowing in the wind. These loose-fitting garments provide excellent protection against the extreme climatic conditions of the Sahara.

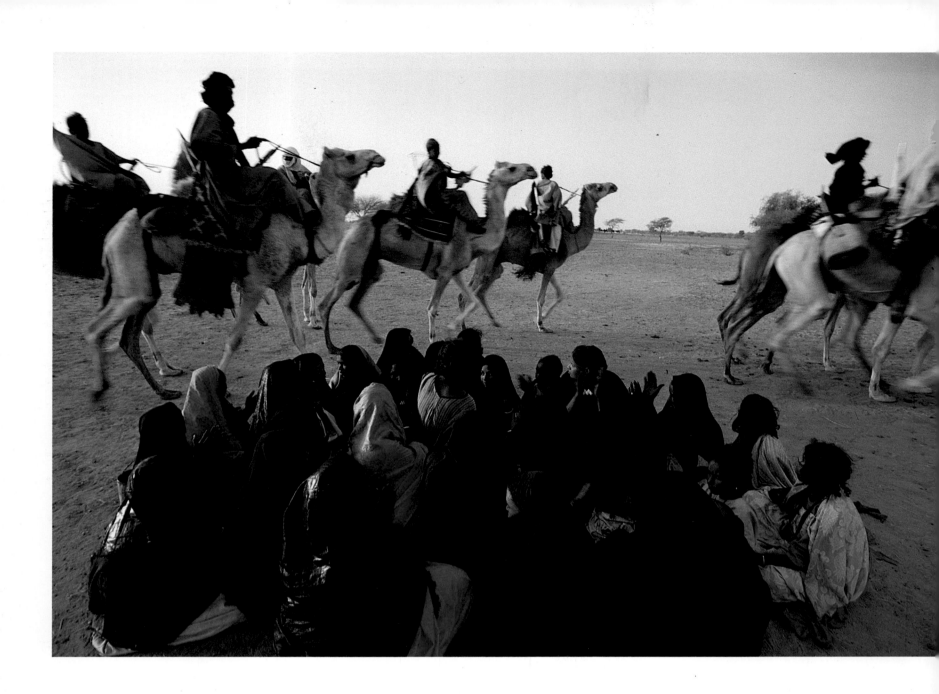

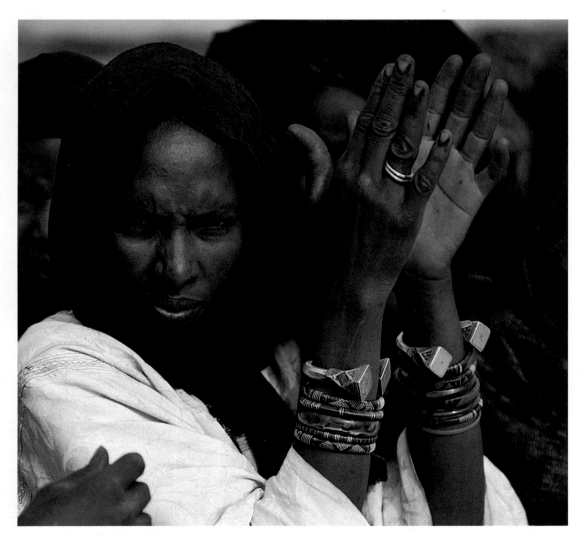

A TIME TO CELEBRATE

Camel racing is a favourite sport of the Tuareg, and the riders are cheered on by women and girls who sing and clap to the rhythm of the *tinde* goatskin drums. The rules are simple: a champion rider takes an indigo headscarf from one of the women and gallops off into the desert, pursued by the others who attempt to catch him and snatch the scarf. The rider who finally attains the scarf is proclaimed the winner, though all will return to the women to receive praise for their riding skills and the beauty of their camels.

The Tuareg woman (*left*), one of the spectators, wears silver bracelets (with faceted knobs) known as *elkiss* – a traditional Tuareg design already noted in the *tsabit* earrings. The woven bracelets, once made of leather by Tuareg women, are now made of plastic. The blue glass bangles are imported from the town of Bida in Nigeria.

RIGHT Newly married Tuareg girls watch the festivities on camels decked in specially tooled leather saddles and cotton canopies. The brides, who must be concealed from onlookers' eyes, are transported on these camels to their new homes.

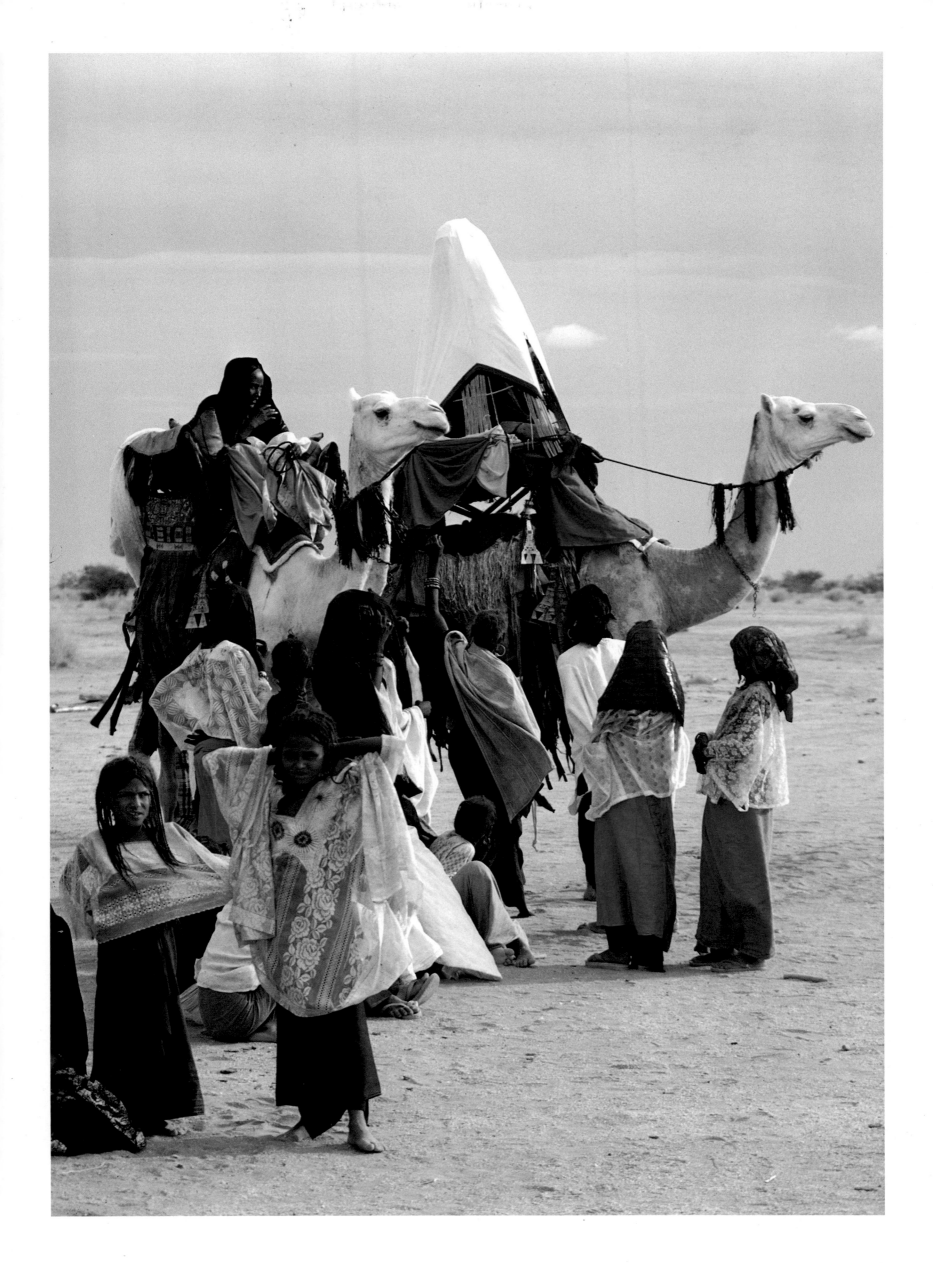

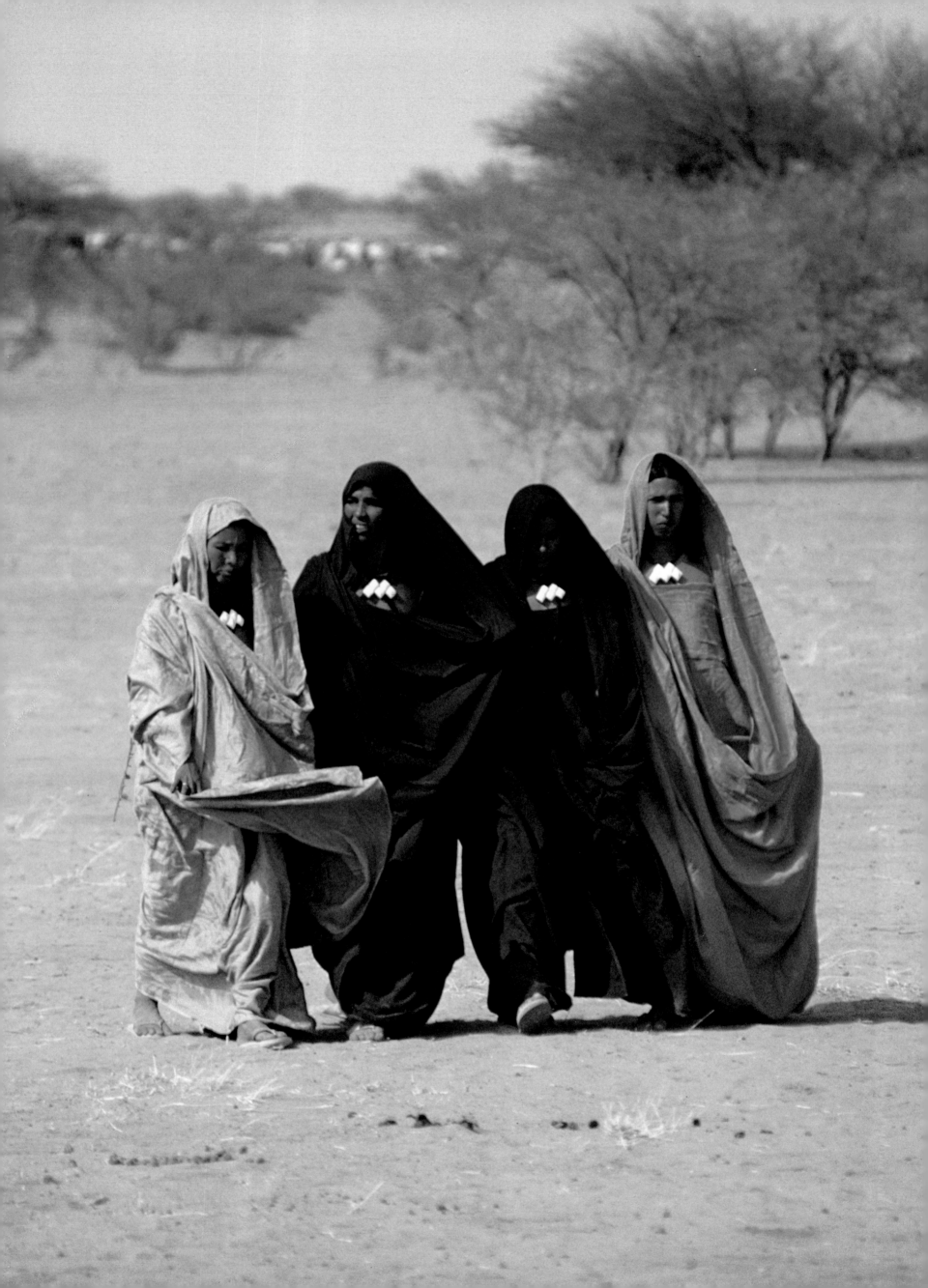

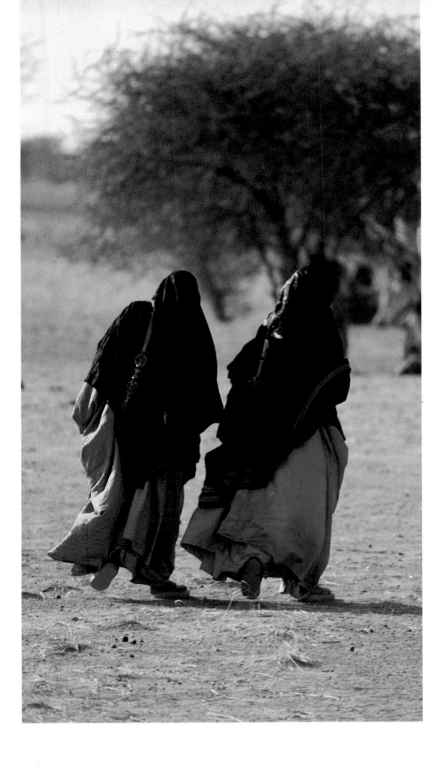

ROBED IN INDIGO

Women of the Niger Tuareg group living in Mali dress uniformly in black or indigo gowns with a length of the same material worn over the head. The *khomissar* pendant, in the form of a stylized hand, is believed to ward off the evil eye and, being made of shell, doubles as a fertility symbol. The women's head-cloths are held in place by counter-weights. These are often improvised from objects such as the large decorative keys of camel-bag locks or even, as seen on the woman on the right (*above*), a bunch of European keys. Wealthier women wear the *assrou n' swoul* (*below right*), an elaborate key-like pendant designed specifically as a counterweight. This is a highly valued piece, made of iron, copper, brass and ivory. The method of laminating used on these materials is known as the 'sandwich technique' and involves very time-consuming and delicate work for the Tuareg smiths. (Length 30cm)

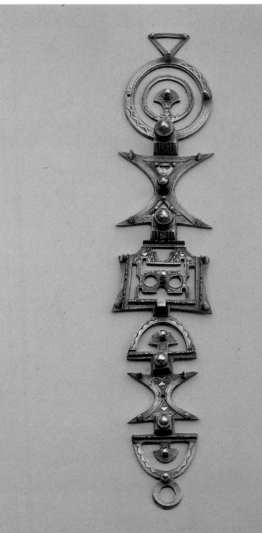

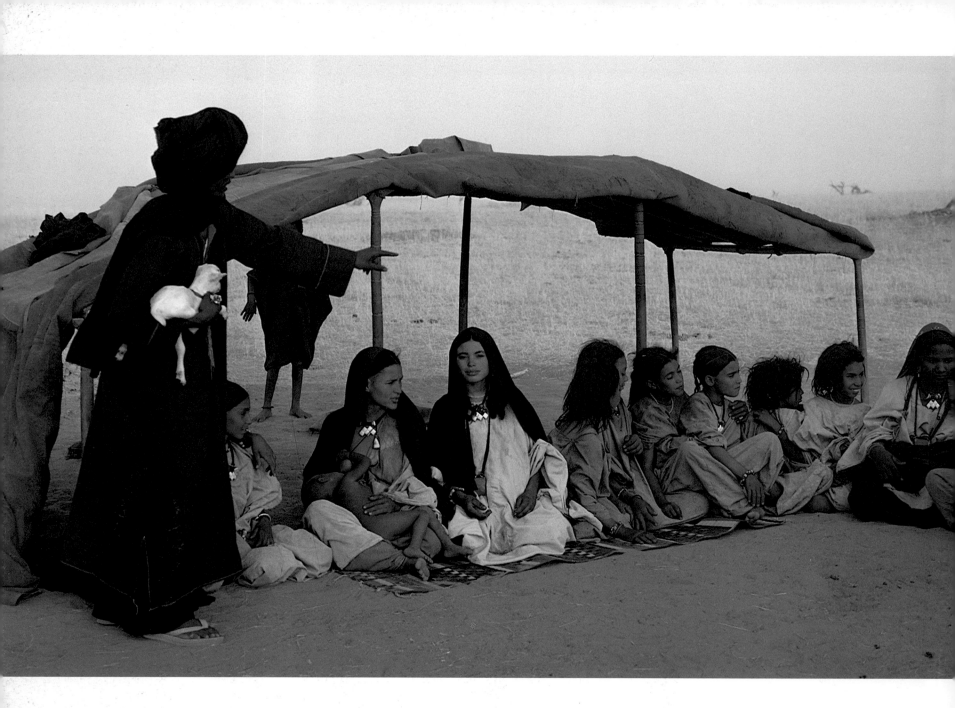

TUAREG AMULETS

Tcherot, talisman boxes made of silver and sometimes decorated with copper and brass, contain pieces of paper on which are written verses from the Koran or old magic formulae known to the Marabout, the Holy Man. At the age of 17 a Niger Tuareg girl receives a *tcherot* and a *khomissar* pendant (2, *below*) from her mother.

RIGHT A young woman in Mali wears these gifts on fine leather thongs round her neck, and she has an *assrou n'swoul* pendant attached to her veil. Her elaborate hairstyle shows that she is of Mauritanian origin, but her choice of jewellery owes much to the Niger Tuareg among whom she now lives.

BELOW The talisman box (1) is worn by women of the Kel Ahaggar group of Tuareg in Algeria, numbers (3) and (4) by both men and women of the Kel Aïr tribe, Niger. (1 : 10cm)

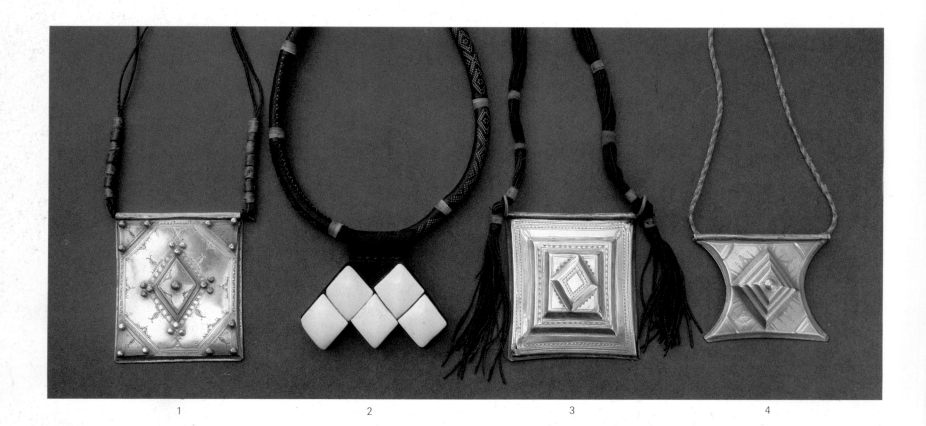

1 2 3 4

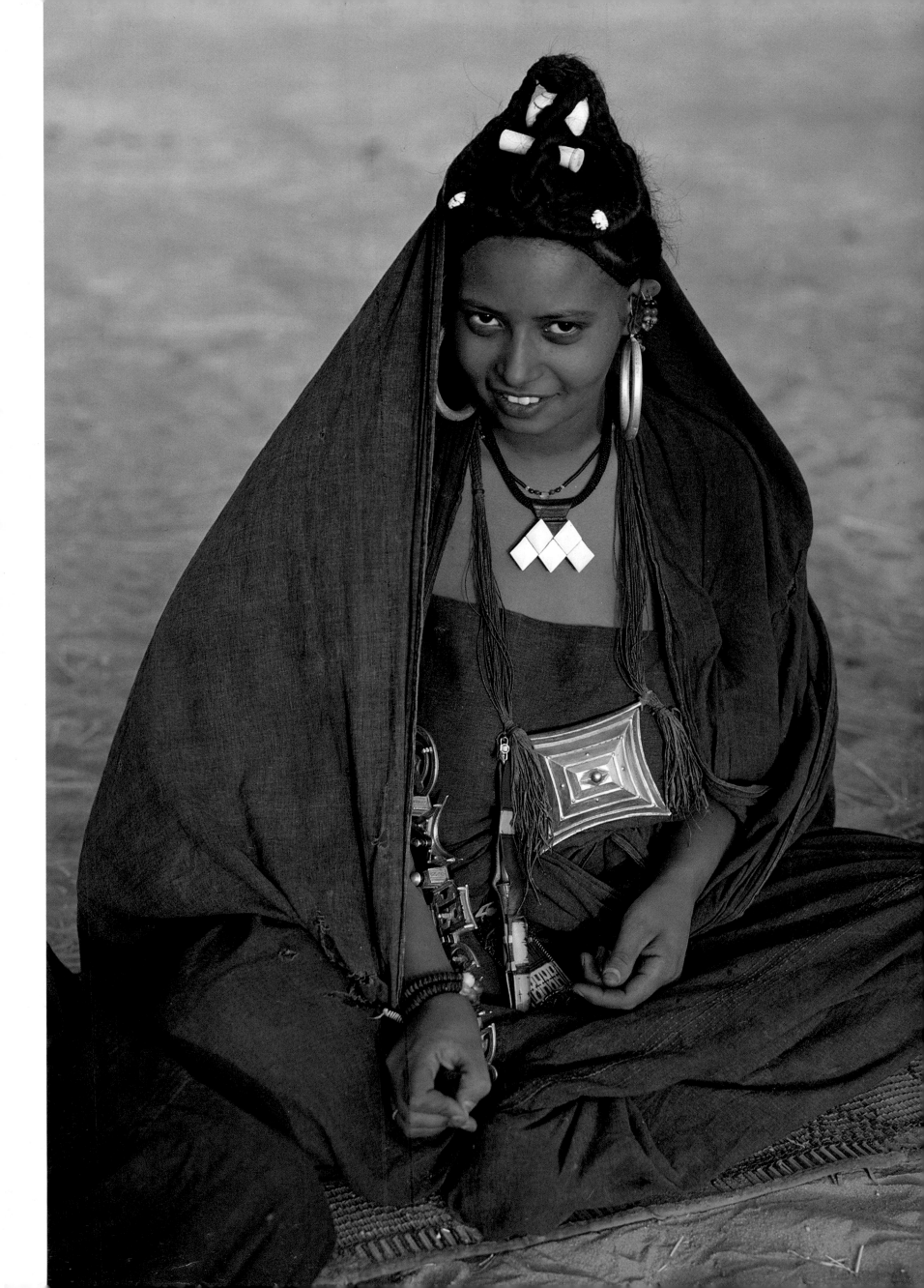

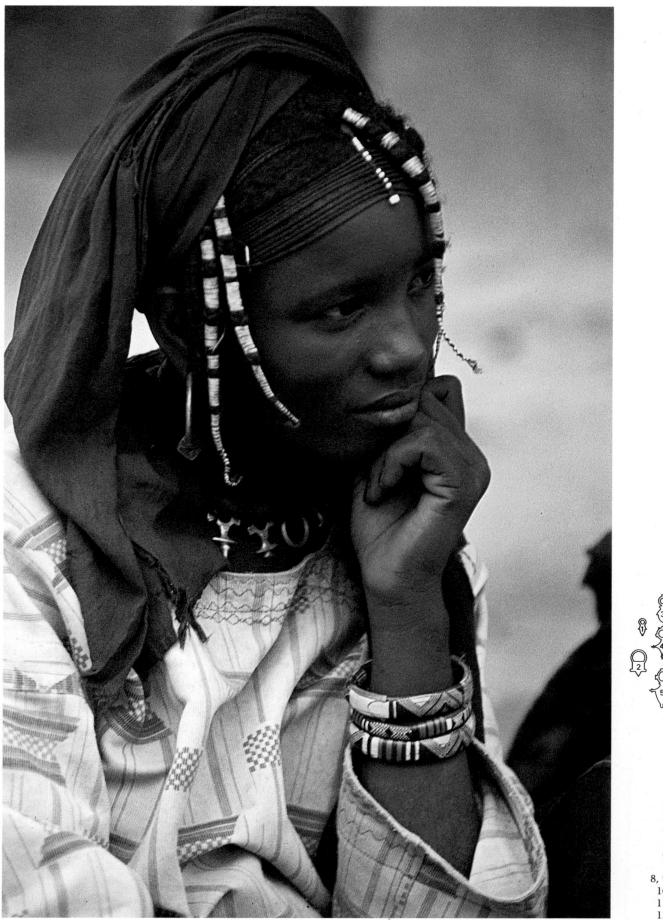

1 Timia
2 In Gall
3 In Waggeur
4 Tahoua
5 Iferouane
6 *Tanfouk*
7 In Gall
8, 9 Agadez
10 *Barchekeia*
11 In Waggeur
12 Zinder

TUAREG CROSSES

Tuareg crosses, now worn by women as pendants round the neck, were originally worn by men, passed down from father to son when the boy reached puberty. The father would say: 'My son, I give you the four corners of the world because one cannot know where one will die.' Most of the cross designs are named after oasis towns between Agadez in Niger and the Hoggar Mountains to the north.

The Agadez cross (8, 9), best known of the Tuareg crosses, is widely worn by the women of Agadez but is also seen on other nomads as far west as Mali. Wodaabe men often include the Agadez cross among their leather neck pendants, as do Bella women who also wear smaller versions of it in their hair. Like other crosses, it is used as a form of currency to buy cattle, cloth or food in times of need. All the crosses

are believed to be powerful talismans; some, incorporating circle and phallus designs are fertility symbols for both sexes (11, 12), others engraved with highly stylized representations of a chameleon's eye and jackal tracks are symbolic of power and cunning (9). The carnelian pendant (6) called *tanfouk*, an ancient symbol of good luck and protection, is seen among all groups of the Tuareg, often strung with a collection of neck crosses. The necklace of fine silver beads with a cross pendant, *egourou* (7), is from In Gall. The intricate cross (10), *barchekeia*, is a popular design among both Hausa women and those of Agadez. (7: 9.5cm)

The girl (*above*) from In Waggeur is wearing a necklace of crosses from that town.

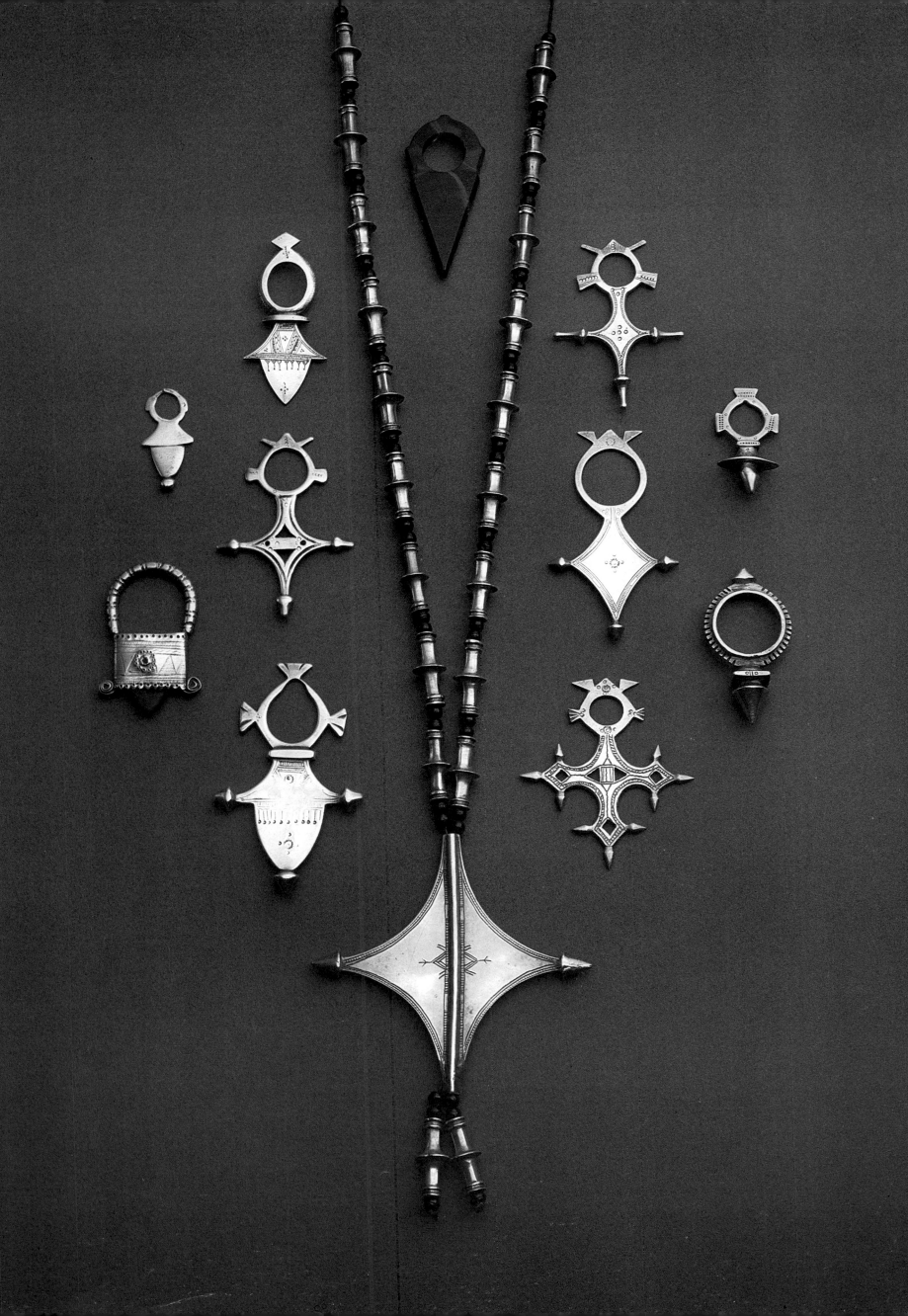

VARIATIONS ON A THEME

Tuareg jewellery varies in design from one group to another, and according to individual preferences and different social levels within the same group. Among the Ullimeden group of Tuareg, fine necklaces with geometrically shaped silver pendants, *tchatchat*, are often worn by women and girls. These pendants may represent the Saharan clay dolls with fat bottoms and open arms and thus symbolize fertility, as do the small triangular beads of red glass, *tanfouk n'gadoun*.

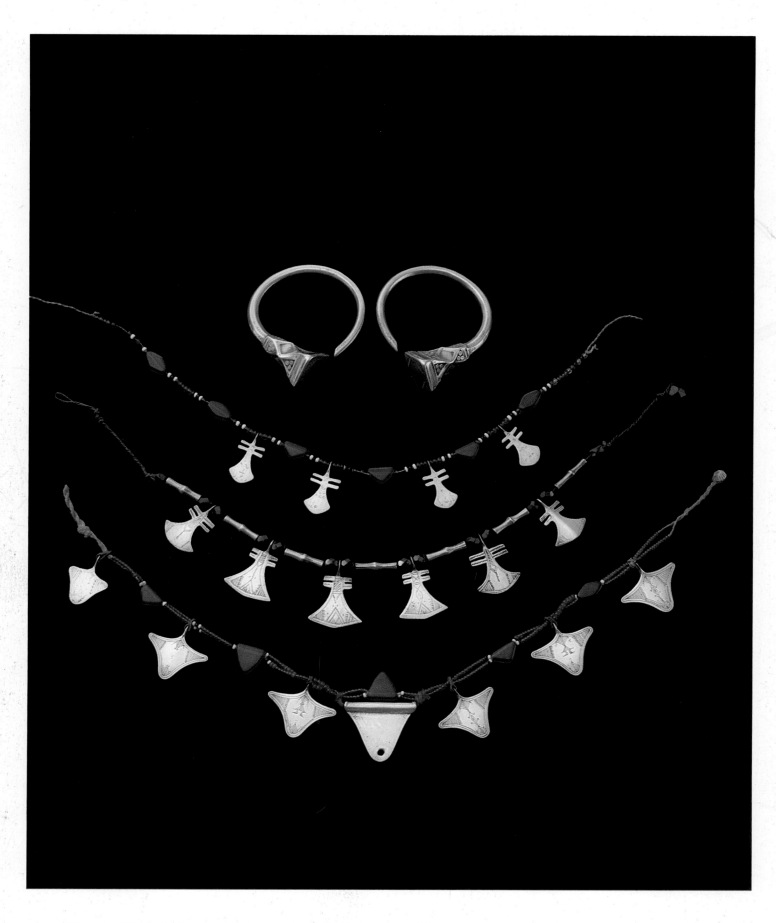

Women of the Kel Aïr group, living near In Gall, often wear necklaces of long silver beads, *ismana*, with a central triangular silver pendant, *lahia*, which they believe is the 'good eye', worn to counteract the evil eye. The *tsabit* earrings with terminating pyramid knobs (*above and opposite*) are worn by the Ullimeden Tuareg. The flat side of the pyramid is often inscribed by smiths (masters of the Tuareg Tifinagh script) with their name and those of the beneficiary and donor. (Earrings 5.5cm)

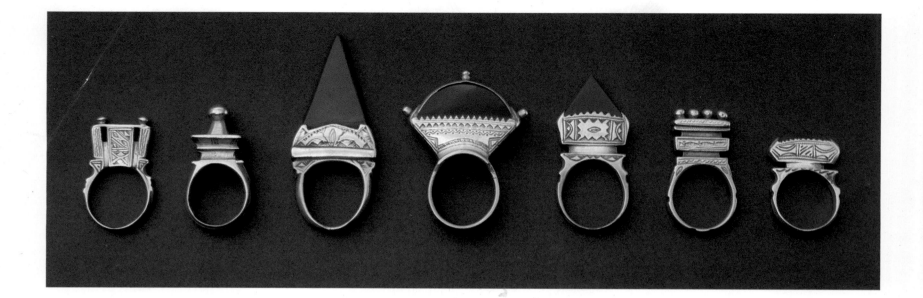

A PREFERENCE FOR SILVER

By tradition, Tuareg jewellery is made of silver, the metal of the Prophet; gold is not worn as it is believed to bring bad luck. This belief is still strongly held by Tuareg living in remote areas, and those who previously made up the castes of vassals and slaves.

Tuareg have long viewed jewellery as a means of barter, to be traded if necessary for an indigo turban, an embroidered blouse or even for millet. Today, for some of the women settled in the oasis towns of the Sahel, their inherent mistrust of gold has been overridden by an appreciation of its market value. They place great store by their necklaces of gold coins and, like this woman from In Gall (*right*), wear them on festive occasions.

Those more remote from the frontiers of the savannah still prefer silver jewellery. Finger rings, *tisek*, are passed between men and women as signs of affection. The finger rings and bracelets shown here are worn by the Tuareg in Mali, the larger ones by men. Those with carnelian settings are believed to have the same properties as *tanfouk* pendants in healing wounds and averting the evil eye. The second ring of pyramid design (*above*) is worn by various groups of Tuareg women. The bracelets with soldered bead decoration are of Mauritanian origin. As a result of the severe drought of 1973 many Moors moved southwards and now live alongside the Niger Tuareg in Mali, spreading Mauritanian jewellery designs into Tuareg territory. (Largest ring 8.5cm)

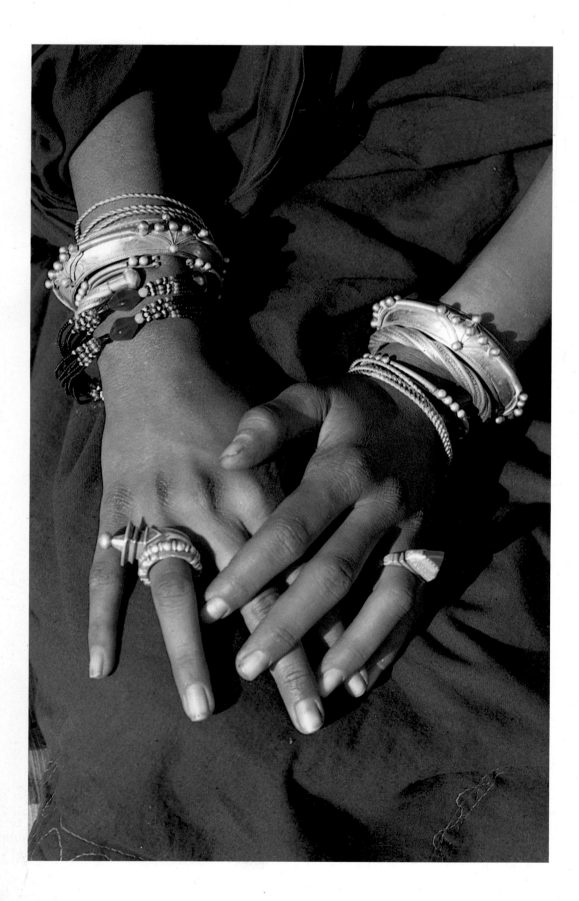

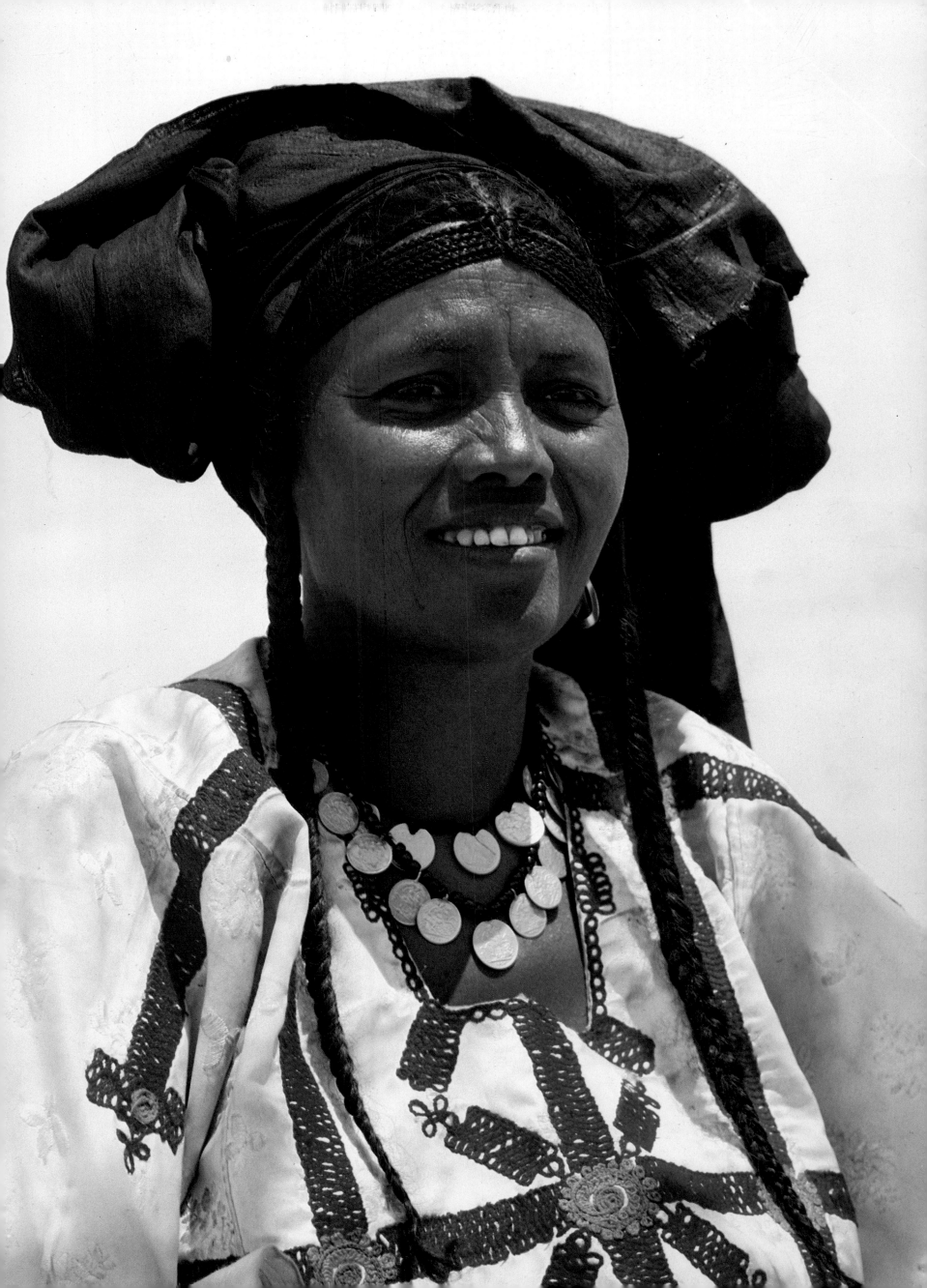

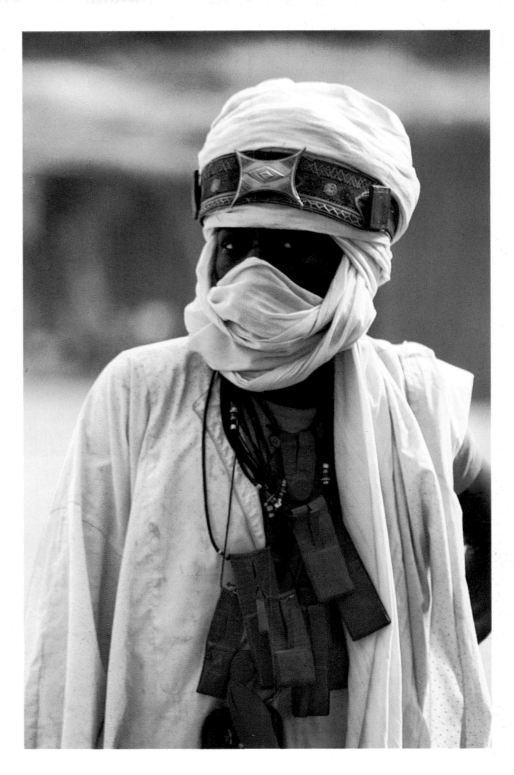

TALISMANS IN LEATHER

The Mali Tuareg (*opposite*) tending his camels at the waterhole wears leather amulet boxes, *ettouben*, round his neck. The Bella herdsman of Mali (*above*) wears several of them at once in a desire to protect his family and herds from the severe hardships of the desert. In Mauritania metal amulet boxes covered in leather (*below*) are often decorated with incised patterns or silver plaques. (10cm)

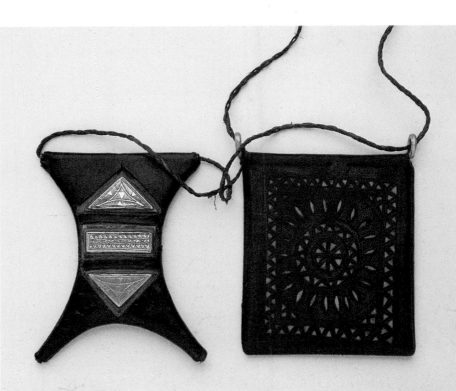

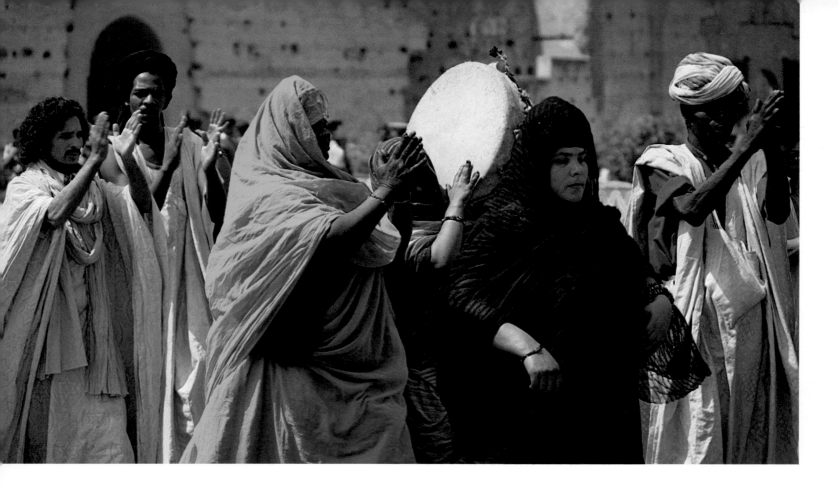

MOORISH STYLE

A group of musicians and dancers from the border of Mauritania and Morocco celebrate a folklore festival in one of the old palaces of Marrakesh. Their robes of blue and black are traditional dress for these desert people. Their jewellery, although similar in concept to that of the Tuareg, is more ornate and flamboyant – a result of Arab influence since the eighth century. The techniques of Mauritanian silversmiths are varied and technically advanced, but their intricate work lacks the purity of line of Tuareg ornaments.

RIGHT The four neck pendants, *bôghdad*, are decorated with incised lines and soldered beads, as is the small talisman holding Koranic verses, known as *kitab*. Beads of glass and carnelian are popular in Mauritanian necklaces, and silk tassels are attached to the terminal beads of silver prayer necklaces worn by *griotes*, professional singers and storytellers. (largest pendant 7cm)

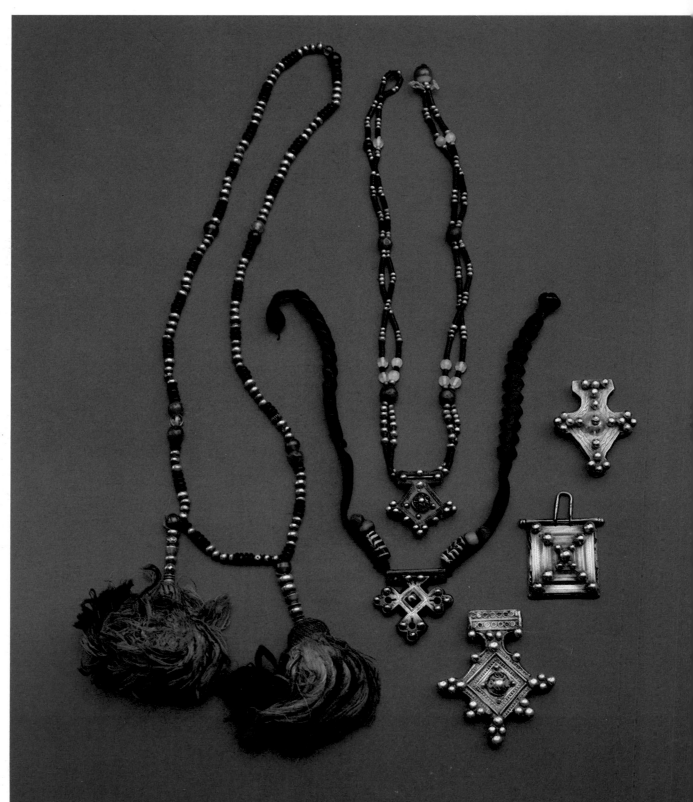

218

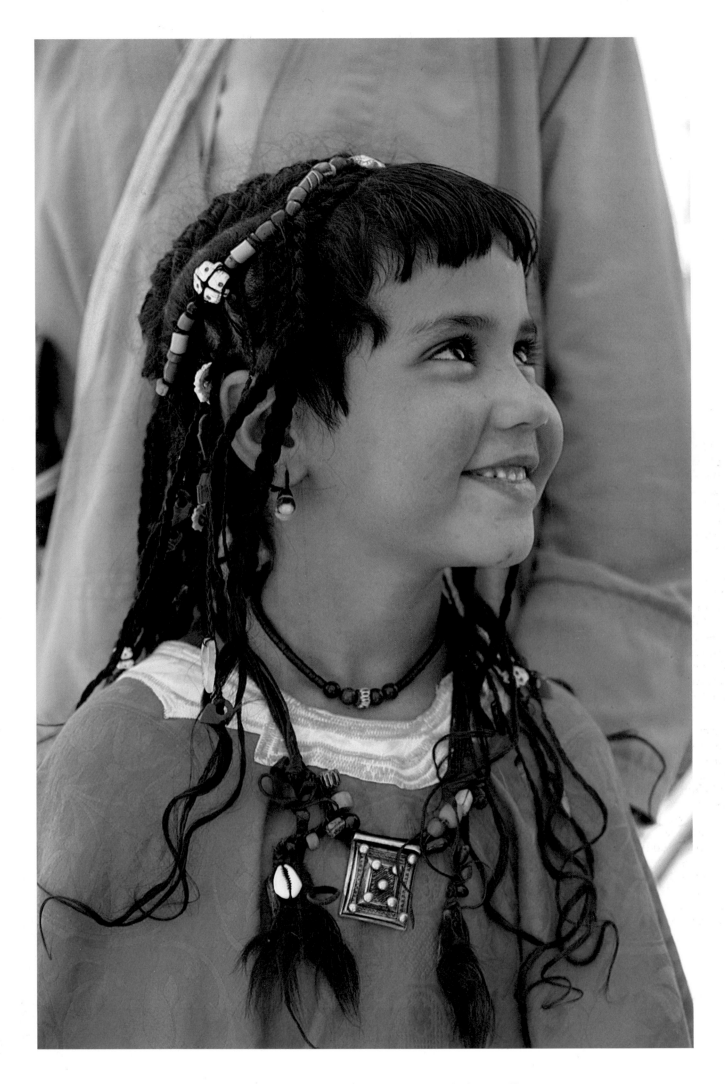

This seven-year-old watching the festivities already has a collection of jewellery, including a small *kitab* on a leather necklace threaded with glass beads. Moorish women, unlike the Tuareg, focus ornamentation on the hair, using glass beads and carved shells for protection as well as adornment.

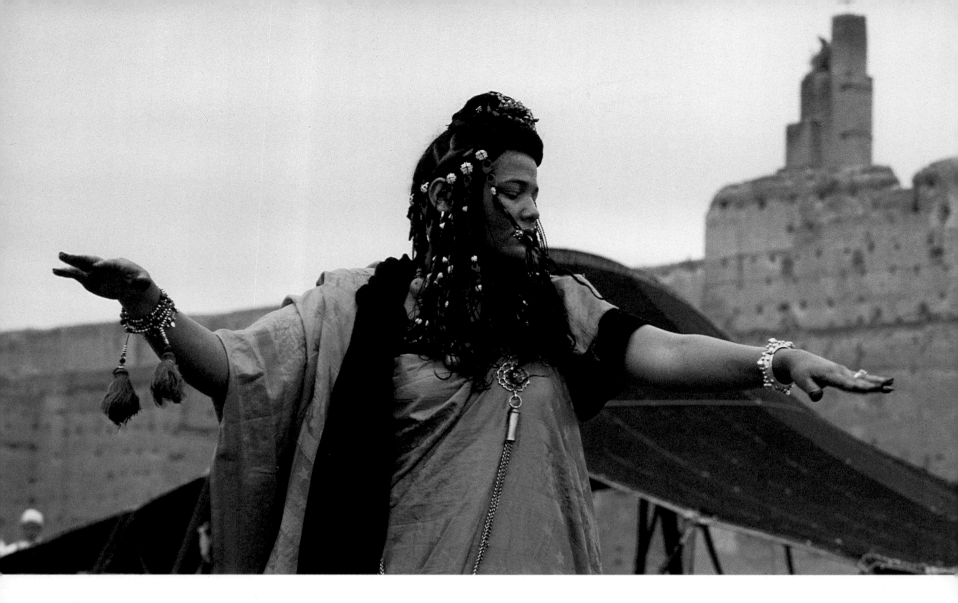

THE GUEDRA

The *guedra* is a ritual dance of love, performed by women for the benefit of men. It is a ballet of hands and feet: sometimes the dancer stands, but more often she squats, covered in a black veil which reveals only the complex movements of her hennaed hands and feet.

The henna designs (*below left*) focus attention on the hands and feet and are of protective significance. Applying the henna is itself a ritual which may take up to six hours.

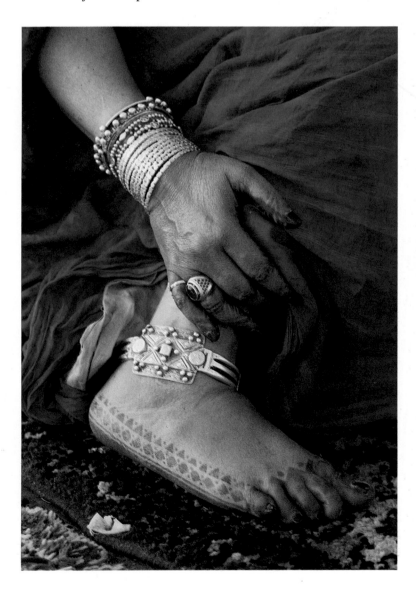

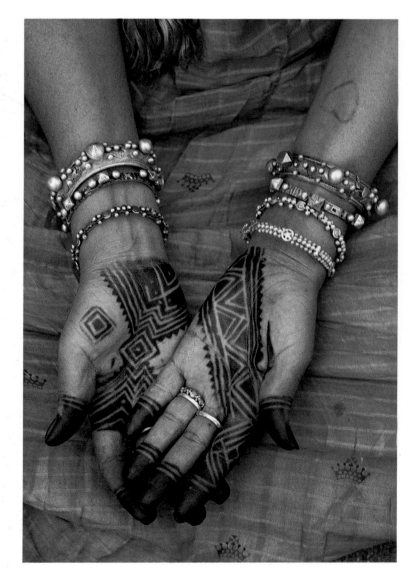

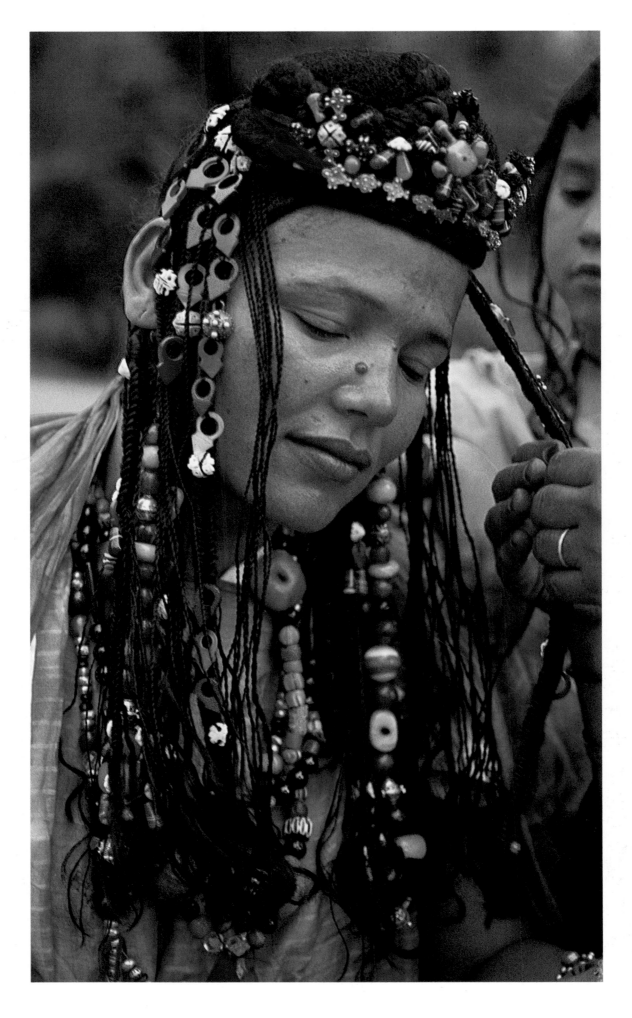

The hair decoration beloved by Mauritanian women is to be seen in
its most sumptuous and varied forms among the *Guedra* dancers.
Every plait is embellished with pendants, carved shell discs called *el
bot min teffou* and triangular talismans, *khourb*, of green and red glass
and carnelian. Glass beads – some made in southern Mauritania, some
imported – are threaded beside real and imitation amber beads and
tiny gold *bôghdad* pendants. Hairstyles vary from one area of
Mauritania to another, and within different social groups. The large
frontal bun, accentuated by artificial hairpieces, is a typical feature
of the *Guedra* dancers.

FINE DETAILS

Although Mauritanian jewellery varies in design according to the region, soldered beads of pyramid and rhomboid shape are used in ornaments throughout Mauritania. Smiths in the Boultilimit area traditionally combine ebony and gazelle horn with silver to make pendants, bracelets and prayer bead necklaces worn by the Marabout and nobility.

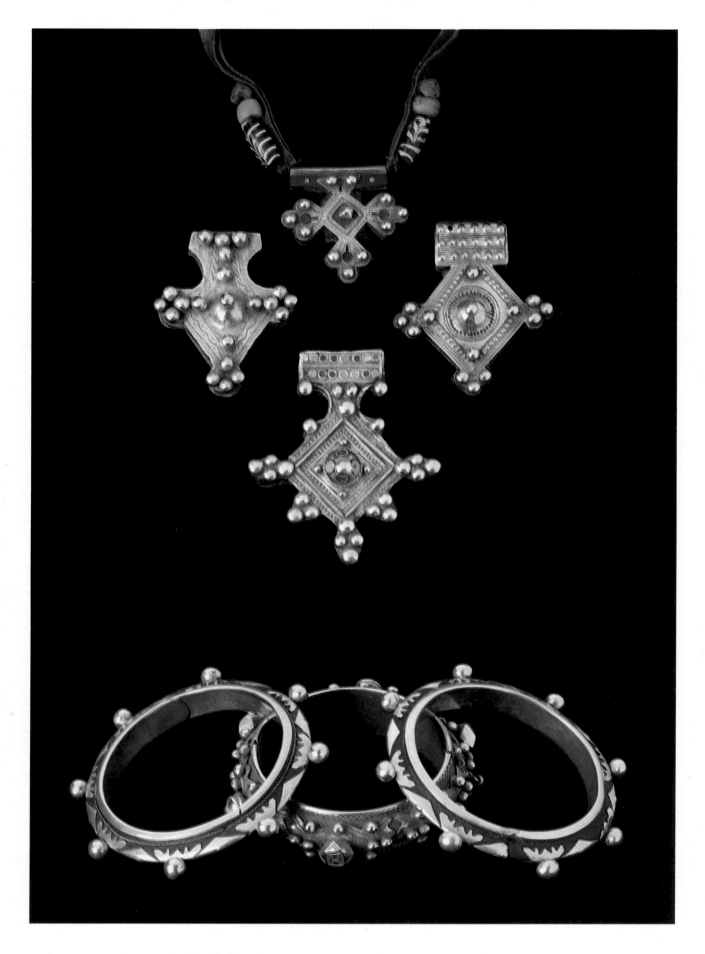

The *bôghdad* pendant (*top*), of engraved silver and riveted beads on a wooden backing, is typical of Boultilimit craftsmanship, as are the two outer bracelets, *deblij*, of silver and ebony. The two plain metal *bôghdad* in the middle are characteristic of the areas from which they come, Walata and Trarza, while the lower one with enamelled decoration shows Moroccan influence. The central bracelet, *mizam*, is one of the pieces of jewellery most favoured by Mauritanian women, and is worn widely throughout the country. (9.5cm)

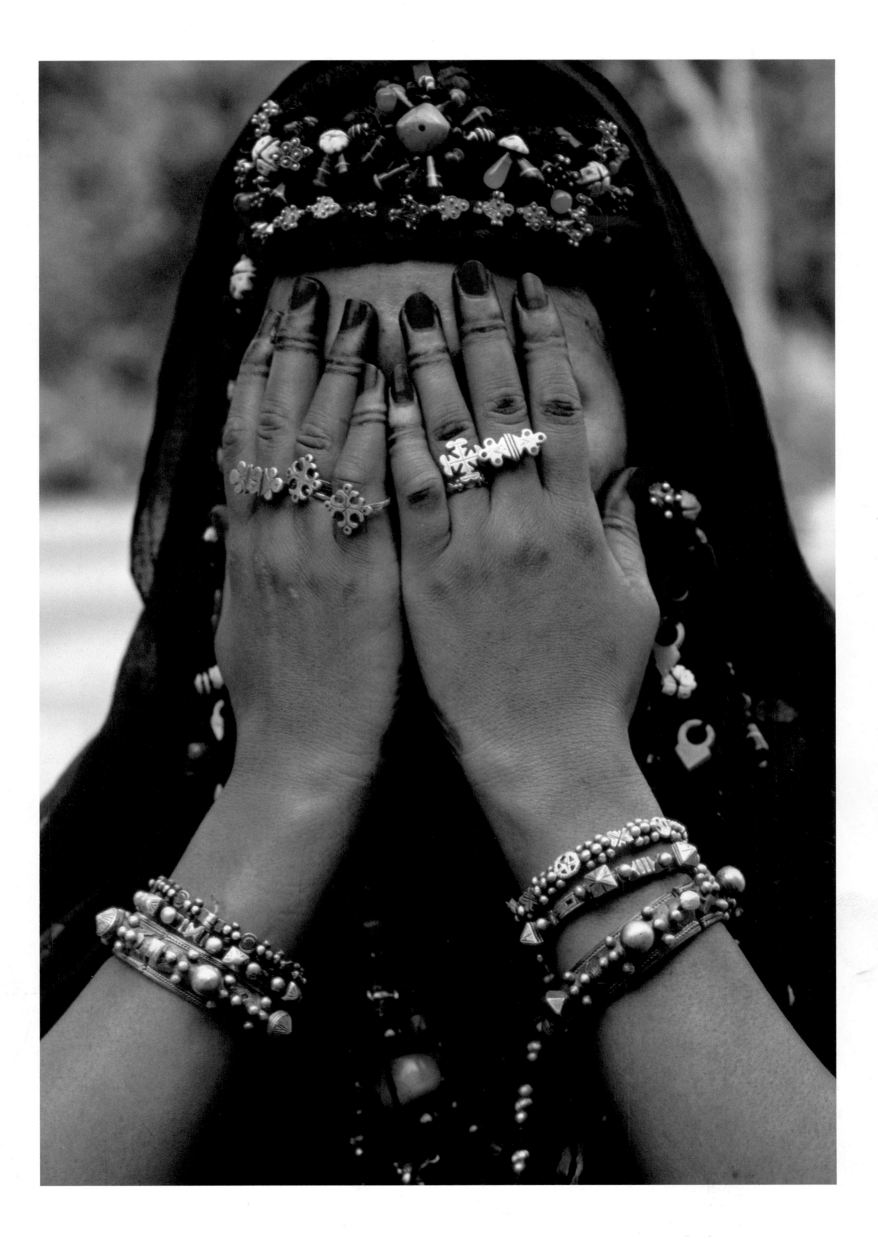

223

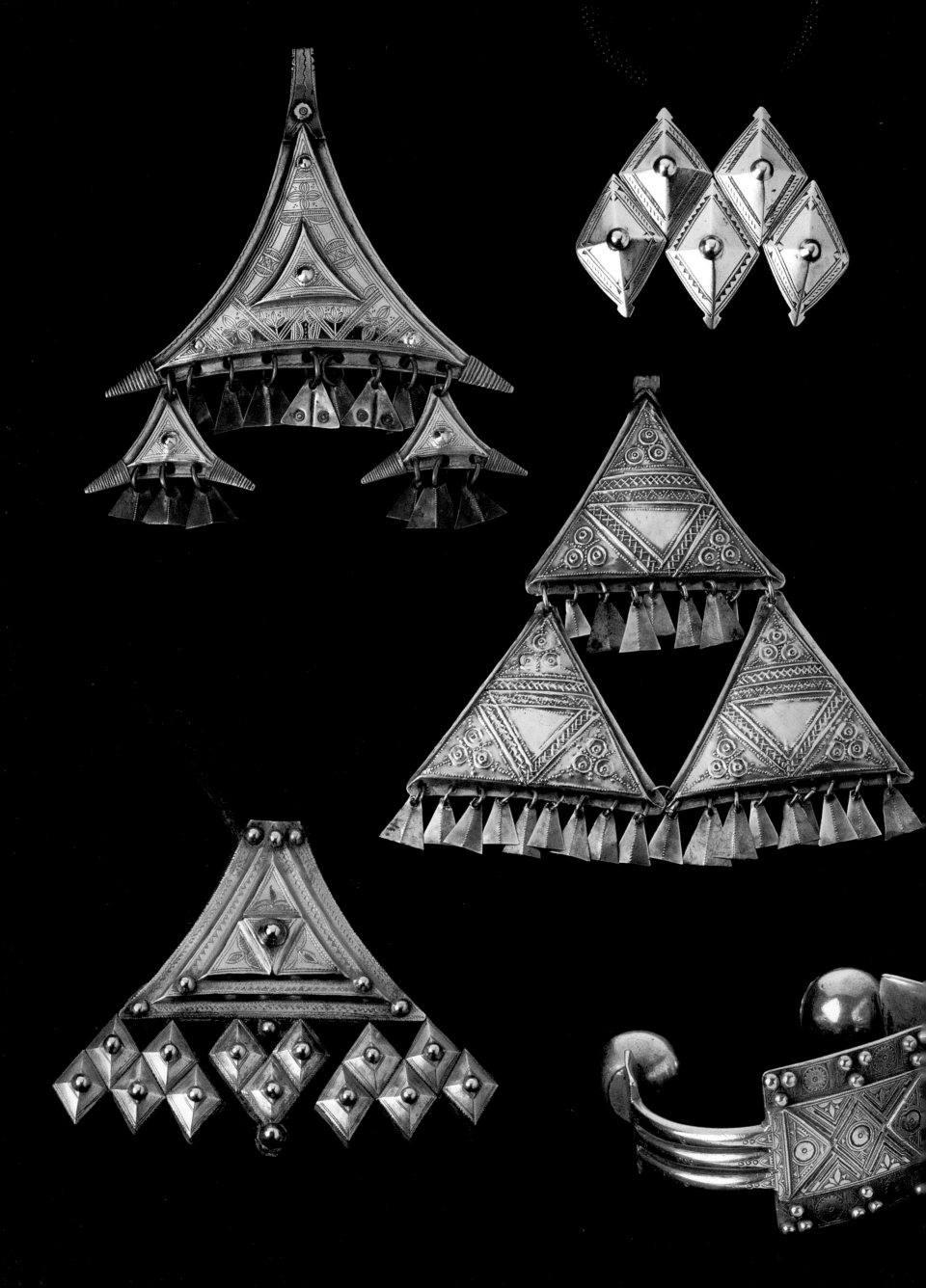

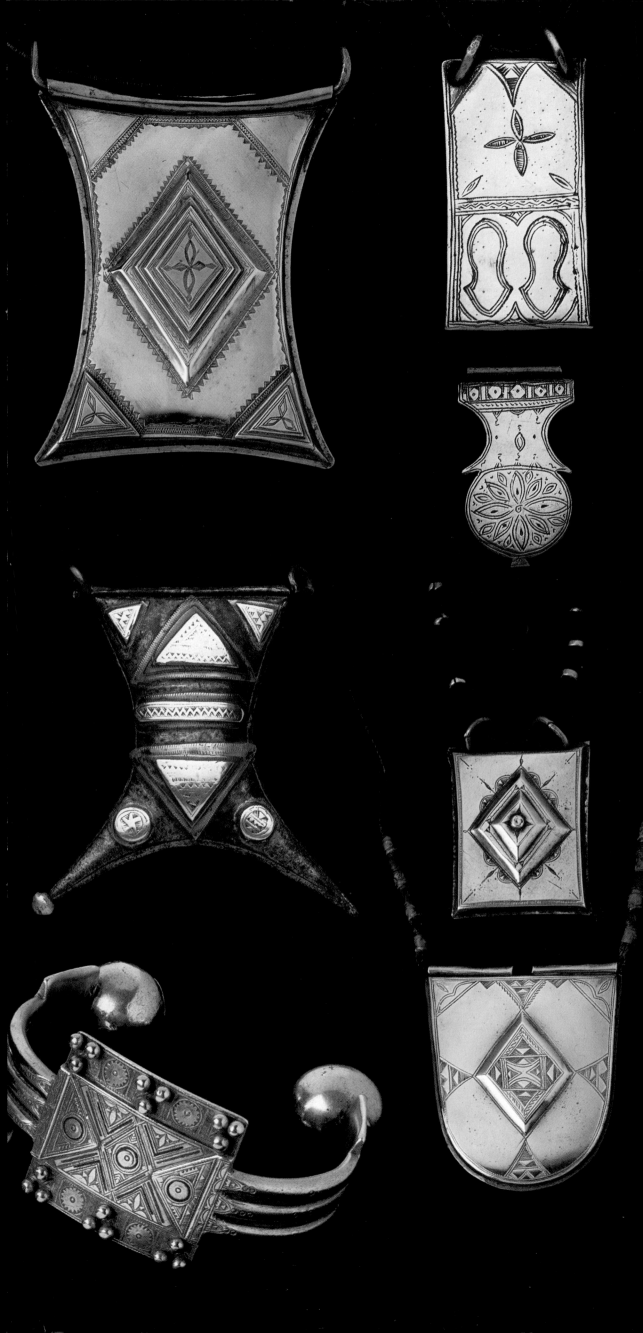

CLASSIC DESERT DESIGNS

1, 2, 3, 4

5

6, 7, 8

9, 10

1 *Tera* silver pendants have small triangular pieces of tin, called *tchatchat*, hanging from them. They were originally worn by the Kel Adjer and Kel Ahaggar; today they are rarely seen on the former. (17cm)

2 This *khomissar* worn by Kel Ahaggar women is made of sheet silver mounted on leather. Its five sections, representing the five fingers of the hand, are fastened with ornamental studs. No. (9), of more recent design, is worn by women of high standing. (2: 8cm, 9: 11.5cm)

3 *Tcherot*, a talismanic box of brass and copper backed with European tin is worn by Tuareg men. Brass reinforces the power of copper to heal wounds and avert injury, and the combination of the two is thought to counteract the evil influence of tin. (12cm)

4 The motifs decorating this small *tcherot* box represent the sandals of the Prophet. This is a symbol of prestige among Ullimeden and Niger Tuareg and is also featured on leatherwork. (6cm)

5 A rare engraved brass pendant worn by Tuareg women in Mali. (5cm)

6 *Tan erat tantamut* is another talisman, decorated with fine repoussé work. Rarely seen today, it was worn by the Kel Ahaggar, either attached to the headdress of masked warriors or by high-ranking women. (17.5cm)

7 A *kitab* enclosing holy verses, worn by men in Mauritania. It is made of iron and decorated with incised silver, copper and brass sheeting. (9cm)

8 Two *tcherot* boxes of the Ullimeden Tuareg. The small one has a tin backing and is worn by women; the larger one is copper-backed and worn by men. (8cm)

10 *Khalakahl* anklets of solid silver were the prerogative of the nobility in Mauritania; now they are worn by any woman who can afford them. Usually engraved with protective symbols, they safeguard against the evil eye and protect the feet from thorns and snakes. (600g, 11cm)

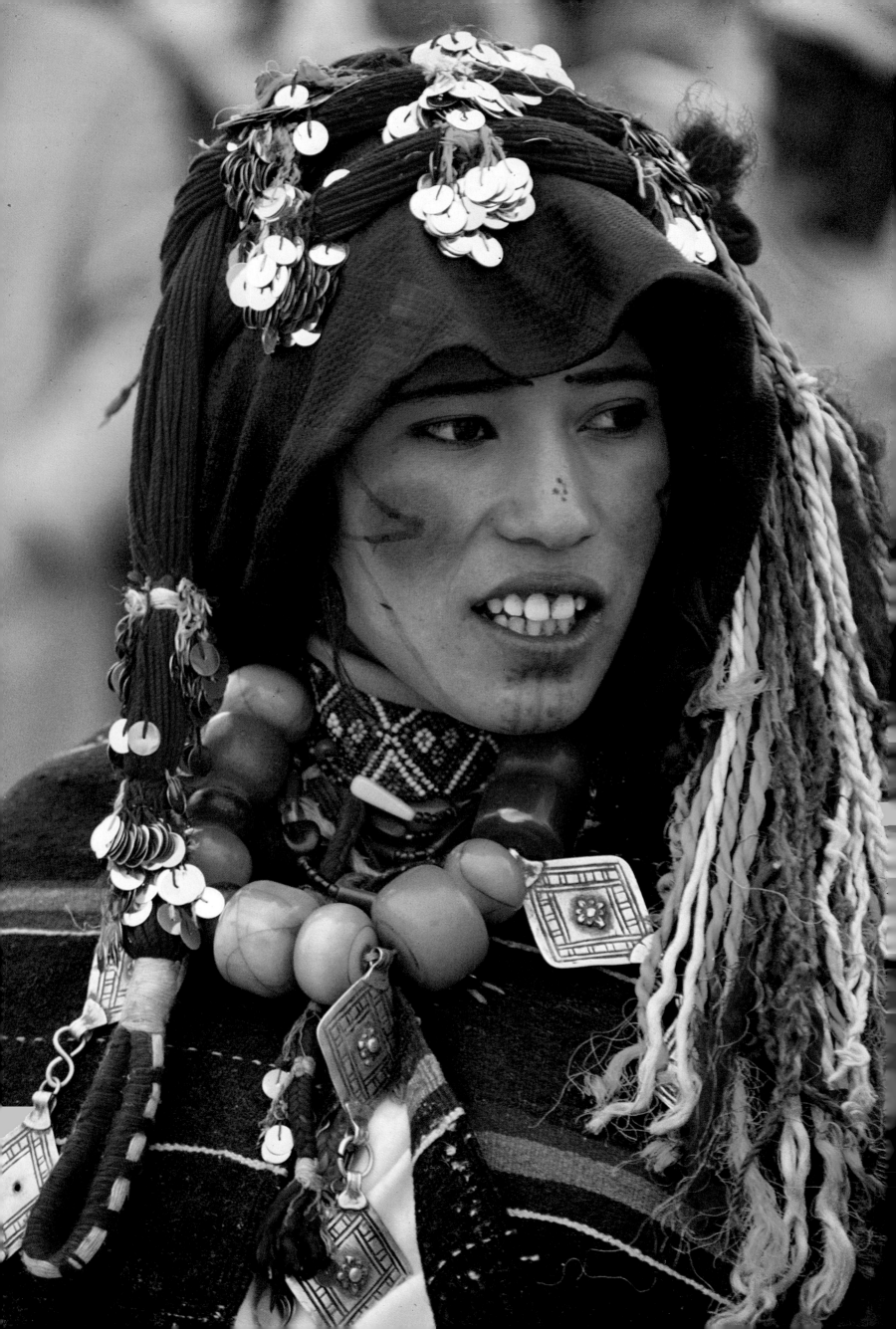

At the southern end of the place were gathered a score of riders pressing one against the other, rearing, fighting and kicking. My eyes searched around to find the man who should command . . . these handsome riders on their wild and lovely steeds, these warriors in their picturesque attire, with their bernouses that will soon be veritable wings, with their fantastic turbans and with their coloured jackets adorned in gold and silver embroidery.

Soon I discovered him in the person of their chief, who sat on his white thoroughbred, with its brilliant red saddle and bridle, there on a mound just opposite me. At a slight signal from his hand the riders shouted . . . then suddenly, as though madness had seized them, they let their reins fall from their hands and gave another wild, sharp and gutteral yell, following which the horses sprang into a gallop at such speed that their bodies seemed raised above the ground . . .

Ferdinand Ossendowski. *The Fire of Desert Folk,* 1926.

THE MAGHREB

A Natural Flamboyance

Berbers, the only white-skinned African race, are strong-willed people with a zest for life. They are the original inhabitants of the 'Maghreb' – meaning 'setting sun' or 'west' – the Arab name for the region of North Africa which includes Morocco, Algeria, Tunisia and the western part of Libya, all bounded to the south by the Sahara. Long ago the Berbers had plenty of good, fertile soil where animals roamed and crops flourished. Theirs was a land of milk and honey which they enjoyed freely until, between the eighth and eleventh centuries, they were conquered by Arab Muslims who drove them from those fertile plains to the less hospitable slopes of the Atlas, Rif and Kabylie Mountains, or onto the arid fringes of the Sahara Desert. Those who went to the mountains settled as farmers and adapted their lives to the harsher climate, while those in the plains began to lead a nomadic life that revolved around the oases scattered along the desert edge.

Over the years, the Berbers have tolerated numerous invaders: Phoenicians, Greeks and Romans, and later Turks, Spaniards and French, all of whom brought their different cultural and artistic ideas. Following the Arab conquest, however, Islam became the most important influence. Those Berbers who remained in the plains near the larger towns fell naturally into the Muslim way of life, and in Tunisia Berbers and Arabs intermarried. The majority, however, hidden away in the reaches of the desert or in mountain retreats, while accepting Islam as their religion retained their individual character and traditional beliefs. Today at festival times Berbers celebrate the glory of Allah, but their songs and dances, vibrant and full of magic, also pay tribute to the spirits of the earth who nourish the soil, supply the rains and bring fertility to the land. Berber women have never covered their faces; unlike the heavily veiled Arab women they are allowed to reveal their beauty and generally enjoy much greater freedom. Some Berber women in the High Atlas Mountains are even allowed to choose their own marriage partners, an unheard-of privilege among Arabs whose marriages are strictly prearranged according to the laws of Islam. The Ait Hadiddu, for example, openly seek partners at an annual Berber festival, the *Moussem* of Imilchil; girls and

Berber woman of the Ait Hadiddu tribe.

young men, having made their choice, must wait until the following year to be married, but divorced or widowed women can instantly formalize their marriages at the fair.

The Berbers delight in every opportunity to celebrate, and weddings are colourful and noisy affairs, with an uproar of music and dancing that continues throughout the night. The celebrations, which involve seemingly endless feasting, may last for a week. Gifts of cartons of tea, bags of flour and sugar are brought through the streets on old wooden carts pulled by men and oxen. On marrying, the husband gives his wife jewellery which she will also wear on other family occasions, at harvest time, and at religious festivities including the celebration of *El Haj*, when her husband returns from his pilgrimage to Mecca.

Celebrations of this kind temper the harsh monotony of the Berbers' daily life. For half the year, many are snowbound behind village walls on the rugged mountain slopes, and during the rest of the year the men move their flocks to

'Desert belle', North Africa, nineteenth century.

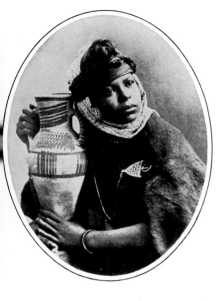

Woman from southern Algeria with fibula, nineteenth century.

upland pastures, leaving the women behind to run the villages and plant the crops. In the valleys of the Moroccan mountains and the desert oases to the south one hears the Berber women singing and laughing at their work, their shrill ululation carrying far over the countryside. They are always colourfully dressed, and whether it is a feast day, a family occasion or simply the time for tilling the fields, grinding corn or bringing water from the well, they take great pleasure in wearing a lot of jewellery. Irrespective of its beauty, it is valued for the protection it offers in day-to-day life, and for many of the women, notably the Kabyle in Algeria, it is considered an offence to be seen in public without certain pieces.

Despite the teaching of Islam, which forbids the representation of human and animal forms, the Berbers often depict creatures believed to have magical powers in their decorative designs. The heads of the snake and ram, the jackal's paw, the dove's foot and the footprints of the gazelle are some of the animal features found on bracelets, earrings and clasps, while the salamander, tortoise and fish are depicted whole, but in a highly stylized form. Faith in the power of these animals stems from ancient Berber beliefs. The snake, for example, is associated with fertility, and a woman anxious to give birth may be advised to swallow its head. The jackal is known for its powers of healing: the melted fat of the animal is rubbed on the body to prevent the common cold, and its gall bladder may be hung at the groin of an impotent man. The salamander, too, is valued for its pharmaceutical properties as well as for its assistance in predicting the future. In Morocco, turtles are believed to represent saints, and tortoises – peaceful animals which deflect approaching adversity – are kept on the roofs of Berber houses to protect the family within.

With the passing of time, although animal designs remained in use some of the symbolism lost its significance. But those symbols which offer protection against the evil eye have continued to exert their power and still provide the inspiration for many pieces of jewellery made today. The evil eye – feared throughout the Mediterranean world – is a power held by certain people whose stares or glances are thought to bring bad luck. The Berbers take elaborate precautions to avoid or divert these looks. They particularly mistrust people with deep-set eyes, eyebrows which meet in the middle, elderly women with blue eyes and, curiously, misers who seldom eat meat. To avoid the evil eye, they cover their mouths with their hands while passing a stranger and for the same

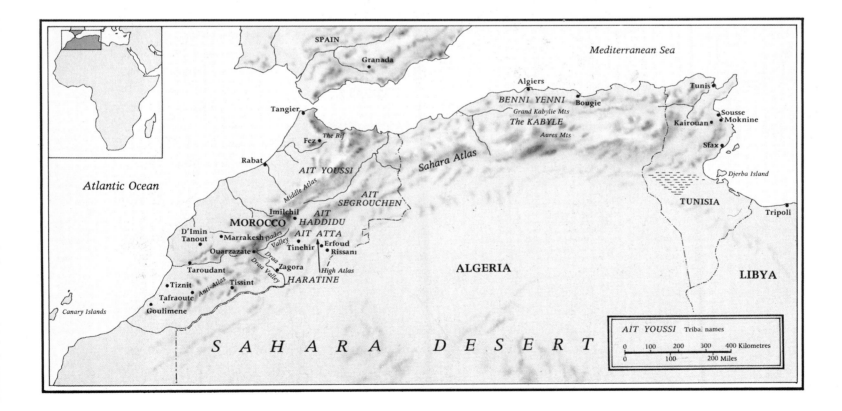

reason women tattoo their faces, tie a strand of wool on their wrists or put a piece of salt under their headdress.

Jewellery featuring the shape of the human hand and the image of the eye is worn to deflect the evil glance and thus protect the wearer. Brides and pregnant women, considered the most susceptible, wear silver pendants cut to the shape of the hand and other pieces of jewellery featuring five dots or lines, which symbolize the power of five fingers. Wearing such amulets is believed to have the same effect as poking the fingers into the evil eye or pronouncing the words 'khamsa fi ainek', 'five in your eye'. Blue glass settings in jewellery simulate the colour of the 'good eye' and are believed to share its ability to outstare the glances of the evil one. Cowrie shells, which recall the shape of the eye, are tied to the necks and wrists of children to offer similar protection. As well as appearing on Berber ornaments, these ancient symbols are carved on wedding chests, woven into shawls and painted on the walls of houses to safeguard their property as well as the people themselves.

Unlike the Arabs in the larger towns, who tend to use over-elaborate or gaudy designs, the Berbers maintain their love of dramatic jewellery executed in simple good taste. In the Middle Ages gold and silver was available throughout Morocco in sufficient quantity to supply all the jewellery-makers of the Maghreb, but when this source began to dwindle, gold and silver coins from Morocco, Spain, France and England were used instead. For centuries gold has been highly valued by the Berber women who live near the big towns on the plains; like the Arabs, they inherit their wealth in the form of jewellery. This form of wealth is forbidden among the village and nomadic Berbers, however, to whom gold is a symbol of vice, despised almost to the point of taboo. Silver, on the other hand, symbolizes purity and honesty and is thought particularly beneficial when set with certain stones whose magical properties are determined by their colour: topaz for example is thought to be effective against jaundice, and emeralds against snake bites, while rubies fortify the heart.

Branch coral, found along the coast of Algeria, is believed to protect children, who wear it hung round their necks. It is also attached to the doors of Berber dwellings to protect them from evil, lightning and tidal waves. Mothers wear coral to assure a flow of milk, and men wear it in the shape of horns, to make them fertile; round corals, imported from Italy, are believed to have more limited powers.

The Berbers have enjoyed the benefits of a rich trade with Europe, the Middle East and West Africa. As a result they have incorporated into their fine silver jewellery bold unfashioned lumps of amber, chunks of coral and unworked amazonite. Amber, highly prized both for its colour and medicinal powers, came from the Baltic Sea and, to a lesser extent, from the Atlantic coast of Morocco. Since Hippocrates' time it has been thought to cure a variety of ailments including gonorrhoea, earache, poor sight, fevers and hysteria. In the oasis towns of the south it is an important component of 'lunar paste', a sticky greyish ointment made with spring water and musk sold in earthenware pots at markets and recommended by a *taleb* (a magician with curative powers) for specific beneficial or evil purposes. Amazonite and shells from Mauritania and copal resin from Senegal have been traded across the desert for many centuries and used in women's jewellery in the arid southern plains of the Maghreb. Cloves, rose leaves, musk, saffron and perfume made from these are believed to be a defence against evil as well as an aphrodisiac, and are given to young girls before marriage to increase their powers of seduction.

Although they recognize these other benefits, Berber men regard jewellery primarily as an indication of family wealth, reflecting the profits of a good farming year. When flocks are decimated and harvests are bad, it may be sold to support the family. The men provide the money for the jewellery but the women are responsible for its safe-keeping in wooden chests when it is not being worn. In

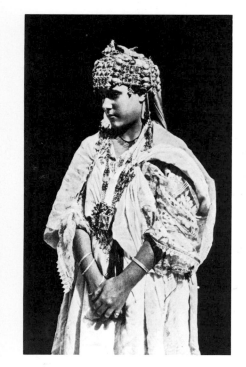

Kabyle woman from Algeria, nineteenth century.

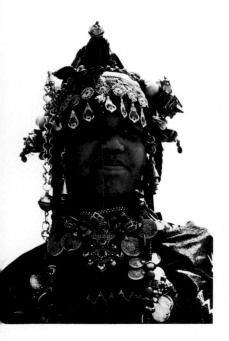

Haratine woman from Morocco in ceremonial dress.

the case of divorce the husband sometimes retains the jewellery as his investment and family security, in which case it will be inherited by his eldest son.

Despite the high standard of craftsmanship of silver jewellery in the Maghreb, its market price is based on the value of the metal alone, and unless pieces are taken by traders to the larger towns for sale to Europeans, they will probably be sold back to the silversmiths who will melt them down and refashion them for their next clients. Although the silver will usually be remade to the same design, a Berber woman feels that secondhand or antique jewellery is inferior, and always prefers to receive pieces which have been crafted specially for her.

Craftsmen throughout the Maghreb, often isolated in stone villages perched on steep mountain slopes, have for centuries carried out the highly sophisticated techniques of filigree, enamelling, *cloisonné* and niello, in designs reminiscent of medieval Europe. It is thought that these techniques may have been brought to the Maghreb by the Carthaginians as early as 500 BC, or by the Jews who arrived during the Roman period, but it seems likely that further skills came with the Jewish smiths who settled in the Maghreb as late as the fifteenth century, after being expelled from Spain. At first they stayed in the larger towns such as Marrakesh, Bougie and Tunis, but later they spread south to more isolated regions. The individual skills of different smiths are today reflected in regional variations in the design and techniques of Berber jewellery.

Most Berbers have always regarded working with metals as an inferior occupation, and they therefore welcomed the Jewish smiths into their villages. Today many of the craftsmen are still Jewish, though they have adopted the local way of life and often speak Berber as their first language. Some of the Kabyle Berbers, however, realized from the first that making jewellery was a profitable exercise which could compensate for the poverty of their land. Unaffected by the traditional bias against the smiths they held them in esteem and learnt their skills, but did not allow them to settle; instead they formed their own groups which specialized in making jewellery and arms. By passing the profession from father to son the Kabyle have kept closely guarded their skills in enamelling, for which they are now renowned the world over.

Today the Kabyle and a few other isolated and seemingly unconnected groups of Berbers around Moknine and Djerba in Tunisia and Tiznit in Morocco are the only craftsmen still practising these sophisticated enamelling techniques. Unlike the smiths in the cities, who are always under pressure to keep up with modern trends, the village smiths have continued to perfect their traditional skills rather than adopting the latest fashion for making gold jewellery of gaudier design by less demanding methods. Their love of naturally formed elements still prevails, and is combined with the most refined techniques in a delicate balance of the primitive and the sophisticated – the essence of traditional Berber jewellery.

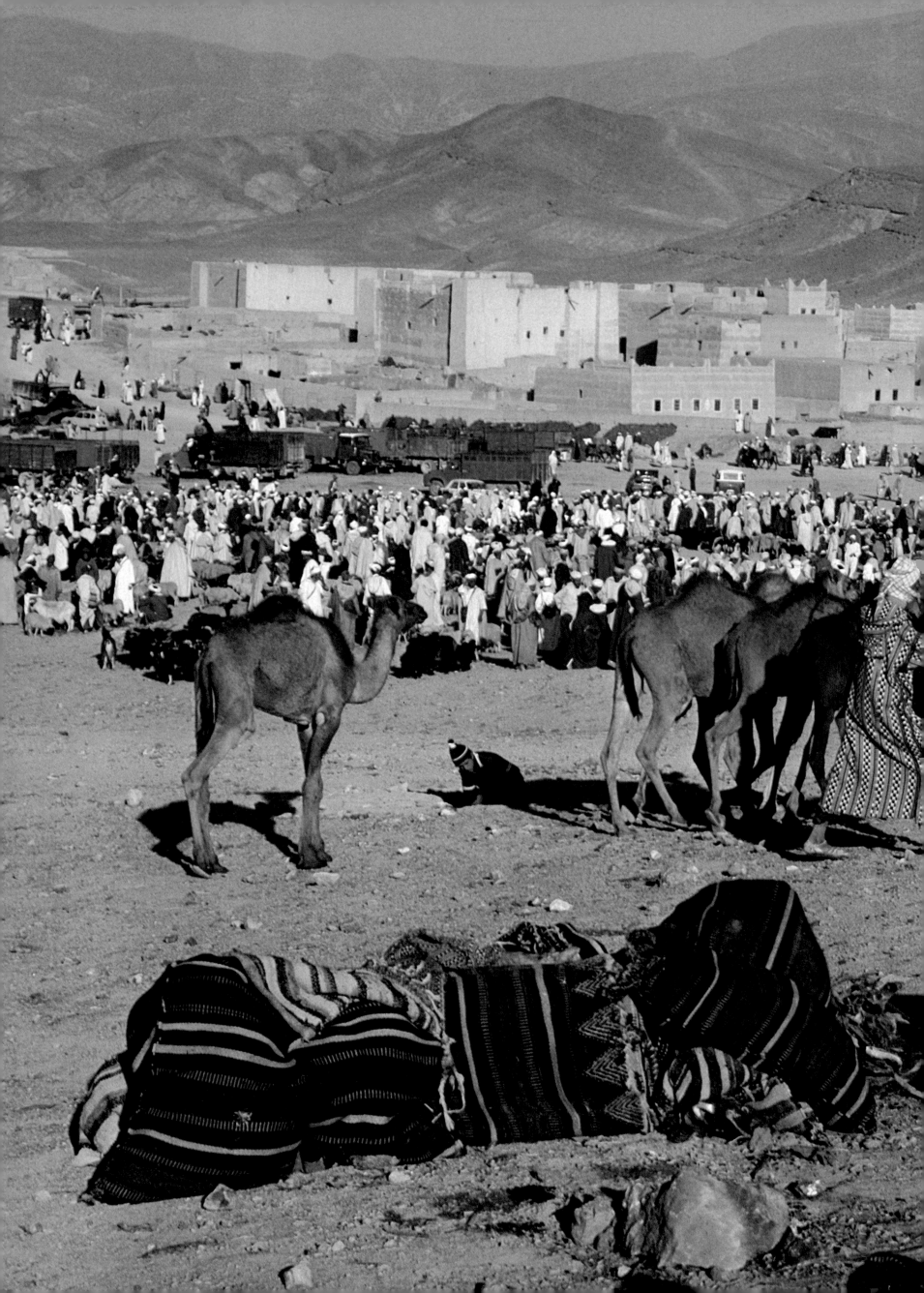

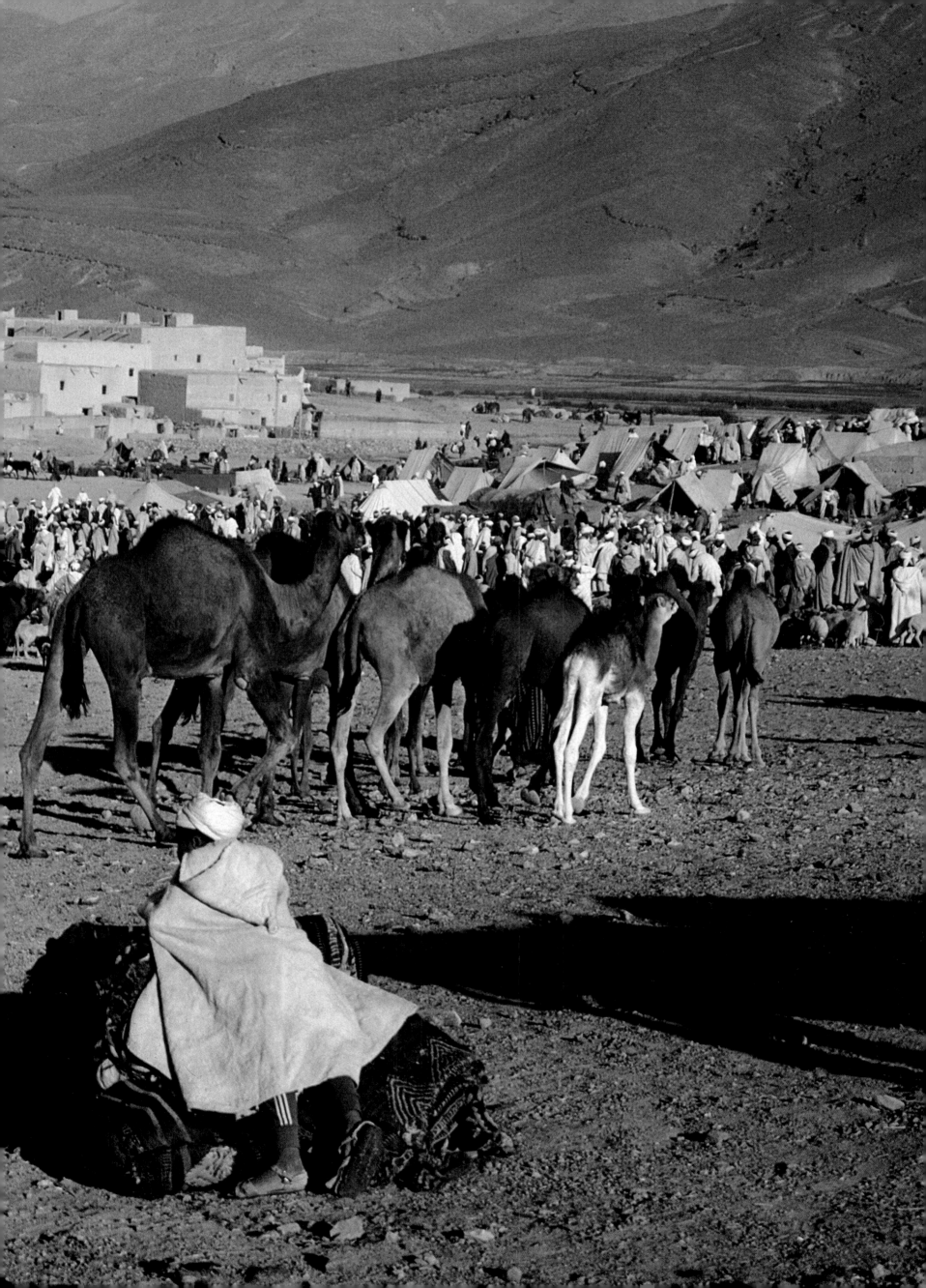

IMILCHIL FAIR

When the harvest is safely in and the Berbers have returned from their summer migration to the high meadows, thousands of them gather from their distant mountain villages bringing camels, sheep and goats to sell or barter at the annual three-day fair in Imilchil (*this and previous page*). The focal point of the gathering is the tomb of a Marabout, Sidi Mohammed el Maheni, whose birth is celebrated there.

RIGHT The fair is also the recognized occasion for meeting marriage partners. When first marriages do not work out, Ait Hadiddu are free to divorce and remarry as often as they wish. These decorative pointed hoods, *aquilous*, are worn by women who are widowed or divorced and looking for a husband.

OVERLEAF After the harvest the Berbers of the Atlas Mountains have money to spend, and itinerant traders come to the fair from many miles around with their wares – jewellery, carpets, domestic goods and agricultural tools. The silver bracelets, fibula (cloak pins), necklaces and ornamental daggers they bring are mostly made by jewellers in the towns of Tinehir and Ouarzazate to the south. Low quality silver often replaces the pure silver once used to make these items, while copal resin from Mauritania and imitation amber from Europe is found in place of real amber.

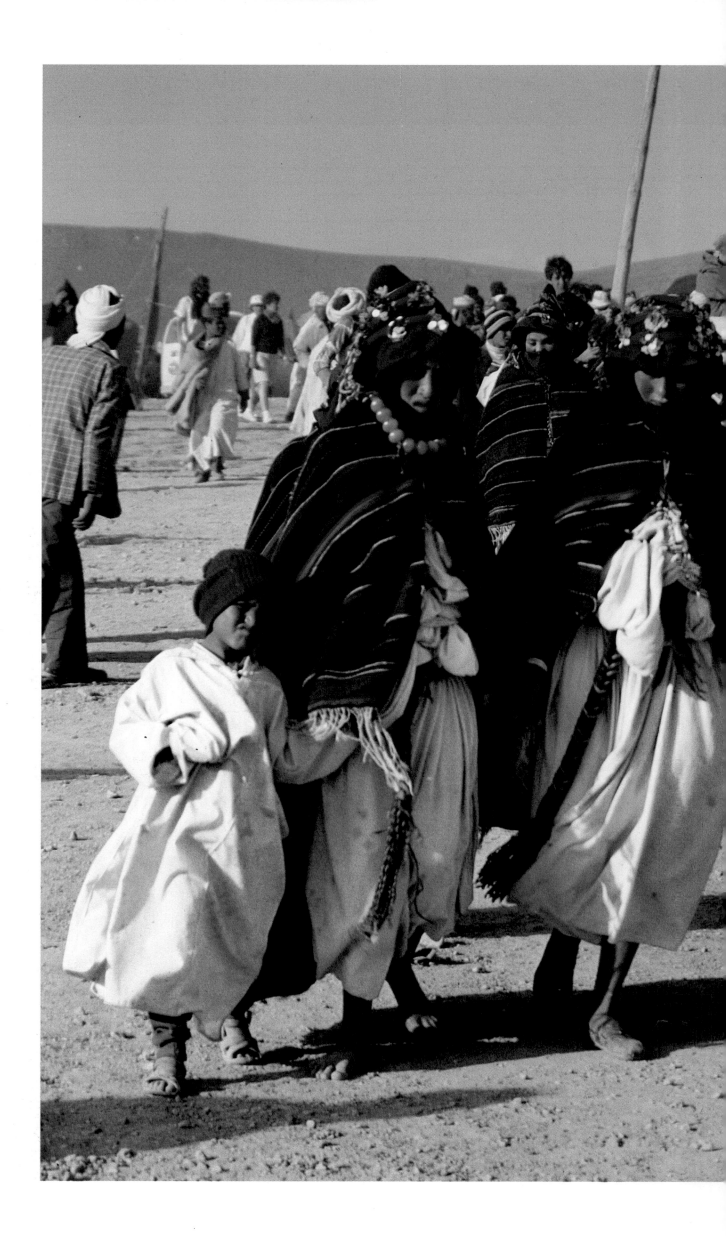

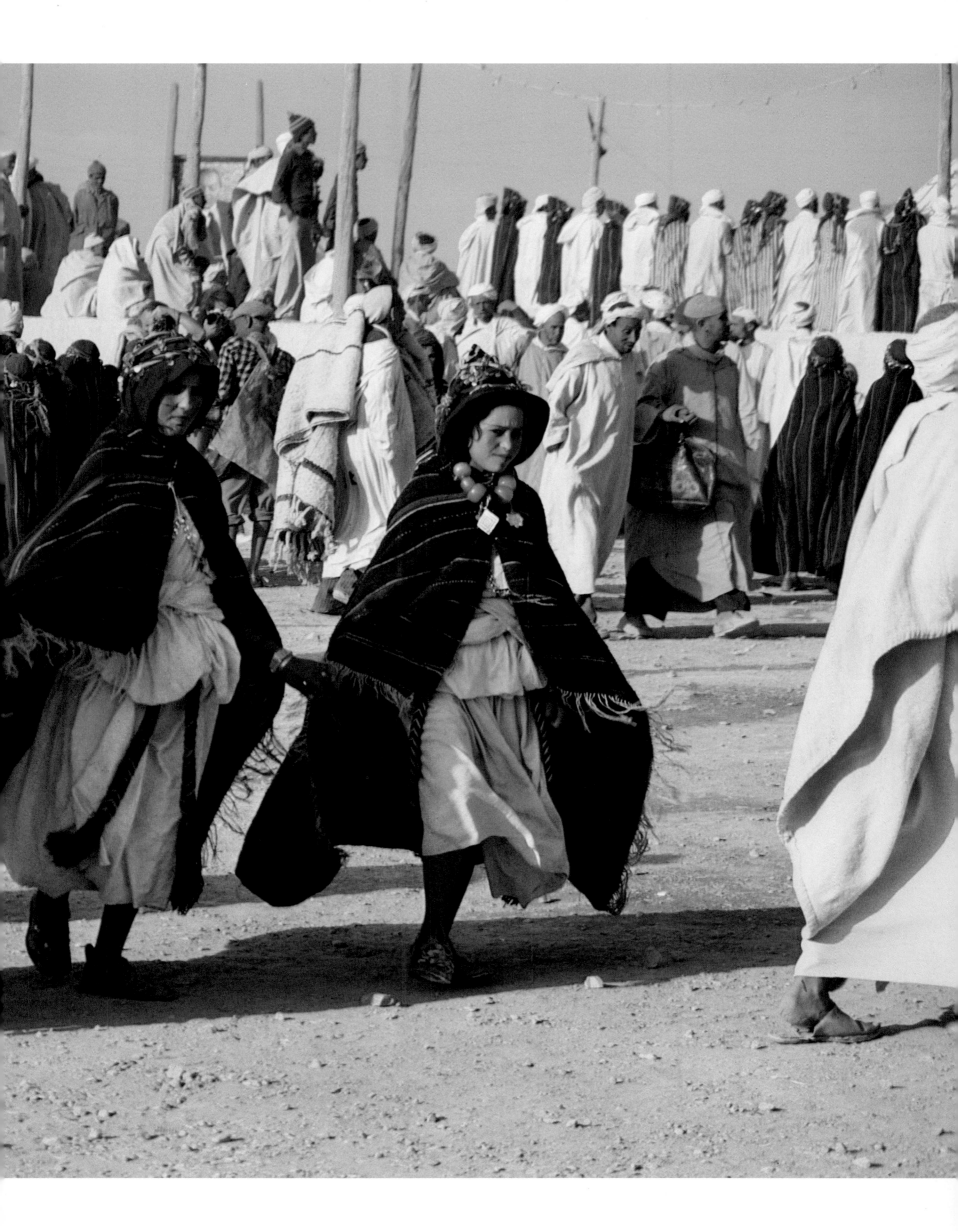

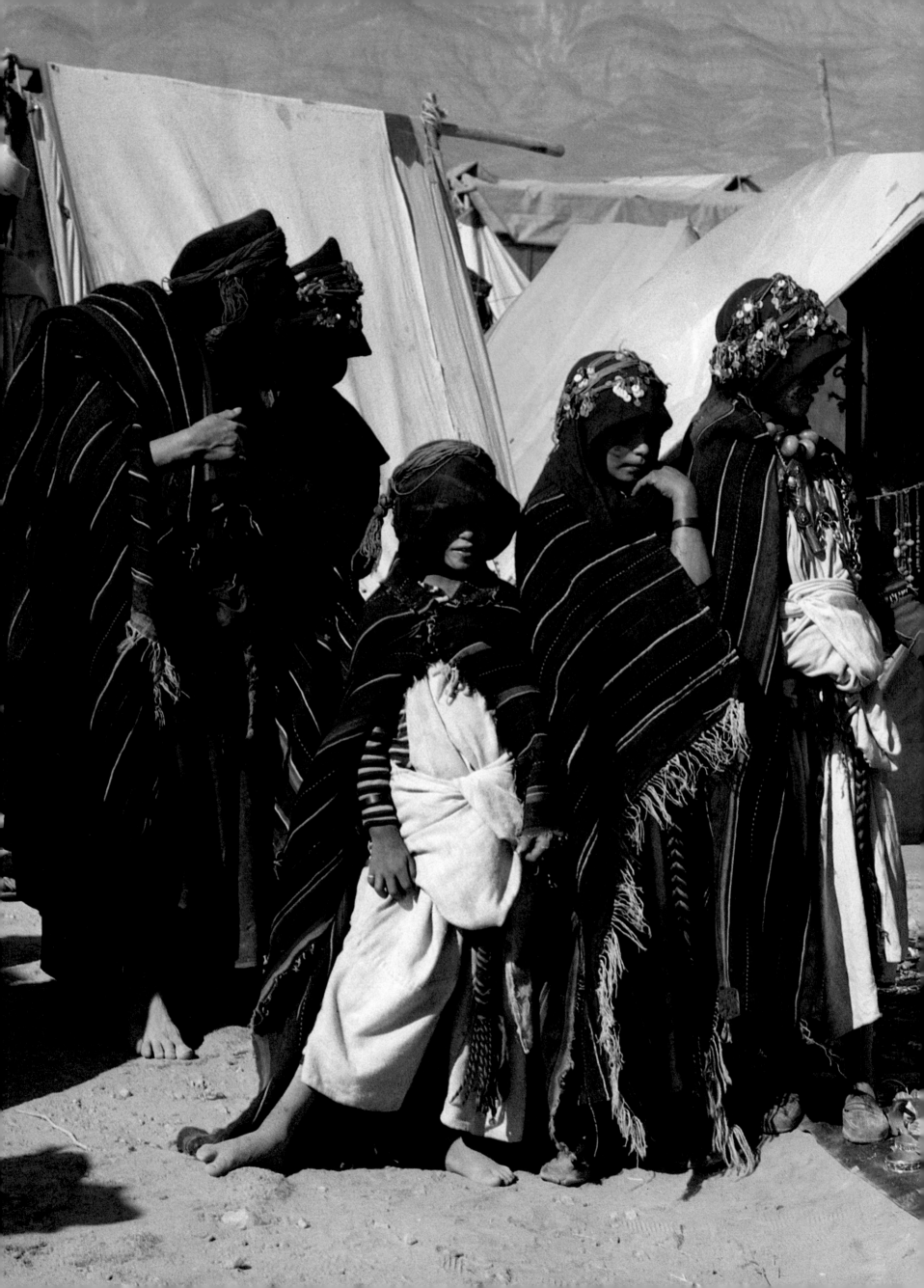

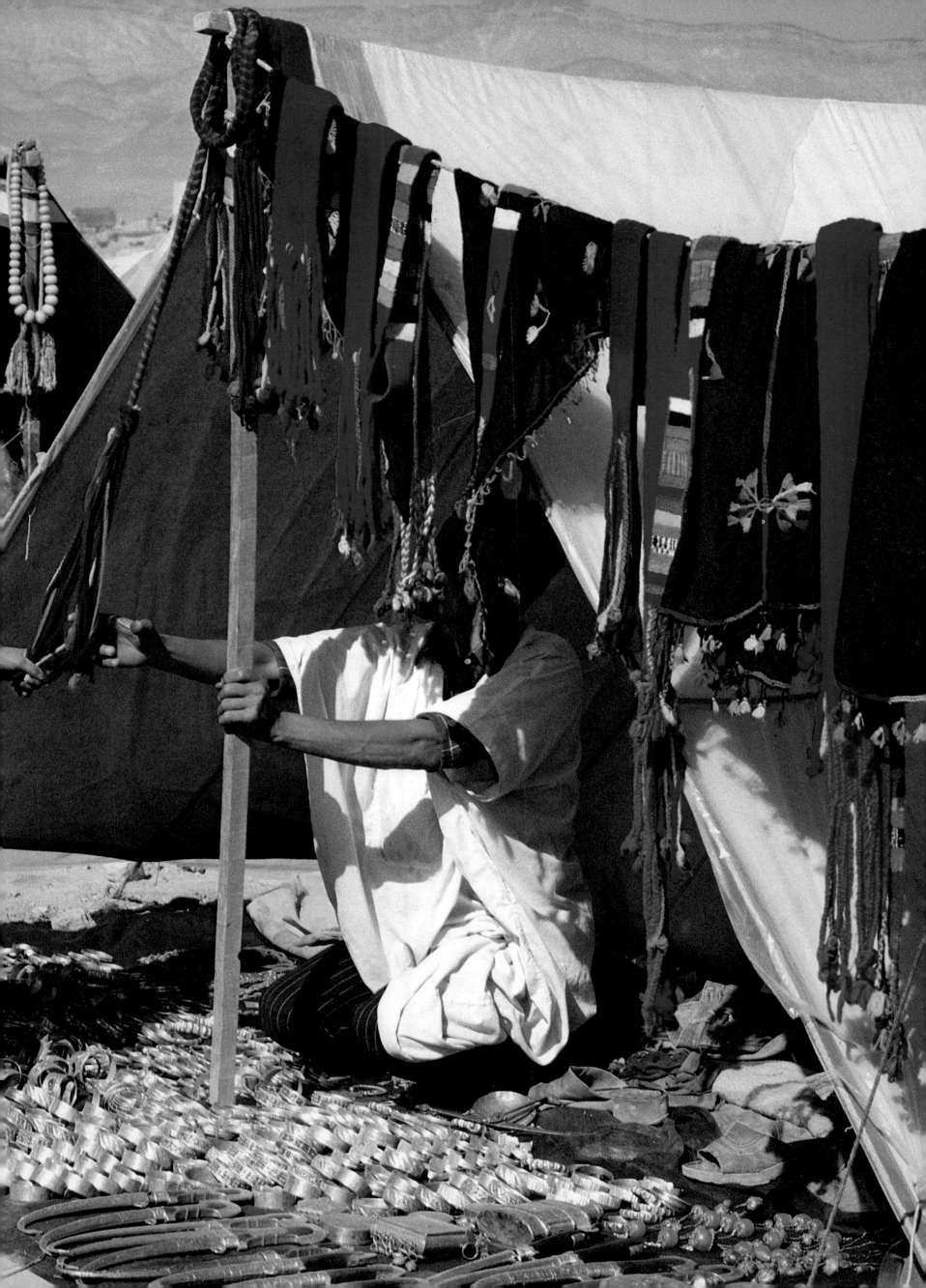

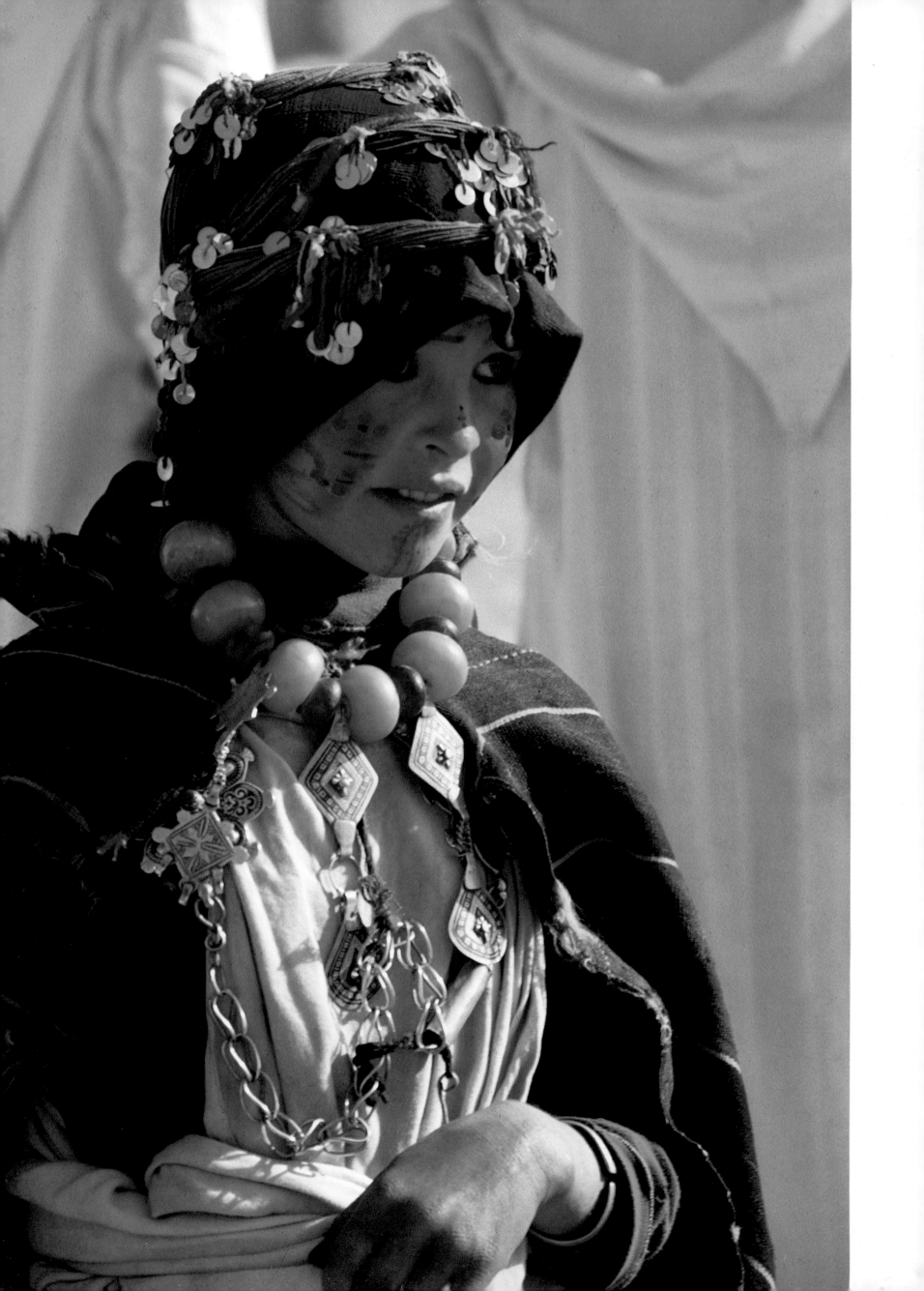

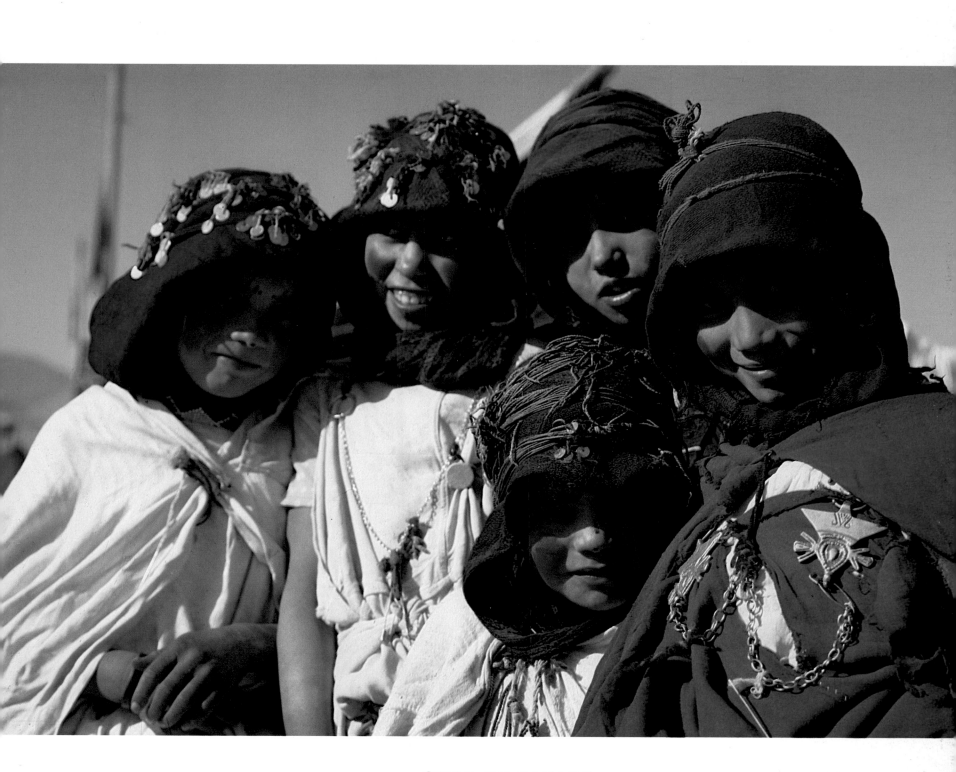

GIRLS ON PARADE

Even very young girls make themselves up for the occasion, with
carmine rouge on their cheeks, saffron-coloured powder on their
eyebrows, their eyes outlined with kohl and noses, cheeks and chins
decorated with black beauty spots. They wear rounded hoods to
show that they are virgins and not eligible for instant marriage at
Imilchil Fair. First marriage depends on the approval and mutual
consent of the families concerned, and although a young girl may
meet her future husband at the fair she will return home with her
father when it is over. A meeting is subsequently arranged with the
young man's family, and if both parties give their consent the
marriage is planned for the following year.

The jewellery of these girls is similar in design to that worn by older
women, though they usually wear fewer pieces and of comparatively
lower value. The fibula pendants worn by the young girl on the
right (*above*) represent the turtle, *ikfer*, believed to be endowed with
protective and magical powers. The various sub-tribes of the Ait
Hadiddu wear fibula of different designs.

OPPOSITE A necklace of imitation amber and silver pendants is worn
with a fibula and chain. The design on the pendants and fibula is
engraved and emphasized with niello, a mixture of lead, copper and
silver which forms an attractive grey-black inlay.

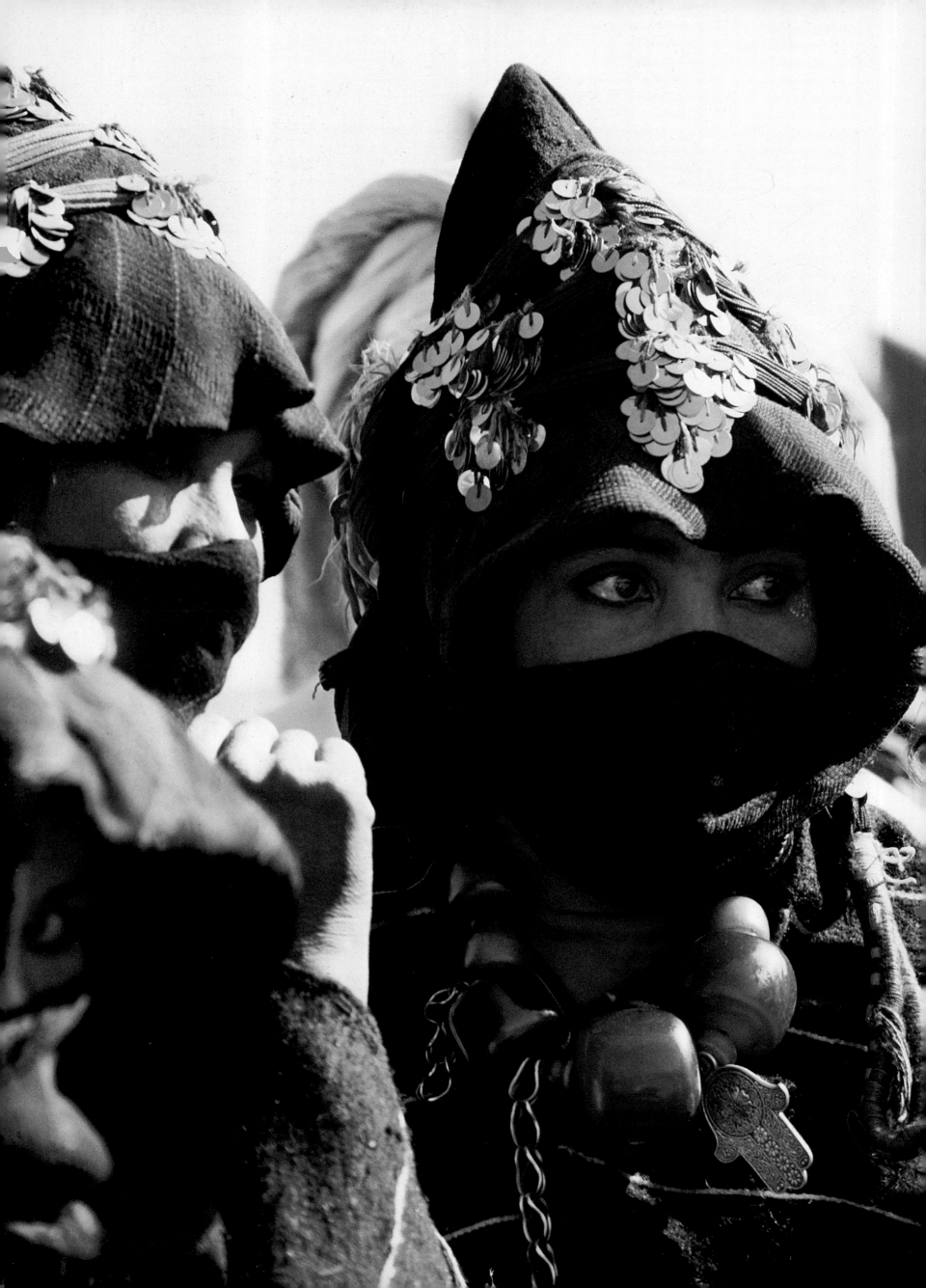

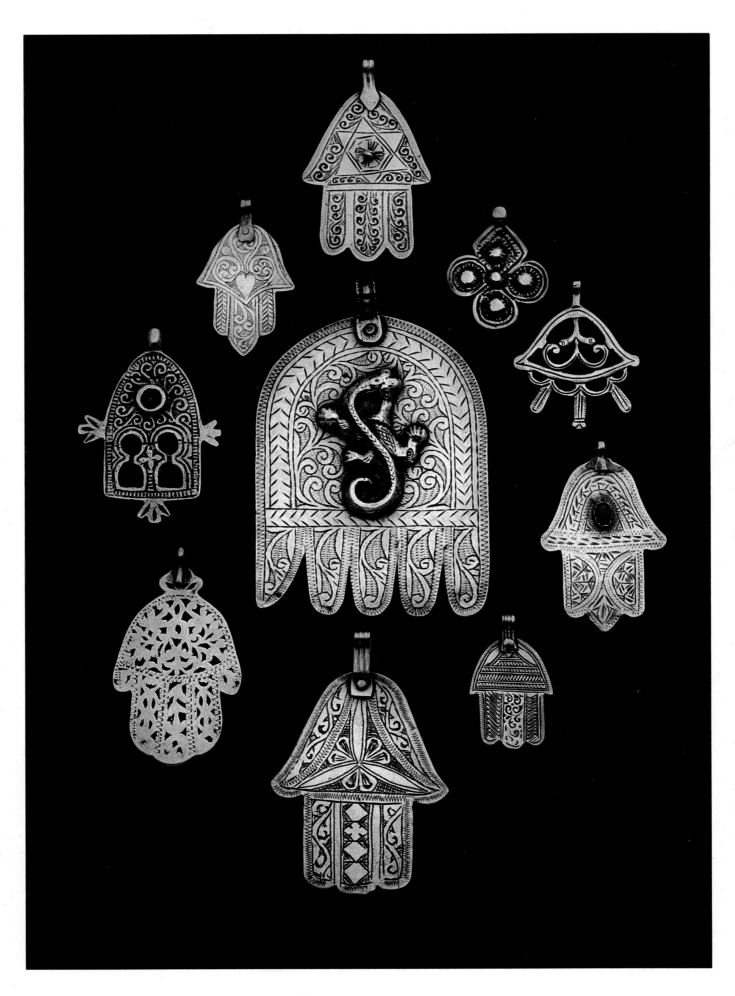

THE PROTECTIVE HAND

The hand is the most important symbol of protection in the Maghreb: as well as offering a defence against the evil eye it represents the five fundamental principles of Islam, and is named *khamsa*, the Arabic for 'five'. The five-fold pattern may be incorporated into a pendant of any shape and still hold the same symbolism as the hand. All the 'hand' designs above are from Morocco, except (3) which is worn at weddings by Berber women from the Aures Mountains of Algeria, and (7) which is from Tunisia and is of typical openwork design. Moroccan designs include the Star of David (1), the heart (9) and popular arabesque and flower motifs (4, 5, 6); (4) includes a blue glass cabochon which symbolizes the good eye – an added source of protection. *Foulet khamsa*, five beans, is the name of the hand (2) found along the Atlantic coast as a pendant and part of a belt. The pendant cast with small hands projecting from the sides (8) is worn hanging from fibula chains by women in the northern Atlas Mountains. The central hand, *luha*, meaning 'small board', is the largest to be used as a single pendant and often incorporates a salamander or lizard, believed to have special healing powers and the ability to predict the future. (Central hand 12.4cm)

BRIDAL FAIR

Berber women, though friendly and flirtatious, are initially shy and whilst at the fair will only ever reveal their eyes. Men searching for prospective brides must choose from one of the many cloaked and hooded figures solely by the look in her eyes and the sound of her voice. On the last day of the festival couples make their choice, shake hands and declare themselves engaged. They say, *'Tq chemt fasa nou'* – 'You have penetrated my liver,' to which the reply is, *'Oula kiy tasa nou'* – 'You too.' (For the Berbers the liver is the source of love.) The couple then formalize their vows in front of a notary.

The various groups of Ait Hadiddu women are distinguished by the design and colour of the stripes on their woollen capes and the type of fibula they wear. These often represent animals believed to have magical properties, such as the jackal's paw, *dar-n-ouchen*, worn in the eastern regions (1) and around Imilchil (4), and the turtle (2 and 3) worn in the south and by the Ait Atta tribe. (1: 13cm, 2 and 3: 6cm, 4: 6cm)

OPPOSITE An Ait Hadiddu woman, distinguished by her jackal's paw fibula, smiles shyly after receiving a wedding proposal.

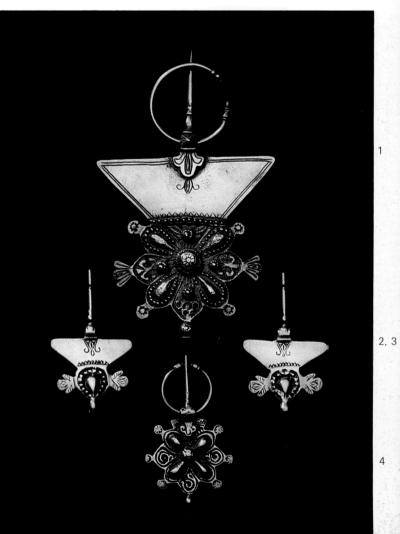

1

2, 3

4

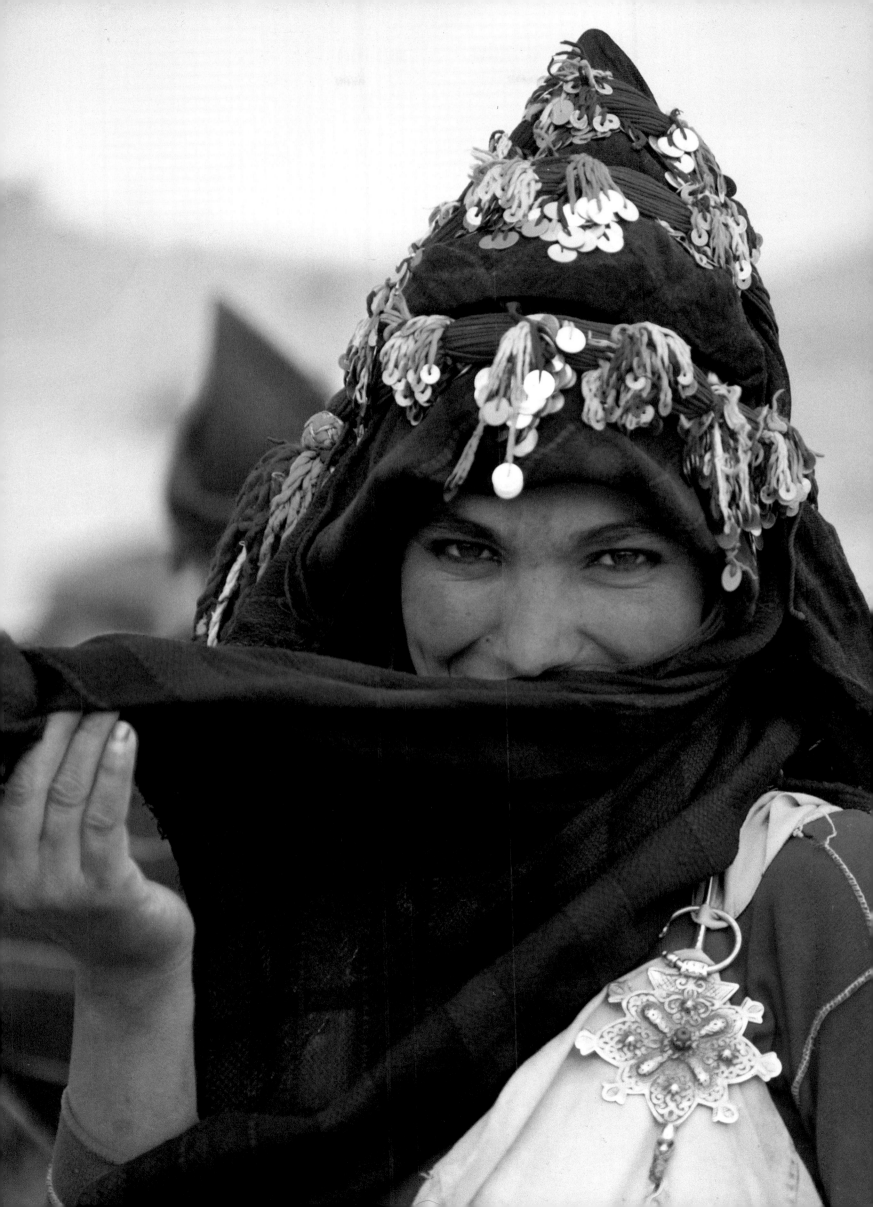

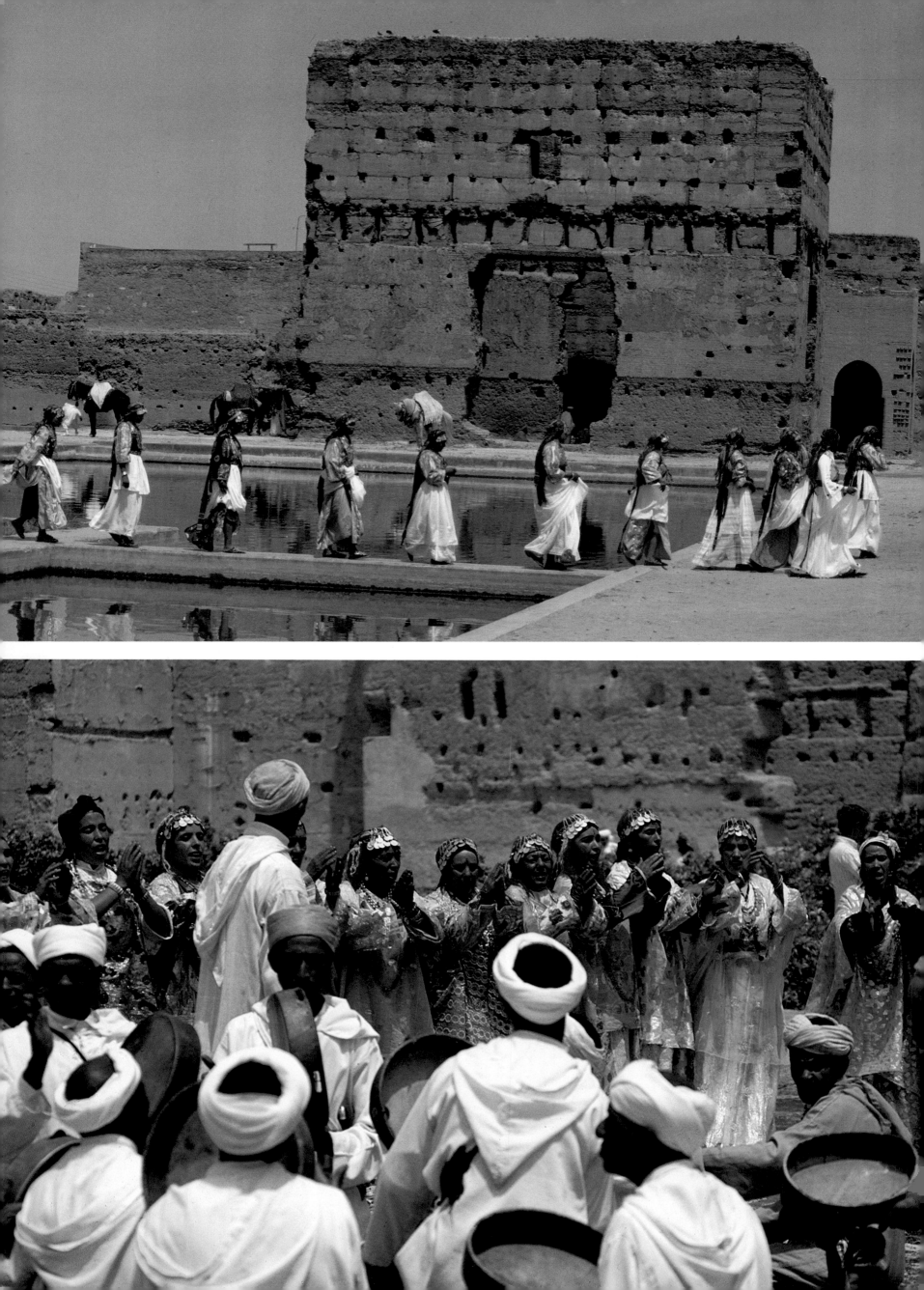

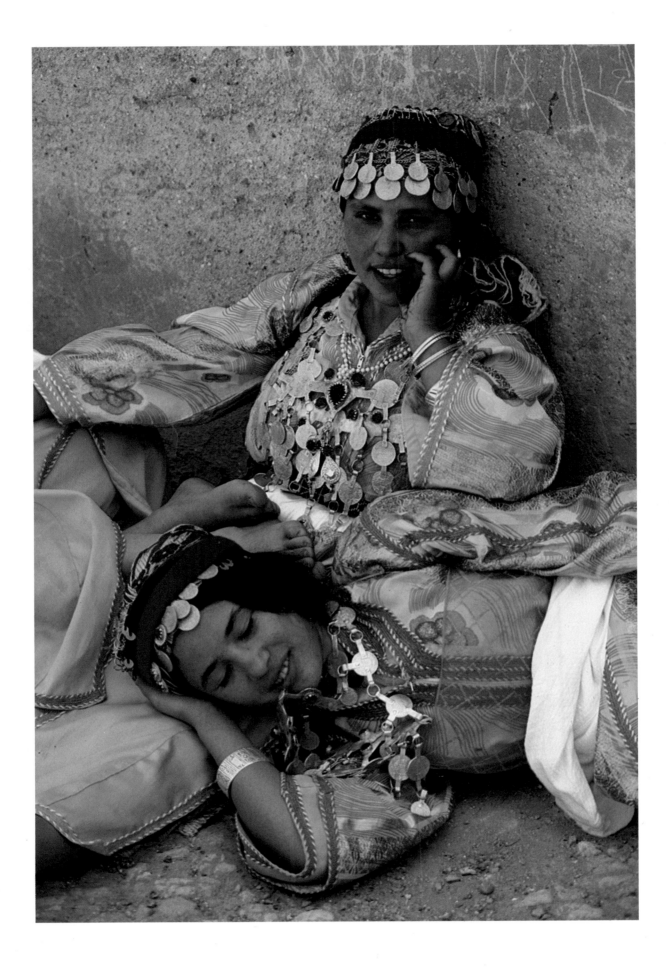

FESTIVE RICHES

Dancers dressed in all their finery attend the annual Berber folk festival in Marrakesh. To these villagers from distant regions of the Atlas Mountains the sixteenth-century El Bedi Palace must seem splendid indeed, with its huge interior courtyard, palatial pool and orange grove enclosed by thick towering walls. The festival is a riot of colour and sound as each group of Berbers performs its own regional dances, displaying an immense variety of traditional dress.

ABOVE Berber women from the Middle Atlas Mountains relax between dances. Their lavish ceremonial jewellery is brought out only on special family occasions or at festival times and otherwise kept safely in cedarwood boxes at home.

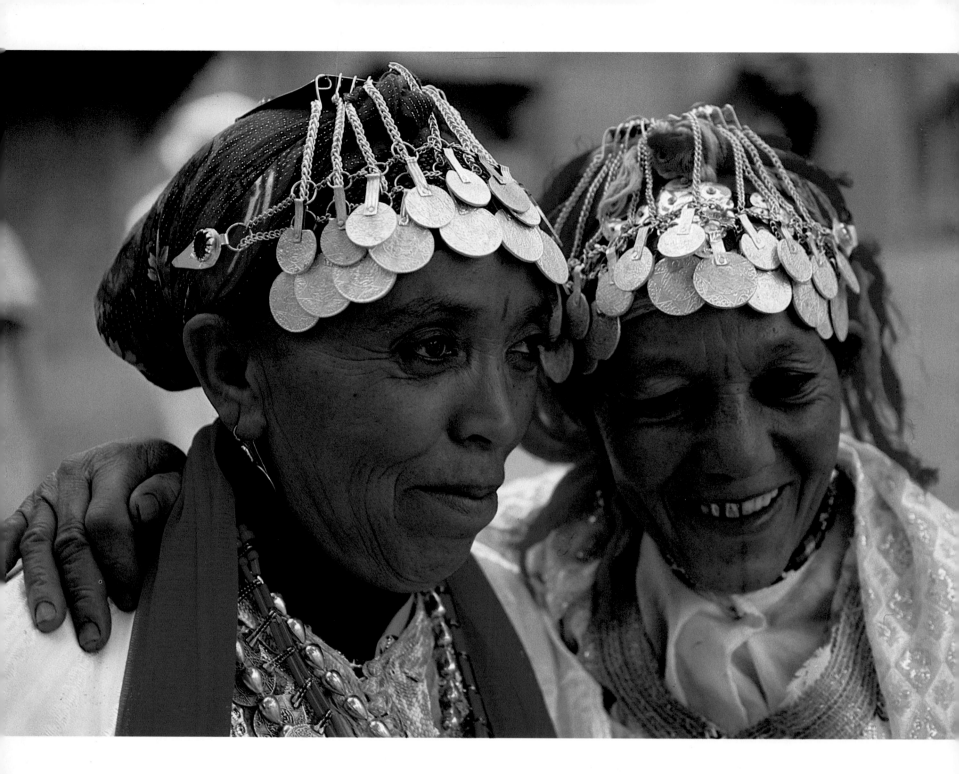

ADORNED WITH COINS

The bold designs of these Moroccan coin headdresses suit the strong, vivacious personality of many Berber women. While the designs have remained unchanged over the years, the silver content has diminished as recent Moroccan and French coins replaced the former French napoleons, Spanish *duros* and heavy old Swiss coins. Moroccan silver coins in the collar shown (*left*) from D'Imin Tanout in the Atlas Mountains date from 1878 (1299 in the Islamic calendar). The clasps also help to secure clothing below the shoulder. (Width of collar 33cm)

RIGHT A Berber woman from Ouarzazate in the High Atlas Mountains wears a necklace of old imitation amber and silver balls interspersed with red felt to protect them. This type of imitation amber bead made in Europe has been traded in Africa for the past century.

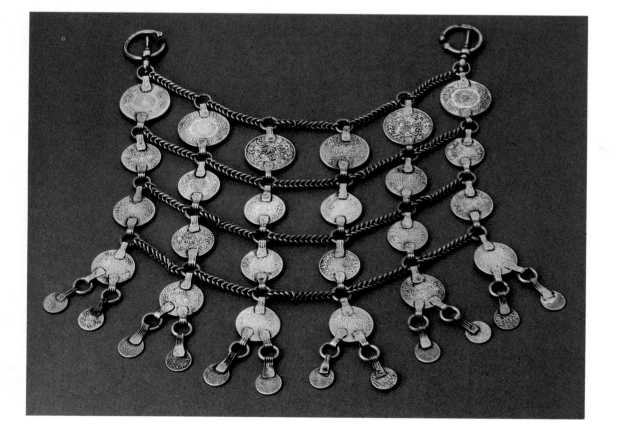

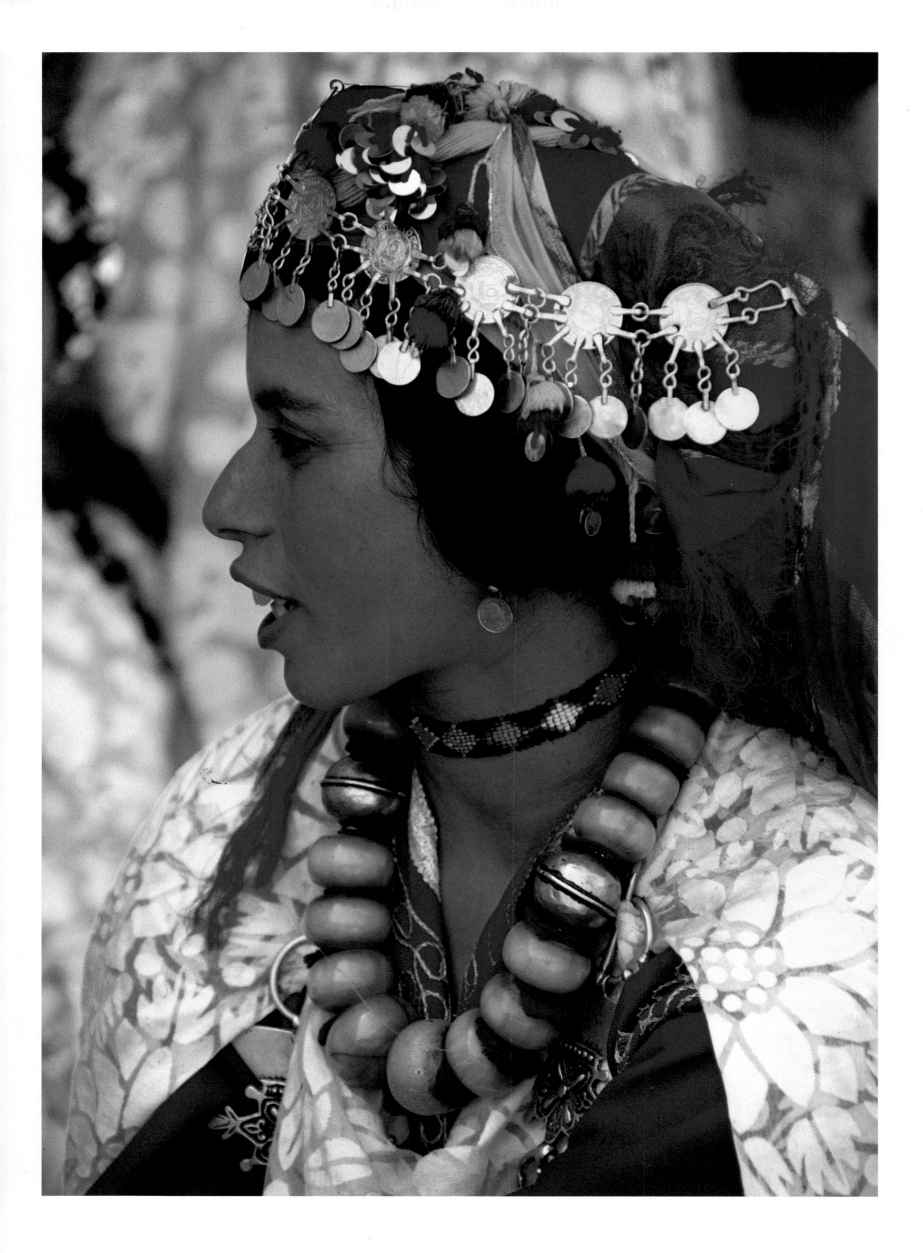

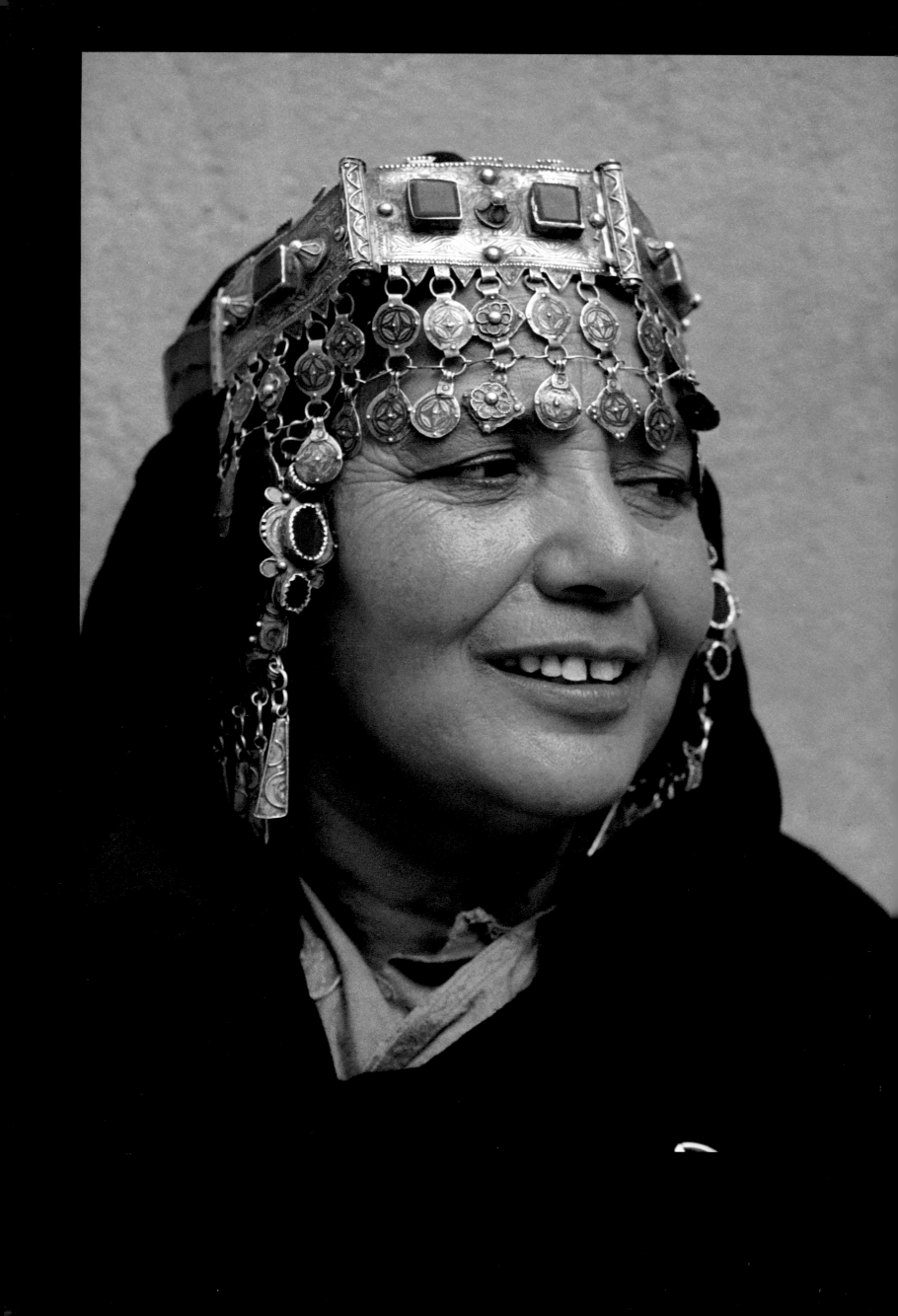

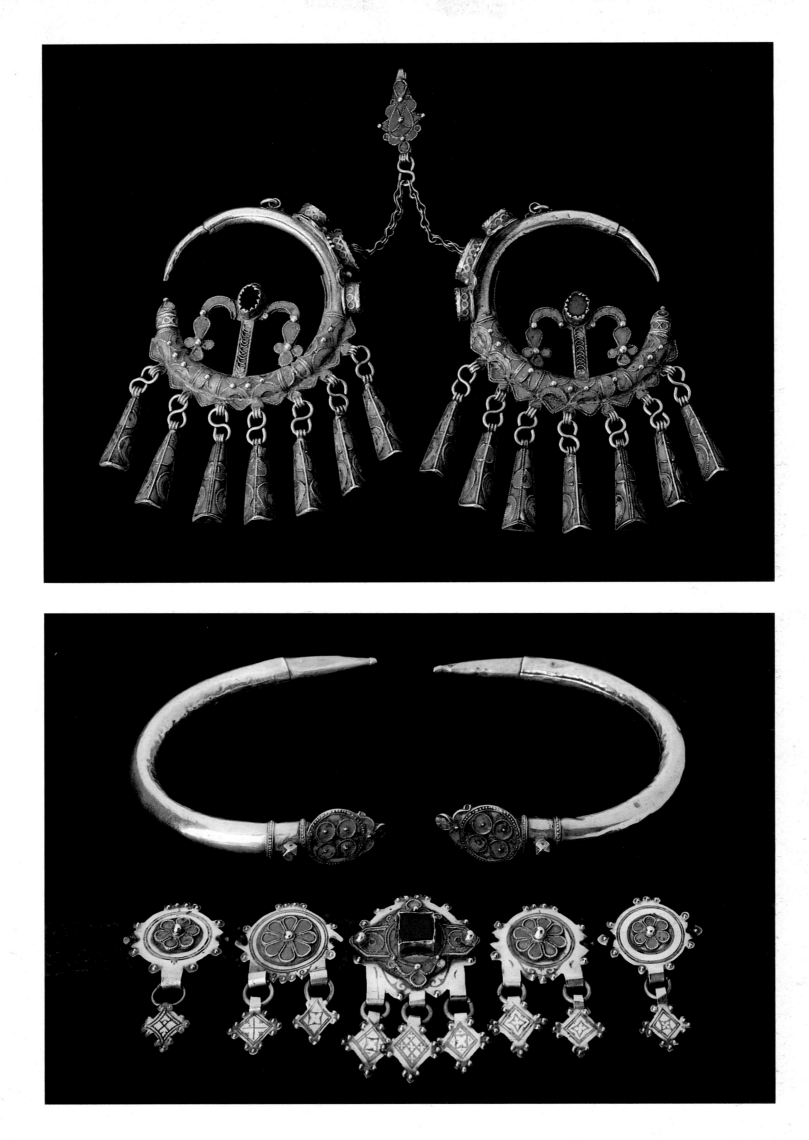

ENAMELLED SILVER

LEFT A Berber woman from Tiznit wears a headdress of hinged silver plaques decorated with enamel, niello and cabochon glass. Her earrings (*also seen above*) are fine examples of *cloisonné* enamelling. The design within the ring represents a dove's foot. Too heavy to hang from the earlobes, they are attached to her headdress by the enamel hook, and hang on chains beside each ear. (15cm)

Also from Tiznit are these silver earrings with enamelled snakes' heads; they too are suspended beside the ear from a cord. Silver pendants from Tafraoute, Morocco, are worn attached to a woollen headband. (Earrings 12cm, headdress 31cm)

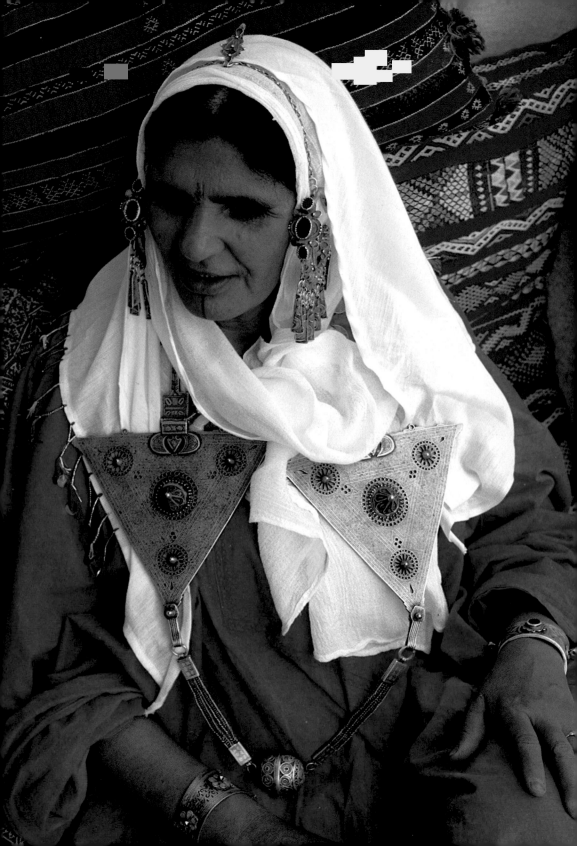

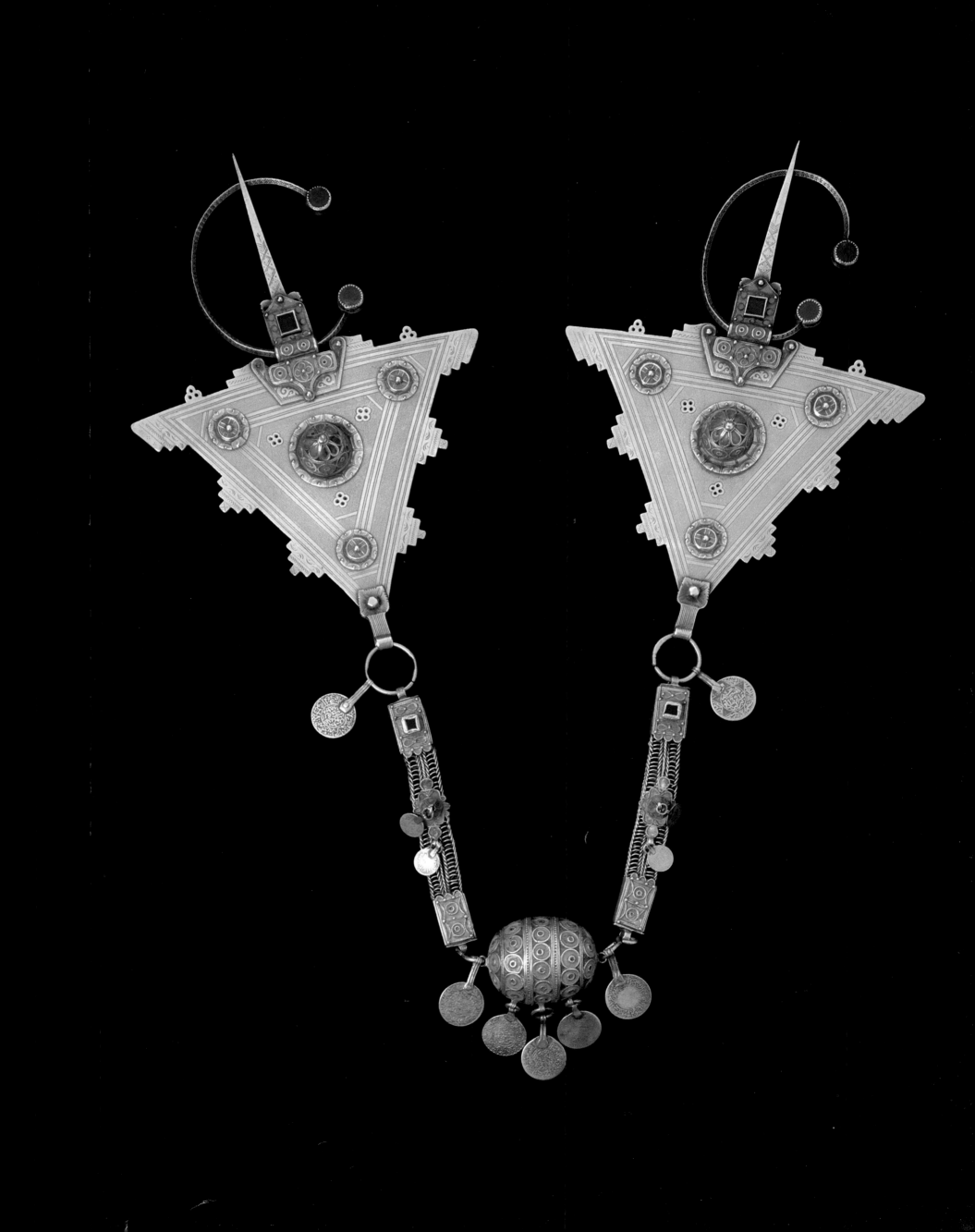

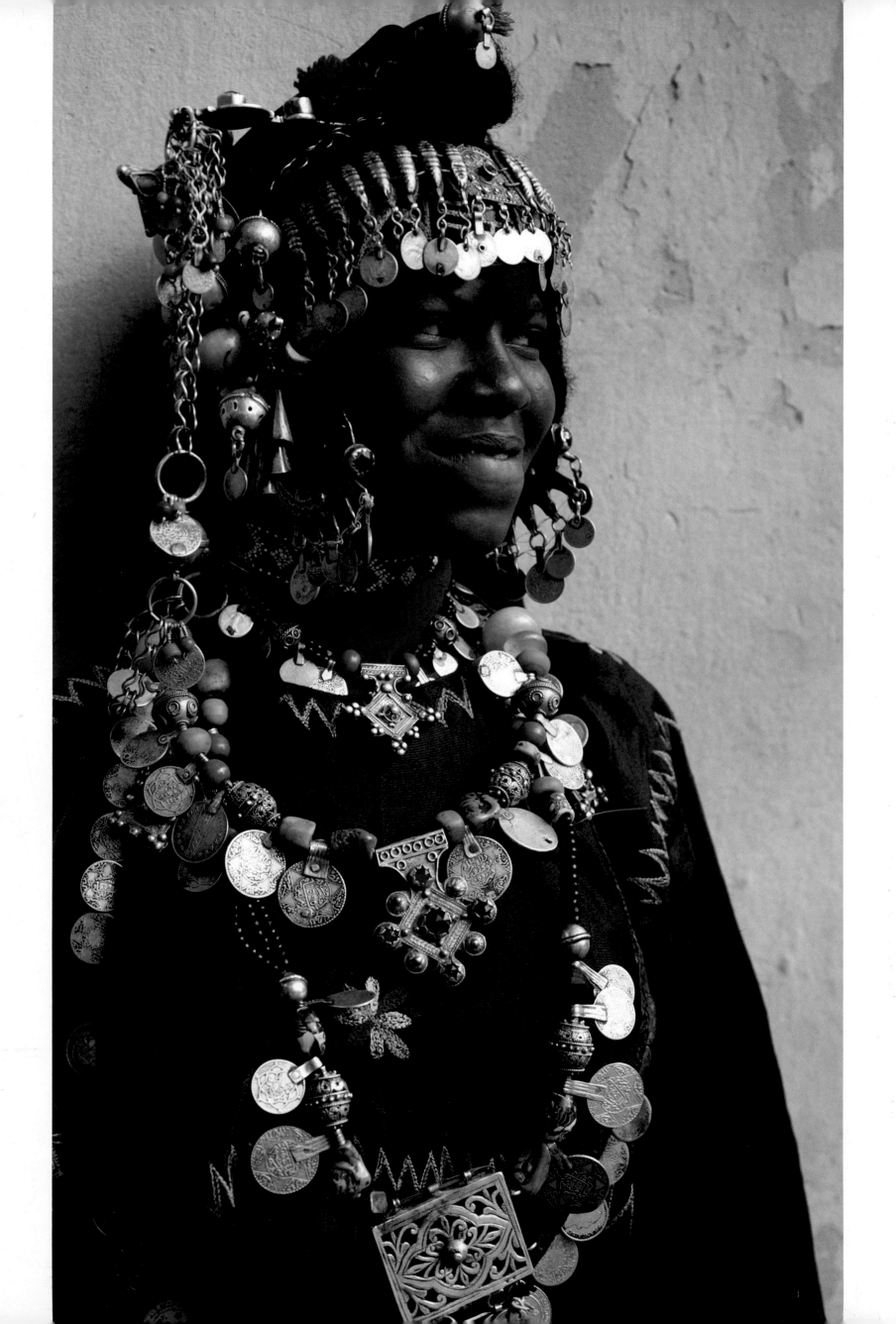

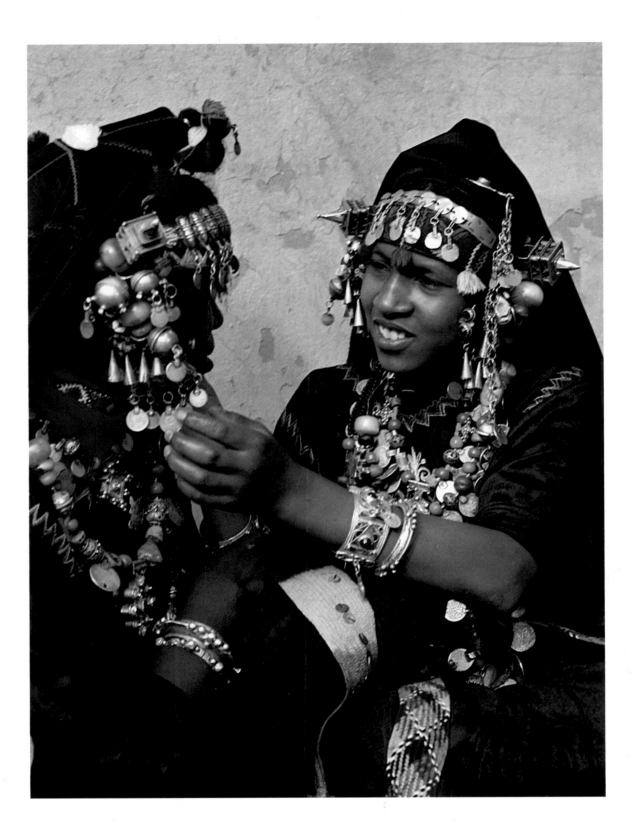

BERBER FLAMBOYANCE

PREVIOUS PAGE Fibula are decorative, symbolic and functional. The size and weight of the fibula worn by this Berber woman indicate her status whilst their shape, the inverted triangle, represents the female form. They also serve as clasps to keep her mantle in place. Craftsmen in the Anti-Atlas Mountains specialize in this unusual form of decoration with many fine holes – a time-consuming technique which is fast dying out. The largest Moroccan fibula (*right*) are worn by women of Tiznit and others of the western slopes of the Anti-Atlas Mountains; their fine engraving, enamel and cabochon work are typical of that area. The central egg-shaped beads, *taguemout*, symbolize fertility. (50cm)

The Tissint from southern Morocco are part of an ancient group of mixed races of part-negroid descent known as the Haratine. With a preference for bold, colourful and flamboyant designs, these women collect quantities of valuable jewellery – of silver, coral and amazonite – as fast as their husbands' wealth allows. The silver pendant, *walata idye*, on the two upper necklaces (*left*) has five decorative points, and the *besakou*, the pendant on the lower necklace, often contains holy verses or magical substances. These two amulets, of a design believed to originate in southern Mauritania, show negroid influence. The pointed box-like rings worn as hair ornaments (*above*) hold sweet-smelling herbs or perfumed wool.

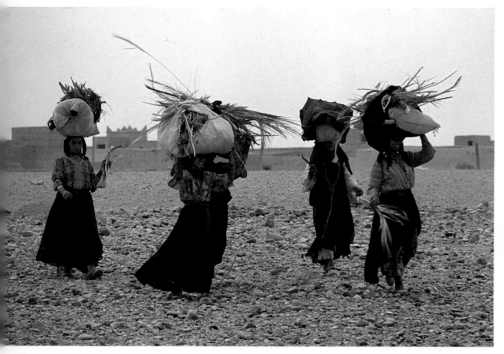

DAILY ATTIRE

The oases dotted along the northern edge of the Sahara are inhabited by Berber nomads and Haratine. The Haratine, although they lead a tough, rural life cultivating the oasis gardens, have retained their preoccupation with jewellery and the women are never seen unadorned. Their ornaments, of bold designs incorporating glass beads and coins of low silver content, are worn for both beauty and protection.

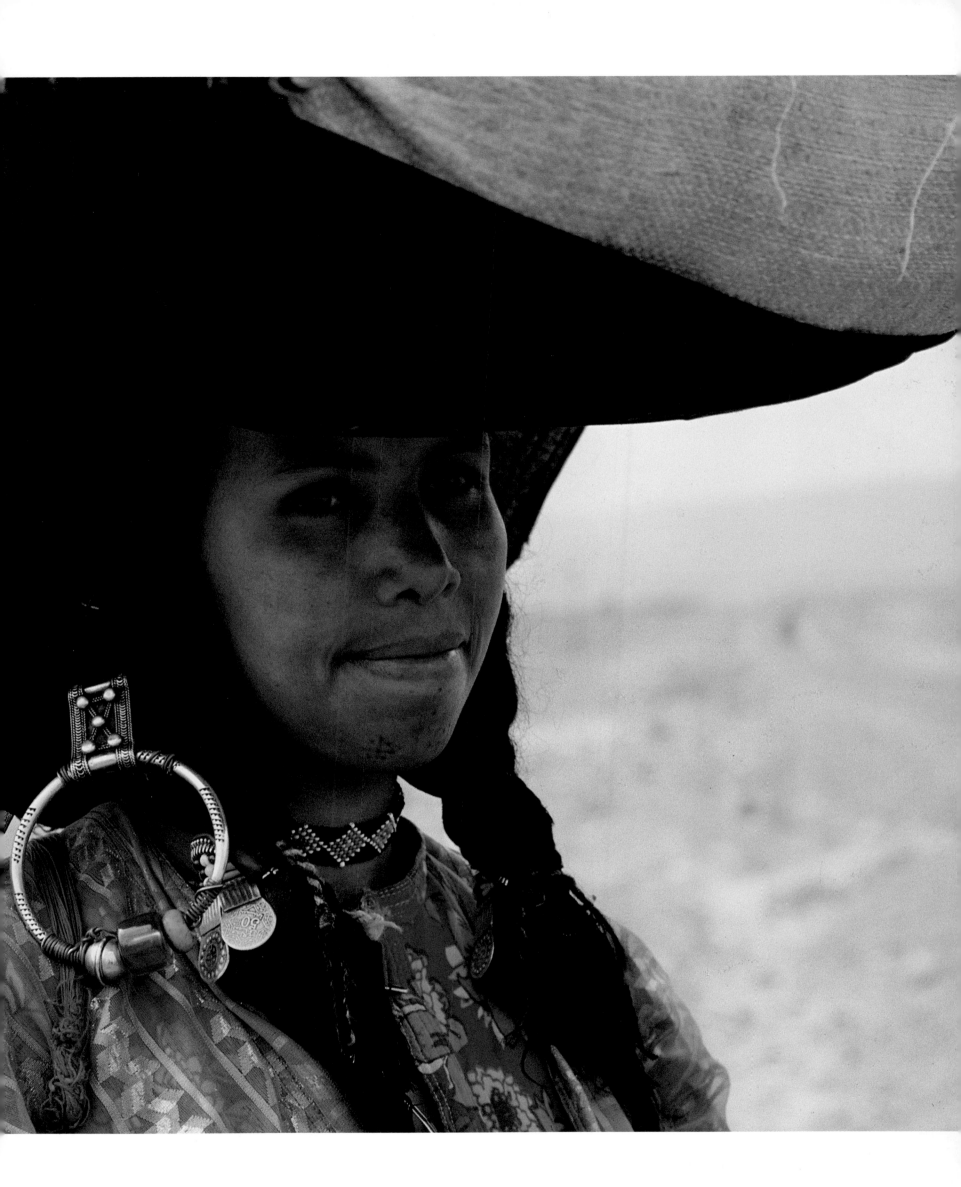

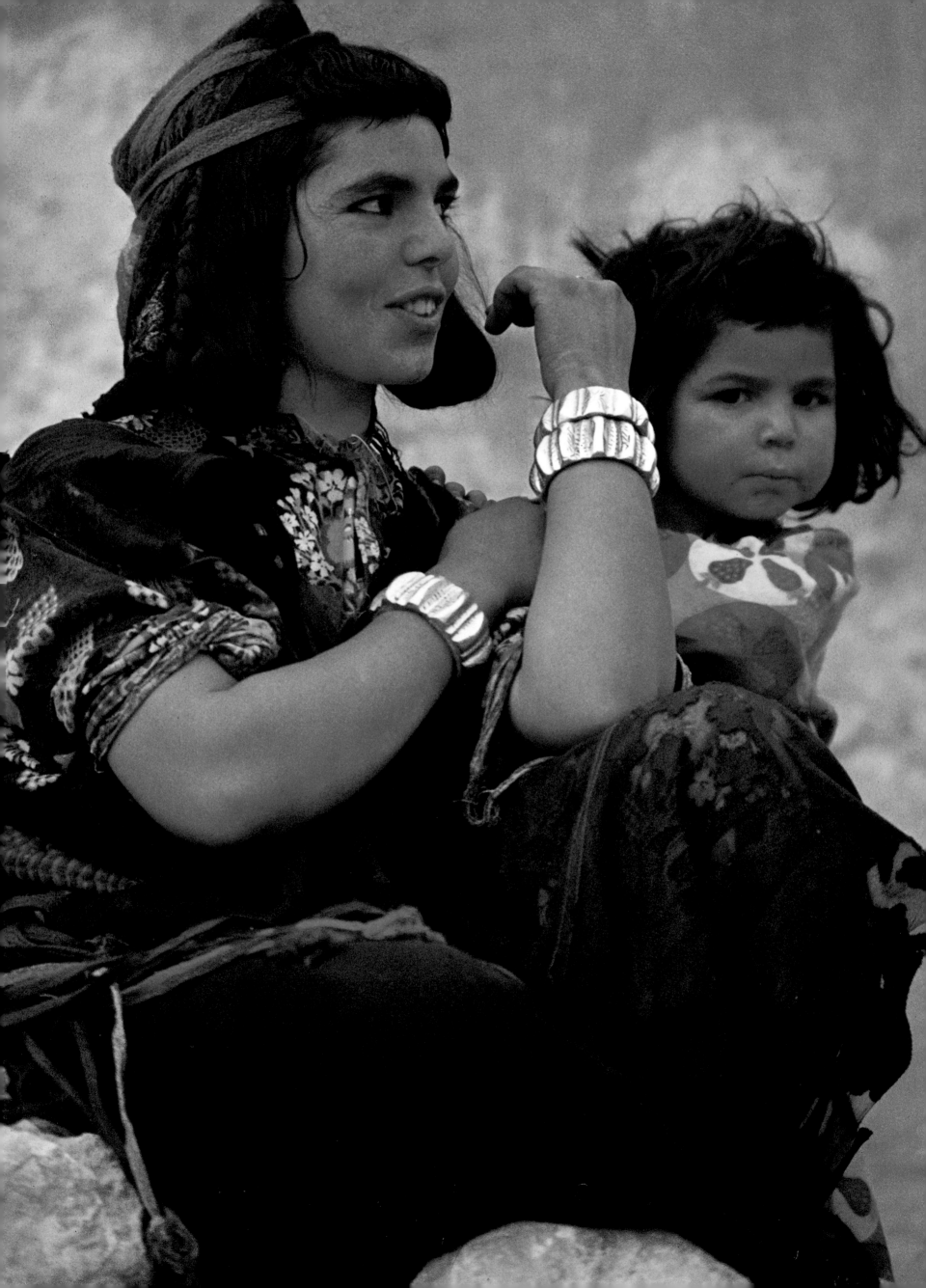

MOTHERS AND DAUGHTERS

At birth a baby girl receives her first set of
beads and a small amulet containing herbs
and seeds believed to have magical powers.
In the Draa Valley young Berber girls wear
foulet khamsa, stylized hand pendants –
referred to among some Muslims as 'Fatima's
hand', that of the beloved daughter of the
Prophet Mohammed. They also wear small
cast silver bracelets, similar to those they will
wear when they are grown up.

The necklace worn by the young girl (*above
right*) is made of the typical elements of
branch coral, amazonite, shells and glass. The
six *foulet khamsa* pendants are interspersed
with old Islamic coins and a gold-plated
centrepiece. (Centrepiece 4cm)

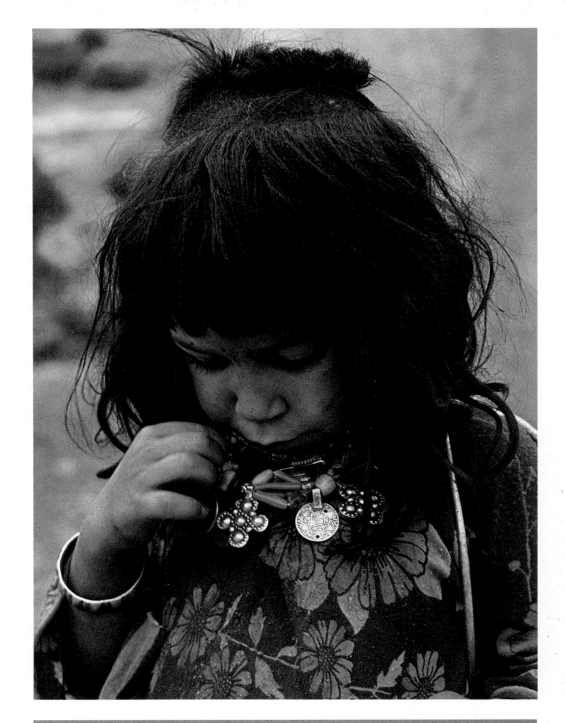

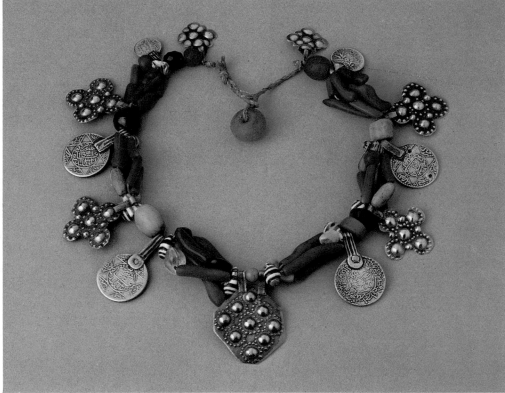

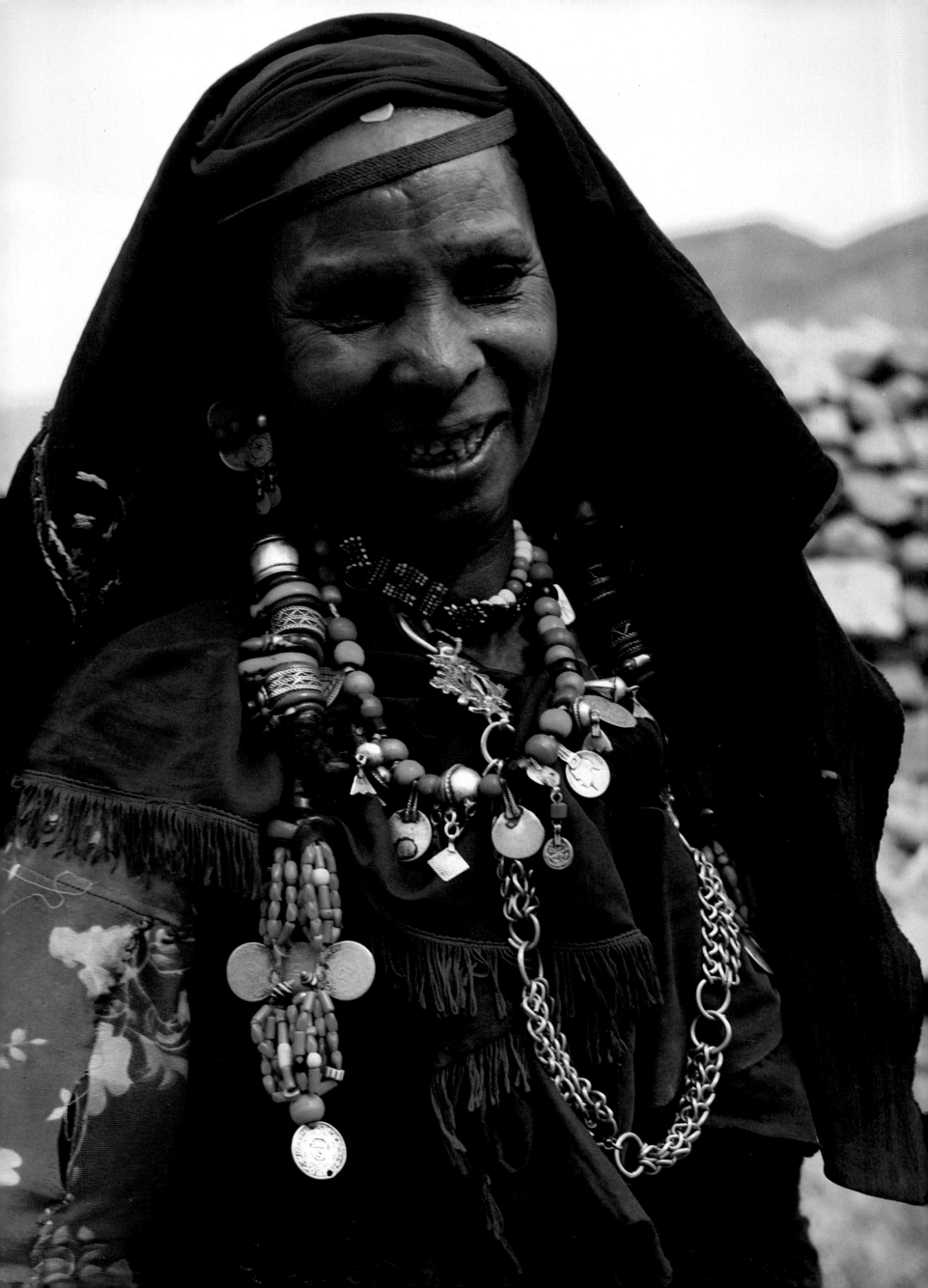

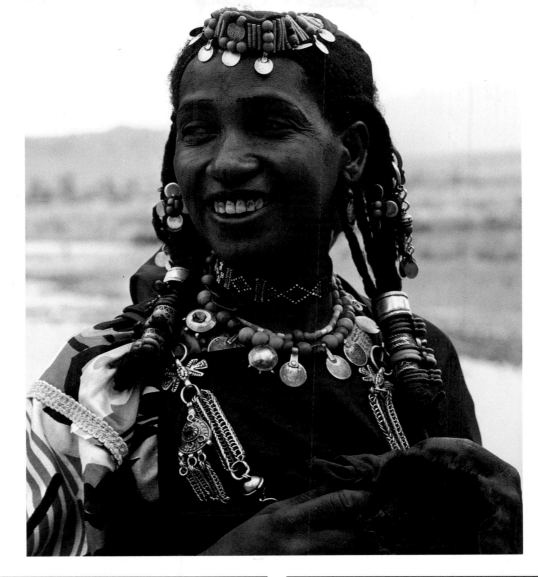

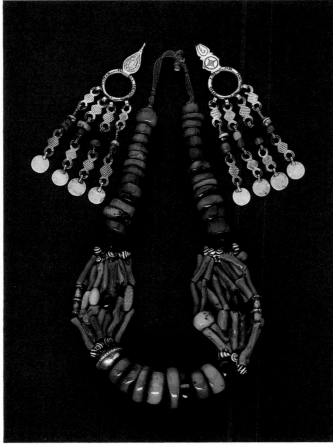

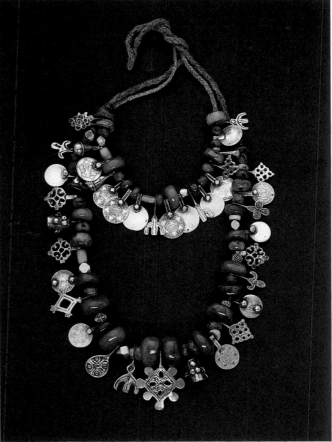

ORNAMENTED BRAIDS

Women from the Draa Valley in southern Morocco decorate their long plaited hair with rings of silver, agate and glass, and hang bunches of branch coral, shells and old silver coins from the ends. The agate and glass rings are of ancient design, similar to the *khourb* triangular talismans used by Mauritanian women in their elaborate hairstyles. In recent years costly elements of coral and amazonite have been superseded by red and green glass beads, as seen here in the women's necklaces.

A flamboyant use of elements and a love of natural forms has resulted in the rich assymetrical jewellery designs worn south of the Atlas Mountains, particularly in the Draa Valley. Traditional materials include amber, coral, amazonite, silver, shells, coins and black glass beads, the latter originally imported from Holland. Many pendant designs which do not bear any obvious resemblance to the hand, such as the central pendant and the three-pronged ones in the larger necklace (*above right*), are nevertheless considered to represent it. (Necklaces 60cm)

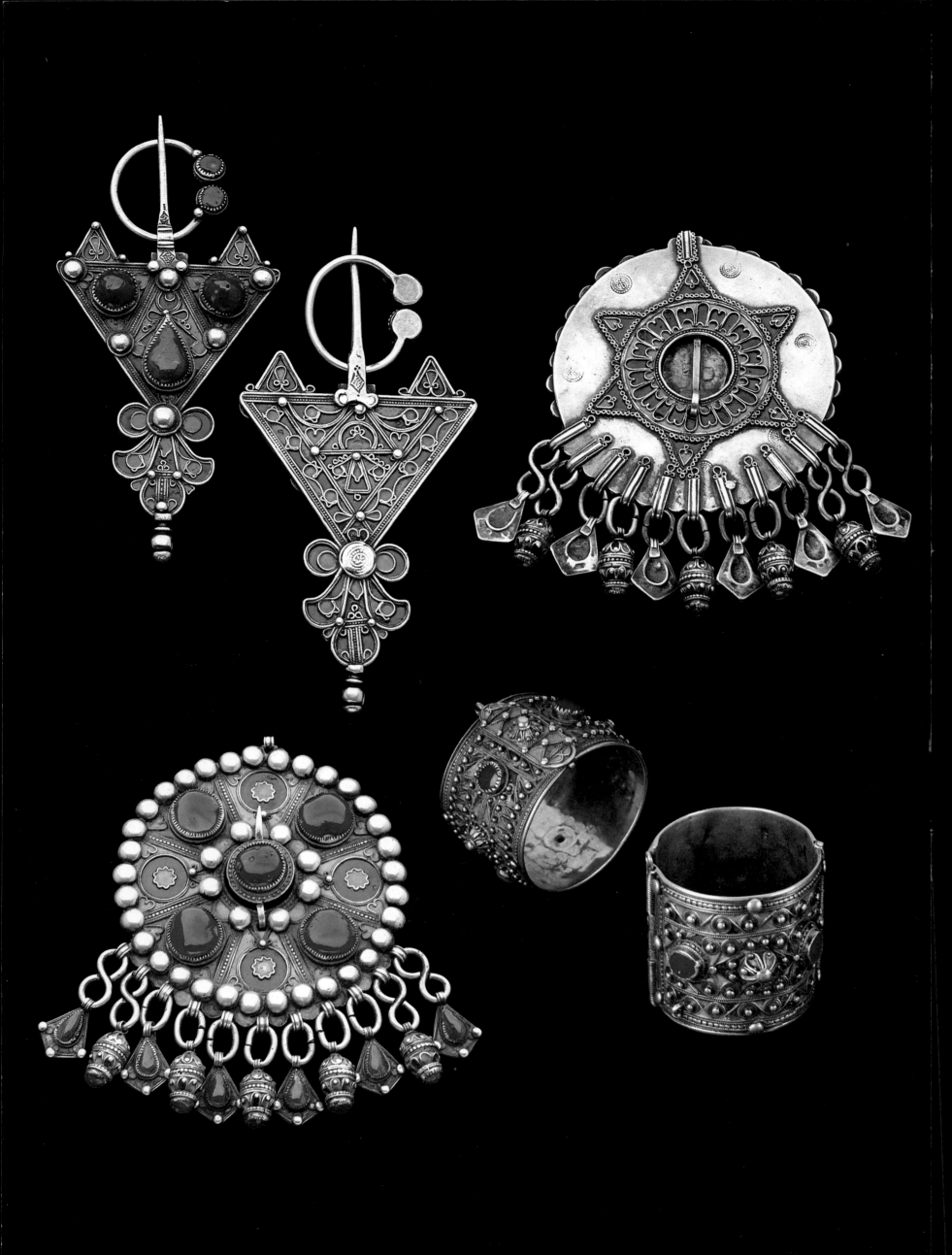

ESSENCE OF CRAFTSMANSHIP

BELOW A Jewish silversmith from Rissani, southern Morocco, uses traditional sand moulds to cast the pointed bracelets, *asbia' iquorain*, shown overleaf.

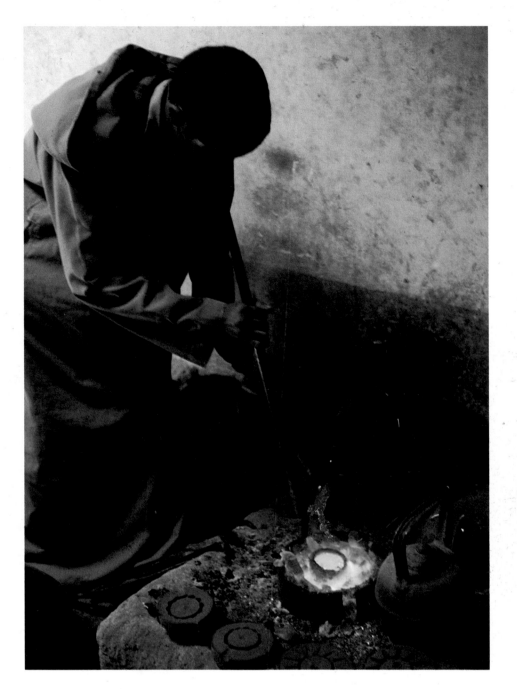

OPPOSITE The Kabyle smiths of northern Algeria specialize in *cloisonné* enamelling and their craftsmanship is unsurpassed in the Maghreb. They decorate their jewellery with traditional green, yellow and blue enamels, paying almost as much attention to the reverse side as they do to the front – as with the diadem *tabzimt* (*below left*), shown in reverse (*above right*). Kabyle women receive their jewellery – diadem, bracelets, anklets, necklaces and fibula – at marriage, a gift from their parents and part of their dowry. Among the Benni Yenni tribe, however, a woman receives the *tabzimt* from her husband after she has borne her first son; in such cases it is worn on the forehead, not on the chest. (21cm)

The enamelled silver fibula (*above left*), shown front and reverse are called *ibzimen*. Kabyle women always wear bracelets in pairs; on feast days they wear several pairs on each arm. Of the two shown (*below right*), the one on the right has a simple uncovered bolt opening, whereas the other, older one has an enamel plaque carefully designed to conceal the bolt. (5cm)

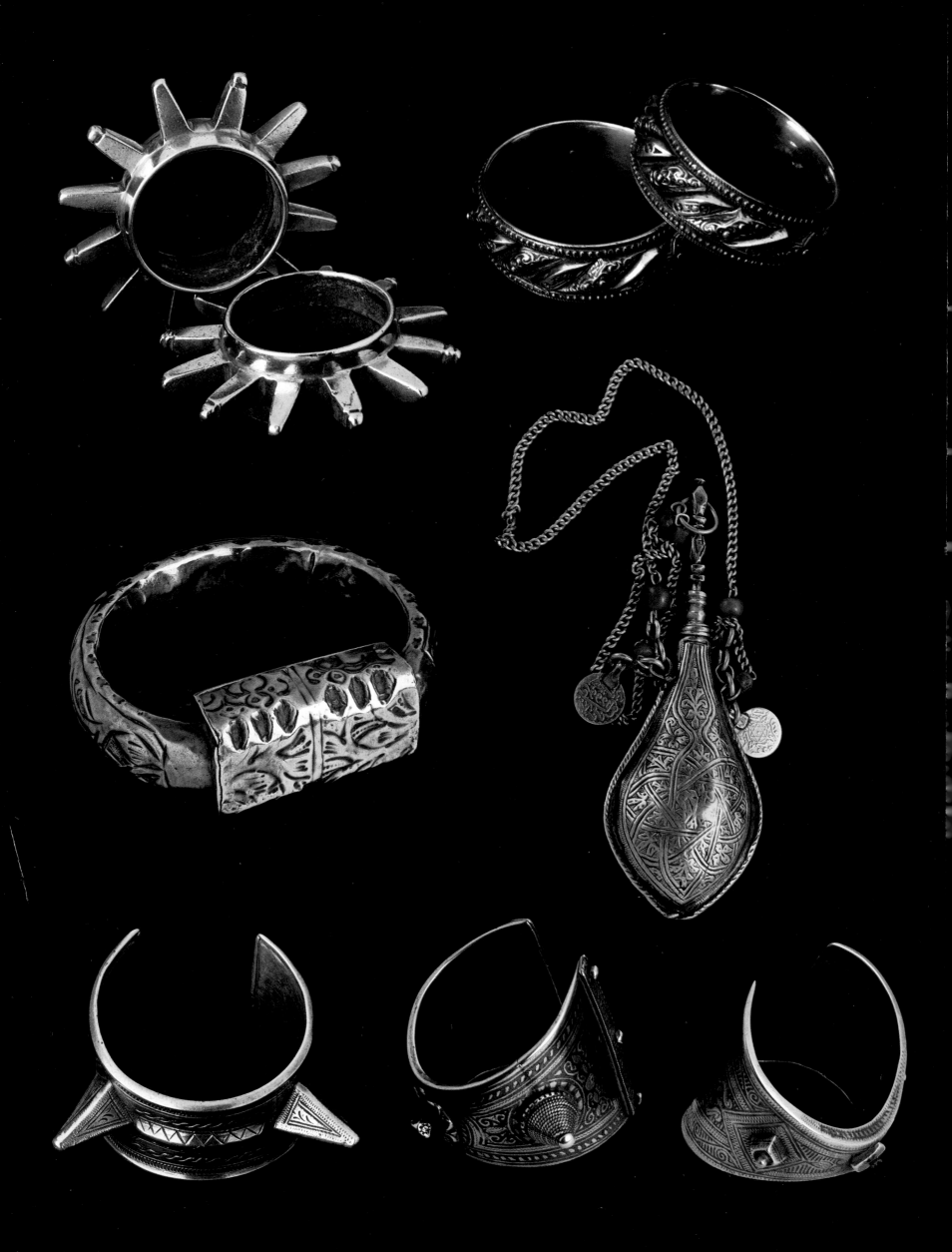

BERBER JEWELLERY

1 These massive bracelets, *asbia' iquorain*, were originally worn by women of the Ait Atta tribe to defend themselves during raids; nowadays they are purely ornamental. (11.5cm)

2 *Shems ou kmer* bracelets with bands of gold and silver symbolizing the sun and moon, worn in the cities of Tangier and Fez. (8cm)

3 A hollow silver anklet, *khelkhal menfouk*, worn by women in Tunisia in the region of Kairouan and Sfax. Pebbles are often put in the anklets during casting so that their rattling will chase away evil spirits. (13cm)

4 An incised silver kohl container decorated with coral beads and silver coins, from the region of Fez. (13cm)

5 A silver bracelet from south of the Atlas Mountains with projections to ward off the evil eye. (7cm)

6 Silver bracelets with riveted cones and niello designs, worn by women from south-west Morocco. (8cm)

7 Silver earrings with inset coral, *iloan*, worn by Kabyle women. (6cm)

8 Crescent-shaped Tunisian fibula, *khellal*, featuring the moon and fish. The fish is the symbol of fertility and of all life. (9cm)

9 A popular style of earring, *tikhrazin*, worn in Morocco. The small stylized birds are doves, carriers of good news. (11.5cm)

10 Silver earrings from Tunisia with glass cabochons, *mercherfa*, are distinctive for their teeth-like lower edge, inspired by a popular 19th-century Spanish design. (14cm)

OVERLEAF

11 A heavy silver collar worn at festivals in the Middle Atlas; the plates decorated with niello are all of different design. (19cm)

12 Necklace of branch coral and silver discs with niello spiral design (symbolizing eternity) worn by Berber women in Tiznit. (26cm)

13 Silver and coral choker with old French, Italian and Spanish coins worn by Kabyle women. (20cm)

14 Silver ear ornaments with clusters of amber and coral beads and silver pendants of fine niello work, from south-west Morocco. (24cm)

15 Necklace of filigree gold, glass and heart-shaped beads, *shab*. Made by women in Tunis to an old Egyptian formula, *shab* always contain ambergris and may include rose petals, cloves, saffron, nutmeg and musk. Their heavy scent, reputed to last a lifetime, is brought out by the body's warmth. (38cm)

16 Two amber necklaces from Ouarzazate, Morocco, given by Berber men to their wives at marriage and worn afterwards on festive occasions. The beads are interspersed with red felt discs to protect them, and the tassels are made of fine silk threads. (55cm)

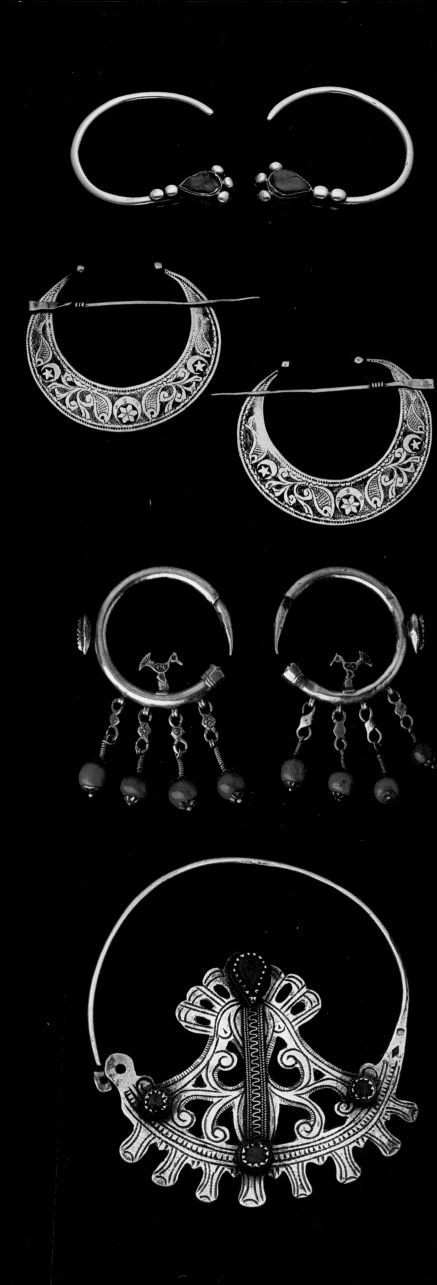

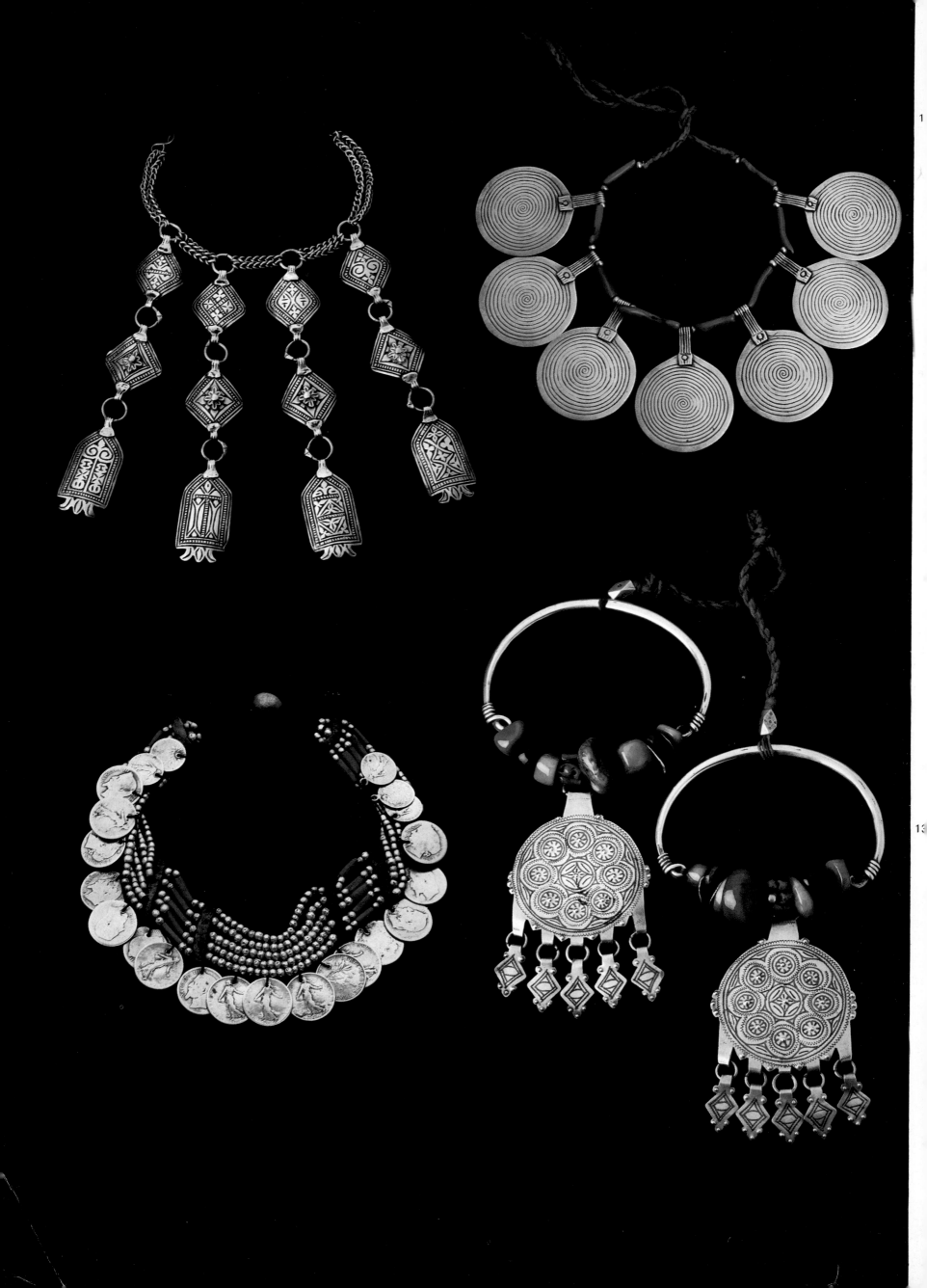

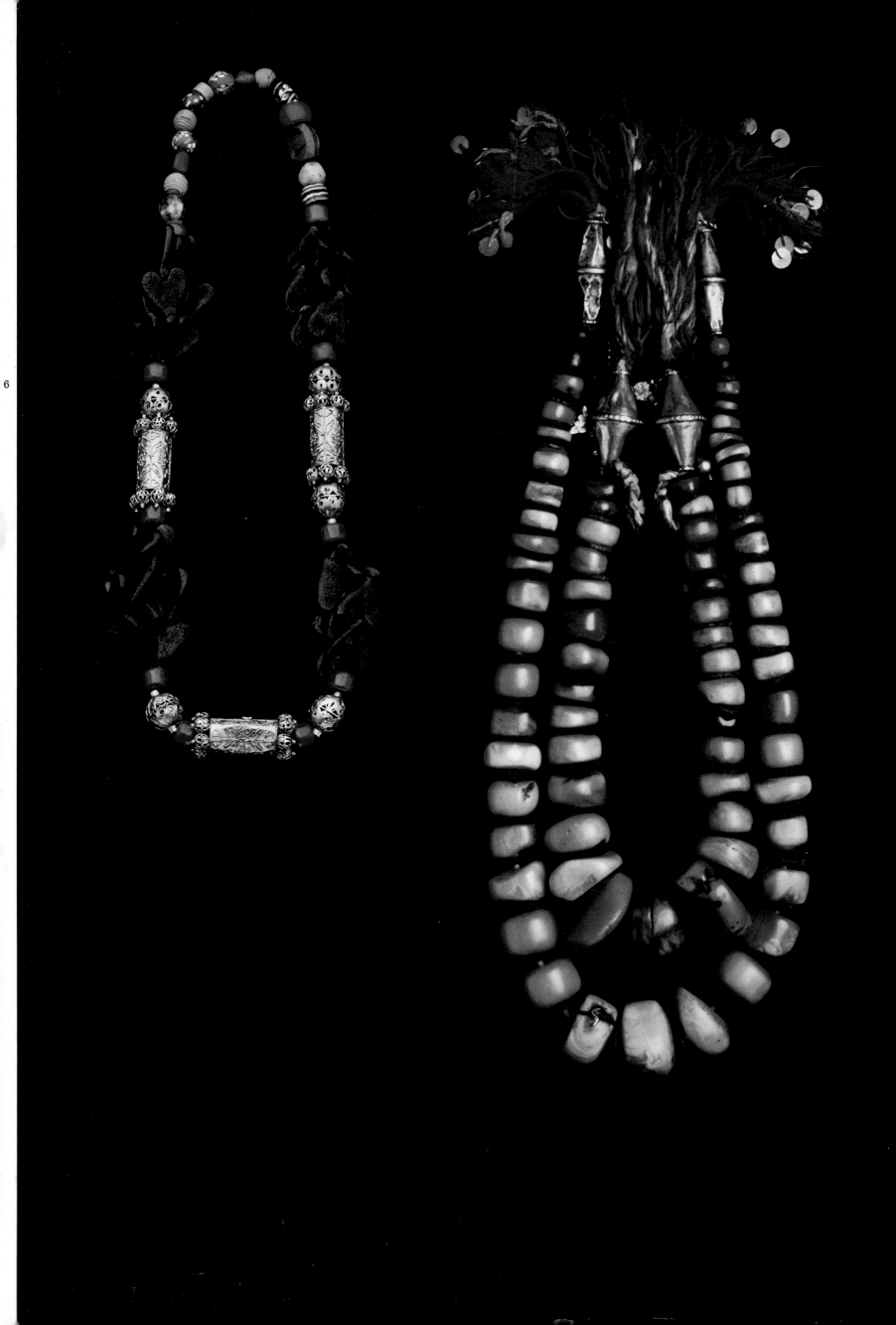

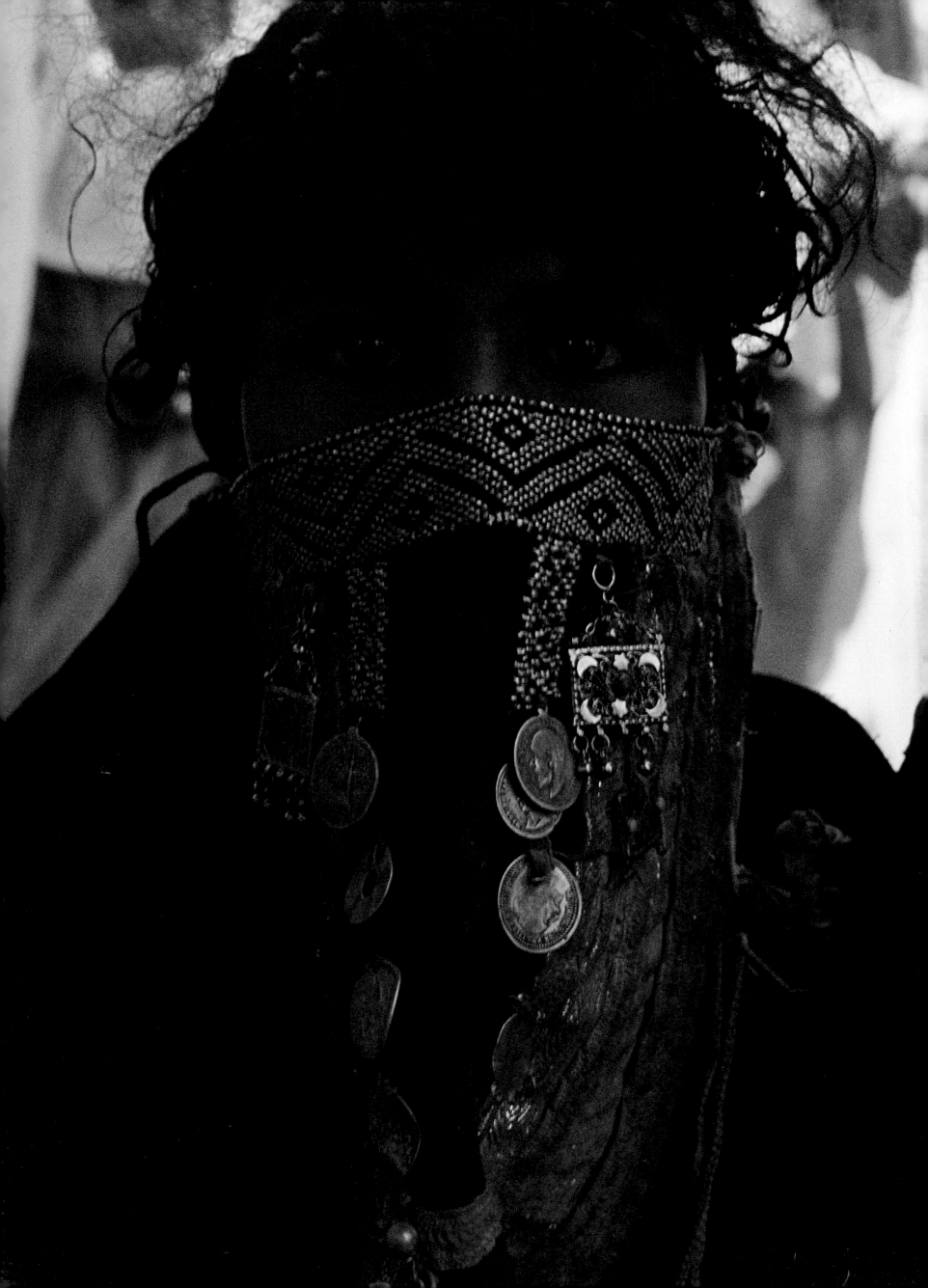

The [Ethiopian] *women of the higher class are remarkable for their beauty, not only of feature but of form, and possess singularly small and pretty hands and feet, all of which beauties their style of dress exhibits freely. Their features are almost of the European type and their eyes exceedingly large . . . as to their ornaments, they are so numerous as to defy description. The women wear several chains round the neck, three pairs of silver or gilt bracelets, a number of little silver ornaments hung like bells to the ankles. A wealthy woman also has a large flat silver case, containing talismans, and ornamented with bells of the same metal suspended by four silver chains, while her hair is decorated with a large silver pin elaborately made. The Tigrean ladies . . . tattoo themselves and cover nearly the whole of their bodies with stars, lines and crosses, often rather tastefully arranged.*

J. G. Wood. *A Natural History of Man: Africa,* 1868.

THE HORN

Links with the East

The north-east corner of the African continent curves around the Red Sea and the Gulf of Aden like the horns of an African cow, from which comes its poetic name, the Horn of Africa. The jewellery of this region clearly reflects the lifestyles and beliefs of two distinctly different peoples: the Coptic Christians of the Ethiopian highlands and their neighbours, the Muslims from the coastal lowlands bordering the Red Sea and the Indian Ocean. The highlanders, early converts to Christianity, have for centuries isolated themselves from the outside world in the craggy barriers of a vast mountain massif in order to sustain their beliefs and protect themselves from the spread of Islam. On these bleak hillsides, inspired by their religion but limited by scarcity of materials, they have perfected a relatively small number of jewellery styles which are outstanding in their imaginative simplicity. By contrast, the Muslims of the coastal plains, through immigration and centuries of trade with Arabia and India, have been greatly influenced by the outside world. The flow of exotic cloth, pottery, perfumes and jewellery brought across the Indian Ocean by dhow sea trade attracted them to a way of life more characteristic of the Middle East than of the continent of Africa. Precious metals were available too and their jewellers, inspired by the new techniques they came across, created a variety of art forms, often miracles of ingenuity though at times lacking in clarity of design.

The coastal plains of East Africa extend from the border of Egypt and Sudan in the north as far south as the island of Zanzibar. The southern part of these plains, though geographically not part of the Horn, is included in this chapter as it has been similarly influenced by Indian Ocean trade. To the north, the Nubian Desert in Sudan is the home of the Rashaida nomads, a Bedouin tribe who crossed the Red Sea from Saudi Arabia some 150 years ago after clashing with neighbouring tribes. Rebels by nature, they continued to be troublesome, smuggling firearms across the Ethiopian border and quarrelling over grazing and water rights with the Beja, the original, nomadic inhabitants of eastern Sudan. Now more peaceful, the Rashaida have settled in the Nubian Desert, where they pay an agreed rent for certain water holes and pastures and carry on a lucrative camel trade with Egypt via the coastal desert of Sudan.

Rashaida girl.

Somali girls with amber prayer bead necklaces, nineteenth century.

Body tattooing on a woman from the Ethiopian highlands, nineteenth century.

A 'fuzzy wuzzy' hairstyle, Eritrea, nineteenth century.

TIGRAY Tribal names

0 100 200 300 400 500 Kilometres
0 100 200 300 Miles

Nubian Desert

Hejaz

Port Sudan

SAUDI ARABIA

Red Sea Hills

HADENDAWA

BEJA

Red Sea

BENI AMER

RASHAIDA Eritrea

YEMEN

Khartoum Kassala Mitsiwa Sanaa DEMOCRATIC YEMEN

Asmera

TIGRAY AFAR

Aksum Tigray

Aden Gulf of Aden

SUDAN Gonder Mekele Danakil Depression

Gonder TIGRAY

AMHARA AFAR Aseb DJIBOUTI

FALASHA Lalibela Djibouti

Lake Tana Welo

Blue Nile AMHARA Dese Bati OROMO

White Nile Gojam AMHARA AFAR

Welega Shewa Dire Dawa Harer Jijiga

Addis Ababa OROMO SOMALI

OROMO GURAGE ETHIOPIA

Jima Ogaden SOMALIA

Kefa SOMALI

White Nile OROMO Wabi Shebele

Lake Abaya OROMO SOMALI

OROMO SOMALI

Lake Turkana

Lake Albert Lake Kyoga

REPUBLIC OF ZAIRE

Equator SWAHILI Mogadishu Equator

UGANDA KENYA Indian Ocean

Lake Edward Lake Victoria

Lake Kivu

RAWANDA Nairobi

BARUNDI Paté Lamu

Mt Kilimanjaro SWAHILI Malindi

Mombasa

TANZANIA

Lake Tanganyika SWAHILI Zanzibar

268

The Rashaida have close tribal and family bonds and do not intermarry with other tribes, so it is not surprising that in appearance and lifestyle they closely resemble the Rashidiyya peoples of Hejaz, their original homeland across the Red Sea. They still traverse the desert with their herds, camping in Bedouin tents made of rugs and woven mats. Proudly orthodox Muslims, the Rashaida believe that the sexes should be segregated and that women must always be veiled. The *burga*, a heavy cloth mask which conceals the front of the female body from just below the eyes down to the waist, is their most obvious link with Arabia.

The men maintain ties with their homeland by trading livestock. across the Red Sea, often returning with gifts of silver jewellery for their womenfolk. Rashaida women collect jewellery from an early age, and by the time a girl is married she may be so weighed down with silver ornaments that she can hardly move. A woman will never part with the jewellery she receives as a bride price or dowry, but will happily barter or sell to strangers silver items received as gifts at other times.

With their forthright, aggressive nature and their bold Bedouin dress layered with jewellery, Rashaida women are conspicuous in the desert and marketplace. Beja women, on the other hand, concealed behind bright cotton veils, are reticent in nature and often extremely shy. The young children are terrified of strangers; this may be due to their more isolated lifestyle, for they move in family groups which are small compared with the Bedouin camps. The Beja are probably of Egyptian ancestry, with some Arab blood; they crossed the Red Sea from the Sinai peninsula and Saudi Arabia at a very early date. The name 'Beja' applies to a group of tribes of which the best known are the Hadendawa and the Beni Amer. Famous for their camel breeding in the Nubian Desert the Beni Amer, like the Rashaida, take advantage of the grazing in south-eastern Sudan and across the Ethiopian border, while the Hadendawa graze their cattle and cultivate the land to the north in the temperate climate of the Red Sea Hills.

These hills, a refuge for the nomadic tribes, rise above the suffocating sandstorms and intense heat of the Nubian Desert. They are also significant as a source of gold, discovered there as early as 3000 BC and carried, together with spices, frankincense and myrrh, along trade routes to the river ports of the Nile Valley. This gold played an integral part in the rites and mysteries of ancient Egypt, maintaining the great state of the early Pharaohs and their temples. Not surprisingly it was therefore gold, rather than silver, that became the chosen metal of ornamentation for the Beja, and their means of indicating status and wealth. Eligible Beja girls still cover their foreheads with finely embossed gold discs, and betrothed women wear a variety of gold nose and ear rings.

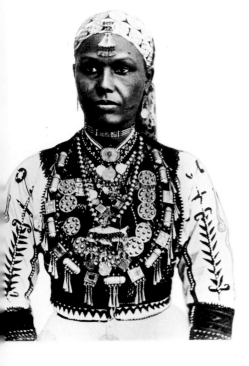

Ethiopian woman wearing, unusually, both Christian and Muslim jewellery, nineteenth century.

Hadendawa men lack the charm of other Beja peoples; they are tough and sullen and renowned for their fighting spirit. They were celebrated by Rudyard Kipling, who named them 'the Fuzzy Wuzzies' on account of their huge mops of teased hair with mud-caked ringlets hanging down the back. In the late nineteenth century the Hadendawa terrified and routed the British soldiers in Sudan, and later made their name as smugglers at the Red Sea ports, concealing the contraband in their 'fuzzy wuzzy' hair. From these hairstyles, still worn today, protrude carved wooden combs and hairpins used for teasing the hair and extricating the occasional louse.

In south-east Ethiopia the people of Harer, like the Rashaida and the Beja, have close Arabian ties: their forebears were southern Arabian colonists who established the ancient city of Harer in the arable land and gentle climate of the eastern foothills, close to the Somali frontier. An important trade centre, Harer was linked to the Ethiopian highlands and Somalia by land, and to the Middle East and the coast of East Africa by sea-going dhows. Even today its thick-walled houses and narrow passageways evoke an atmosphere of medieval Arabia. The marketplace with its sweeping Islamic arches is still the centre of all activity – the meeting place of Arab traders, nomadic Somalis and the Muslim Oromo (formerly

called the Galla) who cultivate and graze herds on the nearby foothills and plains.

Oromo and Hareri women like bright headcloths of Indian muslin, similar to those worn by the Beja. On formal occasions these are decorated with silver accessories and strings of amber beads. For these Muslim women, as for many others in the Horn, jewellery is both a sign of status and a form of security. Under Islamic law, a wife can be divorced at very short notice; she cannot claim any part of the family's savings as her own, and only her personal jewellery remains her property – for this reason she will acquire as much jewellery as she can. To this day in Harer the trade in old jewellery lies in the hands of the competent women of the town. In the quiet of their homes just a few streets back from the busy marketplace these dealers handle a variety of antiquities, selling locally crafted silver, gold jewellery from the coast of Somalia, amber, and silver jewellery brought by dhow from Arabia, Iran or India. Through this highly profitable business, a woman may support her entire family on her earnings alone – a rare situation for a Muslim woman.

Amber is particularly valued by the Somalis and the people of Harer for its vibrant colour and supernatural powers. Men like their long prayer bead necklaces to be of amber, perhaps because it is light to carry but also for its talismanic powers. Some women wear amber in the form of tight neck chokers, believing that its ability to retain the body's temperature will protect them against chills. At marriage, many women receive long necklaces made of large amber beads – a valuable form of security.

For the past 2000 years and more, the coast of East Africa and its offshore islands have been visited by Arabian, Persian and Indian traders. Sailing with the monsoon winds across the Indian Ocean the Arab dhows arrived with pottery, cloth, jewels and weapons, and returned with ivory, rhinoceros horn, turtle shell and aromatic gums. Many Arabs, grown wealthy from this trade, settled in coastal towns, often intermarrying with indigenous Somali and Bantu tribes. Today the Swahili people, the result of this intermarriage, occupy the coastal strip from southern Somalia to Tanzania and islands off the coast such as Paté, Lamu and Zanzibar.

During the Middle Ages the coastal towns enjoyed periods of great wealth. Lamu is described in early Portuguese accounts as having substantial three-storied houses containing Persian carpets and Chinese porcelain bowls. Wealthy merchants lived in luxury, clad in elegant silks; their wives were laden with gold bangles and anklets, and decked with beads of crystal, carnelian, agate and glass. Today, although the towns are no longer prosperous the Arab influence still prevails, and enough of the past has survived in Lamu and Zanzibar to enable one to envisage that golden age. Arab dhows line the waterfront where woodworkers carve beautiful chests and chairs; along shady passageways the houses boast magnificent brass-studded doors, and in the evenings women, covered in black, hold their veils demurely in place with hennaed hands while small girls sell tiny cushions of jasmine flowers.

Gold was brought to these islands from Zimbabwe via Sofala in Mozambique, and was particularly popular with the women of Paté and Somalia, who considered silver jewellery plebeian. Sixteenth-century records tell how invading Portuguese were so greedy for gold that they cut off the hands of living women to snatch their bracelets and beads. The women of Lamu and Zanzibar, however, preferred silver to gold. As both these islands were important sea ports, the influence of the dhow sea trade was especially strong and much of the jewellery made here imitated that of India and Oman. This influence, though clearly visible in Swahili ornaments, had little impact on those living a mere forty miles inland; it is in fact limited to a narrow strip along the coast of Tanzania, Kenya, Somalia and Ethiopia, an even more confined area than the coastal plains of Sudan that show the effect of migration and trade with Arabia.

Roaming the arid wastelands of Ethiopia and Somalia between the coastal

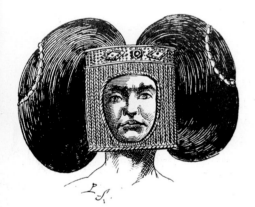

Voluminous hair and embroidered face-frame seen in the Horn, nineteenth century.

Beja woman with gold ornaments, Nubian Desert, nineteenth century.

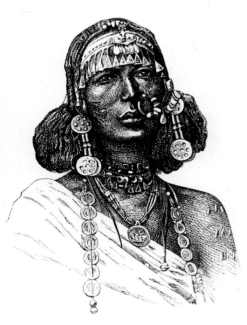

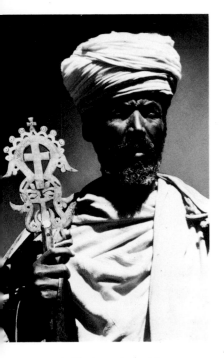

*Ethiopian priest with
processional handcross, Lalibela.*

plains and the highlands are a handful of warlike nomadic tribes. Their possessions are limited to whatever is required for simple survival. Although nominally Muslim, their pagan beliefs are deeply ingrained and much of their jewellery has a protective significance. The Afar or 'Danakil' (a name given to them by the Arabs by which they are still sometimes known) inhabit one of the most inhospitable deserts on earth, lying far below sea level and composed of crumbling rock and broken lava waste. Like the Somalis, the Afar greatly admire male strength, independence and bravery; killing their enemies confers prestige, although the practice of castrating their foes and wearing the trophies round their necks is now a thing of the past. The women, like the men, are fiery: their bodies are oiled and ritually scarred, their teeth are filed to points and their jewellery, though crudely made of beaten brass, copper or animal hides, is colourful and dramatic.

Once a week the Afar climb the 2000-foot escarpment to attend the market in Bati, in the Ethiopian highlands. Here they trade livestock, salt, camel fat and rancid butter with the local Oromo. The Oromo is the largest group of Ethiopian peoples. Some, including those who lived around Harer, were the earliest African converts to Christianity, while others remained nomadic pagans and wandered with their cattle in the south of the country. Those who settled in the south-eastern highlands adopted the Abyssinian way of life, though not all became Christians. The Abyssinians – the Amhara in the central provinces and the Tigray in the north – are the original Christians of the highlands; they accept these highland Oromo but view all other Muslim lowlanders with distaste. They consider themselves a separate and superior race, the most highly cultured in Africa, curiously regarding themselves as white people and referring to Europeans as 'pink'. Their recorded history extends back 2000 years over an almost unbroken line of kings to Menelik I, the reputed son of King Solomon and the Queen of Sheba.

Christianity was established in the highlands as early as the fourth century by Egyptian Copts who were forced to flee their homeland. Early Ethiopian art was influenced by these people, as it was by the Christian world to the east. When Islam began to encroach, the Abyssinians withdrew to their mountain stronghold and for centuries isolated themselves from the outside world. In the words of the historian Gibbon: 'they slept near a thousand years, forgetful of the world by whom they were forgotten.'

The lives of the Ethiopians have always been inextricably bound to the Church, and their religious festivals are rigorously observed. As many as 160 days of the year are treated as fast days, adding further austerity to an already severe lifestyle. Ethiopian Christian crosses, crafted with great skill and worn as silver neck pendants, are the dominant and most valued items of highland jewellery. Individual designs that once identified a woman with her home province or town became less localized when provincial smiths were summoned from afar to work at the Emperor's court and, more recently, as Italian-built roads linked regions previously isolated by precipitous mountains. Despite this, in some areas it is still possible to tell a woman's place of origin by the particular style of jewellery she wears.

As long as the Ethiopians maintained their isolation from the outside world their jewellery remained simple and essentially true to their ancient Christian culture. The art of the Muslims living along the coast, on the other hand, was so strongly influenced by foreign styles and techniques that today it is often difficult to know whether a piece of jewellery comes from the Horn, Arabia, Iran or India, or whether its design is influenced by several of these different cultures.

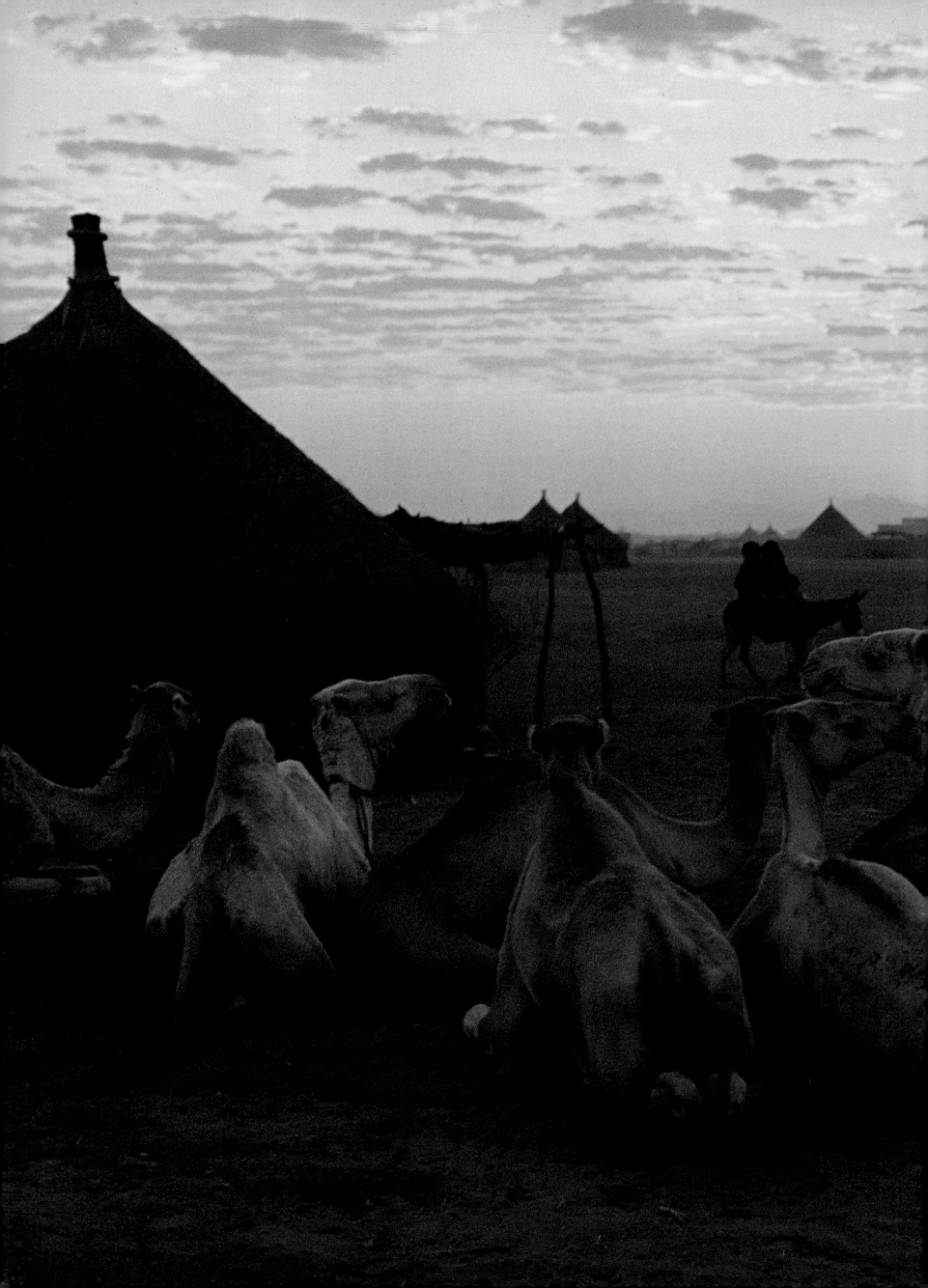

ARAB HERITAGE

Desert nomads preserve the strict Muslim customs of their Arabian past. Elaborate masked veils, *burga*, unique in Africa to the Rashaida women in eastern Sudan, are considered by them an essential part of everyday life. Concealed behind the veils and dressed in bright appliquéd Bedouin skirts, the Rashaida are easily distinguished from the other camel herders of the Nubian Desert.

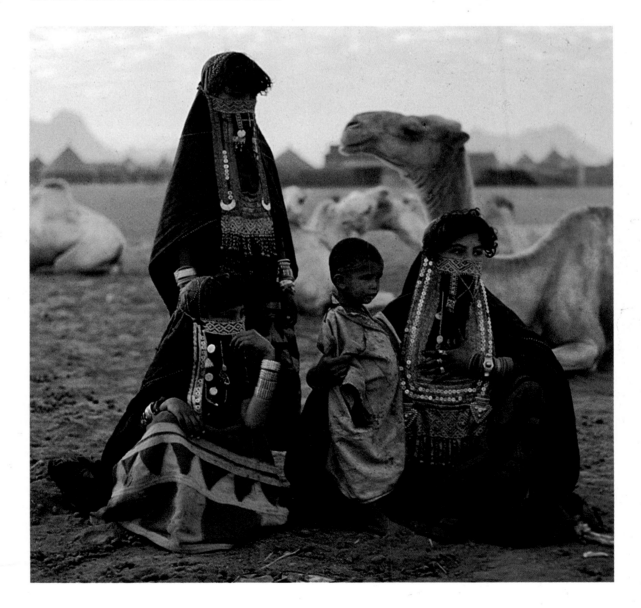

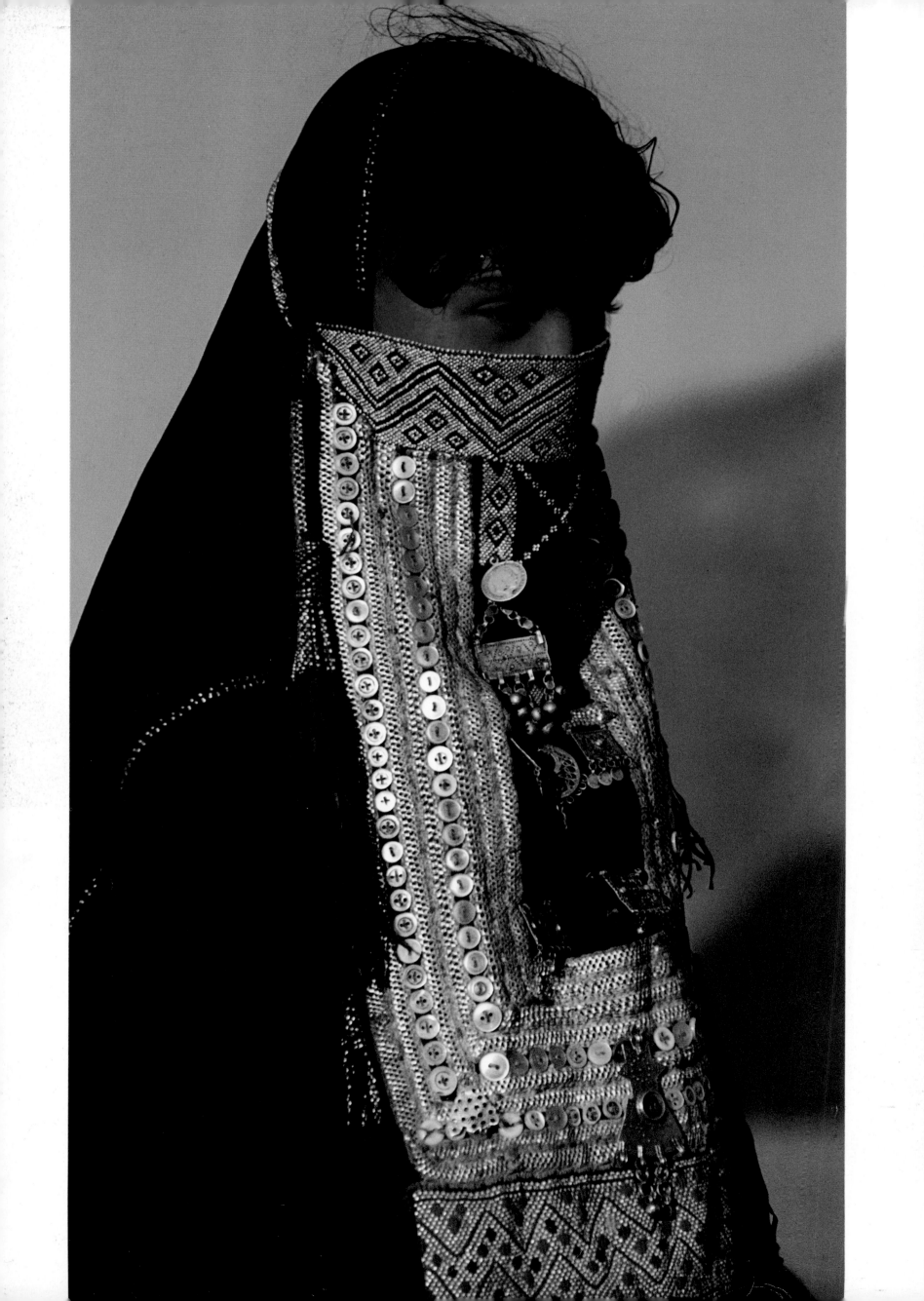

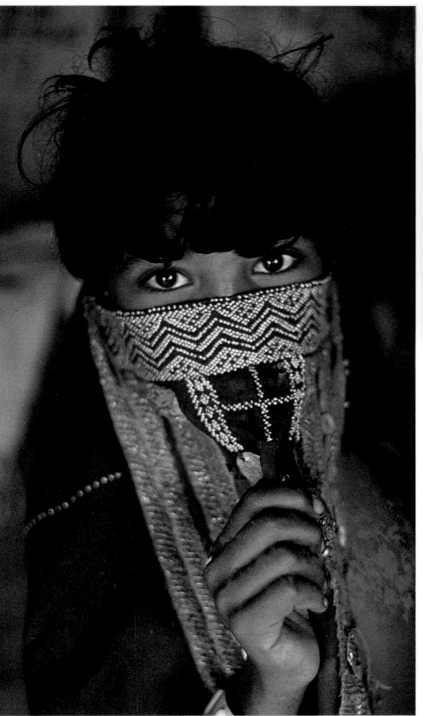

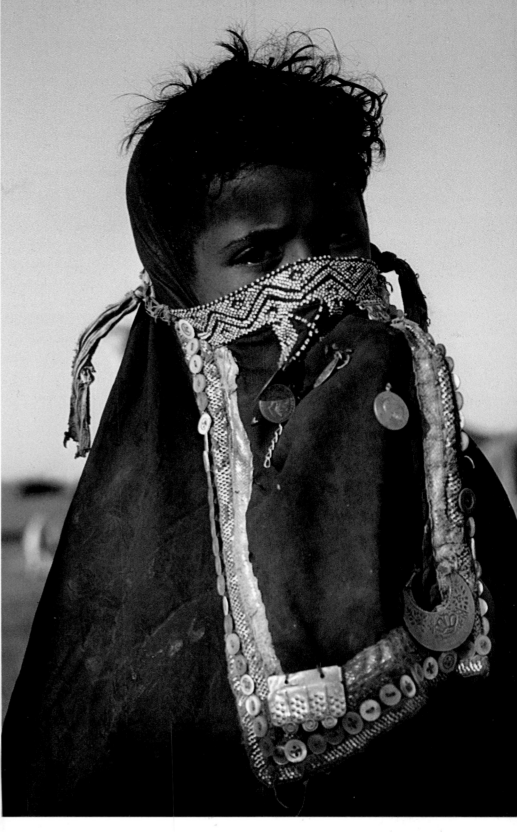

VEILS OF THE DESERT

From the age of five every Rashaida girl wears the *burga*, even (with difficulty) at meal times, removing it only in the privacy of the family tent. Girls frequently sew small gifts of silver thread, buttons and pendants onto their veils to enhance their exotic appearance. The *burga* is usually restyled every three years, and by the time girls are eligible for marriage, it will be impressively long and decorative.

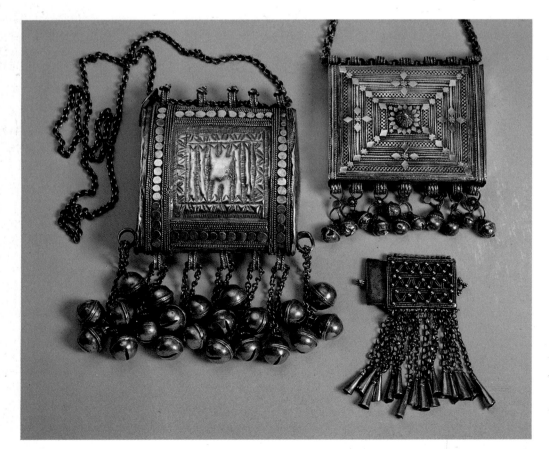

RASHAIDA MARRIAGE

ABOVE On her wedding day a Rashaida bride is almost completely concealed: her elaborate veil, the *aruse*, extended to cover her nose and forehead, leaves only two slits edged with gold coins for her eyes to peep through. A pair of long silver bracelets, a gift from her husband, indicate her new status and remain treasured possessions all her life.

RIGHT Once a Rashaida woman is married she is free to dispense with the awkward *aruse* and enjoy the greater freedom of a cotton headcloth.

LEFT On formal occasions Muslim women from different parts of the coastal plains of the Horn carry or wear beautifully tooled silver boxes, their decoration reminiscent of Arab designs. The flat box (*top right*) contains verses from the Koran and is worn by the Swahili people of Zanzibar and Lamu, while the one with large bells (*left*) is used by Hareri women as a purse on festive occasions. The smaller box with conical bells, from the central highlands, holds a magical formula. (large box (*left*) 10 × 13cm)

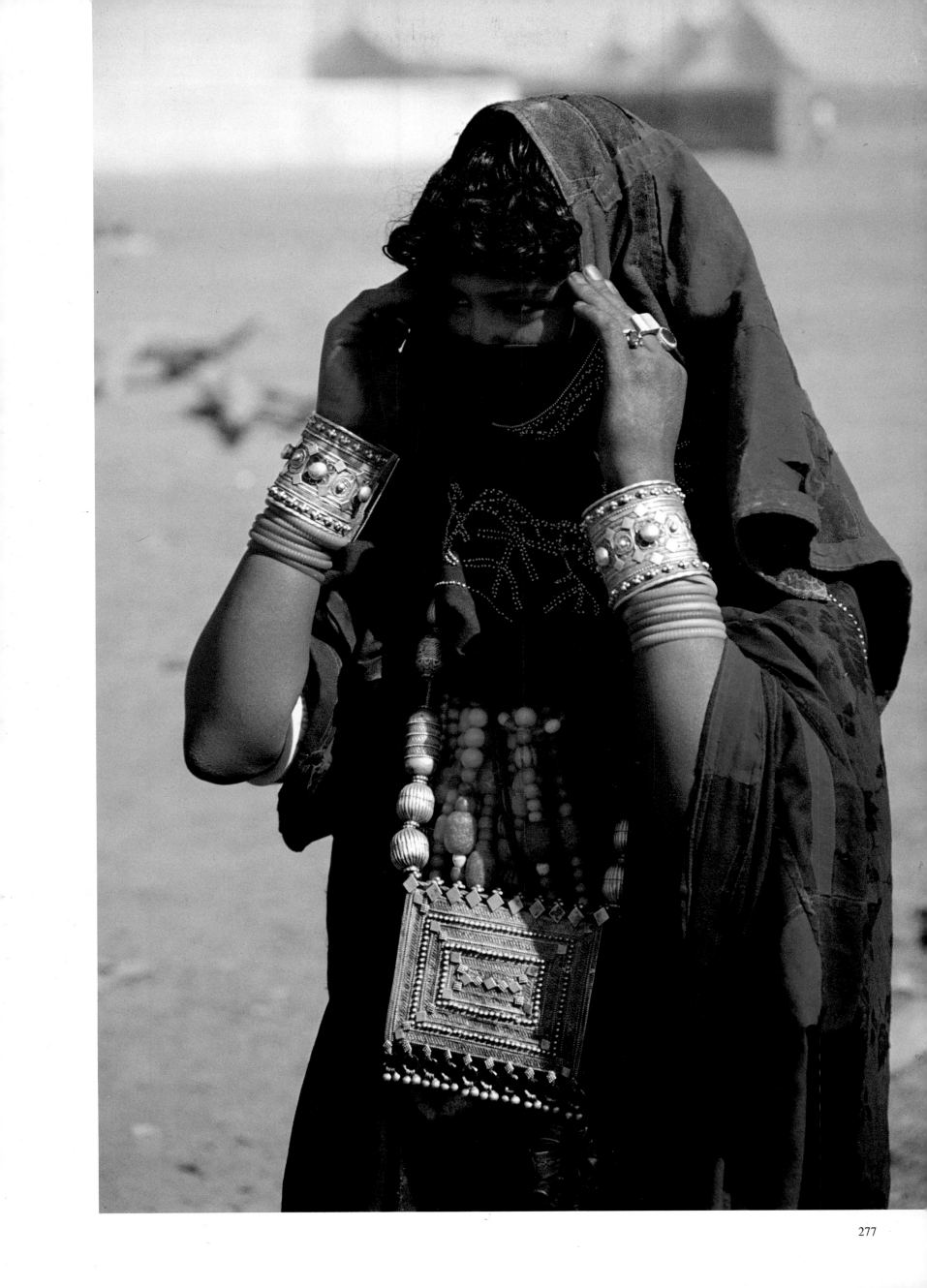

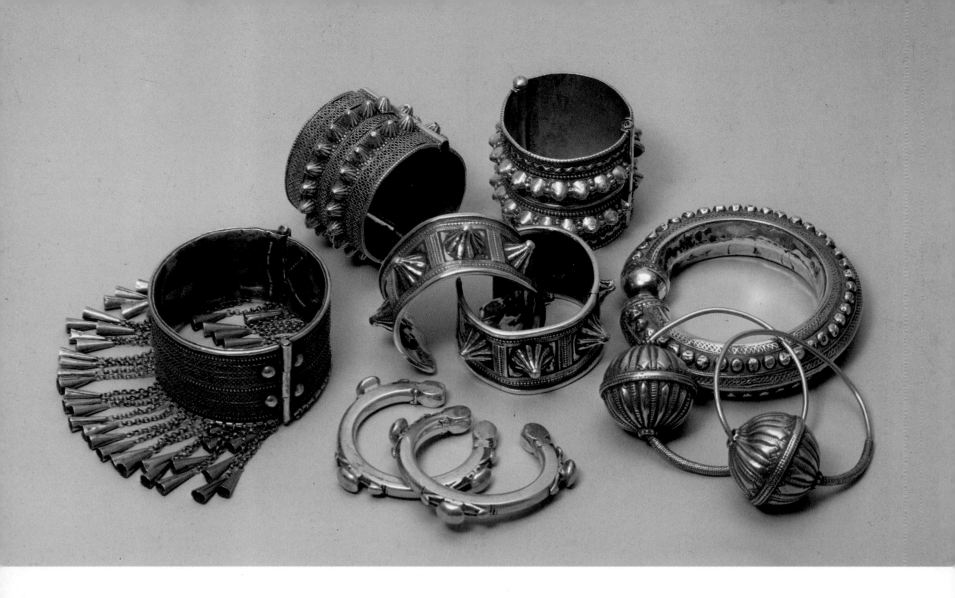

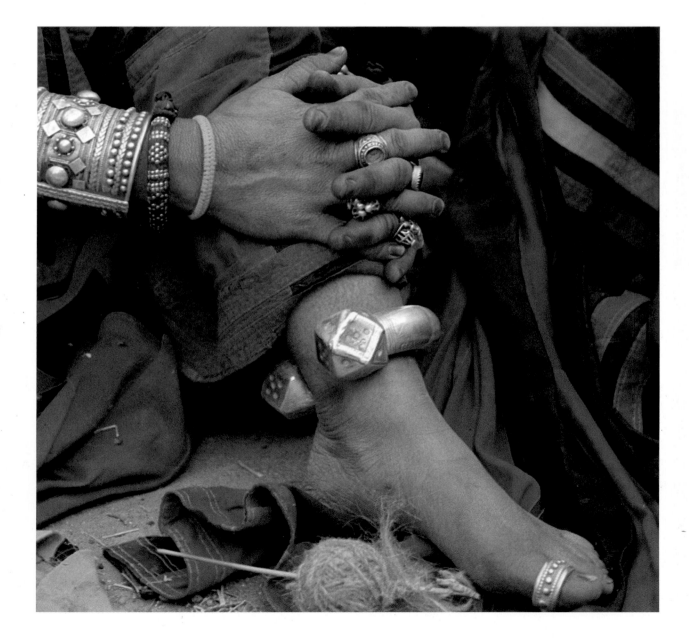

Since most Muslim jewellery of the Horn is very ornate, the plain anklets with cuboid endings, shown right and opposite on the right, are curiously significant. They are more typical of Saharan or Egyptian jewellery than that of East African or Arab design. The pair of bolted anklets (*at the back*) and flat appliquéd armlets (*left and right*) worn by Swahili women are respectively of Indian and Arab design, while the Beja armlet decorated with gold is also seen in Saudi Arabia. (9.5cm)

EASTERN INFLUENCE

Rashaida women, like most Muslim women of the Horn, delight in acquiring large quantities of elaborate jewellery. Silversmiths, influenced by techniques and styles from Arabia and the East, make a wide variety of pieces to suit their tastes.

Filigree and granulated silver rings (*below*) worn by Rashaida women display typical Yemeni and Saudi Arabian designs. Sometimes glass, agate or blue Yemeni stones are used as decoration. Only the high pointed central ring is of local design, from Harer, where the women value it for its magical properties. (5.5cm)

OPPOSITE Large silver armlets decorated with repoussé work (one seen on the right of group) are found throughout the Horn and Arabia; so too are ornate silver bracelets. These vary in style from region to region; the two at the back are found in Harer, as is the large silver armlet (*left*) decorated with filigree and conical bells. The central pair of bracelets and the smaller ones in front are worn by Rashaida women, probably bought in Egypt by their husbands while on camel-trading safaris. The hooped ball earrings on the right are worn by women in Harer, where this design appears to have originated. (Large silver armlets diameter 10cm)

RIGHT Typical Rashaida woman.

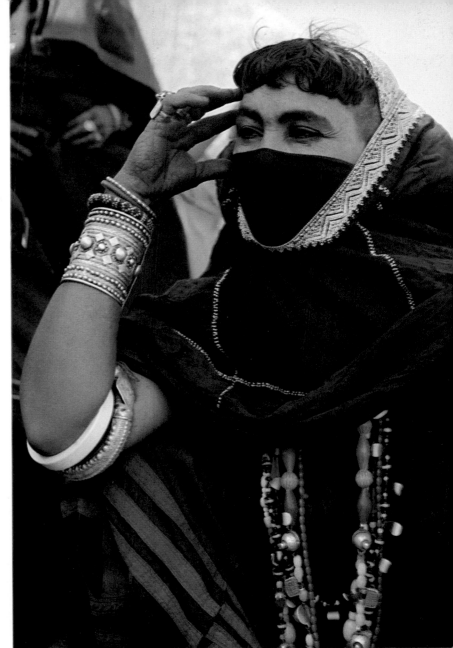

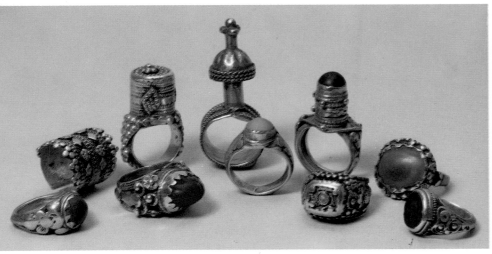

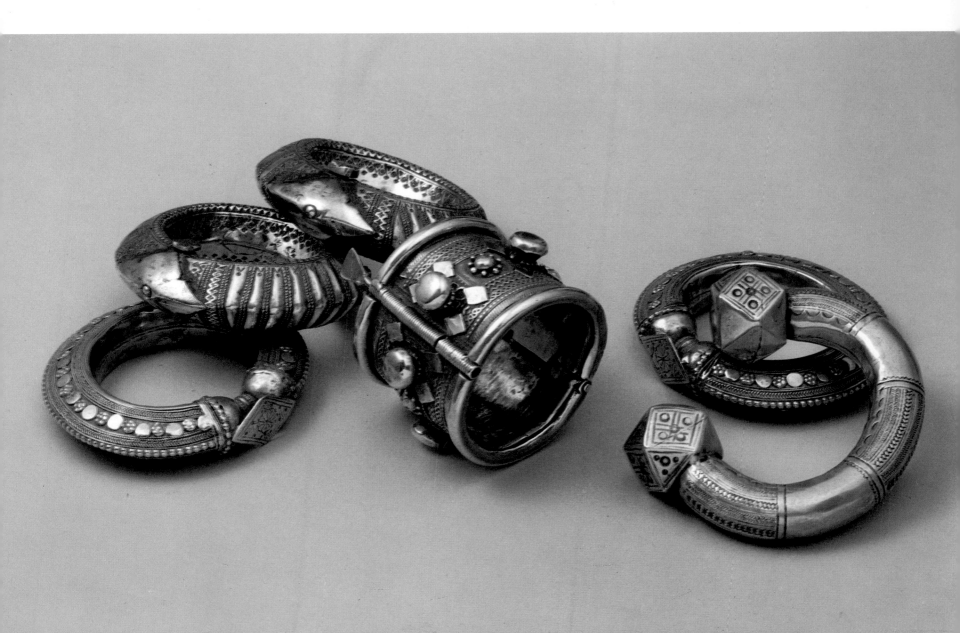

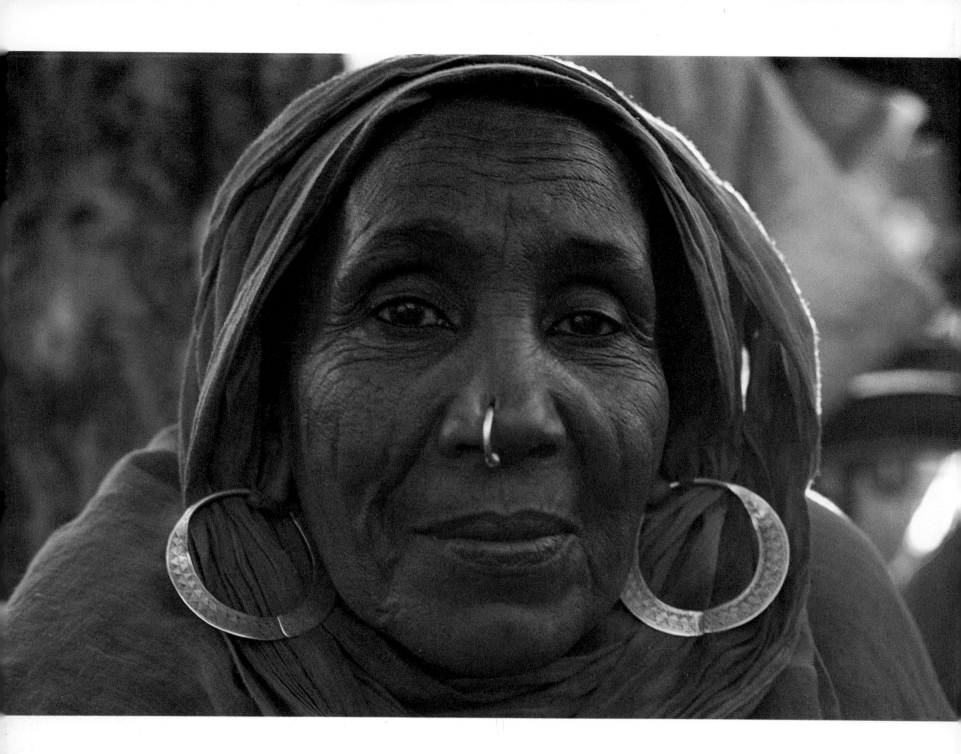

RED SEA GOLD

Beja women from the Nubian Desert are concealed from the gaze of outsiders by coloured muslin veils, a tradition enforced by their possessive husbands and their strict adherence to orthodox Islam. Different groups of Beja are distinguished by their few visible pieces of gold jewellery. For example, Hadendawa women wear flat crescent-shaped earrings and central nose rings (*above*), whilst those of the Beni Amer tribe wear larger hooped gold rings protruding from the left nostril (*right*). When a Beni Amer girl is betrothed, her ears and nose are pierced and rings are inserted; the marriage usually takes place a year later. The most prized Beja jewellery was made from gold mined in the Red Sea Hills; lavish gold hair ornaments and necklaces, though often worn, are hidden by veils and are rarely seen.

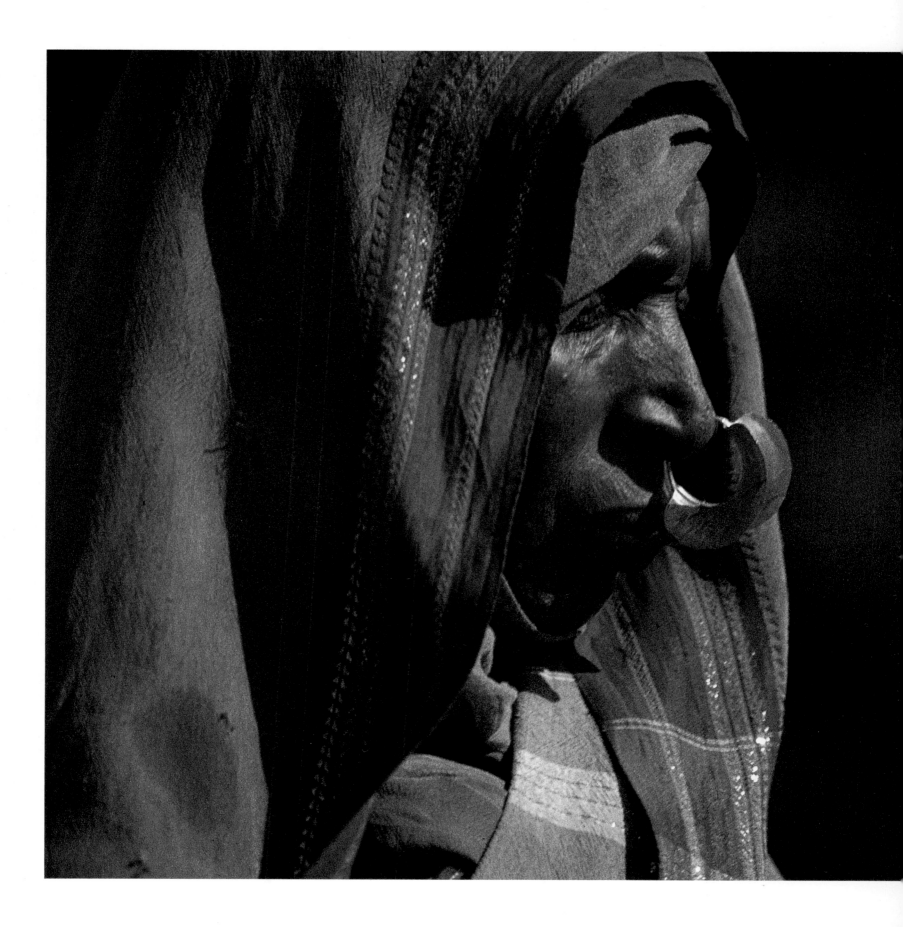

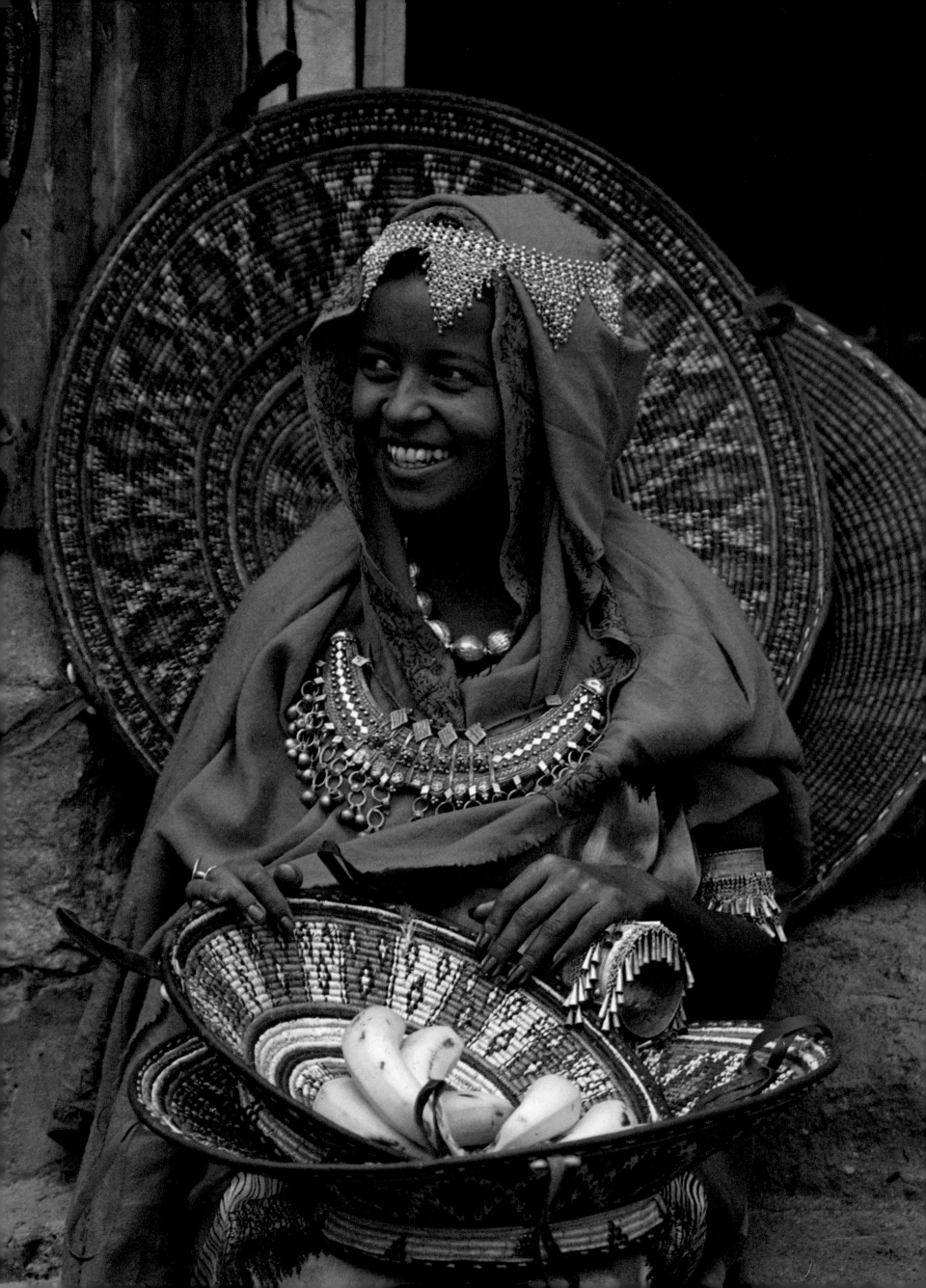

DOWRIES OF HARER

This necklace of amber, prized for its colour, size and magical healing properties, is a valuable wedding dowry in Somalia, as is the *muzé* (*opposite*), the largest, most ornate chest pendant found in the Horn. The *muzé* is traditionally worn in Somalia together with amber and silver balls. Both pieces of jewellery have become desirable items for the women of Harer.

True amber is the fossilized resin of pines and other conifers and may be as much as sixty million years old. Most of the world's amber comes from the bed of the Baltic Sea and has been widely traded, some across the Mediterranean to Egypt and thence along the 'incense route' or via the Red Sea to the Horn. Similar in appearance and precious in its own right is the semi-fossilized resin known as copal brought by dhow from Zanzibar. This copal comes from an area where no trees grow today, and may be up to 300,000 years old. It is mined in shallow pits and often found only a few feet below the ground. Copal beads, like genuine amber, generate a charge of electricity when rubbed together, though to a lesser extent than real amber; they also give off a characteristic fragrance reminiscent of honey and lemons. Amber substitutes of man-made resin, which do not have all these properties, were traded to the Horn during the last hundred years; they were probably manufactured in Russia and were exported either as finished beads or raw material to be carved by local craftsmen.

Recent studies have found the traditional 'amber' dowry necklace (*right*) to be of copal resin, whilst the tassled *tusbah* prayer bead necklace (*below*) is thought to be of amber from the Baltic Sea. The shiny red and barrel-shaped yellow beads are man-made substitutes, the red ones being comparatively rare, found in a limited area near Harer. Artificial resin beads are sold in the Horn to unsuspecting customers as 'Somali amber'. Some of these are combined with silver to form fine pendants. (Copal pendant 5cm)

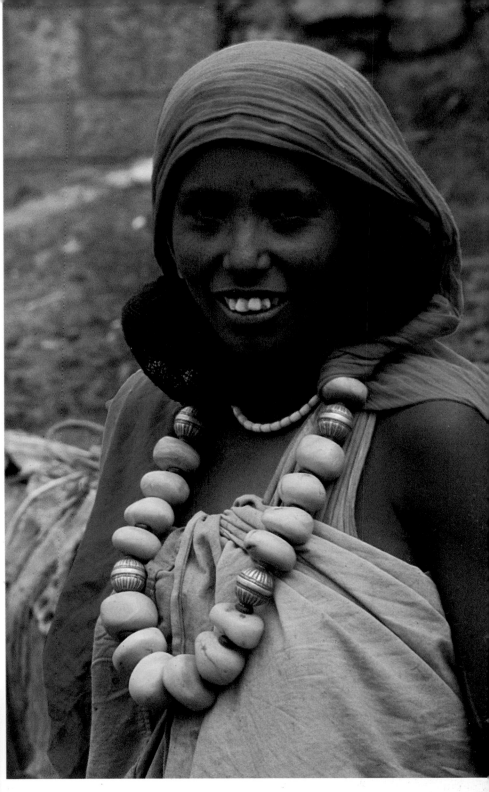

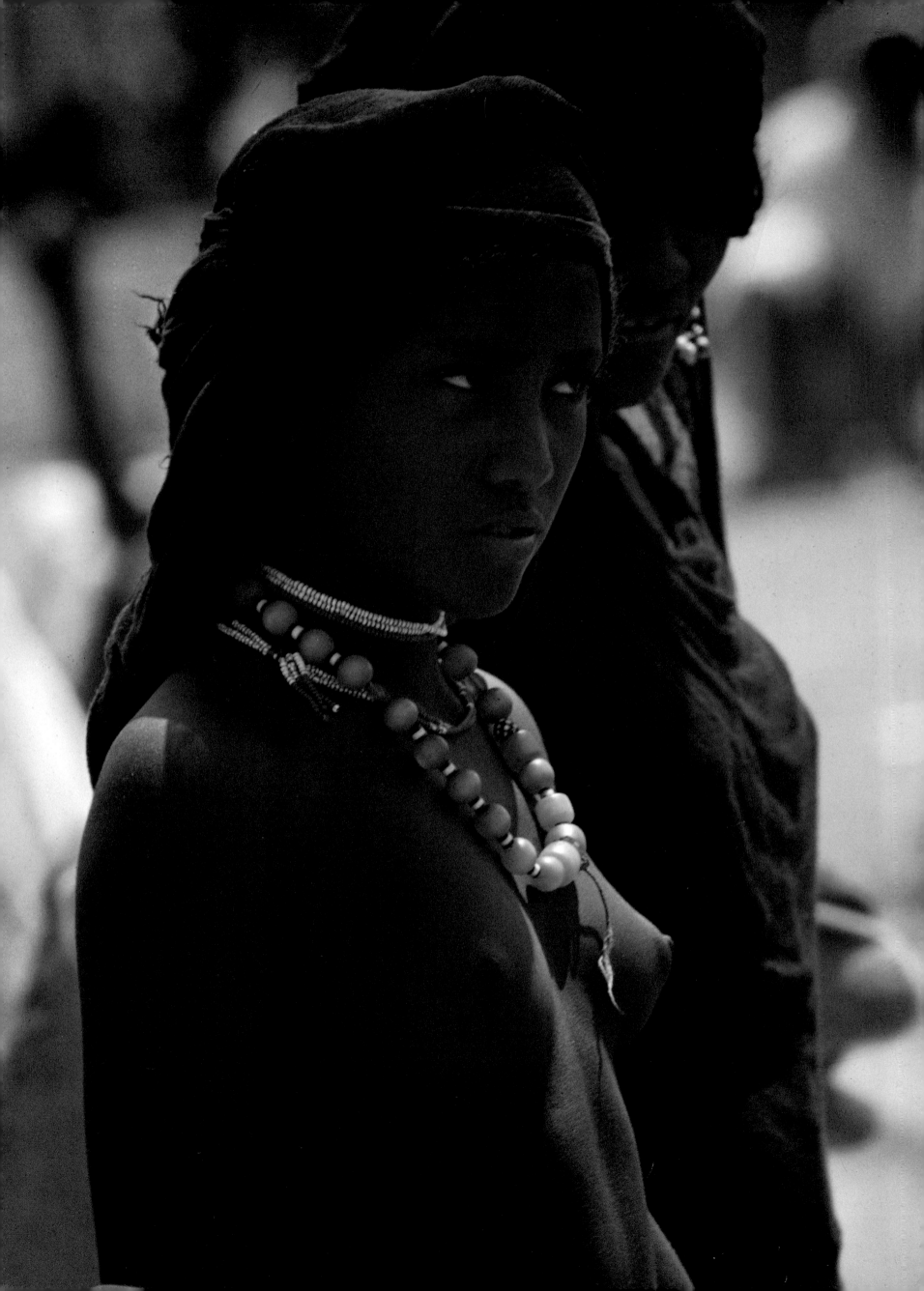

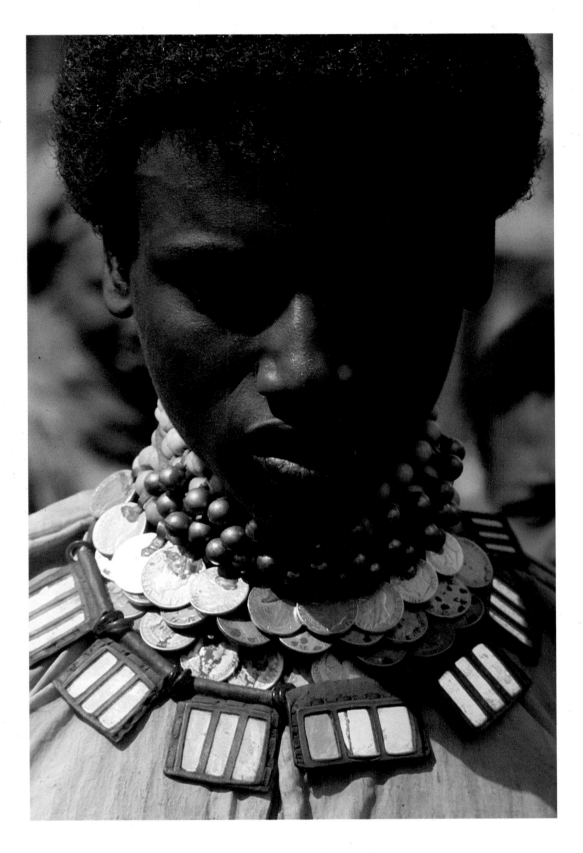

THE FRUGAL NOMAD

Eking out an existence in the harsh Danakil Depression and the
Somali desert fringe, Afar nomads (*left*) and Oromo (*above*) wear
jewellery which is decorative but inexpensive. They love vivid
colours, bright nickel coins and beads, and mirrors encased in
goatskin which they tan themselves. Although these nomads are now
officially Muslim, much of their jewellery has a protective function
associated with traditional pagan beliefs. The Oromo believe that
their mirrors keep away the evil eye, while the Afar ascribe magical
properties to imitation amber beads bought in local markets.

TREASURES BY DHOW

Since the fifteenth century, the Swahili people of the East African coast have benefited from a lively sea trade, which has brought them jewellery designs and techniques from India, the Middle East and Arabia. The silver armlet, bracelet and anklets worn by this woman from Paté Island, made locally, are reminiscent of Indian and Arab designs.

Valuable pieces of jewellery are often secured in chests, and brought out only for special occasions. Among the most valued are the *karmali*, a large silver belt made of many separate sections and fastening with a breast-shaped buckle; the *jambia* or *kucha*, an ornamental dagger worn by men; large bolt anklets in the shape of signet rings; and *hirizi*, the flat box pendants (*top left and bottom right*) which hold religious verses. All this jewellery can be seen in use on formal occasions, particularly weddings, in the Persian Gulf, the Arab Peninsula and Zanzibar. Of typical Swahili origin are the small discs made of velvet and decorated with glass beads, and the larger silver discs (*majasi*), all of which are used as decorative ear plugs by women.

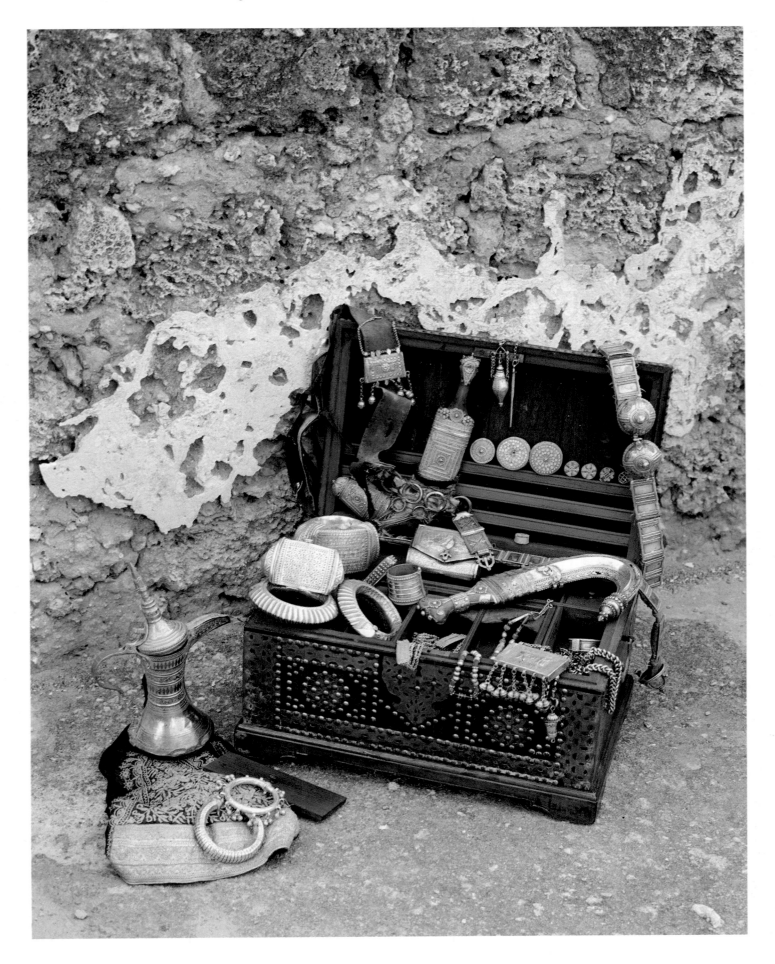

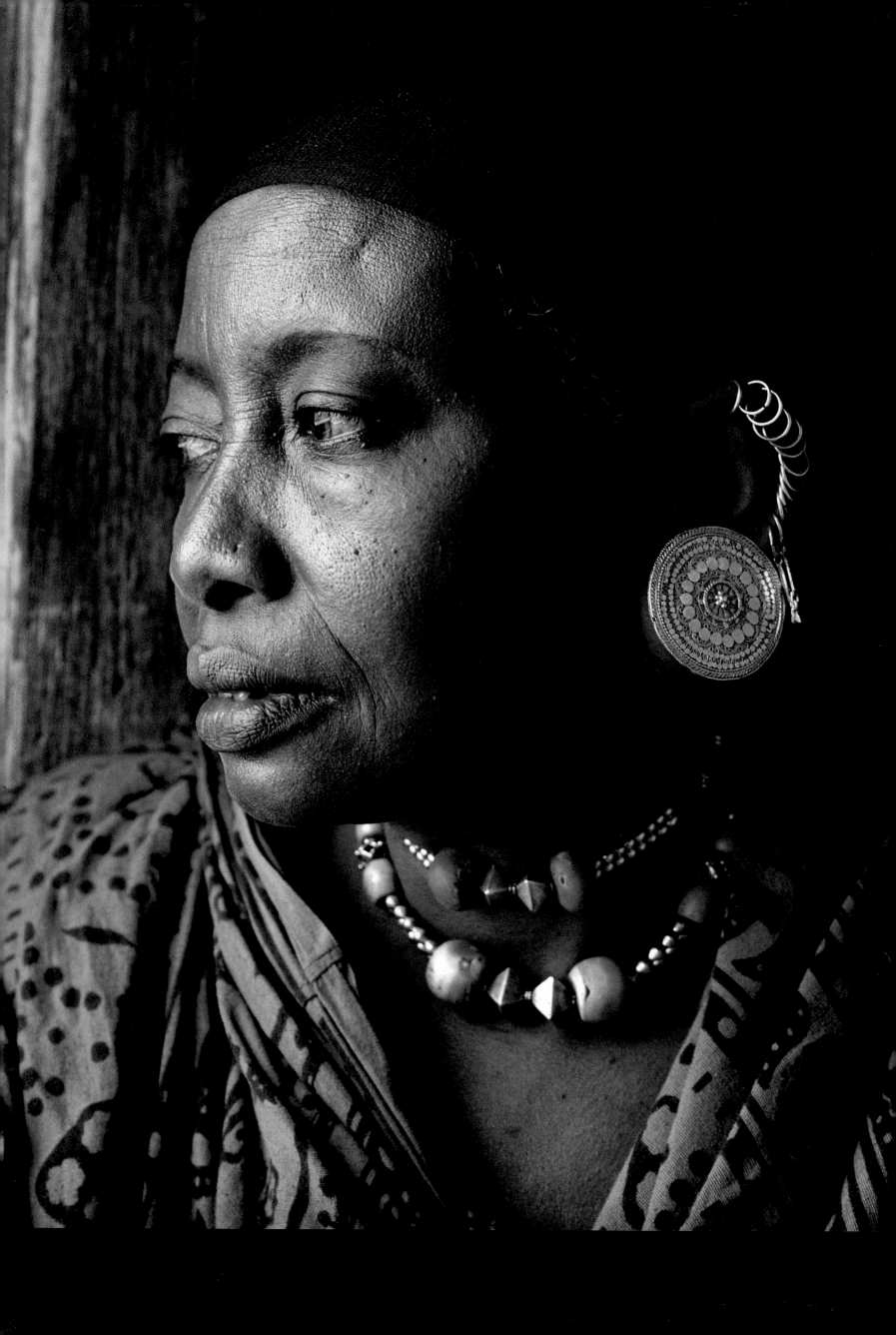

SWAHILI GOLD

Swahili women of Paté Island traditionally wear gold jewellery, much of which is not seen elsewhere and is thought to be of local design. Abundant in the sixteenth century, it is now only found among the older women of a few Paté families.

LEFT A Paté woman has had her ears trimmed with small gold rings, *kipete*, below which hang a larger crescent earring and a gold earlobe disc known as *kuta*. On Lamu Island to the south of Paté women wear similar jewellery, but made of silver rather than gold. Swahili women shave their heads, a fashion which emphasizes the fine details of their ear ornaments. Women from Lamu and Paté stretch their earlobes, maintaining the size of the hole by wearing plugs, known as *kigome*, of buffalo horn, ebony or tortoise-shell. These are replaced on special occasions by discs of silver or gold.

BELOW A collection of gold jewellery from Paté Island. The *kuta* ear plugs are made in several specific designs, always with different decorations on the front and back. Coral is frequently used with gold or gold-dipped beads to form chokers called *kama*. American gold dollars (those are dated 1850) are used as nose studs. Below them is a filigree earring called *kipuli*. The round brass boxes (*left*) called *fura* are worn strapped to the arm. They contain lime which, mixed with spices and wrapped in green leaves, is sucked to refresh the mouth. (*Kuta* diameter 3.5cm)

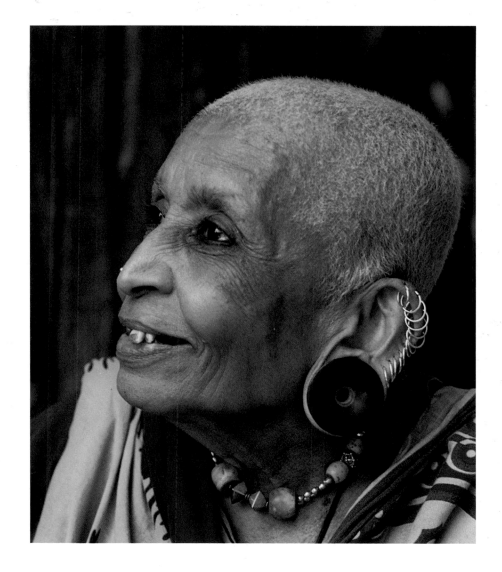

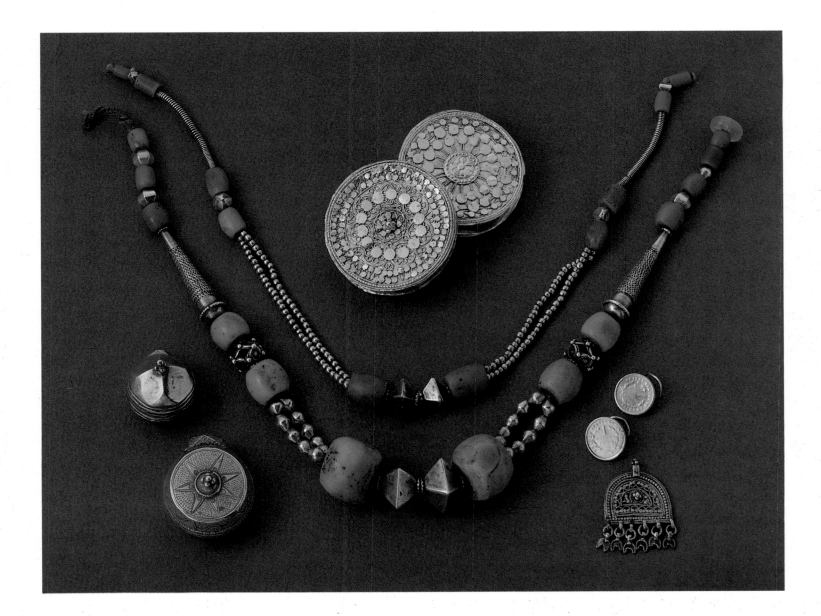

289

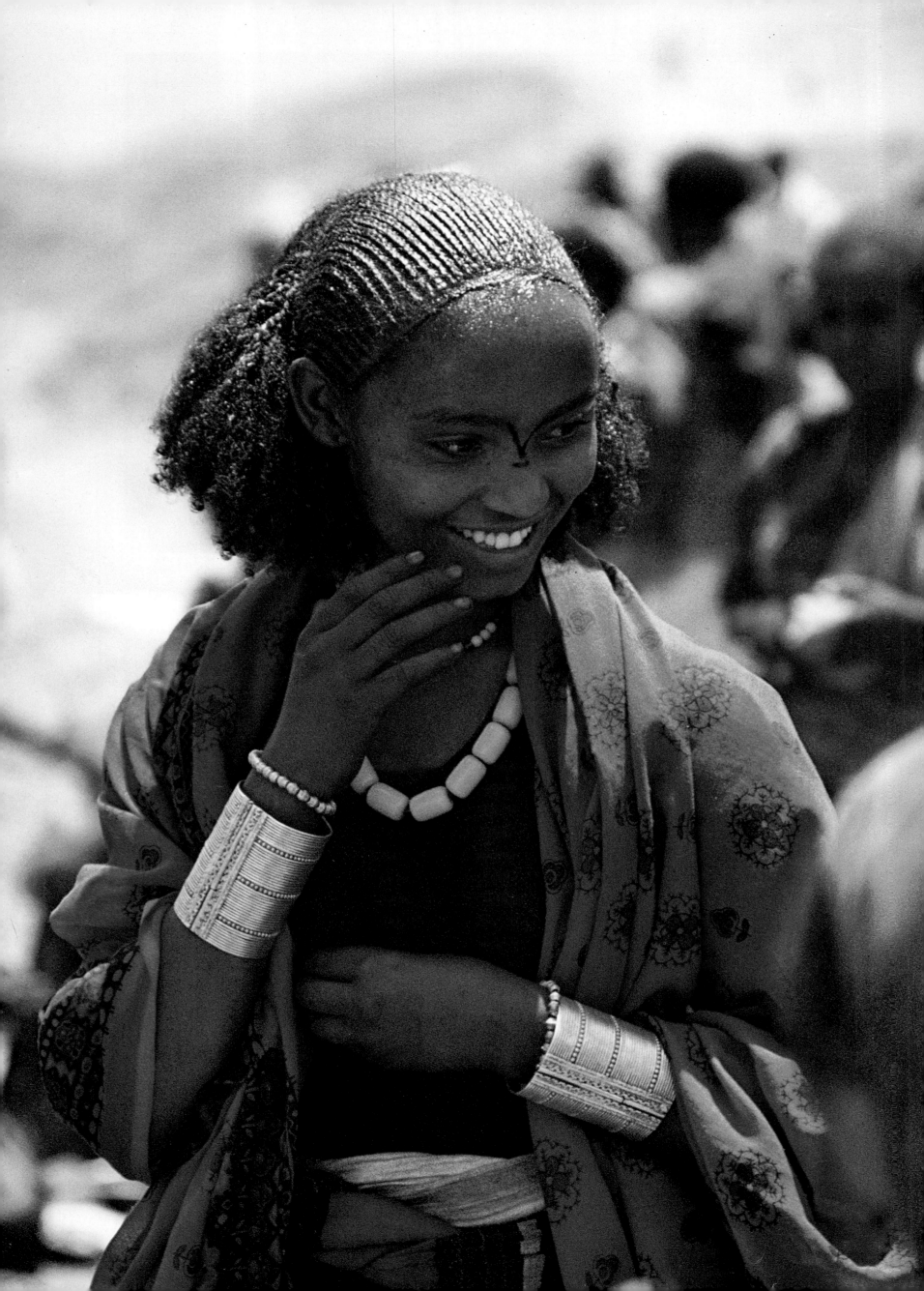

THE HEART OF ETHIOPIA

The exotic designs of India and the Arab world
have barely affected the Ethiopian Christian
highlanders, who lost contact with the
Christian world many centuries ago when
they retreated to their mountain strongholds.
Like most Ethiopians this Oromo woman
(*left*) from Welo Province in the central
highlands, attending market in all her finery,
is stylish without being flamboyant. Her hair
is dressed with rancid butter and her silver
jewellery is simple in design. More elaborate
silver neck collars, like the *yangetget* (here,
right, worn by a woman in northern Yemen)
are seen in Harer and even, reproduced in
less expensive metals, among the poorer Afar
nomads, but never in the highlands.

BELOW A collection of silver bracelets from the
highlands. Smiths developed particular
regional styles: those in the north favoured
more ornate designs with appliquéd wires and
beads (*left*), some of them plaited, whereas in
the centre and south the preference was for
simple pieces, often engraved with a series of
straight lines or dots. The three largest
bracelets are from the central highlands, the
pair in the centre and those at the front from
Jima in the south. (Largest bracelets 8cm)

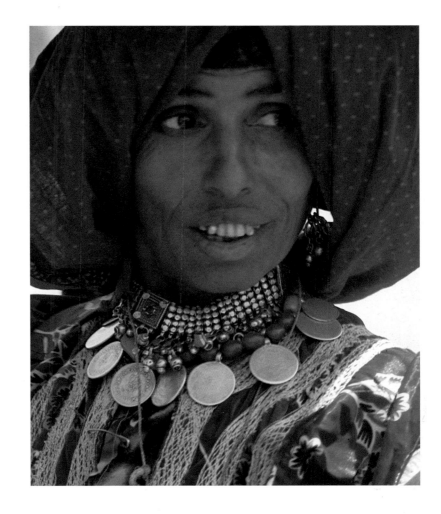

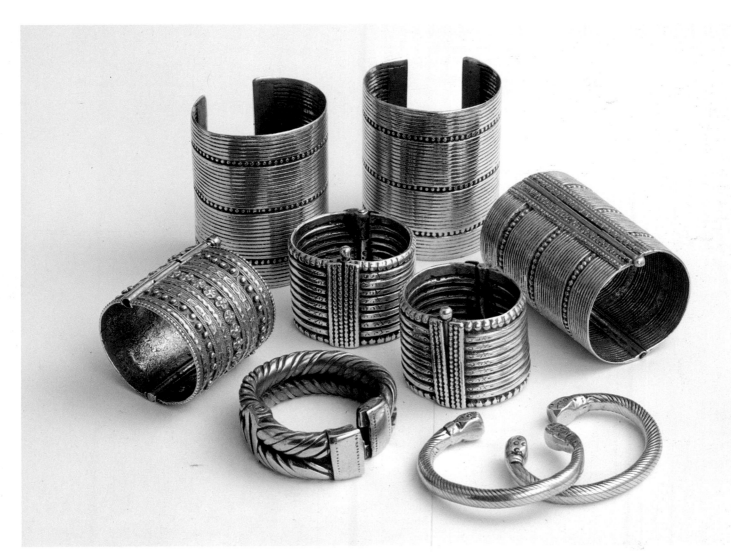

ETHIOPIAN NECK CROSSES

For over 1600 years Christian Ethiopians have worn neck crosses as a proud confession of their faith. An Amhara woman (*left*) of Lalibela wears a cross typical of that region, hanging on a blue cotton cord called a *mateb* which she received at baptism. Lalibela (*right*), the capital of Ethiopia in the tenth century, was named after King Lalibela who was responsible for building the 13 rock-hewn churches for which the town is now famous.

Ethiopian crosses, usually named after towns or provinces of the highlands, are either cast by the lost wax method or cut directly from a Maria Theresa dollar. The oldest are of simple Greek (5) or Latin (11) design. Those with flared arms show the influence of Coptic crosses from upper and lower Egypt; others, probably under Celtic influence, developed trefoils or decorative projections. With the ready supply of silver in the nineteenth century, the crosses became more elaborate: complicated openwork designs, or patterns of endless interwoven lines symbolizing eternity (16) became popular. Additional hinges and crowns (4 and 6 respectively) show the influence of nineteenth century European medals. The Star of David (7 and 8) is worn by the Falasha, a small group of Jewish settlers living near Gonder. The four birds represent the doves of peace (16). (16 : 9.5cm)

1 Gonder
2 Tigray, Gonder, Gojam
3 Dese
4 Gonder
5, 6 Shewa
7 Gojam
8 Gonder
9, 10 Welega
11 Mekele
12 Dese
13 Lalibela
14 Jima
15 Gurage
16 Lalibela
17 Shewa
18 Mekele
19 Gojam
20 Welega
21 Dese
22 Gojam, Gonder
23, 24 Aksum
25 Welega
26 Dese
27 Jima

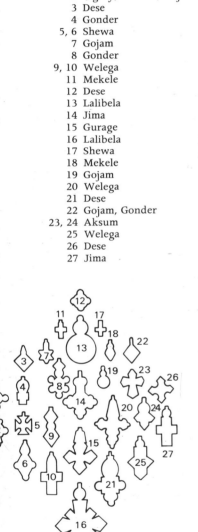

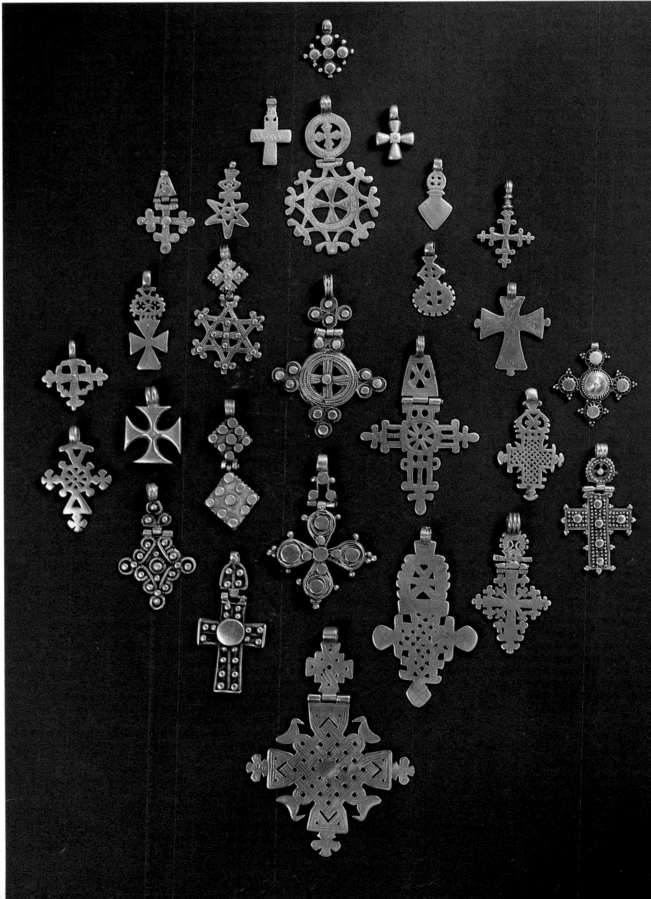

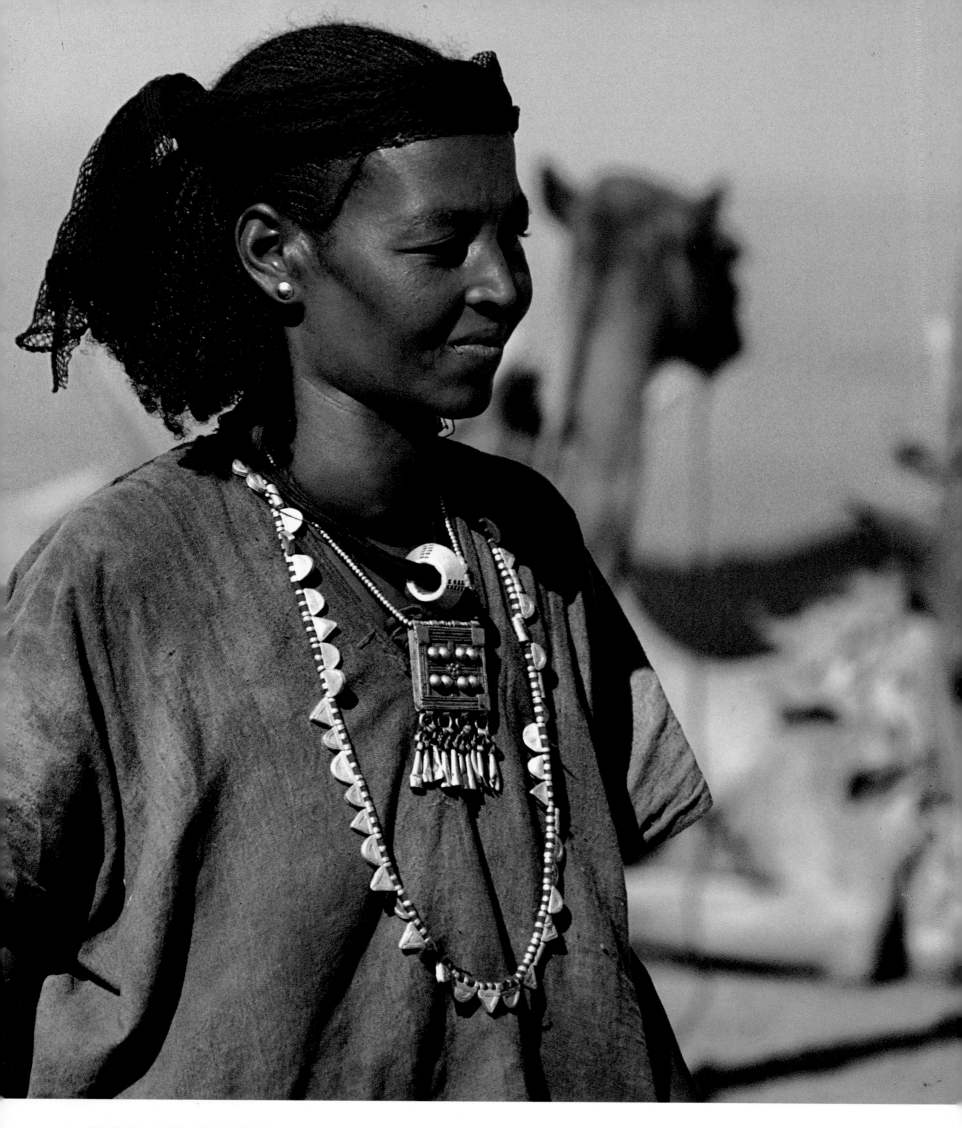

HIGHLAND INHERITANCE

Ethiopian highland jewellery incorporates symbols of ancient design, some of which were first recorded in gold jewellery from Aksum, c.300 AD. An Oromo woman of Welo Province (*above*) wears a necklace of *telsum*, small triangular and crescent-shaped pendants offering protection, respectively, from the evil eye and the power of the crescent moon. Some contain talismanic objects, as does the box pendant, *mergaf*, hanging round her neck. The Oromo woman (*right*)

has a collar of silver beads of phallic design, symbols of fertility.

OPPOSITE BELOW The top two chokers from Welo Province are made of breast-shaped and triangular beads, the former being symbols of fertility. The lower two necklaces are from Kefa Province, one of beads of phallic design, the other of woven silver and glass beads with a small amulet box. (Chokers 25cm)

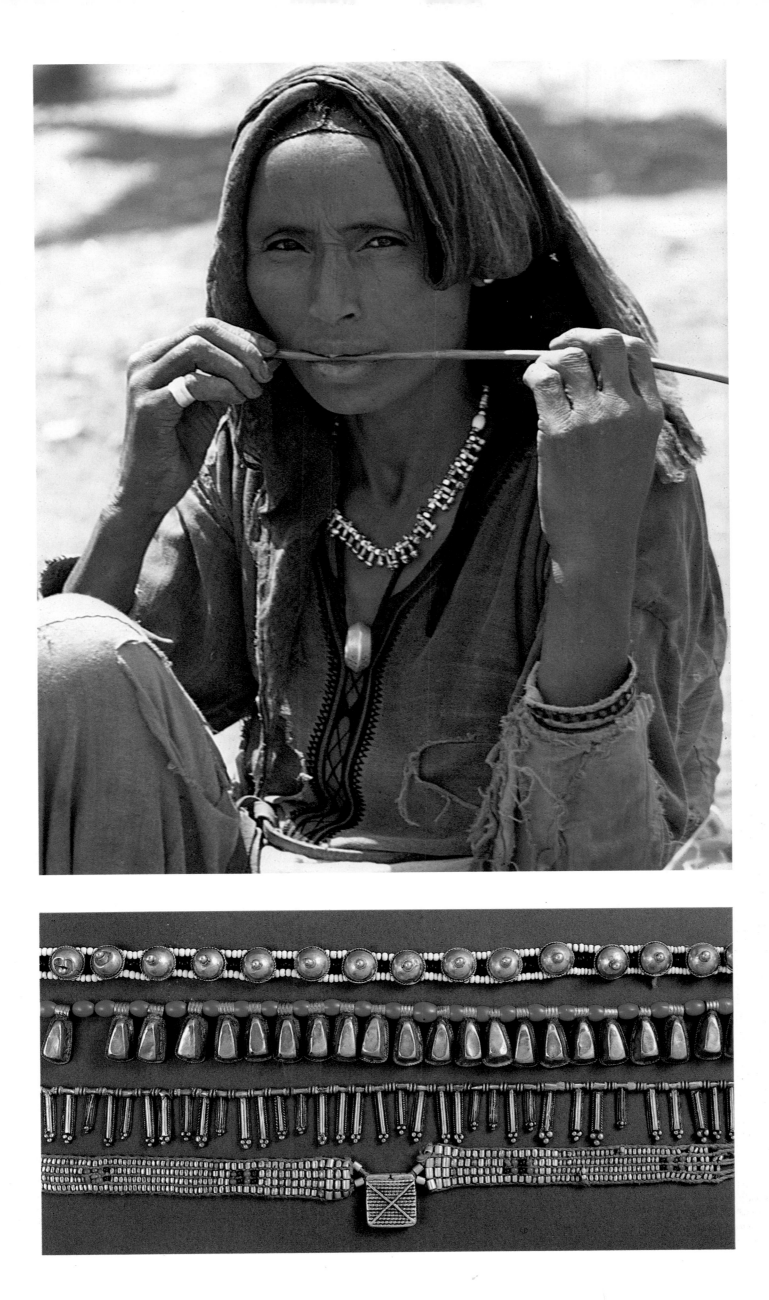

TEXTURES OF ETHIOPIA

Oromo women from Welo Province often wear hair pendants with conical bells to set off their intricately plaited hair. Rancid butter, used chiefly as a cosmetic by the Ethiopians gives the hair its sheen.

The design of Ethiopian highland ornaments varies from region to region, although the same items of jewellery are worn throughout. Earrings from Welo Province (*below*), like the hair pendants, feature conical bells, while those from the northern highlands, like the haircomb worn on special occasions in Tigray and Eritrea, are finely granulated and often gold-plated, showing the influence of Yemeni Jewish smiths settled in Asmera. (Haircomb 10cm)

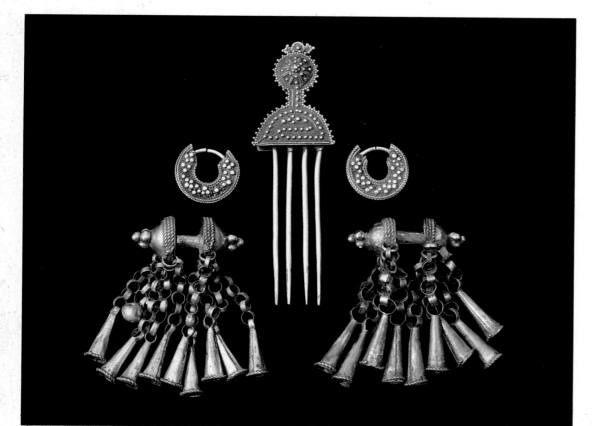

RIGHT Of all the countries on the continent of Africa, Ethiopia is best known for its silver beads of numerous and beautiful designs. They are largely the work of the talented Oromo silversmiths of the southern and eastern highlands.

Small beads are made by cutting cross-sections from tubes of silver, whereas most of the larger ones are cast in halves. The small beads are typical of the southern highlands, while the larger conical and barrel-shaped ones are more common to the central regions. Strands of beads up to eight feet long worn around the neck, or shorter ones for ankles and wrists, may be purely decorative; others with a long central bead and woven tassels, known as *musbaha*, are Islamic prayer beads. The large necklace, *muria*, with long terminal beads, is probably of Yemeni origin and made in Harer. Finely worked gold-washed silver *telsum* beads are worn in the northern highlands by the well-to-do minority. As only small quantities of gold are mined in Ethiopia, solid gold beads are rare; most are made of silver, and a few of them plated with gold for added prestige. (*Muria* beads diameter 2cm)

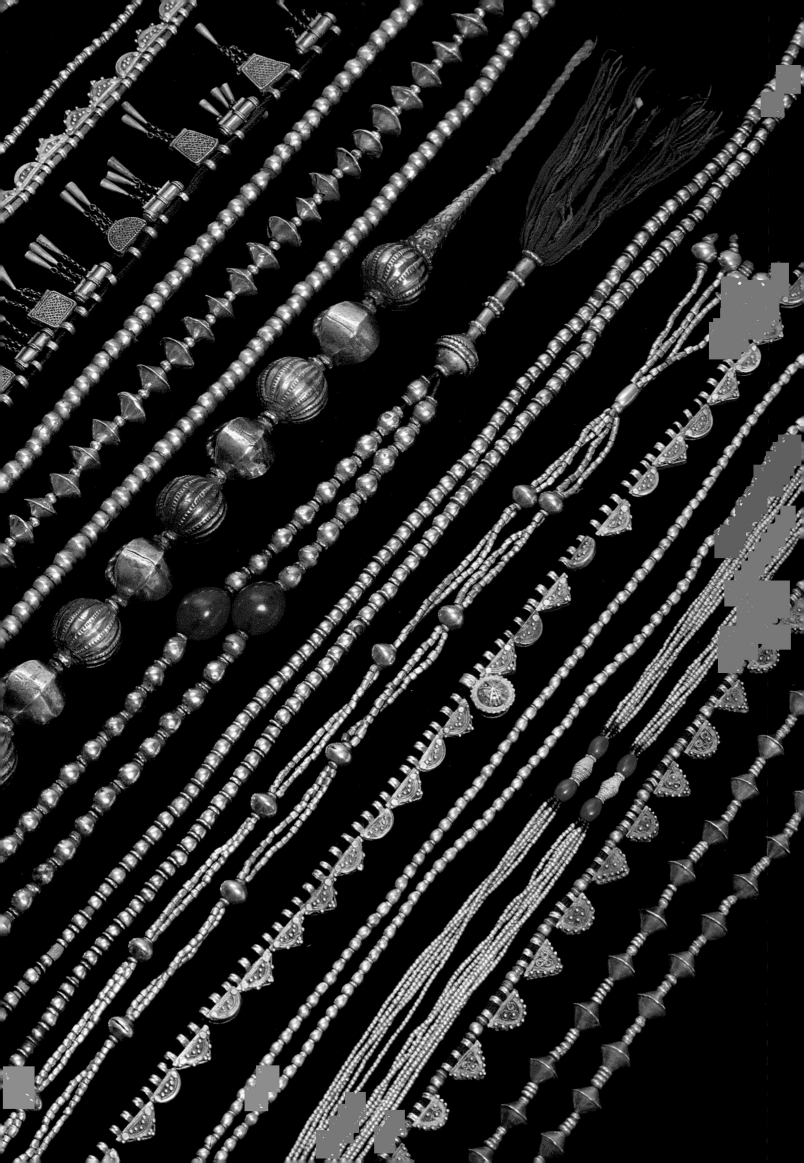

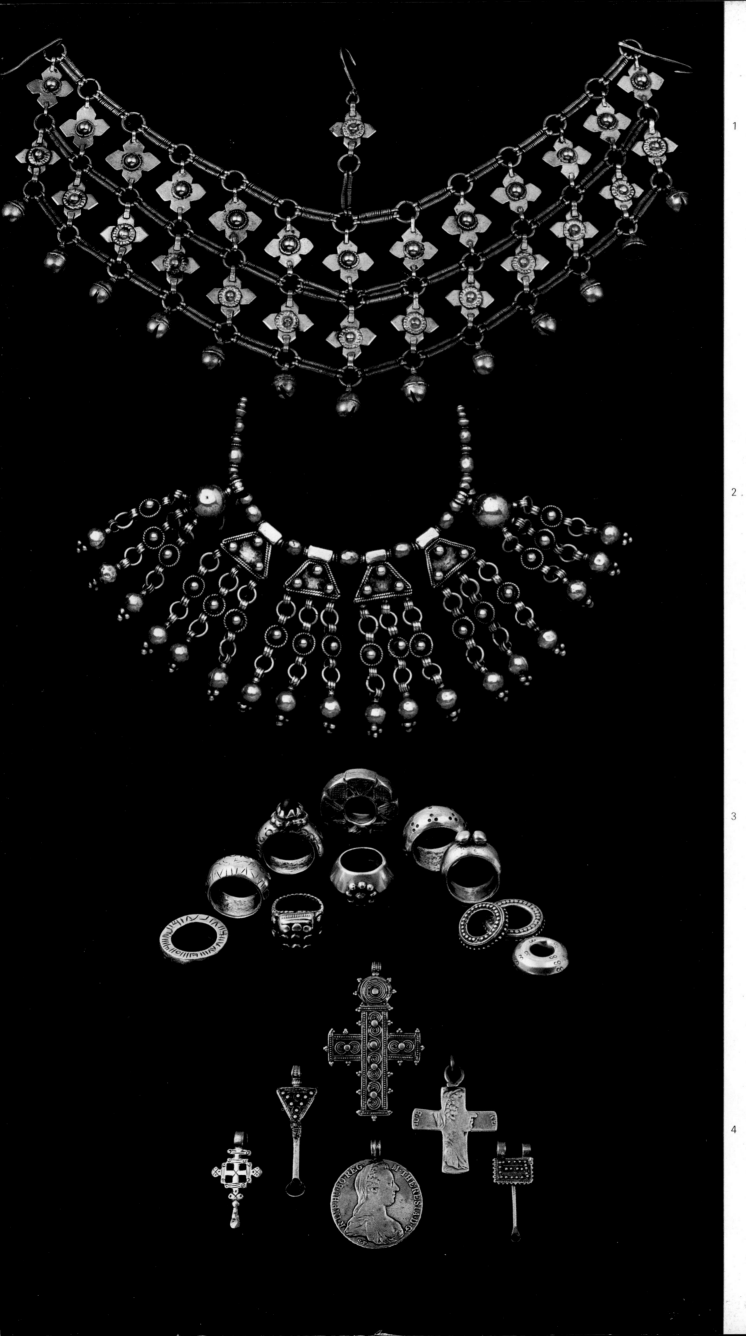

RICHES FROM THE HORN

(1) This silver trellis-work headpiece, *yerasget*, from Harer is also found in northern Yemen. (35 × 10cm)

The *argoba* necklace (2) is considered to be of pure Ethiopian origin. Made near Harer, it is distinguished from the more delicate filigree silver Hareri pieces by its simple and bold design. (22 × 9cm)

Ethiopian silver rings (3) are usually heavy and plain, some have geometrically patterned faces and just a few are set with glass or engraved with the beautiful pre-Islamic Ethiopian script, Gheez. The solid silver wedding rings with a hole too small for any finger are worn on a cotton cord round the neck. (*See pp. 294, 295*) (4cm)

(4) Some Christian crosses cast by the lost wax method were hinged to open like a box (*top*) and probably held holy relics. Others (*below, right*) were cut directly from Maria Theresa dollars, and sometimes the coin itself was used as a pendant. Silver pendants with a spoon-shaped scoop, *ku maucht*, worn by men are used for cleaning the ears; their decorated handles often incorporate the cross (*lower left*) or a box containing holy verses. (MT dollar 4cm)

A necklace of small triangular *telsum* (5) with lion's claw pendants set in silver, *tejer*, and an old coin dating from Menelik I. (Coin 4cm)

Berr koisse (6), large silver balls with appliqué design from Welo Province. Usually only two of these balls are worn, as the centrepiece of a simple glass bead necklace. (Beads 6cm)

(7) Believed to have originated in India or Oman these anklets, *mtali*, appear to have been used first in Zanzibar, Paté and Lamu to enhance the beauty of slave girls for sale in the markets — a curious history considering the value of the anklets, the weight of the silver and the craftsmanship involved. The large silver armlet at the back, one of a pair worn by Swahili brides, is decorated with enamelled glass, and also believed to be of Indian origin. (Armlet 15cm)

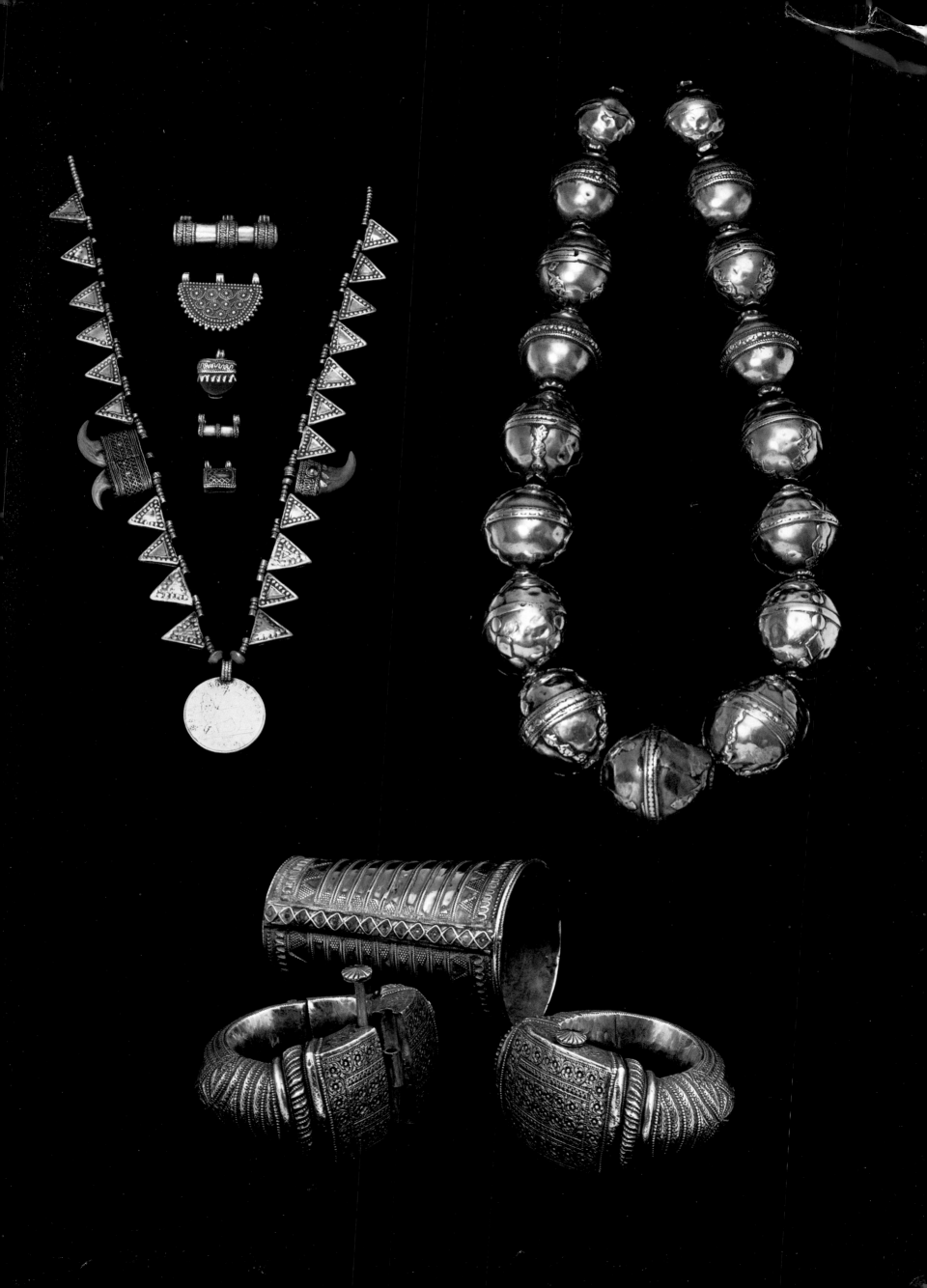

BIBLIOGRAPHY

GENERAL

Afrique, Continent Méconnu, Sélection du Reader's Digest, Paris, 1979.

Anquetil, Jacques. *Afrique Noire. L'Artisanat Créateur*, Dessain et Tolra, Paris, 1977.

Balandier, Georges and Maquet, Jacques. *Dictionary of Black African Civilization*, Leon Amiel, New York, 1974.

Brain, Robert. *The Decorated Body*, Harper & Row, New York, 1979.

Brincard, Marie-Thérèse (ed.) *The Art of Metal in Africa*, African-American Institute, New York, 1982.

Bubolz Eicher, Joanne. *African Dress*, Michigan State University Press, 1969.

Cameron, Verney Lovett. *Across Africa*, Harper & Brothers, New York, 1877.

Chesi, Gert. *The Last Africans*, Perlinger, Wörgl, 1977.

Davidson, Basil. *Africa – History of a Continent*, Weidenfeld & Nicolson, London, 1966.

Delange, Jacqueline. *Arts et Peuples de l'Afrique Noire*, Gallimard, Paris, 1967.

Ebin, Victoria. *The Body Decorated*, Thames & Hudson, London, 1979.

Fuchs, Peter. *Sudan*, Anton Schroll, Munich, 1977.

Gardi, René. *Crafts and Craftsmen*, Van Nostrand Reinhold, New York, 1969.

Gerlack, Martin (ed.) *Primitive and Folk Jewellery*, Dover Publications, New York, 1971.

Gibbs, James L. *Peoples of Africa*, Holt Rinehart & Winston, New York, 1965.

Hammerton, J. A. (ed.) *Peoples of All Nations*, Vols 1–6, Fleetway House, London, n.d.

Hoffman, Edith and Treide, Barbara. *Schmuck Fruher Kulturen*, W. Kohlhammer, Stuttgart, 1976.

Huet, Michel. *Dance, Art and Ritual of Africa*, Collins, London, 1978.

Hutchinson, Walker (ed.) *Customs of the World*, Hutchinson, London, n.d.

Jefferson, Louise E. *Decorative Arts of Africa*, Collins, London, 1974.

Joyce, T. Athol and Thomas, N. W. *Women of all Nations*, Cassell, London, 1911.

Klever, Katrin. *Exotischer Schmuck*, Mosaik, Munich, 1977.

Living Races of Mankind, introduction by H. N. Hutchinson, n.d.

Maquet, Jacques. *Afrique, Les Civilisations Noires*, Horizons de France, Paris, 1962.

'Man, the social animal. Beauty or deformity?' in *Family of Man*, Vol. 1, Part 1, Marshall Cavendish, London, 1974.

Murdock, G. P. *Africa, Its Peoples and their Cultural History*, McGraw Hill, New York, 1959.

Murray, Jocelyn. *Cultural Atlas of Africa*, Phaidon, Oxford, 1981.

La Parure dans le Monde, Musée d'Ethnographie, Geneva, 1949.

Paulme, Denise. *Women of Tropical Africa*, Routledge & Kegan Paul, London, 1963.

Paulme, Denise and Brosse, Jacques. *Parures Africaines*, Hachette, Paris, 1956.

The Secret Museum of Mankind, Manhattan House, New York.

Sieber, Roy. *African Textiles and Decorative Arts*, Museum of Modern Art, New York, 1972.

Weyer, Edward, *Primitive Peoples of Today*, Hamish Hamilton, London, 1959.

Wood, J. G. *Natural History of Man: Africa*, George Routledge & Sons, London, 1868.

CHAPTER 1

Adamson, Joy. *Peoples of Kenya*, Collins & Harvill Press, London, 1967.

Amin, Mohammed. *Cradle of Mankind*, Chatto & Windus, London, 1981.

Baxter, P. T. W. *Warfare Among the East African Herders: Boran Age Sets and Warfare*, Senri Ethnological Studies, National Museum of Ethnology, Osaka, Japan, 1979.

Beckwith, Carol and Saitoti, Tepilit Ole. *Maasai*, Hamish Hamilton, London, 1980.

Beech, M. W. H. *The Suk: Their Language and Folk Lore*, Clarendon Press, Oxford, 1911.

Butt, A. J. 'Nilotes of Anglo-Egyptian Sudan and Uganda' in *Ethnographic Survey of Africa*, International African Institute, London, 1952.

Cerulli, Ernesta. 'Peoples of south-west Ethiopia and its borderland' in *Ethnographic Survey of Africa*, International African Institute, London, 1956.

Cole, H. M. 'Visual arts in northern Kenya' in *African Arts*, Vol. 7, No. 2.

'Artistic and communicative value of beads in Kenya and Ghana' in *Bead Journal*, Vol. 1, No. 3.

Court Treat, Major C. *Out of the Beaten Track*, Dutton, New York, 1931.

Deng, Frances Mading. *The Dinka of Sudan*, Holt, Rinehart & Winston, New York, 1972.

Domville Fife, C. W. *Savage Life in Black Sudan*, Seeley Service, London, 1927.

Dyson-Hudson, Neville. 'The Turkana' in *Primitive Worlds – People Lost in Time*, Special Publications Division, National Geographic Society, Washington, n.d.

Evans-Pritchard, E. E. 'The Nuer family' in *Sudan Notes and Records*, Vol. 31, 1950.

Gulliver, Pamela and P. H. 'Central Nilo-Hamites' in *Ethnographic Survey of Africa*, International African Institute, London, 1953.

Hallpike, C. R. *The Konso of Ethiopia*, Clarendon Press, Oxford, 1967.

Hollis, Alfred Claud. *The Maasai: Their Language and Folk Lore*, Clarendon Press, Oxford, 1905.

Huntingford, G. W. B. 'The Masai' in *Ethnographic Survey of Africa*, International African Institute, London, 1953.

Howell, P. P. 'The value of iron among the Nuer', in *Man*, Vol. 67, Nos 143, 144.

Keith Jones, David. *Faces of Kenya*, Hamish Hamilton, London, 1977.

Lewis, B. A. *The Murle: Red Chiefs and Black Commoners*, Clarendon Press, Oxford, 1972.

Lienhardt, Godfrey. *Divinity and Experience: The Religion of the Dinka*, Clarendon Press, Oxford, 1961.

Lindblom, Gerald. *Fighting Bracelets and Kindred Weapons in Africa*, Smarr. Medd. Riksmus. Ethnogr. Adv., Stockholm, 1972.

Mann, Oscar. 'The Dinka' in *Nairobi Times Magazine*, December, 1977.

Nalder, Leonard Fielding. *Tribal Survey of Mongalla Province*, Oxford University Press, 1937.

Newcomer, P. J. 'The Nuer and the Dinka: an essay on origins and environmental determinism' in *Man*, Vol. 7, No. 1.

Peristiany, J. G. 'The age system of the pastoral Pokot' in *Africa*, Vol. 21.

Ricciardi, Mirella. *Vanishing Africa*, Collins, London, 1971.

Ryle, John and Errington, Sarah. *Warriors of the White Nile: The Dinka*, Time Life Books, Amsterdam, 1982.

Salvadori, Cynthia and Fedders, Andrew. *Masai*, Collins, London, 1973.

People and Cultures of Kenya, Transafrica Publications, Nairobi, 1979.

Turkana Pastoralist Craftsmen, Transafrica Publications, Nairobi, 1977.

Schneider, Harold K. 'The interpretation of Pokot visual art' in *Man*, Vol. 56, No. 108.

Schweinfurth, Georg. *Artes Africanae*, Karl W. Hiersemann, Liepzig, 1875.

Spencer, Paul. *Nomads in Alliance*, Oxford University Press, 1973.

The Samburu, Routledge & Kegan Paul, London, 1965.

Seligman G. C. and Seligman, Brenda. *Pagan Tribes of the Nilotic Sudan*, George Routledge & Sons, London, 1932.

CHAPTER 2

African Ivories [catalogue], Los Angeles County Museum of Art, 1976.

Art from Zaire, [catalogue], African-American Institute, New York, 1975.

Awe, Bolanle. 'The Asude: Yoruba jewelsmiths' in *African Arts*, Vol. 9, No. 1.

Bardon, Pierre. *Collection des masques d'or Baoule*, Institut Francais d'Afrique Noire, 1948.

Basden, G. T. *Niger Ibos*, Frank Cass, London, 1966.

Bastin, Marie Louise, *Art Decoratif Tschokwe* [catalogue], Musée de Dundo, Lisboa, 1961.

Ben-Amos, Paula. *The Art of Benin*, Thames & Hudson, London, 1980.

Bowdich, T. E. *Bowdich's Mission from Cape Coast Castle to Ashantee*, Griffith & Farrar, London, 1873.

Bradbury, R. E. 'Divine Kingship in Benin' in *Nigeria Magazine*, No. 62, 1959.

'The Benin kingdom' in *Ethnographic Survey of Africa*, International African Institute, London, 1957.

Brottem, Bronwyn V. and Lang, Ann. 'Zulu beadwork' in *African Arts*, Vol. 6, No. 3.

Burssens, H. *Les Peuplades d'Entre Congo-Ubangi*, Musée Royale d'Afrique Centrale, Tervuren, 1958.

Casady, Richard and Dorothea. 'A sample book of Western beads from 1704' in *Bead Journal*, Vol. 1, No. 1.

Cole, Herbert M. 'The art of festival in Ghana' in *African Arts*, Vol. 8, No. 3.

Cole, Herbert M. and Ross, Doran H. *The Arts of Ghana*, University of California Press, 1977.

Cornet, J. *Art of Africa: Treasures from the Congo*, Phaidon, Oxford, 1971.

de Negri, Eve. 'Ivory ornaments' in *Bead Journal*, No. 78.

'Jewellery' in *Bead Journal*, No. 74.

'The king's beads' in *Bead Journal*, No. 82.

'Yoruba women's costumes' in *Bead Journal*, No. 72.

Erickson, Joan Mowat. *The Universal Bead*, Norton, New York, 1966.

Fagg, William. *Divine Kingship in Africa*, British Museum Publications, London, 1970.

Nigerian Images, Lund Humphries, London, 1963.

Yoruba Beadwork, Art of Nigeria, Lund Humphries, London, 1981.

Fagg, William and Forman, W. and B. *Afro-Portuguese Ivories*, Batchworth Press, London, 1960.

Fischer, Eberhard and Himmelheber, Hans. *Die Kunst der Dan*, Museum Rietberg, Zürich, 1976.

Gold aus West Afrika, Museum fur Völkerkunde, Zürich, 1975.

Forman, W. and Dark, P. *Benin Art*, Hamlyn, London, 1960.

Frobenius, Leo. *The Voice of Africa*, Hutchinson, London, 1913.

Gebauer, Paul. *Art of Cameroon* [catalogue], Metropolitan Museum, New York, 1972.

Gordon, Albert F. Leonard and Kahan. *The Tribal Bead*, Tribal Arts Gallery, New York, 1976.

Himmelheber, Hans. 'Gelboussringe der Guéré (Elfenbeinkuste)' in *Tribus*, Vol. 13.

Jacob, Alain and Heeckeren, Axel de. *Poteries et Ivoires de l'Afrique*, ABC Décor, Paris, 1977.

Jeffreys, M. D. W. 'The Bamun coronation ceremony as described by King Njoya' in *Africa*, Vol. 20, No. 50.

Jewellery Through 7,000 Years, British Museum Publications, London, 1976.

Johnson, Harry. *George Grenfell and the Congo*, Hutchinson, London, 1908.

Jones, G. I. 'Native and trade currencies in southern Nigeria' in *Africa*, Vol. 28.

Kalous, Milan. 'Powder glass *bodom* beads' in *African Arts*, Vol. 12, No. 3.

Lamb, Alistair. 'Krobo powder-glass beads' in *African Arts*, Vol. 9, No. 3.

'Some seventeenth-century glass beads from Ghana, West Africa' in *Bead Journal*, Vol. 3, No. 4.

Levinsohn, Rhoda. 'Ndebele beadwork' in *Bead Journal*, No. 2.

Lloyd, P. C. 'The Yoruba of Nigeria' in *Peoples*

of Africa, (Ed.) James L. Gibbs, Holt, Rinehart & Winston, New York, 1965.
McCulloch, Meran and others: 'Peoples of the Central Cameroons' in Ethnographic Survey of Africa, International African Institute, London, 1954.
McLeod, M. D. 'Gold weights of the Asante' in African Arts, Vol. 5, No. 1.
The Asante, British Museum Publications, London, 1981.
Meek, Charles Kingsley. The Northern Tribes of Nigeria, Oxford University Press, 1925.
Nicolaisen, Johannes. Art of Central Africa, National Museum of Denmark, 1972.
Niegue, Jocelyne Etienne. Crafts and the Arts of Living in Cameroon, Louisiana State University Press, 1982.
Northern, Tamara. The Sign of the Leopard: Beaded art of the Cameroon [catalogue], Linden Museum, Stuttgart, 1975.
Nzekwu, Onuora. 'Ibo peoples' costumes' in Nigeria Magazine, No. 78.
Penniman, T. K. Pictures of Ivory and other Animal Teeth, Bone and Antler, Oxford University Press, 1952.
Plass, Margaret Webster. African Miniatures: the Goldweights of the Ashanti, Lund Humphries, London, 1967.
Metal casting in the Guinea Coast: Lost Wax [catalogue], ICA, London, 1957.
Quiggin, A Hingston. A Survey of Primitive Money, Methuen, London, 1949.
Ratton, Charles. Fetish Gold, University Museum, Philadelphia, 1975.
Rattray, R. S. Religion and Art in Ashanti, Oxford University Press, 1969.
Ross, Doran H. 'The iconography of the Asante sword ornaments' in African Arts, Vol. 11, No. 1.
Schweinfurth, Georg. The Heart of Africa, trs. Ellen E. Frewer, Harper & Brothers, New York, 1874.
Shaw, Thurston. Analysis of West African Bronzes, University of Ibadan, Nigeria, 1970.
Talbot, P. A. The Peoples of Southern Nigeria, Oxford University Press, 1926.
Traditional African Metal Works, F. Rolins, New York, 1977.
Tyrrell, Barbara. Tribal Peoples of South Africa, Gothic Printing Co., Cape Town, 1968.
van de Sleen, W. G. N. A Handbook of Beads, Liège Musée de Verre, 1967.
Ward, Herbert. Voice from the Congo, Heinemann, London, 1910.
Warren, D. M. 'Bono royal regalia' in African Arts, Vol. 8, No. 2.
Williamson, George C. The Book of Ivory, Frederick Muller, London, 1938.
Yoruba Religious Cults [catalogue], British Museum Publications, London, 1974.

CHAPTER 3

Art of Upper Volta [catalogue], University Art Museum, Texas, 1976.
Arts de la Côte d'Ivoire [catalogue], Musée des Beaux-Arts, Vevey, 1969.
Ashanti Goldweights and Senufo Bronzes [catalogue], Art Gallery de Notre Dame, Indiana, 1970.
Barbot, John. A Collection of Voyages and Travels, London, 1732.
Bronzes de Ouagadougou [catalogue], Direction des Affaires Culturelles, Upper Volta, 1976.
Forde, Daryll and Kaberry, Phyllis, M (Eds.) West African Kingdoms in the Nineteenth Century, International African Institute, Oxford University Press, 1971.
Fortes, M. 'The authority of ancestors' in Man, Vol. 16, No. 2.
Gauthier, J. G. Les Falis de Ngòutchoumi, Holland Anthropological Publications, 1969.
Glaze, Anita J. 'Senufo ornament and decorative arts' in African Arts, Vol. 12, No. 1.
'Women, power and art in a Senoufo village' in African Arts, Vol. 8, No. 3.
Griaule, Marcel. Conversations with Ogotemelli, International African Institute, Oxford University Press, 1965.
Griaule, Marcel and Dieterlen, Germaine. 'The Dogon' in African Worlds, (Ed.) Daryll Forde, Oxford University Press, 1954.
Imperato, Pascal James. The Dogon Cliff Dwellers – The Art of Mali's Mountain People [catalogue], L. Kahan Galley, New York.
Lembezat, B. Kirdi: Les Populations Païennes du Nord, Douala, Cameroun, 1950.
Leuzinger, Elsy. Die Kunst von Schwarz Africa, Aurel Bongers, Recklinghausen, 1972.
Kamer, Henri. Haute Volta [catalogue], Studio 44, Paris, 1973.
Liu, Robert K. 'Spindle whorls – some comments and speculations' in Bead Journal, Vol. 3, No. 3.
Lobi Sculpture [catalogue], Craft Caravan, New York, 1980.
Meyer, Piet. Kunst und Religion der Lobi, Museum Rietberg, Zürich, 1981.
Muraz, G. 'Les cache-sexe du centreafrique', Journal de la Société des Africanistes, Paris, 1932.
Nesmith, Fisher H. 'Dogon bronzes' in African Arts, Vol. 12, No. 2.
Paulme, Denise. 'Dogon: Mali, Volta' in Peoples of the Earth, Robert B. Clarke, London, 1973.
Pern, Stephen. Masked dances of West Africa: the Dogon, Time Life Books, Amsterdam, 1982.
Savage, Henry and Landor, A. Across Wildest Africa, Scribners, New York, 1907.
Smith, W. M. Hovey. 'Kirdi brass jewellery' in Bead Journal, Vol. 4, No. 1.
Soothsayer Bronzes of the Senoufo [catalogue] by Eric de Kolb, Gallery d'Hautbarr, New York.
Wente-Lucas, Renate. Die Materielle Kultur der nicht-Islamischen Ethien von Nord Kamerun und Nordost Nigeria, Franz Steiner, Weisbaden, 1977.

CHAPTER 4

Appia-Dabit, Beatrice. 'Notes sur quelques bijoux sénégalais', Institut Francais d'Afrique Noire, Vol. 5, Nos 1–4, Paris, 1943.
Baring, Andrew. 'Fulani: Sudanic Africa' in Peoples of the Earth, Robert B. Clarke, London, 1973.
Beckwith, Carol and van Offelen, Marion. Nomads of Niger, Collins, London, 1984.
Brandt, Henry. Nomades du Soleil, 1956.
de St Croix, F. W. The Fulani of Northern Nigeria, Government Printers, Lagos, 1945.
Delmond, P. 'Dans la bouche de Niger: Dori, ville peuple' Institut Francais d'Afrique Noire, Dakar, 1953.
Dubois, Felix. Timbuctoo, the Mysterious, (trs.) Diana White, Heinemann, London, 1897.
Dupire, Marguerite. 'La place du commerce et des marchés dans l'economie des Bororo (Fulbe) nomades de Niger', Institut Francais d'Afrique Noire, Niger, 1961.
'Peuls Nomades', Institut d'Ethnologie, Université de Paris, 1962.
Riesman, Paul. Freedom in Fulani Social Life, University of Chicago Press, 1977.
Rouch, Jean. Les Songhay, Presses Universitaires de France, Paris, 1954.
Spicer, E. The Peoples of Nigeria, Longman, Nigeria, 1962.
Stenning, Derrick J. Savannah Nomads, Oxford University Press, 1959.
Vieillard, G. Notes sur les coutumes des Peuls au Fouta Djallon, Librairie de la Rose, Paris, 1939.
Zeltner, Francois. 'La bijouterie indigène en Afrique occidentale', Journal de la Société des Africanistes, Paris, 1931.

CHAPTER 5

Caillée, René. Travels through Central Africa to Timbuctoo and Across the Great Desert to Morocco, Colburn and Bentley, London, 1830.
Creyaufmüller, Wolfgang. Völker der Sahara: Mauren und Tuareg, Linden Museum, Stuttgart, 1979.
Donne, J. B. 'North African jewels' in the Antique Collector, Vol. 2, 1978.
Gabus, Jean. Au Sahara; Arts et Symboles, Editions de la Bacconière, Neuchatel, 1958.
Oulata et Gueimare des Nemadi, Musée d'Ethnographie, Neuchatel, 1976.
Gardi, René. Sahara, Harrap, London, 1971.
Hall, Leland. Timbuctoo, The Cresset Press, London, 1934.
Kirtley, M. and A. 'The inaden and artisans of the Sahara' in National Geographic, Vol. 156, No. 2.
Liu, Robert K. 'T'Alhakimt, a Tuareg ornament' in Bead Journal, Vol. 3, No. 2.
Mickelsen, M. R. 'Tuareg jewellery' in African Art, Vol. 9, No. 2.
Schmuck aus Nord Afrika, Linden Museum, Stuttgart, 1976.
Slavin, Kenneth and Judy. The Tuareg, Gentry Books, London, 1973.
Swift, Jeremy. 'Tuareg' in Peoples of the Earth, Robert B. Clarke, London, 1973.
Touareg Ahaggar, Collections Ethnographiques, Arts et Métiers Graphiques, Paris.

CHAPTER 6

Bernès, J. B. and Jacob, Alain. Armes Bijoux, Céramiques du Maroc, ABC Décor, Paris, 1974.
Bertrand, André. Tribus Berbères du Haut Atlas, Edita Vilo, Paris, 1977.
Besancenot, Jean. Bijoux Arabes et Berbères du Maroc, Editions de la Cigogne, Casablanca, 1939.
Bijoux Berbères du Maroc [catalogue], Galerie de L'Orfèvrerie, Paris, 1947.
Camps-Fabrer, Henriette. Les Bijoux de Grande Kabylie, Arts et Métiers Graphiques, Paris, 1970.
Champault, D. and Verbrugge, A. R. La Main, Musée National d'Histoire Naturelle, Paris, 1965.
'Etudes, notes et documents sur le Sahara occidental', VII Congrès de l'Institut des Hautes Etudes Marocaines, Paris, 1930.
Eudel, Paul. Dictionnaire des Bijoux de l'Afrique du nord, Ernest Leroux, Paris, 1906.
Flint, Bert. Bijoux Amulettes, Vol. I, EMI, Tangier, 1973.
Goudard, J. 'Bijoux d'argent de la tache de Taza', VI Congrès de l'Institut des Hautes Etudes Marocaines, Paris.
Heber, J. Notes sur l'Influence de la bijouterie soudanaise sur la bijouterie Marocaine, Typographia del Senato, Rome.
Liu, Robert K. and Wataghani, Liza. 'Moroccan folk jewellery' in African Arts, Vol. 8, No. 2.
Lyazidi, Rachid. Les Provinces du Maroc, Impressions Iberdos SA, Madrid, 1980.
Morris Bende, Mireille. Le Maroc Etincelant, Editions Marcus, Paris.
Ossendowski, Ferdinand. The Fire of Desert Folk, (trs.) Lewis Stanton Palin, George Allen & Unwin, London, 1926.
Sugier, Clemence. Bijoux Tunisiens: Formes et Symboles, Editions Ceres, Tunis, 1977.
Westermark, Edward. Ritual and Belief in Morocco, Macmillan, London, 1926.

CHAPTER 7

Allen, J. de V. Lamu Town, Rodwell Press, Kenya.
Allen, Jamey D. 'Amber and its substitutes: historical aspects', in Bead Journal, Vol. 2, No. 3.
'Amber and its substitutes: is it real?' in Bead Journal, Vol. 3, No. 1.
'Amber and its substitutes: mineral analyses' in Bead Journal, Vol. 2, No. 4.
Anglo-Egyptian Sudan, HMSO, London, 1920.
Buxton, David. The Abyssinians, Thames & Hudson, London, 1970.
Hamilton, J. A. de Courcy. The Anglo-Egyptian Sudan from Within, Faber & Faber, London, 1935.
Hawley, Ruth. Omani Silver, Longmans, London, 1978.
Huntingford, G. W. B. 'The Galla of Ethiopia: the Kingdoms of Kaffa and Janeira' in Ethnographic Survey of Africa, International African Institute, London, 1955.
Kay, Shirley. The Bedouin, David & Charles, Newton Abbot, 1978.
Korabiewicz, W. The Ethiopian Cross, Holy Trinity Cathedral, Addis Ababa, n.d.
Lewis, I. M. 'Peoples of the Horn of Africa' in Ethnographic Survey of Africa, International African Institute, London, 1955.
McKay, Roger. 'Ethiopian Jewellery' in African Arts, Vol. 7, No. 4.
Pankhurst, Richard. 'The old time handicrafts of Ethiopia with a note on national dress' in Ethiopia Observer, Vol. 8, No. 3.
Paul, Andrew. A History of the Beja Tribes of the Sudan, Oxford University Press, 1954.
Trimingham, J. Spencer, Islam in the Sudan, Oxford University Press, 1949.
von Eike Haberland. Völker Sud-Athiopiens, W. Kohlhammer, Stuttgart, 1959.
Williamson, George C. The Book of Amber, Ernest Benn, London, 1932.

CREDITS TO PHOTOGRAPHERS
AND COLLECTIONS

PHOTOGRAPHERS OF FIELD SUBJECTS

Angela Fisher: Back cover, 12, 18–32, 40, 41, 44–7, 50–7, 59–61, 62 (1), 72–5, 78, 79, 86–8, 90 (above), 92, 97, 106, 112, 113, 115 (above right), 116 (above), 118–23, 128–33, 134 (top left, below right and left), 135, 136 (above right and below), 137, 139 (below), 144, 150–65, 167, 168, 169 (above), 170, 173–6, 178–81, 184–7, 190, 196–200, 202–6, 208, 210, 213, 215–21, 223, 226, 232–40, 242–8, 250, 252–9, 272–4, 276–82, 286, 288, 290, 292–6.

Fabby K. J. Nielsen: Cover and frontispiece, 33, 34, 42, 48, 49, 58, 84, 90 (below), 91, 93, 94, 96, 114, 116 (below), 125–7, 134 (top right), 138, 139 (above centre), 166, 169 (below), 171, 172, 177, 182, 183, 201, 207, 209, 214, 266, 275, 284, 287, 289.

John Hawkins: 36–9, 283, 286, 291.

George Zaloumis: 35, 43

Jon Arensen: 55.

Werner Forman: 81.

Metropolitan Museum of Art, New York: 82.

Jean Morris: 100.

Zefa Picture Library (UK) Ltd: 136.

Annie Brumbaugh: 261.

PHOTOGRAPHERS OF COLLECTION PIECES

Heini Schneebeli: 33, 36, 42, 56, 57, 62 (4), 63 (6 & 7), 64 (1, 3, 4 & 5), 65 (6 & 8), 75, 80 (3 & 4), 85 (2 & 4), 101 (4), 102 (top left, bottom right), 115, 127 (centre, bottom right), 143 (8 & 9), 174, 175, 207, 208, 211, 212, 214, 217, 218, 222, 225, 241, 242, 246, 249, 257, 259, 262 (1, 3 & 5), 263 (9), 264 (11, 12 & 14), 265 (16), 276, 278, 279, 283, 289, 291, 296–9.

Bruno Piazza: 62 (2 & 3), 63 (5), 64 (2), 65 (7), 66, 74, 76, 77, 79, 80 (1, 2, 5 & 6), 81, 83, 85 (1, 3, 5, 6 & 7), 87, 88, 89, 93, 95, 98, 99, 100 (2 & 3), 101 (5), 102 (top right, middle left and right, bottom left), 103–5, 117, 124, 127 (centre, bottom left), 128, 140–2, 143 (10), 188, 189, 224, 251, 260, 262 (2 & 6), 263 (7, 8 & 10), 264 (13), 265 (15).

Fabby K. J. Nielsen: 262 (4), 293, 295.

JEWELLERY COLLECTIONS

33 Collection: Fisher except central earrings: Anschel.

36 Collection: Fisher.

42 Collection (1, 3, 4, 5, 6) Fisher; (2) Anschel.

56 Collection: Fisher.

57 Collection: Fisher.

62/3 Wrist knife (2) Private Collection; rings (3) Private Collection; wrist knife (4) Fisher; arm ornament (5) Private Collection; headpiece (6) Lipton; snuff containers (7) Anschel.

64 Bracelet (1) Lipton; bracelet (2) Ghysels; armlet (3) Anschel; armlet (4) Lipton; armlets (5) Anschel; finger ring (6) Fisher; lip plugs (7) Jernander; armlets (8) Anschel (large) Fisher (others).

74 Necklace: Musée Royale d'Afrique Centrale, Tervuren.

75 Collection: Anschel.

76 Masks (1, 2, 6) Gillion Crowet; (3, 4) Mestach; (5) Musée Royale d'Afrique Centrale.

77 Collection: Gillion Crowet.

79 Hairpins (1, 4) Private Collection; (2, 5 and pendant) Musée Royale d'Afrique Centrale; (3) Jernander.

80 Bracelets (1) Bronsin; (2) Gillion Crowet; (3, 4) Anschel; (5, 6) Ghysels.

81 Bracelet: British Museum, London.

82 Belt mask: Metropolitan Museum, New York.

83 Pendant: Private Collection.

85 Collars (1, 5) Musée Royale d'Afrique Centrale; (2, 4) Anschel; (3) Guisson; (6, 7) Private Collection.

87 Mask pendants: Private Collection; ring and central pendant: Mestach; lower pendant: Private Collection.

88/9 Anklets: (1, 5) Gillion Crowet; (3, 7, 8, 9) Private Collection; (6) Ghysels; armlet (4) Ghysels.

93 Necklaces: (1, 3) Private Collection; (2) Mestach.

95 Mask pendant (top left) Gillion Crowet; pendants (top right, bottom left and right) Private Collection.

98 Collection: Gillion Crowet.

99 Collection: Gillion Crowet.

100/1 Necklaces (2, 3) Ghysels; apron (4) Anschel; apron (5) Loos.

102 Necklace (top left) Lipton; beads (top right) Anschel/Fisher; apron (middle left) Anschel; necklace (middle right) Anschel; ornament (bottom left) Musée Royale d'Afrique Centrale; necklaces (bottom right) Anschel.

103 Bead hoops (top) Anschel; whistle (left) Jernander; arm pendant (centre) Private Collection; hairpin (right) Jernander.

104/5 Armlets (1, 2, 4) Private Collection; armlet (3) Anschel; pendant (5) Mestach; bracelet (6) Anschel; bracelet (7) Ghysels; ring (8) Ghysels; pendant (8) Jernander; bracelet (8) Fisher.

115 Spindle whorls: Fisher; bracelet (1) and anklet (3) Fisher; bracelet (2) Eskenasy; necklace: Lipton.

117 Rings (1, 8) Mestach; (2, 5, 6) Itzikovitz; (3) Private Collection; (7) Jernander; (9) Musée Royale d'Afrique Centrale.

124 Anklet (1) Private Collection; pendant (2) Ghysels; pendant (3) Itzikovitz.

127 Figurines: (centre) Mestach; (bottom left) Private Collection; (bottom right) Lipton.

128 Pendant: Itzikovitz; rings: Private Collection.

140/1 Arm ring (1) Itzikovitz; pendant (2) Private Collection; ring (3) Private Collection; pendant (4) Itzikovitz; pendant (5) Mestach; bracelet (6) Ghysels; bracelet (7) Itzikovitz; ring (8) Private Collection.

142/3 Bracelet (1) Jernander; pendant (2) Jernander; pendant (3) Private Collection; bracelet (4) Ghysels; bracelet (5) Gillion-Crowet; bracelet (6) Anschel; snuff ring (7) Private Collection; armlets (8) Anschel; bracelet (9) Lipton; ring (10) Ghysels; whistle: Ghysels; pendant: Jernander.

174/5 Rings: Fisher except (3, 4) Anschel.

188/9 Bracelets and necklaces (1, 2, 4, 5, 6) Fisher; anklets (3) Ghysels.

207 Collection: Fisher.

208 Boxes: (1) Church; (3, 4) Fisher; pendant (2) Fisher.

211 Collection: Fisher.

212 Earrings and upper two necklaces: Fisher; lower necklace: Church.

214 Collection: Fisher.

217 Collection: Anschel.

218 Collection: Fisher.

222 Collection: Fisher.

224/5 Pendants (1–4, 6–10) Fisher; (9) Anschel; anklets (5) Ghysels.

241 Collection of hands: Fisher; except (3) Ghysels.

242 Collection: Fisher.

246 Collection: Fisher.

249 Collection: Fisher.

251 Collection: Ghysels.

257 Collection: Fisher.

259 Collection: Fisher.

260 Collection: Ghysels.

262/3/4 Bracelets (1) Fisher; bracelets (2) Ghysels; anklet (3) Anschel; kohl container (4) Fisher; bracelet (5) Fisher; bracelets (6) Ghysels; earrings (7) Ghysels; fibula (8) Ghysels; earrings (9) Fisher; earrings (10) Ghysels; collar (11) Lipton; necklace (12) Fisher; choker (13) Ghysels; ear ornaments (14) Fisher; necklace (15) Ghysels; necklaces (16) Anschel/Fisher.

276 Collection: Fisher.

278 Collection: Fisher.

279 Collection: Fisher except central anklet: Anschel.

283 Collection: Fisher.

287 Jewellery collection: Fort Jesus Museum, Mombasa; silver belt (right) Botchinskie; jewellery chest: Omari Bwana.

289 Collection: Fisher.

291 Collection: Fisher.

293 Collection: Fisher.

295 Collection: Fisher.

297 Collection: Fisher.

298/9 Collection: Fisher, except armlet and anklets (7) Anschel.

INDEX